AMERICAN FURNITURE WITH RELATED DECORATIVE ARTS

THE MILWAUKEE ART MUSEUM AND THE LAYTON ART COLLECTION

# AMERICAN FURNITURE

*with Related Decorative Arts*

1660–1830

❧

## THE MILWAUKEE ART MUSEUM
## AND THE LAYTON ART COLLECTION

BROCK W. JOBE · THOMAS S. MICHIE

JAYNE E. STOKES · ROBERT F. TRENT

ANNE H. VOGEL · PHILIP D. ZIMMERMAN

EDITED BY GERALD W. R. WARD

HUDSON HILLS PRESS

*New York*

FIRST EDITION © 1991 BY MILWAUKEE ART MUSEUM, INC.

All rights reserved under International and Pan-American Copyright Conventions.
Published in the United States by Hudson Hills Press, Inc.,
Suite 1308, 230 Fifth Avenue, New York, NY 10001-7704.

Distributed in the United States, its territories and possessions,
Canada, Mexico, and Central and South America by Rizzoli International Publications, Inc.
Distributed in the United Kingdom and Eire by Shaunagh Heneage Distribution
Distributed in Japan by Yohan (Western Publications Distribution Agency).

EDITOR AND PUBLISHER: PAUL ANBINDER

PROOFREADER: LYDIA EDWARDS

INDEXER: GISELA S. KNIGHT

DESIGNER: HOWARD I. GRALLA

COMPOSITION: U.S. LITHOGRAPH, TYPOGRAPHERS

*Manufactured in Japan by Toppan Printing Company*

LIBRARY OF CONGRESS CATALOGUING-IN-PUBLICATION DATA

Layton Art Collection.
    American furniture with related decorative arts, 1660–1830 /
the Milwaukee Art Museum and the Layton Art Collection   ;
Brock W. Jobe . . . [et al.]   ;   edited by Gerald W.R. Ward — 1st ed.
        p.      cm.
    Catalogue of the Layton Art Collection's holdings.
    Includes bibliographical references (p.      ) and index.
    ISBN 1-55595-068-X
    1.   Furniture—United States—Catalogues.    2.   Furniture—Wisconsin—
Milwaukee—Catalogues.      3.   Decorative arts—United States—Catalogues.
4.   Decorative arts—Wisconsin—Milwaukee—Catalogues.      5.   Layton Art
Collection—Catalogues.    I.   Jobe, Brock W.      II.   Ward, Gerald W.R.
III.   Milwaukee Art Museum.      IV.   Title.
NK2406.L38      1991
749.213'074'77595—dc20                                                    CIP
        Library of Congress Catalogue Card Number: 91-71554

FRONTISPIECE:
Desk and bookcase, Boston, Massachusetts, 1735–40 (cat. 45)

# CONTENTS

# COLORPLATES

# FOREWORD

THE PUBLICATION of this catalogue of the collection of American decorative arts and related collections of the seventeenth to early nineteenth centuries marks a significant milestone for the Milwaukee Art Museum. Although the museum celebrated the one hundredth anniversary of the founding of its predecessor institution, the Layton Art Gallery, in 1988, for most of that period the museum did not have a publication of its collections. In 1986, just two years before its centennial celebration, the Milwaukee Art Museum published its *Guide to the Permanent Collection*. Highlighting some three hundred objects reflecting the entire range of the collection, the *Guide* was intended as an introduction to the holdings of the museum. It was the plan at that time for specific areas of the collection to receive extensive scholarly study resulting in catalogue publications fully documenting all objects within a given medium, period, and style.

Happily, the plan coincided with one already being formed by the Layton Art Collection, the corporate continuation of the Layton Art Gallery within the structure of the Milwaukee Art Museum. The commitment of the Layton Board of Trustees and its President, Frederick Vogel III, fit precisely within the plan for more in-depth studies of aspects of the collection. The present catalogue represents not only the expertise and dedication of all of its authors, but also the extraordinary commitment of the Layton Art Collection Board and its President to achieve the first scholarly catalogue of a broad area of the Milwaukee Art Museum collection. This publication will serve as a standard for future endeavors.

The American decorative arts have a long history at the Milwaukee Art Museum. Although decorative arts were not a part of the collection of the founding Layton Art Gallery, objects of European and American decorative arts did begin to enter the collection of the museum's other predecessor institution, the Milwaukee Art Institute, in the 1930s. In 1935 a bequest of Ida Zenecia Riester brought eighty-eight pieces of

Wedgwood ceramics into the collection, followed in 1941 by the Edgar J. Hughes Memorial Collection of Oriental porcelain, given by Mrs. E. J. Hughes. In 1948 one of the most significant events in the development of the decorative arts at the museum occurred with the founding of the Collectors' Corner at the Milwaukee Art Institute. This group of very dedicated women formed the organization with the following goal among their purposes: "to promote interest in collection in the field of the decorative arts." The Collectors' Corner made its first gift to the museum in 1958 and has followed with more than nineteen acquisitions ranging from silver to needlework. All of the Collectors' Corner acquisitions are included in this publication.

In 1957 the Milwaukee Art Center was formed by the merger of the Layton Art Collection and Milwaukee Art Institute. The first decorative arts exhibition at the new Art Center was "Vignettes of the Eighteenth Century in America," cosponsored by the National Society of the Colonial Dames and largely organized by Mr. and Mrs. Stanley Stone. In 1967 Mrs. John J. Curtis donated her home to the Art Center. Called Villa Terrace, it became the decorative arts branch of the museum. A committee headed by museum trustee Dudley J. Godfrey, Jr., set a goal to furnish the wings of the house with period-type rooms creating a history of American design from 1650 to 1810. With a new wing added to the Art Center in 1975, the decision was made to house the primary decorative arts collection within the quadrupled space of the new building. From that time to the present, the American decorative arts have become one of the most distinguished collections and one of the strongest exhibition programs at the museum.

A significant impetus for building a major collection of American decorative arts came in 1972 with the Layton Art Collection's decision to shift its emphasis from the collection of American paintings to American furniture and decorative arts of the kind used in

American homes of the period. Thus, English silver, European glass, and Oriental porcelains joined the American works of the colonial and federal periods as the focus of attention. The Layton Art Collection has made a very significant group of acquisitions in the intervening years, joining with Collectors' Corner, the Friends of Art of the museum, and various private donors in creating a distinctive collection. Of particular significance in this development of the American decorative arts collection have been Frederick Vogel III, President of the Layton Art Collection since 1972, and his wife Anne, Dudley and Constance Godfrey, and Robert and Virginia Krikorian. Each of these dedicated supporters has lent his or her distinctive talents to the leadership of developing the collection, its display, and its various exhibitions. Robert and Virginia Krikorian particularly have been generous in providing numerous gifts over the years. The gallery of decorative arts from the federal period bearing their name was dedicated in 1988.

Since 1985 the museum has also expanded its interests into the American decorative arts of the nineteenth century through funds provided by the bequest of Mary Jane Rayniak in 1980 and into international designs of the twentieth century with the support of InterPlan Office Products, Inc., and several individual donors. In 1979 the museum's first full-time curator of the decorative arts was added to the staff, a position now filled by Jayne E. Stokes, Assistant Curator of Decorative Arts. Numerous major exhibitions of decorative arts have been presented through the years including "American Furniture from Milwaukee Collections" (1966), "Silver in American Life" (1980), "The Domestic Scene: George M. Niedecken" (1981), and "Bent Wood and Metal Furniture" (1987), along with a continuing series of smaller decorative arts exhibitions often drawn from the museum and Milwaukee-area collections. The entire American decorative arts collection was fully reinstalled in 1988 as part of the centennial year program. Most recently, the Art Museum has established an endowed American Heritage Fund for the acquisition of American painting and decorative arts from the colonial period to 1900. The fund, in fact, was initiated in 1979 with a generous gift from Fred and Anne Vogel. All this points to a significant program in the decorative arts, one that received its early impetus from the Collectors' Corner, the Layton Art Collection, and the

vision of several individuals. This publication is a tribute to all that they have achieved.

Of all those whom I would like to acknowledge upon the realization of this publication, I must first cite Frederick Vogel III. As President of the Layton Art Collection for nearly twenty years, he has helped to set the direction of the decorative arts collection in the museum, and his vision and his involvement are directly responsible for this catalogue. His contribution to the American decorative arts collection cannot be measured, but this publication reflects the extraordinary contribution his leadership has provided during the last two decades. Also I must express my gratitude to Anne Vogel, Dudley and Constance Godfrey, and Robert and Virginia Krikorian, who have given so much thought, effort, and direction to the development of the collection since its earliest years. To all the presidents and members of the Collectors' Corner must go our sincere appreciation for the continuity and strength of their efforts for the collection and for offering education about the decorative arts to the community for more than forty years.

Barbara Brown Lee, Director of Education, has served as both Curator of Decorative Arts and acting curator for much of her twenty-five years at the museum. She must be acknowledged as the thread that has bound many of the efforts together within the museum during that period. Since her appointment in 1988, Jayne Stokes has been instrumental in the reinstallation of the collection and in both the research and logistics for this publication.

Finally, I would like to thank all the individuals who have contributed to the growth of the decorative arts collection since its inception and to all the persons whose financial support and scholarly efforts have made this catalogue possible. Without the dedication of so many, the Milwaukee Art Museum could not proceed in its efforts both to build collections of national significance and to publish them in an educationally sound manner. To all the supporters of the American decorative arts at the Milwaukee Art Museum, I offer my deepest appreciation and admiration for the development of this significant collection and this publication that honors it.

RUSSELL BOWMAN
*Director*
*Milwaukee Art Museum*

# PREFACE

IT IS with a great deal of personal pride that I contemplate the completion of this catalogue of the American decorative arts in the collection of the Milwaukee Art Museum and Layton Art Collection. Not so much pride in personal accomplishment, but pride in an institution's growth and maturity of purpose over a relatively small number of years. I would be dishonest not to admit to a personal sense of satisfaction in seeing this achieved, but that is a human frailty reserved for those present at the conception.

Many years ago, on numerous occasions, I discussed with Dudley Godfrey, Robert Krikorian, and Frederick Vogel, the triumvirate of the American wing, my thoughts on its installation and philosophy. My credentials were beyond question, having viewed myself as a professional exhibition goer, the result of trudging through miles of galleries over a long period of years and evaluating the efforts of some of the best minds in the museum field. That my conclusions were not totally mine alone is not important, but I perceived the period room as no longer necessarily being a valid means for the appreciation of the interrelationship of the architecture, the furniture, the paintings, and the accessories of a given time period. In this atmosphere, the objects seemed frozen in time, visually dependent on one another, and even if presented in a scholarly installation with appropriate lighting, almost impossible to see clearly and to study. From a far more practical viewpoint, the period room required tremendous quantities of material related in date as well as in regional qualities. In a new museum this would be an unaffordable luxury. Furthermore, I was motivated by a desire to see American furniture treated as an art form and not as merely functional furniture forms vindicated by rarity, singularity of scale, or collector popularity. I visualized the pieces on pedestals, properly bathed in light where the artistic success of each would become self-evident. The lines and proportions as well as the specific type of ornamentation could be studied at leisure, appreciated, and evaluated. The gallery would be developed chronologically, beginning with the Pilgrim century and continuing through the Empire period. To enhance our appreciation and understanding, the furniture would be supplemented and complemented by paintings and accessories of similar quality of the same period in time, as well as by architectural statements made through graphic presentation.

I was sufficiently convincing to be asked to participate in the development of the American gallery at the Milwaukee Art Museum and the work was begun. The nucleus of material initially available consisted of a small collection formed by the members of the Collectors' Corner and through museum acquisitions. To open, a few dedicated Milwaukee collectors loaned those pieces essential to establish the story line, some of which later became permanent gifts. Frederick Vogel took on the ultimately rewarding but often frustrating task of securing long-term loans of objects from other institutions, museums, and interested friends. As funds and appropriate pieces became available, they were acquired to replace loan items. The Layton Collection annually searched out important additions to the collection and acquired them for permanent display. One of the first major acquisitions was the elaborate late Georgian entrance doorway (cat. 78) from a house in Bristol, Rhode Island, which seemed most appropriate for setting the tone of and introducing the student to the collections.

The initial (1975) installation required that the pieces be placed on pedestals of uniform height that would be comfortable to the viewer while retaining a convincing utilitarian relationship with each furniture form. The pedestals would provide sufficient "breathing space" to permit each piece to be viewed independently of the objects around it, but would allow for a constant awareness of the overall statement made by each object within the gallery. The geometric overtones of the Pilgrim century are quite evident in the

joiner's handling of the rectilinear forms occasionally relieved by the art of the turner with applied or molded ornamentation. This style reflects the rather archaic heritage of the Founding Fathers and not infrequently the severe lifestyle of the first settlers. The William and Mary style continues the use of the rectilinear mode, but refines it with more skillfully composed and executed turnings and adds embryonic carving of Flemish scrolls and broad, stylized leafage, and introduces surfaces of richly figured veneers. The apparent functionalism that dictated seventeenth-century design is finally abandoned in the Queen Anne style when the rectilinear line becomes subordinate to the curvilinear and the cyma curve becomes the major ingredient of furniture design. The scrolls of high chests and cabriole legs are not merely extensions of these pieces but are homogeneous movements carefully integrated into the whole. Exotic veneers and baroque carved, inlaid, or gilded shells stimulate our visual senses, but they are the icing on brilliantly conceived pieces with a flawless control of line. The Boston inlaid blockfront desk and bookcase (cat. 45) is just such a high point in the development of the cabinetmaker's art. The Queen Anne style appears to be a design-apprenticeship that totally prepares us for the Chippendale gallery that is ahead. Here all of the strengths—the control of the curvilinear and flawless concepts of line and proportion—that were resolved in the previous period are now fully evolved in the culmination of eighteenth-century cabinetwork. The Chippendale style reflects a majesty not seen before in American furniture that is equally present in the architecture, the silver, and the paintings. It successfully integrates rectilinear, curvilinear, and architectural elements into a meaningful and homogeneous whole. All of the regional furniture schools developed strong and distinctive characteristics, and these, when combined with the art of the carver, ultimately re-

sulted in the creation of furniture at a level of elegance never before seen in the colonies. The richly carved and ornamented Philadelphia high chest (cat. 62), with its acanthus-leaf carved knees, shell-and-streamer carved drawer, and richly designed, composed, and executed rococo carving of its scrollboard, attests to this demand for excellence and reflects the resulting eloquent artistic statement. Finally, with the birth of the New Republic and the early nineteenth century, the cabinetmakers turned positively toward English design and proved that they were capable of executing the designs of Hepplewhite and Sheraton as well as anyone in the English-speaking cultural world.

The major thrust of the Milwaukee Art Museum installation is not so much to make one aware of the features that define the individual styles, periods, schools, and regional differences as it is to perceive through these features the relative aesthetic success of the individual piece. It is therefore an intellectual challenge to fine tune one's artistic sense of appreciation for the high level of creativity frequently achieved by the colonial craftsman. This permits us to apply artistic judgments generally reserved for sculpture and the fine arts to furniture and the applied arts, and to broaden our understanding and perception of furniture as a three-dimensional art form.

The present installation, opened in December 1988, has finally achieved the original goal of presenting the Milwaukee Art Museum's collection of furniture and appropriate accessories as sculptural art forms that are readily accessible in all of their dimensions to every student. The American gallery at the museum can now take its place with other permanent installations of American furniture with justifiable pride.

JOSEPH K. KINDIG III
*York, Pennsylvania*

# ACKNOWLEDGMENTS

In the autumn of 1985, the Board of Trustees of the Layton Art Collection, Inc., authorized publication of a catalogue of the American decorative arts collection at the Milwaukee Art Museum and pledged Layton's financial support for that distant objective. It was the same Board of Trustees that thirteen years earlier had made the farsighted decision to commit the Layton Collection's resources to the development of a collection of American decorative arts, such that museum visitors could experience the tangible evidence of America's colonial heritage—a link to our country's cultural origins which has proven to be of increasing interest to museum audiences.

It has been my privilege to serve as president of the Layton Board for the past eighteen years, and it is first to my fellow trustees that I want to express my appreciation and to acknowledge with gratitude their support of this project. I also want to recognize and thank the Layton Collection trustees who have made significant financial contributions and who have given me their advice and guidance throughout this project. Their vision and their sponsorship have made possible this catalogue of the museum's American decorative arts collection.

Although the Layton Collection has fostered the growth of the American decorative arts collection at the Milwaukee Art Museum, it was actually the members of the Collectors' Corner, Inc., who made the first acquisition of colonial period art as early as 1958 with the purchase of John Singleton Copley's pastel on paper, *Portrait of Susan Bulfinch*. Collectors' Corner has continued to sponsor, through its ninety members and associates, contributions to the museum's decorative arts holdings. By their pledge of financial support, the officers and members of Collectors' Corner have also made a very important contribution to the publication of this catalogue. With this acknowledgment go my sincere thanks to Collectors' Corner and to those generous members whose contributions have also made this work possible.

The completion of this catalogue project has also been accomplished through the cooperation and the commitment of numerous other individuals and institutions who have been devoted to the purpose of publishing the museum's permanent collection of American decorative arts and related works. Even five years ago when this project began, the notion of such a task seemed quite implausible owing to the complexity of our design plan for the publication and the level of scholarship we sought to incorporate in the essays and the detailed text entries. Our insistence on a high level of quality for all of the photographs gave us pause as we compared our expectations with major catalogues already published by other museums. In time, their success proved to be our inspiration.

More than eighty individuals and organizations have made financial contributions to this work, and I am sincerely grateful to all of them for their support. The limitations of space do not allow me to present here all of their names. However, special recognition is deserved by those devoted sponsors whose contributions of time, encouragement, or financial resources have made this project a reality. Their names are included in the List of Sponsors as appropriate recognition of their generosity. To every person who supported our efforts, I declare my appreciation and thanks.

The publication of a museum catalogue must rely on the faith and good will of that community of scholars and museum personnel whose unqualified participation is essential to success. Over the years certain museums have been directly involved in the development of our collection, and it is gratifying for me to acknowledge their assistance and that of the persons named below in the publication of this catalogue.

BROOKLYN MUSEUM: *Dianne H. Pilgrim*
ART INSTITUTE OF CHICAGO: *Christa C. Mayer-Thurman*
FOGG ART MUSEUM: *Seymour Slive, John M. Rosenfield, and Edgar Peters Bowron*

METROPOLITAN MUSEUM OF ART:
*Morrison H. Heckscher and the late Berry B. Tracy*
MILWAUKEE ART MUSEUM: *Russell Bowman,*
*Barbara Brown Lee, and Jayne E. Stokes*
MUSEUM OF ART, RHODE ISLAND SCHOOL OF
DESIGN: *Christopher P. Monkhouse*
MUSEUM OF FINE ARTS, BOSTON: *Jonathan L. Fairbanks*
PHILADELPHIA MUSEUM OF ART: *Beatrice B. Garvan*
SOCIETY FOR THE PRESERVATION OF NEW
ENGLAND ANTIQUITIES: *Abbott Lowell Cummings*
WADSWORTH ATHENEUM: *Tracy Atkinson*
WINTERTHUR MUSEUM:
*Charles F. Hummel and Gerald W. R. Ward*
YALE UNIVERSITY ART GALLERY:
*Patricia E. Kane and the late Charles F. Montgomery*

On behalf of the eight authors whose writings and research comprise this catalogue, I want to express particular thanks to all those individuals who have so willingly given them important insights and information which have enhanced the level of scholarship presented in the essays and the object entries. Based on intensive study and research, this information is often treated as proprietary or as restricted data to be published at some unspecified future time. However, in the preparation of this catalogue, the authors have consistently received the support of other scholars, without hesitation, for which we are all extremely grateful.

To all of the authors who have researched this collection and have written about the objects in their respective areas of personal expertise, I wish to extend my thanks for their accepting this challenge and for their unrelenting commitment to see it through. A special section of this catalogue is devoted to a biographical profile of each of the authors whose illuminating essays and authoritative text entries are presented in the pages that follow. To our editor, Gerry Ward, and to our designer, Howard Gralla, whose patience and understanding have allowed us to overcome the exigencies and meanderings of an otherwise orderly process, I am enormously grateful. I also wish to acknowledge the significant contributions of Richard S. Marcus and Peter M. Sommerhauser; their legal review of contracts and commitments has placed this publication in museum shops and selected bookstores throughout the United States and overseas.

A catalogue of this kind must inevitably depend on the quality of the photographic images presented. We entrusted this essential requirement to Richard Cheek and to P. Richard Eells, who did the furniture photographs in color, all of the black and white photographs, the chapter heading and other detail photographs, all as noted herein. The striking results of their efforts are evidence of their tireless commitment to a high standard of professional quality. Their personal contribution to this catalogue is hereby acknowledged with appreciation and thanks.

Another special word of thanks is so well deserved by my secretarial assistant, Marilyn Fote, for her invaluable support in managing this project, for handling all of the correspondence and the photographic files, for maintaining accurate records, and for the seemingly endless typing of manuscripts, inventories, and acknowledgments. She has kept the catalogue office on a steady course from beginning to end.

Beyond the measure of my appreciation and the sense of gratitude that I feel in the completion of this endeavor, I wish to acknowledge the innumerable contributions of Joseph K. Kindig III. He has faithfully nurtured the growth of the museum's collection of American decorative arts for the past twenty years. Indeed, he was the designer of the original plan for the 1975 permanent exhibition of American decorative arts at the Milwaukee Art Museum. He also has made available to the Layton Collection significant opportunities to acquire art works that have been central to the growth of the permanent collection. When such works were not on the market, it was Joe Kindig who helped arrange for the loan of comparable works from private collections or from other museums. He personally approved the long-term loan of numerous objects from the collection of Joe Kindig, Jr., and Son and has assisted the museum and the Layton Collection with insight and scholarly criticism of our presentation program. His support and encouragement, his knowledge combined with discernment and aesthetic judgment, and our friendship have made these years since 1970 and this catalogue a most rewarding, once-in-a-lifetime experience.

FREDERICK VOGEL III
*President*
*Layton Art Collection, Inc.*

# SPONSORS

THIS publication has been made possible through the financial support of the many contributors listed below. Their generosity, along with that of the Layton Art Collection, the Collectors' Corner, and members of the museum staff, has provided this catalogue as a gift to the Milwaukee Art Museum.

*Major gifts in support of this publication have been provided by:*

THE CHIPSTONE FOUNDATION
COLLECTORS' CORNER, INC.
R.V. KRIKORIAN FOUNDATION, INC.
MARSHALL & ILSLEY FOUNDATION, INC.
MILWAUKEE FOUNDATION:
   THE GERTRUDE AND ERIC WILLIAM PASSMORE
   FUND AND THE GERDA A. DEBELAK FUND
NATIONAL ENDOWMENT FOR THE ARTS
WALTER SCHROEDER FOUNDATION, INC.

*Significant restricted gifts were provided to underwrite the essays and the related catalogue entries:*

FURNITURE IN THE NEW WORLD:
THE SEVENTEENTH CENTURY
   IN HONOR OF FREDERICK VOGEL III FROM HIS
   WIFE, ANNE H. VOGEL, AND HER MOTHER,
   FAITH HENOCH SELZER

THE EARLY BAROQUE IN COLONIAL AMERICA:
THE WILLIAM AND MARY STYLE
   MR. AND MRS. DUDLEY J. GODFREY, JR.

THE LATE BAROQUE IN COLONIAL AMERICA:
THE QUEEN ANNE STYLE
   MR. AND MRS. ROBERT STENGER

CHANGE AND PERSISTENCE IN REVOLUTIONARY
AMERICA: AMERICAN CHIPPENDALE
   MRS. PHILLIP MAYER AND MR. CARL A.
   WEIGELL IN MEMORY OF THEIR MOTHER,
   MRS. HERMAN WEIGELL, A FOUNDER OF
   COLLECTORS' CORNER

NEOCLASSICISM IN THE NEW NATION:
THE FEDERAL STYLE
   MR. AND MRS. ROBERT V. KRIKORIAN

*Significant gifts were also provided for other restricted purposes which include:*

MRS. WILLIAM D. VAN DYKE
*Color photography*

MR. AND MRS. FREDERICK VOGEL III
*Design and composition of the catalogue*

DOCENT COUNCIL OF THE MILWAUKEE ART
   MUSEUM
*Research and essay of Professor R. Bruce Hoadley presented in recognition of Barbara Brown Lee's twenty-five years of service to the museum*

*Important unrestricted gifts were also received from:*

MR. GEORGE M. CHESTER
MR. ARTHUR J. LASKIN
MRS. WILLIAM LIEBMAN
   IN MEMORY OF WILLIAM L. LIEBMAN
MR. JOHN A. PUELICHER
MRS. JOHN E. SCHROEDER
FIRST WISCONSIN FOUNDATION, INC.

*Funds were also provided through the generosity of the following:*

MRS. JOHN W. ALLIS
MRS. ROBERT H. APPLE
MR. AND MRS. CHARLES ARING, JR.
MRS. GEORGE BANZHAF
MRS. ETTORE BARBATELLI
MRS. ORREN J. BRADLEY
MR. AND MRS. ROBERT BRAEGER
MRS. FREDERICK L. BRENGEL
MRS. ROBERT BRUMDER
MRS. JOHN D. BRYSON
MR. AND MRS. DONALD BUZARD

MRS. LEONARD CAMPBELL

MRS. DAVID L. CHAMBERS, JR.

MRS. GEORGE M. CHESTER

MRS. JOHN C. COOK

MRS. ROLAND S. CRON

MRS. HAROLD E. DANIELS

MRS. GHOLI G. DARIEN

MRS. ROBERT FEIND

MRS. W. NORMAN FITZGERALD

MRS. SAMUEL J. FLEAGER

MRS. KENNETH FRANK

MRS. JOHN FRIEND

MRS. RICHARD D. FRITZ

MRS. WALTER J. GOLDSMITH

MRS. DANIEL B. GUTE

MRS. DAVID HASKELL

MRS. R. GOERES HAYSSEN

MRS. ABNER A. HEALD

MRS. JOSEPH F. HEIL, JR.

MRS. JOHN H. HENDEE, JR.

 IN MEMORY OF GRACE REDWAY VAN BRUNT

MRS. JOHN HOLBROOK

MRS. JOHN HUGHES, JR.

MRS. NORMAN H. HYMAN

MRS. RICHARD JACOBUS

RICHARD G. JACOBUS FAMILY FOUNDATION, INC.

MRS. LEANDER R. JENNINGS

MRS. WILLIAM JONES

MRS. DAVID W. KNOX II

MRS. WALTER E. KROENING

MRS. CARL KUELTHAU

MRS. F. J. LADKY

MRS. JOHN LANE

MRS. HOWARD J. LEE

MRS. JACKSON C. LINDSAY

MRS. JOHN R. LITZOW

MRS. R. H. MACALISTER

MRS. BEN MCGIVERAN

MRS. ARMIN S. MCGREGOR

MRS. CHESTER MEYER

MRS. CHARLES C. MULCAHY

MRS. RAYMOND NEWMAN

MRS. JOHN OGDEN

MRS. PHILIP W. ORTH, JR.

MRS. NORMAN PAULSEN, JR.

MRS. KARL PETERS

MRS. GERALD PETERSEN

MRS. B. VICTOR PFEIFFER

MRS. WILLIAM RANDALL

MRS. PAUL REILLY

MRS. GERHARD SCHROEDER

MRS. WILLIAM SHAW

MRS. HUGH R. SLUGG

MRS. WILLIAM F. STARK

MRS. ROBERT B. TRAINER, JR.

MR. AND MRS. DAVID V. UIHLEIN, JR.

MRS. JOHN H. VAN DYKE

MRS. CARL A. WEIGELL

MRS. DAVID HOWARD WELLS

WHYTE AND HIRSCHBOECK, S.C.

MRS. RUSSELL D. L. WIRTH

# INTRODUCTION

AMONG the many thoughts that came to mind while considering this scholarly catalogue of American decorative arts, two questions kept repeating often enough to cement a decision that they should form the basis for this brief essay.

Why copublication of this catalogue by the Milwaukee Art Museum and the Layton Art Collection, Inc.? Perhaps even more basic, why is there a decorative arts collection in an *art* museum?

The first question is easier to address because of an instructive, concise history by Robert W. Wells that was written for a booklet, *The New Milwaukee Art Center,* on the occasion of the dedication of a large addition to the museum in 1975. Mr. Wells made it clear that without discussions begun in 1946 between the Milwaukee Art Institute, founded in 1916, the Layton Art Gallery, founded in 1888 by Frederick Layton (1827–1919), and the Milwaukee County War Memorial Development Committee, the Milwaukee Art Center would not have become a reality in 1957.

Frederick Layton began to collect art created by his contemporaries in the 1870s and 1880s using funds generated by a successful meat-packing business established by his father. He donated large sums of money for construction of a public art gallery bearing his name, funds for an endowment, and thirty-eight paintings for its collections. In many ways, Frederick Layton personified John Adams's advice in 1777 to his son, John Quincy Adams, that a taste for literature —including a love of science and the fine arts—and a "turn for business, united in the same person, never fails to make a great man." A portrait of Layton painted in 1893 by Eastman Johnson (1824–1906) depicts him as a prosperous patrician with his head turned slightly to the subject's right. Significantly, his eyes are focused into the distance, gazing into the future.

With the merger of Milwaukee art institutions in 1957, the Milwaukee Art Center inherited not only examples of nineteenth-century French academic paintings, but also a number of American masterpieces and the original endowment given by Frederick Layton to the Layton Art Gallery. After 1957 the Layton Art Gallery Collection used this endowment to acquire American art exclusively for display at the Milwaukee Art Center, now the Milwaukee Art Museum. In recent years, the concentration of the Layton Art Collection, especially under the leadership of its current trustees and its president, Frederick Vogel III, has been the acquisition of American furniture and related decorative art. *Ergo*, copublication of this catalogue by the Milwaukee Art Museum and the Layton Art Collection.

Both organizations have taken the long-view gaze of Frederick Layton in deciding to include displays of American decorative arts and related material culture in the museum's galleries. To the question of why a decorative arts collection in an *art* museum, one steeped in the study of such objects for over thirty years can only ask, why not? The answer to this question is, however, not a simple one and involves more than the traditional hierarchy accorded by American museums to the various contents of such educational institutions.

During the period of the Italian Renaissance, a new theory of artistic creation developed in which architects, painters, and sculptors were placed in an elevated position in the art world because of the belief that they were concerned primarily with conceiving a noble design before executing their works of art. This divine spark of inspiration set them apart from other men, especially mere craftsmen. Before the rise and general acceptance of this theory, practitioners of the fine arts were considered artisans like goldsmiths, carpenters, weavers, joiners, potters, and so forth. This split between artist and artisan is still very much in evidence in the art world despite the claim of many present-day craftsmen to be "artists."

But from the earliest settlements in colonial America to the present day, Americans have had an intense interest in, and love for, what has been termed variously as the arts of the home, domestic arts, craft products,

decorative arts, or utilitarian objects. Indeed as writers such as Neil Harris, Robert C. Smith, Alan Gowans, Wendell D. Garrett, Thomas Hoving, and numerous others have pointed out, in the seventeenth through the nineteenth centuries, America's creative genius lay in the decorative arts. The American public was profoundly suspicious of fine art. Fine art was useless, not practical. Decorative art was, and is, not only practical but familiar to museum visitors, a knowledge shared by novice and advanced aesthete alike.

Edward P. Alexander noted in his foreword to an exhibition of decorative arts held at the Milwaukee Art Center in 1960, that collections of seventeenth- and eighteenth-century American furniture and furnishings have especial appeal. Although the glimpses of earlier lifestyles are often distorted by the accidents of survival or collector appeal, decorative art does provide evidence of the taste, fashion, ideas, and permissible ranges of artistic endeavor—small "a," thank you—within a given culture.

In viewing seventeenth-century artifacts, present-day Americans can share and understand the emotions of Puritan poet Anne Bradstreet (1612–72), when at the age of fifty-four she viewed the remains of her burned home in North Andover, Massachusetts, and wrote, "Here stood that trunk, and there that chest; There lay that store I counted best; My Pleasant things in ashes lie, And them behold no more shall I. Under thy roof no guest shall sit, nor at thy table eat a bit." Some years later, Samuel Sewall of Boston wrote in his diary that a wineglass placed on a joint stool was bumped and shattered on the floor of his home. His moral and religious observation that "twas a lively emblem of our fragility and mortality" might not be shared by many current museum-goers, but many would appreciate his use of a joint stool as a cocktail table.

The architect Benjamin Latrobe, in addressing the Society of Artists of the United States in Philadelphia in 1811, recognized that this practical strain of the American public could be harnessed by making art the profitable slave of commerce. As examples, Latrobe cited Wedgwood pots, pitchers, cups, saucers, and plates; Boydell's prints; Bolton, Watt, and other smiths and founders of Birmingham; and the ship figureheads of William Rush.

Alexis de Tocqueville, in an oft-quoted passage from *Democracy in America* (1835), observed "In what Spirit the Americans Cultivate the Arts." He stated that "they habitually put use before beauty, and they want beauty itself to be useful. Craftsmen in democratic ages do not seek only to bring the useful things they make within the reach of every citizen, but also try to give each object a look of brilliance unconnected with its true worth."

Present-day visitors to the Milwaukee Art Museum and any other collection of decorative arts enjoy and appreciate such objects because they illustrate elements of design, craftsmanship, beauty, proportion, and materials that are universal. The objects do not have to belong to important figures of history. It is perfectly acceptable for these objects to illuminate the lives of ordinary citizens. The same public that appreciates and enjoys early decorative arts flocks to exhibitions of modern decorative arts with equal glee.

At the 1988 annual meeting of the American Association of Museums, the first analysis of a project to record what novice museum-goers value in experiencing art was presented by the staff of the Denver Art Museum. The results of this two-year study, sponsored by the J. Paul Getty Trust and the National Endowment for the Arts, indicated that visitors with a moderate-to-high interest in art but little or no formal background in analyzing art, stated that their expectations for a museum visit included experiences that are "beautiful, social, realistic, educational, emotional, eye catching, recognizable, personally connected," and "linked with humanity."

These are reactions to fine and decorative arts that are shared by visitors to museums each day. The Layton Art Collection and the Milwaukee Art Museum have wisely decided that American decorative arts objects should be available to Milwaukeeans and their neighbors. They have also wisely decided that the same beautiful objects available to their visitors should be shared with a broader public audience. In this catalogue, the authors of the sections that follow, the photographs of the collection, and the editor of this publication assure that the reader's experience will be beautiful, educational, realistic, eye catching, and linked with humanity.

CHARLES F. HUMMEL
*Deputy Director for Collections*
*Winterthur Museum*

# A NOTE ON THE CATALOGUE

THIS catalogue is divided into five chapters. Each chapter begins with a short essay discussing the origins and characteristics of a given style in American furniture. Each essay is followed by catalogue entries on furniture and related objects. In the furniture entries, the objects have been ordered in the following manner: seating furniture, case furniture, tables and stands, looking glasses, and clocks. (The entries in the chapter entitled "Neoclassicism in the New Nation," however, begin with two architectural fragments.) Similarly, the related objects appear in the following sequence: ceramics, silver, base metals and candlesticks, textiles, and glass. This arrangement is simply for the convenience of the reader interested in locating entries on similar objects and is not meant to imply any hierarchy or value system.

Unless otherwise noted, the dimensions given for each object are overall height (H.), width (W.), and depth (D.), given in inches (and centimeters). Seat height (S.H.) is provided for chairs and other seating furniture. Weight (WT.) is given in troy ounces (and grams) for silver objects. Diameter (DIAM.), length (L.), and other dimensions are given as appropriate. Reference is occasionally made to correspondence and other information in the object files maintained by the Milwaukee Art Museum (MAM).

In the furniture entries, the woods have been identified by R. Bruce Hoadley of the University of Massachusetts at Amherst (see Appendix A). Woods are cited in the entries by their common names; for their full names, see table 1 in Appendix A.

Sources are cited throughout in an abbreviated author-title form. Full citations are given in the Bibliography.

The authors of the catalogue entries are identified at the end of each entry.

# THE SEVENTEENTH CENTURY

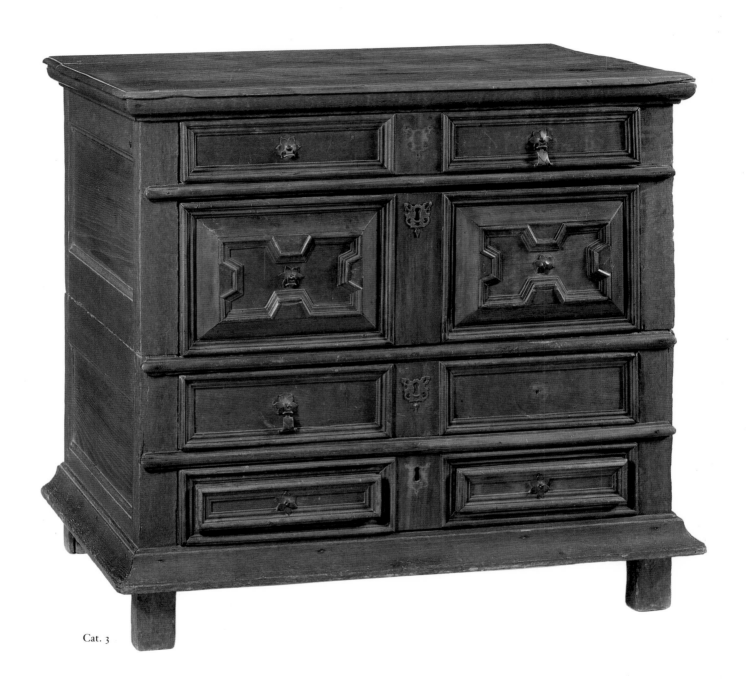

Cat. 3

# Furniture in the New World:
## The Seventeenth Century

### ROBERT F. TRENT

AMERICAN furniture history long has been burdened with misconceptions about the aesthetic, technological, and social meaning of the products of joiners and turners who worked here before 1695. Most scholars continue to believe that full-blown classicism did not reach these shores until the advent of the William and Mary style in furniture and the Wren baroque in architecture, and all works preceding these developments continue to be deemed as on a par with the relics of troglodytes—historically significant, perhaps, but not beautiful. Even publications like *New England Begins: The Seventeenth Century*, the late Benno M. Forman's *American Seating Furniture, 1630–1730*, and Abbott Lowell Cummings's *Framed Houses of Massachusetts Bay, 1625–1725* have not had a significant impact on this prejudice, at least in the marketplace, where the demotic term "Pilgrim Century" holds sway.[1]

The building of the Milwaukee Art Museum collection over the last twenty-five years reflects the perceptions and tastes of a small group of dealers and collectors who have been aware of the classicizing aesthetic and finely attuned craft practices of the early period. The sample of early furniture forms in the collection gives a cross section of styles, trades, and regional schools, and its publication presents an opportunity to interpret important aspects of all these factors.

From a stylistic viewpoint, the collection includes examples of *avant-garde* urban joinery (cats. 3, 7), urban turning (cat. 1), provincial joinery of high quality (cats. 4–6), and upholstery (cat. 2). Only a confluence of varied European national styles and an equally diverse settlement pattern could have produced this many separate and vigorous shop traditions within the narrow confines of New England's popula-

tion and economy. England's marginal involvement in the earliest stages of the Renaissance is only a partial explanation for the complex regional stylistic patterns within England that were reflected in American work.

The two elements that were most responsible were Italianate, French, and Netherlandish stylistic impulses that reached England at variable speeds, and the different ways in which those impulses were transmitted. Those who are acquainted with the European sources hope to identify the exact European antecedent for a particular English style, but when and how the style reached England is never entirely clear.

Most obscure of all the national styles is the Italian, which has been ably expounded by numerous scholars since 1900, but has not received close scrutiny of formal sequences and terminological clarity. Study of the terminology employed in modern surveys suggests that many parallels with northern European practice existed, but it is difficult to assess if Italian practices were the source of the northern European usage. Furthermore, many French terms appear to have crept into Italian usage during the eighteenth century, and non-Tuscan dialects are another worrisome matter.

It is apparent, nevertheless, that Italian practices of the 1480–1640 period were decisive for many later furniture forms. Tuscany was the center where Roman archaeological and pictorial prototypes were first translated into practical furniture. Seating was taken directly from medieval survivals of the wooden or iron folding stool or chair (*faldistorio*), but the real innovation was the square, high-back wooden chair with arms. Longer, non-ecclesiastical seating included the chest without back (*panca*) and the chest with arms and back (*cassapanca*), both of which were, somewhat

illogically, modeled on Roman *sarcophagi*, or on a combination of a *sarcophagus* and a Roman stadium seat, or sometimes on Roman marble close stools. These had little impact outside Italy. Another durable type that was extremely influential in Germany but not in England was the narrow wooden backstool with a board seat, board or stake feet, and a shaped wooden backboard (*sgabello*). Italians had little use for the heavy paneled chair that became so popular in France, the Netherlands, and England, perhaps because no immediate antique classical prototype for it was known and because it was unsuitable for the warmer Italian climate. A confusing factor is the period habit of referring to any chair with leather or textile upholstery as an easy chair (*poltrone*), which persists in modern Italian usage.

The case pieces that furnished the studies or cabinets of Renaissance princes and ecclesiastics were of the utmost importance for later practice in northern Europe, because, obviously, humanistic circles were in the forefront of transmitting the achievements of the Renaissance. Any understanding of case pieces is clouded by the intrusion of tables into the typology and vocabulary of Italianate practice, for in an age when any horizontal working surface was rare, the twentieth-century distinction between a table and a case piece was not current. Any scholar's study had to have a table, whose usual distinction was whether it was of average size (*tavola*), small (*tavolino*), or large (*tavolone*). Later terms for specialized tables do not necessarily apply to this early period, save for the draw table (*tavola allungabile*) and the folding or leaf table (*tavola a ribalta*). However, two important and frequently massive and architectural forms that appeared as a necessary adjunct of any study were the book press (*armadio*) and the cabinet (*studiolo* or *stipo*). It is doubtful if the term *libreria* was used this early to refer to a bookcase, for books in private libraries seem to have been locked up in paneled presses until the eighteenth century. A specialized cabinet for collections was known as a *medaglieri*, after the collections of coins and medals that connoisseurs delighted in.

The exact forms that tables and case pieces took seem to have been dependent partially on medieval practice and partially on the latest archaeological finds from Roman sites. Long tables adapted from medieval trestle types were provided with addorsed console brackets and lion's feet, on the basis of Roman table fragments. Round tables were often given three such console feet joined to a central post. Joined, rectilinear tables had turned columns or urns or balusters on the posts, but these were obviously new designs and probably did not find all that much favor until the seventeenth century. Many of these tables were made of marble or stone.

In contrast, presses and cabinets had to be portable, and the practice of organizing them to resemble the facades of one- or two-story classical buildings with surbases, columns or pilasters, and entablatures swiftly gained favor. These designs are severe, monumental, and extremely impressive. The only exception seems to have been certain cabinets that derived from a cabinet set on a table or stand; these were allowed to deviate from strict architectural rules in having a light base with columnar or baluster supports. Another important case piece with an architectural organization was the serving table or cupboard (*credenza*), which, unlike its ponderous northern counterparts, was rarely more than one case high. The preferred wood for all chairs, tables, and case pieces was walnut, a regional practice that was influential in northern Europe until mahogany, ebony, and rosewood became available during the seventeenth century. The northern European taste for oak was almost always displaced in a courtly context by walnut.

This basic range of furniture forms expanded very little until the balance of power shifted to northern Europe, particularly to France and to Antwerp, in the early seventeenth century. Courtly circles in France and powerful mercantile families in Antwerp that were influenced by Spanish court usage had assimilated Italian furniture forms and styles, but began to deviate from them because of regional specialties. Antwerp took the lead in most of these developments, principally because the city enjoyed a pan-European patronage base and supported powerful guilds of virtuoso designers, artisans, and publishers. Among the principal contributions of the city were upholstered chairs derived from the Spanish *sillón frailero*, or "monk's armchair"; massive cabinets that reflected the cooperation of masters in many media; a broadening of the taste for great joined tables executed in wood; great expertise in veneered decoration on dovetailed board cases; and a wealth of published designs that

converted the somewhat narrow range of archaeologically correct grotesques into a broad base of heavier strapwork patterns that were applicable to many media.[2]

When Louis XIV commanded his ministers to organize workshops under the immediate sponsorship of the crown during the 1660s, the Netherlands and urban centers along the Rhine became the recruiting ground for capable designers and workmen. But this relatively late talent search was less influential than the diaspora of Protestant workmen who had fled from the Spanish Netherlands after the outbreak of civil war in the Low Countries in 1567. Central Germany, Scandinavia, and England were the beneficiaries of the flight of these refugees, and the dominance of Renaissance styles and forms in England can be said to date from that time. The refugees settled in British ports, including London, Exeter, Norwich, Ipswich, and Aberdeen, and their English and Scottish apprentices spread their *avant-garde* mannerism throughout the British Isles within a generation.[3]

Distinguishing between the successive waves of Netherlandish influence and English developments that proceeded from them is often difficult. Flemish pattern books and loose sheets of designs were being employed two or three generations after their initial publication in Antwerp or Amsterdam. Research in these important ornamental sources has not yet established the basic corpus of designs that were available or their exact phases of popularity in various parts of England, but it is clear that they were current throughout England by 1600.[4] What is not clear is how long it took for academic rejection of the heavily ornamented mannerist style to gain influence at the level of commercial production. Inigo Jones and his circle of connoisseurs at Charles I's court regarded their adaptations of Palladio's designs as a purification of the classicizing impulse, but only a few traces of their style in the decorative arts have survived, with one notable exception—the chest of drawers. We might view the late Benno M. Forman's assertion that the chest of drawers literally was *invented* in London in the 1620s with a certain skepticism, given the existence of numerous Italian examples which can be dated to the 1590s on stylistic grounds, but London without question was the first northern European center where that furniture form gained widespread

currency, perhaps because Inigo Jones was aware of the latest developments in Italian furniture. It is no coincidence that the earliest London examples are in a pure Palladian style that owes much both to Jones's architectural style and to Dutch joinery from Friesland and Zeeland, where a similar rejection of heavy ornamentation and a return to earlier Tuscan styles was underway.[5] That these earliest chests of drawers with doors date from the 1620s and 1630s is indisputable; a cabinet in this style belonged to Archbishop Laud (1573–1645), and a cabinet atop a chest of drawers with doors by the same shop is known.[6] These extremely important monuments correspond to an equally significant fireplace frontispiece from a house in Lime Street in London that is confidently dated to the 1620s.[7]

This entire dating question might not be such an issue had not two critics disputed the date range Forman and his students assigned to the American examples derived from this London tradition. A fad for decorating chests of drawers with crude bone or mother-of-pearl inlay arose in London at midcentury, and these inlaid examples are dated from 1649 to 1663. Those who assert that the chest of drawers came into fashion about 1650 rely on the dates found on this inlaid group, but it is apparent that in view of the important 1620s and 1630s examples cited above, the chest of drawers evolved in London much earlier, and the dates found on inlaid examples establish the date range of the *inlay*, not the furniture form.[8] We can therefore convincingly argue that London-trained joiners and turners who emigrated to Boston in the Massachusetts Bay and New Haven in the New Haven Colony in the 1630s began making chests of drawers immediately upon their arrival in New England, a theory that is borne out by references to chests of drawers in Boston in 1641 and in New Haven in 1647.[9]

The simultaneous arrival in New England in the 1630s of the heavily decorated mannerist style and the severe, academic mannerist style is of supreme significance, for the stylistic development of most New England furniture schools during the working careers of the first and second generation of joiners and turners involved the gradual displacement of strapwork and other geometric motifs by applied moldings and more normative or academic proportions. In terms of case pieces in the Milwaukee collection, the Boston

chest of drawers (cat. 3), while it probably dates from the careers of the second or third generation of joiners working in the London tradition, is, stylistically, the most advanced and elevated example. The Dennis box (cat. 4) is relatively conservative, a point made all the more striking by the fact that the shop tradition from which it stems was not transferred from the West Country of England to Ipswich until the 1650s. The Blin chest (cat. 5) unquestionably derives from a shop tradition that incorporated many features of the academic Boston style while retaining certain carved motifs.

Less clear is the stylistic significance of the Salem turned chair (cat. 1). Recent research strongly suggests that most chairs in this manner were based on Netherlandish designs brought to England in the 1570s and 1580s, but these traditions were so broadly disseminated by the 1630s that it is difficult to tie any one chairmaking tradition to secure English regional origins. Only a few traditions have tentatively been assigned to turners working in Boston or Charlestown, and whether these turners were the same London-trained workmen who were producing applied ornaments and turned feet for case pieces in the London manner is impossible to determine.[10]

The late 1660s were a watershed for the further development of New England joinery and turning. At that time, the probate records of Boston reveal the first evidence of new trends that were the result of indirect French influence. The aforementioned designers and artisans assembled at the French court at Louis XIV's behest evolved new formulas for room organization that were immediately copied all over Europe. Among these were a rejection of arrangements with a great table fixed in the center of the room. The court designers introduced a new table form with an oval top and two great leaves supported by hinged frames, today known as a "gateleg" but then called simply a "great oval table" or occasionally a "great leaf table." These tables could not be accompanied by long joined forms, and the seat of preference became the upholstered backstool, a distinct improvement in comfort that was often covered *en suite* with a table carpet, curtains, hangings, and other expensive textile fixtures. The 1669 inventories of Antipas Boyce and Edmond Downes of Boston, the first of a series of three inventories dating from 1669 and 1670 which heralded the new era in furnishing

practices, contained "oval tables" with accompanying upholstered chairs and textile fixtures, and furthermore, they are the first New England inventories to include the term "Dining Room."[11] Before the introduction of early baroque case pieces and seating furniture in the late 1680s, these new fixtures and arrangements were the most advanced ones available in the colonies.

From a technological standpoint, the principal New England innovations resided in a reliance on methods of extracting lumber which had little appreciable impact on stylistic features. England was in the grip of a "wood famine" from the 1580s on, as expansion of the navy and the introduction of metal smelting, glassmaking, and other fuel-hungry industries depleted forests along the coasts and in mining areas. Oak of high quality was especially scarce in some areas and was imported from Scandinavia and north Germany, and this precious imported timber was reduced to posts, panels, and boards through traditional pit-sawing methods. Pit-sawing was labor intensive, but when competently executed, it could yield the greatest amount of usable lumber from a log. In addition, whenever sawmills were erected in England, sawyers immediately rioted and destroyed them in order to protect their trade. By contrast, New England enjoyed an abundance of forests and suffered from a shortage of skilled labor, and sawmills were built in great numbers soon after settlement. Insofar as oak scantling and panels are concerned, joiners and carpenters were under little pressure to conserve lumber and commonly exploited the fast but wasteful riving method of extracting usable lumber: whole tree trunks were split with wedges and great mallets called beetles into quarter sections and further reduced with a splitting tool called a froe and a wooden club known as a maul. The resulting wedge-shaped pieces had to be planed square or rectangular in section, a waste of raw materials which was acceptable when speed and reduced labor costs were of the essence.[12]

It is notoriously difficult to assign social significance to seventeenth-century furniture forms, partly because so little is known about them and partly because relatively little attention has been paid to studying configurations of objects found in probate inventories and to house plans. Scholars are slowly beginning to crack the code of wealth patterns and prestige levels that certain furniture forms suggested to their original

owners and admirers. An important point is the demotion of the cupboard from its former interpretive status as "the Cadillac of its time."[13] In addition to ignoring the relatively higher prestige accruing to other makes and models of automobiles, this interpretation of the cupboard now appears to be inaccurate. From the mid-1630s on, the furniture form that suggested both conspicuous consumption and advanced taste was the chest of drawers, particularly larger versions built in two cases and with doors over the drawers. They were, again, an *avant-garde* form and in an advanced taste at the time of settlement. They were made only in Boston and New Haven during the lifetime of the first generation, for they do not often appear in probate inventories outside urban centers until the 1670s. When they do appear in those areas, chests of drawers are always appraised at high values, and they always appear in the estates of elite figures. The inference is quite strong that if a Massachusetts minister or merchant in Essex County owned a chest of drawers before 1670, he had purchased it in Boston or imported it from London, and under those circumstances, ownership of a chest of drawers was an index of fashionability and of urbanity.

Much the same can be said of upholstered chairs and couches, unified suites of textile fixtures, and small luxury case pieces like cabinets, dressing tables, and looking glasses. All upholstered chairs present in New England before roughly 1655 were imported from England and therefore expensive and somewhat pretentious.[14] As the discussion of Italian cabinets above suggests, ownership of a cabinet indicated that the owner wished to indicate a certain affiliation with humanistic learning, or at least aspired to a level of literacy and frequent correspondence above that of simple Bible reading and signing legal documents. Dressing tables and large looking glasses implied spending power and leisure time to devote to fashionable grooming and costume.[15]

On the level of room arrangement and functions, Boston merchants and ministers seem to have assimilated some aspects of the French courtly *appartement* by the 1650s. A survey of their inventories between 1650 and 1690 reveals that they had augmented the standard East Anglian hall/parlor house plan with new rooms like great and little parlors, great and little chambers, secluded rooms for reading like studies, closets, or counting houses, and dining rooms. Often rooms

were referred to by the color of the textile furnishings, in a manner calculated to suggest a concern for formality and decorum that probably was incomprehensible to members of the rural elite (unless they were allied by marriage to Boston families). These rooms also implied that specifically urban house plans were in use in Boston and Charlestown that were not being built in country towns, including houses with the gable end facing the street, inner courtyards, and service wings. The adoption of room arrangements derived from those of Restoration London accelerated after 1670, and these exceedingly expensive and elaborate decorating schemes, with their attendant code of decorum, hopelessly outdistanced the practices of rural gentry figures and intensified the prestige of the Massachusetts capital and of larger towns like Salem, Hartford, and New Haven where these practices gradually became known, if not fully articulated.[16]

Undoubtedly further research in the surviving furnishings and court records of New York, the Delaware Valley, and the South will uncover similar advanced practices among elite figures. For now it is enough to suggest that the nebulous concept of the seventeenth-century Anglo-American colonies as undifferentiated congeries of isolated yeomanry, leavened here and there by the occasional merchant with a taste for smart London fixtures, is inadequate. Furnishing practices were exceedingly complex in urban areas, and urban artisans had achieved a level of competence and integration by 1690 which made them fully capable of addressing innovations. From this perspective, the arrival of the William and Mary style seems less of a watershed than an extension of existing practice, and we can now address pre-1695 furniture with an enhanced awareness and a new respect.

1. Robert F. Trent, "New England Joinery and Turning before 1700," in Fairbanks and Trent, *New England Begins*, pp. 501–50; Forman, *American Seating Furniture*; Cummings, *The Framed Houses of Massachusetts Bay, 1625–1725*.
2. Pedrini, *Il Mobilio gli Ambienti e le Decorazioni del Rinascimento in Italia*; Odorn, *History of Italian Furniture*; Del Puglia and Steiner, *Mobili e Ambienti Italiani dal gotico al floreale*; von Bode, *Italian Renaissance Furniture*; Kreisel, *Die Kunst des deutschen Mobels*; von Falke, *Deutsche Mobel des Mittelalters und der Renaissance*; Burr, *Hispanic Furniture*; Verlet, *French Royal Furniture*.
3. Robert F. Trent, "The Concept of Mannerism," in Fairbanks and Trent, *New England Begins*, pp. 370–76.
4. Wells-Cole, "An Oak Bed at Montacute," pp. 1–19.
5. Forman, "Chest of Drawers in America," pp. 1–30; Trent, "Chest of Drawers in America," pp. 31–48.
6. Chinnery, *Oak Furniture*, pp. 432–37.

7. Chinnery, *Oak Furniture*, p. 435.

8. See John T. Kirk, "American Furniture in an International Context," in Ward, *Perspectives on American Furniture*, pp. 39–62. On p. 46, Kirk refers to the entire tradition of scholarship founded by Benno M. Forman as a "paper chase." He proceeds on p. 47, n. 7, to refer to the writer's editing of Forman's "Origins of the Joined Chest of Drawers" of 1981, posthumously republished as Forman's "Chest of Drawers in America" in 1985. In the first version, Forman assigned the two earliest examples of Boston joinery the date range "ca. 1650," but discussions of this dating by the writer and Forman before his death in February 1982 convinced us that the tradition was brought to Boston in the 1630s. It is therefore incorrect for Kirk to assert that the dates were "regrettably" altered in the second published version or that the writer "back dated" the objects in a way inconsistent with Forman's thinking immediately before his death. The substance of Kirk's objections is repeated in Ward, *American Case Furniture*, p. 128, where Ward asserts that the writer accepted Forman's argument regarding the origins of the joined chest of drawers "with enthusiasm," hence, one infers, without criticality.

9. Forman, "Chest of Drawers in America," p. 8; Trent, "Chest of Drawers in America," p. 37.

10. Forman, *American Seating Furniture*, pp. 65–89; St. George, "New England Turned Chairs of the Seventeenth Century."

11. Trent, *Saugus Iron Works*, pp. 60–61.

12. Forman, "Mill Sawing," pp. 110–30.

13. Charles F. Montgomery's phrase is referred to in Gerald W. R. Ward, "Some Thoughts on Connecticut Cupboards and Other Case Furniture," in *New England Furniture*, p. 69.

14. Passeri and Trent, "A New Model Army," pp. 10c–16c.

15. Forman, "Furniture for Dressing," pp. 149–64.

16. Trent, *Saugus Iron Works*, pp. 38–64.

## 1  Slat-back great chair

Probably Salem, Massachusetts,
1660–1700

*Description:* The rear posts are 2⅜ in. (6.0 cm) in diameter throughout. They have urn turnings between the two upper slats and urn-and-flame finials. The front posts are approximately the same diameter as the rear ones and have complementary urn turnings. The worked or blade arms are fitted with square tenons so that they will not rotate in their joints. The slats are made of riven wood. The pins holding the top slat in the posts appear to be original.

*Condition:* The slats were originally graduated in height, in a 4 / 4¼ / 4½ in. (10.2 / 10.8 / 11.4 cm) sequence, but the center slat is broken and has lost height. All four posts have restored bottoms 1¼ in. (3.2 cm) high. Many of the pegs currently in various joints appear to be later additions. The arm grips or pommels are restored. The paint layers are black on top of gray, with no traces of original pigment visible. The slat mortises have been repaired with plaster. The rush seat is an old replacement.

*Woods:* Posts, yellow-poplar; slats, arms, seat lists, and stretchers, ash.

*Dimensions:* H. 46¼ in. (170.5 cm), S.H. 15¼ in. (38.8 cm), W. 24⅝ in. (62.6 cm), D. 18¼ in. (46.3 cm).

*Provenance:* Purchased in 1977 from John Walton, Inc., Jewett City, Conn. (dealer).

Slat-back chairs with sufficiently heavy turned posts traditionally are thought to date somewhat later than comparable chairs with backs composed of turned elements, but it is likely that they were made from the time of first settlement. This example belongs to a group associated with the North Shore of Massachusetts, specifically with Salem. Nearly identical chairs have histories of ownership in Salem or Ipswich.[1]

Among the index features of this group are well-executed urn-and-flame finials, graduated slats with arc cutouts at the ends of the upper edges, worked or blade arms with similar arc cutouts at the outside ends, front stretchers with scored barrels at the ends and double-single-

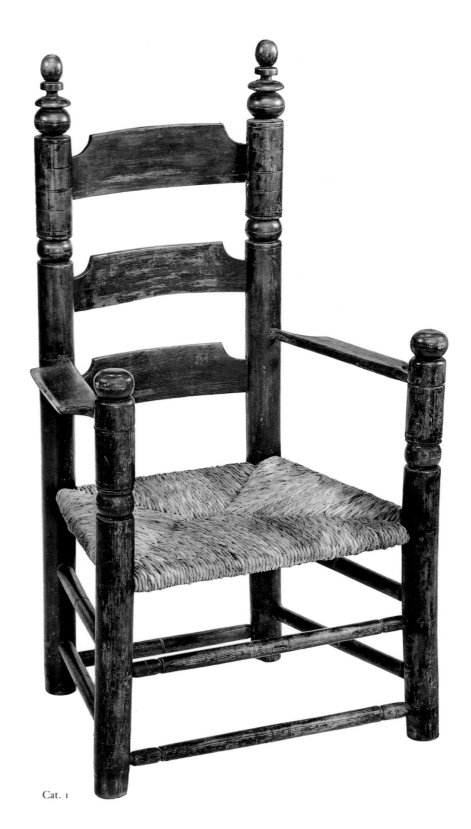

Cat. 1

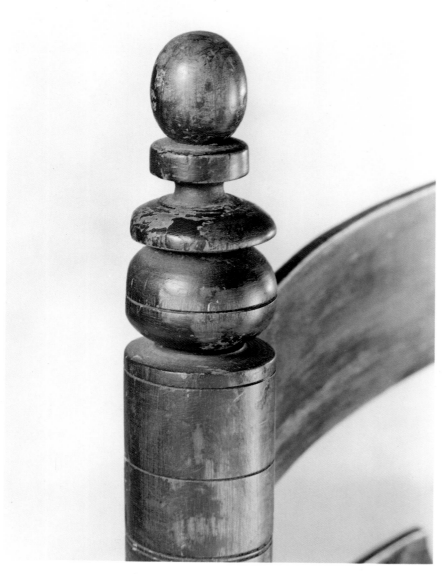

Cat. 1

House Museum, Salem, Massachusetts); and a fairly intact example at the Baltimore Museum of Art.[3] Many others exist in various states of repair in private collections.    *Robert F. Trent*

Purchase, Layton Art Collection
L1977.39

1. Fairbanks and Trent, *New England Begins*, pp. 216–17, fig. 178.

2. X-ray analysis conducted by James DeYoung, assistant conservator, MAM.

3. For the English chair, see Clunie, Farnam, and Trent, *Furniture at the Essex Institute*, no. 3; for the Baltimore Museum example, see Elder and Stokes, *American Furniture*, cat. 1. See also Fales, *Furniture of Historic Deerfield*, fig. 11.

## 2 *Leather chair*

London, England, 1685–1710

*Description:* The twist turnings on the front posts and front stretcher were executed with a round rasp. The entire frame was made of partially seasoned wood which twisted and bowed as it dried. The seat rails have kerfs from pit-sawing on their inner surfaces.

*Condition:* The frame is remarkably well preserved and retains its original feet. The surfaces were stripped of finish when purchased by the donor in 1982. It was refinished walnut color by Robert Walker and reupholstered by Andrew Passeri in 1983. Evidence on the frame suggests that it was upholstered in a textile originally.

*Wood:* Entire frame, beech (probably *Fagus sylvatica*).

*Dimensions:* H. 40 in. (101.6 cm), S.H. 18 in. (45.7 cm), W. 19¾ in. (50.1 cm), D. 16⅝ in. (42.2 cm).

*Bibliography:* Passeri and Trent, "A New Model Army," p. 14C, fig. 16.

*Provenance:* Purchased by the donors in 1982 from Philip A. Budrose Antiques, Marblehead, Mass. (dealer).

Although the Milwaukee collection contains no American Cromwellian chair, this excellent London example represents the form and relates directly to a group

double decorative score lines at the centers, and yellow-poplar posts.

These chairs differ from their Boston/ Charlestown prototypes in lacking pronounced tapered posts and raked back frames as a compositional strategy for lightening the frames. The use of worked arms, an alternative to less comfortable turned arms which tend to cut off circulation in the sitter's elbows, may be specific to Salem chairs.

The turned pommels or grips of the front posts are incorrect replacements.

X rays of the pommels and visible seams between the pommels and the post tops confirm this.[2] The correct form of pommel is epitomized by the Clark family armchair at the Ipswich (Massachusetts) Historical Society, which has pommels with undercut arc turnings beneath ovoid balls with central score lines. They are, in effect, the equivalent of the lower sections of the finials.

The best related examples are the Philip English chair (Essex Institute); a fragmentary chair with no provenance (Witch

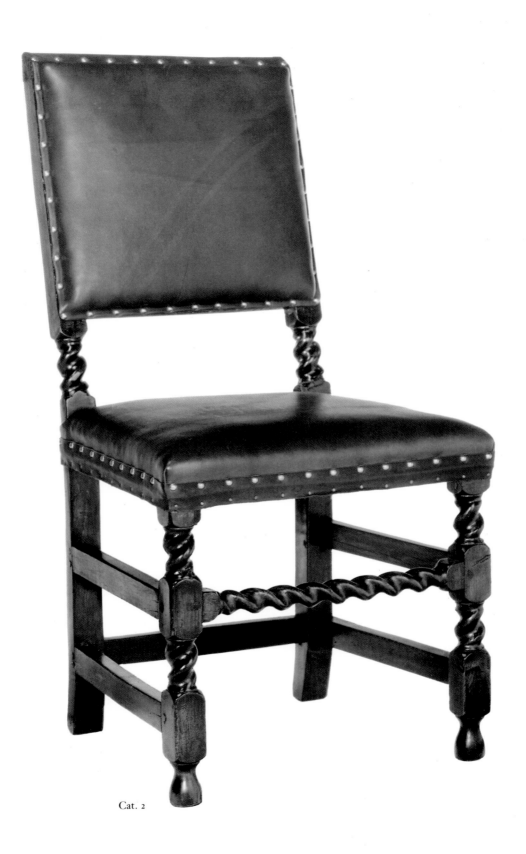

Cat. 2

of Boston chairs with twist turnings.[1] The twist ornament dates the chair late in the development of the form, for that ornament was not introduced in England until the early 1670s, when chairs with frames "turned all over wth the twisted turne" began to be made for the royal palaces.[2] Other late features are the high back copied from Louis XIV prototypes, the pronounced "great heels" that are raked on both front and rear surfaces, and the large overall size. All these new features coalesced in London as of 1680 to 1685.

Some American chairs with twist turning are known, and one pair, in particular, is quite close to the Milwaukee example. They are a pair of Boston chairs with a medial stretcher between the two lower side stretchers (Winslow House, Marshfield [Massachusetts] Historical Society). Like the Milwaukee chair, these were probably upholstered in a textile. Turkey work, a woven, knotted-pile fabric resembling Oriental carpets, continued to be placed on this style of frame long after leather-covered chairs began to be made in the William and Mary style. The high backs of late Cromwellian chairs made them thoroughly compatible with William and Mary chairs, the ordinary sort of which were inappropriate for Turkey work covers.

The Milwaukee example was made of beech that was partially cured, and as a result, the frame twisted as it dried. Because the twist ornament is worked with a round rasp, rather than turned on a lathe with a special advancing mechanism attached to the bed, the wood had to be worked wet. Far finer machine-made turnings on contemporary Dutch chairs are infinitely superior in concept and execution, being true, full-round spirals. *Robert F. Trent*

Gift of Virginia and Robert V. Krikorian M1987.31

1. Passeri and Trent, "A New Model Army," pp. 13C–14C.
2. Symonds, "Charles II: Couches, Chairs and Stools, Part II," pp. 86–87.

## 3 *Chest of drawers*

Attributed to the Ralph Mason or Henry Messenger shop traditions
Boston, Massachusetts, 1660–1715

*Description:* The three top boards are held by pegs. Each case has one large panel at each end. The rear of each case is framed with one large horizontal panel. On each drawer, the bottom is a single board with grain running side-to-side. The bottom of the upper case and the top of the lower case are both enclosed with one-board dustboards set side-to-side. The bottom of the lower case is enclosed with three watersawn dustboards set front-to-rear. The deepest drawer has two dovetails at each front joint (a smaller dovetail key over a larger one). The three shallow drawers have one small dovetail key at each front joint. The upper and lower cases are attached with two chamfered tabs at each end, which are fixed in the lower case and fit into corresponding mortises in the bottom side rails of the upper case. The second and fourth drawers have the original locks, while the first and third drawers had locking tabs originally. The pegs holding the lower joints

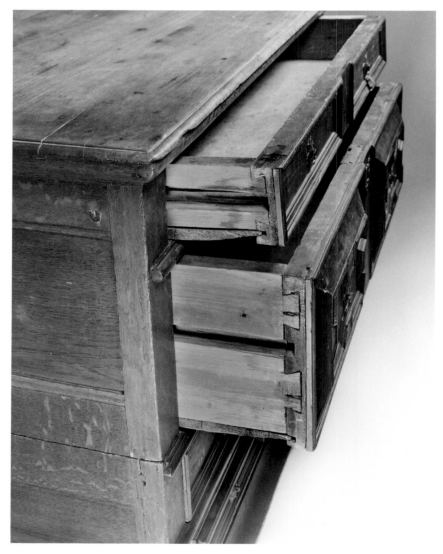

Cat. 3a

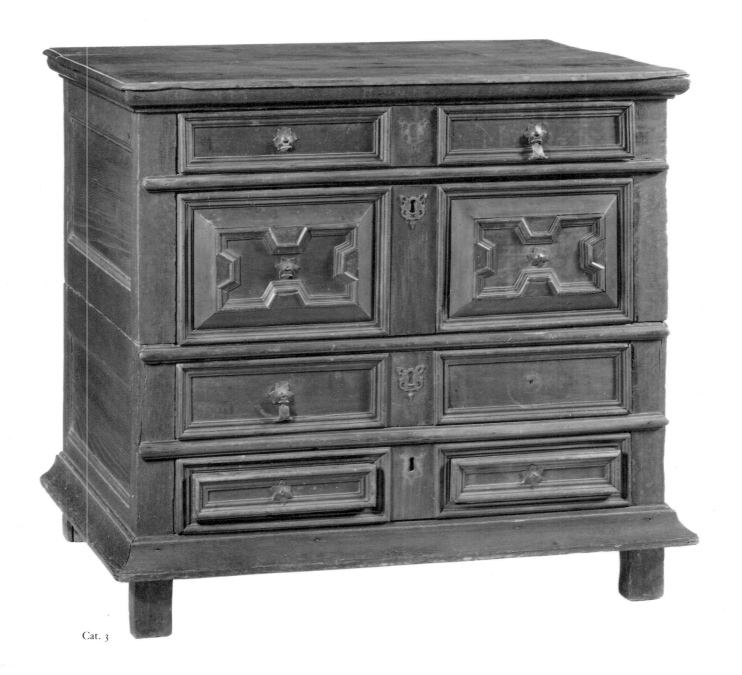

Cat. 3

Cat. 3b

Cat. 3c

of the lower case have never been trimmed off inside. The fragmentary set of brasses is original.

*Condition:* Numerous applied moldings have been restored. The entire exterior is covered with the residue of what appears to have been a later coat of gray paint.

*Woods:* Posts, rails, drawer dividers, base moldings, cornice moldings, oak; top boards, drawer fronts, redcedar; side panels, chestnut; some applied moldings and drawer dividers, cedar; other applied moldings and plaques on drawer fronts, walnut; drawer sides, bottoms, backs, dustboards, rear panels, eastern white pine.

*Dimensions:* H. 35¾ in. (90.8 cm), W. 35½ in. (90.2 cm), D. 20¾ in. (52.7 cm).

*Exhibition:* Fairbanks and Trent, *New England Begins,* cat. 256.

*Bibliography:* Jones, "American Furniture," fig. 1; Trent, "Chest of Drawers in America," p. 42.

*Provenance:* Descended in the Dinnett family of Marblehead, Mass.; Skinner's Auction Gallery, Bolton, Mass., 1976; John Walton, Inc., Jewett City, Conn. (dealer), 1977.

This chest of drawers, in the style attributed by Benno M. Forman to the Mason and Messenger shop traditions of Boston, is the most significant seventeenth-century American object in the collection. It belongs to a large group of four-drawer variants that are thought to date no earlier than the later working careers of the first-generation joiners who transferred the tradition from London to Boston in the 1630s, but might date as late as 1715.[1]

The structural feature of greatest importance to this group is the use of large dovetail keys to secure the drawer sides to the drawer fronts. All other New England joinery traditions that used dovetailed drawer construction are thought to have adopted it in emulation of the Boston shops, save for a small group of case pieces attributed to London-trained joiners working in New Haven, Connecticut, and surrounding towns.[2] It seems, therefore, that dovetailed drawers are a dependable index of either a London

background for the maker or the influence of London-trained joiners working in North America, at least in a New England context.

The massive base and cornice moldings and applied moldings on the drawers and drawer dividers are surprisingly consistent in all examples from the tradition. Many of the moldings of this example have been restored (see cat. 3c), but enough original moldings survive to permit such a restoration without any conjecture about the form of the missing sections. The moldings on the drawer fronts are cedar, while the applied plaques are walnut. The three-board top of the upper case also is cedar. In many other examples, all the moldings and even the major structural elements are made entirely of walnut or of a combination of walnut and exotic hardwoods of the rosewood or ebony families. By English standards, both American black walnut and American red cedar were exotic timbers, and their use in Boston underscores the delight the joiners must have experienced in using native timbers for decorative

purposes. When the chest of drawers was new, the oak and chestnut structural members were a yellowish white, while the cedar was pink in hue and the walnut a dark brown. This original color scheme has been obscured by the darkening of the oak, the fading of the cedar and walnut, and the remains of a coat of gray paint that may have been applied during the federal period.

The construction of these chests of drawers in two parts undoubtedly was intended to facilitate moving them up and down the cramped staircases of seventeenth-century houses. A view of the Milwaukee example dismantled into its component parts (cat. 3d) reveals the unusually extensive use of dustboards to seal each case and the four chamfered tabs that kept the two cases aligned when assembled. A few Boston examples are made in one case, either because they cost less or because they were intended for use in dining rooms or parlors on the ground story of the owner's house and thus did not have to negotiate a staircase.[3] Another option was for turned front feet

of flattened or ovoid contour which were provided with separate, central pins to attach them to the bottoms of the front stiles.[4] The leaf drops and flowered escutcheons, which survive here in a fragmentary state, seem to have been the favored hardware for chests of drawers in Boston and predate the teardrop shaped type popular during the William and Mary period by at least fifty years.

The Milwaukee example has a vague history of descent in a Marblehead, Massachusetts, family. The only four-drawer example with a dependable provenance in the Boston area is one that descended in the Pierce family of Dorchester, Massachusetts (SPNEA collection).[5]          *Robert F. Trent*

Purchase, Layton Art Collection
L1977.3

1. Forman, "Chest of Drawers in America," pp. 1–30.
2. Trent, "Chest of Drawers in America," pp. 43–44.
3. See Trent, "Chest of Drawers in America," for examples of two-case chests,

Cat. 3d

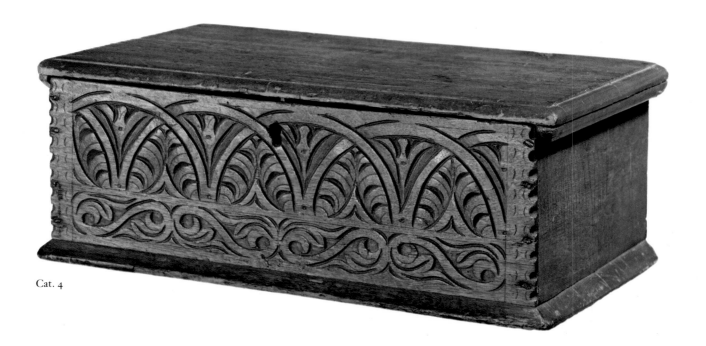

Cat. 4

including the Milwaukee example (figs. 14–16), and one-case chests, including a London example (figs. 13, 17, 18).

4. Trent and Arkell, "Lawton Cupboard," pp. 2C–3C.

5. Trent and Arkell, "Lawton Cupboard," pp. 1C–2C, fig. 3.

## 4   Carved box

Attributed to the William Searle or Thomas Dennis shop traditions
Ipswich, Massachusetts, 1663–1700

*Description:* The front and rear are rabbeted to receive the sides and are nailed to them. The bottom is nailed to the underside of the front, rear, and sides. The top pivots on snipebill hinges.

*Condition:* The bottom has been reset with later nails, and a strip along the back edge of the bottom may be a repair. The hinges have been repaired with wood compound. Later cleats and turned feet have been removed from the bottom. A residue of bluish-black pigment remains in the carved areas, underneath traces of later white and red.

*Woods:* Top (including cleats) and bottom, eastern white pine; left and right side, front, and till, white oak; back, red oak.

*Dimensions:* H. 9¼ in. (23.2 cm), W. 25 in. (63.5 cm), D. 13⅞ in. (35.3 cm).

*Provenance:* Clark Bayley, Newbury, Mass. (dealer), 1947; Stanley MacConnell, Salisbury, Mass., 1983; Robert W. Skinner Gallery, Bolton, Mass., January 1983; Peter H. Eaton Antiques, Newton Junction, N.H., March 1983.

This box belongs to a large group of carved oak furniture associated with William Searle (1634–67) and Thomas Dennis (1638–1706) of Ipswich, Massachusetts. Searle first worked in Ipswich in 1663, and Dennis married Searle's widow in 1668 and continued working until his death. The specific motif that connects this box to the larger body of Searle/Dennis objects is the frieze of intersecting lunettes carved on the front. This same carving, executed in the identical manner, appears on the Dennis family chest which descended in the joiner's family (collection of Edward and Linda Nicholson), as well as a chest that descended in the Smith family of Ipswich (Ipswich [Massachusetts] Historical Society), and a related chest with no provenance (Metropolitan Museum of Art).[1]

This example has no early provenance. It has a pine top and bottom and an oak body, a common formula that might have been interpreted as a sign of later construction but is now accepted as impossible to date with assurance. Most likely Dennis made many boxes with and without carving, but reserved carving for those with at least an oak front.

The carving is laid out with systematic scribed lines made with a ruler and a pair of compasses. After the overall pattern was scribed on the surface of the wood, further guidelines in the form of chisel marks were struck within the lunettes. The carving itself consists mostly of undercutting certain leaves and veins with a gouge to give the impression of relief. The combination of mechanical layout and freehand articulation is characteristic of mannerist carving and is not easily replicated by modern fakers who do not have the disciplined training in carving that permitted such work to be swiftly executed.

Remains of a bluish-black pigment in the carving may represent an original coat of lampblack pigment in a glue vehicle. Overall painting was not, however,

frequently used on the Searle/Dennis objects. More often the background of the carved areas is picked out in black and red and the rest is left unpainted.

Twentieth-century cleats and turned feet removed from the bottom of the box may have been intended to emulate the Dennis family "deed box," which has turned feet.[2]                    *Robert F. Trent*

Purchase, Layton Art Collection
L1983.183

1. Trent, *Pilgrim Century Furniture*, pp. 57, 86, 90.
2. Fairbanks and Trent, *New England Begins*, pp. 518–19.
A related box with a row of strapwork motifs below intersecting lunettes is at the Art Institute of Chicago. The earliest dated Searle-Dennis box (Saint Louis Art Museum) has foliate carving and is carved with "1664" on one side.

## 5  *Chest with drawer*

Attributed to the Peter Blin shop tradition
Wethersfield, Connecticut, 1675–1725

*Description:* Many of the applied moldings and turnings have been renailed at various times. The rear is composed of one horizontal framed panel and a second lower "floating" panel with no rail beneath it. The floor of the chest compartment is made up of boards set back-to-front, butted with V joints. The boards are feathered to fit into a groove in the lower front rail and are nailed under the medial back rail. The posts are riven wood. The lower rear side joints have pegs that were never trimmed on the interior.

*Condition:* The age of the top and the till boards is questionable. The lid has a splice executed at a 45-degree angle along the rear edge along the line of the snipebill hinges. The drawer knobs are modern replacements. The upper tips of the columns on the proper right muntin of the facade are restored. Considerable traces of original black and red painted decoration remain.

*Woods:* Posts, side panels, side rails, and drawer front, white oak; drawer sides, red oak; drawer bottom, drawer back, bottom and backboards of storage com-

partment, bed moldings on sides, southern yellow pine; small decorative moldings in panels and on drawer front, Atlantic white cedar; applied columns and colonnettes, maple.

*Dimensions:* H. 30¾ in. (78.1 cm), W. 45⅗ in. (116.2 cm), D. 19¾ in. (50.2 cm).

*Bibliography: Antiques* 72, no. 4 (October 1957): 294; Jones, "American Furniture," p. 975, fig. 2.

*Provenance:* Purchased in 1980 from George Abraham–Gilbert May Antiques, West Granville, Mass. (dealer).

Chests from this shop tradition traditionally are known as "sunflower chests," on the mistaken assumption that the floral motifs in the center panels represent sunflowers. Two objects with histories of ownership tie the shop tradition to Wethersfield, Connecticut. The first is the cupboard (Lancaster [Massachusetts] Public Library) that was made for the Reverend Joseph Rowlandson (1631–78) between April 1677 and Rowlandson's death in November 1678. The cupboard is appraised in his estate inventory at £2.[1] The second is a chest (Connecticut Historical Society) that traditionally belonged to Gershom Bulkeley (1636–1713), a minister and physician, and descended from Bulkeley's daughter, Dorothy Bulkeley Treat (1662–1757), the executrix of his estate.[2] The chest was identified by Houghton Bulkeley with an account book entry dated 1681 for a chest valued at 10s., purchased from Peter Blin (1640–1725), a joiner and turner.[3]

Blin was a Francophile and is thought to have been from the Huguenot community in Stepney Parish, London, or perhaps from the Netherlands or France. He served as attorney and translator for two Huguenot merchants at various times. A descendant, F. Stuart Blin of Wethersfield, recalled in 1913 a carved chest filled with French books in his mother's possession which was thought to have belonged to their ancestor.[4] It is pertinent to the identity of the flowers carved in the central panels of most case pieces attributed to Blin that the emblem of Marguerite de Valois, Duchesse d'Alençon, the sister of François I, was the marigold, and that the colors of the Huguenot party in France were some-

times yellow and black, the colors of that flower.[5] The flowers on Blin chests are indeed marigolds, although it would appear that in adopting the marigold motif, Blin or his master conjoined it with the thistle of Scotland so that it could also serve as a Tudor rose. These two flowers are accompanied by tulips, a generic motif with no particular associations. The symbolic background of Blin's carving is problematic, however, because his work has a direct relationship to that of an unidentified contemporary in Windsor, Connecticut, whose work appears to be earlier stylistically and who may have been Blin's master. Furthermore, Blin worked in Wethersfield for fifty years and may have trained numerous apprentices, one of whom was his son Peter Blin, Jr. (1670?–alive 1741), who worked in Guilford and is identified with a group of painted chests that originate in Guilford and Branford.[6] Strictly speaking, chests in Blin's style cannot be attributed to him only, but to his shop tradition, in order to allow for the possibility that his apprentices may have made them.

The Milwaukee collection example is significant for a number of reasons. Many Blin-tradition chests were ruthlessly restored from the 1880s to the 1960s, while the Milwaukee example is relatively intact. The restorations are minor, and the applied moldings of the panels retain their original rosewood painted decoration, a coat of red with black cross banding or stripes that survives on only four other case pieces.[7] The black paint on the base and waist moldings and the applied columns and bosses is substantially intact, as well. Finally, Blin chests with only one drawer are rare and are today considered to be more desirable than those with two drawers, which are relatively plentiful.

The Milwaukee example probably dates from later in the tradition's existence. The loose and simplified carving is one detail that suggests this, but the prime feature that does is the form of the two pairs of columns flanking the central panel. On the earlier examples, like the Rowlandson cupboard, the Tuscan Doric columns display a highly mannered, severe taper toward the capitals, while later examples, including the painted chests attributed to Peter Blin, Jr., have

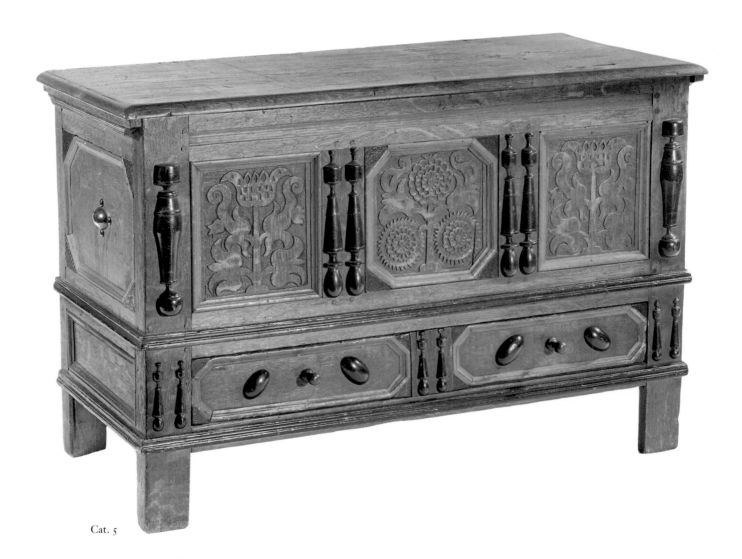

Cat. 5

far more normatively proportioned columns and additional decorative echinus rings.[8] Blin and his son and apprentices may have been prompted to alter this detail under the influence of London or London-style case pieces.[9]

*Robert F. Trent*

Purchase, Layton Art Collection
L1980.4

1. Kane, "Joiners of Seventeenth Century Hartford County," pp. 74–77.
2. Bulkeley, "A Discovery on the Connecticut Chest," pp. 17–19.
3. The Bulkeley account book reference also cites the purchase of trenchers, which were often turned. The consistency of the turned ornament on case pieces in the Blin tradition also argues for his having had turning skills.
4. Jane Blinn, "Blinn Genealogical Manuscript," Connecticut Historical Society, n. p.
5. Lawton, "The Emblematical Flower and Distinguishing Color of the Huguenots," pp. 237–45.
6. The first scholar to identify the flowers as marigolds was the late Benno M. Forman.

The Windsor shop tradition is identified in Zea, "Furniture," pp. 200–201.
7. The four other case pieces with intact painted moldings are a cupboard at Yale University Art Gallery; a chest with one drawer in the collection of George Kaufman, Norfolk, Va.; a chest with one drawer in a private collection, formerly the property of Roy Thompson and Frank Kravic, Glastonbury, Conn.; and a chest with two drawers at Historic Deerfield.
8. For later examples that are dated, see Kirk, *Connecticut Furniture*, pp. 14, 26–27.
9. Trent, "Chest of Drawers in America," pp. 34–40.

## 6 *Board chest*

Probably Middletown, Connecticut,
ca. 1690

*Description:* The cleats of the lid are held by T-headed clinch nails driven in from underneath. The case is also held together with T-headed nails. The brackets are separate from the front board. The back is one board. Three snipebill hinges secure the lid to the case. The original lock, square keeper, and keyhole escutcheon survive. An ogee molding is run on the front and rear edges of the lid.

*Condition:* The lid has shrunk as much as 1½ in. (3.8 cm) across its width. The proper right rear foot and the backboard have experienced slight insect damage. The lid has two old pot burns. The proper left front foot is slightly abraded.

*Wood:* All components, southern yellow pine.

*Dimensions:* H. 26⅝ in. (62.6 cm), w. 53⅜ in. (135.6 cm), D. 20½ in. (52.0 cm).

*Provenance:* Noadiah and Mary (Hamlin) Russell; descended to Robert P. Butler of Hartford, Conn.; Clearing House Auction Galleries, Wethersfield, Conn.; Lillian Cogan, Farmington, Conn. (dealer).

Cat. 6

This board chest with planed, punched, and gouged decoration is one of the few examples that can be securely documented and dated. The initials "N<sup>R</sup>M" on the facade stand for the Reverend Noadiah Russell (1659–1713) and his wife, Mary Hamlin (1662–1745), of Middletown, Connecticut, who were married in 1690. Russell was the son of the London-trained joiner William Russell (1612–64) of New Haven, but his father died when Noadiah was five years old, and the chest bears no resemblance to New Haven–area board chests in the London manner.[1] Rather, it is closely related in concept, if not in detail, to a group of board chests associated with river towns in central Connecticut, notably Wethersfield and Windsor.[2]

The compositional strategies employed in fashioning board chests vary. Some are constructed of boards run with crease moldings that are virtually indistinguishable from those employed in board sheathing for interior walls. At times crease-molded chests are further embellished with linear or geometric scribing, or punched decoration, or architectural scalloping of skirts. Distinct from these treatments are those in which the facade is divided into two or three fields reminiscent of panels on joined chests. Effects of this type are sometimes further enhanced by shallow incised ornament or by applied moldings that simulate joined construction.

Despite the fact that board chests were often referred to as "plain" in order to distinguish them from joined examples, the elaboration of ornament on them suggests that they were regarded as something other than a cheap version of a joined chest.[3] Many received marriage initials and dates. Two silver spoons made by Jeremiah Dummer of Boston were owned by Noadiah and Mary Russell and were inscribed with the same marriage initials as the chest shown here (Wadsworth Atheneum; Yale University Art Gallery).[4]

A further artificial element in the compositions was painted decoration, generally confined to a coat of a single color, but sometimes in two colors. Those examples with stippled, grained, or floral treatments date from the eighteenth century. The Russell chest is painted red with traces of white in the punchwork of

the initials; the initials were later reinforced with gray. Traces of dark brown are on the top, sides, and brackets.

*Robert F. Trent*

Purchase, Layton Art Collection
L1987.1

1. Trent, "Chest of Drawers in America," p. 38, figs. 10–11.
2. Hosley and Zea, "Decorated Board Chests," pp. 1146–51.
3. Hosley and Zea, "Decorated Board Chests," pp. 1146–48.
4. *Great River*, cat. 162.

## 7   *Square joined table*

Probably eastern Massachusetts,
1675–1710

*Description:* The skirts and brackets are made of watersawn wood. The skirt tenons are held in mortises in the posts with large pegs, while the separate brackets are held in extensions of the same mortises by smaller pegs and are secured to the skirts by wrought-iron nails driven

from underneath. An oak medial strut mortised into two opposite skirts supports the middle of the top. The original top was held by four large pegs, one in each post top.

*Condition:* The top is an incorrect modern replacement. The brown paint or glaze on all visible surfaces is late nineteenth century in date. Two of the pendants under the skirts are replacements.

*Woods:* Skirts and brackets, eastern white pine; stretchers and medial strut, red oak; posts and pendants, soft maple; replacement top, white oak.

*Dimensions:* H. without top 27 11/16 in. (70.3 cm), W. frame 31⅛ in. (79.0 cm), D. frame 30⅞ in. (78.4 cm).

*Bibliography:* Nutting, *Furniture of the Pilgrim Century* (1921), p. 407; Nutting, *Furniture of the Pilgrim Century* (1924), pl. 762; Nutting, *Furniture Treasury*, pl. 832; Jones, "American Furniture," p. 975, fig. 3.

*Provenance:* Mrs. George C. Bryant (collector), Ansonia, Conn.; The Metropolitan Museum of Art; Joe Kindig, Jr., and Son Antiques, York, Pa. (dealer).

Cat. 7

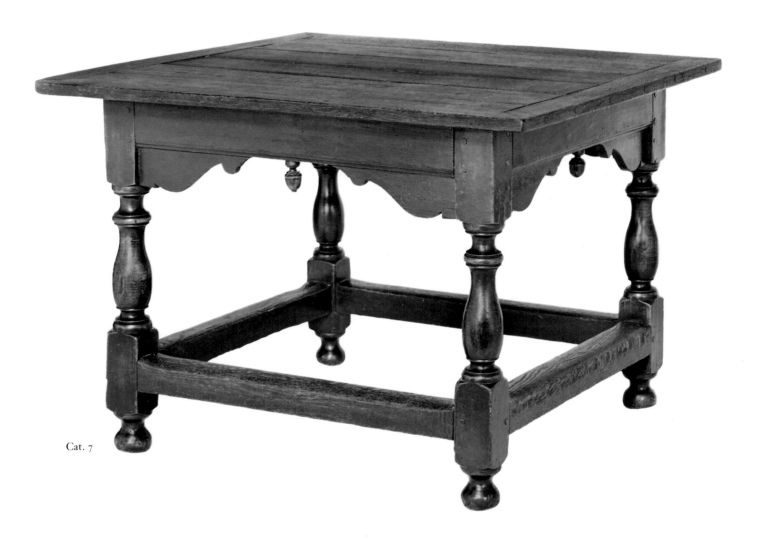

Cat. 7

Square joined tables with box stretchers and heavy columnar or vasiform turnings on the posts are among the rarer seventeenth-century survivals and are to be distinguished from lighter tables with a variety of stretcher arrangements that date after 1720.[1] This example is nearly identical to one in the Metropolitan Museum of Art, with which it shares maple posts with heavy vases, separate brackets, and pendant drops. The regional origins of both examples are not known. Other examples have frames and tops entirely in oak.[2]

The heaviness of these tables does not preclude their having been used in a domestic context. Probate inventories dating before the 1680s frequently cite square tables in parlors with sets of chairs, and the broad stretchers obviously were intended for resting feet upon. Nevertheless, authors in the past have suggested that such tables were "tavern tables" or "communion tables," the theory being that such monumental objects were too large for the average household.

Although the early date range of such tables is beyond question, the Milwaukee and Metropolitan examples have certain features which suggest a date toward the end of the seventeenth century; the use of maple for the posts and a softwood for the skirts are the most important. Furthermore, if the present top of the Metropolitan example is original, which remains to be demonstrated, then the two boards employed may also be viewed as a later feature. The earlier treatment, based on English usage, was for an all-oak frame and a riven-oak, four- or five-board top with mitered cleats, entirely assembled with wooden pins and held to the frame with strategically placed pins at the four corners. The tendency of these oak tops to shear off the pins may account for surviving tops made of wide boards nailed in place. On one example, at the Wadsworth Atheneum, the multi-board oak top was not attached to the base, but rests atop extensions of the posts which fit into corresponding trenches on the underside of the top boards.

Another feature that suggests a later date range for the Milwaukee and Metropolitan tables is the presence of original squiggle dry-brushed paint on the Metropolitan frame, generally speak-

ing a feature found on Boston case pieces dating after 1680.

The present replacement top on the Milwaukee table, made with oak floorboards, is not made with riven or quartersawn material and is furthermore too thin. It is based on the Wadsworth Atheneum example and, perhaps, on the Jaques table at the Historical Society of Old Newbury (Massachusetts).[3]

*Robert F. Trent*

Purchase, Layton Art Collection
L1974.204

1. The other known examples include the Wadsworth Atheneum table, the Metropolitan Museum of Art table, the Jaques table at the Historical Society of Old Newbury (Massachusetts), and three other examples in private collections.
2. The Wadsworth Atheneum table and the Jaques table are the only ones with unquestionably original, multiboard oak tops.
3. The top of the Wadsworth Atheneum example, the usual prototype for replaced tops and fakes, is illustrated in Nutting, *Furniture of the Pilgrim Century* (1924), pl. 689, and in Nutting, *Furniture Treasury*, pl. 825.

## 8  *Looking glass*

England, 1650–90

*Description:* The box frame is 3⅝ in. (9.2 cm) deep and is joined with one-and-a-half dovetail keys at each corner. Two small rectangular notches are cut through the top edge of each side of the frame to receive the ends of the grid formed by the rectangular muntin bars. The grid is secured by half-round face molding, 1 in. (2.5 cm) wide, nailed onto the frame edges. Similar molding, only ¾ in. (1.9 cm) wide, is nailed to the face of the muntins. Thin wood fillets secure the glazing and beveled mirror behind this molding.

The textile was originally tacked directly to a mortise-and-tenoned mounting frame. The four horizontal boards of the frame create a central bevel-edged opening. The textile surrounds this opening, and through the opening a red-covered board is visible. This board rests in a rabbet cut into the back of the mounting frame; successively deeper rab-

bets hold two more boards, each covered with marbleized paper. The side and back of the mounting frame are covered with red silk velvet having silver thread binding. Originally the side velvet was glued in place. A double rabbet on the interior rear edge of the box frame originally held the mounting frame and the backboard.

The needlework is sewn on a satin ground which is stiffened on the back with layers of paper and paste. Cotton wadding and carved wooden elements form the core of some of the most three-dimensional elements, such as fruit hanging from the trees and the faces of the figures. The armatures are formed with fine-gauge brass wire. The costumes on the side figures and the three-dimensional petals and leaves are all sewn with a variety of buttonhole stitches. Satin stitch and laid and couched work are also used.

*Inscriptions:* The top rail of the box frame is stamped with two overlapped Vs forming a W. A partial engraved label, dating about 1760–80, was attached to the backboard; it is known today only from a photograph. It read: "Picture Frame Maker, Carver, Gilder & Printseller. / at the Golden Key, Nº. 36, Leadenhall Street. / London / Makes & sells all sorts of Picture Frames. Carves & gilds Looking / Glass Frames & Girandoles in the newest Taste & at the most / reasonable Prices. Landscape and Sea Pictures neatly Painted. / Pictures carefully cleaned lined and mended. / Old frames new gilt on the shortest / Notice. / Mouldings of different patterns and lengths for the conveniency of Exportation."[1]

*Condition:* The textile and areas of the frame were conserved in 1982–83. Several pieces of the half-round molding were replaced due to worm damage. A spacer board was secured inside the interior of the frame to move the mounting frame back, preventing the needlework from touching the glazing. The backboard was removed and a ¼ in. (.6 cm) retaining strip was added to the rear edges of the frame to accommodate the deeper position of the mounting frame and the thicker layers of ground fabric and support. The location of the backboard is presently unknown. One pane of glass is replaced. The beveled mirror

was either resilvered in the nineteenth century or is a replacement.

The tacks originally securing the needlework to the mounting frame were removed, and the textile was sewn to a fabric ground incorporating polyester batting as a support between these layers. The mount was first covered with mylar, and then the new ground was secured to it. The mount's rear and side velvet pieces were sewn to the new ground. Loose stones and other pieces were reattached to the needlework.

*Materials:* Frame, a ring-porous hardwood, possibly oak; face molding, a softwood, possibly pine, painted black; textile elements, cream-colored silk-satin ground, silk floss, creped silk yarn, silk-wrapped wire and metal purl, pearls, coral, semiprecious stones, glass brilliants, brass wire, wood, and wool batting.

*Dimensions:* H. 30⅝ in. (77.0 cm), W. 26¾ in. (67.0 cm), D. 3⅞ in. (9.8 cm).

*Provenance:* Ginsburg and Levy, New York, N.Y. (dealer); Kenneth and Diana Milne (collectors); John Walton, Inc., Jewett City, Conn. (dealer); purchased by the donors.

The three-dimensional quality of this object is extraordinary. The figures that flank the mirror, although fully attached to the silk ground, are raised outward at least an inch (2.5 cm) from it. The acorns, pears, strawberries, oranges, and their foliage are fully worked in the round, and are suspended from brass-wire stems wound with hair-fine silk thread. The richness of the piece is further enhanced by its multitude of ornaments, such as the pearl jewelry on the standing figures and the coral and other semiprecious and precious stones scattered thickly throughout the creped-silk "shrubbery" along the lower rail.

The coat of arms at the center of the upper portion is that of Currer, a Yorkshire family with several branches. The arms may have been granted as early as the thirteenth century.[2] However, the iconography of figures on the mirror is not as clearly distinguished. The woman at the left carries a stem of lilies, representative of purity and virginity. The woman opposite grasps lightly at a lock of her hair. The portrait in the lower

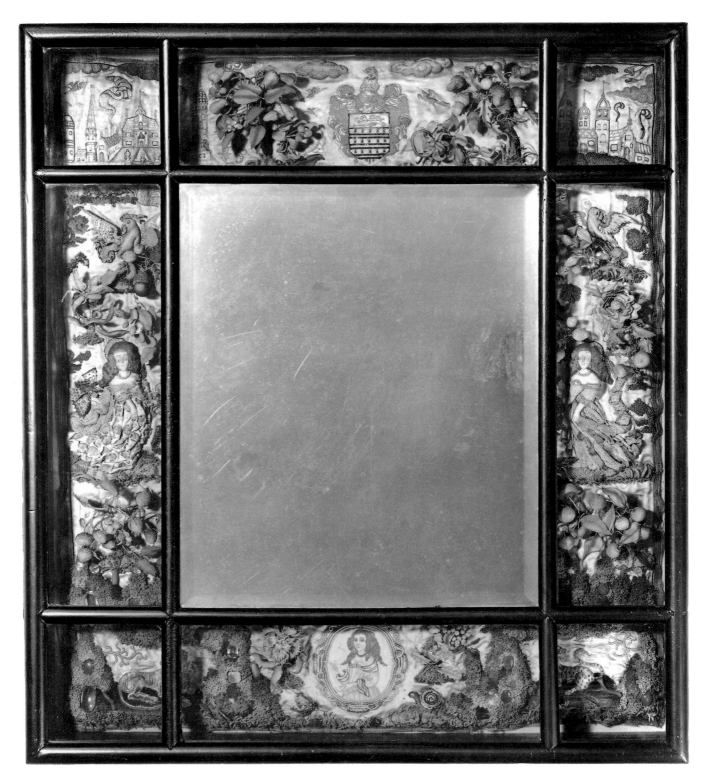

Cat. 8

roundel is of a conventional beauty, not a specific subject; she carries a fan and points upward.[3]

Owing to the eighteenth-century framer's label once glued to the backboard of this piece, there has been some question as to the originality of the frame. However, close examination of the object and careful comparison with published examples indicate that the unknown framer probably did not make a new frame for the needlework, but only performed remedial work such as replacing broken glass or the mirror. The frame may have been veneered originally with tortoiseshell as is the case on many of the most elaborate of these seventeenth-century looking glasses with raised-embroidery frames.[4]                    *Jayne E. Stokes*

Gift of Virginia and Robert V. Krikorian
M1987.49

1. My thanks to Toni Aiken, curatorial intern, for searching *The Dictionary of English Furniture Makers* for the name of a frame maker that corresponds to the address on the label. Unfortunately, the search was fruitless.
2. I am grateful to Henry L.P. Beckwith for his identification of these arms.
3. Santina M. Levey, formerly Keeper of the Department of Textiles at the Victoria and Albert Museum, provided assistance on this point and others; see her correspondence, dated March 16 and March 23, 1989, MAM object files.
4. For related framing, see Hughes, *English Domestic Needlework*, fig. 34, top; Christie's (South Kensington, England) (June 23, 1987), lot 174; and, especially, Sotheby's (October 13, 1990), lot 59. All three of these examples are veneered with tortoiseshell.

# 9 *Tyg*

George Richardson (d. 1687)
Wrotham, Kent, England, 1649

*Description:* This beaker-shaped vessel was built by the coil method and consists of red clay covered with a lead glaze. The iron impurities resulted in a chocolate-brown surface decorated with applied pads of white clay stamped by intaglio dies with designs of rosettes, fleur-de-lis, an angel, the initials of the potter's name, and the date. Additional trailed lines and dots of slip decorate the ground. The slightly flaring form has four double-loop

handles with rope twist and straight cord inserts and bun finials.

*Inscriptions:* Decorated with the potter's initials, GR, and the date 1649.

*Condition:* The tyg is in good condition. The top ball finials on two of the four handles are missing, and there are minor glaze chips on the base.

*Material:* Slip decorated earthenware with applied and stamped ornament.

*Dimensions:* H. 6 in. (15.2 cm), DIAM. 4¼ in. (10.8 cm).

*Provenance:* Purchased by the donors in 1981 from Michael and Jane Dunn, Claverack, N. Y. (dealers).

This fancifully decorated tyg, a multi-handled drinking vessel, is part of a distinctive group of slipware made twenty-five miles southeast of central London in Wrotham. The initials refer to George Richardson, one of the five master potters working in that specific location. He marked approximately twenty-five pieces between 1642 and 1683 and was among the first to include along with his initials the village name, Wrotham.[1] Wrotham potters, in their desire to embellish commonplace objects for commemorative purposes, formulated a distinctive style combining form and function with ornamental flair. Molded and applied decoration were used in Europe but the distinctive dots, dashes, and profuse use of ornament on Wrotham pieces seems confined to England.[2] Wrotham potters produced a variety of useful wares, but mainly the more elaborately decorated pieces have survived.          *Anne H. Vogel*

Gift of Virginia and Robert V. Krikorian
M1987.54

1. I am indebted to Jonathan Horne, Antiquarian, Specialist in Early English Pottery and Member of the British Antique Dealers Association, Ltd., London, for his thoughtful reading and instructive comments on this and other ceramic entries I have prepared. Goldweitz, "An American Collection of English Pottery," p. 9, and Kiddell, "Wrotham Slipware," pp. 105–18. A comparable tyg, dated 1651 with the initials GR, is illustrated in Taggart, *Burnap Collection*, p. 26, no. 17. Rackham, *Glaisher Collection*, nos. 116, 130.
2. See comments by Constance H. Nicholson, quoted in *Antiques* 94, no. 2 (August 1968): 232–34.

# 10 *Dish*

London, England, ca. 1685

*Description:* This ornamental dish has a blue dash rim. It is decorated with three tulips, two lilies, and buds and leaves of pale green outlined in blue, all rising from a small mound. The dish is colored in green, yellow, blue, and ochre. A thin lead glaze covers the back, and the foot rim is pierced. Three spur marks on the front indicate the seventeenth-century method of firing dishes face down in stacks separated by trivets.

*Condition:* Repairs have been made to a 2-in. (5.1 cm) break on the rim where the surface was repainted.

*Material:* Tin- and lead-glazed earthenware.

*Dimensions:* DIAM. 13¾ in. (34.9 cm), DIAM. foot rim 4½ in. (11.4 cm).

*Provenance:* Purchased in 1975 from the Joseph V. Vizcarra collection, Lombard, Ill.

Large shallow earthenware dishes with a tin-glaze were made in England from 1600 until the middle of the next century. The design of the Milwaukee example most closely relates to other dishes similar in style that are associated with the period of 1685 to 1695.[1] In tulip dishes of this period, the leaves flatten and fan out as artistic license begins to replace naturalism.

Most seventeenth-century examples have lead-glazed backs, and eighteenth-century dishes usually are tin-glazed on both sides. They were painted in a wide range of subjects, the most popular being royal portraits, depictions of the temptation of Adam and Eve, and, as here, sprays of tulips.

More decorative than utilitarian, these large dishes were usually displayed on sideboards or hung by their pierced foot rims on a wall. The popular term *blue-dash charger* does not appear in period documents; an object of this size was usually called a *dish* or *platter*. Seventeenth-century flower books as well as Turkish dishes from Isnik inspired the tulip design. The popularity of the tulip motif (see also cats. 5, 11) reflects the tulipomania that swept Holland and England in

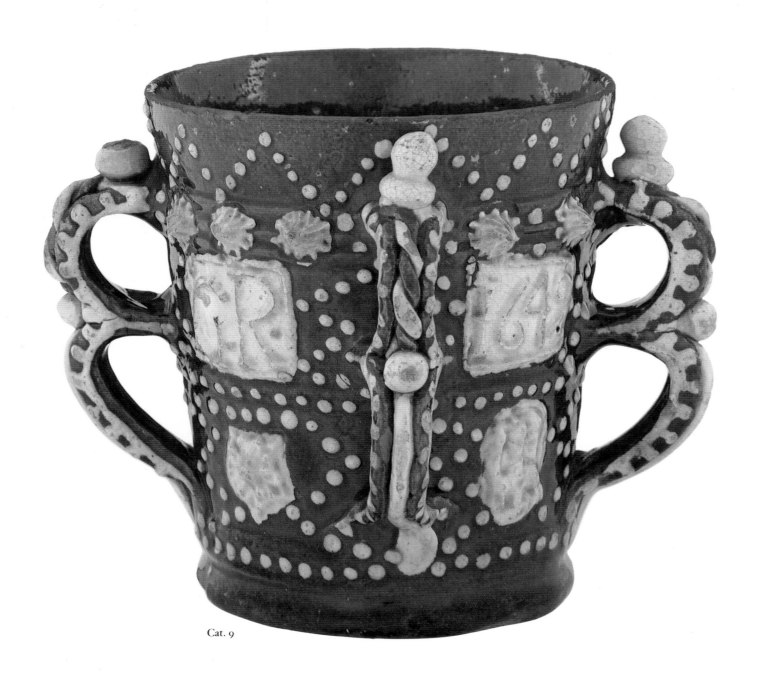

Cat. 9

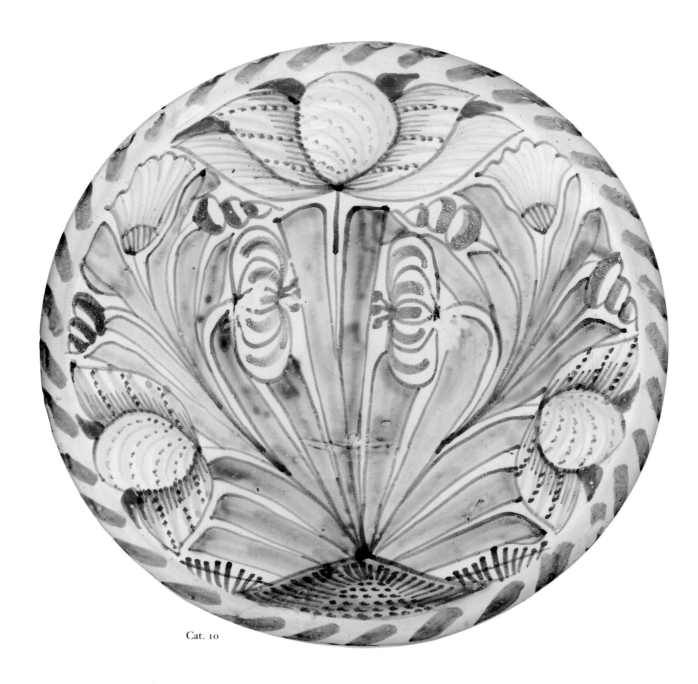

Cat. 10

the late sixteenth and early seventeenth centuries.

Archaeological excavation and research reveal that a full range of London delftware was reaching households in Virginia from the 1640s onward. The presence of English delftware in New England is also documented through written and archaeological evidence.[2]

*Anne H. Vogel*

Purchase, Layton Art Collection
L1975.54

1. Archer, "The Dating of Delftware Chargers," pl. 56a.
2. Noël Hume, *Early English Delftware*, p. 104; Fairbanks and Trent, *New England Begins*, pp. 264, 274, 277; Museum of Our National Heritage, *Unearthing New England's Past*, pp. 101–7.

## 11 *Two-handled cup*

RA in a heart, mullet and two pellets below
London, England, 1667/68

*Description:* The two-handled bulbous cup is raised up in one piece on a short base. It is decorated with six vertical panels containing simple embossing in low relief, each with a chased outline of a single

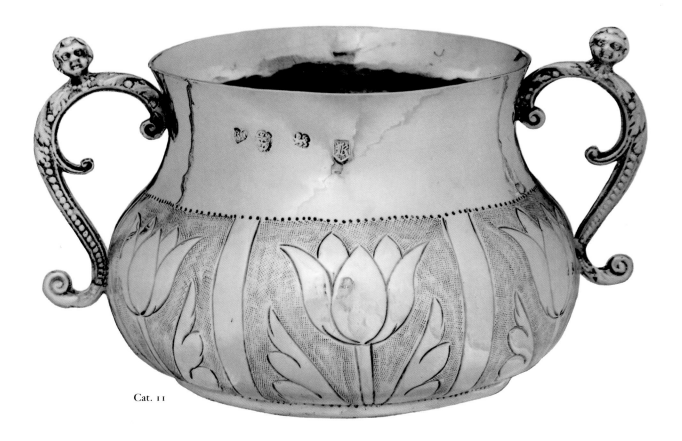

Cat. 11

tulip on a vertical stem and a leaf on each side. The panels have a finely matted ground bordered above and below by a line of punched dots. The base is ornamented with punched dots forming three flowers in geometric pie-shaped spaces. The cast handles have simple caryatid masks attached to foliate and bead-decorated scrolls.

*Marks:* Maker's mark RA in a heart, mullet and two pellets below (Jackson, *English Goldsmiths*, p. 127); date letter for 1667/68, lion's head, and lion passant struck on upper body near lip.

*Inscriptions:* On the side opposite the hallmarks is an engraved armorial. The arms (Gules, two lions passant, ermine in chief and a mullet for difference) are for Sir Roger de Feltone. The Feltone family were of Gloucester and Cirencester, England.

*Condition:* The cup is in excellent condition with unusually crisp matting and chasing, and a minimum of surface wear.

*Material:* Silver.

*Dimensions:* H. 3½ in. (8.9 cm) w. 6½ in. (16.5 cm), D. 4⅞ in. (12.4 cm), WT. 8 oz. 7 dwt. (259.7 gm).

*Exhibition:* Vogel, *Focus: The Flower in Art*, p. 12, no. 37.

*Bibliography: Antique Collector* 48, no. 4 (April 1977): 85; *Antiques* 115, no. 2 (February 1979): 316.

*Provenance:* Purchased from S. J. Shrubsole Ltd., London, July 1977.

The bulbous two-handled cup with flat-chased panels, often called a caudle cup, was popular from 1650 to 1690 in England and America.[1] The simple rectilinear style of this example reflects late Renaissance tradition, and the caryatid handles are an element of mannerist ornament derived from engravings and printed books.[2] By 1690, bolder repoussé decoration flowed continuously around cups, and rich baroque styling replaced paneling and chased punchwork design.

Contrary to the image of Puritan austerity, probate inventories and other documents reveal that some American colonists built up large supplies of plate.[3] William Fitzhugh of Virginia, for example, accumulated 122 pieces of silver before his death in 1701. He recorded his preference for these pieces in a letter of 1688, writing that it was "politic as well as reputable" to fill a cupboard with plate, and noting that silver offered "use and credit" during one's life; became "a sure friend at death"; and provided "a certain portion for a child."[4] The 1675 inventory of Boston citizen John Freake indicates he owned the latest, most fashionable forms of silver including a caudle cup and cover.[5]

The museum's English cup exemplifies the type that first influenced colonial silversmiths. Flat-chased and punched ornament was used repeatedly by first-generation Boston craftsmen. In particular, a well-known cup by John Hull and Robert Sanderson of Boston (Museum of Fine Arts, Boston) is closely derived

from English prototypes and reflects the makers' English orientation.[6] Its ornamentation also consists of six panels, each with a simple embossed five-petal tulip. The conventionalized tulip that decorated silver surfaces was also utilized on many other types of decorative arts.[7]

The silversmith may have ranked at the top of the hierarchy of craftsmen during the colonial period because his work reflected European styles more rapidly than other categories of the decorative arts. The impact of silver objects imported to America was multidimensional. They played a vital role in transplanting English mores and tastes to a new setting and represented a sound investment and social stability for people in a colonial outpost.      *Anne H. Vogel*

Gift of Collectors' Corner
M1977.33

1. Caudle was a warm drink usually made of ale or wine mixed with eggs, bread, sugar, and spices, used for medicinal and convivial purposes.
2. See Fairbanks and Trent, *New England Begins*, pp. 368–79, for a discussion of the transmission of the mannerist style to northern Europe and England and its subsequent implications for artisans in colonial America.
3. See Albert S. Roe and Robert F. Trent, "Robert Sanderson and the Founding of the Boston Silversmiths' Trade," in Fairbanks and Trent, *New England Begins*, pp. 480–88, for a discussion of silver in Boston inventories, and Davis, *English Silver*, for insight to colonial Virginians' silver acquisitions from the mother country.
4. Davis, *English Silver*, p. 3.
5. Fairbanks and Trent, *New England Begins*, p. 482. John Freake's three-quarter-length portrait by an unknown American seventeenth-century artist (ca. 1671–74) is in the Worcester Art Museum, Worcester, Mass.
6. See Buhler and Hood, *American Silver*, cats. 16–18, for three examples of early Boston two-handled cups that remain loyal to their English prototypes.
7. For further comparisons see Kathryn C. Buhler, "Colonial Furniture and Silver," in Kolter, *Early American Silver*, pp. 37–40.

## 12   *Candlestick*

Northern Europe, 1580–1620

*Description:* The candlestick is cast in two sections: a socket/stem and a drip pan/base. A tang on the lower end of the

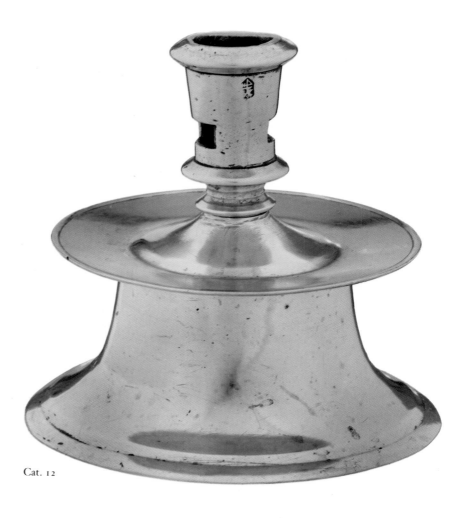

Cat. 12

stem is inserted through a hole at the center of the base, then peened over from underneath. Casting excesses were closely trimmed on a lathe.[1]

*Marks:* A shield-shaped cast, or possibly die-stamped, mark is found below the rim of the candle socket. Marks on this type of candlestick are rare and little is known about them; it may represent the maker, the owner, or a guild or other quality-assurance group (see cat. 40). Recent oral history attributes the mark to the Guild of the City of Ghent; however, research indicates that this is incorrect.[2]

*Condition:* The candlestick has survived in excellent condition, with only normal wear.

*Material:* Brass.

*Dimensions:* H. 5¼ in. (13.4 cm), DIAM. 5½ in. (14.0 cm).

*Provenance:* Purchased by the donors in 1981 from Michael and Jane Dunn, Claverack, N.Y. (dealers).

Known colloquially as a capstan stick, this form of candlestick was popular throughout Europe during the sixteenth century and into the first half of the seventeenth century.[3] The breadth of the low, concave conical base relative to the brief candle socket atop the nearly nonexistent stem creates an extremely stable lighting device. Other features of the form which make it a very practical candleholder are the capacious drip pan for catching run-off from soft tallow candles and the wide apertures for removing the unburnt stub.

Several features date this candlestick to the later years of the form's popularity. Refinements accrued after decades of manufacture include a thin-walled base, closely trimmed by the lathe, a slightly molded foot, an incised line on the socket lip as well as on the drip-pan rim, and the triangulation of the ovolo moldings at the lip and base of the socket and the knop on the stem.    *Jayne E. Stokes*

Gift of Virginia and Robert V. Krikorian
M1987.38

1. I would like to thank Jean M. Burks for her generous sharing of information regarding brass lighting devices, in particular her insights concerning historical production methods and construction.

2. The Ghent attribution is from the dealer, who was told this by his source. Correspondence with the Museum voor Sierkunst and the Oudheidkundige Musea in Ghent, Belgium (October 1989) indicates that the mark is that of an unrecorded foundry master.

3. Michaelis, *Old Domestic Base-Metal Candlesticks*, p. 56.

## 13   *Candlestick*

England, 1660–1700

*Description:* The stick is constructed in two parts. The socket/stem and drip pan/base are each cast as a unit. The tang extending from the lower end of the shaft is inserted into a hole at the center of the base and peened over from underneath.

*Inscription:* "1670" is crudely scratched on the underside of the base.

*Condition:* The lip is slightly bent on one side.

*Material:* Brass.

*Dimensions:* H. 6 in. (15.3 cm), DIAM. 4¼ in. (10.8 cm).

*Provenance:* Purchased by the donors in 1978 from Rupert Gentle Antiques, Milton Lilbourne, Wiltshire, England (dealer).

This trumpet-based candlestick represents one of the most enduringly popular forms of brass candlestick produced in seventeenth-century England.[1] It is also signi-

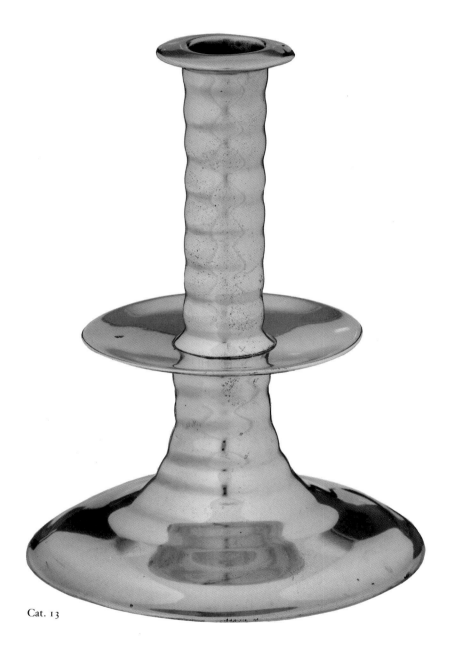

Cat. 13

ficant because it represents the beginning of the brassworking industry in England. Though England had never lacked the raw materials to produce brass and a concerted effort was made under the reign of Elizabeth I (1558–1603) to organize brass making, it was not until after the restoration of Charles II in 1660 that the industry took hold. Mining, transportation, skilled labor, and protectionist trade acts combined to enable domestic production of brass to supply a demand that had previously been met largely with imported goods.[2] Another candlestick in the Milwaukee collection (cat. 12) is illustrative of these foreign products.

The uncomplicated design of this candlestick is economical in its use of metal and the labor required for finishing. The contiguous candle socket and stem are molded with uniform undulations. This flattened-ball design recalls the turnings of some Anglo-American furniture of the period and may be seen as the penultimate reduction of the elaborately molded

stems of Dutch and German antecedents to this candlestick.[3] The ultimate reduction, a simple cylinder, was occasionally produced but was inferior in durability to the ribbed design.

The segmented swelling of the stem continues below the slightly depressed drip pan, increasing in diameter and softening in outline until its final rippling into the shallow domed base. That the base is convex, not concave as the bell of a trumpet, makes the modern descriptor "trumpet based" technically a misnomer. However, the concave foot was often used on sticks of this period similar in other ways to this example, so the term has come to refer to either form of this seventeenth-century candlestick having a low flared circular foot.

*Jayne E. Stokes*

Gift of Virginia and Robert V. Krikorian
M1983.249

1. Michaelis, *Old Domestic Base-Metal Candlesticks*, pp. 79–80. In addition, the Milwaukee

Art Museum collection contains a second taller (9 in. [22.9 cm] high) stick (M1987.37) of this same form, indicating the style was made to suit a range of demand.

2. Gentle and Feild, *English Domestic Brass*, pp. 8–10, 32.

3. Related furniture is illustrated in St. George, *Wrought Covenant*, cats. 52, 75. Kane, *300 Years*, cat. 3. Direct Dutch and German antecedents are illustrated in Michaelis, *Old Domestic Base-Metal Candlesticks*, fig. 91, pp. 72, 79.

## 14  *Andirons*

Northern Europe, 1650–80

*Description:* The shaft is cast solid, incorporating an iron rod which extends from the bottom. This unit sits atop the flattened forepart of the billet bar, which in turn rests on the legs. The legs and the front part of the billet bar are pierced, allowing the shaft extension to pass

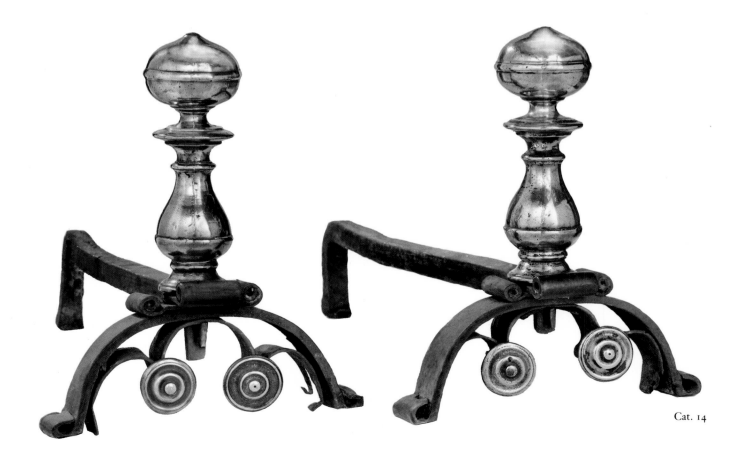

Cat. 14

through them. These three pieces are held together by a wedge driven into a keyway forged through the lower end of the shaft extension.

*Condition:* Each shaft has a small patch made to correct a casting defect. The terminal scrolls of the legs and lower ends of the trefoils have substantial decay and some loss.

*Materials:* Bronze, brass, wrought iron.

*Dimensions:* H. 15⁷⁄₁₆ in. (39.3 cm), W. 12⁵⁄₁₆ in. (31.3 cm), D. 26⁵⁄₈ in. (67.6 cm).

*Provenance:* Purchased by the donor in November 1977 from Joe Kindig, Jr., and Son Antiques, York, Pa. (dealer).

Few seventeenth-century andirons have survived the constant process of reclamation that brings outmoded metal goods to the melting pot to be cast again into new styles and forms. These are outstanding survivors.

The bold shaping of the shaft combines a slight ovoid ball top with a broad reel above a baluster-shaped base. The circular forms of the shaft are repeated by the scrolls which flank the baluster's base on three sides and also form the terminals of the low-arched legs. Concentric rings embellish the round bosses beneath the legs; the rounded trefoil arch that carries the bosses reemphasizes the interplay of the parts forming the geometric whole. These shapes are accented by the use of three different metals. The shaft is a warm red-gold bronze, the legs and firedogs are wrought iron, and the bosses are bright yellow brass.

Intended for use as well as decoration, these andirons could accommodate a substantial amount of fuel in the deep hearths of the period. However, the true working fireplace, found in the kitchen, would have been furnished with much less elegant iron equipment.

These andirons were probably made in Northern Europe, a climate which certainly required heating facilities and a place where the raw materials for brass —copper and calamine ore for zinc—were abundant. The English and, by allied trade restrictions, the American colonies, relied on this source for brass and other base metalwares through most of the seventeenth century.[1]    *Jayne E. Stokes*

Gift of Mrs. Will Ross in memory of her husband
M1978.1A, B

1. Gentle and Feild, *English Domestic Brass*, p. 35, and Mudge, *Chinese Export Porcelain*, p. 87.

## 15  *Chandelier*

G.H. van Hengel, Jr.
Rotterdam, Holland, 1710–30

*Description:* An iron rod forms the core of the chandelier's construction. The rod screws into the acorn drop at the base of the large sphere. Five cast units are placed in sequence over the rod. Above the drop, they are the large sphere, the lower baluster which contains the mortised reel into which the six lower candlearms are tenoned, the upper baluster which has a similar reel, a short urn-shaped unit above this, and at the top, the casting with the hanging ring attached. Each of the candlearms has a tenon on its scrolled end; this passes into a mortise cast in the center reel and is secured by a small urn-shaped pin. The tenons and mortises are marked with a sequence of paired punched dots to match each to its correct placement. The candle sockets have a screw extension which threads through the drip pan into the end of each arm.

*Marks:* Engraved in script just below the diameter of the sphere "Fer Gietery van G.H. van Hengel Jr. te Rotterdam" ("Iron foundry of G.H. van Hengel, Jr., Rotterdam").

*Inscription:* Engraved in upper case block printing around the diameter of the sphere "DE JONGELINGSCHAP VAN DE LAGE ZWALUW AAN DE GEMEENTE DIER PLAATS" ("FROM THE YOUNG MEN'S CLUB OF LAGE ZWALUW TO THE PEOPLE OF THAT TOWN").

*Condition:* The candlesockets and drip pans have been drilled to allow wiring for electrification; the wires were removed before purchase by the museum. Several arms have been pinned or spliced to repair fractures. One arm-securing pin has been replaced. The green-brown patina is not original; the chandelier was

meant to have a yellow gold reflective surface.

*Materials:* Brass, iron.

*Dimensions:* H. 42½ in. (108.0 cm), DIAM. 36¾ in. (93.3 cm).

*Provenance:* Purchased before April 1974 from Daniel Kelly (dealer), Toledo, Spain, by Joe Kindig, Jr., and Son Antiques, York, Pa. (dealer).

The size of this double-tiered, twelve-branch chandelier indicates its original use in a spacious setting. A block-printed inscription around the circumference of the large sphere at its base makes it clear that the chandelier was commissioned by the "Young Men's Club" of the small Dutch community of Lage Zwaluw, and was presented to the people of that town for use in a public building. Below this inscription, a second one, engraved in the scrolled hand of the early eighteenth century, records that the lighting fixture was cast in the Rotterdam foundry of G.H. van Hengel, Jr.[1]

In the Low Countries, where the majority of European brass was produced in this period, Rotterdam's port made it an important center. As early as the late sixteenth century the Spanish invasion of Antwerp made the more northerly Dutch port a haven from the religious persecution and the heavy taxes imposed by the invaders.[2] Until the close of her own Civil War in 1660, England, like the rest of Europe, imported Dutch and German brass goods which came, in large part, through this port. Although the English brassworking industry began to grow after the Restoration, England, including her American colonies, continued to import brass from the Low Countries. Such goods might be transshipped to America through English ports, or imported directly by the Dutch West India Company.

In the colonies, Dutch involvement would continue well into the nineteenth century in their settlement at New Netherlands, later New York.[3] The Milwaukee chandelier may well have been a type of lighting fixture brought from Rotterdam for use here. For English-dominated settlements the mother country's increasing ability to produce brass meant enforced reliance on that source. The English brass products imported

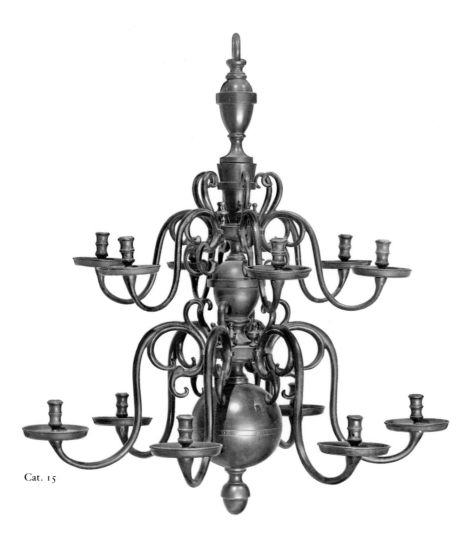

Cat. 15

here included the large chandeliers which illuminated public buildings, predominantly churches of established, prospering congregations. A surviving chandelier in the Old North Church in Boston, dating to 1724, and three from 1728 in Trinity Church, Newport, Rhode Island, all signed by English makers, offer evidence of this practice.[4]

*Jayne E. Stokes*

Gift of Friends of Art
M1974.232

1. I would like to thank Ria Breshears and Nicki Teweles for their translations of these inscriptions.
2. Burks, "English and Continental Brass Candlesticks," p. 1285.
3. Mudge, *Chinese Export Porcelain*, p. 97.
4. Butler, *Candleholders*, p. 41, fig. 23; p. 42, fig. 24.

## 16   *Raised embroidered picture*

England, ca. 1670

*Description:* The panel presents Old Testament scenes from the story of Abraham. At the center, in front of a castle and arched gateway, stand two figures on either side of an altar with sacrificial flames, a reference to Abraham's supreme gesture of faith. In the foreground on the right, Sarah, under the cover of an elaborate detached canopy, orders the banishment of Hagar and Ishmael (Gen. 21:9–21). On the left, Abraham, his wife Sarah, and his nephew Lot leave Egypt for the land of Canaan, Abraham being shown "rich in cattle" (Gen. 13:1–4).[1] The interspaces are filled with the popular motifs of the period—an Italianate fountain rising out of a rocky pool, a lion, a leopard, a rose, a carnation, a kingfisher on an oak branch, a parrot on a cherry branch, clouds, the sun, a rainbow, a deer couchant, a rabbit, snails, butterflies, caterpillars, and a variety of smaller flowers and bugs.

The silk foundation is a warp-float faced satin weave embroidered with silk floss, creped silk yarns, silk-floss-wrapped metal purl, linen yarns, and metal wire. Stitches used include bullion, double knot, looped running, overcast, plaited braid, raised stem, satin, split, and a variety of detached buttonhole. French knots, laidwork, couching, braids of silk, and oblique lacing as well as applied beads and mica enhance the compositional elements.[2] Parts of the design are raised by padding, and the canopy, costumes, and certain flower and foliage motifs are detached, exhibiting a variety of buttonhole stitches. The colored threads are blue, red, green, yellow, gold, brown, and ivory.

*Condition:* There has been some color loss and soiling of the silk foundation at the lower left portion of the composition and portions of the upper left corner.

*Materials:* Silk; embroidered with silk floss, creped silk yarns, silk-wrapped metal purl, linen yarns, metal wire, beads (glass and stone or coral), and mica.

*Dimensions:* H. 16½ in. (42.0 cm), W. 20¾ in. (52.7 cm).

*Provenance:* Purchased by the donors in 1982 from Cora Ginsburg, Inc., New York, N.Y. (dealer).

This panel continues a trend that began during the reign of Charles I for embroidered pictures to be used as wall decoration. A vogue for more elaborate realistically embellished needlework turned the tent-stitch pictorial plane into scenes with padded doll-like figures, lace-stitched detached costumes, beads, spangles, and silk-wrapped wires to give form more dimension. Raised embroidery,

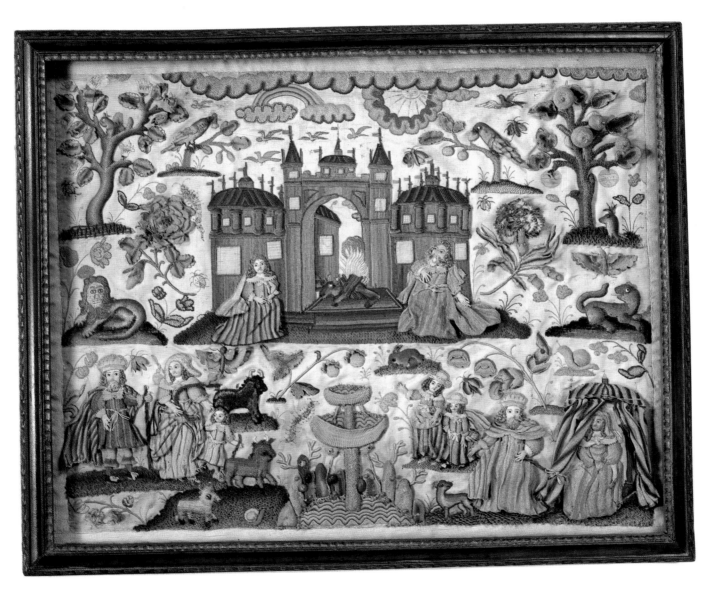

Cat. 16

named "stumpwork" in the mid eighteenth century, reached its greatest popularity in England from 1650 to 1680.[3] The technique grew out of the range of detached buttonhole stitches seen in late Elizabethan and Jacobean embroidery. Flower petals and insect wings were worked up freely from the surface early in the century and became more pronounced until the three-dimensionality of the later raised work pictures was reached. Such fanciful work was used for pictures, caskets, bookbindings, and looking-glass frames. Much of it was the product of young girls.[4]

The panels were often acquired with the design already prepared for the embroiderer; this accounts for only minor variation in the repetitive use of common motifs.[5] The scenes were culled from engravings of classical and biblical subjects and illustrations from a variety of sources: books of natural history, herbals, emblem books, illustrated Bibles, novels, and plays. The most popular designs were gathered into pattern books. Few remain, due to the practice of cutting out pages or pricking designs through which charcoal was rubbed to transfer the pattern.[6]

Among the dramas of the Old Testament, various scenes of Abraham's life, especially his banishment of Hagar and the sacrifice of Isaac, were favored for needlework pictures. In most scenes, the costumes are shown as contemporary fashions. In the Milwaukee panel all figures are wearing seventeenth-century dress. Needlework illustrated isolated scenes and combinations of episodes from Abraham's life. The Untermyer collection at the Metropolitan Museum and the Victoria and Albert Museum have various types of needlework which display a common visual vocabulary celebrating the Old Testament patriarch.[7]

The most common source for the English Old Testament pictures was a collection of biblical illustrations engraved and published by Gerard de Jode in Antwerp in 1585 after drawings by Martin de Vos, under the title *Thesaurus sacrarum historiarum Veteris Testamenti*.[8] Contained within is the story of Abraham, told in six pictures.[9] While prints provided animated scenes for embroideries, many times only the figures

were borrowed. In this panel the figures are freely adapted from the de Jode plates or derived from another source. They are placed in a rural setting near the environs of a large castle and gateway. Between the scenes, the spaces have been filled with the typical collections of flowers, birds, and insects found in the popular pattern books such as those by engravers and publishers Peter Stent and John Overton. It is possible these printers could have supplied the freely redrawn biblical scenes, as their advertisements for the Abraham theme (though not the actual prints) have been found.[10]

Source identification, however, is difficult. Books were repetitive, published in many editions, and publishers pirated freely from each other. Innovation in embroidery usually was reserved to the professional workers, while the books and intermediary designers catered to an established market for patterns which had already proved popular.

*Anne H. Vogel*

Gift of Virginia and Robert V. Krikorian M1987.51

1. "And Abraham went up out of Egypt . . . very rich in cattle . . .unto the place where his tent had been at the beginning, between Bethel and Hai; unto the place of the altar which he had made there at first: and there Abraham called on the name of the Lord" (Gen. 13: 1–4).
2. Examined microscopically for fiber content and structure by Lorna Ann Filippini, Department of Textiles, Art Institute of Chicago, through the courtesy of Christa C. Mayer-Thurman, Curator, Department of Textiles.
3. For discussion of the contemporary name for stumpwork, see Nevinson, *Catalogue of English Domestic Embroidery*, p. xxi; Wardle, *Guide to English Embroidery*, p. 14 n. 46.
4. Kendrick, *English Needlework*, pp. 136–38, refers to two representative examples of young needlewomen in seventeenth-century England: twelve-year-old Hannah Smith, whose casket and handwritten account of it was completed in 1656, and Martha Edlin, creator of a group of signed and dated pieces all accomplished by her thirteenth year. See also Wardle, *Guide to English Embroidery*, p. 15.
5. A raised embroidery looking-glass frame from the third quarter of the seventeenth century reveals unfinished portions of the design outlined in ink. It displays scenes of Abraham, Hagar and Ishmael, Sarah and Isaac, and other motifs in common with the Milwaukee picture; see Nevinson, *Catalogue of English Domestic Embroidery*, pl. xxxvb. Rosemary Ewles, "Embroidery: One Thousand Years of

History," in Synge, *The Royal School Book of Needlework and Embroidery*, p. 40, cites the discovery of an inscription of the name of a Covent Garden dealer on the edge of a pattern which confirms the long assumed notion of professional pattern drawers.
6. The Victoria and Albert Museum's copy of Richard Shorleyker's pattern book, *A Scholehouse for the needle . . .* (1632), has missing pages and pricked designs illustrating the damaging effects of the method.
7. Nevinson, *Catalogue of English Domestic Embroidery*, pls. xxix, xxxa; Hackenbroch, *Needlework in the Untermyer Collection*, figs. 51, 66, 73.
8. Cabot, "Pattern Sources of Scriptural Subjects," pp. 3–58.
9. Cabot, "Pattern Sources of Scriptural Subjects," pp. 33–41, pls. 26, 27, 28.
10. Jourdain, *History of English Secular Embroidery*, pp. 68–69; Nevinson, "Peter Stent and John Overton," p. 283; Johnstone, *Three Hundred Years of Embroidery*, pp. 33–34.

## 17 *Embroidered casket*

England, ca. 1660

*Description:* Allegorical figures and scenes of the five senses, the four seasons, and the elements fill the panels of the rectangular casket. On the lid, in the center, is a seated woman, who plays a lute (representing hearing). Located in the four corners (beginning in the top left and proceeding clockwise) are a standing lady looking at her reflective image in a mirror (sight); an allegorical female figure holding three ears of corn, meaning wheat (taste); another holds a bird pecking at her wrist (touch).[1] The fifth sense is represented by a seated lady holding a flower (smell). These five women in period dress are displayed with their attributes: the dog with his keen nose, the eagle with his sharp sight, the monkey with his kinship to lavish feast, the turtle as a reference to touch, and the stag as a reference to music. Interspersed between all these figures are the typical flowers, insects, a leopard, and a castle.

The side panels of the box refer to the seasons and the elements. The front panel below the lid contains the allegorical figure of Winter next to a fire with a cat, bellows, axe, and pile of wood. Next follows Spring, a fashionable lady, holding a flower; nearby, a shepherd with dog

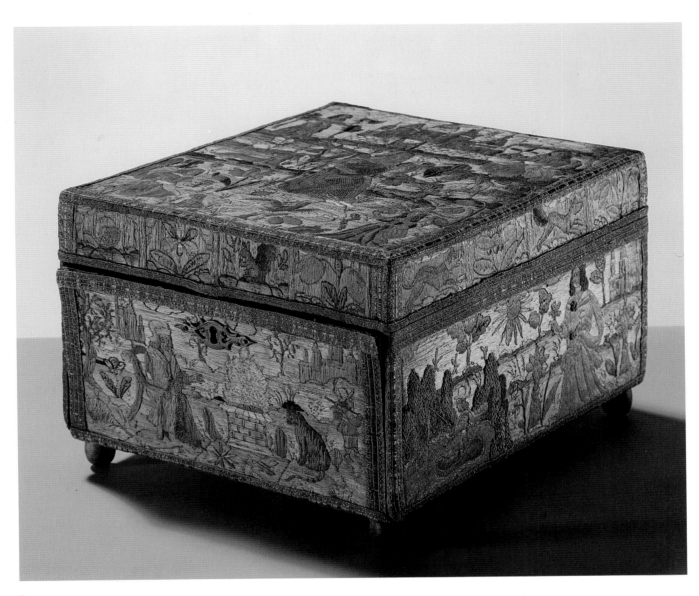

Cat. 17

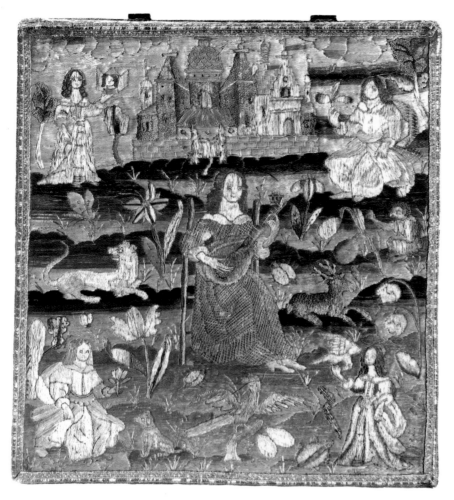

Cat. 17 (lid)

with silk and gilt-metal-strip-wrapped silk, plain weave with supplementary patterning wefts.[2]

The embroidery work is flat, not raised or padded. The colors include tones of blue, green, gold, ivory, red, beige, and brown. The box is lined in rose silk and plush.

*Condition:* The casket has survived in an excellent state of preservation; the needlework is all intact, although the colors are somewhat faded.

*Materials:* Exterior, a wood structure covered with linen embroidered with silk yarn and floss, edged with silk and gilt-metal-strip-wrapped silk, wood feet; interior, silvering of sheet glass with chalk, foil over paper, pressed and polished mercury, silk and plush, engraved colored paper, and tooled leather edging.

*Dimensions:* H. 7¾ in. (19.6 cm), W. 9¾ in. (24.7 cm), D. 11 in. (28.0 cm).

*Provenance:* Purchased in 1973 from Malcolm Stearns, Jr., Hobart House, Haddam, Conn. (dealer).

In England the fashion for richly embroidered boxes was in vogue from about 1650 to 1700. Both documentary evidence and the embroideries themselves show the work to be mostly by young girls trained to reach, at an early age, a high level of technical accomplishment. The earliest known dated example (1656) was worked by Hannah Smith at the age of twelve. The casket and a signed letter record Hannah's own account of beginning the work when she went to Oxford in 1654 and completing it in 1656, when she ordered it to be made up by a cabinetmaker in London.[3] Martha Edlin completed two caskets by her thirteenth year. Such work was part of a series of needlework assignments which were a significant part of a girl's education in the second half of the seventeenth century.[4] Sewing skills were also indicative of moral character. Industrious projects accomplished in needlework were signs of a virtuous woman, one who did not pass her time in idleness. As early as the fourteenth century, the Virgin Mary was painted while knitting, weaving, or embroidering. The work or sewing basket, scissors, and needlework accessories became attributes

and flocks plays his pipe (air) amidst a landscape with castle, trees, and flowers. The other side displays Summer, a woman surrounded by stalks of wheat, and with three ears in her left hand and a sickle in her right. Standing nearby in a boat, a fisherman catches a fish out of a pond (water). The season Fall completes the cycle on the back panel. A male figure with hat and beard prunes a tree, while a shovel leans against the trunk. A basket of fruit resting on the ground (earth) represents the harvest. More trees, a parrot, and two castles embellish the scene. The panels on the side of the lid offer an assortment of flowers and chasing animals.

The dressing case or work box is fitted with a looking glass fastened by metal prongs to the underside of the lid. The lid opens, displaying compartments to receive small bottles, toiletries, or writing implements, as well as numerous drawers of varying size (several concealed). The top section lifts to expose another middle area surrounded on each side by pieces of mirror which reflect the bottom surface covered by a hand-colored engraving contemporary to the period. The bottom layer contains more drawers. The casket stands on four bulbous gilt-and-gesso wood feet.

The box is covered with linen of plain weave; embroidered with silk yarn and floss and creped silk yarns in bullion, detached chain, running (cut to form pile), satin, and single satin stitches; laid work, couching, and French knots; edged

of virtue.[5] It is, therefore, not surprising that in this period a woman's early education emphasized embroidery skills.

Intermediaries were the practical bridge between the embroideress and the pattern books (see cat. 16). Evidence exists of both professional draftsmen attached to aristocratic households and London shops furnishing ladies and young girls with designs.[6] A casket in the Untermyer collection includes an inscription at the base of the tray "Sold by John Overton at the White Horse Inn."[7] He published pattern books and sold prints in London in the second half of the seventeenth century. Overton's contemporary, Peter Stent, also provided the London market with engravings for the use of craftsmen and embroiderers. His 1662 trade list mentions a range of subjects including several versions of the four seasons and five senses.[8]

Among the more popular patterns were the allegories of the seasons, elements, and senses. These widespread motifs were derived from cosmologies, devotional, or emblem books. They were so lasting that modifications to costume were frequently made to keep current with fashion.[9] The engravings by Adriaen Collaert or Crispin van de Passe after Martin de Vos featuring the personification of the five senses show the concept for the figures on the Milwaukee casket and include the attributes that belong to each figure.[10] Form became simplified as the transposition from one

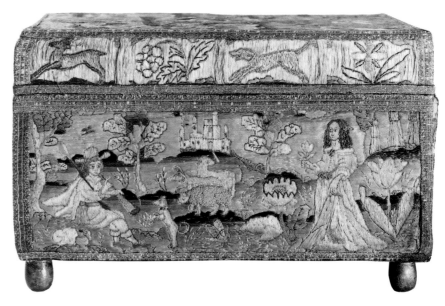

Cat. 17 (Spring)

medium to another took place; sometimes several pattern sources were intermingled. Often more than half a century separates the needlework pattern from the engraving that was the original impetus for it. Perhaps the embroiderer's desire was to reproduce "well-established and approved" designs rather than ones of more fleeting appeal.[11]

The panels of the Milwaukee casket reveal a rich blend of reality and symbolism. The personifications are endowed with worldliness seen in the fashionable

costume, garden, and landscape settings. The interspaces filled with insects, animals, and enduring floral blooms reflect the English love of nature and a desire to recapture the innocence of Eden.[12]

*Anne H. Vogel*

Milwaukee Art Museum, Gift of Their Friends in honor of Mr. and Mrs. Edmund Fitzgerald on the occasion of their Fiftieth Wedding Anniversary M1975.167

Cat. 17 (Winter)

Cat. 17 (Fall)

Cat. 17 (Summer)

1. "Corn" is the generic term used in seventeenth-century England to refer to grain—wheat, oats, or barley. In George Wither's *Collection of Emblemes* (1635), pp. 21, 44, 50, the words "fruitfull eares of corne" are written under images illustrating sheaves of wheat (Winterthur Museum Library).

2. Examined microscopically for fiber content and structure by Lorna Ann Filippini, Department of Textiles, Art Institute of Chicago, through the courtesy of Christa C. Mayer-Thurman, Curator, Department of Textiles.

3. Hannah Smith's casket is fully described by Jennifer Harris, assistant keeper at the Whitworth Art Gallery, in *Antique Collector* 59, no. 7 (July 1988): 49–55. The two side panels of the Hannah Smith casket (figs. 5, 6) show scenes of Winter and Summer almost identical to the Milwaukee box.

4. Kendrick, *English Needlework*, pp. 136–38; Nevinson, *Catalogue of English Domestic Embroidery*, p. 49; Wardle, *Guide to English Embroidery*, p. 15.

5. The engraving by the Dutch artist Hendrik Goltzius, "The Annunciation" (1594), in the MAM collection displays a work or sewing basket with a piece of linen and scissors in the foreground. For an interesting analysis of needlework accessories and their implications in Dutch art, see Schipper-Van Lottum, "A Work-Basket with a Sewing-Cushion," pp. 3–44.

6. Nevinson, "English Domestic Embroidery Patterns," pp. 12–13.

7. Hackenbroch, *Needlework in the Untermyer Collection*, p. 39.

8. See Nevinson, "Peter Stent and John Overton," pp. 279–83. Margaret Swain includes excerpts of Peter Stent's trade list and provides an overview of the influence engravings and pattern books had on needlework

design in *Historical Needlework*, pp. 57–58; pls. 21–23.

9. See Hackenbroch, *Needlework in the Untermyer Collection*, fig. 82, for similar figures representing the senses and their attributes.

10. Hackenbroch, *Needlework in the Untermyer Collection*, figs. 71–75; fig. 103; the reference to Crispin van de Passe is on p. xliii.

11. Hackenbroch, *Needlework in the Untermyer Collection*, pp. xxviii–xxix.

12. The motivation during the sixteenth and seventeenth centuries for botanic gardens, the encyclopedic collections of live plant material, was to re-create the Garden of Eden to produce a setting where man could regain innocence and unlock botanical secrets of health, medicine, and life. See Prest, *Garden of Eden*.

## 18  *Needlework fragment*

England or the Continent, ca. 1700

*Description:* This fragment, cut from a larger panel, consists of single-ply wool and linen yarns embroidered on a plain-weave linen ground in long diagonal laid stitches. The embroidered yarn floats over an average of seven (sometimes five, six, or eight) wefts and across one warp. It then goes to the reverse face under one warp and returns to face.[1] Colors range from rose, pink, rust, brown, gold, and beige to bright green. The edges are bound in modern plain-weave green silk.

*Condition:* The original purpose of this needlework is unknown. Purchased as a large fragment (60 in. [152.4 cm] by 80 in. [203.2 cm]), it was later divided to be used as a table cover. A modern binding has been added. The color and condition of the yarns are excellent.

*Materials:* Linen; embroidered in wool and linen yarns edged in silk.

*Dimensions:* H. 58 in. (147.3 cm), W. 24 in. (61.0 cm).

*Provenance:* Purchased in 1975 from Ginsburg and Levy, Inc., New York, N.Y. (dealer).

The flamelike zigzag design was popular during the seventeenth and eighteenth centuries in Europe, England, and America. Much confusion surrounds the terminology and names of stitches that produce this pattern. In English inventories of the 1630s the term "Irish stitch" seems to identify the zigzag pattern and is synonymous with the French term *point d'Hongrie*.[2] The term "Irish stitch" also refers to a fast-moving vertical stitch which by the late nineteenth and twentieth centuries became known as Florentine, bargello, or flame.[3] This stitch, which moves three to four squares vertically, differs from the diagonal stitch of varying lengths displayed in the Milwaukee fragment.[4] The latter more closely resembles loom-woven tapestry. Loom patterns of this type were referred to as "poor man's tapestry" or more technically as *Tapisseries de Bergame* or *Bergamo*.[5] Rouen and Elbeuf, cities in Normandy, France, exported *bergamos* in the flame design. A 1700–1725 example at the Winterthur Museum is marked both Durufle (for a family of weavers) and Elbeuf.[6] These coarse-woven wall hangings were a substitute for the more costly pictorial tapestries of the Aubusson, Gobelins, or Beauvais factories. Without examining the backside, a flame-pattern woven textile can be difficult to distinguish from its needlework counterpart.[7] The Milwaukee piece seems to be needlework because of the tight weave of the foundation.

European and English needleworkers during the seventeenth century favored the large flame patterns. Examples can be seen in England at Chasleton House,

Gloucestershire, and Parham Park, Sussex. It is this type to which the Milwaukee piece relates. The zigzags of a 4 to 5-inch (10.2 to 12.7 cm) scale were replaced in the eighteenth century by smaller, more complex closed shapes measuring 1 to 2 inches (2.5 to 5.0 cm), executed more frequently in America in the vertical Irish stitch.

Survivals of American Irish stitch exist in patterns other than flame. Diamond-within-diamond, carnation, and fanciful geometric shapes were popular and were used for table covers, upholstery, men's and women's pocket books, hand-held fire screens, and book covers.[8]

*Anne H. Vogel*

Purchase, Layton Art Collection
L1975.4

1. Examined microscopically for fiber content and structure by Lorna Ann Filippini, Department of Textiles, Art Institute of Chicago, through the courtesy of Christa C. Mayer-Thurman, Curator, Department of Textiles.
2. Thornton, *Seventeenth-Century Interior Decoration*, p. 127; p. 359 n. 135.
3. Swan, *Plain and Fancy*, p. 228; Swain, *Historical Needlework*, pp. 122–23.
4. See Hanley, *Needlework Styles for Period Furniture*, pl. 42, for a detail view of an example similar to the Milwaukee fragment. This author uses still another term—"Kalem or Knit stitch."
5. Thornton, *Seventeenth-Century Interior Decoration*, p. 108; Montgomery, *Textiles in America*, pp. 165, 167, fig. D-15.
6. Montgomery, "A Pattern-Woven 'Flame-stitch' Fabric," pp. 453–55.
7. My thanks to Susan Burrows Swan, Curator and in Charge of Textiles, Winterthur Museum, for reading this entry and examining with me loom-woven and needlework Irish stitched patterns that are in the Winterthur Museum collection.
8. For examples, see Swan, *Winterthur Guide to American Needlework*, figs. 26b, 27–34; pls. V, VI.

Cat. 18

# THE WILLIAM AND MARY STYLE

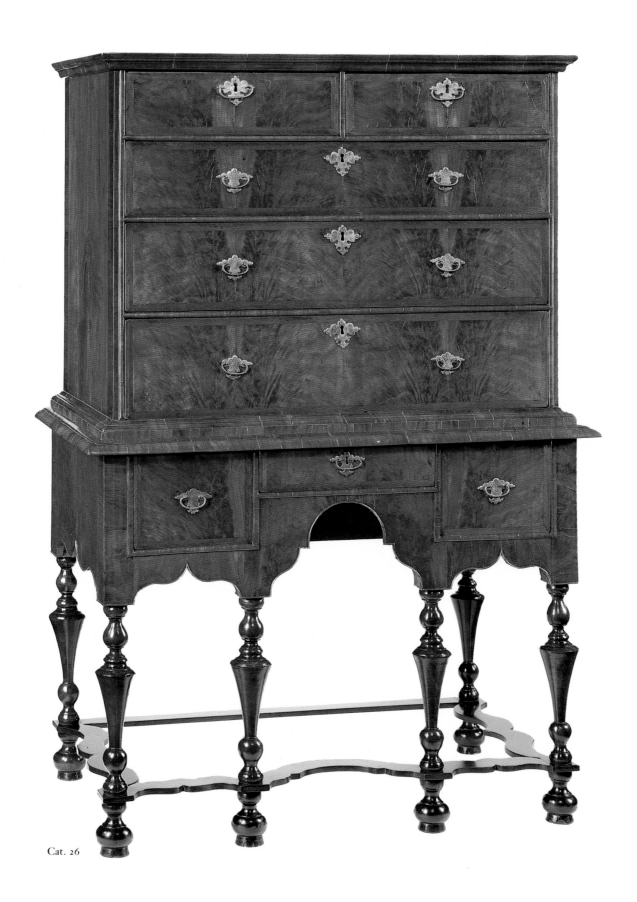

Cat. 26

# The Early Baroque in Colonial America: The William and Mary Style

## ROBERT F. TRENT

THE LATE Benno M. Forman posed the central interpretive question of the 1690–1730 period of American furniture history when, in a 1969 essay, he stated that the introduction of the William and Mary style was a major stylistic, formal, and technological watershed that rendered obsolete the mannerist design impulse and the fashionability of joined construction.[1] This idea has great plausibility. The static, horizontal compositions of seventeenth-century joined case furniture, tables, and seating furniture were displaced by an extreme emphasis on verticality and internal movement. A host of new furniture forms entered the repertoire of urban furnishings with pretensions to modernity. Finally, cabinetmakers trained to fashion case pieces of dovetailed boards decorated with veneers assumed the leadership of new shops in Boston, New York, and Philadelphia, and these cabinetmakers were, for the most part, recent arrivals with few ties to established shop traditions.

As research in this critical transition period has progressed, scholars have become less inclined to accept this interpretation. The discovery of new monuments of the 1670–90 period, detailed examination of how late mannerist furniture was constructed, and renewed interest in urban patronage have all contributed to a new perspective on the advent of the early baroque in colonial America that recognizes many points of continuity between earlier and later practice. It now seems apparent that many trends previously thought to have begun in the 1690s actually date from the 1670s, and colonial patrons were aware of these trends and reacted to them swiftly.

Louis XIV's court was the center for the invention and elaboration of most furnishing ideas after 1660. State-sponsored workshops were put in charge of a building program that included not only the expansion of Versailles, but numerous other palaces, churches, and elevated urban housing. Integral to this program was a constant review and rebuilding of the interiors of new and existing buildings, particularly the state apartments of the king, the royal family, the royal mistresses, and ministers of state. This intricate process of design review, much of which took place under the personal supervision of the monarch, produced an atmosphere where the most subtle adjustments gained notoriety through the publication of designs that were integral to French cultural imperialism.

Already by the 1670s the royal architects emphasized more vertical elevations as they sought to attain a scale for interiors suitable to the cavernous shells of the palaces. Furniture followed suit; for example, the rectilinear, low-back upholstered chair of the 1660s gave way to a high-back type with a frame that grew narrower at the back, wider at the front, and more convoluted in contour by the late 1670s. However, despite the meticulous record keeping of those in charge of requisitioning and keeping track of the royal furnishings, we are still not certain about the exact sequence of formal evolution for many kinds of furniture that were experimented with and then discarded. The records are lacking for some periods, and the furniture itself was often moved about from palace to palace and even sold at many periods during the seventeenth and eighteenth centuries.[2]

The evolution of the chair was paralleled by a new emphasis on other seating. By 1690 it was clearly understood that chairs were to be purchased in sets of six or multiples of six. The French and English practice of having sets of high-backed upholstered

chairs covered *en suite* with a bed was rarely followed in the colonies, probably because of its expense, but a new furniture form that did find favor here was the easy chair. This did not evolve from an augmented version of the standard armchair, but from invalid chairs and aristocratic lounging chairs with hinged backs and footrests, the *fauteuil de commodité*. Similarly, settees and sofas did not descend from the old Cromwellian couch, but were essentially double or triple easy chairs, known as either a *sopha* or a *canapé* in France. The actual descendant of the one-ended version of the older couch was the *lit de repos*, which continued to be called a couch in England and the English colonies; today we would call it a daybed. Easy chairs and settees were always upholstered with stuffed backs, cheeks, and arms, but the seats were softened by a fat, boxed down cushion set on the seat deck. Couches were softened by boxed squabs, with a bolster and a cushion at the head. All these ostentatious leisure forms of seating were found only in bed chambers or in private closets in France and England. Colonials seem to have garbled the intent of French court practice, in some cases. Bedchambers were far more frequently used as quasi-public spaces, as they were in France, but few in the colonies also maintained private closets or dressing rooms, perhaps because they could not afford the space or simply were not quite daring enough. One feature of French court etiquette that rarely made its way outside Versailles and the other royal palaces was the use of stools in order to preserve the dignity of the king, queen, and the royal family. Certainly cane versions of stools and peculiar low stools with squared cushions called *carreaux* were made in London, but they must have puzzled colonials and even most middle-class Englishmen.[3]

In the English-speaking world, cane chairs and couches were the universal symbol of the new style. They were mass-manufactured for export in London, and the cane-chair industry was one of the first to integrate production by coordinating the skills of joiners, turners, carvers, japanners, gilders, and caners on a regular basis. Most cane chairs were closely modeled on the latest French upholstered chairs, but found little favor in France, partly for patriotic reasons, and partly because the government discouraged their importation through high duties. The London cane-chair industry was so successful that chairs made in London and exported to colonial America probably could be sold cheaper than any American version. In Boston, no large-scale manufacture of cane chairs arose until the 1720s. The shops that had been producing the low-backed Cromwellian chair in Boston and New York combined certain features of cane chairs and modest English upholstered chairs in new, high-backed leather chairs. French court practice supplied the prototypes for two cheaper versions of the leather chair, one with vertical banisters or slats and another with horizontal slats. Those who persist in thinking of banister backs and slatbacks as "country furniture" might be amazed to know that such chairs formed a regular part of seating in the French palaces, sometimes in the principal rooms.[4]

All these basic seating types were in favor in colonial urban centers for roughly thirty-five years, from 1695 to 1730. Major stylistic innovations included a conversion from turned rear posts to sawn and molded "crook'd" rear posts in the early 1720s and the introduction of what we regard as "Queen Anne" cabriole legs, vase-shape banisters, and "compass" or rounded seats in 1729 or 1730. However, more conservative seating types with upholstered or caned vertical back panels continued in production well into the 1740s.[5] In addition, chairmakers in outlying towns adopted the banister back and the slat-back and did not begin to integrate Queen Anne–style features into their designs until the 1760s, at a time when they were becoming outmoded in urban areas. Throughout much of New England and the Middle Colonies, turned chairs in the William and Mary style remained fashionable until 1800 and beyond, although their turned ornament changed in response to new fashions. Generally speaking they formed the lower end of a line of models that also featured derivative Queen Anne– and Chippendale-style backs fused with earlier types of undercarriages.[6]

While the evolution of seating was fairly straightforward, that of tables and case pieces continued to be troubled by a lack of understanding about the distinction between the two categories. Certain table types were clearly understood to be tables. These included the oval table with leaves, which was made in various sizes; high and low "standards" or stands for candles (known as *guéridons* or *torchères* in France); and tea tables, which could be four-legged or in the classic pillar-and-claw design with a central post, three legs,

and a top that could be folded up when not in use. Some confusion existed about the names assigned to each functional type. A tea table could be practically any small table used for that purpose. In addition, small stands augmented with a gallery around the edge of the top functioned as kettle stands for the hot-water kettle that was a part of the tea ceremony. Tall candlestands were quite fashionable in Europe but do not appear to have been made here. In Europe they were set on either side of a dressing table or placed in the four corners of the room, but few colonials were extravagant enough to burn that many candles at once, and colonial houses rarely had ceilings high enough to justify having a candlestand that tall.[7]

Other tables and case pieces were subject to the vagaries of high fashion at the French court and to an emerging English taste that was often anti-French in principle, if not in practice. As late as the 1670s, French court taste had not incorporated the English idea of a chest of drawers (which, as stated earlier, may have had immediate Italian antecedents). Indeed, much of the Continent persisted in the use of some sort of wardrobe, either with hanging pegs, or shelves, or a combination of both. At Versailles this lack of interest in the chest of drawers was reinforced by traditions of storing heavily embroidered and delicate clothing in *armoires* to prevent it from becoming wrinkled or crushed. After 1670, the rapid introduction of drawers in major case pieces made for the French court had to do not with storage, but with formal display. The first experiments were with a decorative ensemble that Peter Thornton calls a "triad": a light table set against a pier between windows, with a looking glass and a pair of *torchères*. At times the triad was located in rooms where people rarely sat down, but a modified version was also used as a dressing table (*toilette*). In the 1680s, these dressing tables began to receive a rank of drawers on each side of an area left open for the knees, and they could also be used for writing and were then called *bureaux*. This flat-topped dressing or writing table was distinguishable from an *écritoire* or *secrétaire*, which descended from the old cabinet form and had a vertical flap that could be let down to form a writing surface. Some case pieces called *écritoires* were derived from a desk-box with a slanted lid set on a stand, in which case a slanted lid could be set on a modified stand with one long drawer, or two flanking tiers of drawers in the

manner of a *bureau*, or a series of long drawers that were either exposed or behind doors. Adding to the confusion of these various types was the persistent presence of the grand cabinet on stand, which may or may not have had a falling lid for writing or drawers below instead of pillars. In addition, elaborately carved tables to stand against the wall, often with stone or marble tops, continued to be used in certain circumstances, and they were not yet referred to as console tables. The ultimate product of this rapid experimentation that appeared in the 1720s was a low case piece with either doors or drawers, which was set under a looking glass and was known as a *commode*, although it served no purpose other than display. Comparison of successive royal inventories suggests that case pieces which had been called *bureaux* in the 1690s were termed *commodes* after 1730.[8]

Because the English had been using chests of drawers with doors for storage since the 1620s, their response to wave after wave of French influence between 1660 and 1700 was uneven at best. Each of the major French court types of case piece was adopted at one point or another, but their exact meanings were sometimes lost in the process. By the 1680s, London cabinetmakers were mounting chests of drawers on six-legged stands and making matching toilette tables that, incomprehensibly, also had six legs and were therefore difficult to sit in front of. These appear to have represented a conflation of the French cabinet on a stand and the (by now) traditional English chest of drawers, as well as a compromise with the French form of bureau-like *toilette*. Some English *écritoires* with drawers in the lower case and a vertical writing flap over an upper cabinet-like arrangement of small drawers or "boxes" were made between 1670 and 1700, but they never gained widespread favor, especially in the colonies. The classic eighteenth-century English desk with a slanted lid over drawers, which may have spontaneously evolved in both England and the Netherlands in the 1680s, never was popular in France, where flat writing tables continued in use throughout the eighteenth century. In addition, the French never liked the augmented version of the English desk with a bookcase on top of the desk, for they preferred to store books in book presses or built-in shelves with glazed doors. The English hardly understood the purely decorative *commode* at its inception and did not make them until the 1740s, and

even then they were thought to be specifically French, lacking in utilitarian value, and therefore something associated with a pretentious and somewhat suspicious style of living. The English also adopted the *bureau*, which they usually used as a dressing table. They were called bureau-tables, a survival of their original, somewhat ambiguous French origins, and were never referred to during the period by their modern name, "kneehole desks." When bureau-tables were used as desks, they were fitted with a writing drawer that had a fall front on hinges, because it was impossible to fit one's knees far enough into the narrow prospect recess to use the top for writing.[9]

So much has been made of the Darwinian onslaught of veneered, dovetailed board cases on the joined tradition that a number of important facts about the practice of the best joiners have been ignored. As a close study of Boston chests of drawers and other case pieces in the London tradition has shown, they exhibit a number of techniques that later appeared in William and Mary–style case furniture. The drawers of the best London work of the 1620–60 period had dovetailed fronts. On those chests of drawers with deep drawers, the number of dovetail keys could be as many as four, although three is the usual limit. This dovetailing does not differ appreciably from that used to construct William and Mary–style cases and drawers. London cases of the mid seventeenth century also were decorated with plaques of exotic hardwoods that were glued to drawer fronts that had been prepared for gluing with the tooth plane. These plaques of wood were often thick, and at times they were let into trenches chiseled in the drawer fronts, but if they had been any thinner, we would not hesitate today to call them veneers.

It is possible that modern observers have been dazzled by the brilliant veneers that cover the surfaces of high chests, dressing tables, and desks, for the cases of these objects are actually quite crude. The dovetailing of the cases and of the drawers, executed in conifers, is large in scale and rough in execution. Perhaps the most glaring structural defect to be seen in them is the manner in which the pillars or turned legs are attached to the cases. In high chest bases and dressing tables, no bottom board exists; in order to provide sufficient wood to bore the holes for the socket joints of the pillar tops, glue blocks are added inside the cases, without supplementary nailing or pinning.

Undoubtedly many of these dangerous glue-block joints failed quite soon after the cases were made, with disastrous consequences for the relatively bulky structures perched atop them.

The flimsy construction of these cases bears no relationship to French court practice. The secondary wood of preference for the finest French case furniture was always oak, and the royal shops continued to employ joined construction for many forms. For example, double bombé commodes of the 1720–70 period were made with shaped corner posts, horizontal rails planed to contour, and laminated flush panels that were contrived to minimize movement due to fluctuations in temperature and humidity. Because the surfaces of these commodes were veneered, they had to be constructed in the most stable manner possible, and most were provided with heavy marble tops that a dovetailed board case could not possibly support. Dutch and English cases of bombé form were made of either laminated conifers or great slabs of the primary wood which were sawn to contour, a technique which is celebrated in American decorative arts literature today but would have elicited snorts of contempt from a Parisian *ébéniste*. The explanation for why English workmanship was skewed in the direction of dovetailed board carcasses made of conifers seems to be the influence of Dutch practice on England at critical points in the evolution of the veneered William and Mary style. The Dutch maintained a trade distinction between those who worked in hardwoods and those who worked in conifers; the former were the immediate ancestors of the better French artisans who were called *ébénistes* because they made cabinets and other refined furniture forms veneered with ebony, while the latter were called by the Dutch *witwerkers*, because they worked in conifers, or white woods.[10] It is plausible that when veneered case furniture became fashionable in England, English joiners followed the methods of Dutch *witwerkers* rather than those of the more elevated workmen, principally because fashioning dovetailed board carcasses out of oak was laborious and expensive. The English crown and the nobility may have brought French workmen to London to make furniture not too different from that at Louis XIV's court, but for a middle-class market, this was out of the question.

The first English cabinetmaker to work in Boston was John Brocas, who arrived in 1695. Perhaps some

of the men identified as joiners in Philadelphia were in fact cabinetmakers and were making dovetailed-board case furniture in the 1680s. Little has been published about early cabinetmakers in New York, but undoubtedly they began working there in the 1690s. The same workmen could have supplied tables and seating furniture in the new style. However, the records of Boston and Philadelphia reveal that joinery traditions founded much earlier continued far into the eighteenth century, and the inference is strong that joiners swiftly learned the new cabinetmaking and veneering techniques.[11] Painters and gilders from England also introduced the technique of japanned decoration, wherein layers of gesso, paint, shellac, gilding, and penciling were built up to suggest Oriental lacquer.[12]

Recently Edward S. Cooke, Jr., has suggested that a second generation of cabinetmakers who arrived in Boston about 1715 introduced new styles of case pieces like "cases of drawers," or what we call a chest-on-chest. The principal monument upon which Cooke builds his argument, the Warland case of drawers, certainly is an *avant-garde* object by Boston standards, with walnut veneer and cross-banding, a shell alcove, and multicolored stringing, but in technological terms, it is squarely in the older tradition, with cases built up of glue blocks around dovetailed-board cores.[13] Another form of case piece that appeared in Boston and elsewhere in the colonies at this time was the "beaufait" or corner cupboard. The term applied to them derived from heavy French serving tables called *buffets* that were incorporated in the paneling of dining rooms; when built-in versions with scalloped shelves and doors were evolved, the name was transferred to them. No freestanding example has been securely dated before 1740, but some examples may have been made well before that date.[14] Beaufaits probably took on some of the functions of the seventeenth-century cupboard, but the wares they displayed were refined tea garnitures and tablewares, rather than silver, delft galley pots, and Venice glasses.

Although it is possible to identify the major furniture forms that emerged in this period, it is difficult to tell exactly what they were called in colonial America or what other fugitive furniture forms might have existed. Again, we know that tea tables of the three-legged and four-legged varieties were used here, but a tea table listed in a given probate inventory might have referred to practically any small table used for that purpose. Much the same might be said of toilet or dressing tables. Among the more perplexing and common furniture forms were small joined tables of square or rectangular form, often with a drawer. In modern collector's parlance, these are known as "tavern tables," but we are at a loss as to what they might have been called during the period or what they might have been used for. They seem suited for writing or for dressing, and their turned ornament and fairly high degree of finish does not suggest that all such tables began life in the kitchen or the taproom. Another table form that eludes us is the chair-table, a joined or board base with a round top that is hinged. Chair-tables appeal to our sensibilities because they are multipurpose, like modern furniture forms intended for "urban nomads," but the decorum of their period use is unclear. Equally unclear are the dresser and the settle. Most that survive appear to have been utilitarian in nature, but we cannot be sure that some dressers and settles made of hardwoods did not retain something of the ceremonial nature they enjoyed in Wales, the West Country, and the North Country far into the nineteenth century.

A final category of furniture that flourished in the 1700–1740 period is often classified as William and Mary-style but bears little or no relationship to English furniture-making traditions. Strong enclaves of Dutch, German, and French settlers continued to produce continental furniture forms throughout the eighteenth century, although the high point of their production seems to have been 1750 to 1800. In these ethnic settlements, the Dutch *kas*, the German *schrank*, and the French *armoire*, great wardrobes in the baroque style, successfully competed with English chests of drawers. Each group continued to use distinctive tables and seating forms, the most notable of which were the *klapptische* or folding table of Dutch New York and the *brettstuhl* of the Pennsylvania Germans. A minor footnote were great joined chairs and leather settles made by Welsh and North Country joiners in Philadelphia and adjacent Chester County up until the 1760s, if not later.[15]

Our knowledge of the William and Mary period is far inferior to that of the mannerist period, but new monographs of specific schools and the discovery of new monuments will undoubtedly bring the era into greater focus in the next decade. More, perhaps, than the earlier style, William and Mary–style furniture

seems redolent of courtly prototypes, but this strictly modern perception resides more in a picturesque taste for carving and veneer than it does in a profound understanding of structure, function, and meaning. Ideally the mannerist and early baroque periods should be viewed as a unit that stands in contrast to the Queen Anne and Chippendale periods, especially in an American context, where the disparity of accomplishment between courtly prototypes and colonial interpretations is far more glaring.

1. Benno M. Forman, "Urban Aspects of Massachusetts Furniture in the Late Seventeenth Century," in Morse, *Country Cabinetwork*, pp. 18–27.

2. Verlet, *Le Mobilier Royal Français.*

3. Thornton, *Seventeenth-Century Interior Decoration*, pp. 180–217.

4. Symonds, "Cane Chairs," pp. 173–81; Symonds, "Charles II.Couches, Chairs, and Stools, Part I," pp. 15–23, "Part II," pp. 86–95.

5. Forman, *American Seating Furniture*, pp. 285–88.

6. Trent, *Hearts and Crowns;* Trent and Nelson, "New London County Joined Chairs," pp. 1–195.

7. Thornton, *Seventeenth-Century Interior Decoration*, pp. 226–43.

8. Thornton, *Seventeenth-Century Interior Decoration*, pp. 93–94, 231, 302–3. Verlet, *French Royal Furniture*, pp. 6–28.

9. Forman, "Chest of Drawers in America," pp. 15–24; Forman, "Furniture for Dressing," pp. 149–64.

10. T. H. Lunsingh Scheurleer, "The Dutch and Their Houses in the Seventeenth Century," in Quimby, ed., *Arts of the Anglo-American Community*, pp. 13–42.

11. Forman, "Urban Aspects," pp. 17–33; McElroy, "Furniture of the Philadelphia Area"; Myrna Kaye, "Eighteenth-Century Boston Furniture Craftsmen," in *Boston Furniture*, pp. 267–302.

12. Heckscher, Safford, and Fodera, "Boston Japanned Furniture," pp. 1046–67.

13. Cooke, "Warland Chest," pp. 10c–13c.

14. Abbott Lowell Cummings, "Decorative Painters and House Painting at Massachusetts Bay, 1630–1725," in Quimby, *American Painting to 1776*, pp. 104–7.

15. Blackburn and Piwonka, *Remembrance of Patria;* Palardy, *Early Furniture of French Canada;* Poesch, *Early Furniture of Louisiana;* Forman, "German Influences in Pennsylvania Furniture," in Swank, *Arts of the Pennsylvania Germans*, pp. 102–70.

## 19  *Leather chair*

New York, New York, 1700–1725

*Description:* The joints of all stretchers are mortise-and-tenon joints. The front stretcher is pegged from the front. The seat rails were made of riven wood. The chair has lost a fraction of height on the bottoms of the feet.

*Condition:* The surfaces are covered by nineteenth-century rosewood graining. The upholstery is modern.

*Woods:* All four posts, crest rail, all stretchers, soft maple; seat rails, side rails and stay rail of back upholstered panel, red or white oak.

*Dimensions:* H. 45⅝ in. (115.9 cm), S.H. 18⁵⁄₁₆ in. (46.5 cm), W. 18⅛ in. (46.0 cm), D. 15¼ in. (38.7 cm).

*Bibliography:* Forman, *American Seating Furniture*, pp. 325–26 and fig. 174 (as private collection).

*Provenance:* Traditionally descended in the Vanderlyn family of Kingston, N.Y.; Fred J. Johnston, Kingston, N.Y. (dealer); Dr. and Mrs. James Beavis, Northford, Conn. (collectors), 1982; Robert W. Skinner Gallery (sale 825, June 12, 1982), lot 232; purchased in 1982 from John Walton, Inc., Jewett City, Conn. (dealer).

Although it is a relatively late example, this chair is important in establishing New York as the origin of an entire group of chairs formerly thought to have been made in New Hampshire and hence popularly known as "Piscataqua chairs."[1] According to one dealer who owned this chair, it "belonged to Peiter [*sic*] Vanderlyn 1ˢᵗ portrait painter in N. Y.[;] descended to his son Nicholas and to his son John the famous 18ᵗʰ century painter—on his death, all the Vanderlyn family heirlooms went to an Aunt Kate Vanderlyn[;] on her death to Judge Schoonmaker, and to his daughter Mrs. Lawton[;] from her estate it was purchased. This chair never left Kingston N. Y."[2] Benno M. Forman has speculated that if the chair belonged to the patriarch Pieter Vanderlyn (1687–1778), he may have purchased it when he arrived in New York City from the Netherlands about 1718, which is an

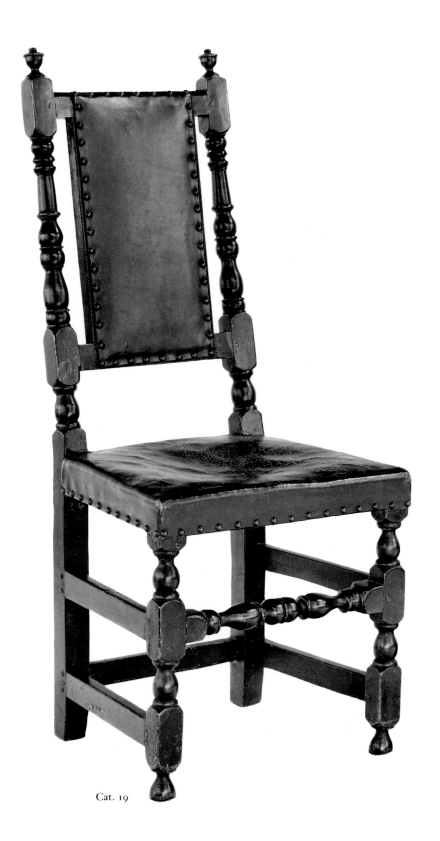

Cat. 19

appropriate date on the basis of the somewhat attenuated turnings.[3]

The Milwaukee example is related to a chair at Winterthur Museum and to one in the Hendrickson House in Wilmington, Delaware. All three share an important detail: the upper and lower rails of the back frame are bowed slightly to conform to the body. This was undoubtedly adopted either from a European upholstered chair or from an English cane chair.

Several features displayed by the chair are indexes of New York design. The rear stretcher is placed at the same level as the lower side stretchers. The heels of the rear feet are molded on the front faces of the posts only. The sequence of turnings on the rear posts, consisting of an urn flanked by fat beads, two urns, and a Tuscan Doric column with elaborate capital, is directly related to those of Dutch chairs, as are the urn-shaped finials with prominent buttons.

Although the present upholstery is not entirely incorrect, it seems far more likely that the Milwaukee chair was double-nailed originally.          *Robert F. Trent*

Purchase, Layton Art Collection
L1982.116

1. Randall, "Boston Chairs," pp. 12–20.
2. Photocopy of invoice, MAM object file.
3. Forman, *American Seating Furniture*, p. 326.

## 20   *Cane chair*

Boston, Massachusetts, 1722–45

*Description:* The joints of all turned stretchers are rectangular mortise-and-tenon joints, even on those stretchers with conical stops at the ends.

*Inscriptions:* A punchwork "I" appears on the rear surface of the proper left post at the level of the gap between the seat and the stay rail.

*Condition:* The entire surface has been stripped of a walnut-colored varnish. Applied toes are missing from the front feet. A scalloped skirt board that was nailed to the front faces of the front legs

immediately below the seat frame is missing. The seat frame was upholstered at some point. The present heavy seat rails, without molded ornament on their outer edges, may be early replacements. The oak upper side stretchers may be relatively modern additions.

*Woods:* Upper side stretchers, oak; all other components, soft maple.

*Dimensions:* H. 45¼ in. (114.9 cm), S.H. 18 in. (45.8 cm), W. 18 in. (45.8 cm), D. 14¼ in. (36.8 cm).

*Bibliography:* Kirk, *American Furniture and the British Tradition*, fig. 727.

*Provenance:* John Walton, Inc., Jewett City, Conn. (dealer).

This beautifully fashioned chair belongs to a large group referred to as "I" chairs, after a punchwork cipher found on the rear posts of all examples. The chairs are a late Boston manifestation of the cane chair and incorporate turned and carved elements from both London cane chairs and Boston upholstered chairs. They undoubtedly were modeled after similar London models. "I" chairs were made in a number of different shops and over an extended period of time, because they display numerous variations in format, turnings, crest profiles, and carved detail.[1]

The strong affinity between "I" chairs and Boston leather chairs in the molded stiles, crooked posts manner (cat. 22) is obvious and pertinent. Both types of chairs were made by joiners, as the treatments and assembly make manifest. The primary wood of which both kinds of frames are made—maple—also suggests the joined tradition, as opposed to turning, where the traditional wood of preference was ash.

Another telling detail is the joint at the junction of the front posts and the seat frame. It is made with a round tenon inserted in a round mortise drilled with a center bit which produces a flat-bottomed hole. This kind of construction, also seen in cane chairs, is restricted to chairs made by joiners, while turners generally used a spoon bit to bore their mortises.

Other points of comparison between "I" chairs and crooked-back leather chairs are enlightening. While the rear posts appear to have been laid out with similar

patterns, almost all "I" chairs have straight posts above the seat, the only known exception being an extraordinary example with an all-walnut frame and curved posts (Wadsworth Atheneum). Undoubtedly the straight posts were intended to complement straight inner back rails that facilitated caning. This is not to say that cane could not be worked on curved frames, but that doing so is far more laborious.

This example has optional details, including carved feet and a structurally unnecessary second pair of upper side stretchers (they may be later embellishments). The few small carved volutes and leaves on the crest are far less ambitious than the profuse leafage and paired plumes seen on other chairs.

Frequently "I" chairs received upholstery after the caning on the seats and backs had failed. Numerous tackholes on the seat of this chair demonstrate that it had an upholstered seat at some point. The seat rails themselves are somewhat thicker than ordinary and have no planed edge moldings; short of dismantling the seat to examine the joints, no way exists to determine if they are replaced.
          *Robert F. Trent*

Purchase, Layton Art Collection
L1977.13

1. Forman, *American Seating Furniture*, pp. 258–67.

## 21   *Banister-back chair*

Boston, Massachusetts, or New York, New York, 1725–70

*Description:* The exposed blocks of the seat frame are integral with the front seat rail. All joints are socket joints except those of the crest and stay rail and the partial tabs on the ends of the banisters. The feet are one piece with the posts.

*Condition:* The black paint is twentieth century in date. The crest joints have been repegged. The feet have lost a fraction of their height through wear. Channels from insect damage have been filled prior to repainting.

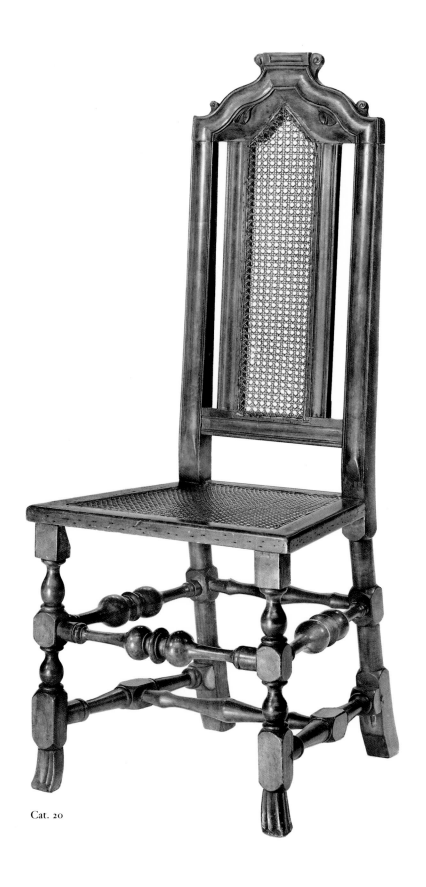

Cat. 20

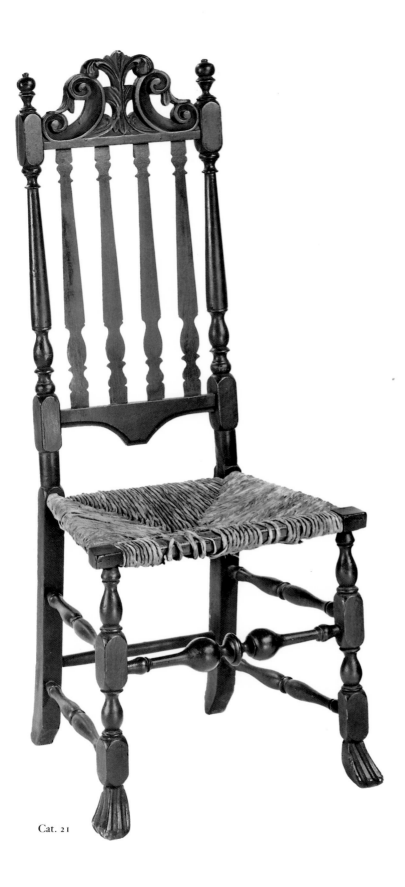

Cat. 21

*Woods:* Posts, poplar (aspen); seat rails, stretchers, stay rail, and columns, ash; crest rail, soft maple.

*Dimensions:* H. 46¾ in. (108.8 cm), S.H. 17¾ in. (45.1 cm), W. 18¼ in. (46.4 cm), D. 14 in. (35.6 cm).

*Provenance:* Purchased in 1982 from John Walton, Inc., Jewett City, Conn. (dealer).

The first banister-back chairs undoubtedly were made in the same shops as joined leather chairs, but they may have become a specialty of turned chairmakers by the 1720s. Distinguishing between urban and provincial examples is difficult because banister backs were widely exported, not only within New England, but throughout the English-speaking colonies of the eastern seaboard.[1] They continued to be made in provincial areas until 1800, although post-Revolutionary examples have uncarved crests and attenuated turnings in the federal taste.[2]

This example displays traits that can be identified with midcentury urban production. The carved crest is neatly done, with an academic economy that is characteristic of mass production by carvers working on a piecework basis. Non-urban carving is usually plainer, with misunderstood articulation of scrollwork, leafage, and veining, but paradoxically, it is often better from the standpoint of finish. The frame has strongly undercut "great heels" on the rear posts and tripartite turnings on the stretchers that postdate 1722 in Boston work.[3] The severely undercut toes are a mannered detail that might represent a later phase of Boston work or perhaps a New York variant.

*Robert F. Trent*

Purchase, Layton Art Collection
L1982.48

1. Forman, *American Seating Furniture*, p. 317.
2. Trent, *Hearts and Crowns*, pp. 23–90; Trent, "Spencer Chairs," pp. 175–94; Trent and Nelson, "New London County Joined Chairs," pp. 113–33.
3. Forman, *American Seating Furniture*, pp. 285–88.

## 22   *Crooked-back leather chair*

Boston, Massachusetts, 1722–40

*Description:* All joints are single-pinned. Slight splits and tear-outs indicate that the rear posts were roughly sawn and planed.

*Condition:* The turned front feet and rear heels are restored. Traces of a later coat of red paint remain. The present leather upholstery and brass nailing are modern.

*Woods:* Right front leg, hard maple; stretchers, rear posts, crest rail, vertical back frame rails, front stretcher, possibly left front leg, soft maple; seat rails, stay rail, red oak.

*Dimensions:* H. 44¼ in. (112.4 cm), S.H. 17 in. (43.1 cm), W. 17¹⁵⁄₁₆ in. (45.6 cm), D. 14⅝ in. (37.1 cm).

*Bibliography:* Jones, "American Furniture," p. 978, fig. 5.

*Provenance:* Roger Bacon, Exeter, N. H. (dealer).

This example of the crooked-back Boston leather chair provides useful comparisons to the "I" chair in the collection (cat. 20) and illuminates the production of this extremely popular, widely exported, long-lived seating type. The earliest date for production in Boston is established by the accounts of Thomas Fitch, who first made such chairs in 1722. They were described as "crook'd back," after the ogee curve of the rear posts, just as cabriole legs were first known as "crook'd feet."[1] In these chairs are the first instances of the replacement of turned elements by those that are exclusively sawn and planed, developments which led directly to the first Queen Anne–style chairs of the early 1730s. However, the use of sawn rear posts and stretchers that are rectangular in section also harks back to heavier "Cromwellian" antecedents of the 1655–95 period.

The carved molding running around the back of the frame is a feature derived from cane chairs, although in this instance it was probably copied from an English upholstered chair of the same type. This example gives a significant clue to how the molding was worked. At the level of the rear posts just above the

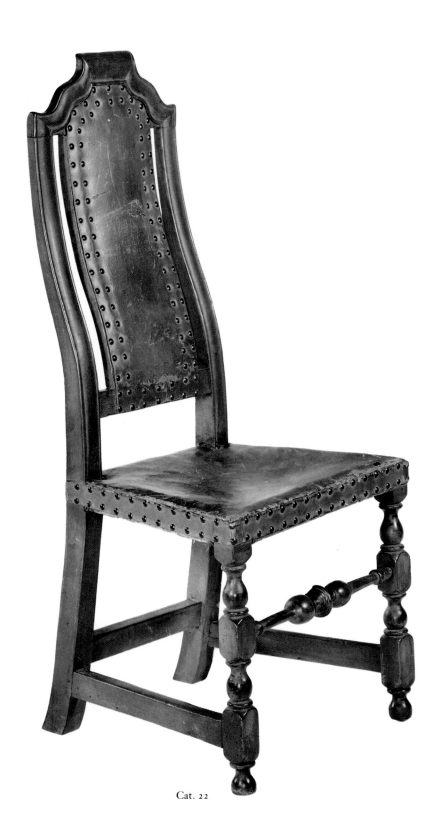

Cat. 22

seat rails, it can be seen that the outer bead was scratched on the posts with a hand-held stock and iron, independently of the rounded molding between the beads. A second stock was, therefore, used to model the inner shape, and here it begins a good 4 inches (10.2 cm) above the seat. The undulating moldings at the crest could mostly be worked with the same scratch stocks, save for the right angles at the corners of the crest, which were perfunctorily incised with chisels. To date, no crooked-back leather chair has been found with more elaborate carving on the crest.

Most chairs of this type have double-nailed upholstery. The foundation and coverings seen here, as well as the nailing patterns, are modern, although probably made of old materials. The seat has collapsed, but was inadequately stuffed in any case. In addition, the nailing of the seat border, which ends with nails set on the bias at each corner, is incorrect. The last nails should be hammered on the two faces of the corners of the extensions of the front legs.

It is possible that this frame had carved feet with applied toes originally.

*Robert F. Trent*

In memory of Mrs. Bonita Beverly
M1976.47

1. Brock W. Jobe, "The Boston Furniture Industry, 1720–1740," in *Boston Furniture*, pp. 40–41.

## 23   *Slat-back chair*

Probably New Jersey or Pennsylvania, 1720–60

*Description:* The five slats have an extreme, double-curved bow made by clamping them in a two-sided caul or mold just after they were worked in an unseasoned state. Several of the slats have prominent break-outs on the rear surface because the radical curve imposed too severe a strain on the wood as it dried in the clamps. Some of the pegging of joints may postdate the chair's manufacture.

*Condition:* The chair has experienced severe insect infestation. The bottoms of

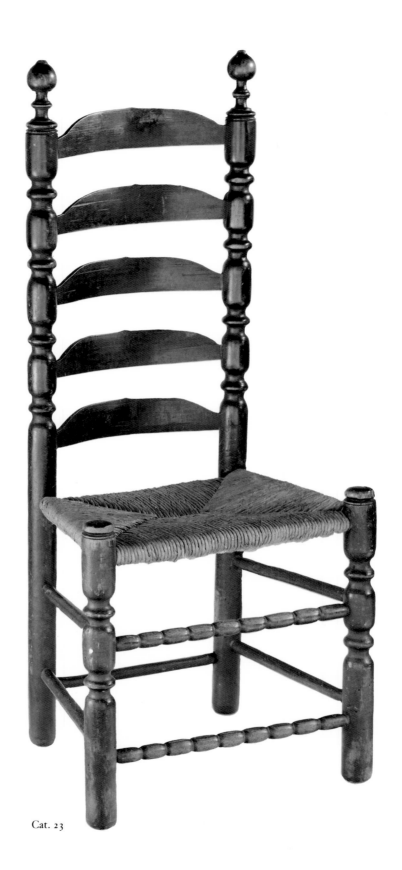

Cat. 23

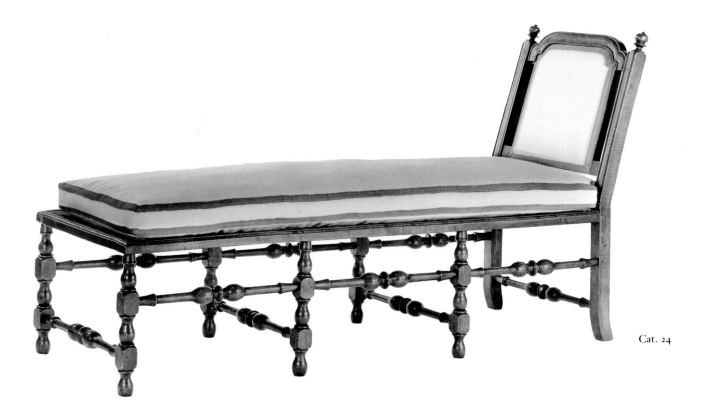

Cat. 24

all four feet have been pieced out 3¼ in. (8.2 cm). The joints for both upper side stretchers were misdrilled originally. The present black paint is partly modern.

*Woods:* Posts, poplar (aspen); upper side stretchers, beech; other stretchers, slats, and seat lists, hickory.

*Dimensions:* H. 45 in. (114.3 cm), S.H. 17½ in. (44.4 cm), W. 19½ in. (49.5 cm), D. 14½ in. (36.8 cm).

*Provenance:* Purchased by the donors in 1978 from Michael and Jane Dunn, Claverack, N.Y. (dealers).

Slat-back chairs are extremely difficult to regionalize. They were not, at the inception of their manufacture, a rural chair type, as they appear in urban inventories as early as 1700 and obviously were influenced by leather chairs, urban banister back chairs, and imported English slat-backs. Presumably they were exported from Boston and New York and competed with both local chair types and with arch-slatted Delaware Valley slat-backs.

At first glance, this example looks very much like New England examples dating from 1720 to 1780. The double-reel-and-ball finials capped by buttons, the gently graduated slats with straight bottom edges, the hollows and blunt reel turnings of the posts, and the "sausage" stretchers are all characteristic of New England chairs. However, several other features argue against a New England origin. The use of hickory for some parts of the chair, while not unprecedented in New England work, is far more characteristic of Middle Colonies seating. The slight cusps atop the slats are often found in New Jersey slat-backs, as are the bold ring turnings above the seat rungs on the front posts. The mannered "lemon" profile of the ball turnings of the finials is also found on New Jersey chairs.[1]

The most striking feature of all is the exceptional double curved bow of the slats. This feature is almost never seen in New England, and it suggests a design tradition influenced by the dramatic compositional effects of continental baroque chairmaking. The technical problems experienced by the maker in forcing the slats to conform to this extraordinary curve demonstrate that it was considered a design element of some importance.

Undoubtedly the chair had turned feet or perhaps tapered bottoms on the posts when it was made.    *Robert F. Trent*

Gift of Virginia and Robert V. Krikorian M1981.112

1. Lynes, "Slat-Back Chairs."

## 24   *Couch*

Boston, Massachusetts, 1722–40

*Description:* The six turned legs of the front part of the frame are attached to the seat frame with round tenons. The front rail of the seat frame is mortised between the side rails.

*Condition:* The entire frame has been stripped of a walnut-colored varnish.

The separate back frame originally pivoted at the level of the stay rail between the posts, while the upper back frame, which is now permanently nailed to the rear posts, originally was free to swing back, supported by chains. The present upholstery on the frame is modern.

*Wood:* All components, soft maple.

*Dimensions:* H. 36⅝ in. (93.0 cm), S.H. 15½ in. (39.3 cm), W. 21½ in. (54.6 cm), D. 60¾ in. (154.3 cm).

*Bibliography:* Jones, "American Furniture," p. 976, fig. 4.

*Provenance:* Purchased in 1967 from Philip Budrose Antiques, Marblehead, Mass. (dealer).

This furniture form, referred to during the period as a couch, derived from the French furniture form called a *lit de repos*, an elongated seat with one end or back. It is to be distinguished from the English form of seating in the Cromwellian style, which was a double or triple armchair, also called a couch, and from the seating form that was derived from an elongated easy chair, known as a sofa or settee.

The William and Mary–style couches made in Boston took their cue from imported English cane couches, but otherwise shared the structure and style of upholstered Boston chairs. No American cane couch is known. All Boston examples are provided with rabbets in the seat rails and the rails of the inner back frame, in which webbing, sacking, and a lining could be tacked to provide support for down- or hair-stuffed cases or a lightly stuffed back. The back frames could be raised or lowered at various angles and were provided with adjustable chains to hold them in position.

It would seem that couches had regional variations in function. In the northern colonies, they were used for formal receiving in parlors and for daytime lounging in bedchambers. In the southern colonies, however, they often were pressed into service as beds for the overnight guests that were an aspect of entertaining on plantations. In addition, southerners also slept on couches to escape from the heat during the summer, when the down mattresses on their bedsteads were unbearably stuffy, sweaty, and confining.[1]

The relatively suppressed ball turnings on the stretchers of this example suggest that it dates from the 1730s, when robust turnings fell from favor and when the fashion for couches of this form was waning.                    *Robert F. Trent*

Purchase, Acquisition Fund
M1967.136

1. Forman, *American Seating Furniture*, pp. 247–48 and 298–99.

## 25  *Banister-back great chair*

Coastal Connecticut, 1750–90

*Description:* The crest is tapered on the rear surface at the ends, with rounded chamfers where it enters the posts. The crest joints are pegged from the rear.

*Condition:* The crest has a lateral split that has been glued. A modern coat of black paint with yellow detailing is applied over an old, if not original, coat of bright red. The seat is a splint replacement for a rush original. The rear feet have lost 1 in. (2.5 cm) in height.

*Woods:* Crest rail, stay rail, posts, front seat rail, arms, front stretchers, and balusters, soft maple; side and rear seat rails and side and rear stretchers, white oak.

*Dimensions:* H. 43⅞ in. (111.1 cm), S.H. 16 in. (40.6 cm), W. 22¾ in. (57.8 cm), D. 16 in. (40.6 cm).

*Provenance:* Roger Bacon, Exeter, N.H. (dealer); Dr. and Mrs. James Beavis, Northford, Conn. (collectors), 1982; Robert W. Skinner Gallery (sale 825, June 12, 1982), lot 176; purchased in 1982 from John Walton, Inc., Jewett City, Conn. (dealer).

This complex and stylized interpretation of the urban banister back of the 1705–1725 period is typical of a large group of chairs produced in Connecticut between 1750 and 1790 (although some examples may date well into the nineteenth century). Of particular interest are the slim, deeply modeled turnings, the scalloped crest, the raking turned arms, and the mannered pommels or

handgrips; this last feature is now popularly referred to as a "mushroom arm." The original production center for this design probably was Norwich, the economic center for all eastern Connecticut. Heavier versions of the design have histories of ownership there, and their more normative sequences of classical forms strongly suggest that the chairs were first produced in the 1740s. The banisters and finials of these prototypes are derived from Boston examples, but the crest rails, composed of bilaterally symmetrical rounds, hollows, peaks, and outer sweeps, are of uncertain origin. Carved crests, while not uncommon on provincial chairs, were usually too laborintensive a feature for standard production, and this crest type was one of the most popular in Connecticut.[1]

The almost universal response of provincial turners to stylistic innovations of the 1740s and later was not to stop making banister-back chairs, but to introduce slimmer, more abstract forms. This tendency was accelerated by neoclassical influences after 1790 which took the form of competitively priced Windsors, fancy chairs, and rush-seated chairs with Queen Anne–style banisters and Chippendalestyle crests. As these forms rendered the traditional banister back old-fashioned, provincial turners retained the chair form as an integral part of their line but updated it.

Unparalleled for their audacity, chairs like the present example retained regional popularity through a proliferation of crest and banister profiles and, especially, through their spectacular pommels. The pommels, which are one piece with the front posts, contradict the idea that these chairs were intended for a lower level of the market, because the waste of timber involved in cutting down the large billets needed to fashion them, as well as the labor involved, probably offset any savings derived from simplifying the rest of the format. Perhaps they were an option to be selected by the customer. They rarely appear on chairs with Queen Anne–style banisters.[2] Because armchairs in this style survive in far greater numbers than matching side chairs, it is difficult to gauge how often they were made.

The latest examples of this style of chair are tentatively identified with

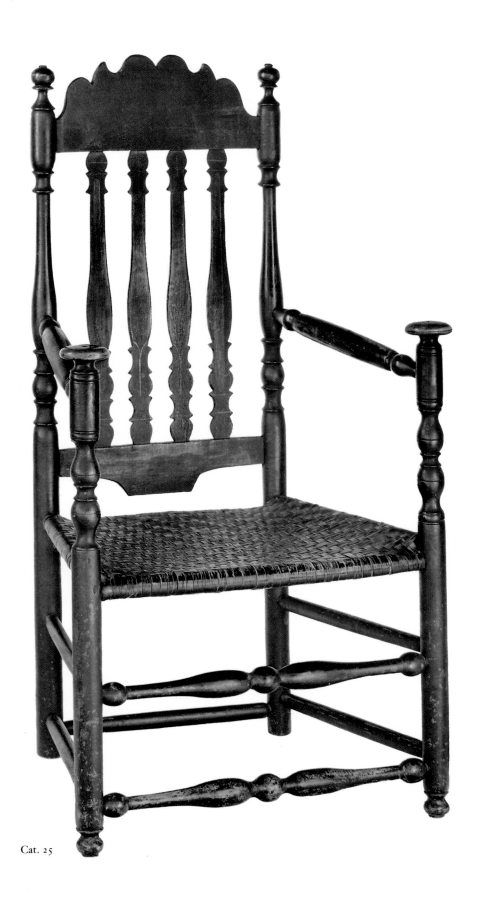

Cat. 25

Wallingford and Guilford in New Haven County, although they may have been made in towns all along the coast from New Haven to the Rhode Island border.[3]

*Robert F. Trent*

Purchase, Layton Art Collection
L1982.49

1. Trent and Nelson, "New London County Joined Chairs," pp. 113–17.
2. See, however, Trent and Nelson, "New London County Joined Chairs," nos. 49–50.
3. Trent, *Hearts and Crowns*, pp. 56–59 and figs. 27–30.

## 26 *High chest of drawers*

Boston, Massachusetts, 1695–1720

*Description:* The upper case sides are dovetailed to the top and bottom. Runners for the drawer dividers are fitted in slots planed in the sides. Each drawer of the upper case is dovetailed front and rear and slides on applied running strips. The dovetail keys of the sides protrude beyond the bottom board and support the weight of the case. The rear boards are nailed on. The lower case is dovetailed at the corners. Full-depth front-to-rear medial braces are attached to the backboard with housed dovetail joints that extend down 2 in. (5.1 cm), while the remainder of the joint is a simple butted dado joint. Three boards mitered at the front corners are nailed to the top of the dovetailed case and supply the substrate for the veneered waist molding, as well as supporting the upper case. Glue blocks provide additional seating for the socket joints of the tops of the legs. The scalloped skirts are chamfered on the inner edges to lighten their appearance. The turned feet have separate center pins that pass through the flat stretchers and engage holes in the bottoms of the upper legs.

*Condition:* The veneer has numerous small repairs, especially the herringbone borders and the cross-banded moldings. The brass is a modern replacement set. New stop blocks are glued inside both cases for the drawers. The age of the feet, stretchers, and legs is uncertain. The entire veneered surface has been refinished.

*Woods:* Veneer, walnut; all secondary woods, eastern white pine; feet, stretchers, and legs, maple.

*Dimensions:* H. 62½ in. (158.7 cm), W. 41⅛ in. (104.4 cm), D. 22⅜ in. (57.1 cm).

*Exhibition:* Museum of Fine Arts, Boston, 1971–72.

*Bibliography: Antiques* 97, no. 4 (April 1970): 493.

*Provenance:* Mr. and Mrs. William H. Coburn, Chestnut Hill, Mass. (collectors).

High chests in this style, with trumpet-turned legs connected by flat stretchers, dovetailed-board cases, and elaborate veneered surfaces, are thought to have been introduced in Boston about 1696 by John Brocas (or Brockhurst), an English cabinetmaker who arrived in that year and worked until 1740.[1] Benno M. Forman first advanced the idea that the arrival of dovetailed-board construction and elaborate veneering constituted a technological divide, wherein joiners trained in the mannerist design tradition of joined construction were "displaced"

Cat. 26a

Cat. 26b

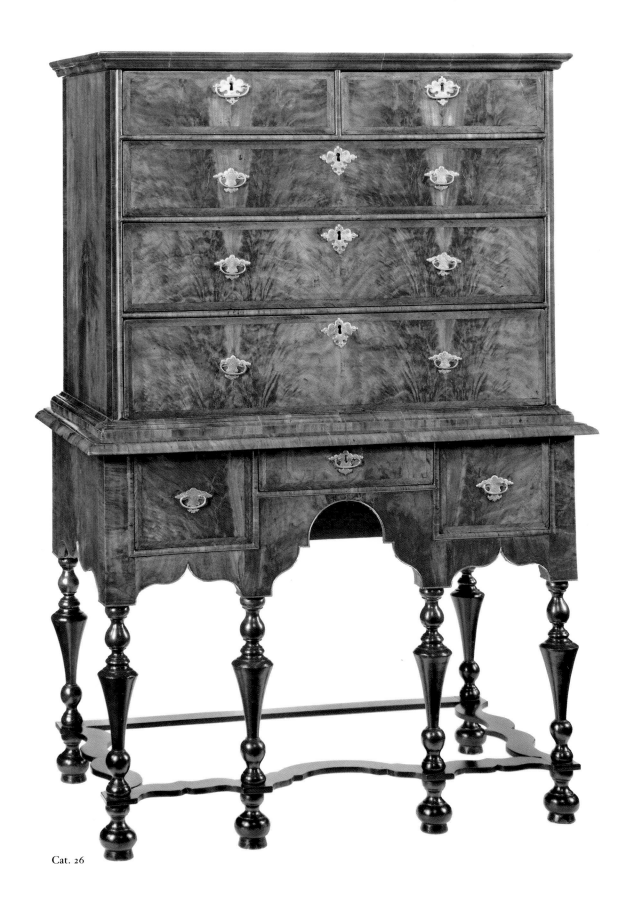

Cat. 26

by cabinetmakers. Certainly this idea has some validity from a design standpoint. The earthbound character of chests of drawers (cat. 3) could not be farther removed from the verticality and evident fragility of high chests in the mature early baroque manner.[2]

The most striking feature of these high chests is their brilliant veneer. Most Boston examples sport book-sawn panels of burl maple, but this one has both panels and herringbone edging in walnut. Only one American case piece, a desk at the Metropolitan Museum of Art, is veneered in olivewood, a treatment common in England and often found cited in New England inventories. Setting aside the woods of which veneer was fashioned, the manner in which it was worked calls for attention. Most veneered cases of any age commonly have suffered extensive repairs, sanding, and wholesale resurfacing. This increases the difficulty in determining how thick the veneers were when first glued to the cases. Cabinetmakers' inventories suggest that burls or roots were sawn into sheets with a large framed saw. The conifer surfaces on which the veneers were to be laid were systematically scored with a toothed plane iron or perhaps a toothed iron held in a scratch stock; this created numerous small channels in the wood which promoted greater adhesion of the glue. The glue itself seems to have been hot hide glue, generally made from rabbit's skin, which had the advantages of greater adhesion and swift drying.

During the actual process of laying the veneer, the earliest cabinetmakers made use of numerous lead weights, rather than large clamps or cauls. In one other aspect of the gluing process, however, they must have employed shaped cauls of some sort, because the cross-banded veneers with which the pediment and waist moldings are decorated cannot have been held in place by weights.

A final detail is the thin beading nailed along the scalloped edges of the skirt. This was an extremely vulnerable point for the veneer, and obviously the beading, which extends beyond the surfaces of the skirt a fraction of an inch, was intended to prevent incidental chipping and lifting of the edges. The relatively thick boards of which the lower case is made are chamfered away behind the beading to lighten the overall appearance of the skirt and to hide the pine substrate.

Even when they were new, such high chests were extremely flimsy. Perhaps their weakest points were the legs and flat stretchers. Unlike later high chests that have crooked or cabriole legs, the earliest examples were attached to the legs with simple socket joints that were located partly in the board sides of the lower case and partly in supplementary pine blocking inside the case frame. A second set of joints was used at the stretcher level, where ball feet with separate central pins were fitted through holes drilled in the stretchers and in the bottoms of the pillars or upper legs.

The vast majority of pre-1730 high chests survive in a fragmentary state, usually an upper case on later feet. Obviously the original legs broke and the lower case was discarded. Less frequently, an entirely new set of legs and stretchers was supplied. Although it is impossible to state flatly that the legs of the present example are replaced without dismantling the socket joints for examination, their overall character strongly suggests that this might be the case.

While it is possible to argue that Boston joiners could not possibly have competed with cabinetmakers like John Brocas, other points of affinity between London-style case pieces (such as cat. 3) and this high chest are worth noting. The earlier style did employ dovetailed construction in the drawers and also made extensive use of thin sheets of decorative hardwoods glued to surfaces. One example, a Boston cupboard, not only uses thin plaques of hardwoods on drawer fronts, but has hardwood plaques glued to many of the structural members of the upper case—veneering, in effect.[3] Finally, it has been suggested that the earliest apprentice who might conceivably have trained with Brocas, John Damon, Jr. (1679–1714), may have transmitted the secrets of dovetailed-board construction and extensive veneering to his numerous relatives in the joinery trade in Charlestown and Boston.[4]

*Robert F. Trent*

Gift of Mr. and Mrs. William H. Coburn
M1985.102

1. Benno M. Forman, "Urban Aspects of Massachusetts Furniture in the Late Seventeenth Century," in Morse, *Country Cabinetwork*, p. 18; Forman, "Chest of Drawers in America," p. 21.
2. Forman, "Urban Aspects," pp. 18–20.
3. Sotheby's (sale 5599; June 26, 1987), lot 183.
4. Trent, "Chest of Drawers in America," pp. 41–42.

## 27 *Dressing table*

Boston, Massachusetts, 1695–1725

*Description:* The case sides are dovetailed to the front and rear. Each drawer is constructed with dovetails at front and rear and slides on applied running strips. Full-depth medial braces run from front to rear and also support runners for the drawers. The top is nailed to the case, with the nailheads concealed under the veneer. The legs are attached to the case by socket joints partially drilled in glue blocks. The feet are doweled up into the legs with separate pins and also engage the stretchers. A turned finial is doweled through a lap joint in the cross stretchers.

*Condition:* The case is heavily restored, with substantial alterations. The top has been reset ½ in. (1.3 cm) to the rear of its original location. The entire center field of the top has been resurfaced with rotary-cut veneer. The entire rear of the case has been replaced and furnished with a scalloped profile and pendant finials. The present splay of the legs is not an original feature and calls the stretchers into question. The proper right front corner of the top has been spliced.

*Woods:* Backboard, top board, medial braces, drawer linings, and front substructure, eastern white pine; sides, legs and stretchers, and later rear pendant finials, soft maple; feet, birch; all veneers, beading of the skirt, and caps above legs, black walnut.

*Dimensions:* H. 30 in. (76.2 cm), w. 32¼ in. (81.9 cm), D. 20⅞ in. (53.0 cm).

*Exhibitions:* See cat. 26.

*Bibliography:* See cat. 26.

*Provenance:* See cat. 26.

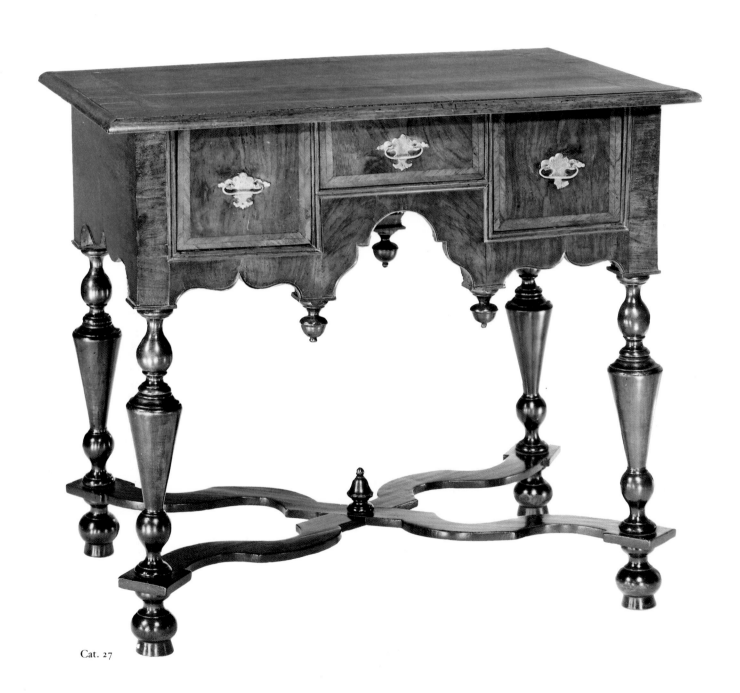

Cat. 27

Cat. 27

Small tables like this, often made *en suite* with high chests of drawers, were known variously as "dressing tables," "chamber tables," or "toilet tables" during the period (the last term was often corrupted to "twilight tables").[1] As the names suggest, they were used in bedchambers for dressing, often with a looking glass and one or two stands for candles.[2]

The present example was for many years represented as the mate to cat. 26, but it is by a different shop and has been heavily altered to match the high chest. At this point, it is more interesting as a late nineteenth- or early twentieth-century object. The restorer sought to alter the object's function, as well as to make it stylistically compatible with the high chest. His most striking addition was to fashion a new rear skirt with a scalloped apron and pendant finials; the skirt was also veneered. Obviously the table was now intended to be seen in the round and had become a "center table." Resetting the top more to the rear reduced its overhang in front and augmented it in the rear, another concession to the center-table concept.

The top was altered by replacing four book-sawn veneer panels with a two-piece burled walnut top made of rotary-cut veneer, which resembles cuts of Carpathian walnut veneer much favored by Victorian designers and artisans.

The legs, stretchers, and feet are problematic. The legs now have a pronounced and inappropriate splay, which can only have been introduced by making a new, larger set of stretchers. The feet are birch and very likely replacements, as is the finial at the junction of the two stretchers. Certain Pennsylvania dressing tables made in part by artisans of Germanic background have splayed legs, but no indisputable New England example with profound splay is known.[3]

The sides, front, internal medial braces, and drawers are the principal original components. The drawers are made with thick linings constructed of pine, with large, fairly crude dovetails. The flimsy socket joints for the legs, drilled partially in glue blocks applied inside the case at the four corners, explain why so many high chests and dressing tables survived in a fragmentary state and had to un-

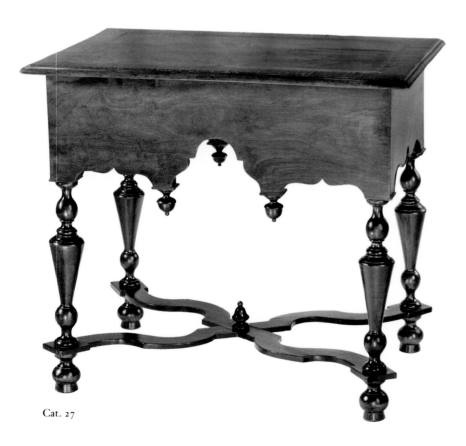

Cat. 27

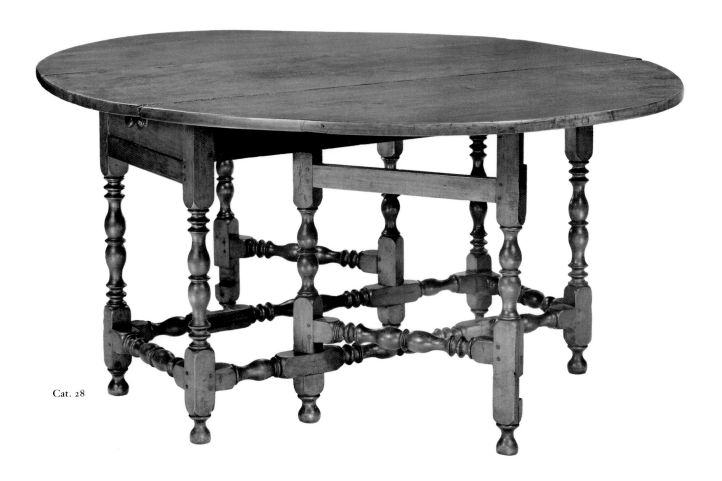

Cat. 28

dergo heavy restoration once fashion had made them desirable again.

*Robert F. Trent*

Gift of Mrs. Pamela B.G. Coburn
M1986.68

1. Forman, "Furniture for Dressing," pp. 149–64.
2. Forman, "Furniture for Dressing," pp. 155–57.
3. See, however, Forman, "Furniture for Dressing," figs. 12–13.

## 28  Oval-leaf table

New England, 1740–80

*Description:* The two leaves and the top are each made of two watersawn maple boards glued together. The leaves are attached to the side rails of the frame with H hinges that appear to be original. The full-length drawer is supported on a central medial strut that is let into the end skirts with mortise-and-tenon joints. The drawer sides are secured by two dovetail keys let into the drawer front. The rear of the drawer is secured to the two sides by two dovetailed keys. The drawer face is ½ in. (1.3 cm) taller than the sides and rear. The drawer bottom is nailed in a rabbet in the drawer front and is nailed to the other three sides of the drawer. The drawer slides on a medial drawer support. The support is chamfered on the front end and let into a slot in the drawer rail, while the rear end is nailed under the skirt. The wooden turned knob is original.

*Condition:* One leaf has a diagonal split that has been repaired with two dovetail keys. The entire surface has extensive residues of a walnut-color finish.

*Woods:* Top, legs, stretchers, drawer front, and end skirts, soft maple; drawer lining and side skirts, eastern white pine.

*Dimensions:* H. 27⅛ in. (68.9 cm), W. top 58¾ in. (149.2 cm), D. top 48⅜ in. (122.9 cm).

*Exhibition:* Museum of Fine Arts, Boston.

*Provenance:* Mr. and Mrs. William H. Coburn, Chestnut Hill, Mass. (collectors), 1972; Sotheby Parke-Bernet (sale 4205; November 1975), lot 1239; purchased in 1976 from John Walton, Inc., Jewett City, Conn. (dealer).

Although oval-leaf tables are among the most common and complex of surviving eighteenth-century furniture forms, they have received little critical attention. The earliest known examples date from the 1670s and have exceptionally wide central frames, which points to the genesis

of the form, when oval leaves were attached to massive rectangular tables of traditional form. By the 1690s, the standard form that remained in production until the 1790s was arrived at, with far more slender posts and one or two gates on each side. The tops were almost always oval and required the use of an asticle[1] in laying them out. The best examples were made of walnut, but the majority were made of maple colored to imitate walnut or painted.

This example is extraordinary for its excellent state of preservation and for its equally excellent quality. The bilaterally symmetrical vase turnings supplemented with reels and fillets are beautifully executed, as are the vase feet. All joints are consistently and accurately double-pinned with fine maple pegs that are square in section. While the relative size of the oval top and the frame was a compositional element that was experimented with by various makers, the exact measurements employed on this example produce the optimum visual effect while still providing adequate leg room.

It is common to find such tables with the outer boards of the leaves broken or missing. Some makers merely attached the two pieces of each leaf together with a butted joint that was held by a technique wherein the two boards were rubbed together to promote adhesion of hot hide glue. Others strengthened the long joints by adding subsidiary blind pegging, splines, or hidden free tenons between the boards. No supplementary joinery techniques can be detected here, but the strength of the leaves is attested to by the fact that the one leaf which has a crack did not experience it at the joint, but developed a diagonal curing crack in one board which was skillfully repaired with dovetail keys. Although the watersawn top boards appear to have been cut on the most stable radial plane, slight deviations in the orientation of the log from which the boards were cut might have skewed the board off the exact radial plane, thus making it susceptible to cracking as it cured.

The full-length drawer is a typical feature of smaller leaf tables with gates or "fly rails," as they were called, but the use of H hinges to mount the leaves

instead of butterfly or rectangular butt hinges is unusual.          *Robert F. Trent*

Purchase, Layton Art Collection
L1976.9

1. This is a cross with tracks, in which a tracer with two studs is run to describe an oval. See Newlands, *Carpenter and Joiner's Assistant*, p. 23.

## 29   *Small oval-leaf table*

Philadelphia, Pennsylvania, 1700–1730

*Description:* One of the leaves is glued up out of two separate boards. The central board of the top was originally attached with four wooden pegs, which have been supplemented by screws let into the skirts from underneath. The toes of the feet are built up by glued-on pieces on two sides of each foot. A crack in the inner piece of the glued-up leaf was caused by a defect in the lumber. The drawer is constructed with two dovetail keys at the front and

the rear. The bottom is chamfered on the front edge and nailed in a rabbet in the drawer front. The bottom is rabbeted on the sides and fitted into grooves in the drawer sides. The rear of the drawer bottom extends ¼ in. (.6 cm) beyond the drawer back and is secured by a single nail. The drawer slides on a medial support nailed to the frame. The engraved brass pull and handle are original.

*Condition:* The outer section of the glued-up leaf may be a later repair. A later stop block has been added to the medial drawer support. Traces of an old, dark finish are visible throughout the object. The top has been spliced with a central strip ¾ in. (1.9 cm) wide.

*Woods:* Top, drawer front, and all visible sections of frame, black walnut; medial drawer support, white oak; drawer linings, southern yellow pine.

*Dimensions:* H. 27⅛ in. (68.9 cm), w. top 35½ in. (90.1 cm), L. top 27 in. (68.6 cm).

*Provenance:* Joe Kindig, Jr., and Son, York, Pa. (dealer).

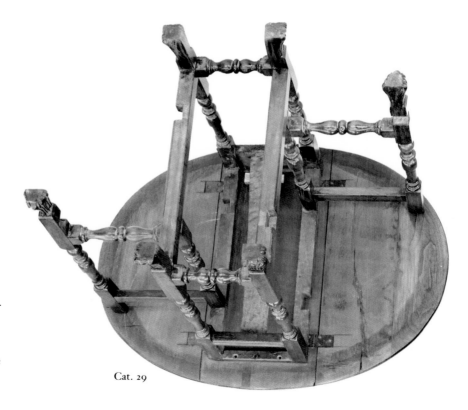

Cat. 29

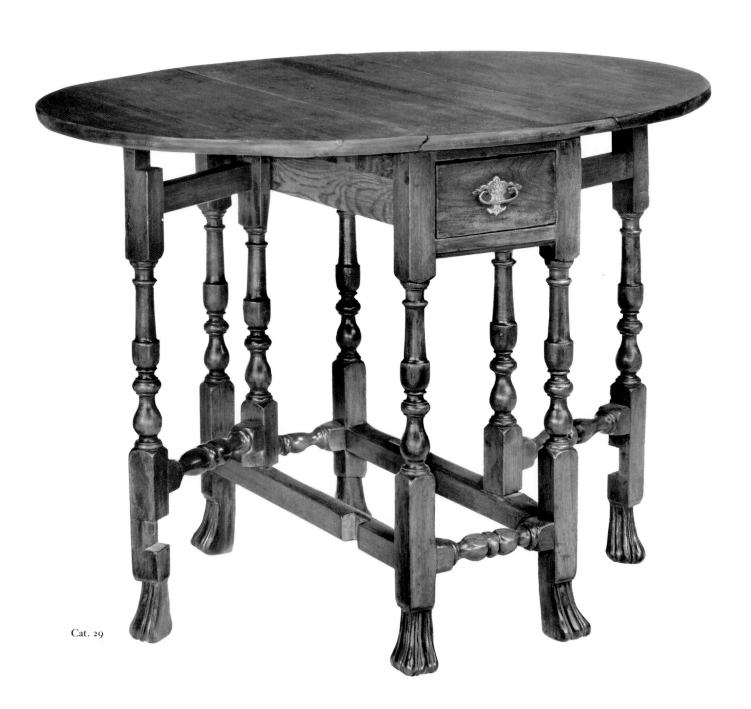

Cat. 29

Small leaf tables with either box or trestle bases are difficult to identify in period inventories. Most often tables are described by size or the shape of the top, less so by the primary woods. Still less significant in the eyes of appraisers was the design of the frame. However, a table with two leaves required a great deal more labor to fabricate, additional lumber, additional features like the flies that support the leaves, and hinges. An exact description of this example in period terms would be "small oval walnut table with two leaves and a drawer."

One of two nearly identical examples, this exquisitely made and beautifully preserved one was far more of a luxury product than might at first appear.[1] The walnut of which it is constructed has a somewhat bland figure, but is fairly high quality wood, despite an obvious flaw in one leaf; the flaw is probably the intrusion of a bark edge from a crotch and indicates that the board was sawn from high up in the tree trunk. Its use in such a visible spot suggests that the crack did not show on the upper surface when the board was planed and only opened up later as the leaf was subjected to vibration and stress.

The workmanship of the table is quite refined. The planing of all parts is exceptionally careful, the mortise-and-tenon joints were cut and fitted with an eye to neatness and a snug fit, and remarkably, the joints are unpegged and are held by glue alone. The detail of the turnings and the carved feet is highly regulated. Obviously, this object was intended to be subjected to close scrutiny by its owners.

The turnings are an important index of the regional origins of the table. Generally speaking, the upper turning of the legs, composed of a Tuscan Doric column leading into a cup and separated from the cup by a sharp ridge, is not found in English work, but is common in continental seating furniture and tables. This suggests, in a Philadelphia context, the influence of Germanic artisans. The distinctive feet, strongly undercut at the top, flat on the inner sides, and modeled with multiple reedings and rounded panels, are unique to Philadelphia chairs and tables, although they probably reflect a specific English tradition of workmanship or perhaps an Irish regional variant.

Exactly what such small tables were used for is open to question. All leaf tables were intended to be folded up and put aside when not in use. The small surface area of the top is nearly the same as that of a tea table with a tray top and four fixed legs, but small tables were also used for dining and evolved into the ubiquitous "Pembroke" or "breakfast" table in the 1760s. The chamfering of the edges of the top underneath, while it visually lightened the table's appearance, also permitted those seated at the table to place their legs under it without snagging clothing on a sharp edge. The presence of a drawer suggests that napery, cutlery, or other refined utensils were stored in the table. It is unlikely that the table was used for playing cards, because it is too small to accommodate four players. *Robert F. Trent*

Purchase, Layton Art Collection
L1978.236

1. Philadelphia Museum, *Three Centuries*, p. 27.

## 30 *Small joined table*

New York or New Jersey, 1720–80

*Description:* The one-board top is held by eight pegs. The roughly worked skirt rails have a scratch stock molding run on their lower edges.

*Condition:* The table recently was dismantled for examination. All original pegs were returned to their respective joints. A dark finish was restored to match the remnants of finish that remained under the stretchers.

*Woods:* Top, sweet gum; skirt rails, birch; legs and stretchers, cherry.

*Dimensions:* H. 25½ in. (64.8 cm), w. 30 in. (76.2 cm), D. 19⁵⁄₁₆ in. (49.0 cm).

*Provenance:* Purchased by the donors from John Walton, Inc., Jewett City, Conn. (dealer).

This intriguing variant of the joined table is attributed to New York or northern New Jersey for two reasons. First, the top is made of sweet gum (*Liquidambar styraciflua*), a timber much favored in those areas, especially for the great *kas* or wardrobes that continued to be used by those of Dutch extraction until well into the nineteenth century. Second, the otherwise generic turnings include one motif—an inverted, ogee-sided urn—that is characteristic of New York furniture.

Perhaps the most important monument of New York William and Mary–style table design is the Sir William Johnson oval-leaf table at the Albany Institute of History and Art. Although it is made of mahogany and is far more exquisitely made, the Johnson table has the same overall turnings on the legs. The ogee-sided urns face upward and have many fine stops and fillets not seen here. The upper vases are likewise finer and have fine collarinos, while those of the present example lack such an academic treatment and subsume the collarinos in pairs of reeded reels. The feet of both tables are the same heavy suppressed balls with heavy necks.[1]

Certain varieties of banister-back chairs identified with the greater New York area display multiple reel turnings on the back posts that are directly related to those of the present example. The bilaterally symmetrical double vase of the table's stretcher, while common in many American regional schools, is reminiscent of the front posts of New York leather-upholstered armchairs of the 1700–1740 period.

Small tables with medial stretcher arrangements probably were meant to be used as dressing tables or writing tables. Certainly this table has seen little of the heavy use experienced by tables used for dining. The use of three different primary woods is unusual, but all were united originally by a walnut-color finish. *Robert F. Trent*

Gift of Virginia and Robert V. Krikorian
M1987.34

1. The Sir William Johnson example is illustrated in Singleton, *Furniture of our Forefathers*, opposite p. 260. Other notable examples are illustrated in *Williamsburg Collection of Antique Furnishings*, p. 89; Butler, *Sleepy Hollow Restorations*, p. 62; and Christies' (sale 5978; October 19, 1985), lot 155.

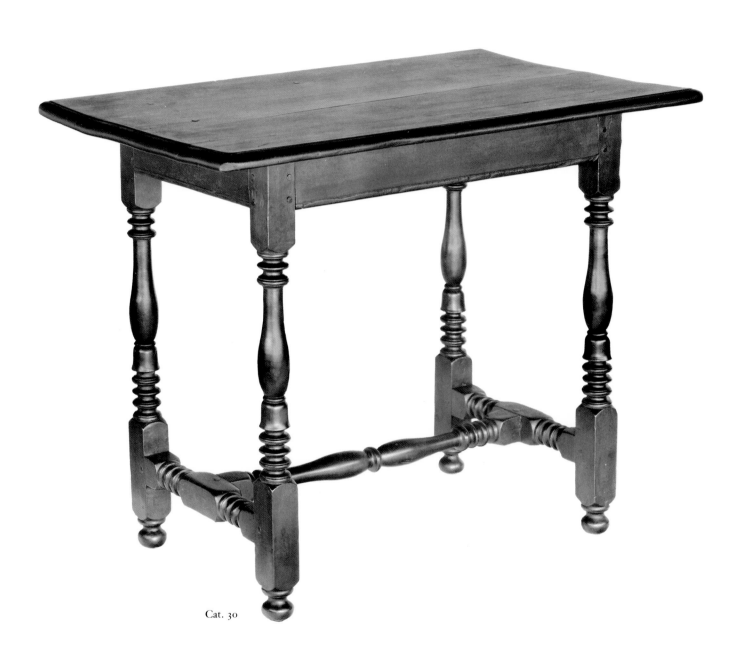

Cat. 30

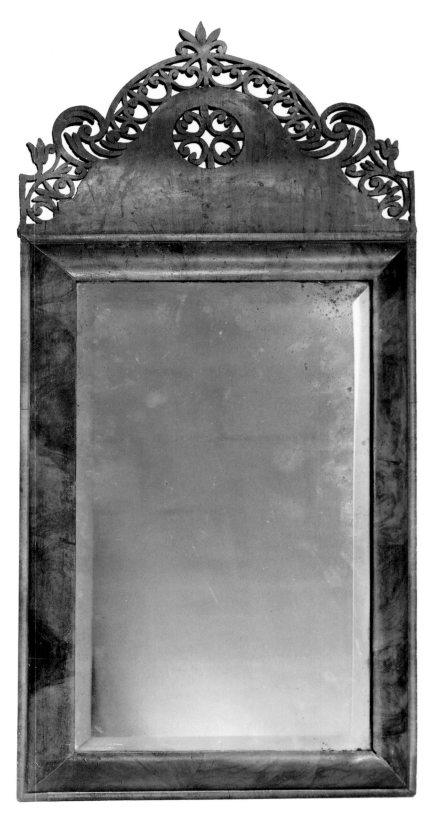

Cat. 31

## 31  *Looking glass*

Probably London, England, 1680–1700

*Description:* The crest is attached to the frame by two vertical dovetailed struts 2½ in. (6.4 cm) long. The side rails of the frame are tenoned into the top and bottom rails.

*Condition:* The original hanging device was suspended from a hole drilled diagonally through the center of the top rail. The glass is now suspended from a hemp rope passed through the original center hole and two later bottom holes. The crest has warped toward the rear and has been repeatedly repaired at the top. The pine backboard is a replacement held in place by iron sprigs. Evidence of glue blocks suggests that blocking was the original treatment for securing the backboard or boards. Remains of a darker finish are visible in crevices. Some of the silvering has fallen away from the glass plate.

*Woods:* All veneers, European walnut (probably *Juglans regia*); crest substrate, spruce; frame substrate, sylvestris pine; replaced backboard, eastern white pine.

*Dimensions:* H. 36¼ in. (92.0 cm), w. 17¾ in. (45.0 cm), D. 1½ in. (3.8 cm).

*Bibliography:* Comstock, *Looking Glass in America*, p. 31.

*Provenance:* Katherine Prentis Murphy, Westbrook, Conn. (collector); New Hampshire Historical Society, Concord, N.H., 1983; Robert W. Skinner Gallery (sale 922; September 24, 1983), lot 195.

Although looking glasses today are regarded as decorative accessories, during the period they represented an expensive indulgence. All were imported before the mid eighteenth century, and they tended to be made by London specialty shops in a fairly restricted range of patterns, sizes, and options.

This example is a middling quality version, with a beveled, one-piece plate, veneered molding, and veneered and fretted crest with simple piercing. The looking glass may have been in the colonies since the eighteenth century, because the replaced backboard is made of eastern white pine and has some age.

The fretted crest reflects strong French influence, but the heavy ovolo molding recalls heavy waist moldings of case pieces in the London tradition that date from as early as the 1620s (see cat. 3). The indifferent and informally pieced-out flitches of walnut-veneer crossbanding on the molding are typical, although burl walnut, burl elm, and olivewood oysterwork were used on better models. Most elevated of all were glasses with extremely elaborate fretwork and veneers or applied plaques of exotic timbers like rosewood or ebony. Some cheap looking glasses were made of softwoods and were painted or grained to resemble veneer. After 1700, japanning became a popular way of decorating these frames.

*Robert F. Trent*

Purchase, Layton Art Collection and Collectors' Corner
L1983.298

## 32   *Spoon rack*

Bergen County, New Jersey, dated 1704

*Description:* The three racks are held to the backboard with wrought-iron nails and long wooden pegs driven in from the back; the wooden pegs are most likely the original securing device. (The body of one of these square, shanked pegs is visible where the underside of the second rack has been broken out slightly.) The upper rack has had its pegs replaced by three modern screws, and a single wrought nail remains. All designs were laid out with a compass and ruler. The overall geometric decoration is composed largely of stars with six or eight points; the largest element is a sixteen-point star above the lower spoon rail. The stars are made of triangular ellipsoidal intaglio cuts. The center crest has a heart with the date and initials (see *Inscriptions*). Each spoon rail has four ellipsoidal holes for holding spoons vertically.

*Inscriptions:* "AAM / MAKER" is carved on the back in block letters 1 in. (2.5 cm) high. "1704 / AZ AZ" is carved in an elongated heart on the center crest. This is flanked by "AN [backwards]" on the top, and "N [backwards] O" on the bottom.

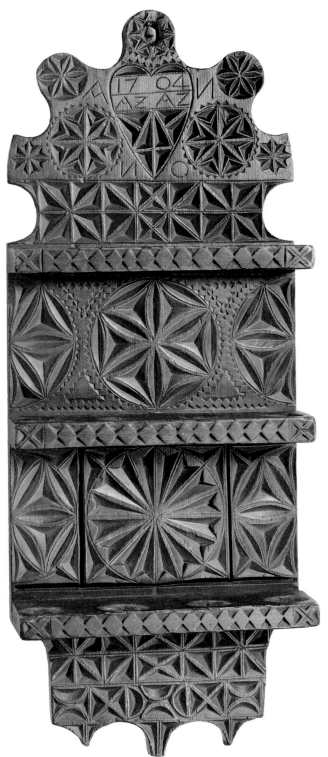

Cat. 32

*Condition:* There have been small losses from the top rounded elements of the crest. The point of the lower left element of the base rail is broken off. The lower spoon rail appears to be a replacement. The spoon rack has had a number of different stain and dark paintlike finishes (apparent on the underside of both upper spoon racks); in comparison, the lower rail is relatively clean.

*Wood:* Yellow-poplar.

*Dimensions:* H. 24 in. (61.0 cm), W. 9 in. (22.9 cm), D. 2 in. (5.1 cm).

*Provenance:* Purchased by the donors from Gilbert May, West Granville, Mass. (dealer).

If the carved date on this spoon rack is to be believed, it is the earliest known example of a type of rack associated with Dutch towns in Bergen County, New Jersey.[1] The latest dated example is dated 1792.[2] Traditionally a spoon rack was given to a bride by her husband upon marriage and was hung in the kitchen. The courtship associations of spoon racks have led to the persistent tradition that they were carved by the groom, a tradition that is widely associated with this style of chip carving, popularly referred to as Friesian carving. The exactitude and close adherence to a traditional format of most objects in this style suggest, however, that most chip-carved objects are professional products. The formal consistency of New World Dutch spoon racks is also remarkable. Almost all have three racks with four slots each. The field holding the three racks is usually rectangular, while the crest with a hanging hole has a lobed or architectural outline and the pendant below the racks has a series of scallops reminiscent of medieval pendants. Evidence on the underside of the two top spoon racks suggests that this example was painted a number of times and its bare surface is a modern state. Originally a dark green or multicolored painted treatment might have been found.

*Robert F. Trent and Jayne E. Stokes*

Gift of Anne H. Vogel and Frederick Vogel III
M1981.182

1. Blackburn and Piwonka, *Remembrance of Patria*, pp. 159–61.

2. Blackburn, "Dutch Arts and Culture," p. 143.

## 33 *Plate*

London, England, ca. 1690

*Description:* This plate is decorated in blue and yellow with half-length images of King William III (1650–1702) in an ermine-trim robe and of Queen Mary (1662–94). Circumferential lines frame the figures and set off the undecorated rim.

*Inscriptions:* The initials w$^M$R are painted under a pale bluish glaze which covers the front and back.

*Condition:* The plate is in fine condition with no breaks or repairs.

*Material:* Tin-glazed earthenware.

*Dimensions:* DIAM. 8⅝ in. (21.9 cm).

*Provenance:* Purchased by the donors in 1983 from Art Trading Ltd., New York, N.Y. (dealer).

Images of kings and queens from Charles I to George II appear on English tin-glazed earthenware (see cat. 34). The inclusion of initials and variances in costume or hair style offer limited clues to identify the figures. The panorama of royal delftware presents an unglamorous and at times bawdy image of the English monarchs. Here, the drawing of the figures corresponds to an example in the Museum of London.[1]     *Anne H. Vogel*

Gift of Virginia and Robert V. Krikorian
M1987.46

1. Britton, *London Delftware*, p. 138, pl. 110.

## 34 *Plate*

Probably London, England, ca. 1700

*Description:* This plate depicts King William III (1650–1702) on a rearing horse, holding reins in his right hand and

a baton in his left. Sponged trees on either side frame the figure. The initials WR identify the monarch. Blue circumferential lines hold the composition within an undecorated edge. The plate is painted in blue, green, and yellow on a white glaze; the back of the plate is covered with a pale green lead glaze and has an unpierced foot rim.

*Inscriptions:* The initials WR (for "William Rex") are painted on the front of the plate.

*Condition:* The plate is in fine overall condition.

*Materials:* Tin-glazed earthenware; greenish lead glaze on back.

*Dimensions:* DIAM. 11¾ in. (29.8 cm), DIAM. foot rim 4¼ in. (10.8 cm).

*Provenance:* Purchased by the donors in 1978 from Michael and Jane Dunn, Claverack, N.Y. (dealer).

The depiction of various monarchs on earthenware plates was taken from a common print source with little attempt to change any details.[1] This figure of William was based on an engraving by Cornelius van Dalen of Charles I entering Edinburgh, an event which took place in 1641.[2] The print was used as a frontispiece in one of five copies of J. Nalson's *Journal of the Tryal of King Charles I* (1684) in the British Library. On the dish, William is in a reverse position from the engraving, and the ermine-trim cloak has been converted to all ermine. After Queen Mary's death in 1694, the mounted figure of King William became prevalent on English delftware. A similar example is in the City of Bristol Art Gallery.[3]

*Anne H. Vogel*

Gift of Virginia and Robert V. Krikorian
M1987.45

1. Britton, *English Delftware*, pls. 3.36, 3.37, 3.38, 3.39. These dishes showing the monarchs Charles II, James II, and William III all derive their design from the Cornelius van Dalen print.
2. Britton, *English Delftware*, fig. 3.
3. Britton, *English Delftware*, pl. 3.39.

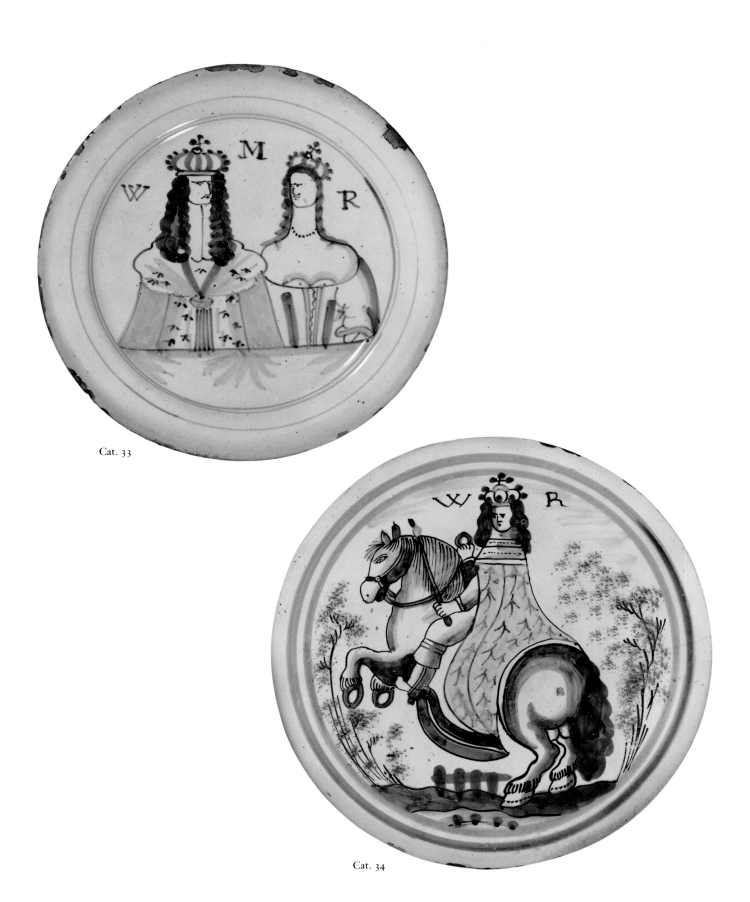

Cat. 33

Cat. 34

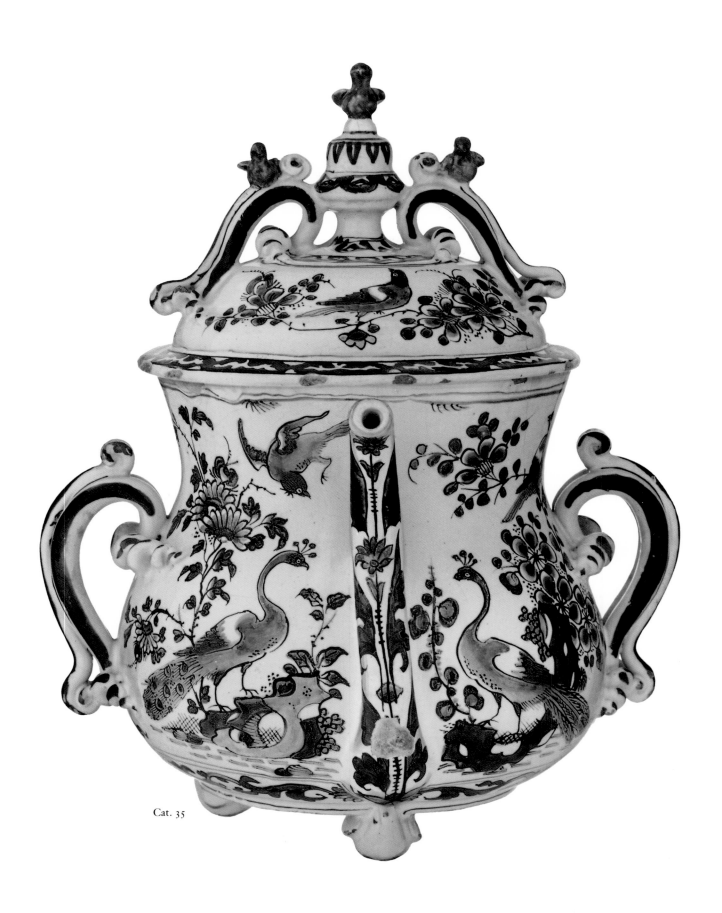

Cat. 35

## 35  *Posset pot*

England, ca. 1695

*Description:* The elongated bulbous pot with clinging spout rests on three bird feet. The body curves to a slightly everted rim without forming a distinct neck. Double-scroll handles with trailing cork-screw terminals embellish the body and domed lid, which is further decorated with a knob and three bird finials. The surface design made up of various shades of blue is enlivened with delicate dark outlines. Peacocks and floral patterns decorate the front; the backside has a central medallion with two seated Chinese figures in a tea ceremony near a partial view of a pagoda. Two smaller medallions above are filled with Chinese floral-scroll patterns. An Oriental scroll pattern covers the spout and rim.[1]

*Condition:* Extensive repairs and replacements have been made to the rim, dome, and finials of the lid. All but the base of the spout is replaced. A 2-in. (5.1 cm) piece on the rim of the pot (directly behind the spout) is replaced. The body of the pot, the handles, and the feet are original, with minor retouching to the glaze.

*Material:* Tin-glazed earthenware.

*Dimensions:* H. pot 7½ in. (19.1 cm), DIAM. pot 11 in. (27.9 cm), H. lid 5½ in. (14.0 cm), DIAM. lid 7¼ in. (18.4 cm).

*Provenance:* Purchased by the donors in 1983 from John Walton, Inc., Jewett City, Conn. (dealer).

Posset pots, two-handled vessels usually with a lid and long tubular spout, were made typically of pottery and glass. Dated extant English delftware posset pots reveal the earliest to be 1631 and the latest 1766.[2] As the seventeenth century ended, posset pots achieved a greater degree of social importance which the form reflected in additional ornamentation: elaborately formed handles, high-domed lids, scrolls, trailing terminals, and various types of finials. The Milwaukee piece fits into a group that sit on three bird-shaped feet and date from 1674–99. Because of the curving shape of the pot and the style of feet and handles, it was probably made in the last decade of the seventeenth

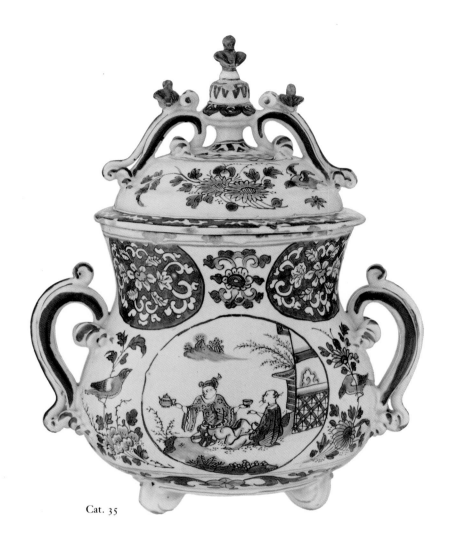

Cat. 35

century. In the eighteenth century, posset pots were rivaled in use and gradually replaced by punch bowls.

*Anne H. Vogel*

Gift of Virginia and Robert V. Krikorian
M1987.47a, b

1. I wish to thank John C. Austin, Senior Curator and Curator of Ceramics and Glass, Colonial Williamsburg, and Jonathan Horne, Antiquarian and Specialist in Early English Pottery, member of the British Antique Dealers Association Ltd., London, for consulting with me on the origins and dating of this pot. I am also grateful to Jonathan Horne for bringing to my attention a dated 1697 pot which is supported on bird feet and displays panels with Chinese figures; see Lipski and Archer, *Dated English Delftware*, pl. 935.
2. Lipski and Archer, *Dated English Delftware*, pp. 203–12.

## 36  *Dish*

Probably Bristol, England, ca. 1720–40

*Description:* This dish is decorated with a delightfully naive representation of Adam and Eve facing one another, each holding a large leaf. The serpent is coiled around the tree of knowledge with an apple in its mouth while Eve offers one to Adam. Ten apples hang among the branches with sponged foliage. The decoration is brightly colored in blue, green, yellow, and red on a white glazed surface. A thin tin glaze is on the back; the foot rim is unpierced. Circumferential lines and a blue dash edge frame the composition.

*Condition:* A break at the lower portion of the dish has been reglued. There are minor abrasions to the rim.

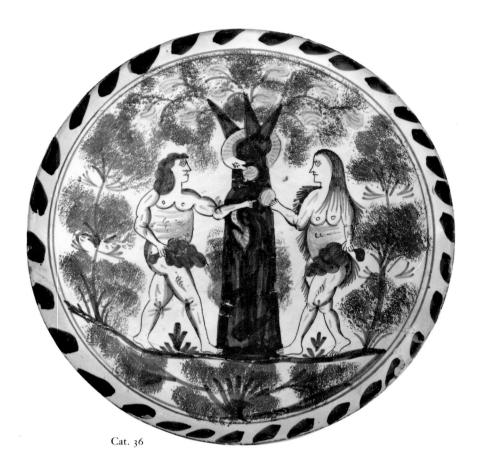

Cat. 36

*Material:* Tin-glazed earthenware.

*Dimensions:* DIAM. 13⁵⁄₁₆ in. (33.8 cm), DIAM. foot rim 4⁵⁄₁₆ in. (11.0 cm).

*Provenance:* Purchased by the donors in 1983 from Christopher Sykes Antiques, Woburn, Bedfordshire, England (dealer).

The subject of Adam and Eve appeared more frequently on delftware than all other religious themes. Such dishes can be grouped chronologically due to a number of dated examples. The earliest are close to a print of the Fall by Crispin de Passe dated 1616 and a biblical illustration by Pierre Lombart that was published in Cambridge in 1659.¹ Figures on eighteenth-century examples such as the Milwaukee piece are less naturalistic and drawn in a hasty schematic manner. They relate little to the carefully composed engravings that originally inspired their design. Similar painted images of

Adam and Eve are found on a dish in the Glaisher collection and on a piece dated 1741 in the Victoria and Albert Museum.²

Although later examples usually were not fired face down, this dish shows spur marks; however, the back is glazed with tin rather than lead, which is an eighteenth-century characteristic. This dish was made at the time production of such heavy pieces began to cease and fashion demanded shapes closer to contemporary Chinese export.

*Anne H. Vogel*

Gift of Virginia and Robert V. Krikorian
M1984.112

1. Britton, *English Delftware*, figs. 1, 2, p. 50, and Lipski and Archer, *Dated English Delftware*, p. 18, note on no. 6.
2. Archer, "Dating of Delftware Chargers," pl. 52f; Rackham, *Glaisher Collection*, pl. 121C (no. 1620); Garner and Archer, *English Delftware*, pl. 15B.

## 37A *Dish*

Probably Staffordshire, England, 1700–1800

*Description:* The shallow circular dish has a notched edge and is decorated with brown slip trailed through a quill device onto the cream slip surface. The linear pattern is covered by a transparent lead glaze. The unglazed earthenware back and rim have acquired a dark patina.

*Condition:* The dish is in fine, original condition.

*Materials:* Buff-bodied earthenware with slip decoration and lead glaze.

*Dimensions:* H. 3 in. (7.6 cm), DIAM. 13³⁄₈ in. (34.0 cm).

*Provenance:* Roger Bacon, Exeter, N. H., 1982 (dealer); Robert W. Skinner Gallery (sale 845; September 24–25, 1982), lot 1136.

Purchase, Layton Art Collection
L1982.120

## 37B *Mug*

Probably Staffordshire, England, 1690–1740

*Description:* This two-handled mug is ornamented with cream slip and large dots and streaks of brown slip.

*Condition:* The mug has minor rim chips.

*Materials:* Buff-bodied earthenware with slip decoration and lead glaze.

*Dimensions:* H. 3½ in. (8.9 cm), DIAM. 4¾ in. (12.1 cm).

*Provenance:* Roger Bacon, Exeter, N. H., 1982 (dealer); Robert W. Skinner Gallery (sale 845; September 24–25, 1982), lot 801.

Purchase, Layton Art Collection
L1982.119

In creating this type of ware, potters achieved magnificent effects by trailing and combing different colored slips while they were in a liquid state, thus enhancing ordinary objects with striking patterns. Pottery of this type continued to

Cat. 37A

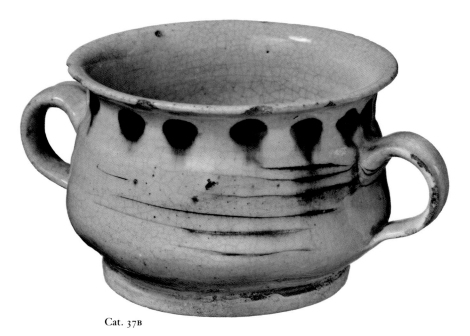

Cat. 37B

be made from the late seventeenth century into the nineteenth century, and therefore it is difficult to determine a precise date for many examples. Here, the bulbous form and tightly shaped handles of the mug (cat. 37B) suggest an early eighteenth-century or possibly late seventeenth-century date.[1] The dish (cat. 37A) could well have been made at any time in the eighteenth century.

The presence of English combed slipware in New England households is well documented through archaeological findings. Sherds have been excavated at Pemaquid, Maine, the Winslow house in Plymouth, Massachusetts, and in the Boston Haymarket area.[2] This type of pottery was also made in Pennsylvania in the eighteenth century, and the use of English and American slipware continued to be popular into the nineteenth century.                *Anne H. Vogel*

1. A related mug, ca. 1680, was sold at Sotheby's (London) (sale 5479; July 1, 1986), lot 88, an auction of the Rous Lench collection.
2. Fairbanks and Trent, *New England Begins*, p. 393; Museum of Our National Heritage, *Unearthing New England's Past*, pp. 64–72, 100–104.

## 38 *Tankard*

Cornelius Kierstede (1674–1757)
New York, New York, ca. 1695–1705

*Description:* The straight sides taper from the applied molded baseband, composed of a meander wire midway and an applied foliate band above, to the applied molded rim. The stepped flat cover has engraved, serrated decoration at the front edge of the flange and at the rear left and right of the corkscrew thumbpiece. The molded hinge-plate has a meander wire and a shaped, engraved drop with an applied cast lion passant on the crest of the scroll handle. An applied cast and engraved female mask decorates the rectangular scalloped terminal. Two vent holes are evident beneath the handle at the upper and lower end. Unidentified arms bear a scorpion and moth contained within a scrolled acanthus cartouche embellished with a helmet and three plumes above and swags of fruit and ribbons below. The engraved armorial is

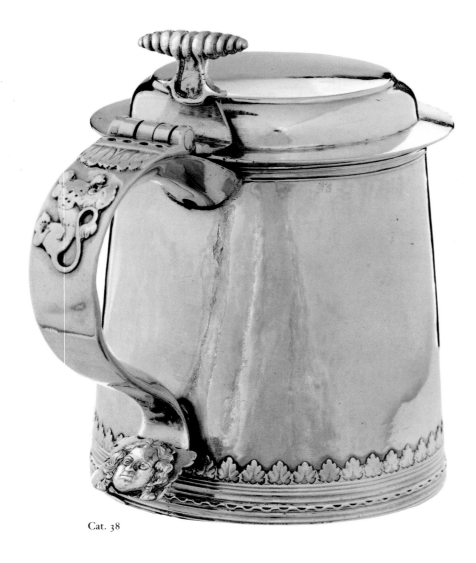

Cat. 38

his master. By 1724 he had moved to New Haven, Connecticut, where he advertised being established at Church Street.[2]

Kierstede's early New York style is revealed in the details of this tankard—the foliate baseband with meander wire, tight corkscrew thumbpiece, elaborate handle, and sophisticated engraving are all elements of this style.[3] New York tankards are derived from the same English prototypes as New England examples; however, being influenced by Dutch tradition, they are also composed of stronger proportions, fashioned of heavier gauge metal, and embellished with more profusely patterned heraldic mantling.[4] The engraved pattern on the front of this tankard is based on a baroque continental heraldic style and follows a format found on other New York pieces. The ornate design of foliate swirls, ribbons, and pendant pomegranates, a fertility symbol, add lavish surface decoration to the form. The design source for the cast decoration especially favored by New York silversmiths evolves from designs in brass pattern books published in Holland in the late seventeenth century.[5] Similar tankards by Kierstede are in the collections of the Art Institute of Chicago and the Yale University Art Gallery.[6]

Inventories reveal the cider or ale tankard to be one of the most popular silver drinking vessels in the colonies. Of Kierstede's surviving work (approximately thirty-two objects), more than half are tankards.[7] Kierstede's mastery of line and proportion are a tribute to both the functional and aesthetic attributes of this piece.                                   *Anne H. Vogel*

Gift of Friends of Art
MI977.11

contemporary to the piece and is almost identical to those on other New York tankards by Kierstede, Benjamin Wynkoop, and Jacobus van der Spiegel in the Yale collection.[1]

*Marks:* "CK" in a square is stamped twice below the molded rim to the left and right of the handle.

*Condition:* The tankard has survived in fine condition.

*Material:* Silver.

*Dimensions:* H. 6⅝ in. (16.8 cm); WT. 25 oz. 8 dwt. (790 gm).

*Exhibitions: International Art Treasures Exhibition,* no. 203, pl. 13; Grand Gallery, p. 55, no. 49.

*Bibliography:* Goldstein, *Milwaukee Art Museum,* p. 46; Holland, *Silver,* p. 83.

*Provenance:* Purchased from Carringtons of Regent Street in 1921 by Sir Evelyn Delves Broughton, London, England; Parke-Bernet (New York) (sale 2825; March 25, 1969), lot 83; purchased from S. J. Shrubsole, Inc., New York, N.Y., in June 1977.

Noted silversmith Cornelius Kierstede was born in New York City on December 25, 1674, baptized January 5, 1675, and appointed a Freeman on May 30, 1702, at the age of twenty-seven. He was the nephew of silversmiths Benjamin and Jesse Kip, one of them perhaps being

1. Buhler and Hood, *American Silver,* cats. 567, 578, 580.
2. Ensko, *American Silversmiths and Their Marks III,* pp. 80, 164; Flynt and Fales, *Heritage Foundation,* p. 262; Blackburn and Piwonka, *Remembrance of Patria,* p. 286.
3. Only one tankard of approximately seventeen in Kierstede's oeuvre is styled in the English form with a tapered barrel, domed lid, and bell-shaped finial. New York characteristics—the applied foliate band, meander wire, and fancy engraving—are omitted. This later tankard made during the 1730s reflects the Anglo-American character of Kierstede's work produced in his New Haven studio. See

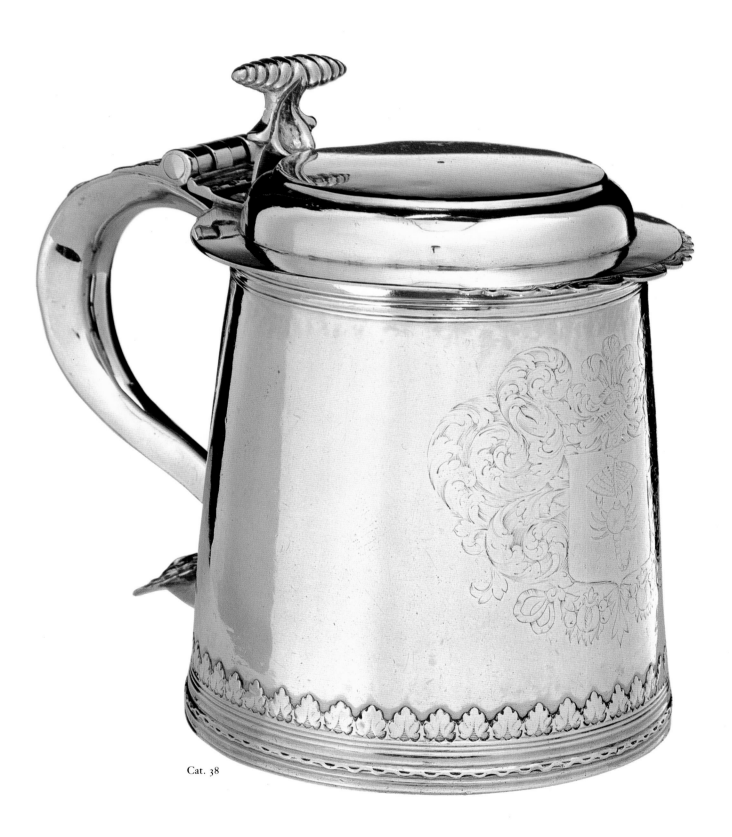

Cat. 38

Gerald W. R. Ward, "The Dutch and English Traditions in American Silver: Cornelius Kierstede," in Puig and Conforti, *The American Craftsman and the European Tradition*, p. 139.

4. For discussions of the amalgamation of Dutch and English characteristics in the tankard form, see Eberlein and Hubbard, "17th Century New York Silver That Was Both Dutch and English," in Semon, *Treasury of Old Silver*, p. 48; Ward and Ward, *Silver in American Life*, p. 127; Puig and Conforti, *The American Craftsman and the European Tradition*, pp. 136–42.

5. Fales, *Early American Silver*, p. 124; for other suggestions of European precedent for cast decoration, see Marshall B. Davidson, "Colonial Cherubim in Silver," in Kolter, *Early American Silver*, pp. 34–36.

6. Hanks, "American Silver," p. 419; Ward and Ward, *Silver in American Life*, cat. 130.

7. Puig and Conforti, *The American Craftsman and the European Tradition*, p. 139.

## 39 *Pair of candlesticks*

Richard Syng (ca. 1660–after 1711)
London, England, 1698/99

*Description:* Each of these William III column candlesticks has a cut-cornered, square-molded, and stepped base with a band of gadrooning with conforming shape and a second round band of gadrooning delineating the area where the column rises from the base. The round-fluted and alternating stop-fluted columns with molding at top and bottom rise out of a flattened gadrooned decorated knop which conforms to the base. The pronounced knop toward the bottom of the stem is a vestige of the earlier drip pan. The bobeche also repeats the shape of the base and is decorated with a circle of gadrooning. The candlesticks were fashioned from sheet with embossed fluting and gadrooning and are therefore very lightweight.

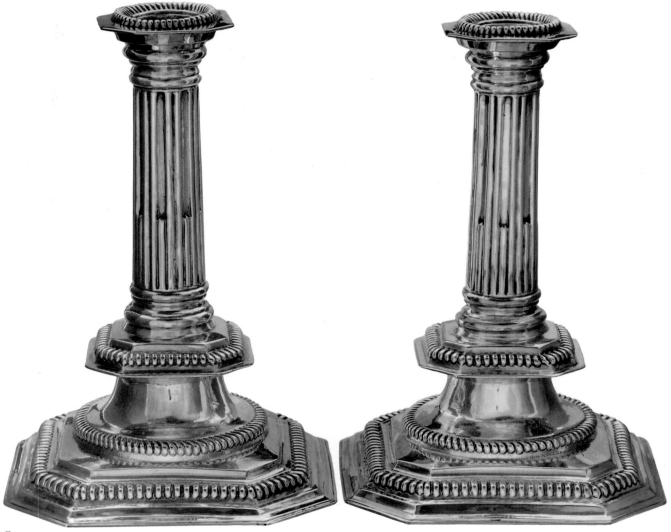

Cat. 39

*Marks:* "SY" in an irregular oval with a bird above and a pellet below (Jackson, *English Goldsmiths*, p. 158); lion's head erased; the date letter for 1698/99; and Britannia standard struck on the underside of each base.

*Condition:* The sticks are of the finest quality and condition.

*Material:* Silver.

*Dimensions:* H. 8 in. (20.3 cm), WT. 23 OZ. (715.4 gm)

*Provenance:* Purchased at Christie's (London) (November 28, 1979), lot 110.

The Doric column, or monument, candlestick was the last type raised from sheet metal and became popular in London during the 1680s.[1] By the turn of the century the style had lost favor. The new approach, a cast baluster form, was heavier and more durable. These Richard Syng candlesticks resemble closely in size, weight, and form a pair also made in London the same year by William Denny and John Bachenow in the Colonial Williamsburg collection.[2] John Noyes, a Massachusetts silversmith, created a comparable pair about 1695–1700 which are engraved with the Bowdoin crest (Museum of Fine Arts, Boston).[3] The handsome baroque design with its gadroons and flutes produces visual excitement through contrasts of light and shade, plain and broken surfaces, and vertical moving lines. The architectonic dignity of these candlesticks matches the importance of their purpose—lighting a household.

Although the actual dates of Richard Syng's birth and death are not recorded, his apprenticeship to Abraham Hinde extended from 1679 to 1687, and he entered his first mark in 1697. A son, Joseph Syng, apprenticed to his father in 1711 but never registered an identifying mark.[4]

*Anne H. Vogel*

Layton Art Collection, acquired by exchange through gifts of Mrs. William H. Bradley; Edwin C. Eldridge; Mrs. B. F. Hales, in Memory of Her Father, James Siddell; David Keene; and the bequest of Dr. Ernest H. Copeland

L1980.3a,b

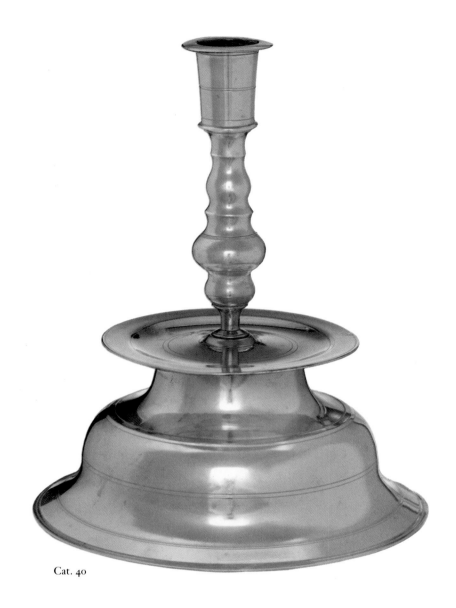

Cat. 40

1. Clayton, *Collectors' Dictionary of Silver and Gold*, p. 37.
2. Davis, *English Silver*, pl. 6.
3. Buhler, *American Silver*, cat. 90.
4. Grimwade, *London Goldsmiths*, p. 675 (no. 2673).

## 40  *Candlestick*

Nuremberg, Germany, 1660–1710

*Description:* The stick is cast in two parts; the socket/stem screws into the drip pan/base section. The base is closely trimmed, leaving thin walls. This characteristic of Nuremberg sticks is a result of the high-tolerance lathe developed and for some time kept a secret there.[1]

*Marks:* A die-stamped mark of a pair of crossed daggers or swords appears on the upper face of the drip-pan rim.

*Inscription:* "610" is painted in black on the underside of the base.

*Condition:* There is an old tear on the socket lip.

*Material:* Brass.

*Dimensions:* H 7⅞ in. (20.0 cm), DIAM. 6⅜ in. (16.2 cm).

*Provenance:* Purchased in 1983 from John Walton, Inc., Jewett City, Conn. (dealer).

The flattened high dome base and elaborately turned stem of this candlestick are characteristics closely associated with the German metalworking center of Nuremberg. As early as the fifteenth century, this city was renowned for superior brass products, a reputation gained by adherence to city council–mandated craft regulations.[2] The result of these regulations is a high occurrence of marks on sticks of this form, including the present example. Other published examples of this candlestick type are marked on the underside of the foot rim; none of these marks repeats any other.[3] The crossed blades recall the emblem of the Elector of Saxony's porcelain factory at Meissen.                    *Jayne E. Stokes*

Purchase, Layton Art Collection
L1983.302

1. Burks, "English and Continental Brass Candlesticks," p. 1285.
2. Burks, "English and Continental Brass Candlesticks," p. 1285.
3. Michaelis, *Old Domestic Base-Metal Candlesticks*, p. 65, fig. 78; Schiffer, *Brass Book*, p. 166, fig. B; Burks, "English and Continental Brass Candlesticks," pp. 1280–81, pl. I.

## 41  *Bed hanging*

England, 1690–1725

*Description:* The structure is linen and cotton, weft-float faced twill weave. It is embroidered with wool yarns in detached chain, split, stem, and a variety of satin and seeding stitches, French knots, laidwork and couching.[1] The worsteds used are in rich tones of blue, green, brown, yellow, pink, and ivory. The piece is edged with modern wool, a plain weave with inner wefts. The tree-of-life pattern is boldly worked in strong colored worsteds with flowers and foliage swirling upward from a narrow stretch of hillocks with dogs chasing stags.

*Condition:* The piece has been trimmed on the top and sides. Twenty percent of the linen-cotton ground is replaced, leaving the original needlework preserved, but remounted to modern linen backing. A modern green binding has been added.

*Materials:* Linen (warp) and cotton (weft); embroidered with colored wool yarns; edged with wool.

*Dimensions:* H. 90¼ in. (229.2 cm), w. 80½ in. (204.5 cm).

*Provenance:* Purchased by the donors in 1985 from William H. Strauss, New York, N. Y. (dealer).

By the middle of the seventeenth century, crewel embroidery was being used in England for bed hangings in preference to canvas work or applied work. Designs were stitched with colored worsted yarns (crewels) on a firm twill fabric. The Elizabethan patterns of coiling stems bearing violets, honeysuckle, or exotic flowers were superseded by large curving tree branches. The bolder designs were suited to the scale of bed hangings and the use of coarser materials.

Trees bearing elaborate baroque leaves, not so different from those appearing on Flemish verdure tapestries and Venetian needlepoint lace, were first worked in monochrome as well as in somber greens and browns.[2] The tree-of-life motif evolved as authentic Chinese works of art reached England after the founding of the East India Company in 1600. A new fashion, chinoiserie, a type of "western parody" of Chinese decorative motifs, emerged. The large plumelike stems and leaves without chinoiserie-inspired earth mounds, exotic birds, and flowers are characteristic of work before 1690. By the end of the century monochromatic crewel embroidery was replaced by multicolored chinoiserie-inspired embellishments.

Influences between East and West flowed in both directions. The initial inspiration was not, as originally thought, Indian palampores.[3] Their conventional flowering-tree patterns complete with hillocks, shepherds, rabbits, stags, and dogs are rather free adaptations from English sample patterns sent to India to be copied on chintz and exported in bulk back to England as a cheaper alternative to embroidered hangings. By the end of the century, a rich interplay of design influences from Europe, China, and India existed.

As eighteenth-century tastes changed, the heavy baroque style gave way to gay flowering branches rich in color. These popular foliage patterns for bed hangings were sold with the design already drawn on the fabric.[4] In the early work many different stitches were used, whereas later eighteenth-century examples often display a predominate use of chain stitch.[5] These trends suggest that the museum's panel, with its variety of stitches and type of heavy patterning, dates from the late seventeenth century to the first part of the next century.[6]     *Anne H. Vogel*

Gift of Virginia and Robert V. Krikorian
M1987.52

1. Examined microscopically for fiber content and structure by Lorna Ann Filippini, Department of Textiles, Art Institute of Chicago, through the courtesy of Christa C. Mayer-Thurman, Curator, Department of Textiles.
2. Wardle, *Guide to English Embroidery*, p. 16; Brett, *English Embroidery*, p. 43; Nevinson, *Catalogue of English Domestic Embroidery*, p. 12, pl. VIII, p. 64, pl. XLVII, and p. 66, pl. XLIX; Montgomery, "A Set of English Crewelwork Bed Hangings," pp. 330–41.
3. Irwin, "Origins of the 'Oriental Style,'" pp. 106–14. See pl. 16 for an early example of English tree-of-life design, ca. 1620. See also Hackenbroch, *Needlework in the Untermyer Collection*, fig. 41.
4. The English custom of ready-made designs is authenticated by a note Lady Forbes left to her daughter in 1643 "of green stamped cloth for bed hangings"; quoted in Swain, *Historical Needlework*, pp. 37–38.
5. Brett, *English Embroidery*, p. 43.
6. For comparative examples, see Rowe, "Crewel Embroidered Bed Hangings," figs. 7, 8; Nevinson, *Catalogue of English Domestic Embroidery*, pl. LI; Cavallo, *Needlework*, pl. 49.

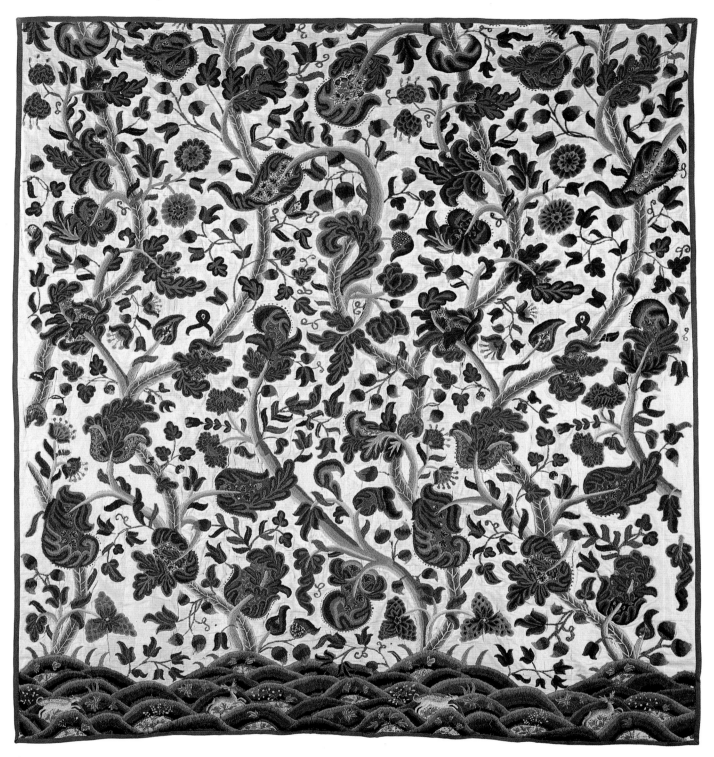

Cat. 41

# THE QUEEN ANNE STYLE

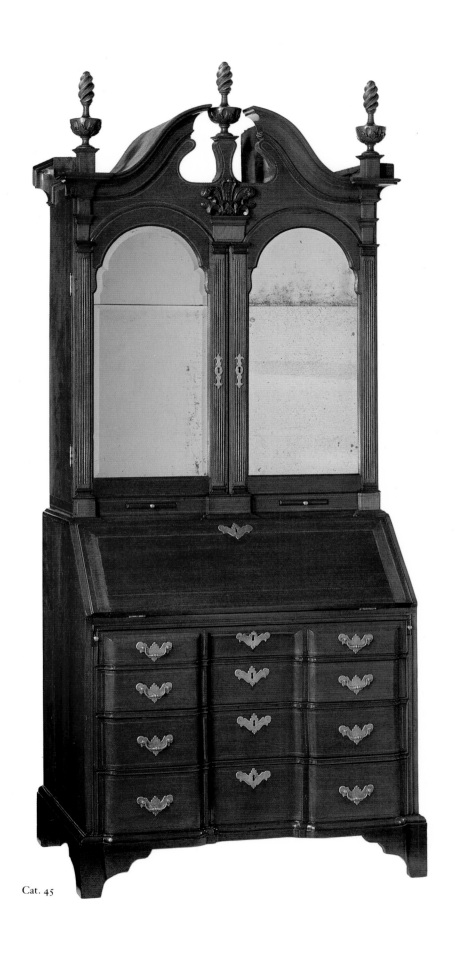

Cat. 45

# The Late Baroque in Colonial America:
# The Queen Anne Style

BROCK W. JOBE

DURING the late 1720s a new style of furniture appeared in America. Instead of the elaborate carving, complex turnings, and vertical thrust of the earlier William and Mary style, the new fashion emphasized overall outline, contrasting curves, and broad proportions. In the 1880s English historians dubbed the style "Queen Anne" even though, as one critic noted, this sovereign "had as much to do with its inception and subsequent development as the proverbial 'man in the moon.'"[1] In America, several early authors preferred the word "Dutch" because of that country's influence on furniture design.[2] But the name never caught on and Queen Anne remained the accepted designation until the past decade, when scholars adopted "late baroque" as a more appropriate substitute. Late baroque best describes the aesthetic of the era for all media and thus brings furniture into the mainstream of art history.

The development of the late baroque in English furniture is a complex subject that has never received thorough study. Nevertheless, the general outline of the story is clear. Chinese and Dutch sources sparked a dramatic shift in design, first evident in London, after about 1715. Imported Chinese chairs catalyzed interest in plain, harmonious forms and introduced such details as solid splats, yoke crests, and bent or "crooked" backs. Dutch design, which reached England through both imported objects and immigrant craftsmen, reinforced the trend toward simplicity but placed greater emphasis on contrasting curves, particularly the S-curve of the cabriole leg. English chairmakers quickly embraced the new style. During the late 1710s they created striking adaptations of Chinese chairs, often japanning these exotic forms in imitation of Oriental lacquerwork.[3] In 1717 Richard Roberts, a London joiner, supplied chairs in the Dutch style to Hampton Court.[4] They feature fashionable shaped stiles, baluster splats, cabriole legs, and hoof feet but retain high backs with carved crests reminiscent of earlier cane chairs. Between 1723 and 1726 John Belchier of London filled a large order for looking glasses, a side table, and probably a set of upholstered chairs and matching settee for Erddig, a country house undergoing refurbishment "in ye grandest manner & after ye newest fashion."[5] These exceptional objects reflect the competent hand of a craftsman who has completely accepted the new style. No hint of William and Mary design remains. Though richly ornamented in silvered gesso, the furniture at Erddig emphasizes the curved outline and restrained design that characterized the initial flowering of the late baroque in furniture.

In case furniture, the shift in style from the William and Mary to the Queen Anne proceeded less dramatically. The same forms of furniture remained fashionable with only one major exception. The high chest of drawers, never a popular form in London, disappeared altogether as the chest-on-chest and clothespress gained greater acceptance during the second quarter of the eighteenth century. Craftsmen continued to favor three traditional types of ornament: burled-walnut veneer, arabesque inlay, and japanning. Chinese design had little influence. Dutch sources, however, played a significant role in the subtle transformation of case furniture. They apparently inspired the introduction of shaped facades, notably the swelled contours of the bombé and blockfront, and contributed to the numerous minor changes in London case design that occurred during the 1720s. Curved pediments, most often scrolled in outline, supplanted the earlier

domed version. Straight bracket feet replaced ball feet in popularity, and the use of architectural details such as fluted pilasters and carved capitals on bookcase doors increased. Two burled-walnut desks and book-cases made in about 1725 by Samuel Bennett of London illustrate the essential characteristics of the style.[6] Bennett, who may have been a Dutch immi-grant, created bookcases of almost identical design for the two case pieces. Both have a single mirrored door flanked by wide fluted pilasters and capped by a molded frieze with arabesque inlay and a scrolled pediment with carved rosettes. The desk sections, both of which have a slanted lid and straight bracket feet, differ noticeably in shape. One has a straight front, the other is bombé. On the latter, the sides of the case are swelled but the sides of the drawers are straight, a practice which continues in English work for the next two decades and appears on the earliest American example of the form, a Boston desk and bookcase made in 1753.[7]

Before Bennett finished his desks and Belchier his silvered table and chairs, two educated gentlemen fresh from a lengthy Grand Tour of the Continent had already sown the seeds for a second phase of the late baroque. Lord Burlington (1694–1753) and his tal-ented protégé, the artist-architect William Kent (1685–1748), sought to revive the classical style of Palladio and Inigo Jones and during the mid-1720s succeeded brilliantly at Chiswick. With Burlington's backing, Kent quickly secured major commissions from a coterie of noblemen and royalty. His responsi-bilities extended well beyond those of the traditional builder or architect. At Houghton, Sir Robert Walpole's residence in Norfolk, Kent "attracted much notice by his skill in interior arrangements—he could plan bookcases, cabinets and chimney-pieces; hang curtains with a grace; introduce ornaments in wood or stone."[8] Kent's unified settings demonstrated his knowl-edge of art and keen imagination. Neither Palladio nor Jones had designed furniture. Kent had to improvise and the results were startling. He created imposing ceremonial forms that matched the dramatic grandeur of his architecture. Decoration was derived from an eclectic grab bag of sources: the classicism of Jones, the French baroque of Louis XIV, and the Italian baroque that Kent himself had studied during visits to Genoa and Venice. On tables and chairs he lavished a rich assortment of bold ornament, including classical

swags, Vitruvian scrolls, and Greek key fretwork, baroque caryatids, lion's heads, and human masks, French reverse-curved legs with fish-scale carving, and the ever-present scallop shell, a favorite of the Italian baroque. His cabinetry was more severe and architectural in design but perfectly suited for its original context. In every case, he served solely as the designer of furniture, turning over the actual fabrica-tion to cabinetmakers such as Benjamin Goodison and James Moore. Kent's documented output of designs is small and largely limited to stately forms in gilt. Yet his influence was significant. To fashionable society, he was the "oracle" to be consulted in matters of taste.[9] In the cabinet trade, his work presaged a more sub-stantial version of the late baroque, often called the early Georgian style.

Like Kentian design, the new style emphasized bolder, more exuberant outlines and deeper, more naturalistic carving. Yet other sources played a role as well. Dutch and German design undoubtedly exerted an influence. London had become a safe, stable haven for craftsmen fleeing the economic hardships and political uncertainties of northern Europe. These talented artisans brought an understanding of current European fashion which reinforced the growing inter-est in more massive and dramatic forms.

The advent of early Georgian design coincided with a major shift in cabinet woods. English walnut veneer gave way to solid Virginia black walnut and West Indian mahogany. The last quickly became a favorite of craftsmen, who needed stock of sizable dimensions for hardwood furniture in the new style. Mahogany was readily available in uncut logs or thick planks, carved easily, and took a handsome finish.

The transformation from slender Queen Anne–style forms to robust early Georgian ones is most evident in London chairs. During the 1730s chairmakers began to round chair seats and shorten chair backs. They also broadened the splats and exaggerated the outlines of splats and stiles, creating striking patterns of con-trasting curves. Sculptural carving reminiscent of Kent's designs became increasingly prevalent. Bird's claws and bear's paws served as feet, bird's heads provided handholds for arms, and lion's heads ornamented chair knees. In addition, shells appeared throughout as an essential decorative element.

Case furniture in the 1730s and 1740s had a decid-edly architectural character and, like chairs, was often

embellished with naturalistic carving. Two mahogany clothespresses made by Giles Grendy of London illustrate the attributes of the style.[10] The first, with a triangular pitch pediment, paneled doors in the upper and lower cases, and ogee bracket feet, is imposing but severe. On the second, the austerity of the form is relieved by egg-and-dart carving on the serpentine edges of the paneled doors and deeply cut leafage and paw feet at the base. By 1745 the late baroque had been transformed. Begun as a refined adaptation of Chinese and Dutch sources, it had become a grander but more ponderous expression of classical and European baroque traditions. Soon the French rococo would alter English taste once again. Nevertheless, aspects of late baroque design would remain, particularly in case furniture, until the end of the eighteenth century.

Knowledge of the late baroque style reached America through immigrant craftsmen and imported furniture. The latter particularly affected design in major New England seaports, where many artisans were third-generation inhabitants by the 1730s and considerable quantities of English furniture arrived annually. London cane chairs and looking glasses were shipped in bulk; other forms such as japanned tea tables and mahogany case furniture came in smaller numbers as special orders. All provided models for native workmen to copy. In many cases, artisans chose to duplicate specific details rather than entire forms. Boston craftsmen adopted the cabriole leg, crooked back, and turned stretchers of London cane chairs of the late 1720s.[11] Twenty years later other artisans in the town integrated the English bombé facade, based on imported precedents, into their case furniture.[12] After the middle of the century, workmen copied imported examples more closely and turned with increasing frequency to pattern books for inspiration, a source unavailable in America prior to the publication of Thomas Chippendale's *Gentleman & Cabinet-Maker's Director* in 1754.[13]

The impact of immigrants was greatest in the Middle Colonies and the South where new, rapidly expanding communities required the services of numerous craftsmen. Peter Scott, a British cabinetmaker who arrived in Williamsburg, Virginia, in 1722, probably introduced late baroque design to the town. For the next fifty years he continued to work in a distinctive style based largely on the English designs and construction techniques that he had mastered as a young man.[14] In Charleston, South Carolina, the most flourishing of all southern ports, a steady stream of craftsmen from London as well as other American cities assured patrons of access to the latest fashion. Josiah Claypoole, the son of a Philadelphia joiner, moved there in 1740 and quickly developed a thriving business. Demand for his work was so great that within a year he advertised that "whereas by a constant Hurry of Cabinet Work, it has so happened that I have disappointed several good Customers, this is further to give Notice, that in a short Time I shall have two good workmen from *London*, and shall then be in a Capacity to suit any Person who shall favor me with their Employ."[15] Even a former Philadelphia craftsman understood the lure of London: British design was the accepted fashion in the colonies and London lay at the center of that design tradition.

Nevertheless, other European traditions affected design in certain areas. In Philadelphia, Germans accounted for one-third of all turners and chairmakers working prior to 1750. These craftsmen introduced a distinctive form of turned slat-back chair and undoubtedly influenced the development of stylish early Georgian seating furniture (cat. 42).[16]

Dutch settlers in New York retained an interest in their cultural traditions long after the English had acquired the colony in 1664. During the first half of the eighteenth century immigrant silversmiths continued to provide exquisite objects in a bold baroque style. In furniture, the Dutch-inspired *kas*, sometimes painted with flowers and fruit in *grisaille*, remained popular for generations.[17]

In New England, British design predominated. Though comparatively few craftsmen immigrated to the region during the early eighteenth century, they still fulfilled a crucial function as conduits of new fashions and ideas. In Boston, a small but influential group of London-trained cabinetmakers and japanners helped to popularize three forms of English ornament: figured-walnut veneer, japanning, and the blockfront facade (see cat. 45).[18] Their work ranked among the most ambitious in Boston and prolonged the town's position as the center of furniture making in America until about 1750.

The frequent arrival of craftsmen and furniture from England assured the rapid transfer of the late baroque to major American seaports. Not surpris-

ingly, the earliest record of the new style occurs in Boston, the most populous community in the colonies. In 1729 the upholsterer Samuel Grant sold a chair with a "New fashion round seat," unmistakable evidence of the curvilinear Queen Anne style. A year later he billed a customer for a couch with "horsebone feet," and in 1732 he provided clients with "6 Leath[er] Chairs maple frames hosbone round feet & Cus[hio]n Seats" and "8 Leathr Chairs horsebone feet & banist[er] backs."[19] The term horsebone refers to a cabriole leg, round feet to turned pad feet, cushion seats to removable slip seats, and banister backs to solid, baluster-shaped splats. In 1733, a Boston artisan received payment for "Jappanning a Piddement Chest & Table Tortoiseshell & Gold."[20] The "Piddement Chest" describes a scrolled-top high chest, the first documented instance of the new style in case furniture.

In Philadelphia, the earliest record of the fashion occurs in 1739 when the chairmaker Solomon Fussell noted the sale of "½ Duz: Crookt foot Chairs & Arm D[itt]o." Fussell's bill comes at the beginning of the second volume of his accounts. The first volume, now lost, may well have substantiated his ongoing production of "crookt foot" chairs for several years.[21] Like horsebone, "crookt foot" refers to a cabriole leg. A chronology tracing the introduction of the Queen Anne style through such terms needs to be assembled for other urban communities. Presumably evidence from Charleston, Williamsburg, New York, and Newport will corroborate the presence of new curvilinear forms throughout America by 1730. Whether a Boston merchant or Virginia planter, the affluent colonist with close ties to England could quickly become acquainted with current London taste. The lag lasted only as long as it took a vessel to reach America.

Craftsmen in each major seaport developed their own interpretation of a particular style. They favored certain woods, construction techniques, and design details. These preferences, perpetuated by apprentices, became over time hallmarks of a local aesthetic. Boston, Newport, and Philadelphia had especially well-defined craft identities and each is represented in the collections of the Milwaukee Art Museum.

During the second quarter of the eighteenth century Boston chairmakers developed three distinct chair patterns. The first two, tall and slender in outline, relate to English Queen Anne design and undoubtedly owe much of their inspiration to im-

ported London cane chairs of the mid-1720s. One version has a bent back with beading on the stiles and crest, a pronounced yoke in the center of the crest, a plain baluster-shaped splat, a square seat upholstered over the rails, and cabriole legs that are often square in section. The form enjoyed only brief popularity in Boston, but a modified version with turned legs, rush seat, and ball or Spanish feet became commonplace throughout New England and remained in production until the end of the century.[22]

The second pattern, considered by many the classic New England Queen Anne–style chair, achieved widespread acceptance in Boston and was soon copied by craftsmen in other urban seaports. Like the previous design, it has a bent back; but the stiles and crest are undecorated, the yoke is longer and more softly contoured, and the splat has a more graceful outline of contrasting curves. The upholstered seat is either square or rounded in a "compass" shape and the cabriole legs are thicker. The stretcher pattern, however, is unchanged. Block-and-turned side stretchers and swelled medial and rear stretchers based on English precedents of the 1720s continue on Boston chairs for the next half century.[23]

The third pattern has long been associated with Newport craftsmen but may well have originated in Boston. Based on early Georgian design of the mid-1730s, it has a lower back than the preceding type, S-curved stiles instead of straight stiles, and a broader, more exuberant splat which cuts in deeply at the neck. The seat is wider and frequently rounded. On the best chairs, the legs often terminate in small squarish claw-and-ball feet and the crest and knees are ornamented with carved scallop shells and bellflowers. Boston chairmakers had probably begun to make early Georgian chairs by 1740. Undoubtedly the "7 Chairs Eagles Foot & Shell on the Knee" owned by the Boston upholsterer Theodore Wheelwright in 1750 corresponded to this design.[24]

Each type of seating had numerous variations. Patrons could choose from options which ranged considerably in price. Claw feet and a compass seat, for example, added several shillings to the price of a basic chair with round feet and a square seat. The side chair at the Milwaukee Art Museum (cat. 43) illustrates one such variation. The maker has added carved shells to the crest and knees of a form that rarely had them.

In addition to stylish joined chairs in the Queen Anne style, specialists in Boston offered two other major types of seating. Turners produced enormous quantities of inexpensive slat-back chairs of a plain but well-proportioned design. Their work usually displays softly outlined ball turnings on the posts, ball finials and feet, and graduated slats with arched upper edges. Chair frames are made of maple, poplar (*Populus* spp.), or ash and invariably painted or stained; seats are covered in rush.[25] Boston upholsterers provided comfortable seating to wealthy residents in every major town along the Atlantic Coast. Their output far exceeded that in any other American community prior to 1750. These versatile individuals combined the skills of merchants and craftsmen. They imported textiles and dry goods for resale, oversaw the production of thousands of pieces of seating furniture, and fashioned the most ornate beds in the colonies. The fabrication of easy chairs, couches (often called daybeds today), stools, and upholstered chairs constituted much of their business. Of these items, the most common was the "Boston" leather chair. Artisans adapted the design from English cane chairs of the William and Mary era, substituting leather for cane on the seat and back. During the mid-1720s they updated the form by inserting a bent back with beaded stiles in place of a canted back with turned stiles. In addition, they adopted two crest patterns: one with a double-round indentation at the shoulders, the other with a more elaborate profile of hollows, rounds, and hollows. Made of maple, covered in brown leather, and decorated with brass nails, the Boston chair remained a fixture of the furniture trade until the middle of the eighteenth century. Its price ranked below most upholstered forms. In 1736 the standard charge was 24s. to 26s. compared to 49s. for a walnut Queen Anne-style side chair with a leather seat. At the same time, slat-back chairs cost as little as 6s. each.[26]

Boston cabinetmakers favored three forms of ornament: japanning, veneering, and shaped or "swelled" fronts. The first two had appeared by 1710 but reached their apex a generation later. Japanning, like upholstery prior to about 1750, was a specialized craft centered in Boston. Except for a handful of New York japanned clock cases, virtually all surviving American japanned furniture originated in Boston. The town supported a dozen japanners; several learned their trade in London and their work closely corresponded to English examples. Using paint, gesso, and shellac, they created colorful and exotic decoration in imitation of Oriental lacquerwork. The best of their Queen Anne-style furniture had raised chinoiserie figures in gilt on brilliant red and black backgrounds simulating tortoiseshell. Joiners and cabinetmakers constructed the cases for japanners to decorate. In Boston these frames were made of maple and white pine instead of the beech and oak frequently selected in England.[27]

Veneered decoration rivaled japanning in its vivid colors and eye-catching patterns. Early eighteenth-century craftsmen preferred flitches of crotch walnut surrounded by herringbone bands. By the 1730s they had begun to enhance the veneer with inlaid stringing and stars as well as carved and gilded shells.

Concurrently a small group of artisans introduced shaped facades. The earliest dated example, a blockfront desk and bookcase, was made by Job Coit in 1738.[28] Within fifteen years, Benjamin Frothingham had built a stylish bombé desk and bookcase.[29] Both the blockfront and the bombé are late baroque in design and conform to English models based on Dutch sources. During the second half of the eighteenth century, swelled fronts became the principal form of ornament on Boston case furniture. However, the construction of the later examples lacked the quality of those of the 1730s. On an early blockfront desk and bookcase (cat. 45), the drawer linings are exceedingly thin, dovetailing is fine and precise, and exotic tropical woods are used with (or sometimes instead of) the more common black walnut or mahogany. Unusual secondary woods such as white oak and red cedar also appear in addition to the ever-present white pine. In design, carving, inlay, and gilded decoration, these extraordinary products represent America's most ambitious creation of the Queen Anne era.

Located near the mouth of Narragansett Bay, Newport benefitted from an excellent deep-water harbor and the astute leadership of a small circle of successful merchants. By 1759 the town contained 953 houses and over 200 shops and stores and served as the commercial hub of southern New England. Its population of 9,209 in 1774 was exceeded in New England only by Boston.[30] Craftsmen formed a sizable part of the community. Between 1745 and 1775 Newport supported sixty cabinetmakers, just four fewer than worked in Boston during the same period.[31] Their

products document the presence of a distinctive local style, first apparent during the late 1740s in the furniture of two brothers, Job and Christopher Townsend. By 1760 local woodworkers had firmly established a singular expression of the late baroque that emphasized bold outlines, fine woods, and impeccable craftsmanship.

In chair design, Newport makers copied Boston patterns, particularly the classic contours of the second and third types described above, and as a result products from the two towns are often difficult to distinguish. Yet occasionally they adopted English features that their Boston counterparts rarely employed. One chairmaker emulated the narrow rectangular splats and hooplike shoulders of London chairs in the Chinese style.[32] Several craftsmen inserted flat stretchers in place of turned ones and cut intricately curved profiles in the front skirts of chair seats.[33]

Late baroque tables from Newport are based on three distinct sources of design. English or Boston tea tables, reminiscent of Chinese forms, served as models for Newport examples with square-edged cabriole legs, slipper feet, and tray tops.[34] A second tea-table design reflects a more innovative use of common English elements. Newport craftsmen mounted a rectangular top with rounded corners, much like the turreted ends of English and Boston card tables, to a turned base with tapering cylindrical legs and round feet. The form, often called a porringer-topped table today, remained a favorite of Rhode Island patrons until nearly the end of the century.[35] A third decorative scheme, possibly derived from a French source, appears on side, tea, and card tables made in the 1750s.[36] These bold forms have deep rails, sometimes faced with ogee curves that meet at the center, and large sculptural cabriole legs, often with claw-and-ball feet at the front and round feet at the rear. On the best examples, stylized leaf carving in low relief ornaments the legs.

Newport case furniture varies dramatically from Boston examples. Two dated objects, a dressing table of 1746 by Job Townsend and a high chest of 1748 by Christopher Townsend, depict many of the essential differences.[37] Both display square-edged cabriole legs with pointed slipper feet instead of the round legs and pad feet associated with Boston work. The knee brackets on the Newport examples are narrower and have a less pronounced spur. Most importantly, their

skirt outlines consist of a series of reverse curves with either a central drop (on the high chest) or large carved scallop shell (on the dressing table) rather than the flattened arches with two turned drops so often seen on Boston dressing tables and high chests.[38]

Both Newport cases feature fine workmanship, particularly evident in the precise dovetailing of the drawers and the skillful handling of the carved shell on the dressing table. Their woods follow common Newport practice. The dressing table is made of mahogany with white pine and yellow-poplar used as secondary woods; the high chest is made of black walnut with white pine and chestnut. Their construction exhibits several characteristics typical of the region but rarely found elsewhere. The frames, for example, are dovetailed rather than joined and the cabriole portion of the legs is tenoned into each corner of the frame. Both are traditional techniques common on William and Mary–style cases but seldom used outside Newport for Queen Anne–style furniture.

Other forms of Newport case furniture also feature distinctive local traits. Desk interiors (cat. 46) usually contain three pigeonholes flanking a central door with shell carving; in comparison, Boston examples have two or four pigeonholes on each side of a central compartment with narrow document drawers and a door (cat. 45). Newport desks may have either three or four thumbnail-edged drawers; their Boston counterparts have four straight-edged drawers surrounded by channel moldings cut on the case sides and dividers. In addition, Newport cases rest on ogee bracket feet with a single spur; Boston versions are supported by either straight or ogee bracket feet of a more complex profile.

Of all Newport features, the best known is the block-and-shell facade. During the 1750s cabinetmakers developed a variation of the Boston formula by capping a blocked front with carved scalloped shells. The motif first appeared in desk interiors but soon became an accepted form of case ornament and remained a fixture of Newport design for nearly half a century.[39] The pattern's longevity not only demonstrates the long-standing prominence of Newport furniture makers but also emphasizes the significance of their contribution to American design. Their bold block-and-shell creation has no exact parallels in English furniture and today ranks as one of the greatest achievements of the colonial craftsman. Yet the

continued popularity of the motif documents another key fact: the late baroque remained the preferred taste in Newport until after the American Revolution. While affluent patrons in Boston and Philadelphia turned to more fashionable rococo furnishings in the third quarter of the eighteenth century, Newport residents clung to traditional forms and ornament.

Though not founded until 1682, Philadelphia quickly became the leading seaport of the Middle Colonies and by 1760 had eclipsed Boston in both population and commercial activity. The town prospered from a lucrative trade with the West Indies, sending timber and agricultural products from the Pennsylvania backcountry. It also benefitted from a continual influx of immigrants. Shiploads of English, Irish, and German settlers disembarked daily to begin new careers in the city or move on to inland villages. Philadelphia as a result doubled in size every twenty years, reaching almost 25,000 inhabitants by 1776.[40] Within this flourishing environment, furniture craftsmen found great demand for their work. They supplied residents with a vast array of household furniture and made considerable quantities of specialized forms for export.

During the 1730s and 1740s four types of seating furniture gained wide appeal. The first two, both costly joined chair patterns, reveal the influence of separate sources on Philadelphia furniture. One is based on Boston chairs in the Queen Anne style. Philadelphia provided a ready market for Boston's sizable export trade, and many examples of the earliest form of Boston Queen Anne–style chair (the first type noted above) reached the town. To compete, craftsmen such as Solomon Fussell, William Savery, and Plunket Fleeson began to offer their own "Maple Chairs as cheap as from Boston."[41] These local products had square cabriole legs, a turned front stretcher, straight stiles, and a plain baluster splat reminiscent of Boston models.[42]

The second pattern adheres to early Georgian design and reflects the influence of English furniture and immigrant craftsmen. Bold contrasting curves dominate the form. The bent back has serpentine stiles and a rounded crest that dips slightly at the center, a far cry from the pronounced yoke on New England examples. On later versions, the crest rises at the center to accommodate a carved shell and two volutes (cat. 42). Two splat patterns predominate. The first is

a broad baluster which cuts in deeply at the neck.[43] The second, termed a fiddleback today, has a complex shape somewhat reminiscent of a violin.[44] The wide compass seat has an applied lip and is fitted with a removable slip seat. The cabriole front legs usually end in rounded slipper feet or distinctive trifid feet. The stump rear legs rake back in a slight curve. Flat stretchers occasionally unite the legs.[45] Most chairs, however, follow fashionable London practice, which had dispensed with the feature by the mid-1730s.

In construction, the chairs vary significantly from those made elsewhere in America. The side seat rails are tenoned into the front seat rail, not the front legs, and usually tenoned through the rear legs and wedged from behind. The top of each front leg is tenoned through the front seat rail and wedged from above. German craftsmen introduced this distinctive method of leg construction and may also have fostered the local preference for through-tenons as well.[46] The Germanic presence subtly altered an English chair design into what today ranks as the most robust interpretation of the late baroque in America.

The third chair pattern is derived directly from German sources. Immigrants developed slat-back chairs with turned posts that taper slightly and shaped slats that arch sharply at the center. The design differs noticeably with Boston examples, which feature straight posts ornamented with ball turnings and slats that are only arched along their top edge. The form had appeared in Philadelphia by 1700 and remained a common form of inexpensive seating throughout the eighteenth century. A plain three-slat version cost as little as 4s. in 1740; at the same time a more elaborate Boston-inspired joined chair (the first pattern noted above) cost about 8s. and an early Georgian example exceeded £1 in price.[47]

The final type of seating, the Windsor chair, traces its origins to early eighteenth-century England. There craftsmen familiar with stick-and-socket construction developed the form to fulfill a need for garden furniture. Customers quickly accepted it for household use as well and a sizable industry arose, led by dozens of specialized craftsmen in London. English Windsor furniture reached Philadelphia in the 1730s and within a decade local craftsmen had begun to offer their own versions of the form.[48] Their products achieved enormous popularity. By 1770 Philadelphia Windsors had become the leading furniture export of America;

merchants shipped thousands of sets to ports along the Atlantic Coast and in the West Indies. The town so dominated the industry during these initial years of production that colonial purchasers often referred to the Windsor form as a Philadelphia chair.[49]

Remarkably few documented examples of Philadelphia case furniture in the Queen Anne style survive. In general, these cases are taller and broader than their New England counterparts. Dressing tables and high chests feature a complex skirt outline which rises at the center to form an arched opening. Cabriole legs usually terminate in Spanish feet with a molded cuff or trifid feet. The corners of the case are sometimes canted and decorated with fluting.[50] Drawer arrangements vary. In dressing tables the upper tier has one or three drawers, the lower tier two or three drawers. By 1760 a standard format of one drawer over three drawers had evolved. Construction practices usually follow English early Georgian precedents. Full dustboards, common on London furniture of the 1740s, separate the drawers on Philadelphia cases rather than the narrow dividers and drawer supports found on most New England work. For stylish case furniture, Philadelphia artisans selected mahogany, black walnut, or occasionally curly maple as the principal wood. They favored yellow pine, white cedar, and yellow-poplar as secondary woods.

The dearth of Queen Anne-style case furniture may result in part from the ready acceptance of the rococo style by Philadelphia craftsmen. As early as 1753 Henry Cliffton had made a high chest with elements of the new fashion, grafting asymmetrical leafage and sprightly curling tendrils on a massive early Georgian form.[51] Over the next thirty-five years Philadelphia craftsmen would lighten the mass (chiefly by substituting sham pediments for enclosed hoods on case furniture) and add more asymmetrical carving. Yet the essential character of the Philadelphia Chippendale style was clearly in place by 1753.

Craftsmen in Philadelphia, Newport, and Boston offered an increasingly diversified array of furniture during the second quarter of the eighteenth century. Some forms appeared for the first time; a few traditional ones came to an end. The fashion for imported cane chairs dwindled in favor of stylish joined chairs with wooden splats and upholstered seats. Interest in upholstered couches receded in favor of easy chairs and lolling chairs (and sofas after 1750). The overall production of costly upholstered furniture jumped significantly in response to a growing demand for luxury goods by a burgeoning class of merchants, planters, and professionals. The supply of inexpensive seating also rose dramatically, in part through the introduction of simple stick-and-socket Windsor furniture based on English models.

Many specialized forms rarely available to colonists before 1725 surged in popularity. Tables to suit a variety of needs became an essential component of tasteful interiors. Household inventories reveal the presence of tea tables, card tables, side tables (often termed sideboard tables, slab tables, or marble tables), pillar-and-claw tables, square tables (so-called tavern tables), and dining tables. The last of these changed noticeably with the advent of cabriole legs. The earlier William and Mary gateleg design gave way to a four-legged table in which two of the legs swing out to support the leaves. The change simplified the table's appearance in keeping with the precepts of the Queen Anne style but lessened its stability.

In case furniture, every form introduced during the early eighteenth century continued in production, with the exception of the escritoire, a rare two-part desk with a large fall-front lid in the upper case. Craftsmen offered slanted-lid desks (with or without bookcases), high chests (often called a case of drawers), dressing tables, chests of drawers, chests-on-chests (sometimes called double chests), lidded chests (with or without drawers), and clock cases. Only one English form, the clothespress, was added to the repertoire after 1725, and its use was limited largely to Southern coastal communities such as Charleston, Norfolk, and Williamsburg. Elsewhere, cabinetmakers preferred to update traditional forms such as the high chest and dressing table with stylish ornament and hardware to suit current taste.

This essay has focused on the origins of the late baroque in England, its transfer to America, and the development of individual expressions of the style in Boston, Newport, and Philadelphia. The history of English Queen Anne–style design is a complex story that deserves further study. A chronology of documented furniture needs to be assembled to understand better when the style evolved in England and how widespread its use was at specific times. Immigrants and imported furniture introduced the new fashion to the colonies during the late 1720s. Subsequent arriv-

als of craftsmen and furniture provided continued access to changes in English taste. Yet only certain elements of the late baroque took hold in this country.

American craftsmen adopted the graceful lines of early Queen Anne design but rarely embellished it with carved vines in low relief (such as that on the furniture at Erddig) or arabesque marquetry (such as that on the desk and bookcase by Samuel Bennett). Artisans never made ceremonial gilt forms in the style of William Kent, presumably because of the high cost and fragility of the ornament. Carved lion's heads and satyr's masks characteristic of the best early Georgian furniture were seldom used. Instead, cabinetmakers of the 1740s preferred the more common elements of Kentian design: the scallop shell and acanthus leaf as well as the increasing architectural emphasis of case furniture during the period.

Distinctive versions of late baroque design evolved in each urban center along the Atlantic Coast. These patterns resulted from a complex overlay of outside influences, apprenticeship traditions, and customer taste. In Boston, the slender proportions of English Queen Anne–style furniture dominated local design until after the Revolution. Newport craftsmen emulated Boston seating furniture but created bolder tables and cases that reflect an imaginative use of large sculptural shells and stylized leaf carving on plain forms. In Philadelphia, German and English immigrants as well as imported Boston furniture contributed to the development of several stylistic patterns simultaneously. In general, these Philadelphia products are taller and broader than comparable New England examples. Their proportions and construction are more characteristic of early Georgian design of the 1730s than Queen Anne patterns of the previous decade.

The publication of Thomas Chippendale's *Director* in 1754 did not signal the end of the late baroque in furniture. In American urban centers, craftsmen continued to offer chairs with cabriole legs and solid baluster splats until at least the 1780s. The essential elements of Queen Anne–style case furniture remained popular, though often with an overlay of fashionable rococo carving, until the end of the century. In rural areas such as inland New Hampshire, customers could still purchase desks with inlaid stars, small curved legs, and round feet in 1815, a century after the first glimmerings of a new curvilinear style in England.

1. Benn, *Style in Furniture*, p. 70. The term <u>Queen Anne</u> does appear in literature of the 1870s but with a different meaning. In *Art Decoration Applied to Furniture*, pp. 154–60, Spofford uses it to describe both old and new furniture of joined construction with broad moldings and geometric carving in low relief. To illustrate the style, she depicts two "Queen Anne Cabinets": a seventeenth-century cupboard and a modern dresser with paneled doors below open shelves. The two objects reflect a greater affinity with the precepts of Queen Anne architecture of the third quarter of the nineteenth century than the curvilinear furniture of the eighteenth century. In England, by the mid-1880s, the definition of Queen Anne furniture had narrowed to what we generally think of it today; see, for example, *The Cabinet Maker & Art Furnisher* (London) 8, no. 91 (January 2, 1888): 169; and 8, no. 96 (June 1, 1888): 329. How the change occurred and who was responsible merit further investigation.

2. Lyon, *Colonial Furniture of New England*, figs. 71, 104; Lockwood, *Colonial Furniture*, figs. 114–23, 196–98. Both Lyon and Lockwood use the term *Queen Anne* to describe a period of time. Though Lockwood customarily refers to late baroque chairs as Dutch, he does identify one example as Queen Anne (p. 151, fig. 105).

3. See, for example, Kirk, *American Furniture and the British Tradition*, figs. 779–80, 782. None of the chairs of this type known to the author are documented; as a result, their exact date of origin cannot be ascertained. The backs and seats of English examples closely correspond to Chinese furniture. The legs, however, are related only in their slender gracefulness. Instead of cabrioles, Chinese chairs have straight legs that are round in section. Often a vertical strip, attached to the inner edge of the front legs, is mitered to the front skirt. For related Chinese chairs, see Ellsworth, *Chinese Furniture*, pp. 110–11, 115, 118–19, 131; and Shixiang, *Classic Chinese Furniture*, pp. 24, 86, 88–89.

4. Rutherford, "Furnishing of Hampton Court Palace," pp. 180–81.

5. Drury, "Early Eighteenth-Century Furniture at Erddig," pp. 46–55.

6. Macquoid and Edwards, *Dictionary of English Furniture*, 1:136, fig. 30; and Symonds, "Two English Writing Cabinets," p. 83. Symonds compares the straight-front desk and bookcase by Bennett to a similar example attributed to an unknown German workman in London.

7. This desk and bookcase, now in the Diplomatic Reception Rooms of the State Department, was made by Benjamin Frothingham; for illustrations of the desk, see Jobe and Kaye, *New England Furniture*, pp. 22–23.

8. This account from the 1830–33 edition of A. Cunningham, *The Lives of the Most Eminent British Painters, Sculptors and Architects*, is quoted in Wilson, *William Kent*, p. 106.

9. Horace Walpole noted that "Kent's style . . . predominated authoritatively during his life; and his oracle was so much consulted by all who affected taste that nothing was thought complete without his assistance"; quoted in Wilson, *William Kent*, p. 108.

10. Edwards and Jourdain, *Georgian Cabinet-Makers*, figs. 49, 51.

11. Jobe and Kaye, *New England Furniture*, pp. 336–38.

12. Jobe and Kaye, *New England Furniture*, p. 22.

13. For examples of New England furniture that are closely modeled on imported furniture, see Jobe and Kaye, *New England Furniture*, pp. 20–21; Fairbanks and Cooper, *Paul Revere's Boston*, pp. 50–51. In 1772 Richard Magrath, a Charleston, S. C., cabinet-maker, advertised that he makes "carved Chairs of the newest fashion, splat Backs, with hollow slats and commode fronts, of the same Pattern as those imported by Peter Maniagault, Esq.," *South Carolina Gazette*, July 9, 1772, as quoted in Prime, *Arts and Crafts in Philadelphia*, 1:176.

14. Gusler, *Furniture of Williamsburg*, pp. 24–57.

15. *South Carolina Gazette*, April 9, 1741, as quoted in Burton, *Charleston Furniture*, p. 78.

16. Forman, "Delaware Valley 'Crookt Foot' and Slat-Back Chairs," pp. 52–53.

17. Blackburn and Piwonka, *Remembrance of Patria*, pp. 266–68. For additional information on the *kas*, see Failey, *Long Island Is My Nation*, pp. 109–15.

18. In "Warland Chest," Edward S. Cooke, Jr., suggests that London cabinetmakers such as John Brocas and William Price played a key role in the transfer of London forms and ornament to Boston. At least three London japanners—William Randle, Robert Davis, and Thomas Johnston—also worked in Boston. For information on Davis, see Rhoades and Jobe, "Recent Discoveries in Boston Japanned Furniture," pp. 1083–84. Johnston is the craftsman described as "late from London" in an advertisement of William Price in the *Boston Gazette* of April 4, 1726; see Dow, *Arts and Crafts in New England*, p. 107. Randle's British background cannot be verified. Nevertheless, it seems the only likely explanation considering the absence of any information on his presence in Boston prior to his marriage in 1714 and advertisement of his business "at the Sign of the Cabbinett" a year later; see Dow, *Arts and Crafts in New England*, pp. 106–7.

19. All of the Grant bills are quoted in Brock Jobe, "The Boston Furniture Industry, 1720–1740," in *Boston Furniture*, p. 42.

20. As quoted in Jobe and Kaye, *New England Furniture*, p. 197.

21. Forman, "Delaware Valley 'Crookt Foot' and Slat-Back Chairs," p. 41.

22. Jobe and Kaye, *New England Furniture*, pp. 343–44.

23. Jobe and Kaye, *New England Furniture*, pp. 347–49.

24. As quoted in Jobe and Kaye, *New England Furniture*, p. 161; see also pp. 358–59.

25. Jobe and Kaye, *New England Furniture*, pp. 10, 312–13.

26. Jobe and Kaye, *New England Furniture*, pp. 339–41; for bills documenting the charges for a Boston leather chair, walnut Queen Anne chair, and slat-back chair, see Samuel Grant, Account Book, 1728–37, p. 458, March 2, 1735/36, accounts with "Shop" and John Arrno, p. 460, March 4, 1735, account with Thomas and John Phillips, Massachusetts Historical Society, Boston.

27. See n. 18; for examples of Boston and English japanned furniture, see Dean A. Fales, Jr., "Boston Japanned Furniture," in *Boston Furniture*, pp. 49–69.

28. Evans, "Genealogy of a Bookcase Desk," pp. 213–22.

29. See n. 7.

30. Downing and Scully, *Architectural Heritage of Newport*, p. 35. The population of Newport is taken from a census of 1774; see *A Century of Population Growth from the First Census of the United States to the Twelfth, 1790–1900* (Washington, D.C.: Government Printing Office, 1909), p. 14. Boston's population in 1771 was 16,540; see Lemuel Shattuck, *Report to the Committee of the City Council Appointed to Obtain the Census of Boston for the Year 1845* (Boston: John H. Eastburn, 1846), p. 5.

31. Jeanne Vibert Sloane, "John Cahoone and the Newport Furniture Industry," in *New England Furniture*, pp. 91, 116.

32. For example, see Ott, *John Brown House Loan Exhibition*, cat. 2.

33. For example, see Ott, *John Brown House Loan Exhibition*, cat. 4; Greenlaw, *New England Furniture*, cat. 52.

34. Compare English and Boston tea tables pictured in Jobe and Kaye, *New England Furniture*, p. 24, with Newport examples in Heckscher, *American Furniture*, cat. 115; and Monkhouse and Michie, *American Furniture in Pendleton House*, cats. 70–71.

35. Monkhouse and Michie, *American Furniture in Pendleton House*, p. 132; for English precedents for the turreted corners, tapered legs, and round feet of porringer-topped tables, see Kirk, *American Furniture and the British Tradition*, pp. 322–23, 345–47. The tapered leg and round foot also appear frequently on Newport dining tables; see Monkhouse and Michie, *American Furniture in Pendleton House*, cat. 63.

36. For examples of this bolder, more substantial style, see Moses, *Master Craftsmen of Newport*, pp. 109, 152–53, 203–4, 223–24.

37. The Job Townsend dressing table is illustrated in Rodriguez Roque, *Chipstone*, cat. 17; the Christopher Townsend high chest, illustrated on numerous occasions in recent years, first appeared in print in Ott, *John Brown House Loan Exhibition*, cat. 57.

38. For examples of Massachusetts high chests with flattened-arch skirts, see Heckscher, *American Furniture*, cats. 153–59.

39. Heckscher, "John Townsend's Block-and-Shell Furniture," pp. 1144–45.

40. Nash, *Urban Crucible*, p. 408.

41. Advertisement of Plunket Fleeson, *Pennsylvania Gazette*, June 14, 1744, as quoted in Randall, "Boston Chairs," p. 13.

42. Forman illustrates two Philadelphia chairs modelled on Boston examples in "Delaware Valley 'Crookt Foot' and Slat-Back Chairs," p. 47, fig. 1; 62, fig. 20; see also pp. 63–64 for Forman's analysis of the relationship between Boston Queen Anne–style chairs and their Philadelphia counterparts.

43. For example, see Heckscher, *American Furniture*, cats. 35, 40–42.

44. For example, see Heckscher, *American Furniture*, cats. 36–39.

45. An armchair with flat stretchers is in the Museum of Fine Arts, Boston; see Randall, *American Furniture*, cat. 137.

46. Caldwell, "Germanic Influences," pp. 70–72.

47. Forman, "Delaware Valley 'Crookt Foot' and Slat-Back Chairs," pp. 42–43.

48. Evans, "Design Sources," pp. 282–83.

49. Jobe, "Boston Furniture Industry, 1720–1740," p. 5.

50. For examples of Philadelphia Queen Anne–style case furniture, see Hornor, *Blue Book*, pls. 17–18, 28, 37, 39, 54–55, 58–59, 61–62; Philadelphia Museum, *Three Centuries*, cats. 21, 40.

51. The high chest, owned by Colonial Williamsburg and illustrated in Sack, "Development of the American High Chest," p. 1125, is signed by Cliffton and Thomas Carteret, presumably a journeyman in Cliffton's shop.

## 42 *Armchair*

Philadelphia, Pennsylvania, 1745–65

*Description:* The intricate baluster splat is framed by serpentine stiles and an arched crest outlined with a scratch bead. At the crest, two deeply cut volutes flank a webbed shell. The S-curved arms terminate in bold one-piece scrolled handholds and rest on concave "lamb's tongue" arm supports. The compass seat retains its original slip seat. Each front leg is embellished with a carved shell on the knee, reminiscent of the shell on the crest, and ends in a trifid foot. The chamfered rear legs rake back at a slight angle.

The construction of the chair adheres to standard Philadelphia practice. The side seat rails are tenoned directly to the front seat rail—not the front leg—and tenoned through the rear legs and wedged from behind. Two pins reinforce each mortise-and-tenon joint. The top edge of the front and side seat rails has an applied lip. The inner edge of the side rails is straight; the inner edge of the front rail conforms to the outer contour. The front legs are round-tenoned through the front seat rail and wedged from above. Like many early Georgian chairs, this example has pieced stiles; the maker glued two narrow boards together to create stock of sufficient width for each stile. The arm supports are screwed to the side seat rails and originally the heads of the screws were covered with wooden plugs. A single screw also secures each arm to the stiles. The splat is made of a solid board of figured walnut.

*Inscriptions:* "VIIII" was cut with a chisel on the front and rear seat rails of the frame and front rail of the slip seat.

*Condition:* This imposing chair has sustained considerable damage. The crest rail was broken and repaired in this century; patches are visible in the crest above the stiles and splat. Half of the left volute on the splat and a ¾-in. (1.9 cm) strip along the top edge of the shoe are replaced. Minor chips in the handholds have been filled and 2 x 1½ in. (5.1 x 1.3 cm) patches were inserted at the base of the arm supports. Both front legs have been broken at the knees; the round tenon of the right front leg has been

replaced and a large patch has been added at the top of the knee. The chair was refinished within the past fifty years, and the seat is upholstered in reproduction worsted damask.

*Woods:* Crest, splat, shoe, stiles, arms, arm supports, seat rails, and legs, black walnut; slip seat, southern yellow pine.

*Dimensions:* H. 41½ in. (105.4 cm), S.H. 17¼ in. (43.8 cm), W. 30¾ in. (78.1 cm), D. 19½ in. (49.5 cm).

*Bibliography:* Parke-Bernet Galleries (sale 3265; November 12–13, 1971), lot 456; Jones, "Museum Accessions," p. 828; Jones, "American Furniture," p. 977; Kirk, *American Furniture and the British Tradition*, p. 248, fig. 826; Goldstein, *Milwaukee Art Museum*, p. 66.

*Provenance:* Sold by Joe Kindig, Jr., and Son, York, Pa., in 1961 to Richard Titelman, Hollidaysburg, Pa.

This handsome chair—a classic Philadelphia form—represents one of America's most exuberant expressions of the late baroque style. The roots of its design lay

in early Georgian furniture. During the mid-1730s London chairmakers adopted broader proportions, more ornately shaped stiles and splats, shell carvings, and deep compass seats. They abandoned the use of stretchers, thickened the front legs, and made the S-curve of the cabriole more pronounced.[1] Immigrant craftsmen and imported furniture undoubtedly introduced the new fashion to Philadelphia, and by 1740 local artisans offered their own versions of the style. Two patterns enjoyed considerable popularity. The first features a rounded crest that dips at the center, while the second, seen here, has an arched crest often with carved volutes and a central shell.[2]

Though clearly within the mainstream of English design, Philadelphia compass-seat chairs rarely duplicate foreign models. London craftsmen seldom used the trifid foot and stump rear leg favored by Philadelphia workmen. Nor did many artisans in England adopt the unusual method of seat construction that gained widespread acceptance in Philadelphia.[3] In English chairs (and most American examples), the front leg extends to the

Cat. 42

top of the seat and the rails are tenoned to the square end of the leg. In Philadelphia work, however, the side rails are tenoned to the front rail and each leg is joined to the front rail with a round dowellike tenon (see *Description*). These distinctive features reflect the influence of other furniture traditions. Irish immigrants may have introduced such details as the trifid foot, and German craftsmen undoubtedly contributed certain structural traits.[4]

Though the impact of the Irish has received considerable attention, Philadelphia's sizable German population had a more pronounced influence.[5] Prior to 1755 Germans accounted for almost one-third of the turners and chairmakers in the town. Many of these men had moved from the Lower Rhine River Valley, where craftsmen used the same method of "doweled" seat construction later adopted in Philadelphia. An immigrant from the area, possibly Jonathan Shoemaker, Solomon Fussell, or Jacob Levering, must have transferred the technique to Philadelphia.[6] It was soon wedded to fashionable early Georgian forms and became a standard practice of German and English artisans alike.

Compass-seat chairs remained a popular choice of Philadelphia's wealthiest residents for more than a quarter-century. The affluent merchant Thomas Wharton ordered a "Half Doz Mehogony Compass chears" in 1758 and no doubt local artisans continued to supply similar chairs throughout the 1760s.[7] Yet these stylish products were never made in significant numbers because of their great expense. The price of a single armchair (including upholstery) could reach £4, and a set of ten side chairs and two armchairs might surpass £25, a sum equal to the cost of a grand desk and bookcase.[8]

Today only about thirty Philadelphia compass-seat armchairs are known and many, like this example, have had numerous repairs resulting from the inherent weakness of the joints binding the legs and arms to the seat rails. All of the chairs vary slightly in design. Their subtle differences illustrate the range of options available within the form. Customers could order sets with either paired or single volutes flanking the shell on the

crest, rounded or flat stiles, baluster or "fiddle-back" splats, leaf or shell carving on the knees, and trifid, slipper, or claw-and-ball feet. To further enhance the form patrons could add a recessed shell at the center of the seat. The Milwaukee armchair displays many of the most typical features. Though no exact mate exists, it closely relates to side chairs at the Metropolitan Museum and the Henry Ford Museum.[9] Its design emphasizes the sculptural and rhythmic grace characteristic of the best Philadelphia chairs and offers a vivid contrast to the more restrained and diminutive chair patterns of New England (see cat. 43).

*Brock W. Jobe*

Gift of Richard Titelman
M1973.89

1. For English precedents in the early Georgian style, see Macquoid, *History of English Furniture*, 2:205–6, figs. 189–92; Kirk, *American Furniture and the British Tradition*, p. 248, fig. 828.
2. For examples of the first type, see Kirk, *American Chairs*, pp. 70–71, figs. 49–50, 52. Philadelphia craftsmen also developed a third late baroque chair pattern based on Boston models; see Forman, "Delaware Valley 'Crookt Foot' and Slat-Back Chairs," pp. 62–64, figs. 20, 22.
3. Philadelphia compass-seat construction has two distinctive features: the side seat rails are tenoned through the rear legs and the front legs are joined to the front seat rail with round dowellike tenons. Kirk notes the presence of through tenons on some Yorkshire chairs, but the technique is by no means typical of English eighteenth-century workmanship; see *American Furniture and the British Tradition*, pp. 128–32. Kirk cites no English precedents for the Philadelphia practice of tenoning the leg to the seat rail but does illustrate an Irish example of the technique; see p. 247, fig. 824. Recent research has suggested that German craftsmen from the Lower Rhine River Valley probably introduced this method to Ireland and Philadelphia; see Caldwell, "Germanic Influences," pp. 71–72.
4. Stockwell, "Irish Influence," pp. 269–71; Caldwell, "Germanic Influences," pp. 70–72.
5. For discussions of the impact of Irish sources on Philadelphia furniture, see Stockwell, "Irish Influence"; Hinckley, *Directory of Queen Anne, Early Georgian and Chippendale Furniture*, p. 23; Kirk, *American Chairs*, pp. 166–67; Kirk, *American Furniture and the British Tradition*, pp. 246–47, figs. 819–24. In a groundbreaking article of 1983, Benno M. Forman suggested that German immigrants played a seminal role in the development of the form of Philadelphia late baroque chair represented here; see his "German Influences

in Pennsylvania Furniture," in Swank, *Arts of the Pennsylvania Germans*, pp. 166–70. Forman's student Desiree Caldwell documented one aspect of his thesis—the Germanic origin of the round tenon joint that secures the front leg to the seat rail on Philadelphia chairs—in her "Germanic Influences."
6. Caldwell, "Germanic Influences," pp. 71–72.
7. Hornor, *Blue Book*, p. 193.
8. For prices of Philadelphia cabriole-legged chairs of the late eighteenth century, see Martin Eli Weil, "A Cabinetmaker's Price Book," in Quimby, *American Furniture and Its Makers*, p. 182.
9. Heckscher, *American Furniture*, p. 85, fig. 40; Comstock, *American Furniture*, p. 93, fig. 167.

## 43  *Side chair*

Probably Boston, Massachusetts, 1750–65

*Description:* The joined frame consists of a rounded yoke crest capped with a carved shell; straight stiles with a bowed profile; a solid baluster-shaped splat; a cavetto splat shoe; a compass seat; cabriole front legs with shell-carved knees, shaped brackets, and round feet; block-and-turned stretchers; and chamfered rear legs that rake back at a pronounced angle. The shoe is nailed to the rear seat rail with two forged sprigs. The knee brackets are glued and nailed to the front legs and seat rails. Round tenons bind the medial and rear stretchers to the side stretchers and legs, respectively. All other elements are joined with rectangular mortise-and-tenon joints, which in every case except the splat are secured with wooden pins. The joined slip seat rests on the rabbeted edge of the seat rails; triangular front corner blocks, each fastened with two roseheaded nails, provide additional support for the slip seat.

*Inscriptions:* There is a chisel-cut "V" in the rabbeted edge of the front seat rail and a chisel-cut "I" in the underside of the front rail of the slip seat. A modern ink label, once pasted beneath the seat, records the history of the chair: "Mary Chapman Winslow's / Chair / It was given by King Caesar (Ezra Weston) to / his daughter Sylvia Church Weston who married / Sylvanus Sampson about 1793.

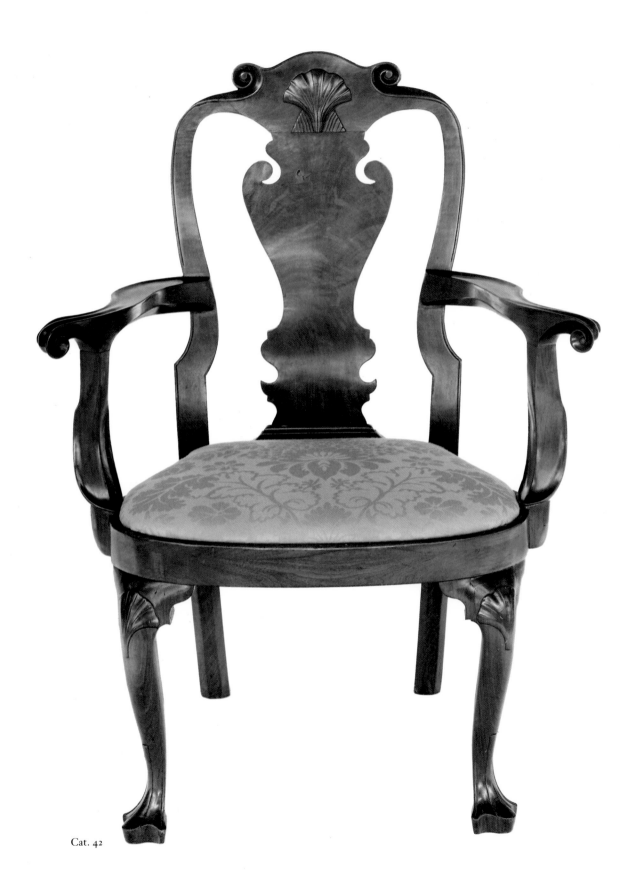

Cat. 42

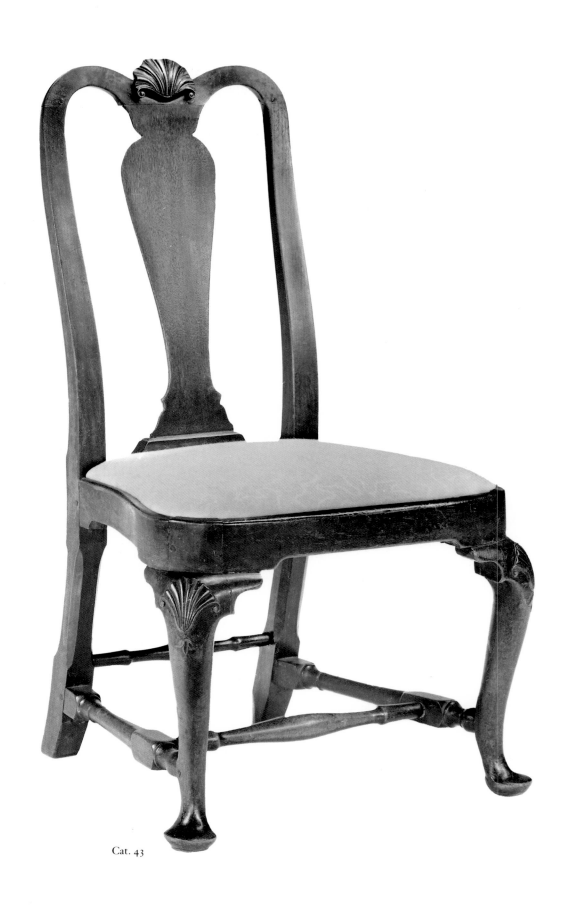

Cat. 43

She gave it to her / son Sylvanus Sampson, Jr.—(Mary Chapman Winslow's Grand- / father) and his wife Mary Chapman Soule Sampson. / They gave it to their daughter Sylvia Church / Winslow; so that now—1931—it belongs to her / daughter, Mary C. Winslow. / I think the chair must be 150 years old if not more. / Elizabeth S. Sampson / Nov. 4th 1931." The label is now preserved in the files of the Milwaukee Art Museum.

*Condition:* The chair remains in excellent condition with no replacements except for the modern yellow worsted upholstery. The medial stretcher and right rear foot are chipped; all joints have been reglued recently. A dark, crazed shellac finish that is perhaps one hundred years old now covers the chair.

*Woods:* Crest, splat, shoe, stiles, legs, seat rails, knee brackets, and stretchers, black walnut; slip seat, soft maple; corner blocks, eastern white pine.

*Dimensions:* H. 39½ in. (100.3 cm), S.H. 16½ in. (41.9 cm), W. 22¼ in. (56.5 cm), D. 16⅞ in. (42.9 cm).

*Provenance:* According to family tradition, given by Ezra Weston (1743–1822) of Duxbury, Mass., to his daughter Sylvia Weston (1768–1836) when she married Sylvanus Sampson (1761–1848) in 1787; descended to their son Sylvanus Sampson, Jr. (1807–1897), whose daughter Elizabeth Seaver Sampson (1842–1937) recorded the history of the chair in 1931 (see *Inscriptions*); subsequently passed to Elizabeth Seaver Sampson's sister Sylvia Church Sampson (1837–1917), who married George Marcus Winslow, then to their daughter Mary Chapman Winslow (1875–1938) and afterward to her nephew Graham T. Winslow (1892–1973); sold by his son Richard K. Winslow to the Layton Art Collection in 1986.

This handsome chair depicts a classic New England design, enhanced with shells on the crest and knees. Its stylistic origins can be traced to the late 1720s when English cane chairs in the new curvilinear style, now called Queen Anne, began to arrive in New England seaports in substantial numbers.[1] Native craftsmen soon adopted many of the motifs of the imported chairs, and by 1732 one

Boston upholsterer had billed clients for "6 Leath[er] Chairs maple frames hosbone round feet and Cus[hio]n Seats" and "8 Leathr Chairs horsebone feet and banist[er] backs."[2] Horsebone refers to a cabriole leg, round feet to turned pad feet, cushion seats to slip seats, and banister backs to baluster-shaped splats.

Though inspired by English models, New England craftsmen did not duplicate English chairs. They combined the graceful curved outline of the new style with the strong vertical thrust of the older so-called William and Mary style, a verticality rarely seen in the English counterparts of the second quarter of the eighteenth century. At first, Queen Anne–style chair design had a lean, spare look reminiscent of Chinese furniture and lacked such embellishments as rounded compass seats, claw feet, and shell carvings.[3] By 1740, however, these features had become available options for patrons who wished to acquire more ornate forms.[4]

Chairs with such decorative details have often been ascribed to Newport.[5] Yet Boston chairmakers undoubtedly made similar examples. In 1750 Theodore Wheelwright, a Boston upholsterer, owned a set of seven chairs with "Eagles foot & Shell on the Knee" that probably resembled, aside from the feet, the chair illustrated here.[6] In addition, at least four shell-carved versions with Boston-area histories of ownership are known.[7] This example also retains a Massachusetts provenance. It descended in the family of Sylvanus Sampson (1761–1848), a Duxbury ship captain, and resided in one location, the Sampson house in Duxbury, from the late eighteenth century until 1975. Although thirty miles south of Boston, Duxbury maintained closer commercial ties with Massachusetts Bay than with Rhode Island.

The skillful workmanship and accomplished carving of the chair suggest that it originated in either Boston or Newport, New England's largest cabinetmaking centers of the colonial era. The chair's history argues in favor of narrowing that attribution to Boston.[8]

*Brock W. Jobe*

Purchase, Layton Art Collection
L1986.1

1. Jobe and Kaye, *New England Furniture*, pp. 336–39.

2. Quoted in Jobe and Kaye, *New England Furniture*, p. 348.

3. Jobe and Kaye, *New England Furniture*, p. 336.

4. The Boston upholsterer Samuel Grant recorded the sale of chairs with claw feet in 1733 and compass seats in 1734. See his accounts of March 8, 1732/33, with Peter Faneuil and of May 27, 1734, with Hugh Hall, Samuel Grant, Account Book, 1728–37, pp. 210, 316, Massachusetts Historical Society, Boston. The introduction of carved shells on the crest and knees is more difficult to document. The pattern of carving closely relates to that on English chairs of the 1730s. See Macquoid and Edwards, *Dictionary of English Furniture*, 1:257, fig. 95, 263, figs. 116–17; and Kirk, *American Furniture and the British Tradition*, p. 244, fig. 805. In all likelihood, craftsmen in Newport and Boston had begun to make shell-carved chairs by about 1740.

5. A chair quite similar to the Milwaukee example but lacking shell-carved knees descended in the family of Roger Williams, founder of Rhode Island, and has been attributed to Newport. See Monkhouse and Michie, *American Furniture in Pendleton House*, cat. 103.

6. Theodore Wheelwright, Inventory, recorded December 4, 1750, vol. 44, p. 381 (new pagination), Suffolk County Probate Records, Suffolk County Courthouse, Boston.

7. The four chairs with shell-carved crests and knees are the Vose family chair at the Museum of Fine Arts, Boston; the General Warren chair at the Henry Ford Museum; the Salisbury family chair at the Worcester Art Museum; and the Holyoke family chair in a private collection. All four chairs are more elaborate in design than the Milwaukee chair. They follow a typical early Georgian formula, featuring ball-and-claw feet, shaped stiles, and a pronounced "bird's beak" profile near the top of the splat.

8. A related chair, also probably of Boston origin, is illustrated in Sack, *American Antiques*, 3:744. It features scratch carving in a fan pattern on the top of the pad feet. The detail occasionally appears on Boston and Salem chairs but has never been found on a documented Newport example.

## 44   *Easy chair*

Boston, Massachusetts, 1745–65

*Description:* The chair frame features an arched crest set between the stiles, serpentine wings, flat arms with circular handholds, cone-shaped arm supports, a trapezoidal seat with rounded front corners, cabriole front legs with shaped knee brackets and round feet, block-and-turned stretchers, and square rear legs chamfered between the seat rails and stretchers.

The construction follows mid-eighteenth-century Boston practice. Each rear leg and stile is of one piece. The arm is nailed to the inside of the wing support and into the top of the arm support. The vertical cone beneath the arm is glued and nailed to the arm support. The knee brackets are glued and nailed to the legs and seat rails. The medial and rear stretchers are secured to the side stretchers and rear legs respectively with round mortise-and-tenon joints. All other elements are joined with rectangular mortises and tenons that are held tight with wooden pins.

*Condition:* The frame is in excellent condition with only minimal repairs. The disks beneath the front feet are nearly worn away. The front bracket for the left front leg and the side bracket for the right front leg are replaced. The vertical cones originally extended to the bottom of the side seat rails. The right rear leg has an old, well-repaired fracture. The chair has been reupholstered at least four times, recently by conservator Elizabeth Lahikainen in conjunction with the preparation of this catalogue. To protect the fragile frame from further damage, she developed a system of nailless upholstery for the chair (see Appendix B). A reproduction crimson moreen now covers the frame.

*Woods:* Front legs, knee brackets, and side and medial stretchers, black walnut; seat rails, rear legs and stretcher, wings, arms, arm supports, and back rail, soft maple; crest, birch; vertical cones, eastern white pine.

*Dimensions:* H. 46½ in. (118.1 cm), S.H. 13 in. (33.0 cm), W. 34⅝ in. (87.9 cm), D. 21⅜ in. (54.3 cm).

*Provenance:* Purchased in 1978 from Joe Kindig, Jr., and Son, York, Pa. (dealer).

Throughout the colonial era Boston served as a center for the production of upholstered furniture. Between 1700 and 1775 the town supported at least forty-four upholsterers; no other New England town had more than half a dozen and most had none at all.[1] These urban specialists sold textiles and wallpaper, made bedding and curtains, and oversaw the fabrication of such specialized seating as easy chairs, couches, lolling chairs, and sofas. Of these forms, the easy chair was the most popular. During the first fifteen years of his career, 1729 through 1743, the Boston upholsterer Samuel Grant sold seventy-seven easy chairs, an average of just over five per year.[2] Grant purchased chair frames from neighboring chairmakers and employed journeymen and seamstresses in his own shop to do the upholstery. Prices ranged from £7.7.3 to £19.10.6, substantial sums at the time. For the average chair, the frame amounted to about 25 percent of the total cost, the labor in Grant's shop added another 20 percent, and the materials for the outer cover and underupholstery made up the rest, a sizable 55 percent.

The great expense of the imported cloth accounted for the high price of an easy chair. Boston customers of the mid eighteenth century preferred English worsteds, particularly three closely related embossed fabrics identified in contemporary accounts as cheney, harrateen, and moreen. These textiles constituted as much as one-quarter of a chair's cost. In a typical bill of 1733, Samuel Grant's charge of £9.8.11 for a walnut easy chair included £2.0.8 for "7¾ Yᵈ. Green Chainy."[3] Worsted damask cost even more and consequently appeared in only the wealthiest homes.

These houses often contained an easy chair as part of a matched suite of bedroom furnishings. John Hancock, Boston's Revolutionary leader, outfitted his "Great Chamber" with an easy chair, ten side chairs, sofa, high-post bed, four window curtains, and four cushions for window seats—all upholstered in yellow worsted damask.[4] To complete the effect a yellow wallpaper hung on the walls.

Hancock's residence ranked among the most lavish in Boston. Yet even in less opulent houses, the coverings of the bed and easy chair usually matched.

This easy chair displays the characteristic outline of a Boston product in its arched crest, flat arms with cone-shaped supports, and leg and stretcher design. Like most examples, the front legs are made of black walnut, the rear legs and rear stretcher are of maple stained to resemble walnut. The essential elements of the design were probably inspired by English imports of the late 1720s. Within a decade Boston craftsmen had perfected the details of the form and for the next thirty years continued to offer chairs of this pattern to affluent clients. Today at least fifty similar examples survive. Only one retains all of its original upholstery, and that example, now at the Brooklyn Museum, served as a guide in reupholstering this chair (see Appendix B).

The frames of Boston easy chairs are remarkably consistent in construction and may well have originated in just three or four shops. Though corresponding to its counterparts in most details, this chair does retain two distinctive features that may eventually link it to a particular craftsman. On many Boston easy chair frames, each front leg is joined to the front seat rail with a sliding dovetail at the corner.[5] Here, the front legs are tenoned through the front seat rail. In addition, instead of a typical medial stretcher with plain tapered ends, the stretcher on this chair has the added embellishment of spool turnings.[6] To a generation of colonists accustomed to hard seats and straight backs, the easy chair presented a comfortable alternative. It enveloped the sitter in padded luxury in a way that no other form allowed. For the elderly and the infirm its soft contours offered restful support.[7] For others it provided an opulent display of costly textiles. Much like silver, upholstered furniture served as an emblem of wealth in early America.          *Brock W. Jobe*

Purchase, Milwaukee Art Museum President's Special Fund
M1979.45

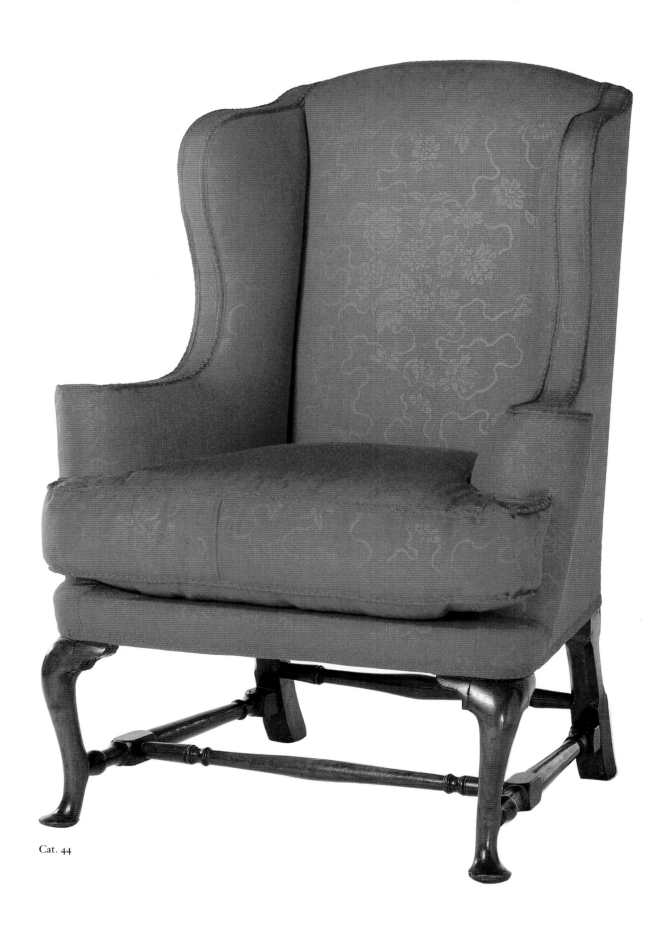

Cat. 44

1. Brock W. Jobe, "The Boston Upholstery Trade, 1700–1775," in Cooke, *Upholstery in America and Europe*, p. 65.

2. These totals are extracted from Samuel Grant, Account Book, 1728–37, Massachusetts Historical Society, Boston; and Account Book, 1737–60, American Antiquarian Society, Worcester, Mass.

3. Like many of Grant's early bills, this one specifies the individual charges of the chair:

Amos Wood D^r. to Shop
| | |
|---|---|
| 1 Easie Chair fframe Walnutt feet | @2..10.. |
| 7¾ Y^d. Green Chainy [@] ⁵/₃ | 2.. .. 8 |
| 18 Y^d. lace @ 7^d 4^lb ½ Curld hair [@] ⅔ | 1.. 2.. 6 |
| Tax 5/ Girtweb & Canvas 13/ 3½^lb ffeath^rs 12/3 1½Y^ds. | ..18.. |
| Ticken ¹⁰/₆ | 1.. 2.. 9 |
| making Easie Chair | 1..15.. |
| [£] | 9.. 8..11 |

Samuel Grant, Account Book, June 30, 1733, p. 248.

4. John Hancock, Inventory, recorded January 28, 1794, vol. 93, p. 13 (new pagination), Suffolk County Probate Records, Suffolk County Courthouse, Boston.

5. See, for example, Jobe and Kaye, *New England Furniture*, pp. 363, 369, 372.

6. Two other chairs with similar stretchers are at the Marblehead Historical Society and in a private collection; see *Antiques* 49, no. 2 (February 1946):109. Spool turnings more often appear on medial stretchers with block-like ends; see Heckscher, *American Furniture*, cats. 70, 74.

7. According to Peter Thornton, seventeenth-century invalid chairs with reclining backs and hinged wings served as the inspiration for the English easy chair. Certainly the form continued to provide a place of repose for invalids in the eighteenth century as well. See Thornton, *Seventeenth-Century Interior Decoration*, pp. 196–98. Easy chairs occasionally appear in American portraits, always as a seat for elderly women. See, for example, John Singleton Copley's *Mrs. John Powell* (ca. 1764) at the Yale University Art Gallery and Christian Gullager's *Mrs. Nicholas Salisbury* (ca. 1789) at the Worcester Art Museum.

## 45  *Desk and bookcase*

Boston, Massachusetts, 1735–40

*Description:* The desk and bookcase, ornamented throughout with string inlay, separates into two sections. On the bookcase, three large urn-and-flame finials cap an open-scroll pediment embellished with carved "Prince of Wales" feathers. The coved front cornice molding conforms to the shape of the pediment. At the sides, the cornice molding rises up at right angles to project above the hood. Two arched doors with mirrored glass and fluted pilasters conceal an elaborate interior. At the top, ornamental shells in silver leaf fill two scooped arches. Below, a row of pigeonholes with flattened-arch valances surmounts a central compartment with shell-decorated door and arched valance drawer flanked by large pilastered document drawers and four slots for ledgers. Each document drawer appears to be one drawer but is actually three: separate drawers are located behind the silvered flame, turned column, and molded rectangular plinth. At the base, two tiers of small drawers complete the interior. Two candle slides with dished turnings for candlesticks fit into the lower front rail of the bookcase.

The desk has a hinged slant lid, four graduated blockfront drawers, and blocked bracket feet. In the desk interior, a complex amphitheater of drawers and pigeonholes sits on a thick shelf with a quarter-round edge. The prospect section resembles the central compartment of the bookcase. It originally had a blocked door but not a drawer behind the arched valance. On each side of the prospect are two tiers of five shaped drawers and a row of four pigeonholes with arched valances. The entire midsection, including prospect and flanking blocked drawers, is removable. Two spring locks in the top release the unit, thus providing access to a secret compartment that once had a hinged door and possibly drawers. The document drawers have sham fronts. The actual document drawers slide out from the back.

The construction varies in many details from typical Boston practice. In the upper case, the two-board sides are dovetailed to the bottom of the case in standard fashion but the carcass is mounted to rails at the sides and front to accommodate the candleslides. As one would expect, the rails of the bookcase doors are tenoned into the stiles. However, the mortises extend through the stiles and are plugged on their outer edge with vertical strips of courbaril, a time-consuming procedure. Above the pigeonholes in the bookcase interior, a thick board set in grooves in the case sides serves as the top for the bookcase. Together, the top and the dividers for the drawers and pigeonholes provide structural stability for the upper case. Six butt-jointed vertical backboards are nailed to the rabbeted edges of the case sides and flush edge of the top. A single horizontal backboard is nailed behind the pediment. The thin pine hood is nailed to the pediment, back, and vertical supports set between the pediment and back. A support strip backed by five wedge-shaped blocks reinforces each side cornice molding. An ogee waist molding nailed to the top of the desk covers the juncture of the two cases. The dovetailed desk has four vertical backboards. Deep drawer dividers—9⅜ in. (23.8 cm) white pine boards faced with 2⅜ in. (6 cm) courbaril strips—are set in grooves in the case sides, and the joints are covered with courbaril veneer. Behind the dividers, drawer supports are nailed to the case sides. The writing surface for the desk interior extends to the back of the case. The shelf for the reverse-curved drawers at the ends of the interior is nailed to the writing surface. The rest of the shelf slides out with the prospect section. The drawer dividers and partitions for the desk interior fit in grooves in the case sides, shelf, or top. Each pigeonhole valance is glued in place and was originally supported by two small pine blocks.

The construction of the feet differs noticeably from the usual method. The blocked base molding is rabbeted along its back edge to receive a secondary strip of cherry. That strip is dovetailed to the case sides and fits against the case bottom —three butt-jointed boards running parallel to the front. During construction, the maker inserted four rectangular patches in the bottom. The side moldings are glued and nailed to the case sides. All of the base moldings project

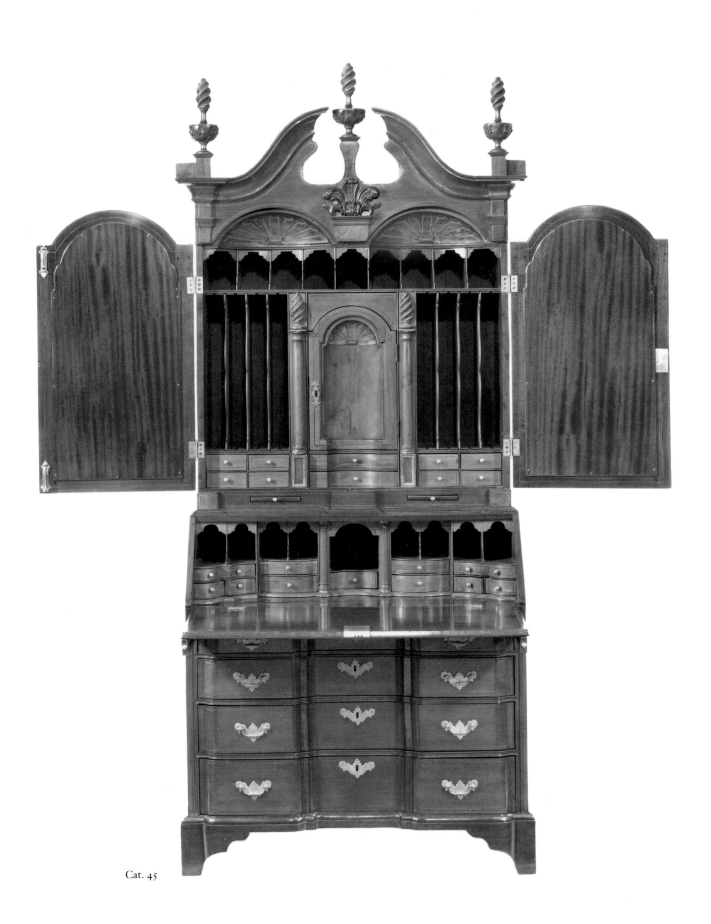

Cat. 45

below the case bottom. Twelve small pine blocks back the front molding; two large cherry blocks support each side molding. Each mitered front foot is glued to the base molding and backed with three vertical blocks flanked by stacks of four horizontal blocks. Each rear bracket foot butts against the rear element. The pattern of blocking duplicates that at the front except for the use of four vertical blocks instead of three.

The drawer construction is exceptional for Boston work. The sides and bottom of the exterior drawers are only ¼ in. (.6 cm) thick, the back is just under ⅜ in. (1.0 cm) thick, and the front dovetails taper to 1/16 in. (.2 cm). In the exterior drawers, the bottom is nailed to the rabbeted edge of the front and sides and the flush edge of the back. In the interior drawers, the bottom is glued to the rabbeted edges of the front and sides. The reverse-blocked portion of each exterior drawer front is reinforced with a large block. The front of the top exterior drawer overlaps the sides and covers the front edge of partitions between the drawer and lid slides. Because of the overlap, the drawer front is grooved to receive the sides rather than dovetailed.

*Condition:* This important object has undergone at least three recent restorations. The first two occurred prior to its sale at Sotheby's in 1976. Record of the first round of repairs is sketchy. Apparently, in about 1974, a cabinetmaker inserted a small ivory portrait bust into the center of the pediment, installed new two-part beveled mirrors in the bookcase, mounted a miniature of a saint to the prospect door, and replaced the hardware and hinges. Approximately a year later, the Baltimore cabinet shop of Enrico Liberti completed the restoration. At the time, the desk and bookcase lacked any finish and had a dry, dirty surface. Two workmen in the shop, Ridgley Kelley and Will Tilghman, made finials and plinths for the pediment and back panels for the mirrored glass doors, carried out numerous minor repairs, and refinished the case.

In 1988 Alan Miller of Quakertown, Pennsylvania, conducted a thorough investigation of the object and restored it to its present appearance. His restoration is based on a careful assessment of the earlier repairs as well as considerable research on related examples by the same maker. He replaced the ivory portrait bust in the pediment with a carved ornament adapted from carvings on two similar objects, made new finials and plinths using the originals on a companion desk and bookcase at the Art Institute of Chicago as a guide, removed modern horizontal shelves flanking the prospect section of the bookcase, and installed vertical partitions for ledgers to correspond to the original design. He replaced all hardware and hinges; outlines of the original hardware, still visible on the drawer fronts, guided the selection of appropriate replacements. In addition, he discovered through microanalysis that the principal primary wood is courbaril, a hard, brittle tropical wood. Previous restorers had used mahogany, black walnut, and purple heart for repairs. Miller replaced their alterations, including the backs of the bookcase doors, in the proper wood. Throughout his work, Miller kept a record of prior damage and repairs. His list of replacements includes the following, from top to bottom: upper 2⅞ in. (7.3 cm) of the shaped support for the central finial, tips of the rounded scrolls of the pediment, right pilaster and capital of the bookcase, lower rail on the right case side, three pigeonhole valances in the bookcase interior, side waist moldings and portions of the front waist molding, one pigeonhole valance in the desk interior, lower edge of all exterior drawer sides, all drawer stops, lower 2½ in. (6.4 cm) of the left front foot, lower 2 in. (5.1 cm) of the right rear foot, and the entire left rear foot and support blocking. In addition, Miller noted small patched repairs next to the lid hinges on the writing surface and on the edges of the bookcase sides and doors, a large triangular oak repair on the back of the bottom exterior drawer, two sets of post holes for earlier brass handles in the exterior drawer fronts, and large shrinkage cracks in the case sides.

*Woods:* Finials, pediment, doors, fluted pilasters and capitals, lower front rail of bookcase, desk lid, candleslides, lid slides, drawer dividers, all exterior drawer fronts, feet, and cornice, waist, and base mold-ings, courbaril; shell-decorated arches and prospect door in bookcase, all interior valances, partitions, and dividers, all drawer sides, bottoms, and backs, all interior drawer fronts, turned columns and carved flames on document drawers, desk shelf, and case backboards except backboard behind pediment, redcedar; case sides, desk top and bottom, and support blocks behind side base moldings, cherry; spring locks in desk interior, oak; hood, backboard behind pediment, bookcase bottom, support blocks behind front base molding and feet, and all secondary work for drawer dividers and partitions, eastern white pine.

*Dimensions:* H. 97 in. (246.4 cm), W. 40⅝6 in. (102.4 cm), D. 24⅛ in. (61.3 cm).

*Bibliography:* Sotheby Parke-Bernet (sale 3923; November 18–20, 1976), lot 983; Lita Solis-Cohen, "Case of the Restored Antique: How Much Work Is Too Much," *Philadelphia Inquirer*, December 19, 1976; Lita Solis-Cohen, "Restoration—How Much Is Too Much?" *Maine Antique Digest* (January–February 1977): 12–13A; Agnes Clark, "American Heritage Sale, New York," *Maine Antique Digest* (January–February 1977): 11A; Goldstein, *Milwaukee Art Museum*, p. 72.

*Provenance:* Supposedly owned privately in Paris since at least 1950; consigned to Paul Martini, a New York City dealer in continental furniture, for sale at auction; sold with a false pedigree in the Berkeley family of Newport, R.I., at Sotheby's (November 20, 1976), lot 983; purchased by Gary Gallup of Milwaukee and lent to the Milwaukee Art Museum in 1977; purchased from Gallup in 1983.

Perhaps no piece of colonial furniture has had a more controversial past than this stylish desk and bookcase. When offered at Sotheby's in 1976, it provoked heated debate. Many disagreed about the extent of its repairs, some questioned its authenticity altogether, and virtually everyone doubted its ownership by George Berkeley, the Anglican Dean who visited Newport with his friend John Smibert in 1729. The desk contained a curious assortment of "Berkeley" ephemera, including a miniature of a saint signed "J. Smibert" and a silver tobacco box and

set of spoons with the engraved seal of the College of Bermuda. The box and spoons seemed to confirm the history because Berkeley had crossed the Atlantic to found the school. However, he failed to obtain sufficient funds from the Crown, had to abandon his plans, and eventually settled in Ireland. The provenance was a sham. Several antiques dealers learned that the desk had been restored to help falsify the pedigree and lost interest in it. At the auction the only bidding came from the private sector, and the desk went to a young Milwaukee collector who later sold it to the Milwaukee Art Museum.[1]

The staff of the Museum knew it had an object with numerous repairs and a spurious history. Yet the true condition and significance of the desk were unknown until 1988 when conservator Alan Miller began a thorough analysis of the object. His efforts, coupled with a study of related furniture by Joe Kindig, revealed that the desk and bookcase was in better condition than expected and had only four major losses: its finials, hardware and hinges, carved pediment ornament, and mirrored glass panels and wooden backs for the bookcase doors.[2] Furthermore, Miller and Kindig recognized the importance of this object in documenting the crucial role of one unidentified Boston cabinetmaker in the production of New England's most sophisticated case furniture during the second quarter of the eighteenth century.

For Boston, the second quarter of the eighteenth century stands as a high-water mark in its colonial development. By 1740 its population reached a pre-Revolutionary peak of more than 16,000 persons. Its merchants still controlled much of New England's coastal trade and shipbuilding, and its craftsmen, according to an account of 1750, "Exceed Any upon ye Continent."[3] Commercial success stimulated architectural development, particularly along the open hillsides overlooking the bustling waterfront. There the town's elite erected a string of large, imposing residences. The grandest, Thomas Hancock's stone mansion of 1737, offered a spectacular view of the harbor. "The Kingdom of England don't afford so fine a Prospect as I have," boasted Hancock.[4]

Merchants like Hancock called upon Boston furniture makers for an assortment of stylish products. Job Coit supplied a blockfront desk and bookcase to Hancock's father-in-law, Daniel Henchman.[5] John Pimm made the frame for a flamboyant japanned high chest acquired by Joshua Loring, a prominent ship captain and naval officer.[6] A third craftsman fabricated even more elaborate furniture for several prominent clients. At least ten desks and bookcases, including the Milwaukee example, can be attributed to his shop: seven with blockfront facades, one with a bombé base, and two with straight fronts.[7] His work reflects a thorough understanding of English furniture, and in all likelihood, he trained as a cabinetmaker in the British Isles before coming to Boston. His success there is surprising, for immigrants had difficulty breaking into a trade controlled by an established network of interrelated native artisans.[8] Apparently, his skills at the bench and knowledge of foreign fashion enabled him to overcome the stigma of immigration and develop a considerable business.[9]

This desk and bookcase well illustrates both his exceptional design skills and English background. The extraordinary bookcase interior, the most ambitious in American Queen Anne–style furniture, follows a London formula of the 1720s.[10] Likewise, the desk interior and the unusual projecting cornice molding on the case sides conform to English precedents, although raised cornices customarily appear with a domed pediment rather than a broken scroll.[11] Even the distinctive use of applied carving at the center of the pediment derives from English sources.[12] In this case, the original carving disappeared long ago but the nail holes documenting its original location remain. Using other carvings on related examples by the same craftsman as a guide, an appropriate pattern could be reconstructed and reproduction carvings put in place.

Several construction details affirm the unknown maker's proficiency at his trade. He selected thin ¼-in. (.6-cm) stock for the drawer linings, joined them with fine, narrow dovetails, and inserted deep dustboardlike dividers between the drawers. In addition, he glued a stack of four horizontal blocks behind the face of each

bracket foot. All of these practices correspond to established London techniques and contrast dramatically with the methods of native-born Boston craftsmen. Job Coit's blockfront desk and bookcase made for Daniel Henchman in 1738 reveals the extent of these differences. Coit used ½-in. (1.3-cm) boards for the drawer backs, installed shallow dividers and drawer supports, cut broad dovetails for the drawers, and glued a single horizontal block behind each foot bracket.

Coit and the unknown maker struggled with the fabrication of the blocked facade. Coit changed the layout of his blocking at least once and had difficulty joining the narrow front base molding to the case bottom. He laboriously cut blocked edges along the back of the molding and front of the bottom, then glued the two together. The unknown maker devised a more complicated method. He selected a deep, 3⅛-in. (7.9-cm) board for the base molding, cut a broad rabbet along its back edge, glued the blocked front edge of a cherry board against it, and then dovetailed the cherry board to the case sides and glued it to the front edge of the bottom. The resulting joint provides a far stronger bond than the simple butt joint used by Coit. Later Boston craftsmen abandoned such a time-consuming treatment, preferring instead to fasten the base molding to the bottom with a single large dovetail.[13]

The Milwaukee desk shares numerous characteristics with its nine related counterparts. In addition to thin drawer linings and fine dovetailing, all have arched bookcase doors of a particular pattern and all but one have fluted pilasters and mirrored glass panels. Deep dividers or full dustboards separate the drawers in every desk. Candleslides with dished turnings for candlesticks are set below the doors. Ornamental shells in gold or silver leaf or carved shells of a similar design fill the scooped recesses behind the doors. Applied carvings embellish the center of the pediment on all but one object, a double-domed desk and bookcase. The design of the pediment carving differs at least slightly on every example. Earlier pieces feature bold baroque patterns of leaves or fruit, often in combination with string inlay. Later cases, including the bombé example, have flatter,

more tightly carved rococo cartouches with trailing vines.

The furniture in the group contains an unusual assortment of woods. The Milwaukee desk is made principally of cherry and courbaril, a tropical hardwood rarely used for furniture. On a closely related mahogany example at the Art Institute of Chicago, the major secondary wood is white oak. On another mahogany desk, which descended in the Quincy family of Boston and is now in the Winterthur Museum, the backboards of the bookcase are made of sabicu, a tropical species related to courbaril. In addition, on every object in the group examined by the author, redcedar serves as a secondary wood. In the Milwaukee example its use is especially pronounced. The maker chose it for the interior drawer fronts and prospect doors in both the desk and bookcase sections.

The Milwaukee desk and bookcase documents the remarkable achievements of a talented Boston cabinetmaker of the second quarter of the eighteenth century. He probably learned his craft in Britain and may have introduced certain fashionable forms of ornament such as the blockfront to Boston. He worked in a skillful manner and undoubtedly trained others in these methods. Yet many of his techniques were not perpetuated by the next generation (unlike the case with Job Townsend in Newport; see cat. 46). Later Boston furniture lacks the quality or precision of his work. Further research on the origins of eighteenth-century Boston craftsmen may eventually lead to the identification of this unknown maker.[14] For now, we must rely on the objects themselves for information about this talented individual. He has left a rich and revealing body of work. Its presence assures his place as Boston's finest maker of Queen Anne–style case furniture.

*Brock W. Jobe*

Purchase through the Bequest of Mary Jane Rayniak in Memory of Mr. and Mrs. Joseph Rayniak
M1983.378

1. Lita Solis-Cohen, "Restoration—How Much Is Too Much?" *Maine Antique Digest* (January–February 1977): 12–13A.
2. Kindig's manuscript, "The Renaissance Influence in Boston," discusses six examples related to the desk and bookcase at the Milwaukee Art Museum. Originally prepared for *Antiques* in 1955, the manuscript has never been published. The author thanks Joe Kindig for making this informative study available.
3. Andrews, *Some Cursory Remarks Made by James Birket*, p. 24.
4. Quoted in Fairbanks and Cooper, *Paul Revere's Boston*, p. 31.
5. Evans, "Genealogy of a Bookcase Desk," pp. 213–22.
6. Fraser, "A Pedigreed Lacquered Highboy," pp. 398–401.
7. Four blockfront examples are in public institutions: the Milwaukee Art Museum, the Art Institute of Chicago (*The Art Institute of Chicago Annual Report 1986–1987*, p. 17), the Saint Louis Art Museum (Christie, Manson & Woods [sale 6536; January 23, 1988], lot 381), and the Winterthur Museum (Downs, *American Furniture*, cat. 226). One blockfront was sold at auction in 1954 and its present location is not known (Parke-Bernet Galleries [sale 1534; October 9, 1954], lot 174). The remaining two blockfront desks and bookcases are in private collections. The bombé example is at Bayou Bend (Warren, *Bayou Bend*, cat. 133). The two straight fronts are in private collections: one belonged to the Reverend William R. Huntington in the early twentieth century and according to Frances Clary Morse had end finials "carved from wood, of men at work at their trade of cabinetmaking" (*Furniture of the Olden Time*, pp. 130, 134); the other is owned by Bernard and S. Dean Levy in New York (*Antiques* 89, no. 3 [March 1966]: 317). The Levy desk is the only example in the group with a double-domed pediment; all of the rest have broken scrolls. A bombé desk and bookcase attributed to the group by Joe Kindig and pictured in Davidson, *American Heritage History of Colonial Antiques*, p. 220, differs from the others in many construction details and represents the work of another craftsman.
8. Brock W. Jobe, "The Boston Furniture Industry, 1720–1740," in *Boston Furniture*, pp. 12–13.
9. In two recent articles, Edward S. Cooke, Jr., discusses the early Georgian attributes of several pieces of Boston case furniture and concludes that they reflect the work of English-trained artisans. Though native-born craftsmen dominated the Boston furniture industry during this period, immigrants had a significant impact on local design. See "The Warland Chest" and "Boston Clothespresses of the Mid-Eighteenth Century."
10. For comparable English interiors, see Cescinsky, *English Furniture*, pp. 188, 225; Macquoid and Edwards, *Dictionary of English Furniture*, 1:133, pl. 2 between 134 and 135, 135; and Robert Wemyss Symonds Collection of Photographs, Winterthur Museum Libraries, Winterthur, Del., BDAPC 59.4977.
11. For a related but more elaborate English desk interior, see Symonds, *English Furniture*, p. 175. An English domed bookcase with raised cornice moldings at the sides is illustrated in Macquoid and Edwards, *Dictionary of English Furniture*, 1:133.
12. Macquoid and Edwards, *Dictionary of English Furniture*, 1:140, fig. 40.
13. Margaretta Markle Lovell, "Boston Blockfront Furniture," in *Boston Furniture*, pp. 84–85.
14. Only a small number of craftsmen are known to have moved from the British Isles to Boston between 1715 and 1730. These include several London artisans who arrived in 1716; Charles Warham, another London immigrant who settled in Boston in 1722; and Francis Clinton and William Freeland, Irish immigrants who arrived in 1730. Often these workmen only remained briefly in Boston. John Drew, a skilled English artisan in Boston by 1714, had removed to Portsmouth, N. H., within four years. Charles Warham had relocated to Charleston, S. C., by 1731. Unfortunately, immigration records for Boston are incomplete and the origins of many craftsmen remain a mystery. Without such information, detailed biographies of all Boston furniture makers of the second quarter of the eighteenth century are needed before attempting to attribute this group of ornate case furniture to a specific maker.

## 46 *Desk*

Job Townsend (1699/1700–1765)
Newport, Rhode Island, 1750–65

*Description:* The dovetailed frame has a hinged slant lid, four graduated drawers, and ogee bracket feet. Three horizontal lap-jointed backboards are nailed to the rabbeted edges of the case sides and top. A vertical batten at the center of the back is tenoned through the bottom of the desk interior and the case bottom. The drawers run on support strips nailed to the case sides and shallow dividers fastened with shouldered dovetails visible on the front edge of the sides. The base rail is tenoned into the case sides and backed by three horizontal blocks. The broad ogee base molding is glued and nailed to the frame; the lower edge of the molding is flush with the underside of the case bottom. The mitered front feet are glued and nailed to the base molding. Two horizontal and one vertical block support each foot. As on many Newport cases, the shape of the rear elements resembles that of the bracket feet. Each element is glued to the case bottom and

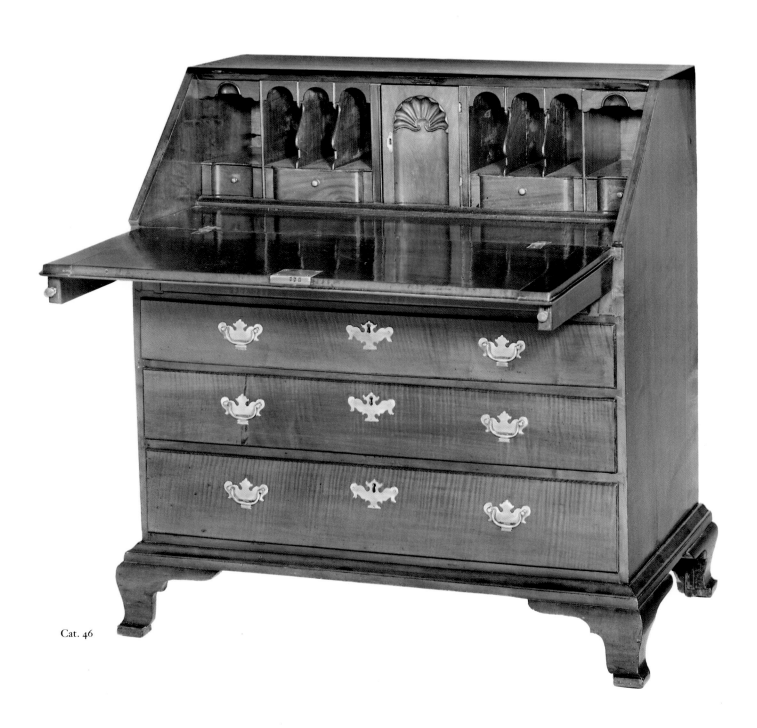

Cat. 46

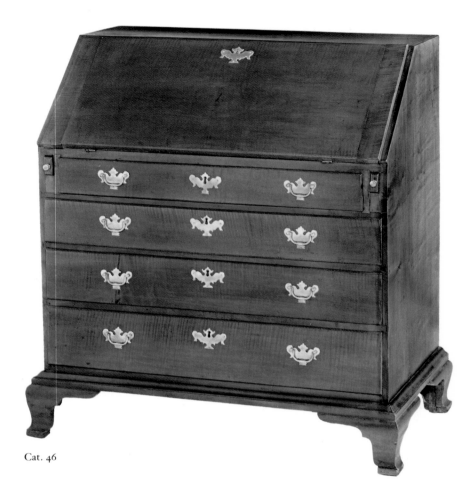

Cat. 46

Cat. 46

tenoned into an open notch in the rear bracket foot. A small vertical block behind the rear element supplements the standard support blocking.

Narrow, neatly cut dovetails bind each exterior drawer front and back to the sides. The edges of the drawer front have thumbnail moldings; the top edges of the sides are slightly rounded. The bottom —two butted boards running parallel to the front—fits into a groove in the drawer front and is nailed to the sides and back. The drawer slides on runners nailed to the bottom.

Within the desk interior, a narrow shelf supports a tier of blocked drawers and a shell-carved prospect door. Three pigeonholes with arched valances and a wider pigeonhole with a valance drawer flank the door. Three reverse-blocked drawers fill the compartment behind the door. The quality of the dovetailing matches that of the exterior drawers. Each drawer bottom in the desk interior is glued to the rabeted edges of the front, sides, and back.

The drawers retain their original iron locks; the lid retains its original brass lock and iron hinges.

*Inscriptions:* An old penciled signature, "Job Townsend," and the modern penciled date, "September 6th 1916," appear on the bottom of the top drawer. The modern penciled inscription, "Returned from F. Freeman's / September 6ᵗ 1916," is written on the bottom of the next to the top drawer.

*Condition:* In 1963, at the request of the owner, John Walton removed most of a crazed, reddish-brown stain. In 1989 Alan Miller refinished the worn and abraded areas in the desk interior to match the surface color. Except for these alterations to the finish, the desk survives in excellent condition with only minor repairs. The front edge of the case top has two small patches and all but one of the drawer dividers have patches above the drawer locks. The drawer runners are replaced and shims fill large shrinkage cracks in each drawer bottom. A black walnut support for the top exterior drawer replaces the original yellow-poplar support. The side of the left front foot is broken and nailed in place; the front tip

of the left front foot is replaced. The brass hardware is replaced.

*Woods:* Case top and sides, lid, lid slides, writing board, exterior drawer fronts and dividers, base rail, base molding, and feet, hard maple; interior drawer fronts, prospect door, partitions and divider, front edge of desk shelf, and drawer sides, bottoms, and backs of valance drawers, mahogany; drawer sides, backs, and stops for lower two drawers behind prospect door and two blocked drawers in desk interior, drawer supports for upper three exterior drawers, and rear elements for rear feet, yellow-poplar; sides and back of top drawer behind prospect door and sides and backs of reverse-blocked drawers in desk interior, poplar; batten nailed to back and all support blocks for feet except vertical blocks for front feet, chestnut; case bottom, support blocks behind base rail, vertical blocks for front feet, drawer supports for bottom drawer, drawer bottoms for all interior drawers, and drawer sides, bottoms, and backs for all exterior drawers, eastern white pine; case back and secondary wood of desk shelf, southern yellow pine.

*Dimensions:* H. 40⅞ in. (103.8 cm), w. 38⅝ in. (98.1 cm), D. 21½ in. (54.6 cm).

*Bibliography: Antiques* 80, no. 6 (December 1961): 502; Moses, *Master Craftsmen of Newport;* p. 257.

*Provenance:* John S. Walton, Inc., New York, N.Y., 1961; purchased from Walton in 1963 by Mrs. William D. Hoard, Jr., Fort Atkinson, Wis.

In 1923, the discovery of a desk and bookcase labeled by Job Townsend helped to establish Newport as a center of colonial cabinetmaking.[1] Since then, only two other items by Townsend have come to light: this maple desk and a dressing table documented by his bill of sale.[2] The surprising paucity of material belies his importance to the furniture trade. Job Townsend and his brother Christopher founded a family dynasty that dominated the craft for more than a century. Born on Long Island, Job received his training in Newport and by 1727 had set up on his own. He trained

three of his sons as well as his future son-in-law John Goddard and maintained a successful woodworking business until the early 1760s. In addition, he served the town for many years as treasurer and a "viewer of lumber." His obituary of January 21, 1765, records that "he was remarkable for Honesty and Integrity, and his Death is deemed a public Loss."[3]

Townsend produced a wide range of wares. Certainly his labeled desk and bookcase, now at the Rhode Island School of Design, represents one of his finest works. For it, he chose costly mahogany, installed an elaborate interior with carved shells on the prospect door and flanking drawers, and capped the bookcase with a scrolled pediment (removed long ago to fit the object into a smaller room).[4] This desk, by comparison, is a plainer and less expensive product. Its original cost was about one-half of that for a comparable mahogany desk. During the 1750s Townsend and his son Job, Jr., charged from £26 to £56 in inflated Rhode Island currency for maple desks and from £65 to £105 for mahogany ones.[5]

Though made of maple, this desk was finished to resemble mahogany. Townsend applied a reddish-brown stain to the surface and, in the desk interior, actually used mahogany for the drawer fronts and prospect door. For secondary work, Townsend chose five readily available local woods: white pine, yellow pine, chestnut, poplar (*Populus* spp.), and yellow-poplar. All appear in other Newport furniture, but the presence of seven different materials in one item is rare in urban New England furniture.

In workmanship, this desk rivals Townsend's finer products. The shell is well carved, the dovetails are skillfully executed, and the feet and their support blocks are carefully wrought, even in hidden areas. Job Townsend established high standards for construction, and his apprentices continued this tradition for the rest of the century. Undoubtedly he also helped to establish Newport's distinctive style of case furniture. This desk and the labeled secretary illustrate many characteristics of that style: a plain ogee bracket foot with a single cusp, a broad ogee base molding, thumbnail-molded drawer fronts, and a particular pattern of

desk interior as well as the unmistakable "Newport" carved shell on the prospect door and "bird's beak" profile on the pigeonhole partitions. These details remained a fixture in Newport furniture design for another generation and demonstrate the seminal role of Job Townsend in the creation of a remarkably long-lived expression of regional taste.[6]

*Brock W. Jobe*

Gift of Mrs. William D. Hoard, Jr.
M1985.33

1. Norton, "More Light on the Block-Front," p. 65.

2. In 1947, Joseph Downs attributed the dressing table to Townsend on the basis of a 1746 bill to Samuel Ward of Newport that included "a Mahogany Dressing Table [£]13:10:0." This table descended in the Ward family and is now owned by Mrs. Stanley Stone. See Downs, "Furniture of Goddard and Townsend," pp. 427, 430; Rodriguez Roque, *Chipstone*, pp. 38–39. In 1961, John Walton published the signed desk (see *Bibliography*). Townsend is also tenuously associated with a group of seating furniture. An auction catalogue of 1932 illustrates a Queen Anne–style side chair (one of six), an easy chair, and a daybed supposedly by Townsend. The caption for the side chair states that "this set of six chairs, the following wing chair, and the curly maple daybed (Number 85) form part of a group of pieces made by Job Townsend for the Eddy family of Rhode Island in 1743. One of these pieces, which bears Townsend's label, still remains in the possession of this family"; see Anderson Galleries (sale 3940; January 9, 1932), lots 80–81, 85. This group of furniture had appeared on the market two years earlier in the Philip Flayderman sale with an attribution to Job Townsend but without any reference to a labeled object still in the family; see Anderson Galleries (January 2–4, 1930), lots 345, 492–93. The labeled item has never been published.

3. Quoted in Garrett, "Goddard and Townsend Joiners," p. 1155. For additional biographical information on Job Townsend, see Moses, *Master Craftsmen of Newport*, pp. 247–50.

4. Monkhouse and Michie, *American Furniture in Pendleton House*, pp. 94–96.

5. An account book kept by three generations of the Townsend family is owned by the Newport Historical Society. Moses credits the authorship of the accounts from the 1750s to Job Townsend. See Moses, *Master Craftsmen of Newport*, p. 248. Jeanne Vibert Sloane attributes the accounts to his son Job, Jr. See Sloane, "John Cahoone and the Newport Furniture Industry," in *New England Furniture*, p. 120, n. 19. For a list of the furniture in the account book and the prices of each item, see Moses, *Master Craftsmen of Newport*, p. 346.

6. No doubt other craftsmen also contributed to the development of the Newport aesthetic in furniture. For an excellent assessment of one craftsman unrelated to the Goddards and Townsends, see Sloane, "John Cahoone," pp. 88–121.

## 47  *Dressing table*

Wethersfield, Connecticut, 1750–60

*Description:* The two-board, thumbnail-molded top is secured with eight pins to a joined frame containing four drawers with thumbnail-molded fronts. A carved shell ornaments the central drawer, and below it, an ogival arch punctuates the serpentine skirt. Larger versions of the arch embellish the sides. The cabriole legs terminate in round feet resting on thick (⅜ in. [1.0 cm]) disks. Shaped knee brackets are glued to the frame. The mortise-and-tenon joints binding the sides and back to the legs of the frame are fastened with four pins each. Two pins secure the skirt to the legs. Sliding dovetails bind the shallow (1½ in. [3.8 cm] deep) drawer dividers and partitions to the frame. The drawers run on side supports nailed to the case sides or tenoned into the back and set into notches in the skirt. Large, precise dovetails join each drawer side to the front and back. The drawer bottom is set into grooves in the front and sides and nailed with forged sprigs to the back. The drawers retain their original brass hardware but never had locks. Iron cotter pins fasten the handles and brass brads secure the escutcheon.

*Inscriptions:* The maker drew a chalk "X" 2 in. (5.1 cm) high on each drawer side.

*Condition:* The table retains all of its original elements with three exceptions. The knee brackets are replaced. The top has a large triangular repair at the right rear corner. The central drawer contains a small patch to the left of the carved shell. In addition, the underside of the top is chipped along the left edge, the left rear leg is split just beneath the top, the central drawer is cracked in three places to the right of the carved shell, and small

Cat. 47

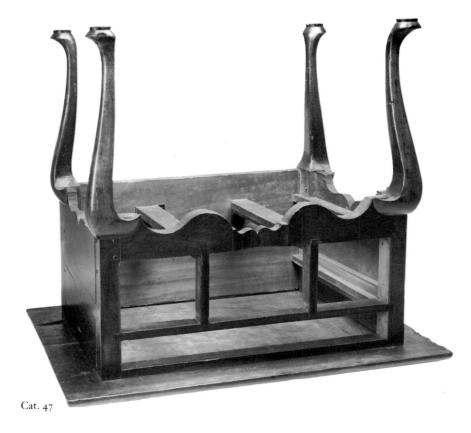

Cat. 47

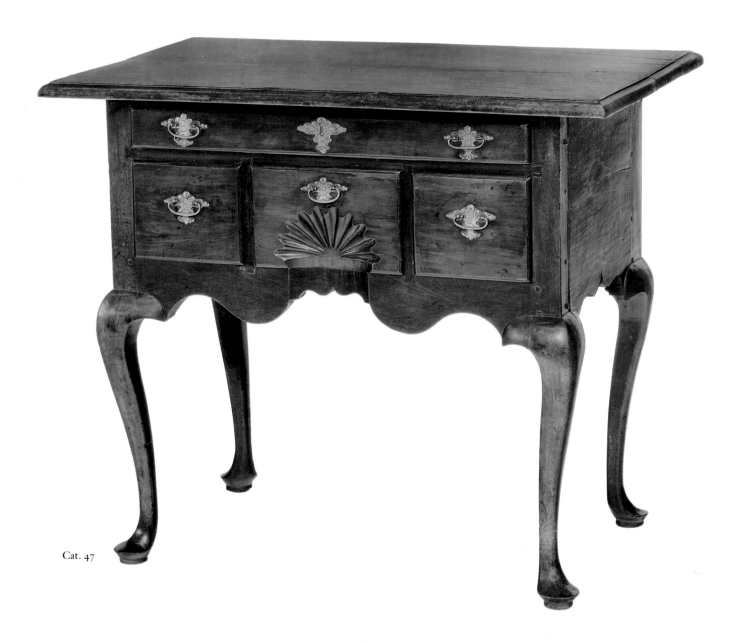

Cat. 47

sections of the lipped top edges of three drawer fronts are replaced.

*Woods:* Top, front skirt, knee brackets, case sides, and drawer fronts, dividers, and partitions, cherry; legs, birch; case back and drawer supports, backs, sides, and bottom, yellow-poplar; one board in drawer bottom of top drawer, chestnut.

*Dimensions:* H. 30¼ in.( 76.8 cm), w. 33 ¹⁄₁₆ in. (84.0 cm), D. 21¼ in. (54.0 cm).

*Bibliography:* Christie, Manson & Woods (sale 5047; April 11, 1981), lot 509.

*Provenance:* Acquired at auction in 1981 by John Walton, Inc., Jewett City, Conn. (dealer), and purchased from Walton by the Layton Art Collection.

Though influenced by design sources from eastern Massachusetts, Rhode Island, southeastern Connecticut, and even Philadelphia, the eighteenth-century furniture of Connecticut River towns has an unmistakable identity. This cherry dressing table illustrates one particular pattern of ornament found on case furni-

ture from Middletown, Connecticut, to Northampton, Massachusetts.[1] The chief characteristics are a thick top with thumbnail edges, scalloped shell in the middle drawer, and serpentine skirt with an ogival arch. The formula relates to coastal Massachusetts furniture, but in Connecticut Valley work the individual elements are thicker, the overall outline is less exuberant, and cherry is the standard primary wood.[2]

The cost of such tables can be readily identified. In his handwritten price list

of 1759, Windsor joiner Timothy Loomis cities a price of 25s. for a "Dressing Table Cherry—4 draws." [3] In comparison, for a "Cherry case of 9 draws [flattop high chest] Shel at y$^e$ Bottom," he charged 54s.[4] The two items ranked among the costliest of Loomis's products and, not surprisingly, required the most labor. The dressing table took approximately six days to build, the high chest thirteen days.[5]

Both forms—the high chest and the dressing table—first appeared in central Connecticut during the 1730s. Prosperous customers often purchased them as a set, usually for their best chamber. Today these pieces survive in quantity; yet originally, less expensive case furniture such as board chests and boxes were far more prevalent. In Wethersfield, fewer than 20 percent of the late eighteenth-century households had a high chest and even fewer had a matching table.[6] For the wealthy farmers and merchants who could afford them, the two objects served as a tangible symbol of rank and affluence.

Though this dressing table lacks an early provenance, it can be linked specifically to Wethersfield. Its overall design and woods—even the birch—are consistent with documented examples from the town.[7] Furthermore, its construction details correspond to those on a group of four dressing tables and a high chest with Wethersfield histories.[8] The thickness of the parts, placement of the pins which secure the mortise-and-tenon joints of the frame, and the length of the saw kerfs cut for the dovetails of the drawer fronts so closely resemble similar details on the other tables in the group that all can be attributed to the same shop. The name of that shop's master is unknown. The likeliest candidates are Return Belden (1721–64), Timothy Phelps (d. 1757), and Hezekiah May (1696–1783). May and Phelps had large, well-equipped joiner's shops by rural standards. Belden served an apprenticeship with William Manley, a Charlestown, Massachusetts, cabinetmaker who may have introduced the Queen Anne style in case furniture to Wethersfield during his stay there from about 1730 to 1745. Belden himself had made a "phanned Dressing Table" as early as 1745.[9] A table attributed to him features the same pattern of hardware that appears on the Milwaukee example but varies in several construction details.[10] The output of Belden, May, and Phelps documents the importance of Wethersfield as a craft center during the mid eighteenth century. This dressing table exemplifies the best of their work.

*Brock W. Jobe*

Purchase, Layton Art Collection
L1981.106

1. *Great River* illustrates case furniture in this style from Middletown (cat. 94), Windsor (cat. 95), and Amherst or Northampton (cat. 98). For documented examples from Wethersfield, see Sweeney, "Furniture and Furniture Making in Mid-Eighteenth-Century Wethersfield," pp. 1158–59. A related dressing table from the Lyme-Saybrook area near the mouth of the Connecticut River features a thinner top with ogee-molded edges; see Venable, *American Furniture in the Bybee Collection*, cat.9.

2. Several Salem, Massachusetts, high chests and dressing tables feature similar skirt outlines and shell carvings but are usually made of mahogany or walnut with white pine as a secondary wood, display finer dovetailing in the drawers, and have thinner parts throughout. See, for example, Sack, *American Antiques*, 4:1092, 6:1556, 7:1921. One so-called Massachusetts dressing table bears a remarkable resemblance to the Connecticut examples. However, this table has not been examined by the author and may, in fact, be of Connecticut origin. See Elder and Stokes, *American Furniture*, cat. 60.

3. Quoted in *Great River*, cat. 214.

4. *Great River*, cat. 214.

5. The amount of time spent on building a high chest and dressing table is based on estimates proposed by William N. Hosley, Jr., in "Timothy Loomis and the Economy of Joinery in Windsor, Connecticut, 1740–1786," in Ward, *Perspectives on American Furniture*, pp. 137, 139. Materials comprised approximately 25 percent of the total cost of an object. Labor accounted for the rest. Loomis, like most of his fellow craftsmen in the Hartford area, charged three shillings a day for his time.

6. Sweeney, "Furniture and the Domestic Environment in Wethersfield," p. 23.

7. Sweeney illustrates a Wethersfield Queen Anne–style chair made of birch in "Furniture and Furniture Making in Mid-Eighteenth-Century Wethersfield," p. 1162. In a conversation with the author, he noted that several pieces of Wethersfield case furniture probably include birch among their woods but microanalysis has never been done to verify it.

8. Sweeney, "Furniture and Furniture Making in Mid-Eighteenth-Century Wethersfield," pp. 1158–59.

9. Sweeney, "Furniture and Furniture Making in Mid-Eighteenth-Century Wethersfield," pp. 1156–57; *Great River*, pp. 212–13.

10. *Great River*, pp. 212–13. The brass handles on the Milwaukee dressing table seem surprisingly antiquated in appearance. Similar hardware had come into general use by 1710. However, English brass founders continued to offer such hardware for sale until at least 1780. See Hardware Catalogue, Birmingham, ca. 1774, p. 84, Essex Institute, Salem, Mass., 739.4 B82; and John Barker, Hardware Catalogue, Birmingham, ca. 1780, p. 99, Winterthur Museum Libraries, Winterthur, Del., NK 7899 B61fa*.

## 48   *Looking glass*

England, 1745–70

*Description:* The narrow rectangular frame contains two plates of mirrored glass. A carved and gilt border and applied molding surround the glass. A scrolled pediment ornamented with a circular gilt shell caps the frame. Walnut veneer covers the facade (except for the carved areas) and the outer edges of the stiles.

The stiles and rails of the frame are lap-jointed and glued. The crest is glued to the top rail and supported with four vertical blocks. Originally a series of small wedge-shaped blocks separated the glass and the four-board back.

The antique glass may be original. The upper plate rests on a lip cut in the edge of the frame.

*Inscription:* "£ 2.4" in ink on the backboard.

*Condition:* The looking glass has only minor damage. Small chips in the veneer above the carved shell and on the upper left corner of the frame have been patched. A 1-in. (2.5-cm) section at the bottom of the veneered strip on the edge of each stile has been replaced. The lower glass plate has a small crack in its lower left corner. The gilt decoration on the frame is well worn and the silvering on the glass has clouded and begun to flake. A thick crackled varnish, which has darkened with age, now covers all finished surfaces.

At least a century ago, a repairman removed the original blocks mounted between the glass and the backboard, placed the backboard against the glass, and glued the blocks to the outer surface of the back. Later someone removed the blocks, reused seven blocks to separate

the glass and backboard again, and secured the backboard to the frame with cut nails.

*Woods:* Veneer on frame and pediment, English walnut; all secondary wood, spruce.

*Dimensions:* H. 45⁹⁄₁₆ in. (115.7 cm), w. 16³⁄₁₆ in. (41.1 cm).

*Bibliography: Antiques* 83, no. 5 (May 1963): 535; Schiffer, *Mirror Book,* p. 55.

*Provenance:* Herbert F. Schiffer Antiques, 1963; private collection; purchased in 1976 from Joe Kindig, Jr., and Son, York, Pa. (dealer).

*"Lately imported from London, a fresh Parcel of choice Looking-Glasses of divers Sorts and Sizes. . . . To be sold at the Glass-Shop in Queen Street, Boston."* [1]

Unlike other furniture forms, the looking glass was rarely made in America during the colonial era. Residents relied on English imports which arrived in increasing numbers as the period progressed. The few colonial craftsmen who attempted the costly and complicated process of manufacturing mirrored glass met with little success. In 1767, Stephen Whiting of Boston lamented that he *"does more at present towards manufacturing Looking-Glasses than any one in the Province, or perhaps on the Continent, and would be glad of Encouragement enough to think it worth while to live."* [2]

This English looking glass follows a popular mid-eighteenth-century pattern. Its narrow proportions, applied molding on the frame, and scrolled pediment resemble similar features on glasses owned originally in Boston, New York, and Philadelphia. [3] On this example, the carved border and gilded shell provide added elegance. More ornate versions sometimes display pierced shells. [4]

An old inscription on the backboard— "£ 2.4"—probably records the original price of the looking glass. The charge conforms to those of the 1750s. On December 8, 1759, George Pynchon paid £ 2.2.8 to a Boston importer for "1 large look^g: Glass Walnut frame." [5]

*Brock W. Jobe*

Purchase, Layton Art Collection
L1976.8

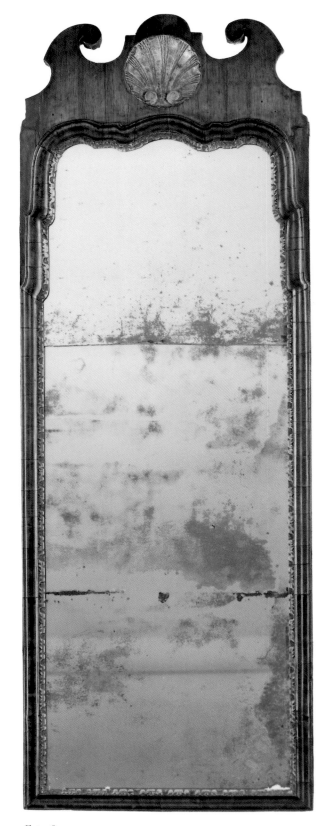

Cat. 48

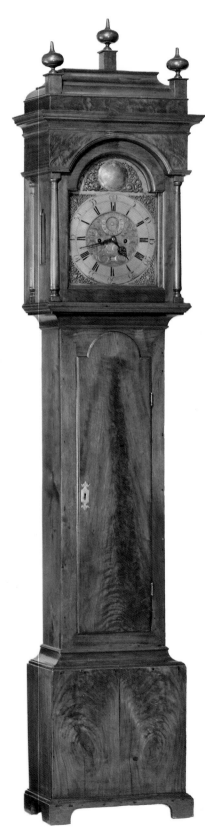

Cat. 49

1. *Boston News-Letter*, Aug. 17, 1719, quoted in Dow, *Arts and Crafts in New England*, p. 97.

2. *Boston News-Letter*, Nov. 12, 1767, quoted in Dow, *Arts and Crafts in New England*, p. 129.

3. Jobe and Kaye, *New England Furniture*, pp. 452–53.

4. Sack, *American Antiques*, 8:2242–43.

5. Joseph Green, Account Book, 1753–62, December 8, 1759, p. 167, American Antiquarian Society, Worcester, Mass. Green lists his price in Massachusetts "Lawful Money." The inscription on the backboard may refer to British sterling. If so, £ 2.4.0 would equal approximately £ 3.17.0 in "Lawful Money" in 1759.

## 49  *Tall clock*

Works by Joseph Wills (ca. 1700–1759)
Philadelphia, Pennsylvania, 1740–55

*Description:* The case separates into three sections: top, hood, and body. The dovetailed top has three flattened ball finials on rectangular plinths and contrasting cove and ovolo moldings. The hood, lap-jointed and glued at the front corners, is capped by a deeply coved frieze and features an arched door and side lights. The turned columns at the front corners are mounted to the door. The turned quarter-columns at the rear are nailed to the sides of the case. The body of the clock, nailed along the rabbeted edges of the sides, includes a cove-molded waist with a solid arched door and a base with straight bracket feet. One long wedge-shaped support block is nailed along each inner corner of the waist. The base moldings and feet are a single unit mitered at the corners. Horizontal and vertical glue blocks support the bracket feet. The bottom of the case is nailed to the lower edge of the case sides.

The wrought-brass dial has a silvered chapter ring with Roman hour numerals and Arabic minute numerals, cast-brass ornaments with masks and arabesques in the spandrels, cast dolphin ornaments flanking the signature plate in the arched top, stippled center with swirling floral engraving, a seconds dial above the pierced hands, and calendar aperture below. The eight-day movement has brass plates and wheels, two iron weights, and an iron and brass pendulum. The brass door hinges are original; the waist-door escutcheon and lock are replacements.

*Inscriptions:* Inscribed "Jo$^s$: Wills / Philadelphia" on the dial; "Th  Th/24 [?]/ of 12th/1804" in chalk on the front of the backboard; and "12–13–07 / cord / B B" and "Nov 1868 / Feb 9 Warranted / E W C" in pencil on the back of the waist door.

*Condition:* The case and works are in exceptional condition with most of their original elements intact, including finials, plinths, moldings, and feet. The case bottom and rear foot elements are the only significant replacements; in addition, the vertical blocks behind all but the right front foot are missing.

*Woods:* Finials, plinths, moldings, columns, feet, and body and hood sides, front, and door, black walnut; hood top and support blocks for top, white pine; top and back of removable top, secondary wood for veneered front edge of removable top and lower right backboard behind base, yellow-poplar; backboard, white oak; seat board for works and case bottom, southern yellow pine; movement, brass; dial, brass.

*Dimensions:* H. 101⅝ in. (258.1 cm), W. 21½ in. (54.6 cm), D. 10¾ in. (27.3 cm).

*Provenance:* Purchased in 1984 from Joe Kindig, Jr., and Son, York, Pa. (dealer).

During the early eighteenth century Philadelphia supported numerous clockmakers. Abel Cottey had arrived from England by 1700, Peter Stretch emigrated from Staffordshire before 1702, Joseph Wills had begun to work in the town by 1725, and John Wood advertised his skills as a clockmaker in 1734.[1] Other craftsmen supplemented these better-known artisans, and throughout the colonial era Philadelphia tradesmen supplied costly timepieces to wealthy residents.

The output of Joseph Wills illustrates the variety of wares offered by a Philadelphia craftsman. He made both thirty-hour and eight-day movements. He offered plain dials as well as those with a sweep second hand and a revolving moon dial. The cases for his works vary considerably in elaboration and reflect the changing tastes of the second quarter of the eighteenth century. Ten documented examples are known. The earliest three have hoods with flat tops and square doors; a fourth has a flat top and an

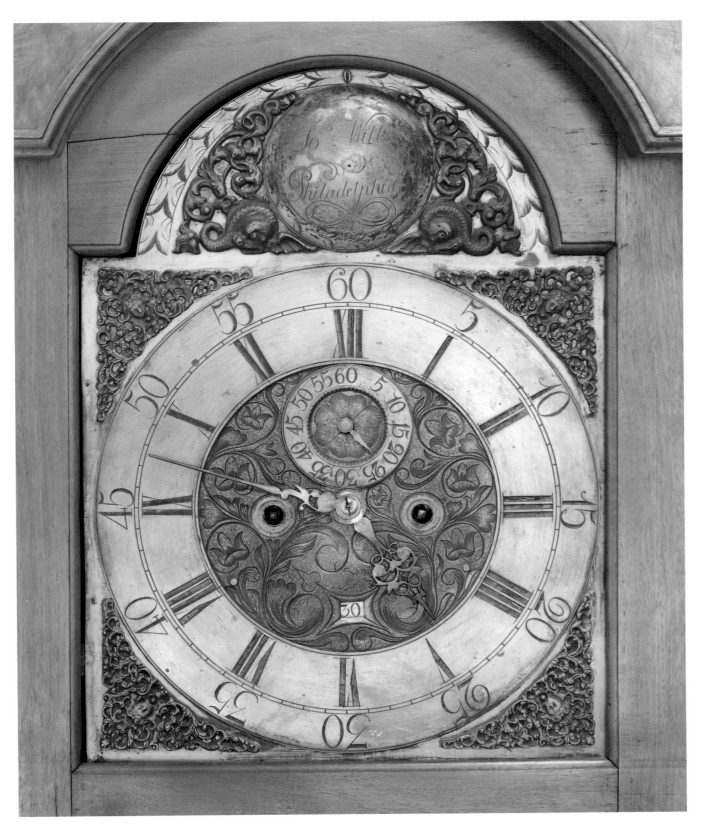

Cat. 49

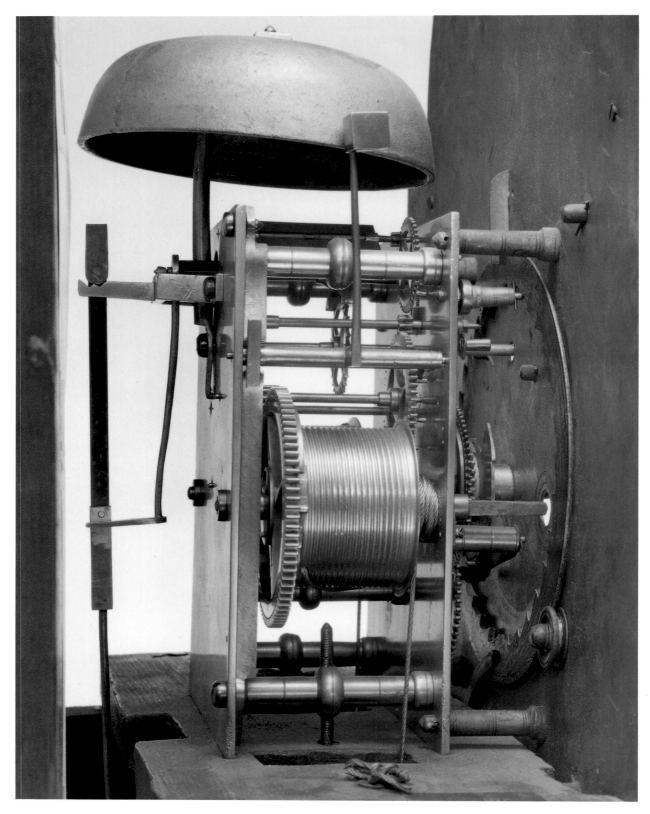

Cat. 49

arched door. Five late baroque cases have
domed tops, arched doors, and straight
bracket feet. The final case, undoubtedly
constructed late in Wills's career, has a
pitch pediment, rococo carving over the
hood door, quarter-columns on the waist,
and ogee bracket feet.[2]

The domed-top example at the
Milwaukee Art Museum ranks among the
best preserved of all Philadelphia pre-
Revolutionary clocks. It retains its origi-
nal finials, plinths, and feet. Though
undated, it can be ascribed to the late
1740s because of its similarity to a pri-
vately owned clock bearing the inscribed
date of 1748.[3] Wills's works are well
crafted and typical of English movements
of the same period. Like his clockmaking
colleagues throughout the colonies, Wills
obtained his dials and many of the parts
for his movements from England.

The design of the case conforms to a
popular local pattern. A similar case
houses a movement by Peter Stretch.[4]
Both feature matched boards of figured
walnut on the front of the base, arched
doors, closely related turned columns
and moldings on the hood, and three
flattened ball finials. Use of the pattern
extended into New Jersey. A tall clock
by Aaron Miller of Elizabethtown closely
resembles its Philadelphia counterparts
but may have been made as late as 1779,
more than a half century after English
artisans developed the initial precedents
for the design.[5]                *Brock W. Jobe*

Purchase, Layton Art Collection
L1984.141

1. For information on early clockmakers in
Philadelphia, see Stretch, "Early Colonial
Clockmakers in Philadelphia," pp. 225–35;
Eckhardt, *Pennsylvania Clocks and Clockmakers;*
Gibbs, *Pennsylvania Clocks and Watches.*
2. Photographs of all but the Milwaukee Art
Museum's clock are filed in the Decorative
Arts Photographic Collection (DAPC) in the
Winterthur Museum Library. For published
illustrations of five of the clocks, see "A Tory
Clock," *Antiques* 19, no. 2 (February 1931):
96–97; *Antiques* 29, no. 6 (June 1936): 234;
Battison and Kane, *American Clock*, pp. 110–13;
Gibbs, *Pennsylvania Clocks and Watches,*
pp. 78–79.
3. Gibbs, *Pennsylvania Clocks and Watches,*
pp. 78–79, fig. 65.
4. Hornor, *Blue Book,* pl. 34.
5. Battison and Kane, *American Clock,*
pp. 86–89.

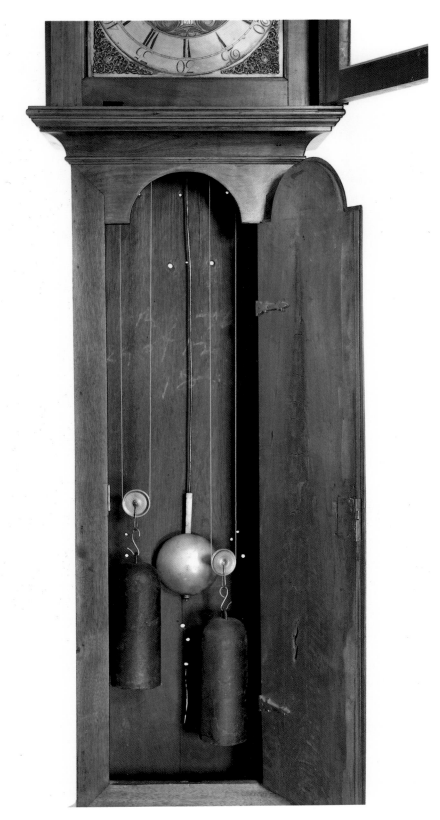

Cat. 49

Cat. 50

clockwise.[2] A fragment excavated at Vauxhall contains parts of the well-known rhyme stated above, and tankards with this inscription are now associated with that factory in London.[3]

Pastoral and hunt scenes increased in popularity in England during the early eighteenth century. They were used to decorate embroidered pictures, chair covers, and bed hangings (see cat. 41) as well as ceramic surfaces. The print source associated with needlework scenes is a 1726 engraving entitled "The Chase" by B. Baron after John Wooten.[4] A specific reference to the site mentioned on this tankard, spelled "Bansty," refers to Banstead Downes, near Epsom not far from London. In 1663 Samuel Pepys describes in his diary a thronging to the great horse race and footrace there.[5]

These imposing hunting tankards were often commissioned pieces, usually bearing dates, inscriptions, and ornamentation, and are thus appealing documents of social history that reveal the spirit and mores of the times.      *Anne H. Vogel*

Gift of Virginia and Robert V. Krikorian
M1987.48

1. Museum of Our National Heritage, *Unearthing New England's Past*, pp. 17, 105, pl. 330.
2. Horne, *Catalogue of English Brown Stoneware*, p. 20, and Oswald, Hildyard, and Hughes, *English Brown Stoneware*, pp. 48–50.
3. Hildyard, *Browne Muggs*, pl. 119.
4. Cabot, "Engravings and Embroideries," p. 369.
5. Oswald, Hildyard, and Hughes, *English Brown Stoneware*, p. 49.

## 50   *Tankard*

Vauxhall, London, England, 1729

*Description:* This imposing half-gallon stoneware tankard with a silver rim mount has a thick strap handle. It is decorated with a thin white dip on the lower portion and a light brown freckled dip on the upper. The applied decoration consists of trees, rosettes, a central plaque with the bust of King George and his initials, two beefeater figures, a hunting scene with a houndsman sounding his horn, and hounds chasing a hare. The dogs are speckled with iron black color.

*Marks:* The silver rim mount bears four indistinguishable hallmarks.

*Inscriptions:* An inscription around the top reads: "On Bansty Downes a Hare we found which led us all a Smoking Round." The piece is dated 1729. The central plaque is initialed "GRII."

*Condition:* The tankard is in excellent condition.

*Materials:* Salt-glazed stoneware with applied ornament and silver rim mount.

*Dimensions:* H. 8⅜ in. (21.3 cm), DIAM. 5¾ in. (14.6 cm).

*Provenance:* Purchased by the donors in 1978 from Michael and Jane Dunn, Claverack, N. Y. (dealer).

In England and on the Continent, stoneware was part of everyday life during the seventeenth and eighteenth centuries, and excavations in America reveal its use at early colonial sites.[1] This piece belongs to a group of large, heavily potted tankards ranging in date from 1713 to 1744 upon which the hunt always runs

## 51   *Posset pot*

Bristol or London, England, ca. 1720–40

*Description:* The bulbous body rests on a small foot, has two strap handles with blue and red dashes, and a clinging spout also daubed with blue and red spots. It holds a domed lid which has a mushroom knob and a rim decorated with cloud scrolls. The white-glazed surface of the pot and lid are decorated with blue, red, and green floral painted designs held within circumferential lines.

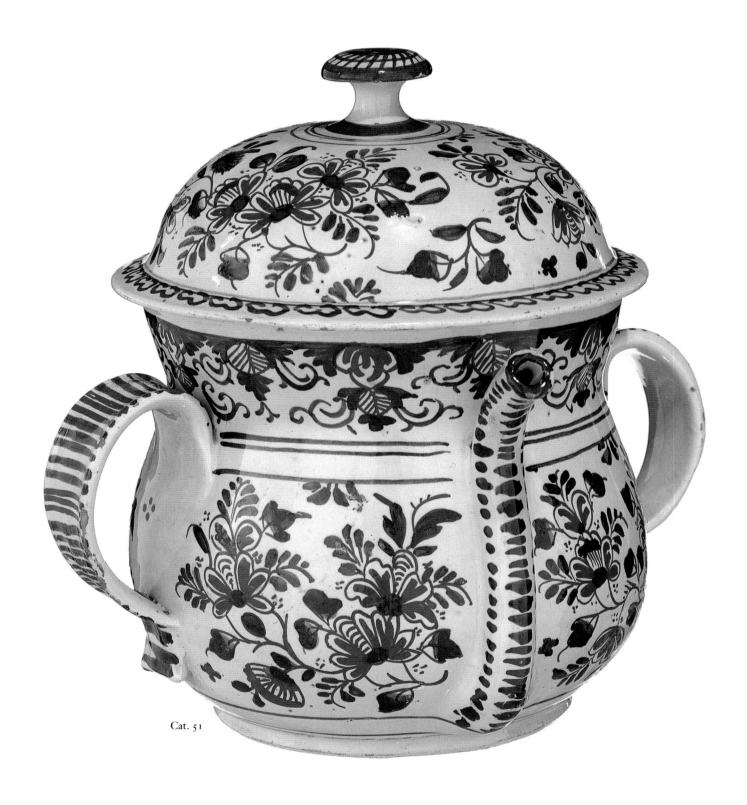

Cat. 51

*Condition:* There is a 1-in. (2.5-cm) restoration to the rim of the lid, and a ¾-in. (1.9-cm) triangular piece has been broken and reglued on the rim of the pot.

*Material:* Tin-glazed earthenware.

*Dimensions:* H. 9⅛ in. (23.2 cm), DIAM. 6¾ in. (17.1 cm).

*Bibliography:* Charleston and Towner, *English Ceramics,* pl. 11.

*Provenance:* Louis L. Lipski, London, England (collector), 1981; Sotheby's (London) (sale, March 10, 1981), lot 89.

Posset pots were designed usually with a spout, handles, and a lid to sip or spoon out of the bowl a drink composed of hot milk curdled with ale, wine, or other liquors. More sophisticated recipes included spices and fruit flavors or the use of herbs to accommodate medicinal needs. Early London examples in delftware were straight sided; later, the shape developed into bulbous and then more gracefully curving forms. At the end of the century the significance of posset pots increased and the form itself became more decorative and flamboyant. Lids were shaped like crowns, while handles and spouts were enriched with snakes. Gradually during the eighteenth century its status and style returned to that of a plainer, more ordinary utilitarian object. Comparable examples are in the City of Bristol Museum and the Ashmolean Museum, Oxford.[1]               *Anne H. Vogel*

Purchase, Layton Art Collection
L1981.13a–b

1. Britton, *English Delftware,* p. 71. Ray, *English Delftware Potters,* pl. 69. See also Delhom, *Delhom Gallery Guide,* p. 138.

## 52  *Punch bowl*

Probably Holland, 1743

*Description:* This deep-sided delftware bowl is painted in blue. The outside has three panels surrounded by wreaths enclosing ornate vases filled with flowers; three shaped lappets with scrolls and foliage; and the remaining surface is covered with tight patterns of Chinese scroll and floral designs. The inside is decorated with birds, rocks, flowers, and a Chinese fence with an inscription around the edge.

*Marks:* The underside of the bottom carries either an unidentified mark or, possibly, the number 10.

*Inscriptions:* "George . Mary . Marven Washbrook 1743" is painted around the interior rim.

*Condition:* The bowl is extensively damaged and reglued.

*Material:* Tin-glazed earthenware

*Dimensions:* H. 8½ in. (21.6 cm), DIAM. 15⅞ in. (40.3 cm).

*Bibliography:* Lipski and Archer, *Dated English Delftware,* pl. 1111.

*Provenance:* Marven family, Washbrook, England; Sotheby's (London) (sale 5201B; February 2, 1982), lot 82; purchased by the donors from Cora Ginsburg, Inc., New York, N.Y. (dealer), 1983.

This punch bowl displays several Dutch decorative characteristics in the painted style of its exterior, which lacks typical English spontaneity and flow of design, and in the large-scale pattern which dominates the interior.[1] The inscription itself does not confirm an English origin. A group of Dutch marriage plates made for export to an English market have been identified.[2] These plates, dated between 1738 and 1759, have inscribed on them only the names of English towns and other names of a purely English character. Most of the plates name communities in Essex, Suffolk, and Norfolk—England's eastern counties known to have close commercial connections with Holland.[3]

A matching bowl to the Marven piece in the Milwaukee collection has been discovered recently.[4] It bears the inscription "John . Jane . Marven . Cobdock 1743" and is owned by a descendant still residing in the same area. Copdock (often spelled and pronounced Cobdock) is the village next to Washbrook in County Suffolk. John Marven III succeeded his father at Copdock Hall in 1742–43 while his brother George was tenant of Amor Hall in Washbrook. Perhaps the date 1743 commemorates their simultaneous tenancies or some other event common to both families.[5] The inscription and imposing size of the Milwaukee bowl reinforce its ceremonial significance and the festivity of serving punch.

*Anne H. Vogel*

Gift of Virginia and Robert V. Krikorian
M1986.155

1. I wish to thank John Austin, Senior Curator and Curator of Ceramics and Glass, Colonial Williamsburg, and Jonathan Horne, Antiquarian and Specialist in Early English Pottery, member of the British Antique Dealers Association Ltd., London, for consulting on the origins of this bowl.
2. Ray, *English Delftware Pottery,* p. 141; Garner and Archer, *English Delftware,* p. 30; Warren, "Dutch Marriage Plates for the English Market," pp. 304–7.
3. With appreciation, I credit Robin Emmerson, Assistant Keeper of Art, Norwich Castle Museum, Norwich, England, for bringing to my attention Phelps Warren's research on Dutch delftware with English inscriptions and on Dutch commercial connections with the East Anglian market.
4. Dr. Noel Mander, MBE, FSA, St. Peter's Organ Works, London, is the owner of the "John . Jane . Marven" bowl. I am grateful to him for corresponding with me about this object.
5. I thank Mr. Richard Pipe, Washbrook, Ipswich, Suffolk, for his explanations of Marven family lineage and his publication *Copdock: A View of the Parish* (1977).

## 53  *Bowl*

England, possibly Liverpool, ca. 1750

*Description:* The tin-glazed bowl has gradually curved and moderately high sides. The Oriental design on the exterior includes birds on perforated rocks, and a flowing floral pattern colored in blue and pale green with red striations to define the blossoms. A narrow border of flower heads in panels reserved on a diaper band encircles the outer rim. The interior has a flower at the center and floral sprigs dispersed around the upper portion of the bowl.

*Condition:* The bowl has survived without chips, cracks, or breaks.

*Material:* Tin-glazed earthenware.

*Dimensions:* H. 5 in. (12.7 cm), DIAM. 11½ in. (29.2 cm).

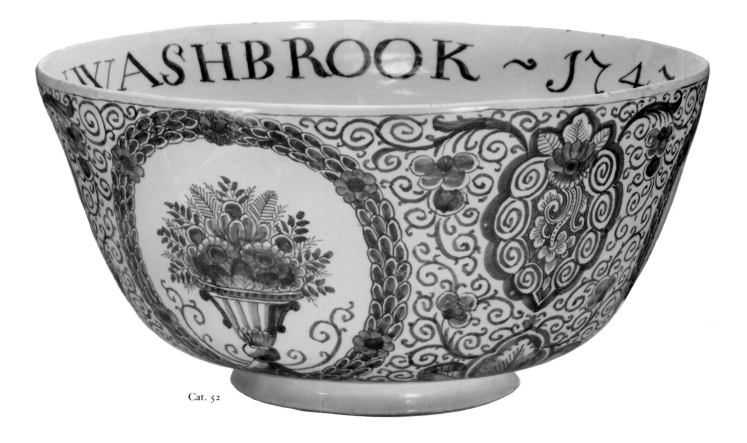

Cat. 52

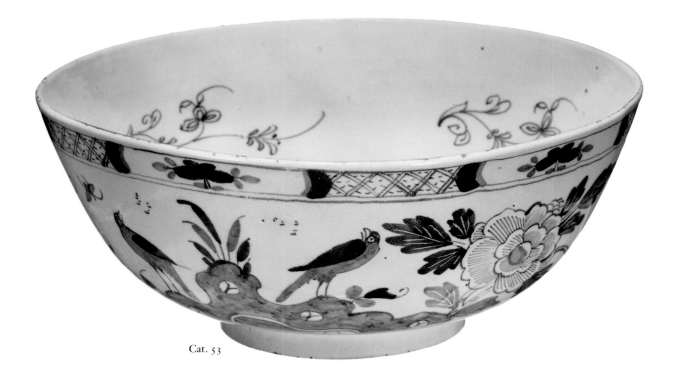

Cat. 53

*Provenance:* Purchased in 1976 from Ginsburg and Levy, Inc., New York, N.Y. (dealers).

Great quantities of delftware were made in Liverpool between 1735 and 1775. The less deep-sided scale of this piece is typical of mid-eighteenth-century bowls from all factories. The lower sides accommodate more general use for holding fruit or potpourri, as contrasted with the large ceremonial size of punch bowls.

*Anne H. Vogel*

Purchase, Layton Art Collection
L1976.38

## 54 *Teapot*

Gabriel Sleath (1674–1756)
London, England, 1713

*Description:* The squat pear-shaped pot has a domed, hinged lid with a well-proportioned cast-ball final and simple C-scroll ivory handle. The body is raised in one piece and sits on a narrow foot rim. It has a gracefully curved octagonal spout with a duck-head terminal.

*Marks:* "SL" in a scalloped heart with pellet below (Jackson, *English Goldsmiths*, p. 166); lion's head erased; the date letter of 1713/14; and the Britannia standard are clearly struck on the bottom. The maker's mark and lion's head erased are also stamped on the underside of the lid's rim.

*Inscriptions:* On one side is engraved the Greene family coat of arms with the Latin inscription, "Donum Johannis Greene Socio—Commensalis 1713" ("Given by John Greene, Fellow Commoner, 1713"). On the other side are the arms of St. John's College, Cambridge, England, which are also the arms of the Foundress of the College, Lady Margaret, Countess of Richmond and Derby, mother of Henry VII, and the inscription "St Johan:Col:Cant:"

*Condition:* The teapot is in good condition with minimum surface wear and crisp engraving.

*Materials:* Silver with ivory handle.

*Dimensions:* H. 6½ in. (16.5 cm), w. 4½ in. (11.4 cm), D. 7¾ in. (19.7 cm); WT. 15 oz. 15 dwt. (489.9 gm).

*Bibliography:* Goldstein, *Milwaukee Art Museum*, p. 49.

*Provenance:* Purchased in October 1978 from S. J. Shrubsole, Inc., New York, N.Y. (dealer).

The fashion of tea drinking, from elaborate tea services to the tea tables on which they were placed, had an enormous impact on the decorative arts. In the 1670s, the earliest form of teapot was a tall tapering cylinder with a conical cover and straight spout.[1] About 1700 the form evolved to a more suitable pear-shaped pot in which the wider circumference allowed the tea to steep in a maximum amount of water. The form disappeared about 1725, only to reappear in the 1740s as an inverted pear. To combine function with style even further, teapots were produced with ivory or wood handles, as silver was highly conductive to heat. The earlier florid engraved and gadrooned baroque style changed to one of great simplicity, lightness of line, and restrained ornamentation. Decorative art forms took on a new profile. The emphasis was on contour, and the carefully chosen curves of this teapot illustrate the epitome of Queen Anne styling.

The well-known London silversmith Gabriel Sleath made this teapot for the Greene family of Navistock, Essex, England. The inscription indicates that it was commissioned as a gift to St. John's College, Cambridge, in 1713, the very year it was crafted. About 1711 a new style of heraldic ornament was favored, and it was inspired by contemporary architecture rather than by the earlier heraldic devices (see cat. 38).[2] The round, more tightly shaped armorials engraved in the new manner found on both sides of the Milwaukee teapot are well suited to its small curving form. A similar pear-shaped teapot by a contemporary English silversmith, William Gamble, dated 1714/15, is in the Wadsworth Atheneum.[3]

The stamp of Sleath's first mark, entered in 1706, is on this teapot. During this period he worked in metal of the Britannia standard. Use of this purer, softer alloy, by order of Parliament, was an attempt to prevent hard silver coinage from being melted down for utilitarian objects.[4] Sleath entered his second mark in 1720, at which time he changed to the sterling standard. He used another mark in 1739 and a fourth one in partnership with Francis Crump in 1753.[5] Throughout his productive career he specialized in cups, wine cisterns, and coffee and teapots.

The painting of *A Tea Party in the Time of George I* (Victoria and Albert Museum) pictures a family of three seated before a table covered with silver plate, central to which is a pear-shaped teapot on a stand, an octagonal, straight-sided tea caddy, sugar tongs, and all the other accoutrements necessary to the service of tea. The painting reveals the social ritual and craftsmen's artistry that evolved with the custom of drinking tea.[6]

*Anne H. Vogel*

Layton Art Collection, acquired by exchange through the bequest of Mrs. Jesse Hoyt Smith
L1979.16

1. Oman, *English Silversmiths' Work*, pl. 66.
2. Phillips, *American Silver*, p. 61; Buhler, "Some Engraved American Silver," pp. 268–71.
3. Miles, *English Silver*, pl. 52.
4. Jackson, *English Goldsmiths*, p. 166.
5. Grimwade, *London Goldsmiths*, figs. 890, 904, 906.
6. The English conversation piece, a painting genre frequently featuring the family drinking tea, developed in the eighteenth century. The example in the Victoria and Albert Museum is illustrated in Oman, *English Silversmiths' Work*, pl. 110. Another painting including a similar but abbreviated grouping of silver plate, *Man and Child Drinking Tea*, by an unknown English artist, ca. 1725, is in the Colonial Williamsburg collection and is pictured in Baumgarten, *Eighteenth-Century Clothing at Williamsburg*, p. 51.

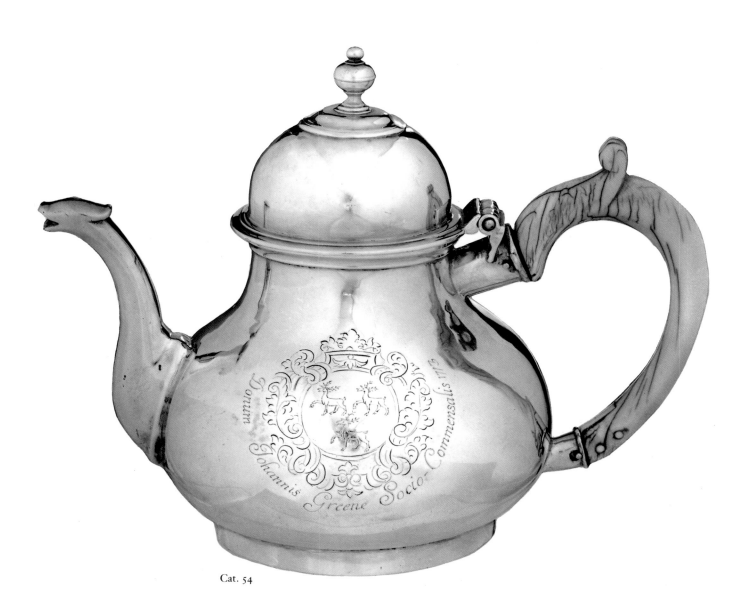

Cat. 54

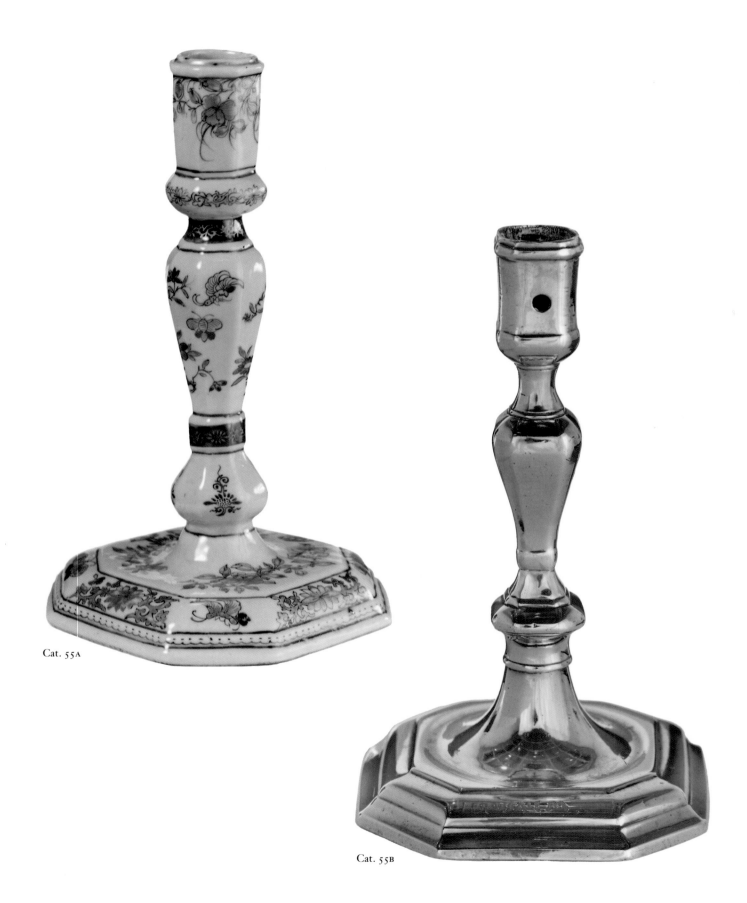

Cat. 55A

Cat. 55B

## 55A *Candlestick*

China, 1710–40

*Description:* This cast candlestick has a gray-white body that is overglaze decorated with iron red enamel and gilt.

*Condition:* The candlestick is in excellent condition.

*Materials:* Porcelain, with enamel and gilt decoration.

*Dimensions:* H. 7½ in. (19.1 cm), w. base 4½ in. (11.4 cm), D. base 4½ in. (11.4 cm).

*Provenance:* Purchased by the donors in 1980 from Circa Antiques, Inc., Fort Lauderdale, Fla. (dealer).

Gift of Virginia and Robert V. Krikorian
M1987.43

## 55B *Candlestick*

England or Northern Europe, 1710–40

*Description:* This candlestick is cast in two units. The socket/stem is two vertically cast halves joined with solder. Its lower end is threaded to screw into the base, which is a separate cast unit.

*Inscription:* "JERUSALEM" is printed on the upper face of the base with tiny, contiguous dot punches.

*Condition:* The candlestick is considerably worn.

*Material:* Brass.

*Dimensions:* H. 7⅝ in. (19.4 cm), w. base 4½ in. (11.4 cm), D. base 4½ in. (11.4 cm).

*Provenance:* Purchased by the donors in 1972 from Philip H. Bradley Co., Downingtown, Pa. (dealer).

Gift of Virginia and Robert V. Krikorian
M1987.42

In early eighteenth-century Europe the broad curves of the baroque style and increasingly improved candles that no longer required enormous drip pans brought a new form of candlestick into popularity. This small-based, slender-columned porcelain stick (cat. 55A) represents the new form as popularized in England during the reign of Queen Anne (1702–14). Though this piece was made in China, it was produced for the European market and was probably modeled after a brass example brought to the Orient by an East India Company trader expressly for that purpose. The brass model would have looked very much like the example (cat. 55B) illustrated here.

The porcelain and brass sticks are very similar, though hardly identical. Both have octagonal sockets with a half-round molding just below the rim. Each has an octagonal vasiform shaft, flaring to a faceted knop above the concave conical stem which increases in diameter as it joins the octagonal foot. The brass version is more complex in its moldings and better balanced in its proportions. In the porcelain version the length of the stem overbalances the base, and the transition from base to stem has been truncated for a heavy, elongated knop. Despite the simplification of the shape, the elaborate *rouge de fer*, or iron red, overglaze decoration with gilt accents elevates the porcelain stick to a high level of sophistication. The multitude of tiny arabesques, butterflies, and floral designs enlivens the entire surface of the form. Where the brass stick relies on the complexity of its moldings and the reflective quality of the metal to create visual interest, the porcelain piece depends on intricate surface decoration.

Due to trade restrictions imposed on the American colonies by England for most of the eighteenth century, Chinese goods, like this candlestick, were re-exported through London by East India Company merchants.[1]

*Jayne E. Stokes*

1. Mudge, *Chinese Export Porcelain*, pp. 87, 128.

## 56 *Andirons*

America, possibly Rhode Island, 1740–60

*Description:* The shaft, from ball finial to plinth top, was cast in halves and soldered into a fully round form. The base of the shaft is soldered to the plinth, which is a single cast fascia element ½ in. (1.3 cm) in depth. The boss is attached to the plinth face with two brass pins, soldered in place, the shanks protruding through the rear of the plinth. The cast front legs are attached to the shaft/plinth unit by a bolt and a small rivet. The front log stop is solid cast; an iron extension from its base is riveted through the billet bar. The billet bar joins the plinth behind the boss and has a secondary leg riveted 2 in. (5.1 cm) in front of the log stop. An iron block with arms loosely forged around the billet bar acts as an adjustable rear log stop.

*Condition:* Both andirons have had one leg repaired: .A has been re-soldered at the join of the right foot to the leg, .B has an iron brace riveted to the inside of the lower end of the right leg. The join of the plinth to the shaft of .A has been repaired and the boss below this is replaced. The bolt joining the base of .A to the shaft is not original.

*Materials:* Brass, iron.

*Dimensions:* H. each 18⅜ in. (46.7 cm), w. each 12 in. (30.5 cm), D. each 19½ in. (49.5 cm).

*Provenance:* Harlan W. Angier collection, West Brookfield, Mass.; George Abraham and Gilbert May, West Granville, Mass. (dealers), May 1971; a private collection, Milwaukee, Wis., until purchased by the donors in 1975.

Several elements of the design of these mid-eighteenth-century American andirons recall elements of northern European andirons of a century earlier (see cat. 14). The large ball finial and bulbous baluster on the shaft, concentrically molded bosses, and low arched legs have been used in both cases; it is the way these individual pieces are brought together that make them very different, each appropriate to the prevailing taste of its time.

The andirons illustrated here are less massive and simpler in outline, following the generally restrained character of objects in the Queen Anne style. The body of the shaft is a tapered column with a molded ring at top and bottom. A single raised boss decorates the rectangular plinth which meets the top of the arched legs with a cavetto over quarter-round molding. The round forms of the finial, shaft base, and boss are repeated by the large flat disks of the penny feet. The log stop diminutively echoes the shaft form.

Andirons in this style may have been among the earliest produced by American brass founders. English manufacture of andirons declined in the early eighteenth century as coal grates replaced the equipage of the wood-burning hearth.[1] Colonial brass producers may have been casting brass as early as 1721, and were certainly doing so by midcentury when the Geddys of Williamsburg, Virginia, advertised "brass firedogs of their own manufacture" in 1751, and Daniel King notified the people of Philadelphia that he made andirons, chandeliers, and other brass items.[2] Andirons of this form are believed to have been produced in Rhode Island.[3]

The basic form of this andiron type could be altered to a more rococo design by the use of cabriole legs with ball-and-claw feet in place of the low arched legs with penny feet.[4] The exchange of this single element allowed the brass founder to keep many of his old patterns in use and still satisfy the customer's desire for more current styling.    *Jayne E. Stokes*

Gift of Virginia and Robert V. Krikorian
M1982.8A,B

1. Fowler and Cornforth, *English Decoration*, p. 226.
2. Cooper, *In Praise of America*, pp. 39–40.
3. Schiffer, *Brass Book*, p. 71.
4. Schiffer, *Brass Book*, p. 71, fig. a; Sotheby's (sale 5755; October 22, 1988), lot 266.

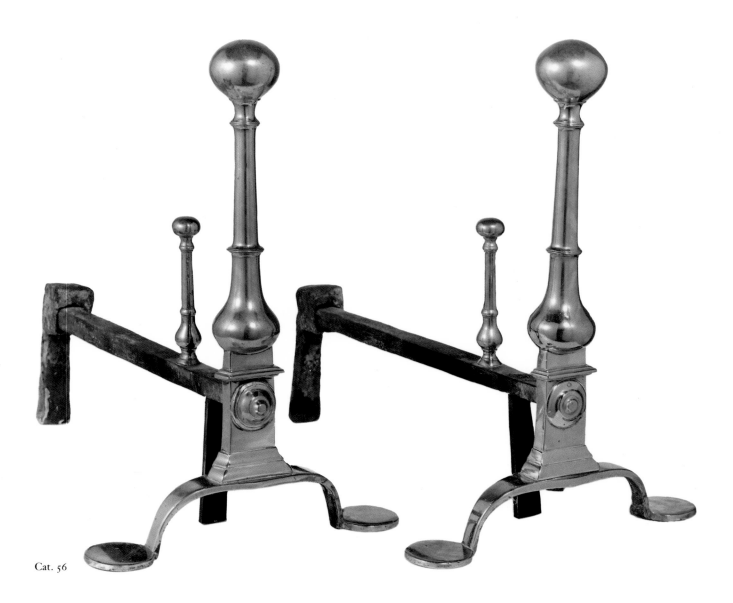

Cat. 56

## 57 Andirons

America, 1760–1800

*Description:* The body and legs of these andirons are wrought iron. The columnar shaft and urn at its base are welded to the flattened slab-form plinth. The plinth pierces the center of the arched legs and is peened over underneath. The rod-stock legs are flattened to form penny or pad feet. The billet bar passes through the upper portion of the plinth and is peened over on its face. The cast-brass finials fit over the rod extension of the iron shaft, which is peened over at the top to secure them.

*Condition:* One andiron (.A) has a ¾-in. (1.9-cm) dent at the mid-line of the ball finial, a crack to the left of the billet join to the plinth, and substantial corrosion at the rear foot of the billet. The other (.B) has two small dents on and near the midline of the ball finial and extensive corrosion with an open fracture on the rear foot of the billet.

*Materials:* Iron, brass.

*Dimensions:* H. each 22 in. (55.9 cm), w. (.A) 13 in. (33.0 cm), w. (.B) 13½ in. (34.3 cm), D. each 15¼ in. (38.8 cm).

*Provenance:* Purchased by the donors in 1978 from Jane and Michael Dunn, Claverack, N.Y. (dealers).

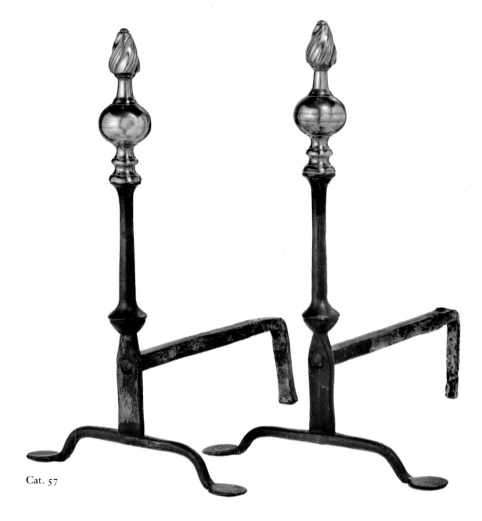

Cat. 57

Andirons were produced in all styles with varying proportions of brass and iron elements. The more brass that was used, the more decorative and costly the andirons. The most elaborate fireplace equipment was used in the most important public room in the house, such as the parlor or sitting room. Plain iron equipment would have been suitable for the working hearth of the kitchen. In a wealthy household these andirons, with brass used only for the finials, might have been used in the second-floor chambers, while in a less affluent setting they might have been found in the best room.

The ball-and-flame finials of these andirons are a variation of the faceted sphere-and-flame finials used on cat. 76. Both of these represent an elaboration of the plain ball finial of earlier andirons, such as those illustrated in cat. 56, and both

were used concurrently.[1] It may appear that the andirons of the present entry are earlier in date because everything below the finial is less á là mode than the finial. Indeed the bulbous-based columnar shaft and low arched legs with pad feet are in the earlier style of cat. 56; but that does not cause the finials to be earlier and the andirons cannot originate in a time before the earliest date of their latest element. The lack of current styling in the iron elements is not due to an ignorance of the rococo but to the blacksmith's desire to produce a less expensive product for the market. Andirons with penny feet, iron shafts, and brass urn or later "lemon" finials of the federal and post-federal periods provide clear evidence of the continued economy offered by the

blacksmith's reductionist version of all-brass andirons.[2]

Although andirons such as these, having an essentially iron body and using brass only for the finial, are not well represented in the Milwaukee collection, they were certainly far more common in the eighteenth century. However, these andirons are unusual in that the shaft has an urn form at the base of the column rather than a swelled baluster. Also rare among surviving examples, the shaft is of wrought iron, not cast, and yet is formed in the round.[3] Typically those that are wrought have a slab type shaft which creates only an outline of the column and baluster, rather than being fully formed.[4]

Slight differences in metal color and in some of the detailing of the finials of

these andirons raises the possibility that each cast element may be from a different source. Both finials are clearly eighteenth century in date, and the variations noted may only signal that they were produced at slightly different times by the same foundry. It is possible, however, that the blacksmith, who would have been solely the maker of the ironwork, purchased the brass from two foundries which made finials so similar that the smith would commingle them. The difference in color (red tones in .A against the greenish tinge of .B) indicates two batches of brass. In colonial America the copper and zinc required for making brass was in short supply, so new brass might contain remelted old brass articles which had been damaged or had passed out of style.[5] Consistency from one batch to the next would have been difficult and slight color differences very probable. The variance in the detailing of the finials occurs chiefly in the proportions of the turnings below the sphere. The center reel and quarter-round basal molding of one andiron (.A) are thinner than the other, and the same andiron has an added quarter-round rim around its lower edge. However, measurements of the entire neck unit show both to be of the same height and the thinner elements of one andiron (.A) to be compensated for by thicker turnings above and below the reel. What appears to the eye to be a real difference in the dimensions of these elements is actually a result of the demarcation lines drawn in the skimming process. The castings come from identical molds but different workmen must have been at the lathe when each of these finials was finished. The symmetry of the paired lines that span the circumference of one andiron (.A) are visible proof of a more experienced, or perhaps more assiduous, craftsman than those that encompass the other (.B).

*Jayne E. Stokes*

Gift of Virginia and Robert V. Krikorian
M1981.131.A, .B

1. For andirons that illustrate the use of both these finial forms on the same type of body, see Schiffer, *Brass Book*, p. 60, B and C, with ball-and-claw feet and brass baluster shafts; p. 62, B and C, with ball-and-claw feet and fluted shafts; and pp. 40 C and 41 C, with iron legs and cast-iron baluster and column shafts.
2. Schiffer, *Brass Book*, p. 44 A–E, p. 45 A–C.
3. Schiffer, *Brass Book*, pp. 40–41.
4. Schiffer, *Brass Book*, p. 38 B–E, p. 39 C, D, pp. 42–43.
5. Fennimore, "Metalwork," p. 94.

## 58  *Bed rug*

Hannah Baldwin
Canterbury, Connecticut, 1741

*Description:* The natural wool tabby weave foundation is made up of two breadths seamed vertically. Colored wools embroidered in running stitch, with cut and uncut pile, form the pattern and cover the entire surface in deep orange, yellow, dark green, brown, and undyed on a ground of blues. At the center is a circle with petals, meandering vines, and flowers contained within black and white rectangular outlining with more meandering vines, and flowers bordering it.

*Inscription:* The initials HB in cross-stitch are sewn on a handwoven linen patch on the foundation.

*Condition:* The bed rug is in very good condition with only minor thread loss. A modern layer of cotton reinforces and covers the back.

*Materials:* Wool embroidered through tabby weave wool foundation in colors.

*Dimensions:* L. 85½ in. (217.2 cm), W. 79 in. (200.7 cm).

*Bibliography:* Warren and Callister, *Bed Ruggs*, pl. 4, p. 28; Christie's (January 25, 1986), lot 253.

*Provenance:* Baldwin family, Canterbury, Conn.; Mr. and Mrs. Paul Weld, Middletown, Conn.; sold at Christie's (January 25, 1986), lot 253; purchased in 1988 from Cora Ginsburg, Inc., New York, N. Y. (dealer).

This piece was originally from the Baldwin family home in Canterbury, Connecticut, and is identified with the family by a handwritten label pinned to it reading "Baldwin Senior" to distinguish the mother from her daughter. Further evidence of the maker is found on a handwoven linen patch on the foundation with the initials HB in cross-stitch. While most extant examples of bed rugs have Connecticut origins, they were also made in other parts of New England.[1]

This stunningly designed and colored artifact, entirely a home product, provides insight into the resourcefulness of New England women. Wool from the sheep had to be sheared, carded, spun, woven, and dyed even before setting the needle to work. With these solidly sewn bedcovers, the colonial housewife created a new art form not known in England and seemingly unique in the history of needlework.[2]

The bed rug was not made with the technique of hooking; they were needle-worked coverlets, piled or smooth faced, worked with wool yarns covering the entire wool or linen foundation. There is no evidence to confirm the actual source of the decorative design of American bed rugs; however, the predominate coiling vine motif terminating in flowers appears to derive from an Elizabethan prototype. Later bed rugs may also relate to the tree-of-life design and its exotic floral meanders.[3]

The term "rugg" in colonial probate inventories was chiefly associated with the bedstead. Few floor coverings were used in this early period except in the grandest houses. With the understanding of "rugg" as a bedcover, the eighteenth-century expression "snug as a bug in a rug" further clarifies the purpose of this rare indigenous art form.[4]

*Anne H. Vogel*

Purchase, Layton Art Collection
L1987.2

1. Warren and Callister, *Bed Ruggs*, p. 16.
2. Warren and Callister, *Bed Ruggs*, p. 16 and note 26.
3. For discussion of the origin of bed-rug design, see Mayer-Thurman, *Masterpieces of Western Textiles*, p. 161, and Warren and Callister, *Bed Ruggs*, pp. 16–18.
4. Iverson, "The Bed Rug in Colonial America," p. 107.

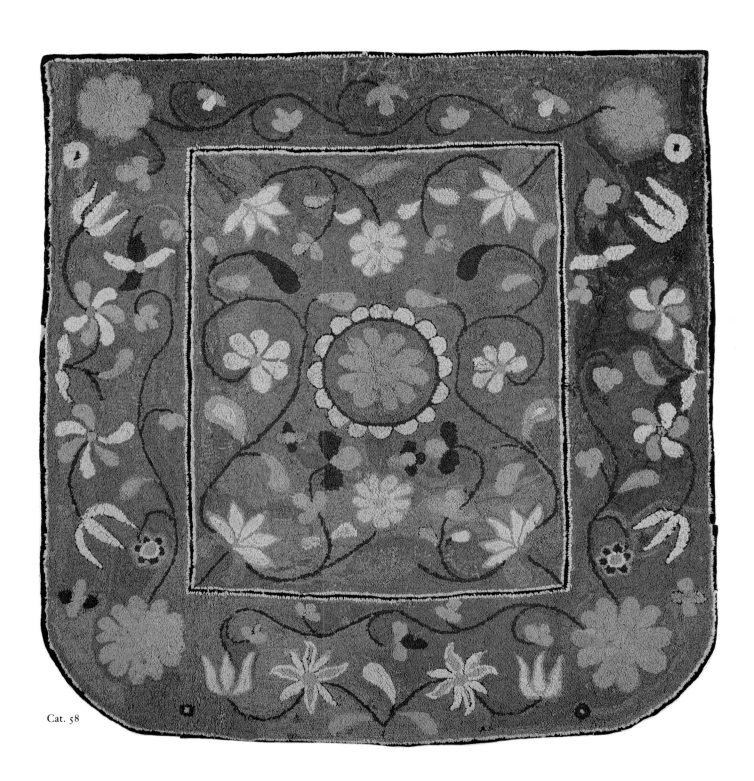

Cat. 58

# AMERICAN CHIPPENDALE

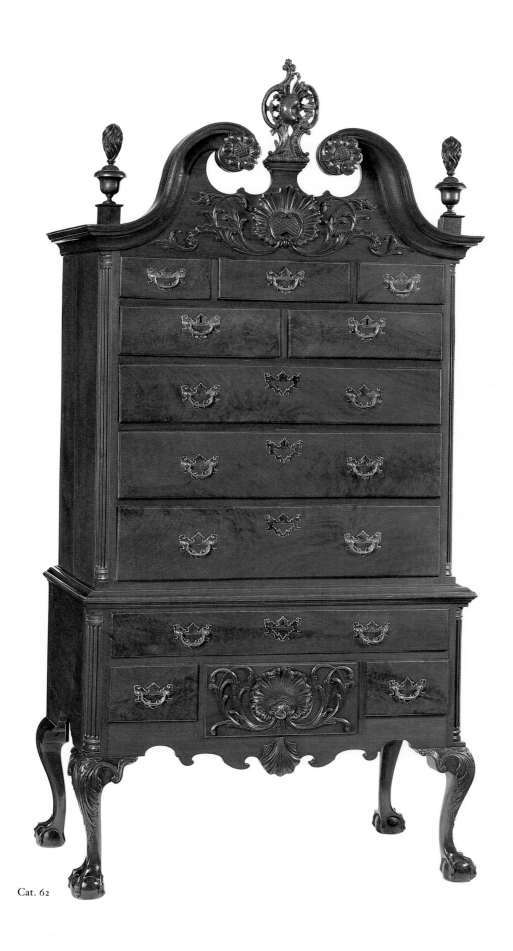

Cat. 62

# Change and Persistence in Revolutionary America: American Chippendale

### PHILIP D. ZIMMERMAN

THE TASK of furniture historians is to organize the unruly past and to attempt to explain and interpret it. Their detailed examination of the objects, accompanying documentation, and broader historical and cultural contexts often reveals shared characteristics. Repetitions among these shared traits in turn enables the furniture historian to describe broader patterns and other meaningful relationships among surviving pieces of furniture. Investigation into the possible reasons these patterns exist becomes a key means of understanding the past. Like any other historical endeavor, however, the conclusions we may draw are simplifications of historical circumstances that are often too complicated to comprehend fully or even to recognize. Moreover, as our assumptions and interests shift from time to time and from generation to generation, our understanding of the past is subject to change.

Examination of furniture through the medium of style has long been a successful approach to unlocking meaning and value, whether historical or aesthetic. Style analysis sets the objects into a chronological sequence. Additionally, it may be used to separate objects into regional expressions, which classify them geographically, or across space. Investigation of style may also identify objects as being expensive or cheap, thus providing a sense of social and economic context.

Because style analysis is used so pervasively, we seldom question its strengths and weaknesses, nor do we often consider alternatives. Among the alternatives, recent exhibitions and studies instruct us that objects may be organized and understood by form, by function, by region, by maker, or by owner or provenance.[1] A potential weakness of style analysis comes from how style is defined, which may introduce

biases. Use of style requires an exacting knowledge of a set of characteristics or principles. The degree to which an object adheres to or omits these properties yields its place within the style matrix. Consequently, if a definition of style assumes that a particular time, place, or group of people originated the purest statement, unwanted value judgments may arise.

Until relatively recently, for example, in the eyes of many scholars all American furniture was considered provincial, therefore of less worth than English or French. This viewpoint was a logical extension of interpreting American furniture styles in relation to their European sources. Over the last two decades, greater self-confidence on the part of collectors and dealers of American furniture has leveled, and in some cases surpassed, American market prices with European, thus fueling the question of which is better. At the same time, however, furniture scholars from both sides of the Atlantic have made great strides in understanding early furniture by defining the use of style more broadly and without ethnocentric references. In this manner, style measures the degree of influence of certain knowns—the furniture of a particular style center at a particular time, for example. Thus, the absence of certain manifestations or expressions of a style may be as important and meaningful as their presence. For instance, an unusual combination of "Queen Anne"–style shells in a high chest may be understood as a creative expression of a regional subculture rather than as a misinterpretation of London design by out-of-touch and unskilled provincial craftsmen.

Mid-eighteenth-century American furniture does not conform readily to any particular label, whether based on style or any other point of view. The terms

*Queen Anne* and *Chippendale*, which borrow from English furniture history, conjure up real historical facts that have few or no ties to the American experience. At the same time, these terms have been in use for so long that they clearly communicate a particular body of furniture made from the late 1720s through the 1750s and from the 1750s through the 1780s, respectively. Thus, they are useful in that limited way. However, attempts to make the terms more precise or meaningful inevitably create significant exceptions, qualifications, and other problems. These difficulties stem in part from interpretations that inadequately address the inherent shortcomings of the style names.

Reference to Queen Anne, the English monarch who died in 1714, has obvious limitations in the study of American furniture. The term Chippendale has a closer tie: to Thomas Chippendale (1718–79), a London furniture maker and author of *The Gentleman & Cabinet-Maker's Director*, published in 1754 and 1755 and in an enlarged version in 1762. Although direct influence of the *Director* may be discovered in American furniture, detailed investigation into furniture from this one perspective ultimately limits rather than expands our understanding.[2]

The *Director* was available to furniture makers in only a few of the major style centers. In Philadelphia, the Library Company listed a copy in its 1769 catalogue, and Thomas Affleck owned another copy.[3] John Goddard of Newport, Rhode Island, and Nathaniel Gould of Salem, Massachusetts, owned other copies. The fact that these important cabinet-makers owned such a volume underscores its rarity: no copies, for example, may be associated with the New York furniture-making trade, to say nothing of the hundreds of other furniture-making communities throughout the American colonies. Moreover, characteristics generally ascribed to American Chippendale-style furniture were in use before the *Director* was first published, as evidenced by a Philadelphia high chest at Colonial Williamsburg inscribed "Henry Cliffton Thomas Carteret/November 15th 1753."

The role of the *Director* and of the many other furniture-design books published in London from the 1740s on, is not sufficient to account for the form and decoration of American furniture in this period.[4] Numerous other factors contributed. Among them were English and other European-trained immigrant craftsmen who, by virtue of their superior skills or because of advantageous patronage relationships, influenced the products of the craft communities they joined. Perhaps most notable in this regard was Thomas Affleck, an accomplished furniture maker brought to Pennsylvania by Gov. Thomas Penn in 1763.[5] Newspaper advertisements and letters from merchants and travelers to Europe occasionally provide insight into another significant source—direct importation of stylish European furniture. An excellent example of this design source exists in comparison between an English armchair and side chair, each with a Massachusetts history, and a set of two arm and ten side chairs of Boston manufacture. Their construction is similar; carving differs only in minor details; but the use of beech as a secondary wood in one points to a likely English origin.[6] Another instance of design transmission by this means lies in the likelihood that an English bombé chest-on-chest owned by Charles Apthorp of Boston before his death in 1758 was an important source for bombé shapes in Boston furniture.[7] In sum, evidence of many different kinds suggests that American craftsmen and those who patronized them appear to have been relatively well informed about developments in furniture styles of the English merchant classes.

Traffic in furniture and ideas between England and America takes tangible form in such references as Samuel Walton's 1785 advertisement in the *Pennsylvania Mercury* in which he states that he "Makes and sells all kinds of Household Furniture, of the newest and most elegant patterns, which have been lately imported from Europe."[8] Less exact historical information about the nature of a design appears in references like a 1755 Boston sale advertisement listing "an exceeding good Sett of Mehogany carv'd Chairs, new Fashion."[9] Are the seven chairs listed in Boston upholsterer Thomas Wheelwright's 1750 inventory and described as having "Eagles foot & shell on the Knee" the first reference to American production of what we now understand as claw-and-ball feet?[10] Similarly, early manuscript references to such things as "claws" on furniture, stated in the context of "pillar and claw foot tables," may confuse more than clarify since this term may identify the shape of the leg rather than treatment of the foot.[11] These inherent ambiguities make it necessary for the historian to construct a meaningful profile of the major design issues and

components that takes into account a number of dynamics.

Style is often thought to be a force directed toward change, which in turn is usually associated with strong positive values. However, style may be understood better as a particular and temporary balance between change and persistence. Persistence provides the repetition necessary to form the similarities among objects that make them recognizable participants within a certain style. Consider a "stylish" eighteenth-century side chair. The design of the back splat changes from a solid dependent upon outline to a pierced element intended to be seen through. Such expressive pierced splats are emblematic of the Chippendale style. But the essential factor is that they are persistent within the style period; they do not change through time or space.

Recognition of the dynamic tension between change and persistence introduces a useful flexibility into understanding the Chippendale style in America. The Chippendale style is not a uniform set of design codes or principles. Instead, it draws easily from two seemingly contradictory sources: the "artificial" properties of classical architecture and nature. William Hogarth saw this duality clearly in his essay "The Analysis of Beauty," published in London in 1753. In it he argued in favor of his "line of beauty," an S-shaped (or ogee) curve of particular inflection, that has "a real foundation in nature." Straight lines were both unnatural and not aesthetically pleasing.

Hogarth's essay, published a full generation after ogee curves had gained widespread acceptance in English and American furniture, summarized existing art theory and application rather than precipitated change.[12] Cabriole legs and compass seats, curved backs, and scrolled pediments were commonplace. At midcentury, a stronger dependence upon nature for design may be seen in some English furniture forms, especially looking glasses, brackets, and pier tables, but in America the evidence for a parallel change is weak. In fact, midcentury seems to signal a return to architectonic forms and decoration, in opposition to Hogarth's argument. An important furniture document is a desk and bookcase signed and dated by Benjamin Frothingham in 1753 which uses engaged pilasters to define the doors of the upper case.[13]

American Chippendale furniture employs architectural rules to shape the basic form, whether a large case piece, a table, or a chair. To a greater degree than in Queen Anne–style furniture, horizontal and vertical elements are defined by classical architectural techniques. Classical moldings define seat and table rails and case tops and bottoms; rear posts on chairs have fluting; columns support tea-table tops; and desk interior drawers carry a broad vocabulary of classical design. Classical architecture also gives proportion to furniture, evident in the definition of classical orders in the introductory pages of Chippendale's *Director* and other design and ornamental books such as Robert Manwaring's *The Cabinet and Chair-Maker's Real Friend & Companion* (London, 1765).

Chippendale-style ornament derived from nature overlays the architectonic foundations. This relationship is most apparent in the use of carved finials placed atop plinths or foliage around and along certain design elements such as the pediments of high chests. Similarly, intricately worked pierced splats, the apparent antithesis of architectural order, are set within square-framed chair backs (in contrast to curvilinear backs of stylish Queen Anne–style chairs), often on plinthlike shoes that provide visual transition to the rear seat rail. Good Chippendale-style design also accommodates substitution of a straight, architecturally derived "Marlborough" leg, often with little molded bases, for a naturalistically derived cabriole leg with animalistic feet.[14]

The flexibility to substitute architectural for naturalistic design components within a single furniture form is well documented by surviving objects and manuscripts.[15] The Philadelphia furniture price book of 1772, for example, lists furniture by form and details options, such as easy chairs and card tables, each listed with plain feet, "Ditto with Claw feet," and "Ditto Marlborough feet bases & brackets."[16] It is apparent from both the objects and supporting written evidence that the Renaissance-based classical architecture and ornament of eighteenth-century England, as represented in design books, was itself a significant design component of Chippendale-style furniture. Carved ornaments such as fans, pinwheels, corkscrew finials, and other imaginative devices derive not from rococo or other sources but come directly out of the classical design vocabulary of shells, rosettes, urns, and the like.

Distinctions between ornate architectonic and other decorative Chippendale-style designs may be defined

further. Ornate Chippendale-style decoration identified today as rococo (or "French" or "modern" in its time) commonly takes nature as its source.[17] However, another recognizable source is Gothic, typified by pointed arches, trefoils and quatrefoils, crockets, and clustered columns. A third source is Chinese adaptations, often termed chinoiserie and evident in the use of pagodas and related fanciful structures, bamboo elements, and tracery. As with other aspects of Chippendale-style characteristics, these three distinct tastes are interchangeable. Pattern books, for example, show the same furniture forms decorated with rococo, Gothic, and Chinese motifs with virtually no change in proportion or other design properties. Moreover, eighteenth-century Gothic and Chinese ornaments may be confused for one another, suggesting their function was limited to conveying a design mood rather than more specific or accurate cultural knowledge. Gothic clustered-column legs differ little from clustered bamboo legs, and certain eighteenth-century fret patterns fit into Gothic or Chinese contexts equally well.[18]

Specific American representations of the three design tastes are not as well-defined as in English furniture and published designs, but American makers were aware of them.[19] Chair splats often express rococo tastes but occasionally emphasize trefoils and quatrefoils or show tiered Gothic arches. Gothic arches, clustered columns, and fretwork decorate some case pieces and bedsteads. Chinese motifs occasionally appear on tea or china tables and often appear on ornate looking glasses, although many of the latter are probably of English origin.

In addition to ornate Chippendale-style furniture that expressed one or more of these design tastes, furniture price books, individual furniture bills, and specific furniture survivals that may be securely dated indicate that furniture of plain design was still popular throughout the eighteenth century.[20] These objects were typically made of walnut or maple instead of more stylish and expensive imported mahogany. In most respects, they were virtually unchanged from their chronologically earlier counterparts, which were considered high style in the Queen Anne period. Simply put, the Chippendale style embraces this plainer variation along with the decorated examples.

Interpretive ambiguities exist when considering plain furniture as a desired taste of the period. Plain-

ness also meant lower cost, which introduces another motivation, and historical evidence is seldom sufficient to determine why a buyer chose plainness. Nonetheless, sufficient evidence survives to substantiate the use of plain furniture in the same settings as more ornate examples. And in a complementary manner, the makers of the most ornate pieces of Chippendale-style furniture typically supplied plain products as well.

One of the compelling factors in American Chippendale-style furniture is the degree of variation in design expressions, construction practices, and preferences for certain forms from place to place across the colonial American landscape. Despite good communication across great distances, objects made and used in regions and subregions exhibit strong common denominators that link them to each other and differentiate them from other objects. This phenomenon, called "regionalism," is based on complex and changing factors.[21] During the Chippendale period, dominant factors included well-organized craft communities that reinforced regional consistency by virtue of common training and shop practices, well-developed economic and social ties among leading families, and to a lesser extent cultural isolation or influence of specific groups, like the Pennsylvania Germans, New York Dutch, and perhaps the Connecticut and New Hampshire Scotch-Irish.[22] Inclination toward regional identification rather than toward a national sense of style is aptly captured in New Hampshire yeoman Abner Sanger's journal entry for April 22, 1778: "This is Continental Fast throughout the Divided States of America."[23]

Regionalism in American furniture has been the focus of substantial study over the past half-century.[24] Scholars have identified regional characteristics that help organize vast numbers of object survivals. Among the major furniture-making centers, Philadelphia products show the broadest range of designs and forms, including objects that were very design-book oriented and a wide range of upholstered forms. The broad range reflects Philadelphia's complexity and urbanity. At the same time, striking consistencies in construction practices suggest a tightly organized furniture-making community. New York furniture, in contrast, exhibits little or no design-book orientation, more limited design vocabulary, and distinct construction variants. Carved decoration does not have a similarly

light and fanciful character nor is there a similar range of motifs.[25]

Of all the style centers, Rhode Island is most dependent upon form and line, the key components of Queen Anne–style furniture, for its unique regional design. Architectonic qualities, prominent in many Rhode Island tables and in features of some large case pieces, account for the only significant expressions of current Chippendale-style principles and practices. Boston furniture, like that of Philadelphia, exhibits broader ranges in design. Although many Boston products display common characteristics, some Boston furniture—notably bombé case pieces and a few richly carved chairs—is richly appointed and evocative in its design references.

Subregions outside the major centers display so many different design variations that an attempt to summarize them is of limited value. Their characteristics, however, may often be understood in relation to the larger centers, which supplied many goods and services. Acceptance or rejection of specific object properties may reveal cultural relationships that find little expression in other historical sources. In terms of furniture history, examination of these products from secondary centers or subregions may reveal standards of workmanship and creativity that equal those of the best urban products.

Furniture-making designs and practices in America from the 1750s through the 1780s were diverse. The Chippendale style encompassed a broad and complex range of choices, as well as rules that governed those choices. Choices and rules affected maker and patron. Cabinetmakers (like John Goddard of Newport) owned, and all but ignored, the latest English design books. They advertised themselves as capable of making furniture in the latest European styles, yet surviving examples show preferences for prevailing local tastes. Patrons could choose among various forms—high chests on legs, tall chests that stood on bracket feet, or double chests, for example—that performed the same general function, yet consistently demanded certain forms. Our understanding of the mechanisms that drove issues of style is incomplete, if indeed the furniture historian's attempt to organize the unruly past by investigation of style can approximate the actual circumstances.

Within a few years of 1790, design vocabulary and rules changed dramatically. A new furniture style, inspired by European neoclassical ideas formed in the 1760s and realized subsequently in European furniture and interiors, took hold in several American furniture-making centers. Called the federal style, it spread throughout the rest of the United States with surprising speed and uniformity.

The abrupt and widespread changes in design are strong indicators of better communication across distances and through social and economic layers. Other historical conditions affected furniture style in different ways. New trade routes opened new markets for American furniture-making centers, stimulating production. Production itself changed as new relationships formed between workers and masters and shop owners and as parts jobbing and specialization assumed greater importance. These and other factors argue that use of style to organize and understand the past must be reevaluated with each new time period. Interpretation through style analysis of furniture made after the 1780s demands new perspectives before it too can yield a rich historical or aesthetic context for understanding and appreciating the objects.

1. Gerald W. R. Ward raises some of these possibilities in *American Case Furniture*, pp. 3–17. His essay sees furniture from a fresh perspective—namely that of the object from the point of view of the user or consumer.

2. See also Morrison H. Heckscher's discussion about inherent shortcomings of these terms in his *American Furniture*, pp. 19–20. Having cited the weaknesses, Heckscher uses the terms to advantage.

3. Hornor, *Blue Book*, p. 73.

4. Two other pattern books from which designs were taken directly include *Thomas Johnson's One Hundred & Fifty New Designs* (London, 1758) and Robert Manwaring's *The Cabinet and Chair-Maker's Real Friend & Companion* (London, 1765).

5. Hornor, *Blue Book*, p. 184.

6. Discussed in Mary Ellen Hayward Yehia, "Ornamental Carving on Boston Furniture of the Chippendale Style" in *Boston Furniture*, pp. 201–6. For additional information, see Kane, *300 Years*, cats. 97–98; and Fairbanks and Cooper, *Paul Revere's Boston*, pp. 50–51, cats. 53–54.

7. Gilbert T. Vincent, "The Bombé Furniture of Boston," in *Boston Furniture*, p. 150.

8. Prime, *Arts and Crafts in Philadelphia*, 1:184.

9. *Boston Gazette*, Nov. 17, 1755, quoted in Dow, *Arts and Crafts in New England*, p. 115.

10. Quoted in Lyon, *Colonial Furniture of New England*, p. 161.

11. Quoted from 1745 and 1748 sources in Hornor, *Blue Book*, p. 95. Hornor understands the term to refer to claw-and-ball feet.

12. In his essay, for example, Hogarth makes reference to his own engraving published in 1745 and entitled "The Line of Beauty."

13. Published as fig. 97 in Vincent, "Bombé Furniture." Earlier high chests with fluted pilasters are known, but because they have no capitals or bases, they do not convey the same degree of architecturally derived design as do those of the Chippendale period.

14. Cabriole legs with pad feet were sometimes called "horsebone" in the period, linking them to more elaborate English and other European sources which were carved animal legs with hoofs and fetlocks.

15. For examples of chairs made in the same shop that interchange parts, see Zimmerman, "Workmanship as Evidence," p. 297, figs. 11–13.

16. Martin E. Weil, "A Cabinetmaker's Price Book," in Quimby, *American Furniture and Its Makers*, pp. 183, 186.

17. No attempt is made in this essay to distinguish between rococo and late baroque designs as they were realized in such things as carved foliage.

18. Chippendale's third (1762) enlarged and revised edition of the *Director* contains a number of interesting comparisons and examples. The armchair in pl. 17 has a Gothic back, rococo arms, and classical decoration across the front rail and down the leg. Pls. 25 and 26 compare Gothic and Chinese versions. The Gothic frets and Chinese railings in pls. 196 and 197 are very similar.

19. One clear indication is the carved decoration on a Philadelphia upholstered armchair related to those made by Thomas Affleck for Gov. John Penn. It has strong rococo-carved arms and Marlborough legs with Gothic and Chinese panels (illustrated as pl. 6 in Hummel, *Winterthur Guide to American Chippendale Furniture*).

20. For references to specific objects, see the entry for the Massachusetts high chest (cat. 63).

21. See Philip D. Zimmerman, "Regionalism in American Furniture Studies," in Ward, *Perspectives on American Furniture*, pp. 11–38. For an excellent comparative study of regional characteristics, see Kirk, *American Chairs*.

22. The influence of the Scotch-Irish in Connecticut and New Hampshire holds tantalizing possibilities for further scholarship. See Zimmerman, "Regionalism in American Furniture Studies," pp. 33–38.

23. [Sanger], *Very Poor and of a Lo Make*, p. 193.

24. Recent scholarship in English furniture made outside of London has made important strides in identifying regional patterns there as well. For examples, see issues of *Regional Furniture: The Journal of the Regional Furniture Society*.

25. Little has been written about New York Chippendale-style furniture.

## 59 *Side chair*

Philadelphia, Pennsylvania, 1750–65

*Description:* The front seat rail is tenoned into the front legs and secured by a blind tenon. Each side rail tenon is held by a single pin in front; it projects through the rear stile and is secured by small wedges at the top and bottom. The rear rail is held in place by two pins in each stile. Vertically grained two-piece corner blocks reinforce each inside corner of the seat frame. The front shell is applied although no seam is visible through the finish.

*Inscriptions:* "21.44.3" is painted on the front edge of the right side rail.

*Condition:* Plugged mortises in the rear stiles, repairs to fluting and quarter-round molding on the side rails, and dovetail cutouts inside the side rails indicate that the chair was once fitted with arms attached to the side rails by two screws. Evidence does not reveal whether the arms were fitted to the side chair at the time of its manufacture.[1] The left leg is restored below a carefully spliced cut just below the knee carving. The finish appears to be old and undisturbed. The chair is upholstered in a modern yellow silk damask.

*Woods:* Legs, stiles, splat, and other primary wood, mahogany; right rear corner block, yellow-poplar; right rail of slip-seat frame, southern yellow pine.

*Dimensions:* H. 39⅛ in. (100.2 cm), S.H. 16⅝ in. (42.6 cm), W. 23¼ in. (59.5 cm), D. 21½ in. (55.0 cm).

*Bibliography:* Nutting, *Furniture Treasury*, pl. 2181; Jones, "American Furniture," p. 976, pl. I.

*Provenance:* Acquired in 1973 from Joe Kindig, Jr., and Son, York, Pa. (dealer); formerly in the collection of the Metropolitan Museum of Art.

American Chippendale-style chair designs achieved a uniquely satisfying balance of form and decoration in certain examples from Philadelphia. These chairs blended precise handling of massing with intricately carved surface ornament so that the one reinforced the other. Naturalistic motifs and organic shapes resulted in a

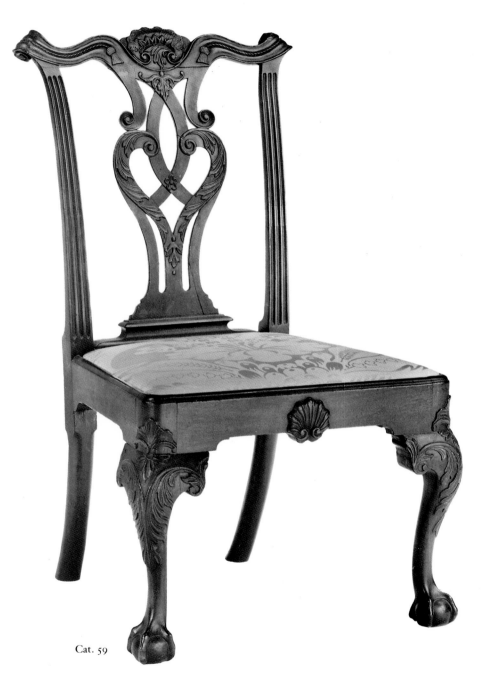

Cat. 59

distinctly American version of rococo designs that, since the earlier 1740s, had been used throughout Europe in furniture, architectural interiors and plasterwork, silver, and all sorts of two-dimensional decorative media.

Renewed interest in the American rococo has led to a more comprehensive understanding of Philadelphia products. Although Germanic and English roots of Philadelphia's urban high-style Chippendale-style designs need further identification and sorting, if indeed they can be identified, the style period can be divided into distinct subperiods, thus ending the tyranny of a single aesthetic standard.[2] This treatment of the furniture gives a fuller context for certain otherwise anomalous characteristics that might appear incongruous.

The plasticity of chair forms makes them excellent sources for detailed study. Milwaukee's example combines archetypical motifs with certain unusual characteristics that lead directly to a chair subgroup. The most representative aspect of the chair's design is the strapwork pattern of the splat. This particular pattern was among the earliest, the most widespread, and probably the longest-lived of Philadelphia designs.[3] The undulating crest rail almost invariably accompanied this strapwork splat. Also representative of the chair's Philadelphia origin are the stump rear legs, which in this chair are oval in cross-section and curved backward.

Beyond these basic elements, the chair exhibits a number of features that attest to its ambitiousness. The splat is fully relieved with four carved volutes, leafage, a bellflower at the top, and a five-petaled flower at the center. An asymmetrical shell is in the hollow of the crest, and tassels lead inward from the heavily rolled ears. In other chairs lacking this degree of ornament, the massing exists but remains unarticulated and somewhat unaccounted for. The applied shell on the front seat rail, the knee carving extending up into the seat frame, and the fluted rear stiles fill out and balance the chair's design. Further touches refine certain details: the undercut front and side rails lighten the appearance of these heavy structural members, and the chamfering of side edges of the splat, crest rail, and

rear stiles gives each of these parts a sharply defined edge when viewed from the front.

A deeper level of analysis exists which qualifies the otherwise clinical description and gives context to specific features and aspects. The oddly shaped stay rail —the horizontal element between the splat and rear rail—links the Milwaukee chair to a small group of Philadelphia Chippendale chairs.[4] In this group, the stay rail flares up and outward to form a heavy quarter-round molding which joins the base of the splat at a fillet. In some, including the Milwaukee example, swelling at the base accentuates the heaviness. The asymmetrical oval shell motif and ears of the crest, knee brackets, and broad quarter-round molding atop the seat rails also contribute to the chair's heavy aspect.

Heaviness is not an attribute that rests easily with the ideal of Philadelphia Chippendale. Yet when the style period is subdivided, the properties inherent in this chair acquire clearer meaning. The group to which the Milwaukee example belongs appears to be an early manifestation of the fully carved, naturalistic work which ultimately acquired a light, fanciful character that may be understood as rococo. Here, however, the elements recall baroque weightiness. The decoration pointedly lies *on* substantial structural elements. In some of the best of later Chippendale period work, decoration blends *into* structural elements.

Although the provenance of the Milwaukee chair is limited, histories of related chairs point to Philadelphia as the probable origin of the group. One was owned by John Rozet of Philadelphia; another was owned in nearby Camden, New Jersey.[5]

An often-cited regional characteristic of Philadelphia Queen Anne– and Chippendale-style chairs is the use of side rail tenons that project through the rear stile. This practice was not universal. Some 10 percent, including a labeled example by Benjamin Randolph, do not have exposed tenons.[6] One technical explanation for making tenons in this way holds that the joint is less likely to break from tension produced by the backward flaring rear legs. The longer tenon provides more wood behind the drilled hole

for the pin, thus reducing the likelihood of longitudinal shear.[7]

*Philip D. Zimmerman*

Purchase, Acquisition Fund
M1973.154

1. Evidence for this practice is discussed in Zimmerman, "Workmanship as Evidence," pp. 298–300.

2. See Benno M. Forman, "German Influences in Pennsylvania Furniture" in Swank, *Arts of the Pennsylvania Germans*, pp. 102–70.

3. English counterparts may also be found, but they do not exhibit any known regional pattern. For visual reference, see Kirk, *American Furniture and the British Tradition*, fig. 879. Another example is at Uppark, Sussex, England.

4. They include side chairs with acc. nos. 59.785, 59.1288, and 60.1063.1–2 at Winterthur; 1930.2496 at Yale University; 18.110.54 at the Metropolitan Museum of Art; one pictured in an Israel Sack advertisement in *Antiques* 63, no. 6 (December 1953): 425; another pictured in a Ginsburg and Levy advertisement in *Antiques* 68, no. 4 (October 1955): 313; and pl. 44 in Hopkins and Cox, *Colonial Furniture of West New Jersey*.

5. Sack advertisement, *Antiques* 63, no. 6 (December 1953): 425; Hopkins and Cox, *Colonial Furniture of West New Jersey*, pl. 44.

6. Published in Kane, *300 Years*, pp. 128–29, cat. 108.

7. See Fitchen, *Building Construction before Mechanization*, pp. 66–67.

## 60 *Side chair*

New York, New York, 1755–85

*Description:* The rear bracket responds are cut out from the side rails, not separate pieces applied below. Two pins secure each tenoned joint of the front and side rails. Blind tenons join the rear rail to the rear stiles.

*Inscriptions:* One of a set of at least six, this example is marked "II" on the inside of the rear rail.

*Condition:* There are repairs to the joints between the crest rail and posts and splat, including a new tenon let into the right post. The left side rail is refitted with a new rear tenon, and the inside of the molding at the rear is repaired. The right side rail, which projects outward slightly from the front leg, has been

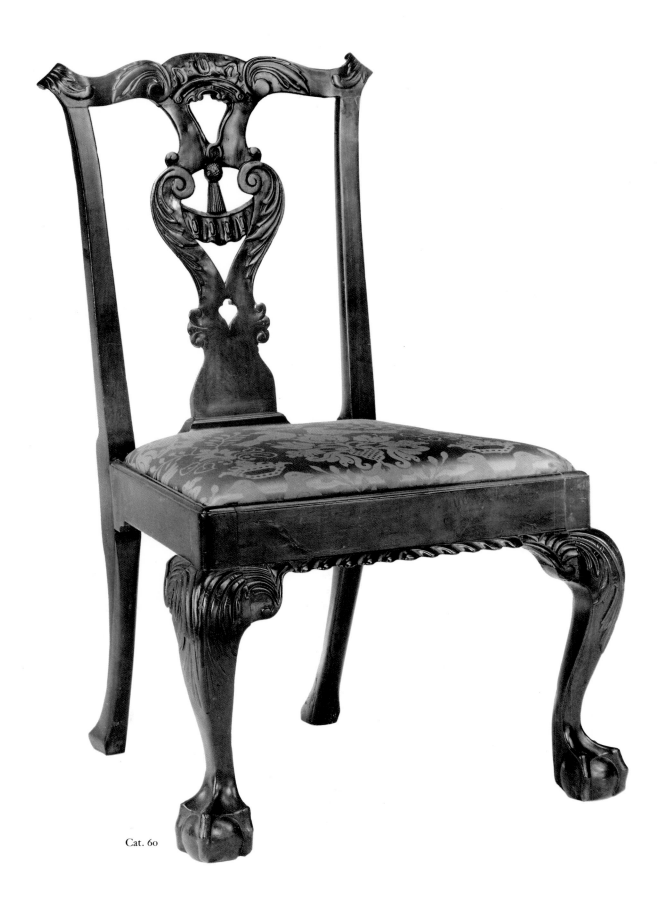

Cat. 60

refitted into a repaired joint. The front rail has been refitted with new tenons into each leg and has a square patch in the lower left. All leg brackets are replacements except for the left front which has been reattached. All corner blocks are replaced. The chair appears to have been completely disassembled at some time except for the gadrooned strip across the front. The chair is upholstered in a modern blue silk damask.

*Woods:* Legs, stiles, splat, and other primary wood, mahogany; right front corner block, sylvestris pine; right rear corner block, hard pine (possibly a western yellow pine); left and rear slip-seat rails, sylvestris pine.

*Dimensions:* H. 38⅝ in. (98.9 cm), S.H. 17 in. (43.5 cm), W. 24¼ in. (62.1 cm), D. 22¾ in. (58.2 cm).

*Exhibition: Villa Terrace,* cat. 39.

*Bibliography: Antiques* 92, no. 1 (July 1967): 18; Jones, "American Furniture," p. 976, pl. 1. (Another chair from this set, formerly owned by the Milwaukee Art Museum, is illustrated in Levy, *"Opulence and Splendor,"* p. 15.)

*Provenance:* History of ownership before 1917 in the Danish Government House at Christiansted, St. Croix, the Virgin Islands.[1] Purchased from Petit and Hug, Neenah, Wis. (dealer).

Some New York furniture exhibits highly localized design and construction characteristics in contrast to other examples which defy neat patterns. The Milwaukee side chair combines the most typical of the many New York regional features in a design that is itself pervasive within the region and unique to it.[2] Many sets of chairs nearly identical to this one survive, and where object histories are known, object ownership may be placed in and around New York City and north to Albany. Despite the large number of survivals, none carries any documentation to its maker. However, even if the maker of one set were known, the widespread practice of borrowing designs from one shop by another precludes extending an attribution to other undocumented sets on the basis of design.[3]

The dominant feature of the Milwaukee chair (and others like it) is its broad,

flatly carved splat composed of leafy scrolls enclosing a tassel and ruffled mantle. The center of the crest recalls the splat decoration, and the ears, with their carved foliage and flipped ends, direct the eye inward. Other characteristics pointing to a New York origin include the heavy gadrooning across the front rail, the blocky feet with unarticulated rear talons, the rear legs ending in blocks, and the use of a decorated bracket below the side rails where they meet the rear stiles.

The carving on the front knees is characteristic of New York work. It is composed of long veins, originating from across the brackets, that cluster in parallel lines to form large leafy motifs. Although many scholars have argued the need to evaluate relative depth and flatness as properties when examining regional characteristics of leg carving, more important to understanding the differences is appreciation of how each naturalistic element is realized. Factors include the massing and outline of each leaf part, veining patterns, and leaf textures achieved by secondary cutting and occasionally punchwork.

The date range established through stylistic analysis for the Milwaukee chair and others like it must necessarily be broad. The chair's design concentrates on surface ornamentation in keeping with rococo trends of the Chippendale period. This is especially evident in the splat and crest rail, which are the most style-sensitive parts of the chair. Yet the execution of these particular designs is heavier, suggesting an earlier, more baroque quality. The projecting ears and broad, square proportions are its later features and help assign its earliest date. Further analysis of this chair reveals workmanship and design that is characteristic of the 1760s, yet nothing precludes its manufacture in the 1780s. By 1790, high-style chairs of this sort are likely to show neoclassical influences.

The specific history of the Milwaukee chair is complicated and uncertain, attributable in part to the great similarities among different sets of this particular design. It belongs to a set of six chairs acquired in 1968 by the Milwaukee Art Center with a history of ownership by the Danish government in St. Croix. In

1984 the St. Croix Landmark Society sold three side chairs and one armchair which appear to be identical to and are probably part of this set.[4]

Other chairs appear virtually identical. However, the existence of small differences in construction or renderings of specific carved details distinguish some of these chairs, most of which carry an association with the Van Rensselaer family of Albany.[5] A thorough examination of all New York chairs of this particular design is necessary to reconstruct the original sets with reasonable certainty. Those in this category include ones owned by the New York State Museum, the Albany Institute of History and Art, the Winterthur Museum, and the Museum of Fine Arts, Boston.[6] In many instances, the vague provenances accompanying these various chairs require additional supportive historical information to determine which branch of that important family may have owned the chairs and when. *Philip D. Zimmerman*

Gift of Friends of Art
M1967.28

1. The provenance recorded in *"Opulence and Splendor"* indicates acquisition from the Danish Government by Solly Wulff, an import/export trader in St. Croix. The set of chairs remained in his family, traveling to Denmark and subsequently to Evanston, Ill., via his daughter, who sold them to Hug.

2. For related comments, see Heckscher, *American Furniture,* p. 69. As with so much American furniture, certain design similarities exist between American and English examples. Kirk illustrates a related English chair in *American Furniture and the British Tradition,* fig. 934.

3. New York eighteenth-century furniture in general demands considerably more scholarly attention to resolve this and many other questions.

4. Sotheby Parke-Bernet (sale 5142; January 26–28, 1984), lots 860–61.

5. Heckscher states that "at least four different sets have associations with the Van Rensselaer family"; see his *American Furniture,* p. 70.

6. Scherer, *New York Furniture,* fig. 10; Kirk, *American Chairs,* p. 117, fig. 137; Hummel, *A Winterthur Guide to American Chippendale Furniture,* p. 17, fig. 1 (the Van Rensselaer association is recorded in Winterthur registrar records for this and a matching set of six side chairs); and Hipkiss, *Eighteenth-Century American Arts,* cat. 87.

## 61 *Side chair*

Boston or Salem, Massachusetts, 1765–75

*Description:* The rear stiles join the crest rail at a point about ¼ in. (.6 cm) higher than the splat. The front and side rails are secured to the front legs with blind tenons. One pin holds the side and rear rails into the rear stiles. The rear rail has mahogany veneer over soft maple. Four maple cross braces in the inside corners reinforce the seat frame. Horizontal-grain corner blocks are applied with two nails each in the front corners and with two screws each in the rear.

*Condition:* A repair has been made to the right strap of the splat. The left rear stile is split at the juncture of the seat rail, and the left side of the shoe is split. The knee brackets have been reattached but appear to be original. The rear cross braces, also appearing to be original, are now screwed into place. Severe finish losses appear on the outside of the right front leg. The upholstery is a modern red silk damask.

*Woods:* Legs, stiles, splat, and primary wood, mahogany and mahogany veneer; rear seat rail, soft maple; right side and front seat rails, birch; right front corner brace, soft maple; other corner blocks and braces, birch.

*Dimensions:* H. 38 in. (97.3 cm), S. H. 17⅞ in. (45.8 cm), W. 22⅞ in. (58.6 cm), D. 21½ in. (55.0 cm).

*Bibliography:* Robert W. Skinner, Inc. (sale 373; March 25–27, 1976), lot 280; Jones, "American Furniture," p. 976, pl. 1.[1]

*Provenance:* Purchased from the estate of Dr. Lloyd Cabot Briggs of Boston, Mass., and Hancock, N.H., at a Robert W. Skinner, Inc., sale (March 25–27, 1976), and sold by John S. Walton, Inc., Jewett City, Conn. (dealer).

American Chippendale-style furniture seldom bears any direct relationship to the published design books of cabinet-maker Thomas Chippendale or those of his London colleagues. Of the American products that reproduce designs of Chippendale's *Gentleman & Cabinet-Maker's Director* (published in London in 1754, 1755, and 1762), most come from Philadelphia. The Milwaukee side chair represents the only known Massachusetts set of chairs which faithfully conforms to a specific printed design from the *Director*, in this case plate 12 dated 1753 in the first, or 1754, edition.[2] Nathaniel Gould of Salem is known to have owned a copy of the *Director*, and "Boston 1768" appears on the title page of another copy.[3] Chippendale's commentary on the plate is also germane: "The Seats look best

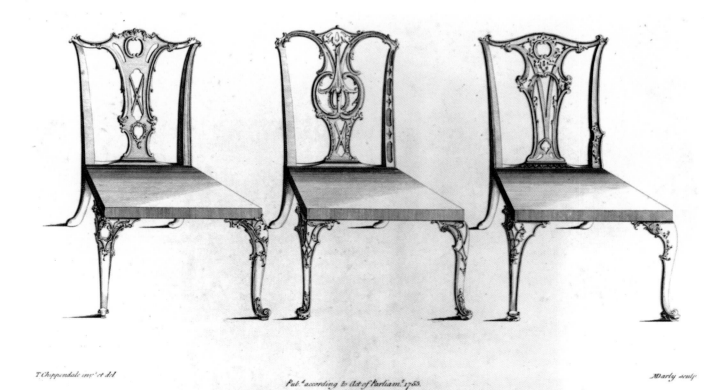

T. Chippendale inv.' et del.    Pub.' according to Act of Parliam.' 1753.    M.Darly sculp.

Designs for chairs. From Thomas Chippendale, *The Gentleman & Cabinet-Maker's Director* (London, 1754), plate 12. (Courtesy, The Winterthur Library: Printed Books and Periodical Collection.)

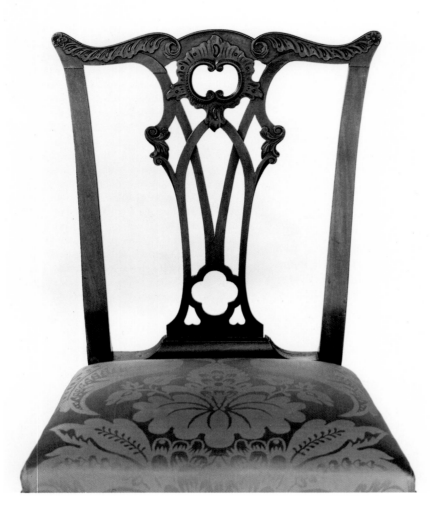

Cat. 61

that brace the lower portion of most Massachusetts chair legs. Although stretchers may have appealing designs of their own, their placement interrupts the line of the legs. Consequently, such details as the subtle taper of the rear legs just above the bulbous squared base evident in the Milwaukee example might otherwise be lost.

The unusual design features of the Milwaukee chair link it to other notable examples, thereby broadening our understanding of this object. Its dependence upon English pattern books associates it with at least two sets of chairs that use a back design based on Robert Manwaring, *The Cabinet and Chair-maker's Real Friend and Companion* (London, 1765), plate 9, a publication known to have been owned in Boston.[5] One example which retains its original over-the-rail upholstery foundation, now at the Massachusetts Historical Society, faithfully reproduces the published design in full-relief carving.[6] Another example, at Winterthur, has no relief carving on the splat or crest rail but carries an important pencil inscription on the front rail, "Bottumd–June 1773 / by WVE Salem," giving the time and place that that chair was upholstered.[7] Further evidence is needed to determine whether these chairs were made in Boston or Salem.          *Philip D. Zimmerman*

Gift of Friends of Art
M1976.37

1. Another chair from this set was published in Cooper, *In Praise of America*, fig. 207, and again in Jobe and Kaye, *New England Furniture*, p. 24, fig. 1–20.

2. The plate remained number 12 in the second edition of 1755 but became plate 14 in the enlarged third edition of 1762. Plate 13 of the third edition, which is dated 1761, also duplicates this particular chair design.

3. Another copy of the *Director* descended in the Goddard family of Newport. See Brock Jobe, "Urban Craftsmen and Design," in Jobe and Kaye, *New England Furniture*, p. 19 n. 60.

4. Chippendale, *Director*, p. 3.

5. Jobe reports that a 1767 Boston newspaper advertised this publication and that architect Thomas Dawes owned a copy ("Urban Craftsmen and Design," p. 19).

6. Published as fig. 1–12 in Jobe, "Urban Craftsmen and Design," p. 19, and as fig. 152 in Mary Ellen Hayward Yehia, "Ornamental Carving on Boston Furniture of the Chippendale Style" in *Boston Furniture*, p. 219.

7. Accession number 56.52.

when stuffed over the Rails . . . most [are] commonly done with Brass Nails, in one or two Rows."[4]

The chair back expresses a level of control of wood that is notable in New England furniture making. The straps of the splat vary in thickness and exhibit considerable depth in their two-dimensional relief. The carved volute sprays at either side and the central double C-scroll mantle provide strong naturalistic focal points that are reinforced by the ruffle carving along the crest rail. The tightly curled leaves at the center end of each ruffle impart a visual tension that lends vitality to the whole.

The strong rococo character of the chair back, a quality not generally associated with New England furniture, is not as apparent in the knee carving of the front legs. Acanthus leaves flow out from under the upholstered seat rails and down the leg, but their edges conform too neatly to the hollow curve of the leg and the applied brackets at each side. The spareness of the leg, however, then contributes to a tensioned stance as the leg bends sharply at its slender ankle, and long, thin talons, measuring 1¼ inches (3.2 cm), stretch around a large ball.

Part of the drama visible in the front legs comes from the lack of the stretchers

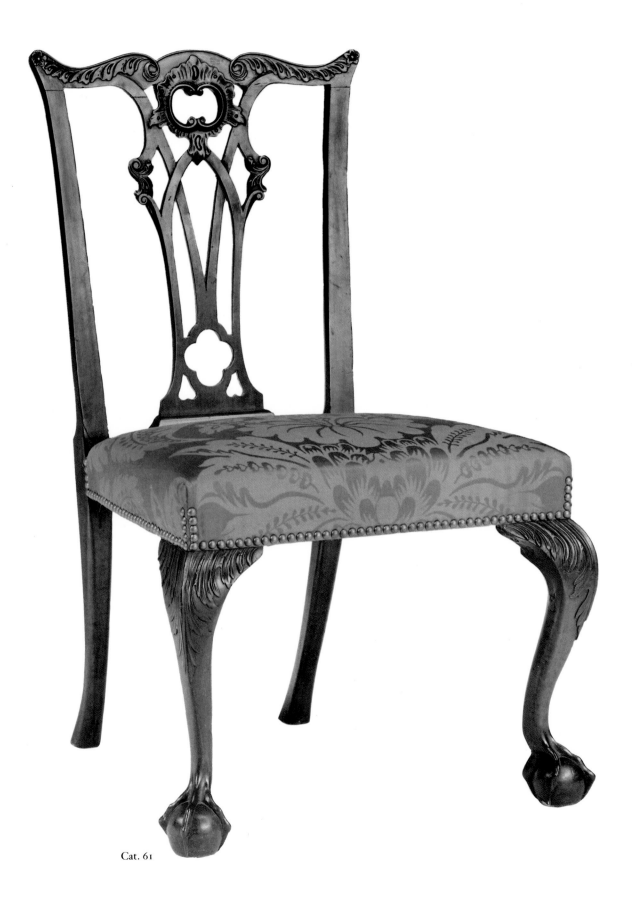

Cat. 61

## 62 *High chest of drawers*

Philadelphia, Pennsylvania, 1760–75

*Description:* The dovetailed top of the upper case rises above the cornice moldings about ¼ in. (.6 cm) and is rounded at the edges, suggesting that the moldings have not been relocated. The bonnet is formed by a large board, unsupported from behind, to which moldings are attached by screws from the back. The rosettes and scroll-board carving are applied. The flame finials, urns, and plinths are each attached with dowels. The drawer dividers are double-tenoned into the drawer blades, which are 3-in. (7.7-cm) mahogany strips with full dustboards behind. Two wide backboards with grain running from side to side are lapped and nailed into rabbets. The top and bottom quarter-columns are made of three parts. The moldings separating the upper and lower cases are composed of two pieces of wood and enclose the base of the upper case. The lower drawer dividers are secured by single tenons. The bottom is enclosed by boards reinforced by horizontal strips nailed to the back and front skirts. The lower shell is applied. The rear legs have no decorative carving.

All drawers have thumbnail molded edges.

Small neat dovetails secure the drawer sides to the front and back. The bottom boards run from front to back and are let into a groove on the front and sides. Reinforcing strips are secured with sprig nails and glue to the underside of the drawer bottom at the front and sides. The back edge of the drawer bottom is flush with the drawer back and secured with wrought nails.

*Inscriptions:* "Vain youth beware the trap is nigh / And Dangers great in ambush Lie / Waiting with Jaws Extended wide /

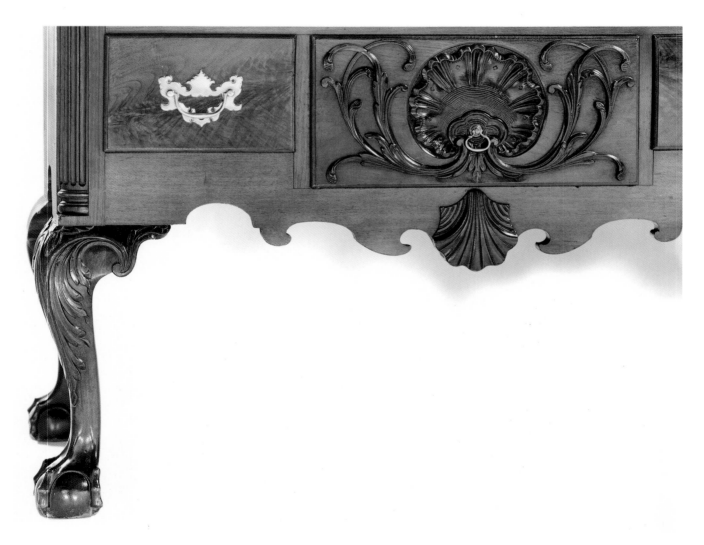

Cat. 62

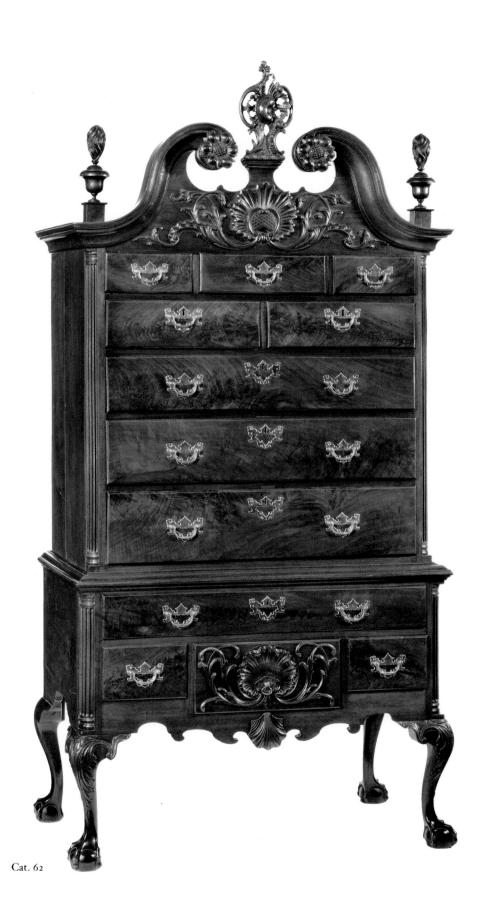

Cat. 62

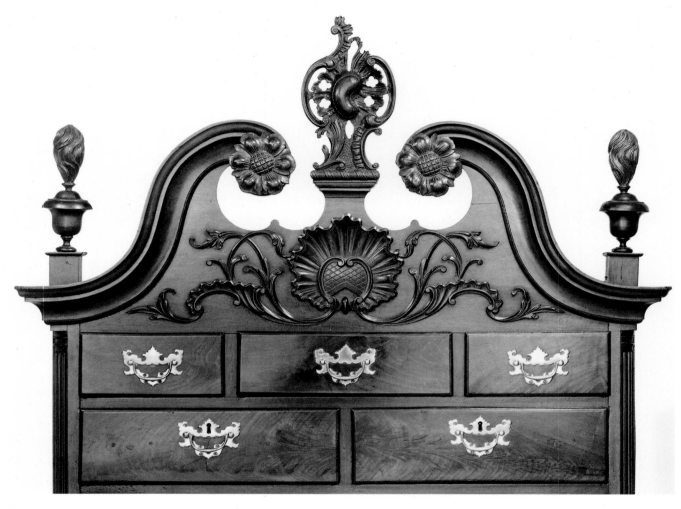

Cat. 62

Your soul & Body to Divide" in pencil on the bottom of the middle long drawer of the upper case.

*Condition:* The central cartouche is a replacement. The plinth on which it rests is oxidized and colored the same as other bonnet surfaces; no evidence points to any previous plinth. The flame finials and their plinths are replacements. The original side ornaments fitted into rectangular mortises, now unused, cut beneath the present plinths. Small foliate returns are missing from each extremity of the scroll-board carving. The rosettes appear

to be original. The left side of the upper case has pulled away from the engaged quarter-column, revealing some of the tenons that hold the column in place. Filled holes in the two drawers comprising the second tier indicate that each drawer once had two sets of brasses. All five upper drawers and the two lower side drawers once had center pulls as well. Repairs have been made to all of the blades above the long drawers where locks are fitted. All of the brasses are replacements; their design is appropriate to this particular high chest.

*Woods:* Primary wood, black walnut; drawer sides and backs, dustboards, yellow-poplar; drawer bottoms and runners, top board of upper and lower cases, glue blocks, Atlantic white cedar.

*Dimensions:* H. 94½ in. (241.9 cm), W. 46¾ in. (119.7 cm), D. 23¾ in. (60.8 cm).

*Provenance:* Acquired by Joe Kindig, Jr., and Son, York, Pa., from Robert R. Logan about 1938. Logan's mother was related to the Wistars of Grumblethorpe in Germantown, Pa.

The Philadelphia Chippendale-style high chest is an icon of early American furniture, and deservedly so. It embodies substantial craft skills as well as expressing sophisticated and distinctly American design. Scholars and connoisseurs have often dissected this furniture form in order to reveal and understand its complexities, but its richness provides still-untapped reserves. After a time of relative neglect, the Philadelphia high chest is again undergoing intense scholarly examination.

To a degree unsurpassed in examples of other regional style centers, the Philadelphia high chest successfully integrates form and decoration to produce an object of monumental scale and minute detail. A sketch of the major design features must emphasize attention to proportion, balanced carving, and effective use of decorative detail. Massive cabriole legs visually bend to support the weight of a broad base, which carries a slightly narrower upper case. Carved knees, skirt, and shell drawer in the lower case balance the expanse of carving at the top. The elevated cartouche establishes a strong axis which drops down the line of brass escutcheons and through the lower shell drawer to a carved motif at the lowest part of the skirt. Engaged quarter-columns and the lines formed by the brass handles give vertical definition to the high chest's mass.

The richest detail in the high chest appears as the carved decoration on the shell drawer, on the pediment, and in the cartouche. Although combinations of shells and leafy vines in shell drawers and in pediment carving typify many fine examples from Philadelphia, identification of particular mannerisms evident in the Logan high chest allows relationships to be drawn to other known examples. No single trait is sufficient to establish any such object groups, but a number of traits considered together makes these relationships compelling.

One key to linking the Logan high chest to other Philadelphia Chippendale-style chests is the selection of motifs and their arrangement in the scroll board and in the lower shell drawer. The scroll board contains a large shell-like motif composed of opposed C-scrolls enclosing diapering and surrounded by a large

ruffled mantle. Vines trail out to each side. Although the particular treatment of the center motif changes among the related high chests, the use of C-scrolls and mantle does not. Moreover, the pattern of the vines is nearly identical among examples in the group.

Strong similarities, again especially evident in the trailing vines, recur in the lower shell drawer of these various high chests. The drawer itself is the only drawer to carry carved decoration, unlike many other high chests which have a carved drawer at the top of the upper case. The decoration of the skirt, scalloped in this instance, varies among this group of high chests.[1]

Among the distinctive characteristics of carving on the Logan high chest is the treatment of the tips of the leafy vines. These foliate ends are textured by a series of parallel cuts placed perpendicular to the vine's stem, rather than being more naturalistically modeled. Use of parallel lines occurs again in the shell drawer as concentric rings emanating from a trefoil, again representing a device that adds texture to a naturalistic surface. Both the rings and the trefoil appear in carving on other Philadelphia Chippendale-style high chests (as well as dressing tables and other case forms). The trefoil, for example, appears in the pediment shell of a high chest at Yale as well as a closely related high chest at Winterthur.[2] Cross-hatching in the Logan pediment shell and rosettes is another common denominator linking carving techniques on this object to the others. Lastly, the shells themselves exhibit distinctive mannerisms in defining the outer edges of the motif and in forming the undulating movement within.

By relating the Logan high chest to a larger body of furniture, one that will grow further as scholarship continues to unravel the intricacies of Philadelphia carving, this particular high chest becomes better understood.[3] Original brasses surviving on the Winterthur and Yale examples relate closely to the replacements now on the Logan high chest and suggest a date range somewhere in the middle of the Chippendale period. Omission of the upper shell drawer below the decorated pediment represents a particular drawer configuration that evolved during the

Chippendale period, perhaps after 1760 or so (the earlier configurations having an enlarged upper shell drawer or a shell drawer stacked on top of the range of three small drawers).

*Philip D. Zimmerman*

Purchase, Virginia Booth Vogel Acquisition Fund
M1984.120

1. A nearly identical skirt appears on a high chest illustrated as fig. 11 in Comstock, "The Collection of Dr. William S. Serri," pp. 256–57.

2. The Yale high chest is reproduced and discussed in Ward, *American Case Furniture*, cat. 147; and Kirk, *Early American Furniture*, pp. 30–33, figs. 17–18. The Winterthur chest is reproduced as cat. 197 in Downs, *American Furniture*. Other closely related high chests include one in the Department of State collection reproduced in Sack, "The Furniture," p. 164 (also advertised by David Stockwell in *Antiques* 87, no. 4 [April 1965]: 365); and examples owned by the Philadelphia Museum of Art and the Nelson-Atkins Museum of Art, Kansas City, Mo. Another high chest showing slight departures in carved ornament and carrying markedly different brasses which may not be original was sold at Sotheby's (sale 5094; October 21–22, 1983), lot 315.

3. Alan Miller and Luke Beckerdite continue to expand our understanding of carving and the relationships among Philadelphia Chippendale-style furniture (see, for example, the recent articles by Beckerdite listed in the Bibliography). The author acknowledges their important and insightful contributions.

## 63 *High chest of drawers*

Boston or Salem, Massachusetts, 1755–75

*Description:* The pine bottom of the upper case is dovetailed into the sides. Three large boards with horizontal grain nailed into rabbets cover the back. The bonnet is fully enclosed. All moldings are cut from solid stock. The drawer runners of the lower case are set into blind mortises in the rear and are tusk-tenoned in front. The rear board of the lower case is tenoned into the legs and secured with three pins. The sides, composed of two boards, are tenoned into the legs and also secured with three pins on each side. Two fielded

panels cover the top of the lower case. Cockbeading appears as a molding cut into the drawer blades and side facings. The wide dovetailed drawers have bottoms made of two or three wide boards with grain running front to back and nailed in back. The top of the bonnet and the backboards have a black coating. Each shell is a half-circle with a 4½-in. (11.5-cm) radius with fifteen lobes.

*Condition:* The upper case rests on pads at each corner; these raise the case about ⅛ in. (.3 cm) above its original location and make the bottom dovetails visible from the sides. The top backboard is split at the arch. The top framing member and molding of the lower case are repaired at a split in the center. The right leg is repaired at the top, and various other fills and small repairs appear elsewhere. The drops are replacements. The second escutcheon from the top is replaced, but all other brasses appear to be original. The finials are probably replacements. The finish is modern.

*Woods:* Primary wood, mahogany; drawer linings, bottom of upper case, other secondary wood, eastern white pine.

*Dimensions:* H. 85½ in. (218.9 cm), W. 40½ in. (103.7 cm), D. 20¾ in. (53.1 cm).

*Bibliography:* Jones, "American Furniture," p. 979, fig. 7.

*Provenance:* Descended in the Manniere family of Boston, Mass. Purchased from Ginsburg and Levy, New York, N.Y. (dealer).

The American high chest of the 1760s and 1770s continued a design tradition begun in England and reinterpreted in America from the beginning of the eighteenth century. The high chest was, in form and function, a chest of drawers lifted on a four-leg base which was also fitted with drawers. Often called a "case of drawers" or "chest of drawers" in New England probate inventories, the high chest typically accompanied a dressing table, in turn referred to at times as a chamber table, bureau, or just a table.[1] Together, these two case pieces served as the major case furnishings of a bedchamber.

New England cabriole-leg high chests of the Queen Anne and Chippendale styles had either flat cornice-molded tops or bonnets created of a central finial separating a broken ogee-curved arch. Flat-top high chests represented a direct inheritance of the William and Mary style and might be considered the earlier form. Nonetheless, they were made throughout the Chippendale period. For example, a high chest of this general form in the collection of the Manchester (New Hampshire) Historical Association is dated "1785" on the back.[2] The earliest dated example of a broken-arch topped case piece is the 1738 desk and bookcase signed and dated by Job Coit of Boston, now at Winterthur. A very slender-proportioned Boston desk and bookcase with star-and-line inlays, at the Museum of Fine Arts, Boston, also has a broken-arch top and may be dated on stylistic grounds as early as the late 1720s.[3] Thus, the treatment of the top did little to signal a significant design change between the Queen Anne and Chippendale styles.

One of the key differences between Queen Anne– and Chippendale-style high chests is the organization of the skirt. Queen Anne–style skirts were divided into three distinct sections, defined by the front legs and two inverted plinths into which were fitted turned elements called drops. Skirt contours between the vertical elements were typically horizontals or double ogees at the sides and often a simple curved void below a small shallow drawer in the center with hollows and fillets providing visual transitions. This entire organization recalls the six-leg high-chest bases of the William and Mary period.

New England Chippendale-style designs omitted the drops in favor of bisymmetrical scalloping across the entire skirt. Visual movement begins at the curved leg, moves through the leg bracket, and crosses the front at a carefully modulated pace, often incorporating the shell more directly than the detached elements of the Queen Anne period. In both style periods, the lower shell recalls directly the upper shell, usually identical, and unifies the lower and upper cases. The practice of retaining Queen Anne–style designs throughout the Chippendale period makes dating on the basis of style

problematic. This fact, very much in evidence in the Milwaukee high chest, demands detailed analysis to narrow the date range from the extremes of both styles, namely from 1730 to 1790.

The use of claw-and-ball feet, here executed in the Massachusetts manner of long, narrow talons on a high ball with the side talons raked back, is a convenient device to suggest an earliest date of midcentury. Another detail, decidedly of the Chippendale style, appears in the shape of the leg bracket. The tightly curled volute mass, which many furniture historians associate with Salem work, introduces a rococo touch that breaks the dependence upon line across the skirt. The skirt itself is close in form to that on an ornate high chest made in 1739 by Ebenezer Hartshorn (1689–1781) of Charlestown or Boston (Museum of Fine Arts, Boston). In each, the lower shell is indented, which introduces additional movement front-to-back, and prominent ogees make the transitions to the drops. Unlike the Hartshorn high chest, however, the Milwaukee example carries Chippendale-style brasses which are positioned in keeping with the later style, namely in vertical rows centered on the two small drawers in the top and bottom cases.[4] In the earlier positioning of brasses, the outer rows are closer together, since they follow the position of escutcheons centered in each of two small, rather than three small, drawers in the upper case.

The upper case drawer configuration of three small drawers above four wide drawers graduated in height is the most common in Massachusetts and in New England furniture. The higher central shell drawer carries the geometric shell scribed out by a compass and then carved. The lower side drawers give space for the bonnet molding. Other New England patterns include two small drawers across the top in some late eighteenth-century Rhode Island high chests, a holdover from early Queen Anne–style designs, and an arrangement in Connecticut and New Hampshire that has a large shell drawer with two small horizontal drawers on each side. This arrangement also appears in some Scottish furniture and may prove useful in separating Scotch-Irish influences from English in New England case furniture.

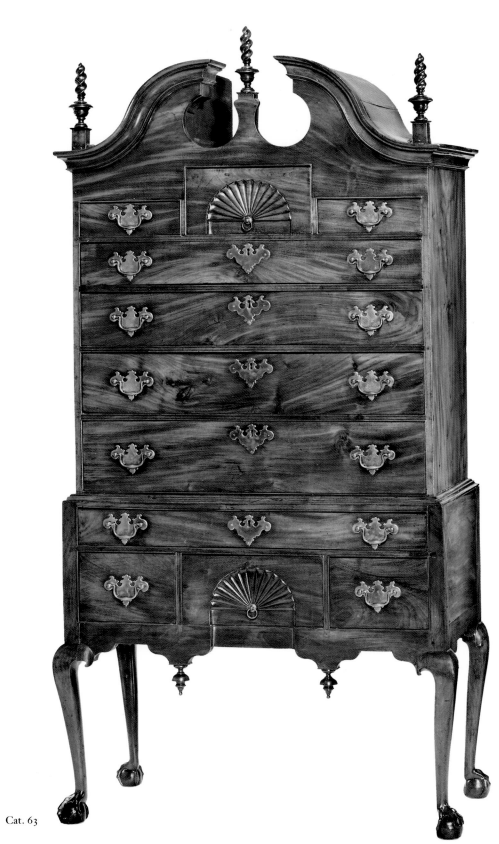

Cat. 63

The Milwaukee high chest has cock-beading molded into the case around the drawer openings. Alternatives include thumbnail moldings around the drawer fronts, which tend to be favored in less urban work, and cockbeading around the drawers. The latter reflects the original function of cockbeading which was to protect edges of veneered drawer fronts, a common practice in English and European furniture.

*Philip D. Zimmerman*

Gift of Friends of Art
M1969.13

1. See Jobe and Kaye, *New England Furniture,* p. 194.
2. Another in a private collection, closely related to the Manchester one, is dated "1790" on the back.
3. The Coit desk is discussed in detail in Evans, "Genealogy of a Bookcase Desk," pp. 213–22. The inlaid desk is published in Hipkiss, *Eighteenth-Century American Arts,* pp. 28–30, cat. 18.
4. For reference, see the important documented high chest of much the same form, signed by Benjamin Frothingham of Charlestown (working ca. 1755–1809), at Winterthur (acc. no. 67.1445). Another important high chest documenting the longevity of this general form in New England is one signed by Brewster Dayton of Stratford, Conn., and dated 1784, also at Winterthur (acc. no. 68.772).

## 64 *Desk and bookcase*

Boston, Massachusetts, 1765–90

*Description:* The pediment is supported from behind by two solid braces. Each side plinth has a molded fragment supporting it from the rear. The rosettes are carved from the solid stock used to make the applied pediment moldings. The pilasters, capitals, bases, dentiling, and moldings are all applied. All molding segments are from solid stock except the dentiling, which is built up from two pieces of stock. The tenons of the top and bottom door rails show through the sides of the doors. Top and bottom boards of the upper and lower cases are dovetailed into the sides. Three wide horizontal boards are nailed to rabbeted sides of both upper and lower cases. The upper case fits inside molded edges on the top of the lower case.

The sides of interior drawers have quarter-round-molded top edges. The prospect door encloses an open compartment with a drawer above and below. The upper drawer front has a double-ogee scalloped bottom. The drawer blades of the lower case have mahogany facings on pine boards 4½ in. (11.5 cm) wide. Cockbeading around the drawer openings is molded into the blades and case sides. Drawer bottoms are composed of three wide boards glued with grain running front to back. The recessed bottom blade is let into the bottom board with squared, rather than dovetailed, sides. The leg brackets are faced on large blocks made up of thick, horizontally laminated boards. The inside surfaces of the rear claw-and-ball legs have been left unarticulated. A thin strip along the front edges of the side boards of the lower case covers the drawer blade joints. The lopers have 1½-in. (3.8-cm) mahogany facings applied to cherry boards.

*Inscriptions:* "Bought at Auction–/1st Sept–1827–/cost $30.00cts" is written in ink on top of the left candle slide. "H.P.H / 1846" is in blue paint on the side of the left column drawer, and "C.C.N." appears on the back of the right column drawer.

*Condition:* Diagonal splits and inset repairs appear in the pediment; the right brace is split. The finials are probably old replacements. The central one, different from each side, is covered with gold paint, which is not original. The lower drawer behind the prospect door and the right bottom interior drawer are replacements. The prospect door has replaced hardware which now requires that the column door be removed before the inside bottom drawer may be opened. The hinges of the slant lid have been repositioned toward the outside. The escutcheons on the lid and on the top drawer have square post-hole fills. All escutcheons are applied with brass nails. The brasses appear to be original.

*Woods:* Primary wood, mahogany; secondary woods, drawer bottom, foot block, pediment brace, top, back, and bottom boards of upper case, eastern white pine.

*Dimensions:* H. 101⅞ in. (260.8 cm), W. 45⅛ in. (115.5 cm), D. 23⅝ in. (60.5 cm).

*Provenance:* Purchased from John Walton, Inc., Jewett City, Conn. (dealer).

Eighteenth-century desks and bookcases were among the largest and most expensive pieces of furniture in a household. These imposing objects not only announced their owners to be men of letters and accounts, but they conveyed their taste. Estate inventories typically locate them downstairs, often in a back parlor or hall, but individual circumstance and convenience governed their location.[1]

Massachusetts desks vary considerably and are among the most creative expressions of this form in America. They are designed and constructed in two distinct parts: a lower case that may stand alone as a well-proportioned slant-lid desk, and an upper cabinet that sits within moldings applied to the desk top.[2] The upper cases are often architectonic, having engaged pilasters supporting a pedimented top. The desk bases are handled in a variety of ways.

The blocked facade of the Milwaukee desk is a characteristic, but not exclusive, New England treatment. Its origins are European, and its first documented use in America is on the 1738 Job Coit desk and bookcase at Winterthur. In that use, the blocking of the top drawers is rounded, rather than squared, which seems to have been used subsequently. Early blockfronts were also made with rounded projections, with massing like half-round cylinders, rather than the truncated vertical elements evident here.[3] At the end of the century, many desks were made with reverse serpentines or "oxbows," which follow the same general massing with quite a different visual effect.

Blockfront furniture clearly was more expensive than that with plain graduated drawers. The blocking required substantially larger pieces of primary wood as well as additional labor. In some examples, often associated with Salem, the blocking is carried up into the lid.[4] Aside from blocking, a rarer and more costly treatment of the desk was a bombé, or "swelled," form to which was sometimes added a serpentine front.[5]

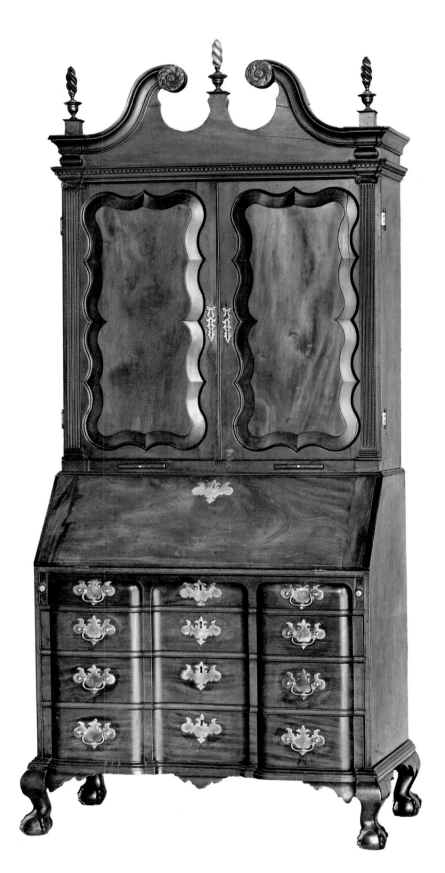

Cat. 64

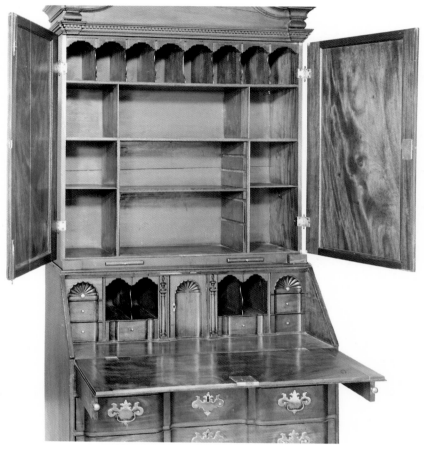

Cat. 64

Boston Chippendale-style desk interiors vary among basic designs. All interiors have a central door, typically fan- or shell-carved, which provides a strong axial focus. It can be flanked by pigeonholes only or have shell-carved drawers at each side, as does the Milwaukee desk. The interiors may also be stepped, in which case the bottom row of drawers projects forward. One other variant has drawers and pigeonholes on either side of the central door that are scalloped in plan. The better interiors incorporate such features as thin column drawers, hidden drawers behind the prospect, and other conceits. Although it is tempting to try to draw relationships among Boston desks based on their interiors, the many documented desks by Benjamin Frothingham show that he, and by extension other competent cabinetmakers, could supply virtually any design.[6]

The very best bookcase tops had mirrored glass set within scalloped-framed doors. The Milwaukee desk has deeply fielded mahogany panels with engaged Ionic pilasters at the sides. The pilasters support a narrow dentiled architrave, and above each pilaster is a bold pulvinated frieze. Lesser examples lack scalloping and fielded panels, as well as the rich architectural detailing. Separation of the pediment from the bookcase doors by the architrave appears to be a design alternative introduced about midcentury.[7] The earlier design, which continued to be popular throughout the century, employs paired doors with round-arch tops that extend into the tympanum of the pediment.[8]

Current scholarship does not allow precise regional identification for many desks and bookcases like the Milwaukee one. Their histories and similarities to one another clearly place them in the urban communities of eastern Massachusetts, but distinctions between Boston and its neighboring towns like Charlestown cannot be made. Although many Salem products display their own distinctive characteristics not in evidence on the Milwaukee desk, some Salem furniture makers worked in styles indistinguishable from those of the best Boston craftsmen.[9] Thus, Salem too may possibly have been the place of origin for this desk.              *Philip D. Zimmerman*

Purchase, Layton Art Collection
L1979.11

1. Cummings, *Rural Household Inventories*, p. xxx.
2. Desks that were originally made to support a bookcase typically have tops made of pine or other secondary wood that was hidden by the upper case. Those desks intended to stand alone have primary woods neatly dovetailed in place.
3. For a thorough discussion of Boston blockfront furniture, see Margaretta Markle Lovell, "Boston Blockfront Furniture," in *Boston Furniture*. pp. 77–135.
4. See, for example, such a desk and bookcase signed by John Chipman of Salem in Israel Sack, Inc., *Opportunities in American Antiques*, Brochure 43 (July 1, 1988), pp. 28–29, and a desk by Henry Rust illustrated as fig. 84 in Lovell, "Boston Blockfront Furniture," p. 121.
5. For a good serpentine-front bombé desk and bookcase, see Downs, *American Furniture*, fig. 227. Gilbert T. Vincent discusses the bombé form in "The Bombé Furniture of Boston," in *Boston Furniture*, pp. 137–96.
6. Frothingham's breadth is evident in Richard H. Randall, Jr., "Benjamin Frothingham," in *Boston Furniture*, pp. 223–49.
7. An early use of engaged pilasters, a necessary design precursor to separating the pediment, is documented by the 1753 desk and bookcase signed by Benjamin Frothingham and D. Sprage in the collection of the Department of State, Washington, D.C.
8. A particularly fine example of this design in the collection of the Currier Gallery of Art, Manchester, N.H., is dated 1799.
9. Some Salem characteristics are detailed in Lovell, "Boston Blockfront Furniture," pp. 120–25.

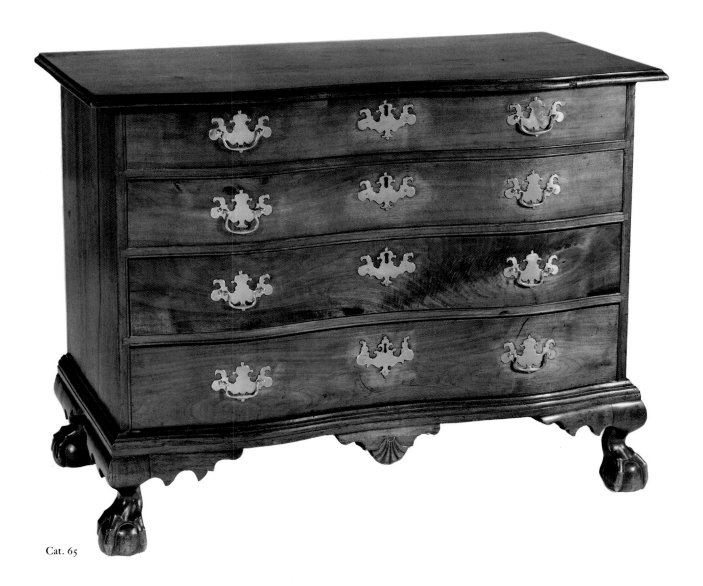

Cat. 65

## 65 Chest of drawers

Probably eastern Massachusetts,
1790–1800

*Description:* The top is made of three boards glued together and secured to the sides by half-dovetails. The three top drawers are fitted with locks. The top drawer is divided into three equal compartments by dividers slotted into the drawer front and back. Drawer sides are attached to the fronts by two large dovetails and to the rear by three dovetails. Drawer bottoms are single boards with grain running side-to-side, slotted into the sides and secured to the rear with three nails. All drawer blades are cut straight behind except the third from the top which has an oxbow contour paralleling the front. The bottom blade is backed by a narrow strip of maple. The center drop and all front and side brackets are mahogany facings on thick pine. The insides of the rear feet are uncarved. Water-powered saw marks remain on many drawer parts.

*Inscriptions:* "I.S." is branded on the right side of the backboard of the top drawer and on the right edge of the backboards of the case.

*Condition:* A dovetail splice appears on the underside of the top in the left rear overhang where the top boards join. A surface repair has been inset into the left rear bracket. A crack running the length of the left side has been filled, as has been a partial crack on the other side. Evidence suggests that a small label, perhaps a dealer's, was affixed to the right drawer side, inside at the front, of the top drawer. The top drawer bottom is split and repaired. The brasses appear to be original.

*Woods:* Primary wood, black walnut; secondary wood, inner frame, back, drawer

runners, left front foot block, eastern white pine.

*Dimensions:* H. 33 in. (84.5 cm), W. 41¾ in. (106.9 cm), D. 22¾ in. (58.2 cm).

*Bibliography:* Jones, "Museum Accessions," p. 828.

*Provenance:* Purchased from Philip Budrose Antiques, Marblehead, Mass. The "I.s." brand may indicate ownership at one time by Israel Sack, Inc., New York, N.Y.

Oxbow chests are distinguished by their double-swelled front. Drawer fronts and framing are cut into this undulating shape from solid wood stock. Vertical rows of brass handles define the forwardmost projections, and brass escutcheons mark the central recess. Projecting board tops and stepped molded bases also conform to the double curve. Oxbow chests with claw-and-ball feet appear to be as common as those with bracket feet.

Many examples of oxbow cabinetry survive. They exist as chests of drawers, as desks with or without bookcase tops, and as the bottoms of double chests. Comparisons with other pieces of furniture and specific documented examples place their manufacture in Massachusetts, Connecticut, and, to a lesser degree, New Hampshire and other regions.[1] What makes them a particularly interesting furniture form to consider, however, is their time of manufacture, which the weight of evidence places in the 1790s. Thus, they represent an imaginative and visually pleasing adaptation of Chippendale-style designs that competed successfully with the new federal designs that were just then spreading rapidly throughout New England.

Not many pieces of American Chippendale-style furniture can be dated precisely by inscriptions or makers' labels for which narrow date ranges are known. Bills and family histories are less certain indicators of date because they represent evidence that historians must judge to be associated with particular objects. Given the variety of furniture forms known, it is notable that many oxbow examples can be firmly dated by inscriptions and makers' labels. Except for a single example dated 1780, a

relatively long list of oxbow chests well documented by intrinsic evidence establishes that they were made from 1789 through, and doubtless beyond, 1800.[2] Those in public collections include a desk and bookcase made by George Belden of Hartford and inscribed 1791 (Wadsworth Atheneum); a chest of drawers with a printed label dated November 4, 1794, of Daniel Clay of Greenfield, Massachusetts (Historic Deerfield); a desk and bookcase inscribed 1794 (Metropolitan Museum of Art); a chest of drawers by Bates How of Connecticut inscribed 1795 (Yale University); and a desk and bookcase inscribed 1799 and "Gilmanton, N.H.," its probable destination (Currier Gallery of Art).[3] Three other objects lending further support to the narrow date range for oxbows are a desk labeled by Benjamin Frothingham with a federal-style fan inlaid in the interior prospect door and two chests of drawers labeled by Jacob Forster.[4] Except for the 1780 chest-on-chest noted above, evidence supporting earlier dating is virtually nil.[5]

Furniture scholars have not identified a specific source for the oxbow design. In terms of line, it reverses a serpentine, a shape that appears in printed design books such as Chippendale's *Director* and Ince and Mayhew's *Universal System of Household Furniture*.[6] These and related sources associate the serpentine with French furniture, particularly chests of drawers or "bureaus." They use the term "commode" with some consistency, which underscores the French origin. That term occurs in American written sources, notably the 1772 Philadelphia price list, but its use in other regions is rare. There, the favored adjective seems to have been "swell'd," a generic term for any kind of curved shaping. "Swelled bracket feet" typically refers to ogee-shaped profiles; "swelled ends of a pembroke table" probably identifies a simple convex shape.

Period references identify the serpentine as "swelled" or occasionally "commode." Swelled was also used to describe oxbow furniture, which introduces obvious ambiguity for the historian. Commode, in contrast, not only specifies a serpentine shape but underscores its origins in early eighteenth-century French furniture.

In terms of massing, the oxbow has precedents in blockfront furniture. This relationship is especially apparent when considering an example such as the Jonathan Bowman chest of drawers made by George Bright of Boston in 1770.[7] The creased edges that define the blocked projections and central recess have given way to a smoother surface more in keeping with federal designs.

The Milwaukee example displays many of the best features of this particular furniture form. Its massive, articulated claw feet support a fully developed base. The double cusped brackets provide a satisfying visual transition from the feet to the carcass by leading directly into the rows of intricately cut brass handles. The center drop anchors the center row of escutcheons. The bold overhang of the molded top stops the form abruptly. Among the subtler details, cockbeading around the drawer openings helps define their graduated heights.

*Philip D. Zimmerman*

Gift of Friends of Art
M1973.151

1. John S. Walton, Inc., illustrates an oxbow slant-top desk with Rhode Island features and provenance in *Antiques* 102, no. 2 (August 1972): 148.

2. A chest-on-chest in the Museum of Fine Arts, Boston, signed and dated by Nathan Bowen and Ebenezer Martin of Marblehead, Mass., is reproduced in Randall, *American Furniture*, cat. 41. An oxbow desk inscribed "EM 1789" was sold by Sotheby's (sale 5622; October 24, 1987), lot 470 (not examined by the author).

3. Others in private collections include a desk bearing the label of the Boston partnership of Samuel Stone and Giles Alexander which lasted from 1792 to 1796 (reproduced in Sack, *Fine Points*, p. 147); a desk labeled by Abner Toppan accompanied by a 1795 bill of sale (both reproduced in Spalding, "Abner Toppan," pp. 493–94); and an oxbow desk and bookcase marked 1799 discussed in Young, "Five Secretaries and the Cogswells," pp. 478–85. The design and other physical properties of the Currier desk suggest a Boston or northeastern Massachusetts origin. In any event, nothing about the object suggests anything retardataire.

4. The desk is discussed in Jobe, "A Desk by Benjamin Frothingham," pp. 3–23. One chest carries a label dated "179-" and is reproduced in Sack, *American Antiques* 7: 1934–35. Forster (1764–1831) acquired land and established a shop in Charlestown in 1793, which suggests a reasonable earliest date for the labels. A bill of sale for a desk and bookcase

and a double chest (both at the Newburyport Public Library) indicates that each was made by Abner Toppan of Newburyport in 1795, but the bill is now lost (see Benes, *Old-Town and the Waterside*, cat. 180).

5. In light of the date ranges of intrinsically documented oxbows, the date range of 1764–80 given the Barrett family chest of drawers and chest-on-chest requires further substantiation (Jobe and Kaye, *New England Furniture*, cats. 19, 27, pp. 154–56, 176–78). A paper label recording the purchase in 1776 of a desk by John Aitken of Philadelphia bears no apparent relationship to the Massachusetts oxbow desk on which it is affixed (sold by Sotheby Parke–Bernet [sale 4590Y; April 29–May 1, 1981], lot 860). No references to the well-known cabinetmaker by that name predate 1790.

6. See, for example, pls. 52, 66, and 70 in Chippendale, *Director*, and Ince and Mayhew, *Universal System of Household Furniture*, pls. 42, 43.

7. Jobe and Kaye, *New England Furniture*, cat. 15, pp. 142–46.

## 66  *Tilt-top tea table*

Probably Connecticut, 1765–95

*Description:* The top is composed of four boards. Two long cleats screwed to the underside reinforce the top as well as hinge it to the swiveling box. The four turned elements of the box are wedged into their holes. Three old screws secure a strip of wood having the hinge pintels to the top of the box; they may represent a very early repair. Three iron straps, nailed to the bottom of the supporting pillar and into each leg, reinforce the dovetail joints of the legs into the pillar.

*Condition:* A 5-in. (12.8-cm) long patch in the table top appears to be very old, perhaps original. There are various small repairs to the scalloped edge. A rectangular splice on the underside of the top holds the center glue seam, now opened, together at one end. Screw-hole patterns indicate that the snap was once secured to the opposite side as well as being reattached near its present position. Alignment of all the holes suggests that the present snap is probably original. Some extraneous nail holes visible along the inside edges of the cleats indicate that they are probably replacements. The wooden key in the box is replaced. One

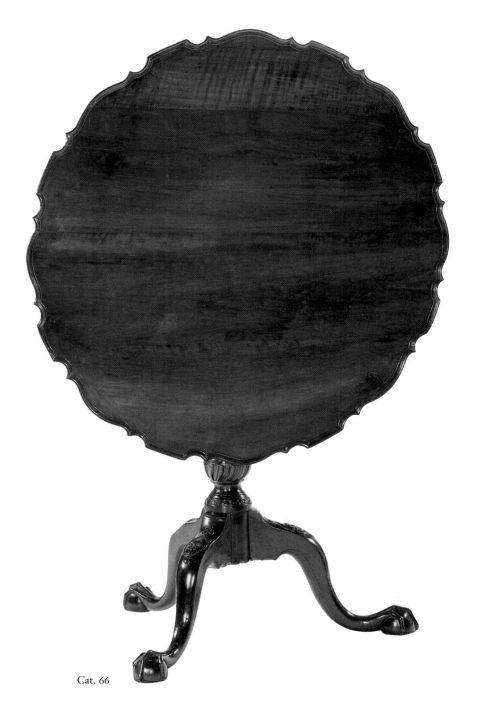

Cat. 66

leg has broken and has been carefully repaired. A portion of the surface of one knee has been lost, perhaps due to an old fissure in the wood. A hole drilled through one cleat and into the side of the top of the box indicates that a wooden peg probably once locked the top down.

*Woods:* Primary wood, cherry; lower board of box and box spindle, cherry.

*Dimensions:* H. 30 in. (76.8 cm), DIAM. top 36⅝ in. (93.8 cm).

*Bibliography:* Joe Kindig, Jr., and Son, advertisement, *Antiques* 56, no. 3 (September 1949): inside front cover; Jones, "American Furniture," p. 977, pl. III.

*Provenance:* Acquired from Joe Kindig, Jr., and Son, York, Pa. (dealer).

The initial appearance of tea tables in American furniture, as well as their subsequent rise and decline in popularity, corresponds to the notable domestic practice of tea drinking. Fewer than a half-dozen rectangular tea tables in the William and Mary style are known. Rectangular Queen Anne–style examples are more prevalent. By midcentury, when tea drinking was widespread, round tables with tilting tops such as the Milwaukee example were introduced.[1] Those with ornate carved ornament are easily recognized as being in the Chippendale period. However, plainer, therefore less expensive, tilt-top versions were also made concurrently and may be mistakenly identified today as being earlier products. The form, either ornate or plain, remained popular until the early nineteenth century.

When in use, tilt-top tea tables held stylish silver tea vessels, ceramic or porcelain tea cups, and fine linens.[2] The hostess could pour tea and then distribute the filled cups to her guests by rotating the tabletop, a gesture that incidentally displayed her objects to best advantage. All of these objects declared a degree of wealth, leisure, and urbanity. It is no wonder then that tea tables tended to be more elaborately decorated than most other tables.

Tea tabletops were cut round and, in the more expensive examples, dished out in the center to leave a raised molded edge. The finest tops had scallop-carved edges, typically bearing eight repeats.

The relationship between these ornate tops and silver salvers, which could be used in taking tea, has often been noted by furniture historians and, given the purpose of the table, is likely not an accidental design relationship.

The central supporting shaft, or "pillar" as it was called in the period, supported the top. It was generally turned in the shape of a column, baluster, or column above an urn or ball. Here again, the finer examples incorporated carved decoration into these basic forms. The Milwaukee table pillar, composed of a column above a balusterlike element, is exceptional in this regard. The column is richly ornamented with fluting which is stopped at the bottom with half-rounds and has small ornamental holes above. The baluster or ball has spiral-carved gadrooning which imparts complex visual movement to the entire design of the table. The transition from the pillar to the legs is aided by a ring of stylized "leaf-grass" carving.

The pillar is supported by three legs, called "claws" in price books of the 1790s.[3] Those books identify the table form as "pillar and claw," a change in terminology from "tea table" that may reflect the decline of the specialized practice of tea drinking in favor of more general entertainments.[4] Period references to "claw tables" may indicate round tea tables, but the ambiguity of the term, which may also have described the nature of the foot, makes such interpretations less certain. In any event, tea-table legs are cabriole and terminate in either a plain round foot, sometimes carved with a ridge down the top, or a claw-and-ball foot. Both designs were available in the Chippendale period, and the difference was cost. The Milwaukee tea table has the added feature of carved knees.

The device between the pillar and top, called a box, allowed the top to swivel and tilt. With the top in its vertical position, the table took up less space and could be stored against a wall or in a corner. With the top down, the box lent stability to the broad table surface. On one end the box was attached by wooden pintels set into lateral cleats applied to the underside of the top. A brass catch, or "snap," screwed into the top's underside, secured the other end of the box.

Accordingly, period manuscripts mention "snap tables" as well. Snaps were also commonly used on tilting candestands, which were called in their time "snaps" or "snap stands."

Despite generally strong regional variations in most American furniture design, the Milwaukee table does not fit easily into any known regions or schools. Tentative assignment of the table to Connecticut rests on negative and positive factors. The table's dominant features, namely the scalloped top, the gadrooned baluster, the leaf-grass ring, and the richly carved knees, are characteristics of the best examples from Philadelphia.[5] However, Philadelphia work is well known, and the particular articulation of those features on this table, along with other small details like the double astragal molding around the bottom of the box, suggest that the table was made elsewhere. Similarly, it does not conform to designs commonly associated with New York, Rhode Island, or Boston.

The positive evidence for a Connecticut origin is problematic. Some strains of Connecticut subregional furniture follow Philadelphia designs and construction.[6] Cherry was commonly used in Connecticut high-style furniture as a presentation wood. And a very similar tea table, whose present whereabouts is unknown, was pictured in 1947 in the Connecticut home of a collector of Connecticut and other New England furnishings, suggesting a possible origin nearby.[7]                    *Philip D. Zimmerman*

Purchase, Layton Art Collection
L1974.205

1. Stylistic evidence suggests that tilting tripod-base tea tables with square tops were introduced later, perhaps in the 1760s.

2. Early eighteenth-century estate inventories suggest that tea equipage was also stored on the tables (see Jobe and Kaye, *New England Furniture,* p. 286), but the tilting feature suggests alternative storage spaces were the rule after midcentury.

3. For terminology, see *Cabinet-Makers' London Book of Prices and Designs of Cabinet Work* (London, 1793) and later Philadelphia and London editions. There is no reason to doubt that these same terms were in use at the mid eighteenth century.

4. See Martin Eli Weil, "A Cabinetmaker's Price Book," in Quimby, *American Furniture and Its Makers,* pp. 175–92, esp. 187. "Tea tables" had tops of wider diameter, usually

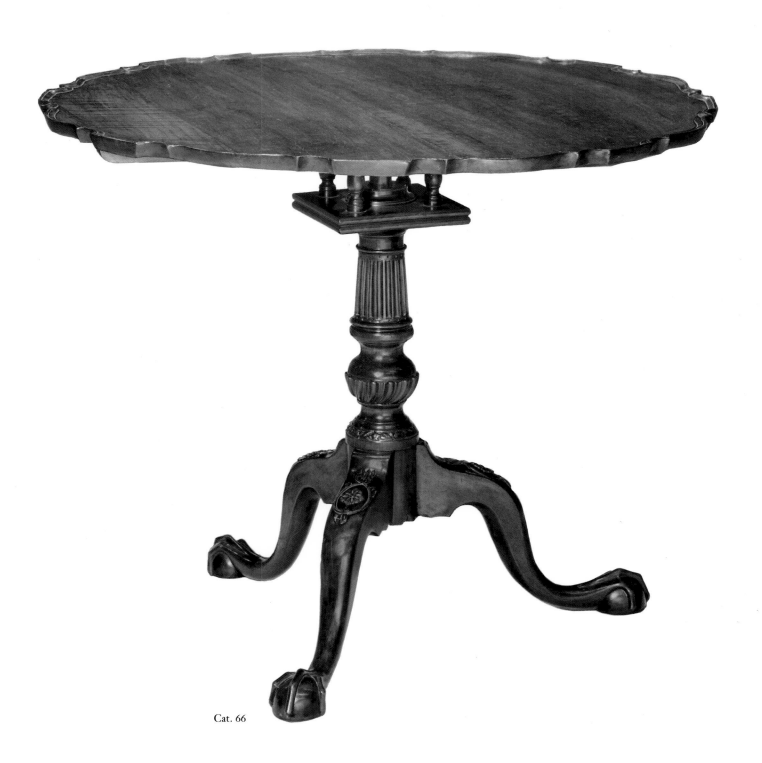

Cat. 66

over 30 in. (76.2 cm), than "folding stands" with diameters of about 22 in. (55.9 cm).

5. The table was identified as a Philadelphia product by Joe Kindig, Jr., in the 1949 *Antiques* advertisement. A scalloped-top walnut tea table at the Connecticut Historical Society (illustrated on pp. 30–31 of *Frederick K. and Margaret R. Barbour's Furniture Collection*) was owned by Silas Deane of Wethersfield, but the table's place of origin has not been firmly established. Another cherry tea table at Yale University, related to the Milwaukee example, is published as of Pennsylvania origin in Ward and Ward, *Silver in American Life*, cat. 85.

6. For a fuller discussion, see Philip D. Zimmerman, "Regionalism in American Furniture Studies," in Ward, *Perspectives on American Furniture*, pp. 26–28.

7. "Living with Antiques: The Connecticut Home of Mr. and Mrs. Louis L. Davis," p. 314 (top).

## 67 *Card table*

Probably Boston, Massachusetts, 1760–90

*Description:* The left leg swings back to support the top, which opens to reveal inset red leather with gilded and tooled edges (a replacement) and four oval counter pockets located to each sitter's left. Two guide pins in the top leaf fit into holes in the fixed bottom leaf when the tabletop is opened. The fly leg has a seven-part hinge. The top is secured to the frame by three screws and by a peg in each front corner. The drawer has mahogany sides and a yellow-poplar bottom, originally nailed in front and back, and now nailed on all four sides. The drawer slides on mahogany strips tenoned into the rear and tusk-tenoned into the front. The absence of any wear suggests that they are probably replacements. No pins are used in the mortise-and-tenon joints securing the frame to the legs.

*Condition:* At least two generations of repairs have been made to the right hinge, which, like the left hinge, has split the surrounding wood. An inset repair appears along the left rear bottom edge of the bottom leaf. All of the legs have minor splits in the mortises for the rails; the right rear leg has been repaired where it joins the fixed rear rail. The wooden spacer between the inner and outer rear rails is a replacement. The right rear bracket is replaced. Glue blocks have been added underneath the fixed top and in the front corners. Thin strips have been added to each side of the drawer opening. A split in the front rail below the drawer opening has been secured by a screw from the bottom. A strip of wood has been added to the underside of the fixed top to prevent the drawer from tipping down when it is opened. One pin in the front and two pins in the back legs of the right side appear to be later reinforcements.

Cat. 67

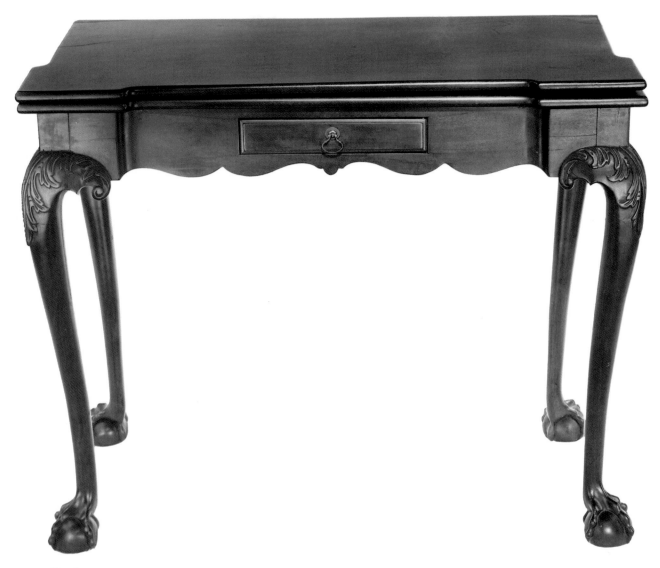

Cat. 67

*Woods:* Primary wood, mahogany; drawer bottom, yellow-poplar; swinging hinged rail, white oak; stationary hinged rail, birch; fixed rear rail, red gum; front corner blocks and spacer between hinged and fixed rails, mahogany; rear corner blocks, cherry; drawer runners, mahogany and cherry; drawer stops on rear rail, eastern white pine.

*Dimensions:* H. 28 in. (71.7 cm), W. 34⅛ in. (87.4 cm), D. 17½ in. (44.8 cm), D. open 35 in. (89.6 cm).

*Bibliography:* Jones, "American Furniture," p. 979, fig. 8.

*Provenance:* Acquired in 1975 from Joe Kindig, Jr., and Son, York, Pa. (dealer).

The earliest American card tables seem to have been made in the Boston region in the 1730s and 1740s. Some important examples survive with inset needlework covers wrought in elaborate pictures, including playing cards and other symbols of the table's function.[1] A number of Boston Chippendale-style examples are known, as well as representatives from most other regions of the American colonies. By the federal period, card tables

were among the most common table forms produced.

The Milwaukee card table follows a well-defined Boston form that in turn has ample precedent among English card tables. A key document to the Boston area is a similar card table at Winterthur labeled by Benjamin Frothingham.[2] The form in question is marked by cabriole legs supporting squared corners which are joined by recessed horizontal elements. The shape of the tabletops follows the contour of the frame. Many card tables of this particular form have a centrally placed drawer, which provides convenient

storage for cards, counters, and other gaming accoutrements, as well as a strong visual focus for the broad front.

The scalloped lower edge of the front and side rails of the Milwaukee table is a distinctly New England design. It uses paired ogee curves on either side of a central half-round drop. This organization of motifs is evident in some tables and many ornate Queen Anne–style chairs which employ a large half-round drop flanked by single ogees.[3] A slightly smaller card table with very similar scalloping and knee carving is owned by the Baltimore Museum of Art.[4] Other Boston examples of note include a card table with an inset needlework playing surface in the Chipstone collection.[5]

One of the finer features of the Milwaukee table is its carving. The feet have well-articulated claws grasping a large ball. The side talons angle back slightly, rather than point directly downward, resulting in an outward thrust of the strong middle talon. The acanthus-carved knees grow out from the bottom of the frame, but their design has a strong visual origin in the prominent volutes of the brackets. These volutes seem to pick up the undulating rhythm of the scalloped frame in a manner that surpasses much Boston design.

Close inspection of the knee carving, especially the left front, reveals the manner in which the craftsman executed his work. The broad, fleshy acanthus leaves are outlined by spare cuts, and the recessed background still shows some of the cutting contours and blade scratches. The leaves themselves are given form and texture by the simple device of running deep veins, often paired, down their centers. The apparent speed with which the work was done is visible in the discontinuities in the seemingly bisymmetrical design. These differences are particularly evident in the foliated C-scrolls of the carved brackets. The visual effect of the whole, however, is not of something unfinished; rather, the inconsistencies lend an air of naturalism to the carving that is appropriate to its purpose. *Philip D. Zimmerman*

Purchase, Layton Art Collection
L1975.6

1. A table having needlework playing cards by Mercy Otis Warren is owned by the Pilgrim Society, Plymouth, Mass., and reproduced as fig. 95 in Fairbanks and Cooper, *Paul Revere's Boston*. Other card tables of similar form with inset needlework covers include cat. 79 in Randall, *American Furniture*, and cat. 57 in Warren, *Bayou Bend*.
2. Published as fig. 349 in Downs, *American Furniture*.
3. See, for example, a Boston rectangular tea table illustrated as fig. 67 in Jobe and Kaye, *New England Furniture*, p. 287.
4. Published in Elder and Stokes, *American Furniture*, fig. 95. For a table very similar to the Milwaukee example, see Sack, *Fine Points*, p. 278, top left.
5. Published in Rodriguez Roque, *Chipstone*, fig. 150.

## 68 *Card table*

Probably Newport, Rhode Island,
1770–90

*Description:* The top opens to reveal a plain playing surface and rests on each swinging rear leg. Five screws secure the top to the frame in addition to four long glue blocks along the front and back (the left front block is missing). Two pins secure each tenoned joint between the legs and frame. Vertically grained corner blocks are glued in the rear. The rear rail is affixed to each side by two large dovetails. The bead molding along the bottom of the frame is applied to the underside except where it is channeled into the sides of the rear legs. Each rear leg swings on its own five-part hinge. In cross-section, the front legs follow the serpentine shape of the frame. The front brackets are ¼ in. (.6 cm) thick and follow the contour of the frame. The rear side brackets are ½ in. (1.3 cm) thick.

*Condition:* The left rear solid bracket is a replacement. Both swing legs were once screwed closed. The wooden hinge pins are replacements. The front bracket on the right side has been repaired; all others appear to be in original condition. An old finish covers the entire object.

*Woods:* Primary wood, mahogany; corner blocks and glue blocks, eastern white pine; swinging hinged rail, cherry; hinge pin, hickory; fixed rear rail, eastern white pine; spacer between hinged and fixed rails, eastern white pine.

*Dimensions:* H. 28¾ in. (73.6 cm), w. 34 in. (87.0 cm), D. 16¾ in. (42.9 cm), D. open 33¼ in. (85.1 cm).

*Bibliography:* Jones, "American Furniture," p. 982, fig. 10.

*Provenance:* Purchased in 1969 from John S. Walton, Inc., New York, N.Y. (dealer).

Any attempt to understand Rhode Island eighteenth-century furniture inevitably raises the subject of regionalism. Regionalism is important because it provides an historical structure that gives particular identities to geographical areas. In the case of Rhode Island furniture, that identity is quite distinct from other major regions such as Boston, New York, and Philadelphia.

Rhode Island furniture of the Chippendale period in many respects does not share the same style attributes of the other regions. It relies on form and line far more than on surface ornament. Rich graining in dense mahogany gives character to broad, planar surfaces. Carving, where it does exist, is simple, often incised, and is baroque in character. In many respects, Rhode Island Chippendale-period furniture relates more closely to high-style Queen Anne–style furniture of other regions than to their Chippendale-style expressions.

In an essentially naturalistic style period, the one design subgroup of Rhode Island furniture that does parallel Chippendale-style furniture of other regions is its Marlborough-legged examples. Marlborough legs, which appear on seating furniture and tables, are squared support elements given architecturally derived designs. The relationship of architecture to furniture design was made clear by Thomas Chippendale, who introduced his book of furniture designs with explanations of the five classical orders along with testimony to the importance of good proportion.

The Milwaukee card table is as fine an expression of Rhode Island architectonic furniture as can be found.[1] The legs are fluted, with the bottom two-fifths "stop-fluted" by the introduction of a reed within each of the flutes, a detail and placement typical of Rhode Island work.

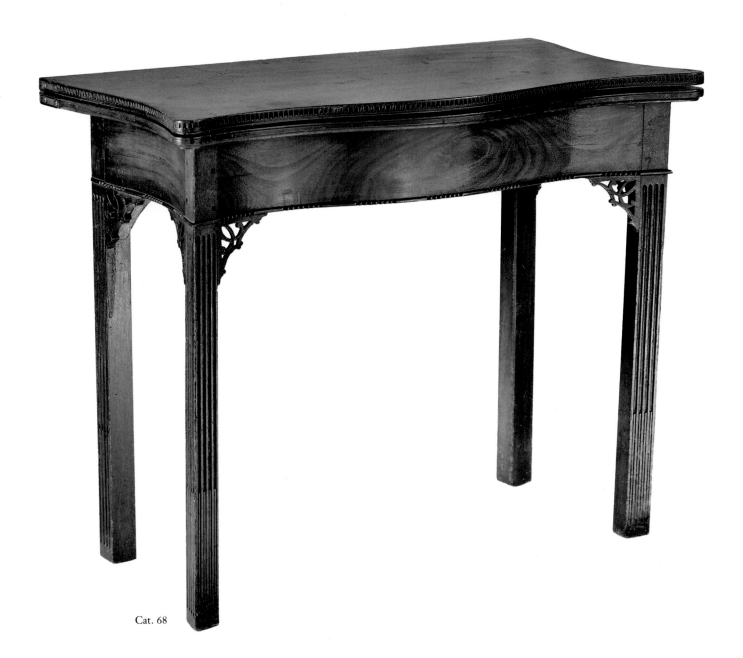

Cat. 68

The fluting ends where a bead around the table carcass defines the lower edge, or architrave, of what may be seen as an entablature. The entablature's frieze is the broad, smooth rail cut to a serpentine shape. Its cornice, or top, is defined by the overhanging table leaves, the bottom of which has an undercut molded edge. The top leaf is decorated with a line of gouge-cuts suggesting a kind of dentiling. Architecture is the wellspring of this table's design, not its limitation, as is apparent in the pierced rococo brackets that visually tie the legs to the carcass.

The quality of design parallels the table's workmanship. In cross-section, the front Marlborough legs follow the serpentine contour of the front and side rails. The brackets attached to the front leg are cut from thin stock so that they too are shaped to follow this contour. The rear brackets, in contrast, are cut from unshaped thicker stock and are simply directed along the relatively uncurved rear portion of the side rails. Small details, like the bead molding in the rear swing legs, have not been lost through time because they have been channeled into the leg, a bit of extra workmanship that emphasizes longevity. The wood is characteristically finely grained. A rotted section visible on the insides of each side rail confirms that the wood was split apart to yield matching grain patterns.

Fine Rhode Island furniture also inevitably raises the question of authorship, which in turn evokes the cabinetmaking dynasty of Goddards and Townsends. Their dominance in the latter half of the eighteenth century has been equaled by the focus of research into Rhode Island furniture. The written and artifactual record has been mined again and again for information about these cabinetmakers, and the historical picture that this work yields is substantial. But confident assignment of authorship is still problematic: the historical argument has traced only half of the picture. Researchers have established relationships that allow attribution to the Goddards and/or Townsends, but they have not excluded with reasonable certainty the possibility that other Rhode Islanders may have been responsible as well. Cabinetmakers like Judson Blake, John Newton, Grindal Rawson, and Benjamin Baker are relative unknowns who worked in styles that seemingly overlapped that of the Goddards and Townsends.[2] Additionally, other artisans like Jonathan Swett and John Cahoone need to be investigated more thoroughly so that the quality of their work may be better evaluated.[3] Until then, and perhaps to remind us of the need for more research into these other makers and their relationship to the Goddards and Townsends, it is probably best to leave undocumented examples anonymous, as in the case of the Milwaukee card table.

*Philip D. Zimmerman*

Gift of Friends of Art
MI969.12

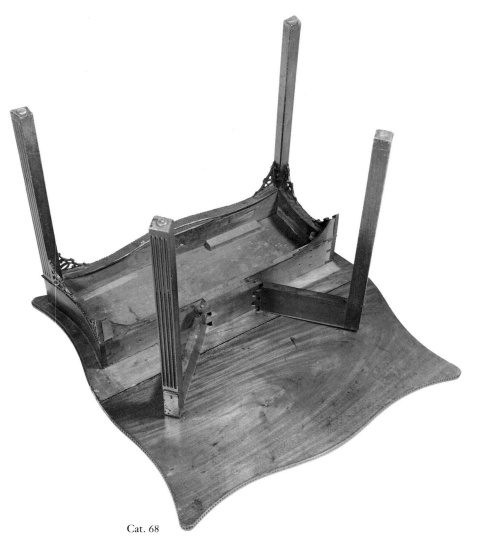

Cat. 68

1. A similar form, in which the front rail is also undercut in a serpentine shape and the flyleaf is supported by a single swing leg, is represented by a number of examples, none of which is well documented. Neither the structure nor design details suggests particularly close manufacturing ties between the Milwaukee table and these other tables. One of that group is discussed in detail in Jobe and Kaye, *New England Furniture*, cat. 70; and another, represented by a pair of card tables, is published in Carpenter, *Arts and Crafts of Newport*, cat. 67. The remaining tables include ones pictured in the *Girl Scouts Loan Exhibition*, cat. 657; one in *Antiques* 105, no. 5 (May 1974): 948; one at the Winterthur Museum (acc. no.

65.2905); and a variant pictured in Israel Sack, Inc., *Opportunities in American Antiques*, Brochure 44 (September 1, 1989), p. 45.

2. A card table by Blake is illustrated in Moses, *Master Craftsmen of Newport*, fig. 3.29. For Newton, see a Ginsburg & Levy advertisement, *Antiques* 90, no. 4 (October 1966): 405, and Garrett, "Providence Cabinetmakers," p. 518. For Rawson, see Ott, *John Brown House Loan Exhibition*, cat. 66, and Monahon, "Rawson Family of Cabinetmakers," p. 135, pl. 3.

3. For an example of this kind of research, see Jeanne Vibert Sloane, "John Cahoone and the Newport Furniture Industry," in *New England Furniture*, pp. 88–122. Sloane illustrates a high chest by Baker as fig. 1.

## 69 *Looking glass*

England, 1750–70

*Description:* A pine frame encloses the mirrored glass, which is held in place from the front by scalloped presentation pieces of veneered pine. Small glue blocks secure the glass from the rear. A backboard made up of six horizontally grained pine boards covers the back. Remnants remain of old rag paper used to seal the back from dirt and dust. The crest is secured by two horizontal glue blocks and three vertical reinforcements, of which only the center one survives. Glue blocks reinforce the upper projections at each side. The lower projections are thick pine elements. The bottom element is of a thinner pine board secured by two glue blocks. The garlands at each side are not heavily gessoed and are applied to the side of the frame. The floral cartouche is applied to the front of the plinth. Its uppermost flower is applied to the rest of the cartouche, which in turn sits on a separate bracket composed of the downturned leaves and reel-turned neck of the vase. The outer border of C-scrolls is applied. The leaves at the corners of the glass and across the hollows in the pediment are incised. All of the gilt is on a red bole. Certain repairs indicate the gilding was redone after the looking glass had been damaged.

*Inscription:* A printed label glued to the lower center of the backboard reads "A Cripps / Picture Frame Maker / 6 Thatched House Row. / Lower Road /

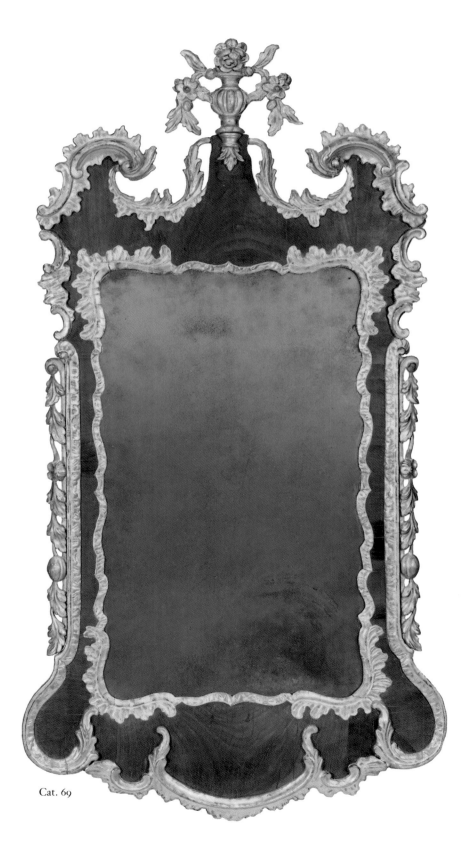

Cat. 69

Islington. / Old Frames Regilt Old Pictures Relined."

*Condition:* Minor cracks appear in the veneer and in the gilded ornament. The pine backing in the pediment has split where each curved element begins to rise. The left leaf joining the top of the plinth has been repaired from behind.

*Woods:* Primary woods, mahogany and gilded softwoods; secondary woods, spruce and softwoods.

*Dimensions:* H. 55 in. (139.7 cm), w. 28¼ in. (71.8 cm).

*Provenance:* Formerly in the collection of Dr. Ray Franklin. Purchased by John S. Walton for the donors at Christie's (October 13, 1984), lot 435.

Large and impressive looking glasses typically were placed in parlors where they hung among a family's finer furnishings. They were decorative, expensive, and fragile. Often hung between windows, they were sometimes called pier looking glasses in reference to the technical term denoting that section of the wall. Given the importance of looking glasses in their time, the current state of knowledge about these objects is limited. This circumstance may reflect in part the fact that most looking glasses were imported from England and have not enjoyed the same attention as American-made furnishings.

The reason why looking glasses were imported is clear: England was a leading producer of glass, especially the large, clear sheets needed to create a high-quality reflective image. Although window glass was made in eighteenth-century America, there is little evidence that the more demanding requirements for such things as clock glasses or mirrored glass sheets could be met by pre-Revolutionary American glassmakers.[1] Some mirrored glass was likely imported and set into American-made frames, but ornate looking glasses seem to have been imported in their finished state. Analysis of secondary woods in a large looking glass bearing the label of "looking glass maker" John Elliott of Philadelphia, for example, suggests that he imported European-made products which he then labeled and sold.[2]

In addition to the labeled Elliott looking glass, a number of other English looking glasses similar to the two Milwaukee examples (see also cat. 70) have histories of ownership in America. A related example in the Chipstone collection, for instance, descended in the Van Rensselaer family of Albany, New York. Like the Milwaukee looking glass, which bears the label of a nineteenth-century looking glass-repairer working in London, the Chipstone looking glass is labeled by a nineteenth-century Boston "carver and gilder."[3]

The importance of glassmaking technology to eighteenth-century looking glasses extends into their design. Early in the century, limitations imposed by the crown-glass and cylinder-glass techniques restricted the size of the glass sheets.[4] Consequently, large looking glasses were typically made of two or three separate glass sections. The large, clear single glass sheets used in later looking glasses were made by casting molten glass which was then ground and polished. This process, used in France in the late seventeenth century and in England shortly thereafter, virtually eliminated warpage due to cooling and reduced streaks and blisters. By the 1770s cast glass was in large-scale production in England.[5]

Aside from the mirrored plate, looking glasses were products of the woodworking and related crafts and of their respective design vocabularies. Depending upon the demands of the style then current, looking glasses were carved, veneered, inlaid, japanned, or gilded using gold or silver leaf. The two Milwaukee examples employ veneering, carving, and gilding.

*Philip D. Zimmerman*

Gift of Virginia and Robert V. Krikorian
M1987.32

1. Kenneth M. Wilson notes reference to clock glasses in the Pitkin Glassworks, begun in Connecticut in 1783, in *New England Glass*, p. 66.
2. The presence of spruce in this looking glass, in the collection of the Winterthur Museum, points to its European origin. The Elliott label may be dated between 1753 and 1761.
3. Rodriguez Roque, *Chipstone*, cat. 118. A looking glass very similar to the Milwaukee example is owned by Winterthur (acc. no. 52.154) but has no specific American history. Another, owned by the Brooke family of Philadelphia and Birdsboro, Pa., is reproduced in Comstock, *Looking Glass in America*, fig. 27, p. 55. A bill of sale indicates that another English looking glass with incised decoration similar to the other Milwaukee looking glass (cat. 70) was sold in Boston in 1770 (Jobe and Kaye, *New England Furniture*, cat. 147).
4. These techniques are outlined in Wilson, *New England Glass*, pp. 45–46, 56.
5. Comstock, *Looking Glass in America*, pp. 15–16.

## 70 *Looking glass*

England, 1750–70

*Description:* Four thin mahogany boards are applied to a rectangular pine frame to form the front presentation surface. The mirrored glass fits within the pine frame and is held in place in front by the scalloped mahogany edge and by glue blocks in the back. The projecting ears at the top and bottom of each side are separate pieces of mahogany. The gilded garlands on each side and the ruffled mantle carving above are gessoed wood nailed into the pine frame and mahogany crest, respectively. The urn with floral spray is gessoed and gilded wood applied to the front of the mahogany crest plinth. The uppermost floral element is a second part applied to the first. The outermost portion of the bulbous urn is another glued part. The urn rests on a separate carved bracket. The sunflower-and-vine motif at the bottom is incised and gilded. The original glue blocks reinforce each of the four ears, and two reinforce the crest and bottom element.

*Condition:* The central plinth has split at the base of the urn and has been repaired by the addition of a reinforcing wood strip glued and screwed into the back. Four other reinforcing wood strips have been added to the back of the crest and to the center of the bottom. The left side of the crest is split below the ruffled mantle appliqué. A break in the right cartouche sprig has been reinforced from behind by a wood strip. The left bottom ear has been repaired. The gilding has been retouched. A thin yellow wash remains on much of the back surfaces. The back-

board is replaced. Remnants of old wall-paper remain on the frame.

*Woods:* Primary wood, mahogany; back panel, white pine (possibly western or sugar pine, but not typical eastern white pine); left side of frame and carving along left side, sylvestris pine; bottom and top scrolls, spruce; glue block in lower left rear, spruce.

*Dimensions:* H. 47½ in. (120.7 cm), w. 22¾ in. (57.8 cm).

*Provenance:* Purchased from John S. Walton, Inc., New York, N.Y. (dealer).

The overall design of this looking glass (and cat. 69) draws from classical architectural designs reshaped into or overlaid with rococo elements.[1] The design of the top, for example, recalls broken-arch pediments, and the foliate pendants at each side make clear reference to architectural designs published in the 1720s, 1730s, and 1740s. The rectilinear border of the mirrored plate is reshaped into a richly scalloped edge, although classically derived "leaf grass" carved and gilded moldings remain. Ruffles and other organic masses hang from and, to a certain extent, reshape the classical scrolls and other elements. This organic matter also grows along and up into the lower rail. Lastly, naturalistic flowers grow out of and around the central urn finial.

The two Milwaukee looking glasses occupy the same style period, but they differ in character and provide notable comparison. One (cat. 69) displays fully modeled rococo flourishes that ebb and flow with such vitality that the structural aspects of the object almost disappear. The other (cat. 70), in contrast, is more obviously a wood frame supporting a mirrored plate. Its decoration is more linear—apparent not only in the incised sunflower and vines at the bottom, but in the parallel strokes of the carver's gouge in the gilded leaves of the pediment. The effect is one of ornament applied to a structure instead of ornament that has grown into and altered the structure. This character extends into the floral cartouche in the pediment, which is stiff and weightless. Much of the decorative impact of this looking glass depends upon the sawn scalloped outline of the frame,

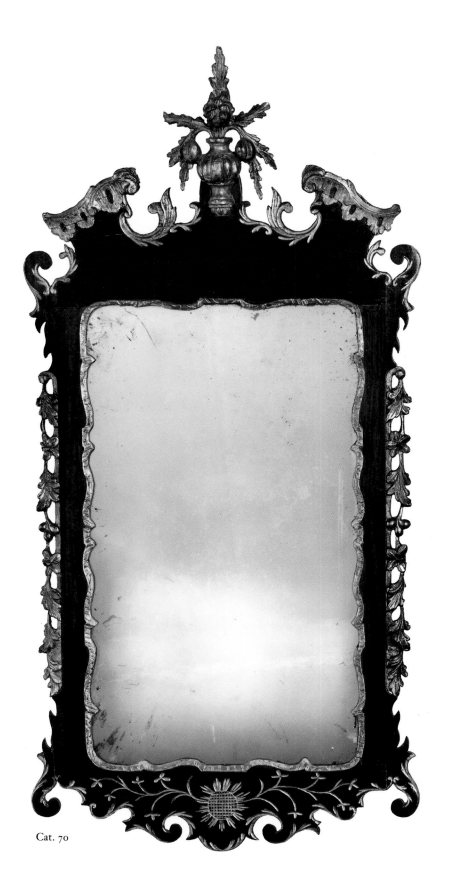

Cat. 70

a technique that dominated late eighteenth-century looking glasses of American manufacture.

*Philip D. Zimmerman*

Gift of Friends of Art
M1969.11

1. Some looking glasses made at this same time represented much purer rococo statements. In them, the shapes of all of the framing members are naturalistic and asymmetrical, as well as the shape of the mirrored plate. Many such designs were published in pattern books of the 1750s and 1760s.

## 71 *Pair of dessert tureens on stands*

Worcester Porcelain Company
Worcester, England, 1770–80

*Description:* Each of the oval tureens has a conforming low-domed cover and rests on an oval stand. All of these elements are press molded. The flanged cover has a slight overhang, the tureen body is stepped in ½ in. (1.2 cm) below the rim and tapers slightly to the base, and the stand has a ½-in. (1.2-cm) wide rim and central ovoid well. The surface of each of these three elements is underglaze-decorated in transfer-printed cobalt blue.

The covers have a central twig-form applied handle with applied foliage and florets at the point of their attachment to the cover. Each of the tureen bodies has a twig-form handle at each end attached in the same manner as for the cover. The stands have this same end placement of the twig-form handles and same method of attachment.

*Inscription:* The trays and tureens are marked on the underside with a hatched crescent.

*Condition:* There have been small losses to the applied foliage on the covers and stands of both units.

*Materials:* Soft-paste porcelain, cobalt underglaze decoration.

*Dimensions:* H. tureen 3½ in. (8.9 cm), w. tureen 5¼ in. (13.4 cm), D. tureen 3⅝ in. (9.2 cm). H. stand ⅞ in. (2.2 cm), w. stand 7½ in. (19.1 cm), D. stand 5⅜ in. (13.7 cm).

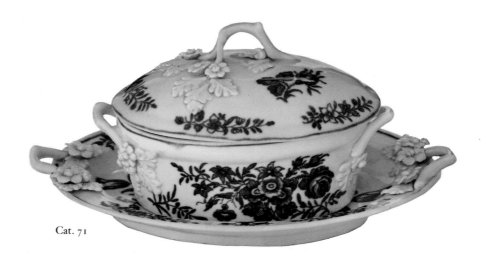

Cat. 71

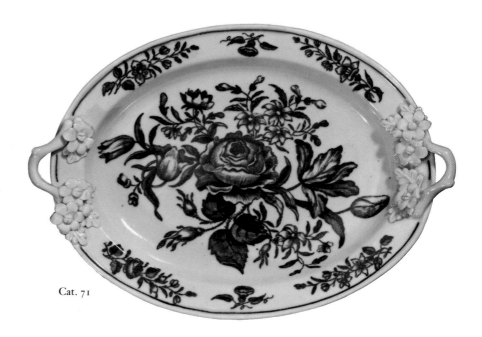

Cat. 71

*Provenance:* Purchased by the donor from Newman and Newman, London (dealer).

These beautifully detailed individual-serving tureens were most likely a part of a matched service of dessert wares. The whole service would have been decorated with the same transfer-printed design seen here, now known as "The Three Flowers."[1] This pattern was one of the most popular produced by Worcester Porcelain Company, as evidenced by the frequency of sherds with this decoration

found in excavations of their eighteenth-century site.[2] "Three Flowers" first appears on Worcester's wares in about 1770 and was used for at least a decade.

Blue-and-white porcelains were produced by many English manufactories in the eighteenth century, but Worcester developed and made the most extensive use of the transfer-print technique of decoration.[3] They began to use the process in 1757, and by 1775 the majority of their porcelains were decorated with cobalt-blue designs transferred from an

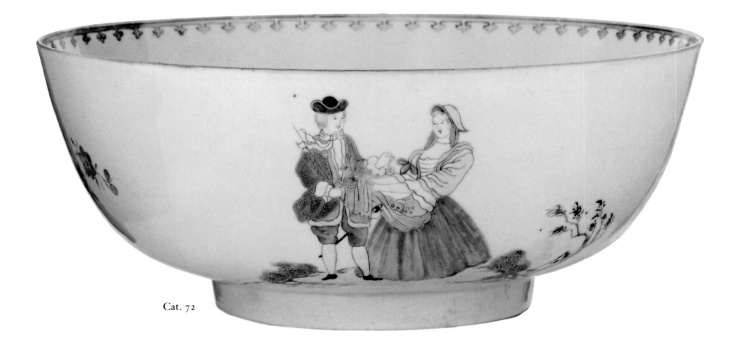

Cat. 72

etched or engraved copper plate using moistened tissue paper as a medium for placing the patterns.[4] Cobalt was the only glaze color known at the time that could withstand the heat of the glazing kiln and was far more durable than overglaze decoration fused under lower temperatures.[5]

The American taste for blue-and-white porcelains is illuminated by the many advertisements, inventory references, and sherds from colonial sites.[6] It is also made evident by the extant wares of the American China Factory of Philadelphia. The rare surviving pieces of this first porcelain maker in America are decorated in underglaze blue.[7]

*Jayne E. Stokes*

Gift of the Estate of Florence Eiseman
M1988.31.a–.c, .32.a–.c

1. Branyan, French, and Sandon, *Worcester Blue and White*, p. 362.
2. Branyan, French, and Sandon, *Worcester Blue and White*, pp. 19–20.
3. Clarke, *Worcester Porcelain in Colonial Williamsburg*, p. 8.
4. Branyan, French, and Sandon, *Worcester Blue and White*, p. 20.
5. Clarke, *Worcester Porcelain in Colonial Williamsburg*, p. 8.

6. Roth, "Tea-Drinking in Eighteenth-Century America," p. 451.
7. Graham Hood, "The American China," in Puig and Conforti, *The American Craftsman and the European Tradition*, pp. 240–55.

## 72 *Punch bowl*

China, 1750–1800

*Description:* The bowl is simple in form with a straight-sided, circular foot supporting the body. The interior rim is overglaze-decorated with a spear or fleur-de-lis motif in iron red enamel and gilt edging. The colors of the polychrome scenes include yellow, pink, orange, blue, green, white, and black. Enameled floral sprigs are scattered between the scenes.

*Condition:* The bowl was broken in two. The clean break was slightly to one side of the center line; the repair is nearly undetectable.

*Materials:* Porcelain, overglaze enamel and gilt decoration.

*Dimensions:* H. 4½ in. (11.5 cm), DIAM. 10½ in. (26.7 cm).

*Provenance:* Charles Fain, Milwaukee, Wis. (collector).

Intended for use at social gatherings, punch bowls were often made of porcelain, as in this example, or of an imitative material, such as tin-glazed earthenware.[1] By their size alone punch bowls were showy, and their prominence was further enhanced by elaborate decoration. This Chinese export piece bears a design that was popular with the seafaring traders who called at the port of Canton for fine silks, spices, and ceramics.[2] The scene is in two parts; one side depicts the sailor's farewell, and the opposite, his return. Overglaze polychrome enamels were used to paint these detailed pictures in which an ordinary seaman leaves his tearful female companion, and returns to her dressed as a ship's officer, dropping trinkets into her apron.

Bowls with similar decoration were probably imported by American merchants after this country's introduction to the China trade in 1784. However, the two flags flown by the ship on this bowl, both having a white field with a blue upper-left quarter bearing a red cross that overlays a white X, repre-

sent the British Navy. Though the painter of the flags may simply have been careless in leaving out the red X that would complete the Union Jack, it is also possible that he painted it before 1801, when that third and final element, which represented Ireland, was added to the British flag.                    *Jayne E. Stokes*

Gift of Charles Fain
M1975.78

1. For a tin-glazed example in the Milwaukee collection, see cat. 52.
2. Beurdeley, *Chinese Trade Porcelain*, p. 64.

## 73  *Coffeepot*

Thomas Shields (w. ca. 1765–94)
Philadelphia, Pennsylvania, 1775–85

*Description:* The body of the pineapple finial, with its upper leaves, is cast as a unit; the lower end of the fruit has a threaded shank. The leaves at the finial base are a separate element pierced at the center for the screw shank to pass through to the inside of the cover, where the whole is secured with a silver nut. The raised lid is hinged to the body. The spout and handle sockets are cast in halves and soldered to the raised body. The foot is raised and soldered to the body.

*Marks:* Struck with "т · s" in a square, three times on the underside of the foot.

*Inscriptions:* "1155.4" is scratched under the foot. The body is engraved on one side with the arms of the Shields family enframed by crossed boughs, pendant from an open loop draped with bellflowers.

*Condition:* The handle is a replacement.

*Materials:* Silver, fruitwood handle.

*Dimensions:* H. 13½ in. (34.3 cm), w. 8⅞ in. (22.6 cm), DIAM. 5¼ in. (13.4 cm), WT. 41 oz. 17 dwt. (1,301.7 gm).

*Bibliography:* Goldstein, *Milwaukee Art Museum*, p. 73.

*Provenance:* Purchased from S.J. Shrubsole Corp., New York, N.Y. (dealer).

Thomas Shields spared no effort in making this ebulliently rococo coffeepot which bears his own family arms.[1] The complexities of this double-bellied form show off his skills in a way which no ordinary pear-shaped, single-bellied pot could.

The beautifully detailed cast pineapple finial is a robust introduction to the serpentine shaping, which begins with the domed cover, accented by gadrooning, that forms a shoulder around the lower third of the cover. The pleasure of seeing the relationships between various elements, as the eye is carefully led to see the whole, clearly separates the work of the artist from that of the artisan. Scrolls and shell forms which characterize rococo design boldly model the serpentine spout and the handle sockets.

When first considered, the engraving of the Shields arms may not seem in keeping with the rococo form it embellishes. The simply outlined shield, suspended from an open loop and flanked by thin, in-curved boughs, is in the neoclassical style associated with post-Revolutionary design in America. However, comparison of this coffeepot with another of the same form by Shields, at Yale, provides clear evidence that in shaping the body of the Milwaukee pot Shields was working toward a simpler, more neoclassical outline.[2] The cover and foot in particular have a less complex profile. Transitions from vertical to horizontal are not clearly demarcated by an edge or molding but flow uninterruptedly.[3]

The influence of neoclassicism may have affected Shields's work as early as the mid-1770s. The earliest known example of American silver in this style was made in 1774 by a fellow Philadelphia silversmith, Richard Humphreys (1750–1832).[4] Humphreys created a presentation urn, styled after an ancient classical form, for Charles Thomson, secretary to the First Continental Congress.                *Jayne E. Stokes*

Gift of Friends of Art
M1981.5

1. Bolton, *American Armory*, p. 148.
2. Buhler and Hood, *American Silver*, cat. 872.
3. Shields fashioned a teapot bearing engraved arms identical to the Milwaukee coffeepot and probably also intended for his own use. The teapot is in the fully neoclassical

form of a drum with straight tapered spout (DAPC, 78.4202).
4. Cooper, *In Praise of America*, p. 242, fig. 277.

## 74A  *Candlestick*

England, 1740–60

*Description:* The construction is in two parts. The socketed stem forms one element resulting from the soldering of two vertically cast halves. The lower end of the stem is inserted through a hole at the center of the one-piece cast base, and hammered over to secure the two units together.

*Condition:* The socket appears to be slightly cut down; an integral drip pan may have originally topped the socket.

*Material:* Brass.

*Dimensions:* H. 7¼ in. (18.4 cm), w. base 4¼ in. (10.8 cm).

*Provenance:* Purchased by the donors in 1976 from Moira Wallace, Waterbury, Conn. (dealer).

Gift of Virginia and Robert V. Krikorian
M1987.39

## 74B  *Candlestick*

John Cafe (w. 1740–57)
London, England, 1744/45

*Description:* The construction is in two parts. The socketed stem forms one element resulting from the soldering of two vertically cast halves. The lower end of the stem is inserted through a hole at the center of the one-piece cast base, and hammered over to secure the two units together.

*Marks:* Fully marked on the underside at the base with Cafe's second mark as entered in the Guild's records in 1742, the initials J and C in Gothic style surmounted by a star all enclosed in a trefoil. This mark is easily confused with the 1739 mark of James Gould (fl. 1722–

Cat. 73

Cat. 74A

Cat. 74B

Cat. 74c

47), under whom Cafe apprenticed. The remaining marks are the date letter, the leopard's mask crowned within a shield, and the lion passant. Cafe's initial mark and the lion passant are also found on the candle socket.

*Inscriptions:* An engraved armorial device on the top of the base pictures the head of a barking talbot hound mounted on a pedestal. The talbot is often representative of the surname Hall, though it was used in many arms.[1] Scratched on the underside faintly is "461(?) dwt 7."

*Condition:* The stick probably had a removable bobeche originally, now absent. A thin fracture line is expertly repaired just below the baluster.

*Material:* Silver.

*Dimensions:* H. 7⅞ in. (20.0 cm), w. base 4⅜ in. (11.1 cm), WT. 17 oz. 10 dwt. (544.3 gm).

*Provenance:* Purchased by the donors from Milwaukee Auction Gallery, Milwaukee, Wis.

Gift of Virginia and Robert V. Krikorian
M1987.40

## 74c *Candlestick*

China, 1740–60

*Description:* The stick is cast in one piece. The gray-white body is intricately decorated in overglaze polychrome enamels with gilt highlights.

*Condition:* The stick has been drilled through the core, presumably to electrify it. There is a fracture just below the base of the baluster.

*Materials:* Porcelain, overglaze enamel and gilt decoration.

*Dimensions:* H. 7½ in. (19.0 cm), w. base 4⅜ in. (11.1 cm).

*Provenance:* Formerly in the collection of Philip Suval, New York, N.Y. Purchased by the donors in 1983 from Taylor B. Williams Antiques, Chicago, Ill. (dealer).

Gift of Virginia and Robert V. Krikorian
M1987.41

Elaborating on the baroque trend toward slender, baluster-stemmed candlesticks without drip pans, these three rococo examples illustrate the adaptation of a basic form in three different materials: brass, silver, and Chinese porcelain made for the Western market.

The mid-eighteenth-century vogue for complex serpentine and cyma curves is reflected in the stepped, lobed bases and lobed shafts of each of these sticks. Although no two of these are identical, the silver (cat. 74B) and porcelain (cat. 74C) versions are very similar in their degree of complexity, each having three levels of molding at their base and well-articulated balusters. The porcelain candlestick has the addition of four low scrolled feet, reflecting the inevitable influence of the Oriental craftsman in the process of imitating European prototypes. The brass example (cat. 74A) is the simplest of the three, indicating that the market for base-metal candlesticks would not bear the cost of elaboration on the same level as that for more precious materials.[2]

Although the silver candlestick is unquestionably the most carefully and distinctly molded of this trio, among silver sticks of this period it is a relatively simple form. A taperstick in the Colonial Williamsburg collection, also by John Cafe, maker of the present example, and dated just one year later, demonstrates the next step in dressing up the simpler form, by replacing the bipartite lobed corners seen here with an intricate shell form.[3] Cafe, one of the most prolific candlestick makers of mid-eighteenth-century London, undoubtedly had a variety of molds in differing degrees of sophistication, enabling him to appeal to a broad sector of the market.[4]

*Jayne E. Stokes*

1. My thanks to M.B. Munford, Associate Curator, Decorative Arts, Baltimore Museum of Art, for her assistance with the heraldic research.
2. Burks, *Birmingham Brass Candlesticks,* p. 30.
3. Davis, *English Silver,* p. 37, fig. 28.
4. Davis, *English Silver,* p. 30.

## 75A *Candlestick*

### England, 1740–70

*Description:* The candlestick consists of a socket/stem unit, resulting from the soldering of two vertically cast halves, and the base, a single cast element. An extension at the bottom of the stem is inserted through a hole at the center of the base and hammered over to secure the units together. The bobeche is cast as a single element and is removable.

*Condition:* There is a fracture on the spool molding below the socket.

*Material:* Paktong.

*Dimensions:* H. 10¾ in. (27.3 cm), W. base 4⅞ in. (12.4 cm), D. base 4⅞ in. (12.4 cm).

*Provenance:* Purchased from an unknown dealer in England by Jackson-Mitchell, Inc., New Castle, Del. (dealer); purchased by the donors in 1983 from Jackson-Mitchell.

Gift of Virginia and Robert V. Krikorian
MI987.35

## 75B *Candlestick*

### England, 1740–70

*Description:* The candlestick consists of a socket/stem unit, resulting from the soldering of two vertically cast halves, and the base, a single cast element. An extension at the bottom of the stem is inserted through a hole at the center of the base and hammered over to secure the units together. The bobeche is cast as a single element and is removable.

*Condition:* There is an obscured casting fault or damage on the gadrooning at the top of the base.

*Material:* Paktong.

*Dimensions:* H. 10¾ in. (27.3 cm), W. base 4⅞ in. (12.4 cm), D. base 4⅞ in. (12.4 cm).

*Provenance:* Purchased from an unknown dealer in England by Jackson-Mitchell, Inc., New Castle, Del. (dealer); purchased by the donors in 1983 from Jackson-Mitchell.

Gift of Virginia and Robert V. Krikorian
MI987.36

The form and decoration of these candlesticks create an exceptionally adroit, visually exciting composition of contrasting elements. The beautifully modeled, three-dimensional quality of the gadrooning (like a well-mannered flow of candlewax) on the domed center of the base and at the top of the baluster stem stands in opposition to the short geometricized gadrooning which punctuates the edges of the horizontal stages of the tall, slender form. By comparison, the vertical elements of the design are sheer, bright, mirrorlike surfaces meant to create an interplay with these darker modeled areas. The gentle biplanar serpentine of the base and bobeche as well as the baluster are brought to a sharp angle at each corner. The ribs formed by these angles give a strong vertical thrust from the base up through the stem, then return to the horizontal, with the rings encircling the candle socket capped by the repetition of the base form in the bobeche.

The quality of the modeling and the elegance of the composition of these candlesticks are matched by the rarity of the metal—paktong—of which they are cast. This white metal is very similar to silver in appearance, although paktong, an alloy of copper, zinc, and nickel, can be distinguished by a slight yellowish tinge resulting from the high proportion of the first two elements of the alloy, which are the constituents of brass.[1] Paktong is a harder metal than silver and does not dent or scratch as easily, and its surface oxidation is much slower and less difficult to clean than silver. Despite these advantages, paktong is rare because the refining of nickel was not achieved in Europe until the early nineteenth century.[2] Paktong was known to Europeans before this time only through its exportation from China, where it had been in use, primarily as coinage, since at least the sixteenth century. Because of the role it played in domestic economics, exportation of paktong was extremely limited by the Chinese.[3] However, in the eighteenth-century heyday of the English East India Company's trade in Canton, enough of the metal was brought to England for craftsmen to produce limited quantities

Cat. 75A

Cat. 75B

of items. The hard metal could be used near a fire without danger of softening as silver would. Although its lack of malleability meant it could not be hammer-raised into hollowware forms as silver was, as a casting metal paktong could be formed using the same mold patterns as silver and brass and assembled in identical fashion.[4]

The makers of paktong wares are largely unknown because these goods were seldom marked in any way. This lack of identification suggests that brass founders may have been chiefly responsible for producing paktong items because they were an unregulated trade which never used the elaborate system of markings required by the silversmiths' guilds. It is also clear that the alloyed elements of paktong make it more likely that those who worked with base metals would have found this material more familiar than those who worked with precious metals.

These two candlesticks are remarkably similar. Their variations are most noticeable when the gadroons at the top of the baluster and the rings around the candle socket are closely examined. One stick (cat. 75A) has fewer, larger baluster gadroons and thicker socket rings. A single candlestick which makes an exact mate for this heavier-ringed example is illustrated in the most recent and in-depth study of paktong by W.D. John and Katherine Coombes.[5] The two sticks in the Milwaukee collection were probably brought together sometime after each had left its maker's shop. It is unlikely that they were produced by the same maker, as he would have found it uneconomical—patterns were very expensive—and illogical to have had two nearly identical patterns for the same form. It would have been too easy to sell mismatched sets.        *Jayne E. Stokes*

1. John and Coombes, *Paktong*, p. viii.
2. Gentle and Feild, *English Domestic Brass*, p. 78.
3. John and Coombes, *Paktong*, pp. viii, 11.
4. For nearly identical silver and paktong sticks see Michaelis, *Old Domestic Base-Metal Candlesticks*, pp. 120–21, figs. 173–75. A paktong stick closely related to the silver example by John Cafe is illustrated in Schiffer, *Brass Book*, p. 203, fig. A.
5. John and Coombes, *Paktong*, p. 40.

## 76 Andirons

America, possibly New York, 1760–1800

*Description:* The legs are cast in the round. The iron billet bar rests on top of the legs and is secured by an iron rod which is peened over underneath the arc of the legs, passes up through the legs, the billet, and the finial to form the core of the body. The body is composed of three elements, each cast in halves: the plinth, the shaft (from the disc at the top of the plinth and including the square terminus above the capital), and the head (including the spool-and-reel molded neck, faceted sphere, and flame finial). The iron-core rod is peened over on top of the flame. The andirons do not disassemble.

*Condition:* The rear leg and a section of the billet bar of .B have been replaced; it is now 2¼ in. (5.7 cm) shorter than .A.

*Materials:* Brass, iron.

*Dimensions:* H. 24¼ in. (61.6 cm), w. 12 in. (30.5 cm), D. (.A) 21¼ in. (54.0 cm), (.B) 19 in. (48.3 cm).

*Provenance:* Before 1975, Mrs. Henry W. Breyer, Haverford, Pa. (collector); lent to the museum, 1975–89; purchased in 1989 from Joseph Kindig III, York, Pa. (dealer).

The complexity and variety of shapes that make up these andirons typify rococo design. Several elements used here are common features of architecture and furniture from the period. Cabriole legs with ball-and-claw feet and stylized twist-flame finials are often seen on case pieces in the Chippendale style. The baluster shaft with square head and pedestal base is an element drawn from stair railings and other low vertical supports found in buildings of the eighteenth century.

These andirons share many features with a pair bearing the mark of Richard Wittingham, a New York City brass founder (1747/48–1821).[1] Twist-flame finials and geometrically faceted spheres form the heads of both pairs and below this each has a baluster shaft. The most striking difference between these andirons is the modeling of the baluster: the Milwaukee andirons have a smooth baluster, whereas the Wittingham andirons have the same twisted-lobed surface as

the finials.[2] Intended for a client willing to pay for this element of elaboration, the New York andirons also have a taller plinth below the baluster (overall they are 2 in. [5 cm] taller than this entry) and have a decorative log stop where the andirons illustrated in this entry make use of a simple step-down billet bar to serve this purpose. A second pair of andirons by Wittingham, once in the Bowers collection, have the shorter plinth of the Milwaukee andirons, but retain the twisted-lobed baluster of the Wittingham andirons discussed above.[3]

The patterns used for casting the legs of these two pairs of andirons were clearly not the same and indicate production by different foundries. The unmarked Milwaukee andirons have thicker, more upright ankles and feet; the elongated claws of the Wittingham andirons appear to hold an egg rather than a ball.

In the past, andirons such as these had often been termed "Revere" type because of their basic similarity of form to a pair in the Metropolitan Museum's collection marked "Revere and Son, Boston."[4] Paul Revere II (1735–1818), well known to us as a patriot and silversmith, also operated a foundry where cast cannon, bells, and possibly andirons were produced.[5] However, questions have been raised about the authenticity of the markings on these andirons which remain unresolved.[6] At this time, the association of the Milwaukee andirons with New York, although probably not the Wittingham foundry, offers more certain ground.        *Jayne E. Stokes*

Purchase, Layton Art Collection
L1989.1A, B

1. The Wittingham foundry is discussed fully in cat. 110. The marked pair of andirons were sold at Sotheby's (sale 5883; June 21, 1989), lot 254.
2. A very similar pair having plain billet bars rather than the step-down form used in this entry is illustrated in Schiffer, *Brass Book*, p. 60, fig. B.
3. Kauffman and Bowers, *Early American Andirons*, p. 50.
4. Kauffman, *American Copper and Brass*, p. 148.
5. Buhler, *American Silver*, p. 385.
6. Per phone conversation and correspondence in February and March of 1990 with Peter Kenny, Assistant Curator, American Decorative Arts, Metropolitan Museum of Art, New York, N.Y.

Cat. 76

## 77 *Embroidered picture*

England, or possibly America, ca. 1745

*Description:* The linen plain-weave structure is spaced two warps and two wefts. It is embroidered with tones of blue, red, yellow, white, brown, and black with wool and silk yarns in tent stitch.[1] A shepherdess seated under an oak tree holds a staff in one hand and three flowers in the other. The shepherd companion stands with a staff wreathed with flowers. The figures' hats are also decorated with floral sprigs. The foreground contains numerous animals—four sheep, a leopard, a lion, a spotted dog, and two rabbits; in the background are a house, flowering trees, numerous flying birds, a parrot, and a squirrel.[2]

*Condition:* The picture retains good color, and there has been only scattered minor thread loss.

*Materials:* Linen, plain weave; embroidered in tent stitch with wool and silk yarn in colors.

*Dimensions:* H. 17¼ in. (43.8 cm), w. 16¾ in. (42.5 cm).

*Provenance:* Francis Wood, a descendant of the Waln family, Waln Grove, Frankfort (Philadelphia); Carl Linborg (dealer), 1952; purchased by the donors in 1978 from Joe Kindig, Jr., and Son, York, Pa. (dealer).

Needlework pictures became increasingly popular in the eighteenth century in England and the colonies. A woman was considered poorly educated if not skillful with a needle and able to execute a picture and other embroidered items for the household. The religious fervor stitched into the biblical scenes of the earlier period was replaced by a passion for "arcadia."[3] The common designs of elegant shepherds and shepherdesses in rural settings were usually adapted from engravings and simplified to meet the embroiderer's needs. Engravings, such as one by N. de Larmessin after Nicolas Lancret, or another by Jacobus Neefs after Jacob Jordaens, provided the idea for the configuration of a seated shepherdess with staff, dog, and sheep at her feet with a gnarled oak for a backdrop.[4] Idyllic subjects, conceived more for ornamentation than moral lesson, spread onto the surfaces of chair covers, curtains, valances, and bed hangings (see cat. 41), as well as needlework pictures. Unlike stump-work compositions with randomly scattered motifs, these later cohesive designs reflect the general change in taste and fashion from baroque to lighter, fluid rococo patterns.

New England embroidered pictures in this period show a strong English influence. A 1738 newspaper advertisement of Mrs. Susannah Condy, Boston schoolmistress, stated that she provided patterns from London and, in addition, her own cheaper redrawings.[5] While certain English patterns show many American versions to be plainer and, therefore, less costly, the fact that they flooded the colonial market and could be stitched as imported or redrawn from the model, makes the origin of these popular pastoral scenes difficult to determine. However, the less stylized, more whimsically drawn figures on the Milwaukee picture and its ownership in a Philadelphia family could indicate the work of a colonial embroideress.                    *Anne H. Vogel*

Gift of Virginia and Robert V. Krikorian
M1987.50

1. Examined microscopically for fiber content and structure by Lorna Ann Filippini, Department of Textiles, Art Institute of Chicago, through the courtesy of Christa C. Mayer-Thurman, Curator, Department of Textiles.
2. For an example of similar figures in a pastoral setting, see Synge, *Antique Needlework*, pl. 22; Hackenbroch, *Needlework in the Untermyer Collection*, figs. 132, 164.
3. Elizabethan antecedents to the pastoral theme with shepherds and idyllic country scenes are seen in the borders of the late sixteenth-century Bradford carpet. See Nevinson, *Catalogue of English Domestic Embroidery*, pl. III.
4. Cabot, "Engravings as Pattern Sources," pp. 477–79, fig. 6; Hackenbroch, *Needlework in the Untermyer Collection*, fig. 50.
5. Cabot, "Engravings and Embroideries," pp. 368–69.

Cat. 77

# THE FEDERAL STYLE

Cat. 102

# Neoclassicism in the New Nation: The Federal Style

## THOMAS S. MICHIE

DEFINED by the end of the Revolutionary War in 1783 and widespread economic hardship following the War of 1812, the federal period in American history spanned a generation that witnessed the creation of a new nation and weathered fundamental shifts in the social, economic, technological, and artistic life of the country. The transition from colony to nation was neither smooth nor automatic. Writing retrospectively in 1818, John Adams noted that "the colonies had grown up under constitutions of government so different, there was so great a variety of religions, they were composed of so many different nations, their customs, manners, and habits had so little resemblance, and their intercourse had been so rare, and their knowledge of each other so imperfect," that to unite them under a single government had been almost inconceivable. Adams was pleased to affirm, however, that "thirteen clocks were made to strike together—a perfection of mechanism which no artist had ever before effected."[1]

On the role of the arts in the new republic, Adams was plagued by contradictions, infatuated as he was on the one hand by cultural and material riches that he had observed in the course of a decade abroad, and sternly distrustful on the other hand of luxury for its own sake, which he associated with the aristocracy, oppression, and decadence of Europe.[2] His ambivalence, the legacy of New England's Puritan past, was scarcely shared by his contemporaries among Boston's mercantile elite. James Swan, Richard Codman, and Thomas Handasyd Perkins, for example, were all busily acquiring French royal furniture for their Boston-area homes designed in the neoclassical taste by Samuel McIntire, Charles Bulfinch, and others. At the same time, Thomas Jefferson in Virginia,

Gouverneur Morris and Alexander Hamilton in New York, and Robert Morris in Philadelphia were also importing high-style French decorations as they were dispersed from Versailles and other royal estates.[3] Together these patrons and collectors embody the polarity during the federal period between those who sought to plunge into the mainstream of European culture and others who advocated restraint and foresaw America's destiny as altogether distinct from that of Britain and the Continent.

In spite of the number of acquisitive Francophiles in more than one region of the country, the impact of French design upon American cabinetmakers of the early federal period is rarely discernible. By the time of the French Revolution in 1789, America's loyalty was torn between gratitude to Louis XVI for assistance in the rebellion against England, and sympathy for the French revolutionaries' cause. The arts in America tended to reflect the English neoclassical style, a sober and rational response to the sensual frivolities of the rococo style. The more severe brand of French neoclassicism carried disturbing associations of radical political and philosophical reform, beginning with the abolition of the monarchy. In this sense, France and the United States ought to have had much in common, yet the subsequent course of French anarchy and despotism terrified many Americans, whose fledgling confederacy was less than secure during its first decade.[4]

Although few people shared John Adams's puritanical suspicions of art or articulated them to the same degree, almost everyone who addressed the subject of the arts at the national level advocated the pursuit of "useful" arts and "applied" sciences for pragmatic ends that would enhance the public good. The 1780

charter of the American Academy of Arts and Sciences, for example, directed its members to pursue knowledge that could be applied, rather than knowledge for its own sake, and to "cultivate every art and science, which may tend to advance the interest, honor, dignity, and happiness of a free, independent and virtuous people."[5] The same sentiments pervade contemporary accounts of a bustling country, scrambling to recover from nearly a decade of strife. One observer writing from Baltimore in 1789 summed up the times by noting a "spirit of emulation, of industry, of improvement, of patriotism, raised throughout the states. . . . In no period have they made a more rapid progress than within this year or two. . . . Every nerve and sinew seems to be at its utmost stretch."[6]

In spite of the new country's apparent zeal to rebound, the disjunction caused by the Revolution and the absence of well-to-do loyalist patrons made tangible an artistic lag often noted by historians of American art. Had war not intervened, the taste for fashionable shield-back chairs like those from Baltimore, Philadelphia, and New York (cats. 80–82) might have prevailed a decade earlier in this country, as it had in England. Although very few American-made neoclassical objects date from as early as the 1770s, a presentation silver tea urn made by Richard Humphreys of Philadelphia in 1774 is a tantalizing exception that hints at artistic achievements unfortunately postponed or precluded by war.[7] It is fitting that the shield- and heart-back chairs in the Milwaukee collection should have come from Philadelphia (cat. 81) and Baltimore (cat. 80), the former serving as the national capital between 1790 and 1800, and the latter one of the fastest growing cities in the federal period. When George Washington ordered a set of Philadelphia chairs similar to cat. 81 to furnish Mount Vernon, he was choosing a recognizably English design, though he was departing from a long tradition on plantations in the middle and southern colonies of importing furniture and furnishings directly from England. Considering that these and other related chair designs by Thomas Sheraton and George Hepplewhite were readily available by the late 1790s to cabinetmakers in every part of the country by means of engraved pattern books, it is remarkable that regional preferences remained so strong and distinct. Unfettered by either sacred or secular institutions with a lengthy past, the United States was uniquely

receptive to the rationalism embodied in the neoclassical style.[8] Ironically, Windsor chairs, not high-style shield- or urn-backs, were among the first furniture to transcend regionalism, due in part to the practicality of mass-produced, interchangeable components (see cats. 87–89). Furthermore, in every region in all but the very best parlors, fashion never completely displaced traditionally joined and turned furniture. Even the double parlors occupied by Charles Carroll of Carrollton were described as "presenting in their furniture a singular medley of old and modern fashions."[9] Though not represented in the Milwaukee collection, ordinary household furniture has always existed alongside of high-style examples but is less likely to have been preserved.

As a result of restricted post-Revolution trade with Britain, the volume of domestic trade along the Atlantic seaboard increased dramatically. An inscription on a drawer of the Milwaukee tambour desk (cat. 92) indicates that it was owned in Baltimore during the federal period and was probably imported as venture cargo from New England, just as leather chairs had been almost a century before.[10] Smaller coastal cities that had not been occupied by the British sought to regain prosperity by experimenting with new kinds of manufactures and by seeking new trade routes beyond British imperial colonies. The opening of trade between the United States and China in 1784 marked an important turning point in the commercial and artistic life of the country. Merchants brought back elegant textiles and porcelains, as well as a taste for exotic materials such as bamboo. The legs of the Boston card table (cat. 95), turned to simulate bamboo, give it an unusual appearance of lightness and informality associated with Chinese design, by way of Regency England. The overall design, however, remains well within the American canon, in which the influence of English taste was as predominant during the federal period as it had been before. More direct influence occurred as provincial English cabinetmakers, turners, and carvers emigrated to Boston in search of greater economic opportunity in a land without restrictive guilds. John and Thomas Seymour are among the better-known arrivals, having left their native Axminster to settle first in Portland and eventually in Boston. In addition, the carver Thomas Wightman, who arrived from Liverpool in 1797, and the turner Thomas Ayling, who arrived from Sussex in 1801,

were undoubtedly familiar with the latest English fashions.[11] They and others helped raise the local standards of cabinetmaking, as suggested by the unusual mechanism of the pole screen (cat. 94) and the delicate mahogany drawers of the worktable (cat. 93).

Immigrant craftsmen brought with them not only the knowledge of the latest styles, but also perhaps the latest pattern books. At the least, three copies of Hepplewhite's *Cabinet-maker and Upholsterer's Guide* (3d ed., 1794) are known to have been owned in Salem in 1810, and other Salem- and Boston-made furniture based on Sheraton's *Cabinet-maker and Upholsterer's Drawing Book* (1793) indicate its likely presence in both cities.[12]

Western Africa was a second market much closer than China but no less lucrative as a source of slaves for southern plantations that supplied molasses to northern rum distilleries. Between the China trade and the "triangular" trade with Africa and the West Indies, many New England seaports grew rapidly, as did mercantile fortunes. The Ionic doorway (cat. 78) is one of dozens like it in Bristol and nearby Rhode Island towns where neighborhoods close to the harbors expanded rapidly during the federal period. As the number of houses grew, the size of urban lots shrank, and door frontices like Milwaukee's were one of the few exterior extravagances that proclaimed one's social status. Interior extravagances like the composition mantelpiece (cat. 79) were more likely to be coordinated with the overall decoration of rooms. The room in which the Milwaukee mantel originally stood probably contained other plaster or composition ornament in the neoclassical taste. If one imagines chairs like cats. 80–82 lining the walls of a room and further embellished with upholstery tacks in swag patterns like a classical frieze, or perhaps standing in a double parlor symmetrically arranged, one begins to appreciate the elegance of a well-furnished federal house, which some historians have likened to the musical compositions of Haydn and his contemporaries.[13]

An aggressive spirit of patriotism informs the inlaid ornament that was popular in several cabinetmaking centers at the outset of the federal period. The eagles on the Baltimore chair (cat. 80) and the New Jersey tall clock (cat. 102) appealed to Americans as emblems of combative tenacity, and therefore appropriate for the national seal adopted in 1782.[14] Gradually, however, the tone of popular imagery became less shrill and was gradually supplanted in the first decade of the nineteenth century by more optimistic emblems of liberty, peace, and prosperity, represented in this collection by the carved and gilt pineapples and cornucopias on the New York card table (cat. 97). In a similar transformation, the decoration of clock dials changed from traditional images of the four seasons or Father Time and an hourglass accompanied by epitaphs emphasizing mortality, to more decorative, timeless subjects such as the flowers on the dials of the three Milwaukee clocks.

In contrast with the shield-back chairs, pole screen, tall-case clock, and looking glasses that were inspired by British prototypes or derived from pattern books, other furniture forms like the lolling chair (cat. 84) and two shelf clocks (cats. 100, 101) represent native American improvisations upon traditional English designs that resulted in novel American products. The combination of sinuous arms on a chair with a tall, upholstered back has no English counterpart. Likewise, the upper portion of Simon Willard's shelf clock (cat. 101) resembles an English bracket clock, and yet by joining it to a larger base that accommodates the pendulum, Willard created an original design. The case on the Hutchins clock (cat. 100) is even more creative in its architectural embellishments, a vernacular combination of miniature and over-scaled classical ornament. The three clocks in the Milwaukee collection speak for other important changes in patronage and shop practices that took place during the federal period. The collaboration among clock-related craftsmen was both cause and effect of an extended network of apprenticeship and interrelation that governed other trades in cities as well. Levi and Abel Hutchins were the apprentices of Simon Willard. They were further united by marriage when Abel married the sister-in-law of Simon's nephew, Aaron Willard, Jr., who in turn was the brother-in-law and business partner of Spencer Nolen, a clock-dial painter, who was also related by marriage to a fifth clockmaker, Zaccheus Gates. Other segments of clock manufacture in Boston were similarly entwined. John Doggett, the carver and gilder who supplied numerous clock-case components to the Willards, was the nephew of Stephen Badlam, a Dorchester cabinetmaker whose daughters married the cabinetmakers James Howe and Samuel Crehore. Crehore's brother

was conveniently a lumber merchant. Considering the number and extent of these interrelationships, it is remarkable that the Hutchins clock case originated entirely outside of the Boston-Roxbury group and their apprentices. It demonstrates instead the role of the patron, who, in this instance, lived in Gloucester and evidently chose to commission the clock case separately from a local cabinetmaker.

The New Jersey tall clock (cat. 102) reflects the gradual industrialization of crafts in an expanding country with improving means of transportation and communication. Though unsigned, it is most likely the product of subcontracted labor. A typical example of this practice in the Boston area appears in a running account kept by the cabinetmaker Benjamin Bass, Jr., of "sundry small jobs," "one evening's work," and multiple hours and days worked intermittently by Edmund Fowler of Dedham, a cabinetmaker living twenty miles or so to the south who provided cabinet-work during the winter months to larger, urban shops.[15] While not an entirely new practice, subcon-tracted seasonal piecework hastened the breakdown of the traditional apprenticeship system, diminished the boundaries between regional styles, and ultimately paved the way for the mechanized production of furniture by unskilled wage-based labor in urban factories by the second quarter of the nineteenth century. Ironically, the hard-won liberty and equality of the federal era helped to change workers' percep-tions of apprenticeship: no longer was it a virtuous period of delayed gratification but rather "an irksome burden."[16] The simultaneous rise of charitable me-chanics' associations also hints at the reduced stature of apprentices and journeymen.

Several new furniture forms that came into exis-tence during the federal period provide a glimpse of changing roles for men and women, the changing use of household rooms, and the birth of modern consum-erism. The tambour desk (cat. 92), for example, served a very different function from larger desks and book-cases (cat. 64), from which business was conducted at home. Since a tambour desk contains significantly less space for writing and storing letters, fewer drawers below or secret compartments within, and no provi-sion for tall account books or ledgers, one might conclude that business and banking practices had changed and that their location had moved from the parlor to the countinghouse. Tambour desks were

evidently intended for more casual, perhaps even more feminine, domestic use. The alternating strips of light and dark wood on the tambour shutters create a surface that is more decorative and compact than that of a slant-front desk, whereas the gadgetry of the sliding, retracting shutters probably appealed in an era that rewarded novelty and mechanical ingenuity.

By the end of the eighteenth century, the term "dining room" was commonly used to distinguish between separate sitting and eating rooms. Many Americans continued to eat in their drawing rooms, or wherever it was most comfortable to set up a table according to the season, while affluent builders of new houses increasingly made provision for a separate dining room. As a result, one finds inventory refer-ences in the early federal period to sideboards (cat. 96) in either a parlor or dining room, and sometimes in both.[17] Milwaukee's sideboard offers further evidence of recent prosperity in Baltimore, whose population more than tripled between 1790 and 1810. In the same interval, the number of households in New York City more than doubled.[18] The number of federal side-boards that survive with histories of ownership in these two cities alone attests to the number of new houses constructed and furnished after the war, many of which probably included dining rooms. Whereas the design of a sideboard with deep cupboards for plates, deep drawers fitted for storing bottles, and other drawers for cutlery, was a practical innovation of the federal period, its secondary function as a surface for the prominent display of valuable and decorative objects had changed very little since the similar function of court cupboards in the seventeenth century.

The exquisitely made worktable (cat. 93) was another furniture form first introduced at the end of the eighteenth century. The fact that women had long managed without special tables for sewing suggests the impact of greater disposable income combined with a proliferation of "new" products to choose from, luxuries that soon became necessities. With its con-struction as refined as the letter-writing and needle-work that it engendered, such furniture was well suited to be seen from all sides in fashionable parlors. The women for whom such costly furniture was made were increasingly the products of "female academies," or finishing schools, where fancy needlework was taught together with other social skills that contrib-

uted to the quest for vertical social mobility and encouraged the emulative spending that fueled a consumer society.[19]

With few exceptions, the taste of Boston patrons remained conservative relative to that of well-to-do patrons in other cities. For example, just before Jefferson's Embargo of 1808, Nathan Appleton was ordering furnishings from England for his new house on Beacon Street. His instructions provided for "a pair of Grecian lamps—rather elegant than showy, some handsome chimney ornaments novel and elegant—a pair of stylish bell ropes . . . something tasty." Appleton's remark the same year that his neighbors "are very stylish but have not annoyed us by their civilities," likewise reveals a taste for luxury tempered by contempt for ostentation.[20] Indeed, contemporary Boston counterparts to the New York gaming table (cat. 97) are much more restrained, which attests to the growth and prosperity of New York and the attraction it held for immigrant craftsmen such as Charles-Honoré Lannuier and Duncan Phyfe, who introduced high-style Directoire and Regency fashions (cat. 86) to this country.

By the conclusion of the War of 1812 and as peace with England was restored in 1815, several factors undermined the kinds of patronage and craftsmanship that had produced the furniture represented in the Milwaukee collection. By cutting imports of manufactured goods, Jefferson's Embargo had stimulated demand that brought about rapid and extensive development of American manufacturing well beyond the Atlantic seaboard. An increasingly national economy tied to a large-scale network of land and water transportation also meant the end of any village economy, and with it changed the manufacture and consumption of furniture. The earlier spirit of emulation also seems to have diminished, which for the industrial arts did not mean a loss of innovation but a much greater emphasis on exclusive rights and patents.[21]

By the mid-1820s, remarks by many who had assisted at the birth of the republic confirm the end of the optimistic days of the early federal period. Many were simply responding to the economic hardship that prevailed throughout the country. Under the headline "Dull Times in Boston," for example, one journalist reported in 1827 that "times are duller than they ever were before; business is going to New York, and enterprize is entirely at a stand."[22] Others expressed a more deeply troubled sense of loss prompted by seemingly contradictory observations. In 1825 Oliver Wolcott, a signer of the Declaration of Independence, complained to his niece that "the whole world seems to be crazed—every thing seems to be in rapid motions. Men, women and children are hurrying to and fro—will not stop long enough in any one place to give one time to enquire, what objects they are pursuing."[23] The aging Wolcott was expressing anxiety that often comes with maturity, whether personal or national. Later nineteenth-century manufactures would once again inspire national pride and prosperity, and yet by 1825, as grittier issues of industrialization and the rising tide of foreign immigration turned the nation's attention from abroad to within, there was a distinct realization that the idealism of the federal period had passed.

1. Adams, *Works of John Adams*, 10:283.

2. See Garrett, "John Adams," pp. 243–55. The aesthetic taste of the next generation of Bostonians is examined in Howe, *Unitarian Conscience*, pp. 186–97.

3. For the links between France and the United States in general, see Kennedy, *Orders from France*. See also Garrett, "French Decorative Arts in America," pp. 696–707; Watson, "Eye of Thomas Jefferson," pp. 118–25; Delorme, "James Swan's French Furniture," pp. 452–61; Boyett, "Thomas Handasyd Perkins," pp. 45–62; and Garvan, *Federal Philadelphia*, pp. 54–60.

4. For the political implications of neoclassicism, see Herbert, "Neo-Classicism and the French Revolution."

5. *Memoirs of the American Academy of Arts and Sciences* (Boston: Adams and Nourse, 1785), 1:vii.

6. *The American Museum* VI (Philadelphia, 1789), p. 238, quoted in Bjork, "Weaning of the American Economy," p. 546.

7. Warren, Howe, and Brown, *Marks of Achievement*, pp. 60–62. For other evidence of neoclassical taste in pre-Revolutionary Virginia and Massachusetts, see Cooper, *In Praise of America*, p. 242.

8. For a discussion of the United States as the heir to eighteenth-century European rationalism, see Commager, *Empire of Reason*.

9. Quoted in Van Devanter, "*Anywhere So Long as There Be Freedom*," pp. 78–79.

10. See Swan, "Coastwise Cargoes," pp. 278–80.

11. For the Seymours, see Sprague, "John Seymour," pp. 444–49. Wightman's and Ayling's immigration and naturalization are recorded in the Extended Record Books of the Suffolk County, Massachusetts, Inferior Court of Common Pleas (September 1813), folios 286, 291.

12. Clunie, "Furniture Craftsmen of Salem," p. 200.

13. See Pierson, *American Buildings and Their Architects*, pp. 224, 228. It may not be coincidental that the Handel and Haydn Society of Boston was founded as early as 1815.

14. For other eagle-decorated furniture, see Conger and Pool, "Some Eagle-Decorated Furniture," pp. 1072–81. The evolution and significance of such national symbols is examined by Kammen, *A Season of Youth*, pp. 95–97.

15. See *Fowler v. Bass*, Suffolk County, Massachusetts, Inferior Court of Common Pleas (March 1813), case 128.

16. See Rorabaugh, *The Craft Apprentice*, pp. 24–25. For a

contemporary apprentice's first-hand account, see Mullin, *Moneygripe's Apprentice*.

17. See Garrett, "The American Home, Part IV: The Dining Room," pp. 910–22.

18. See Rorabaugh, *The Craft Apprentice*, p. 25; and Weidman, *Furniture in Maryland*, p. 71.

19. See McKendrick, Brewer, and Plumb, *Birth of a Consumer Society*.

20. Quoted in Fox, "Nathan Appleton's Beacon Street Houses," p. 114.

21. Brown, "Modernization and the Modern Personality," pp. 201–28. See also Hindle, *Emulation and Invention*.

22. *Niles Weekly Register* (July 21, 1827): 347.

23. Oliver Wolcott to Laura Gibbs, June 14, 1825, Manuscripts Division, Library of Congress, Washington, D.C.

## 78 Door frontice

Bristol, Rhode Island, ca. 1790–1815

*Description:* The door casing consists of multiple and superimposed moldings applied to a pine frame. The fluted pilasters, molded and mitered plinths, and carved capitals are separate elements, as are the entablature, keystone, and cornice.

*Condition:* Portions of the plinths of both pilasters, the threshold, door, and glazed fanlight are later additions. Cornice brackets are missing on both sides. The entire surround has been repainted several times.

*Materials:* Eastern white pine; the top of the pediment is sheathed in tin.

*Dimensions:* H. 142¼ in. (361.3 cm), W. 86¼ in. (219.0 cm), D. 16¼ in. (41.2 cm).

*Bibliography: Antiques* 110, no. 4 (October 1976): 701.

*Provenance:* Purchased ca. 1905 by Elizabeth Dimond Church, Bristol, R.I., from the owners of a house being demolished; sold ca. 1950 to Joe Kindig, Jr., and Son, York, Pa. (dealer); Bolling Jones III, Thomasville, Ga. (collector).

Just as eighteenth-century domestic interiors revolved around the fireplace and its hearth, so the symmetrical exteriors of many Georgian houses were designed to accentuate the front doorway and its ornamental surround. Doorways and porches, often the most imposing architectural statements on otherwise plain exteriors, received frequent attention in late eighteenth-century pattern books and housewrights' manuals, which usually contain several design options within each of the classical orders. Even as late as 1839, Asher Benjamin acknowledged in *The Builder's Guide* that the location and function of the front door "subjects the frontispiece to a severer scrutiny than the other parts of the same front, and it will therefore be proper and expedient to give to it a greater portion of decoration."[1] In an urban context such as Bristol, where similar houses line both sides of many streets, door surrounds with optional embellishments made each house distinctive, while collectively fostering a sense of architectural unity.

Cat. 78

The unity of architectural ornament was also a practical result of the limited number of builders and carpenters working in the same town and throughout a single region. In the small state of Rhode Island, this style of door surround was popular on both sides of Narragansett Bay, where hundreds of similar examples can still be found between Bristol and Providence and southward to Apponaug Four Corners, Kingston, and Wickford, on houses dating from the turn of the eighteenth century.[2]

Whereas freestanding houses built on generous lots could accommodate projecting doorways with a shallow porch and interior vestibule, more concentrated urban street-front construction during the federal period required more compact "frontices" like this one. The most distinctive features of the Rhode Island doorways to which this one relates are the carved and applied ornaments in the frieze on either side of the fanlight and the prominent keystone. Carved leaves or flowers, as seen on this example, were the most popular motifs, although carvers could readily provide other designs to fit within the same space. Applied ornaments were also occasionally cast out of pewter and painted, as on the main staircase in the Siril Dodge house in Providence.[3] Like the composition ornament of the Wellford mantelpiece (see cat. 79), metal, once painted, is nearly indistinguishable from wood and less costly than carving.

The greatest variation among these doorways occurs in the number and use of applied moldings and dentils, for which carpenters charged accordingly. On the Milwaukee doorway, for example, the egg-and-dart molding in the pediment is an addition to the more common cross-cut fret and carved brackets. Likewise, the cross-cut molding below it probably cost slightly more than common dentils, which required less time and effort to execute. The shaping of the upper brackets added further to the cost of this doorway.

The list of prices compiled by Providence housewrights in 1796 records several of the features found on the Milwaukee door. Pilasters, for example, ranged between 9 and 14 inches in width, with the option of fluting. The "joiner's

capital" on this doorway cost £1 extra. In addition to wooden muntins, an assortment of leaded fan- and sidelights were available locally from Robert W. Jenks, a metal-sash manufacturer whose illustrated advertisement offered sashes "finished to any pattern."[4]

Bristol's boom-and-bust economy in the first quarter of the nineteenth century was as extraordinary as it was notorious, dependent as it was upon unscrupulous privateering and slave trade in Africa and the West Indies. Led by members of the De Wolf family who lived extravagantly in several large mansions designed by the architect Russell Warren, Bristol's wealthy elite lived in more modest houses enhanced by classical exterior doorways like this one. After severe economic depression in the 1830s and gradual displacement by larger seaports, Bristol's economy declined steadily throughout the nineteenth century, accompanied by the decay and demolition of many early buildings. Dozens of doorways from Bristol and other Rhode Island towns were salvaged by collectors in the early part of this century, most notably by Henry Davis Sleeper at "Beauport" in Gloucester, Massachusetts, and Arthur Leslie Green of Newport. Both designed houses and interiors around doorways and other architectural fragments salvaged from Bristol buildings.[5] A contemporary of Elizabeth Dimond Church, the Bristol antiques dealer who salvaged this doorway around 1905, Green became the foremost supplier of "Bristol doorways" and interior woodwork to collectors and museums who were eagerly acquiring and installing period rooms across the country in the 1920s, a tradition more recently continued by the donor of this doorway. *Thomas S. Michie*

Gift of Bolling Jones III
M1974.184

1. Benjamin, *Builder's Guide*, pl. 24.
2. For related Rhode Island doorways, see Embury, "A Comparative Study," pp. 3–14 (1917), 3–14 (1921); and Robinson, *Old New England Doorways*. Two more related doorways appear in *Antiques* 106, no. 6 (December 1974): 1002. Another formerly installed in the American Wing of the Metropolitan Museum was sold at Sotheby's (sale 5551; January 28–31, 1987), lot 1187.
3. A soapstone mold for casting fanlight ornaments, from the shop of the Greenfield,

Mass., pewterer Samuel Pierce, is in the collection of Historic Deerfield.
4. See *Rules for House-Carpenters Work, in the Town of Providence* (Providence: Carter and Wilkinson, 1796). Jenks's engraved trade card is illustrated in Roelker and Collins, *One Hundred Fifty Years of Providence Washington Insurance Company*, facing p. 35. For a statistical survey of doorways, fanlights, and their owners in Providence, see Grey, "Fanlights and 'Good Style' in Providence, Rhode Island."
5. Sleeper's Beauport is a property of the Society for the Preservation of New England Antiquities; see *Antiques* 103, no. 3 (March 1973): 532. An account of Green's career appears in Monkhouse and Michie, *American Furniture in Pendleton House*, pp. 40–45.

## 79 *Mantelpiece*

Attributed to Robert Wellford
(w. 1798–1839)
Philadelphia, Pennsylvania, ca. 1810–20

*Description:* The composition ornament is attached to a pine framework, whose simpler moldings and dentils are milled wood. The columns and plinths are turned and applied pine, as is the thin board that forms the top.

*Condition:* Small areas of applied composition ornament are missing, especially at the corners and in the central medallion. The surface details are partially obscured by multiple layers of paint.

*Materials:* Eastern white pine, with applied and painted plaster composition ornament.

*Dimensions:* H. 55¾ in. (141.6 cm), W. 76⅜ in. (193.9 cm), D. 10¾ in. (27.3 cm).

*Provenance:* Joe Kindig, Jr., and Son, York, Pa. (dealer).

Directly inspired by mid-eighteenth-century English mantelpieces by Robert Adam and engraved designs by James and William Pain, this elaborate Philadelphia chimneypiece combines multiple registers of swags, tassels, urns, and bowknots in the latest neoclassical taste. Its combination of turned and carved pine with applied plaster mounts represents the collaboration of house carpenters, who provided the underlying pine

Cat. 79

frame, and stucco or composition workers, who cast and applied the individual ornaments, but who also sold ready-made chimneypieces.

Composition, a mixture of plaster, resin, and size, was poured into wooden or ceramic molds to harden and later affixed with an adhesive, or else lightly screwed into place. Once painted, composition ornament is nearly indistinguishable from finely carved wood, yet obviously less costly to produce. Even by 1801, Robert Wellford admitted that the low cost of composition had "encroached so much upon [wood-carvers'] employment, that several embarked in this [composition] work, and by their superior talents greatly improved it."[1] Also appealing was its relative ease of application, which precluded the extended inconvenience to homeowners of conventional plasterwork. Compo-

sition ornament not only enabled older woodwork to be readily "updated," but also provided a stylish alternative to the low-relief gouge carving with its profusion of "spindle shanked, gouty legged, jewelled, dropsical, cryspaglatic, hydrocephalic columns" decried by Benjamin Latrobe in 1816.[2]

In addition to "complete setts" of ornaments for chimneypieces, advertisements recommended composition for embellishing stairwells, cornices, friezes, and other interior woodwork on both public and private buildings. A partial list of ornaments stolen in 1808 from the shop of the Boston stucco worker Daniel Raynerd, including bas-relief figures, a small trophy of music, a horn of plenty, the figure of a dove, the sun and its rays, a festoon of roses, and drapery, hints at the range of popular motifs. A similar range of

patterns was available in Philadelphia.[3] Specifically American subjects such as the Battle of Lake Erie, the Victory of Columbia, and Washington's Tomb were popular for the central tablet of the frieze. These were cast in the manner of classical reliefs, much as the English sculptor John Flaxman had reinterpreted antique themes for ceramic chimneypiece medallions by Josiah Wedgwood.

Philadelphia supported at least a half dozen composition workers during the federal period. Newspaper advertisements frequently emphasized the fact that English, Irish, and Scottish craftsmen directed local shops.[4] Nearly identical decoration on dozens of chimneypieces installed between the Carolinas and New England attests to both the widespread importation of individual ornaments or molds from Britain, and the successful

distribution of mounts by a few mass-producers like Wellford. Even cabinet-makers occasionally used composition ornament to embellish furniture, as on a pier table at Winterthur with the same swag-and-tassel motif found in two registers on the Milwaukee chimneypiece.[5]

One of Philadelphia's best-known composition workers was Robert Wellford, who first appears in city directories for 1801 but was evidently at work along Virginia's Eastern Shore as early as 1798.[6] Like his principal competitors, Zane, Chapman and Co., who occasionally labeled their work, Wellford frequently included his name prominently within his mounts.[7] Although none of the mounts on the Milwaukee chimneypiece bears his mark, several motifs, such as the rinceau of roses, the swags with bowknots, and the swelled central portion of the frieze, resemble other signed or documented examples.[8]          *Thomas S. Michie*

Gift of the Elizabeth Elser Doolittle Charitable Trust in Memory of Elizabeth Elser Doolittle
M1975.7

1. Kauffman, *American Fireplace*, p. 135.
2. Quoted in Garvan, *Federal Philadelphia*, p. 46.
3. The inventory of Raynerd's shop is recorded in Suffolk County, Massachusetts, Inferior Court of Common Pleas, Extended Record Book (April 1808), folio 584. See also Quinan, "Daniel Raynerd, Stucco Worker," pp. 1–21. For Philadelphia patterns, see Garvan, *Federal Philadelphia*, p. 46.
4. See Prime, *Arts and Crafts in Philadelphia*, 2: 316–20.
5. See Montgomery, *American Furniture*, no. 345.
6. Philadelphia Museum, *Three Centuries*, p. 225.
7. A labeled example by Zane, Chapman and Co. is installed in the Billiard Room at Winterthur Museum.
8. See, for example, *Antiques* 117, no. 5 (May 1980): 1039; Bernard and S. Dean Levy, *Brochure 3* (Fall 1977), p. 63; Warren, *Bayou Bend*, p. 75; and the Metropolitan Museum of Art (Cornelius, "Two American Mantelpieces," pp. 36–37). Of the three installed at Winterthur Museum, only the one in Lake Erie Hall is signed, but the composition work in the Baltimore Parlor and McIntire Bedroom came from Wellford's own Philadelphia home at 249 South 10th Street.

## 80  *Side chair*

Baltimore, Maryland, ca. 1795–1810

*Description:* The front and side rails are shaped on both sides and tenoned respectively to the front legs and stiles. Four open corner braces are set into the tops of the rails. The shield back consists of five pieces: the crest rail, to which the stiles are tenoned; the central splat and two separate banisters pinned to the crest rail; and the stay rail tenoned to the stiles. The rear seat rail is solid mahogany but capped with an additional strip that covers the upholstery tacked along its upper edge.

*Condition:* The joint between the crest rail and the right stile has broken and been repaired. The veneered fan at the base of the back has also been restored.

*Woods:* Legs, back, stretchers, and rear seat rail, mahogany; front and side seat rails, soft maple; seat corner braces, yellow-poplar; eagle inlay, probably dyed maple; fan at base of back, eastern white pine.

*Dimensions:* H. 39 in. (99.0 cm), S.H. 17¼ in. (43.8 cm), W. 20½ in. (52.0 cm), D. 19 in. (48.2 cm).

*Exhibitions:* State Historical Society of Wisconsin, September 1971; *Villa Terrace*, cat. 60.

*Bibliography:* Jones, "American Furniture," pp. 981–82, fig. 11, pl. VII.

*Provenance:* Purchased in 1967 from John C. R. Tompkins, Millbrook, N.Y. (dealer).

The heart-shaped chair back was an especially popular design in Baltimore and Philadelphia, where cabinetmakers produced hundreds of similar chairs with minor variations. A reference in the 1795 Philadelphia book of prices to a "heart back stay rail chair, with a banister and two upright splatts" was first linked to this chair pattern by Charles F. Montgomery.[1] The pattern, which appears to be based upon aspects of several plates in Sheraton's *Drawing Book*, was popular in England and soon adopted in Virginia, Baltimore, New York, and Massachusetts by chairmakers and their

patrons who thus helped foster a more unified national style.[2]

In 1966, Montgomery proposed that chairs like Milwaukee's with molded front legs and carved foliage on the splats were more likely products of Philadelphia than of Baltimore, yet several documented Baltimore chairs with these features have subsequently come to light. One of a set of eight chairs in the Diplomatic Reception Rooms of the United States Department of State that are nearly identical to this chair is branded "W.S.," probably by the Baltimore cabinetmaker William Singleton, and many other unmarked examples have histories of ownership in Baltimore.[3]

The inlaid eagle set within a vertical oval, bearing a shield and clutching both arrow and olive branch, derives from the Great Seal of the United States first adopted in 1782. This particular inlay and its reverse image were produced almost exclusively in Baltimore, where at least one inlay maker, Thomas Barrett, worked and may have produced similarly patriotic eagles carrying other symbols of liberty.[4] Other decorative options within this pattern include inlaid leaves instead of carving at the tops of the outer splats, and no leaf carving at their bases. A more unusual variation consists of a solid banister with inlaid strips of wood in place of the fanlike piercing.[5] A group of related Philadelphia "drawing-room" chairs by Adam Hains with stop-fluted, turned legs and paneled seat frames demonstrates the latest French taste applied to an otherwise English design. Together with the other Philadelphia-area chair from the federal period in the Milwaukee collection (cat. 81), these chairs and their decorative options bring to life the creative use of English pattern books by American cabinetmakers. Ultimately, it is the similarities and not the differences among these diverse chairs that make them so pleasing and instructive.

*Thomas S. Michie*

Purchase, Acquisition Fund
Gift of Collectors' Corner, 1969
M1967.25a

1. Montgomery, *American Furniture*, nos. 101–2.
2. For English sources, see Nichols, "Furniture Made by Gillow and Company for

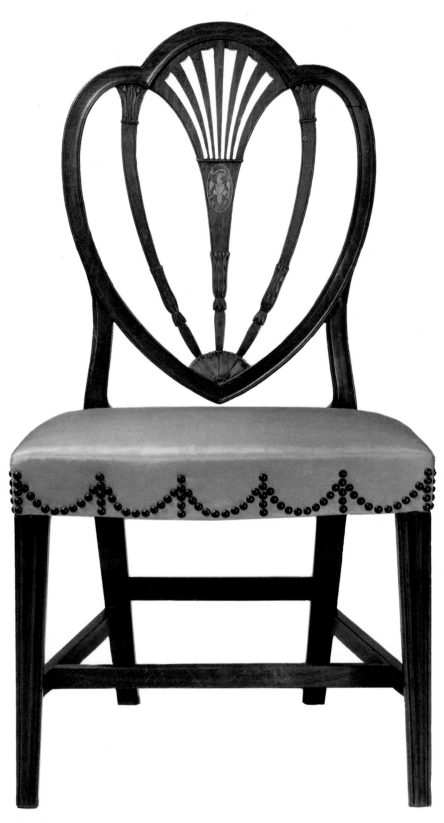

Cat. 80

Workington Hall," pp. 1353–54. A related chair attributed to Norfolk, Virginia, is discussed in *The Luminary* (M.E.S.D.A. newsletter) (Winter 1988): 4. For related chairs from Philadelphia, see Sack, *American Antiques*, 7:2049. Others attributed to New York are discussed in Levy, *"Opulence and Splendor,"* pp. 32–33, and Sack, *American Antiques*, 4:942. Massachusetts versions also appear in Sack, *American Antiques*, 4:882.

3. The Singleton chairs are illustrated in *Antiques* 105, no. 5 (May 1974): 1079. For others owned in Baltimore, see Weidman, *Furniture in Maryland*, no. 49, and *Baltimore Furniture*, no. 61.

4. See Hewitt, Kane, and Ward, *Work of Many Hands*, pp. 83–84; for other Baltimore eagles, see Monkhouse and Michie, *American Furniture in Pendleton House*, cat. 67.

5. See Sotheby's (sale 5599; June 26, 1987), lot 146.

## 81 *Side chair*

Philadelphia, Pennsylvania, ca. 1795–1810

*Description:* The front legs are laminated with two pieces of mahogany. The side and front rails are shaped on both sides and tenoned to the legs and stiles. The rear rail is faced with mahogany. The back comprises three separate pieces: the crest rail, to which the stiles are tenoned; the stay rail, which is tenoned to the stiles; and the carved splat, which is set into both stay and crest rails.

*Condition:* The scrolled end of the upper-right volute of the back has cracked and been replaced. All four triangular corner blocks have been replaced, as have large portions of the front legs. The outer sides of both side and front seat rails have been recently built up with new wood before reupholstery. Filled and refinished tack holes indicate that the seat was formerly upholstered over the rear seat rail. The chair has been refinished.

*Woods:* Back and legs, mahogany; seat rails, soft maple; corner blocks, yellow-poplar.

*Dimensions:* H. 36¾ in. (92.1 cm), S.H. 17 in. (43.1 cm), W. 20½ in. (52.0 cm), D. 20 in. (50.8 cm).

*Exhibition:* State Historical Society of Wisconsin, 1970–71.

Cat. 81

*Provenance:* Purchased in 1968 from Peter Tillou, Litchfield, Conn. (dealer).

This pattern of chair back incorporating an urn, leafy volutes, and drapery swags is best known as a variant of the twenty-four chairs that George Washington ordered in 1797 from John Aitken of Philadelphia for the banquet hall at Mount Vernon.[1] Ultimately derived from plates 33 and 36 of Sheraton's *Drawing Book* (1793), this particular version is more elaborately carved than the Mount Vernon set, since the S-shape volutes flare out again at the base of the urn, enclosing carved husks within an oval poised on a plinth with its own beaded scrolls. Such a free combination of elements gleaned from various engraved designs expresses the potential of pattern books to inform and inspire confident and skillful craftsmen.

Charles F. Montgomery believed that New York City as well as Philadelphia cabinet shops produced similar chairs, and yet the optional molding or stringing on the legs that he proposed as distinguishing features must have been equally available in both cities.[2] Rare examples with integrated inlays resembling Baltimore work suggest that this model was popular in other mid-Atlantic cabinetmaking centers. The majority of chairs of this kind that have come to light since Montgomery's research were owned originally in Philadelphia and New Jersey. Nevertheless, the pair of chairs at Winterthur remain the most closely related to Milwaukee's of all those published.[3]

In addition to the volutes with either acanthus or scroll carving, other options within this overall design include the shape of the top rail, whether it had "elliptic corner tops" like this example, or a straight crest rail. Only rarely are the legs ornamented by more than stringing or molding. Further variation exists among the carved details of the backs.[4] Few chairs, however, are better executed than this one, on which the carver evidently took considerable pains with the guilloche above the vase, the gathered folds of the drapery swags, and the inverted leaves within the oval at the base.

*Thomas S. Michie*

Purchase, Acquisition Fund
MI968.24

1. These chairs are now at the Smithsonian Institution. See Philadelphia Museum, *Three Centuries*, cat. 145.

2. See *Antiques* 100, no. 4 (October 1971): 477.

3. Montgomery, *American Furniture*, no 96. Other chairs with Pennsylvania and New Jersey histories of ownership include a set discussed in Philadelphia Museum, *Three Centuries*, cat. 129; a second set sold at Sotheby's (sale 5282; January 31–February 1–2, 1985), lot 973; and Hornor, *Blue Book*, pl. 420.

4. See, for example, Sack, *American Antiques*, 4:1102–3.

## 82 *Vase-back side chair*

New York, New York, ca. 1795–1810

*Description:* The side and front rails are shaped on both sides and tenoned to the legs and stiles. The rear rail is faced with mahogany and tenoned between the stiles. The front legs are secured with compound quarter-round and rectangular glue blocks set vertically. The front and back rails are further joined by two "swept rails" (medial braces) set into the tops of each. The back comprises three separate pieces: the crest rail, integral splat, and stay rail.

*Condition:* The right rear leg has been repaired at the seat rail and the right stile repaired where it joins the stay rail. The rear two glue blocks in the corners of the seat frame have been replaced with iron braces. The seat was reupholstered in 1989.

*Woods:* Legs and back, mahogany; front, rear, and right seat rails, maple; left seat rail, ash; medial braces, yellow-poplar.

*Dimensions:* H. 39¼ in. (99.7 cm), S.H. 17¾ in. (45.1 cm), W. 21¼ in. (54.0 cm), D. 19 in. (48.2 cm).

*Provenance:* Purchased in 1989 from Joe Kindig, Jr., and Son, York, Pa. (dealer).

In spite of the availability in this country of engraved pattern books and the redistribution of furniture by trade along the Atlantic seaboard, distinct regional preferences are still apparent for most forms of early neoclassical furniture. These preferences generally persisted until the

Cat. 82

second quarter of the nineteenth century, when factory production methods and improved transportation networks ensured national rather than merely regional patterns of consumption.

This particular chair-back design was especially popular in New York, where the cabinet- and chairmakers' book of prices for 1796 describes both "urn back" and "vase back" chairs with three upright splats and "strait seats made for stuffing over the rail."[1] Ultimately inspired by antique urns, several designs for vase-back chairs appear in Hepplewhite's *Guide* (3d ed., 1794), from which this pattern was indirectly derived. Although tapering, molded, or reeded legs with thermed or inlaid feet were the most popular options itemized in price books, outwardly flaring front legs like these appear almost exclusively on New York chairs.[2] Similar chairs with broader shields have been attributed to Charleston, and others with incurving back legs to Salem, although few sets owned outside of New York are actually documented. In New England, a popular variation consisted of a central vase in place of the forked leaves and Prince of Wales plumes that New Yorkers evidently preferred.[3]

Several New York shops undoubtedly produced chairs in this pattern, for many variations exist among the carved details of surviving examples. This chair is noteworthy for the skillful articulation of the drapery that is tightly gathered on either side of folds that hang naturalistically from carved flowers, as on the bedposts of cat. 90. The angular veining of the leaves on the central splat extends below the swags on this chair; on others it is left plain.

The overall similarity between these carved water leaves and those often found on furniture traditionally associated with Duncan Phyfe has led some to ascribe chairs like this one to the young Phyfe, although there remains no documentary basis for such an attribution. By 1815, however, such chairs had been supplanted in the most fashionable New York homes by Regency chair designs (cat. 86).

*Thomas S. Michie*

Purchased by the Milwaukee Art Museum through funds provided by the gift of Virginia and Robert V. Krikorian M1989.5

1. Quoted in Montgomery, *American Furniture*, p. 103.
2. For a related set, see *Antiques* 112, no. 3 (September 1977): 310.
3. Documented New York chairs include a set originally owned in Dutchess County, now at Winterthur (Montgomery, *American Furniture*, no. 50), and another that is said to have belonged to Sir William Johnson (see Sack, *American Antiques*, 1: 66). For chairs attributed to Salem, see Montgomery, *American Furniture*, no. 22, and for Charleston, Kane, *300 Years*, cat. 140. For New England variants, see Monkhouse and Michie, *American Furniture in Pendleton House*, cat. 123.

## 83 *Sofa*

Probably Salem, Massachusetts, or possibly Portsmouth, New Hampshire, ca. 1800–1820

*Description:* The seat rails are laid horizontally, tenoned to the legs, and fastened with glue blocks. The outer front legs and arm supports are integral; the back legs are not. The crest rail is tenoned to the stiles, or possibly held with screws concealed by the turned and applied disks. Three banisters are set between the crest rail and the rear seat rail, one at either end adjoining the stiles and a third above the middle leg. The veneered panels behind the arm supports are backed by banisters tenoned to the arms and side rails. A stay rail runs between the banister and the stiles at either end.

*Inscriptions:* "728" is typed on an old gummed label affixed to the inside of the right rear leg.

*Condition:* The tops of the left and right front legs have cracked and been repaired. Triangular brackets have been added behind the front legs. The left stile has split where it joins the crest rail. The rear left leg has also cracked near the seat rail. The sofa has been reupholstered in a modern silk damask.

*Woods:* Legs, arms, rails, mahogany; inlays, birch and satinwood; front rail, redgum; left rail, birch.

*Dimensions:* H. 37¼ in. (94.6 cm), S.H. 14½ in. (36.8 cm), W. 77 in. (195.5 cm), D. 30 in. (76.2 cm).

*Exhibition: Villa Terrace*, cat. 54.

*Bibliography:* Jones, "American Furniture," p. 981, pl. VI.

*Provenance:* Henry Ford Museum, Dearborn, Mich. (attributed to Duncan Phyfe); sold at Plaza Art Galleries, New York (March 31, 1951), lot 555; where purchased by James Graham and Sons, Inc., New York, N.Y.; A. D. Braun, Oconomowoc, Wis.; sold at Milwaukee Auction Galleries (attributed to Duncan Phyfe) (September 12, 1964), lot 163.

Sofas with carved crest rails were a specialty of Salem, where at least sixty-one cabinetmakers, fifteen chairmakers, and six carvers, turners, and upholsterers are known to have worked between 1790 and 1820.[1] Sofas like this one are therefore best understood as products of extensive collaboration among at least four different craftsmen in one or more cities, which makes difficult any attribution to a particular shop on the basis of carving or turning. Samuel McIntire is the most famous of Salem's woodcarvers, and yet several of his Salem contemporaries, such as Nehemiah Adams, are also known to have executed similar carvings on furniture well after his death in 1809. Joseph True, for example, worked for every major cabinetmaker in Salem. An 1812 bill records his "carving a sofa" in addition to "carving a bow and arrow cornice" for a bed.[2]

Bows and arrows, the traditional attributes of Eros, have led some to interpret similarly carved furniture as commissions by or for newlyweds. Such erotic associations are certainly appropriate to the carved and painted cornices on a group of Boston and Salem tall-post bedsteads, although bows and arrows would also have been familiar to upholsterers as embellishments recommended for stylish curtain rods and pelmets.[3] In any case, carved ornaments in the form of baskets of fruit and flowers are far more typical of Salem seating furniture than bows and arrows, which are known on only a few other sofas and three high-backed upholstered armchairs.[4]

An unusual aspect of the carving on the Milwaukee sofa is the limp bowstring that merges with the tips of the arrows (cat. 83a), as if the carver had misunder-

Cat. 83

Cat. 83

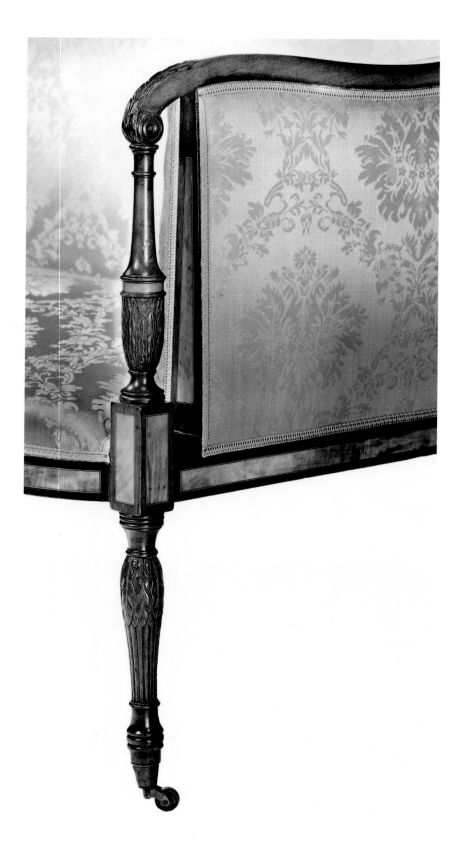

Cat. 83

stood a visual source or was several steps removed from it. The elegance of the attenuated, scrolling armrests and supporting urns with inlaid bands of satinwood set this sofa apart from contempoary Boston and Salem sofas that have more common "cabriole elbows" set horizontally, as illustrated by Thomas Sheraton in plate 35 of *The Cabinet-Maker and Upholsterer's Drawing-Book* of 1793.

The addition of leaf carving to the reeded legs and arm supports relates this sofa to a pair of upholstered armchairs and a wine cooler that descended in the Derby and West families of Salem but may have been supplied by the Boston cabinetmaking firm of Vose and Coates.[5] The slight tapering of the veneered panels behind the arm supports and the matching panels that continue around the seat rails indicate careful attention to detail that is rarely seen, except on the Derby furniture and other "bespoke work" that represent the finest workmanship of Boston and Salem cabinetmakers, carvers, turners, and upholsterers.

*Thomas S. Michie*

Purchase, Acquisition Fund
Gift of Collectors' Corner, 1969
M1964.113

1. Clunie, "Furniture Craftsmen of Salem," pp. 192–95.

2. For a carved sofa by Adams, see Clunie, "Joseph True," p. 1013. The work of True is further documented in Clunie, "Furniture Craftsmen of Salem," p. 196.

3. Other beds with similar cornices are in the collections of the Essex Institute, SPNEA, Winterthur (Montgomery, *American Furniture*, no. 1), Bayou Bend (Warren, *Bayou Bend*, no. 171), and RISD (Monkhouse and Michie, *American Furniture in Pendleton House*, pp. 218–22). For contemporary pattern-book illustrations for curtains, see Thornton, *Authentic Decor*, p. 203.

4. A sofa with very similar carving is illustrated in *Antiques* 116, no. 5 (November 1979): 1093. Another in the Karolik collection (Hipkiss, *Eighteenth-Century American Arts*, no. 122) and a second owned by John Walton (*Antiques* 117, no. 4 [April 1980]: 5) have only carved arrows. The related easy chairs are at the Essex Institute (Clunie, Farnam, and Trent, *Furniture at the Essex Institute*, p. 33) and at Winterthur (Montgomery, *American Furniture*, no. 118).

5. See Cooper, "The Furniture and Furnishings of the Farm at Danvers," pp. 29–31.

## 84 *Lolling chair*

Portsmouth, New Hampshire,
ca. 1800–1810

*Description:* The serpentine front seat rail
is shaped on both sides. Corner blocks
reinforce the rails, which are tenoned
to the legs and stiles. There is a stay rail
4 in. (10.2 cm) above the rear seat rail,
just above the point where the mahog-
any rear legs are probably spliced to the
stiles. The serpentine crest rail is shaped
on one side only. The frame of the chair
was not examined prior to reupholstery
with modern silk in 1963.

*Condition:* The top of the left arm is
cracked near the front at the ring joint
and at the back, near the stile. The right
arm has cracked at the same point and at
the ring turnings just above the arm
support. Both vase-turned arm supports
are cracked, the front surface of the right
one having a large, rectangular patch.

*Woods:* Legs and arms, mahogany; inlays,
satinwood; seat rails, birch; corner blocks,
eastern white pine.

*Dimensions:* H. 45¾ in. (116.2 cm),
S.H. 15¼ in. (38.8 cm), W. 25½ in.
(64.8 cm), D. 30 in. (76.2 cm).

*Exhibition: Villa Terrace,* cat. 59.

*Bibliography:* Jones, "American Furniture,"
p. 980, pl. IV.

*Provenance:* John Walton Antiques, New
York, N.Y. (dealer).

"Lolling" chairs, the period term for
upholstered easy chairs with open arms
and tall backs, represent one of the few
distinctively American contributions to
furniture design in the federal period.
Whereas in England and on the Conti-
nent easy chairs with high backs faded
from popularity toward the end of the
eighteenth century, New England cabi-
netmakers and upholsterers gave new life
to this old form. Onto a traditional high-
back easy chair with serpentine crest and
seat rails they grafted such up-to-date
neoclassical details as reeded and tapered
front legs and arm supports with inset
panels of satinwood veneer.

Probate inventories from the federal
period refer frequently to pairs of lolling
chairs, and they were evidently used

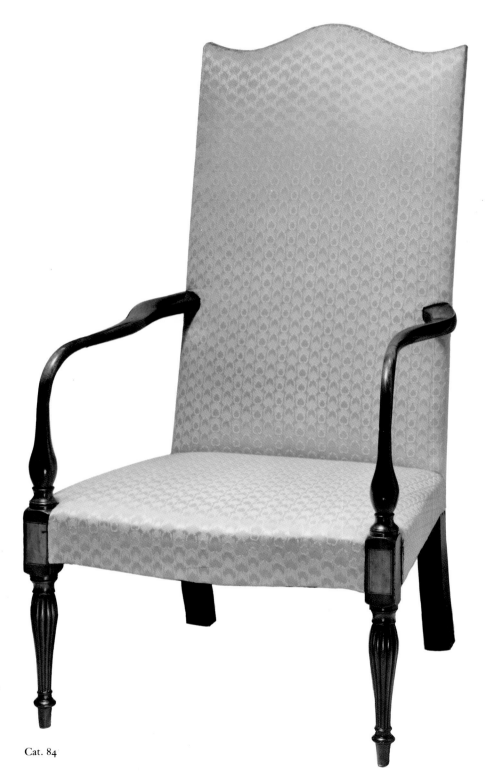

Cat. 84

both in bedchambers and in downstairs parlors. A pair of lolling chairs that belonged to the Portsmouth silversmith William Simes was accompanied by a matching sofa with arms similar to this chair's. Examples by Newburyport chairmakers and others attributed to southern Maine are also known.[1]

Although neither Sheraton, Hepplewhite, nor Shearer illustrates any comparable design, English price lists refer to this chair's most salient feature, its shapely arms. Beginning in 1802 with the *London Chair-Makers' and Carvers' Book of Prices for Workmanship*, under "shaping elbows for chairs," the term "crane-neck elbows" is used to identify chair and sofa arms like these and it remained current through the first quarter of the nineteenth century.[2] The gradual transition from canted rectangular elbows to the strikingly thin and sinuous front arm supports creates a visual tension missing altogether from more stout and substantial easy chairs of the mid eighteenth century. The maker of a closely related lolling chair visually acknowledged the arms' fragility by adding C-scroll brackets under the crook of the arm.[3] Other design options included reeding on the vase turnings of the arm supports, turned rather than square blocks at the front corners of the seat, and carving on the legs or arm supports.[4] Whether with a loose cushion, as some early photographs depict, or without, this chair's generous proportions were ideally suited to the contemporary dictionary definition of lolling as: "to lean, or lie here or there in an idle, careless, or lazy manner or posture."[5]

*Thomas S. Michie*

Gift of Mr. and Mrs. Robert Stenger
M1968.94

1. According to Mabel Swan, the label of Newburyport cabinetmaker Joseph Short referred to these as "Martha Washington" chairs, a popular term that Montgomery disputes (see *American Furniture*, pp. 155–56). The Simes furniture is illustrated in *Antiques* 2, no. 2 (August 1922): 50. A chair by the Newburyport cabinetmaker Robert Clark is illustrated in *Antiques* 101, no. 1 (January 1972): 60. For others made or owned in Maine, see Sprague, *Agreeable Situations*, cat. 56.
2. See Montgomery, *American Furniture*, no. 268. The term appears as late as 1827 in the *Leeds Chair-Makers' Book of Prices*.
3. Flanigan, *American Furniture*, p. 152, no. 52.

4. See, for example, Comstock, *American Furniture*, no. 438; Warren, *Bayou Bend*, no. 148; *Antiques* 83, no. 3 (March 1963): 259; Sack, *American Antiques*, 5:1287, and 6:1506.
5. Thomas Dyche, *A New General English Dictionary* (1765), quoted in Cooper, *In Praise of America*, p. 57.

## 85 *Easy chair*

Probably New England, ca. 1790–1810

*Description:* The frame was not examined prior to the present reupholstery in a modern silk.

*Condition:* The legs have been refinished and the entire chair reupholstered.

*Woods:* Legs, mahogany; seat rails, birch; corner braces, eastern white pine.

*Dimensions:* H. 44¾ in. (113.6 cm), S.H. 13¼ in. (33.6 cm), W. 33 in. (83.8 cm), D. 25 in. (63.5 cm).

*Provenance:* The history of the chair before it was acquired by the Collectors' Corner is unknown.

Easy chairs were primarily bedroom furniture with padded wings designed to shelter and be leaned against, and to keep the sitter warm. They also frequently served as commodes and were fitted with a chamber pot that was concealed by a loose cushion on the seat. Few easy chairs with commode seats have survived later improvements in domestic plumbing.[1] The style of federal-period easy chairs differed very little from earlier Georgian counterparts, with the exception of modified arms and wings. Unlike earlier chairs on which the arms are attached to the wings, the wings on most neoclassical chairs are attached to the arms, which are tenoned to the stiles. As a result, the wings appear more distinct, which adds emphasis to their serpentine contour and recalls the shield shapes of contemporary chair backs and pole screens. The overall effect resembles a hybrid mixture of a sofa with a lolling chair. Conversely, some lolling chairs resemble easy chairs without wings.[2]

In keeping with the overall lightness of the neoclassical style, the straight legs on this chair are molded and tapered. These details are itemized in the *Philadelphia*

*Cabinet and Chair-Makers' Book of Prices* (1796) as "working two beads and two hollows, each side, 4½d." Tapering cost slightly more. The front seat rail, shaped to complement the swell of the wings and the even more pronounced curve of the crest rail, was called a "commode front" and cost one additional shilling. Although similar chairs have been attributed to Philadelphia, most others have been attributed to New England.[3]

According to price books, this chair would have been called an "easy chair frame plain, no low rails [stretchers]." However, its low price reflected only the cost of the wooden frame. The remainder of this chair's considerable cost represented the time, and particularly the materials, of the upholsterer. He would have nailed webbing to the chairmaker's hardwood frame, stuffed it with hair or wool, grasses, and other materials, and then covered the foundation with canvas before applying the finish fabric. When the chair is completely upholstered, only the legs remain visible as evidence of the chairmaker's contribution and are therefore usually the only parts made of expensive mahogany.

In bedchambers, the finish fabric often matched the bed and window curtains. For example, an 1802 bill from the Boston upholsterer Moses Grant records an easy chair with cushion at £4.10, fifteen yards of India cotton, tape, etc., for two "suits" of curtains, and "making 2 suits curtain covering easy chair" at £4.7.[4] The cost of the entire ensemble, easy chair and matching curtains, amounted to over £25, a considerable outlay comparable with the most expensive furniture of the day.

*Thomas S. Michie*

Gift of Collectors' Corner
M1967.37

1. For a similar chair with its commode seat intact, see Morrison H. Heckscher, "18th-Century American Upholstery Techniques: Easy Chairs, Sofas, and Settees," in Cooke, *Upholstery in America and Europe*, p. 108.
2. See Heckscher, *In Quest of Comfort*, pp. 7–8, and Montgomery, *American Furniture*, no. 113.
3. See Downs, *American Furniture*, no. 93; Kane, *300 Years*, cat. 215; and Rodriguez Roque, *Chipstone*, no. 97.
4. *Grant v. Carnes*, Suffolk County, Massachusetts, Court of Common Pleas, case 181 (October 1802).

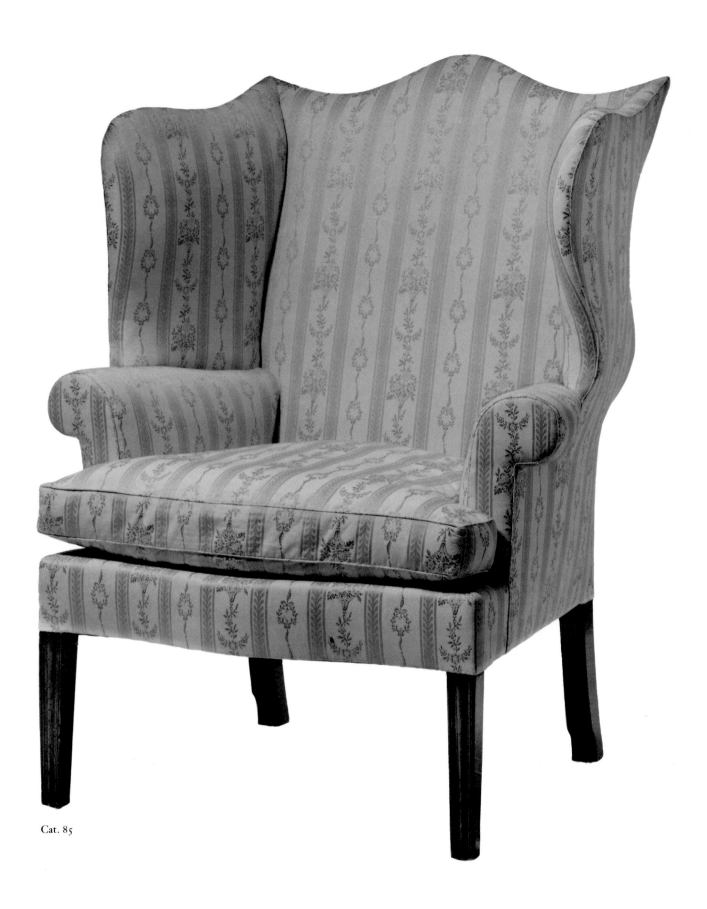

Cat. 85

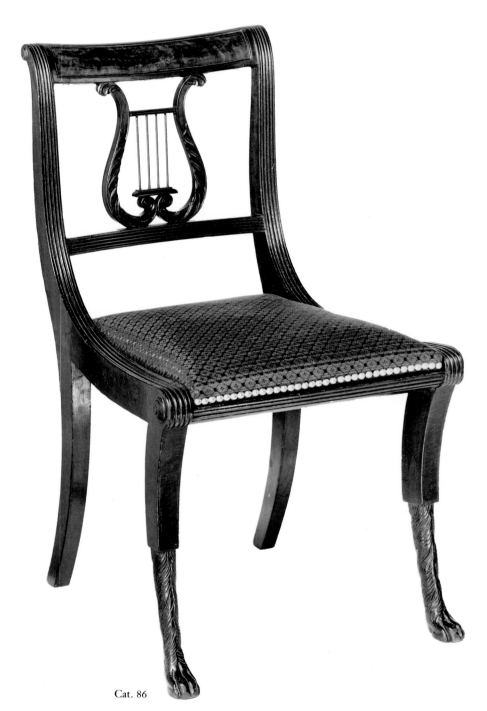

Cat. 86

## 86 *Side chair*

New York, New York, ca. 1800–1820

*Description:* The side rails are tenoned to the stiles and legs. The front and rear seat rails are faced with mahogany and tenoned to the legs and stiles. The stay and crest rails are also tenoned to the stiles. The turned buttons on the legs and stiles are applied. The loose seat is held in place by screws through both front and rear seat rails.

*Inscription:* The number "III" is chiseled on the inside of the loose seat frame.

*Condition:* The frame has been refinished and the seat reupholstered with modern horsehair damask.

*Woods:* Legs, rails, and back, mahogany; upholstery rails, red oak; front and rear seat rails, ash; lyre rods, brass.

*Dimensions:* H. 32¾ in. (83.2 cm), s.h. 16 in. (40.6 cm), w. 18¼ in. (46.4 cm), D. 20¾ in. (52.7 cm).

*Provenance:* Charles Over Cornelius (1891–1937), New York, N. Y.; acquired in 1986 from Joe Kindig, Jr., and Son, York, Pa. (dealer).

During the first quarter of the nineteenth century, furniture designs derived from antique prototypes became popular internationally and gradually superseded the more delicate neoclassical interpretations of the federal period. In this country, antique designs bore particular significance, as many Americans perceived their young country to be the heir to the democratic and republican values of ancient Greece and Rome.

Whereas the furniture of the early classical period consists of delicate abstractions of antique forms and ornament, chairs such as this one in the Grecian manner display more overt and robust references to antiquity. For example, the continuous line of the reeded stiles and seat rails reflects a knowledge of the Greek *klismos*, whereas the naturalistically carved legs with paw feet and backward flowing fur reflect a knowledge of Roman design sources. These and other designs were first popularized in Regency England by Thomas Hope, whose *Household Furni-*

ture and Interior Decoration (1807) helped disseminate the taste for chairs with saber legs and continuous seat rails and stiles.

An 1816 bill from Duncan Phyfe to Charles Bancker of Philadelphia records a lyre-back chair like this one with two seat options: a "cane bottom" with cushions ($25) or a "stuffed" seat ($23).[1] An accompanying sketch by Phyfe includes additional features not found on the present chair, such as carved cornucopias across the crest rail and a winding key that extends through the arms of the lyre. The greatest variation occurs in the water leaves that embellish the lyre, some having single leaves and others double. The paw feet on this chair were a more expensive alternative to plain or leaf-carved saber legs and were sometimes gilded.[2] Other differences among the carved details on surviving chairs indicate that many different carvers of varying talent were at work. Among them was Duncan Phyfe's nephew, James Phyfe.[3]

The generally high quality of carving on this chair relates to work from the shop of Duncan Phyfe. A set of twenty-four chairs made for Governor William Livingston of New Jersey and others made for James Brinckerhoff in 1816 are similar in every respect, except the lyre key. Additional evidence often cited in support of an attribution to Phyfe includes a rare watercolor view of Phyfe's New York City workshop and the adjoining salesroom in which two women are admiring a lyre-back chair like this one.[4]

The Scottish-born and -trained Phyfe would have been well aware of high-style British designs and may have introduced the lyre-back chair to New York. Nevertheless, in the absence of documentation, an attribution to any individual chairmaker is difficult, since many New York shops evidently produced chairs of this design. By 1805 at least sixty-six cabinetmakers, nineteen chairmakers, and fifteen carvers were working in New York City, and by 1817, the New-York Book of Prices for Manufacturing Cabinet and Chair Work listed the "lyre banister" as a standard option.[5] Phyfe alone employed over one hundred skilled craftsmen, many of whom could have produced similar chairs on their own. In 1802 and again in 1819, journey-

men cabinetmakers in New York did just that, proclaiming their work to be "as elegant as any ever offered in this city," and according to Phyfe's disgruntled journeymen, "equal to any on the continent."[6]      *Thomas S. Michie*

Gift of Collectors' Corner
M1986.43

1. See Montgomery, *American Furniture*, p. 126.
2. See Fairbanks and Bates, *American Furniture*, p. 259.
3. For the work of Phyfe and his shop, see Brown, "Duncan Phyfe," p. 11.
4. See McClelland, *Duncan Phyfe*, p. 279, and Sloane, "A Duncan Phyfe Bill," pp. 1106–13. The view of Phyfe's shop is reproduced in McClelland, *Duncan Phyfe*, p. 115.
5. Quoted in Montgomery, *American Furniture*, p. 128. Population figures are based on data from *Longworth's American Almanack* for 1805.
6. Quoted in Rock, *Artisans of the New Republic*, p. 275.

## 87  Brace-back Windsor armchair

Probably Coastal Massachusetts, 1780–1800

*Description:* The arched crest is tenoned into the turned rear posts and held by pegs. The posts reverse-taper toward the seat where they are round-tenoned through and secured beneath the seat by a large wooden peg. The arms are shaped to conform to the rear posts and are held in place by a tenon pegged from the front. The arm supports pass through the arms and are all pegged at the top from the inside. The knuckles are carved from the solid. The front arm supports pass through the seat and are wedged from the bottom. The tongue supporting the two braces is a separate block of wood applied to the seat. Its grain runs front to back while that of the seat runs side to side. The four legs pass through the seat and are held in place by two wedges driven into opposite sides of each round tenon. The side stretcher on the left side is secured to the legs by nails which represent a later repair.

*Inscriptions:* An indecipherable inscription appears on the underside of the seat.

*Condition:* All front legs were once slotted for rockers or wheels and are now pieced out about 2 in. (5.1 cm). The right stretcher and the medial stretcher—both ash—appear to be replacements. The left, maple stretcher is now secured to the legs by nails. The left post is split in half through the two lower baluster turnings and is repaired with two pins. The crest mortise of the right post has split open and has been repaired. The chair has been repainted.

*Woods:* Seat, eastern white pine; left stretcher, soft maple; right and medial stretchers, ash; legs, maple; arms, soft maple.

*Dimensions:* H. 45⅛ in. (115.5 cm), S.H. 17¼ in. (44.2 cm), W. 29¼ in. (74.9 cm), D. 21¾ in. (55.7 cm).

*Provenance:* Purchased in 1979 from Joe Kindig, Jr., and Son, York, Pa. (dealer).

Understanding this complicated chair is a challenge. Its overall form is a braced fanback with arms. However, a number of aspects of the chair's design and fabrication fall outside customary Windsor chairmaking patterns. Even so, little about the chair seems to lie outside the boundaries of eighteenth-century practice.

The widely splayed legs are turned in the usual sequence. The baluster, or vase-shaped, turnings have cylindrical necks, a feature which appears on some other eastern Massachusetts Windsors, as well as many Rhode Island products. The multiple-disk-turned medial stretcher has no eighteenth-century precedent. It is an imaginative replacement, along with the right side stretcher, turned to match the other original side stretcher.

The oval shape of the seat, the protruding legs wedged from the top, and the incised line marking the edge of the contour of the dished seat are features commonly encountered in this time and place. The thick tongue extending from behind the seat is tenoned into it. Often the tongue is shaped from the same wood as the seat—a considerable but reasoned expenditure of materials because of the strength necessary to bear the pressure of

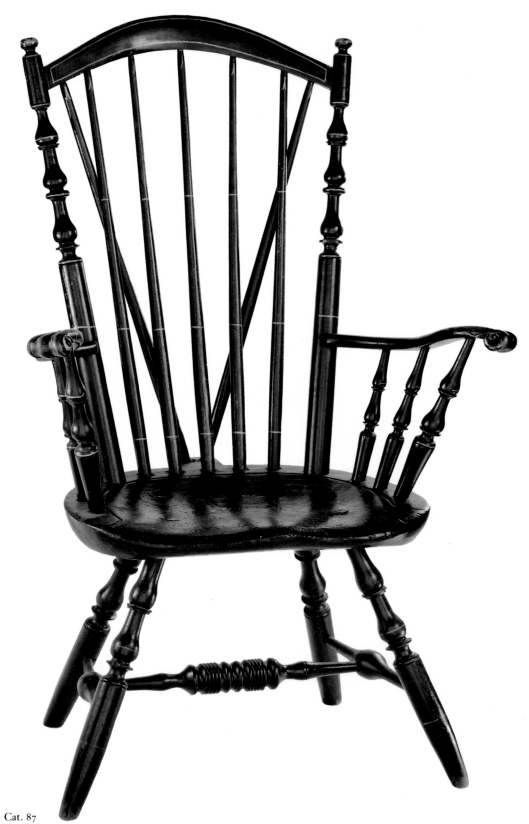

Cat. 87

the braces. The tenoned alternative on the Milwaukee chair occurs on a number of similar coastal Massachusetts chairs including some distinctive examples associated with Nantucket.[1] The massive joint on two similar chairs in the Winterthur collection is held by two pegs driven in from the top.[2] In contrast, the Milwaukee chair has no visible pins, suggesting dependence upon glue or possible use of a blind wedge to secure this joint.

The two diagonal spindles lodged into the tongue and set into the corners of the crest serve as compression members that brace the back. Their slight rearward projection at the base helps stabilize the back from bending backward, and their triangular configuration minimizes side-to-side racking. The crest rail is tenoned into the posts, thus ensuring that it will not pop apart under the severest pressure. The arms, in contrast, are relatively flimsy, being secured by a tenon into the posts and by the turned supports set into sockets in the thick edge of the seat.

The arrangement of elements and the resulting dynamics of the overall design fall within the corpus of American Windsor chairmaking. However, many of the decorative details and some minor construction features are puzzling. The arched and slightly bowed crest rail is a most unusual, but effective, treatment. The swelled center of the crest emphasizes its verticality, as does the fine tapering of the spindles and rear posts. The undercutting and bowing make alignment of the rear spindles more difficult than the typically level crest, which may explain why the outer spindles rub against the diagonal braces.

The heavy rear posts have three stacked baluster turnings—one more than related chairs of the better sort.[3] Similarly, the legs have two stacked balusters (the upper not being as fully developed as the lower) instead of the more common elongated ovoid turning above the prominent baluster. The arm supports are unusual in that each has fully developed turnings. Typically, only the front support, which is larger in diameter, is turned.

The arms curve in two planes. Like the arms on most fine Windsors, they curve laterally around the sitter and flare outward at the ends. They also curve

gently upward between the first and second arm supports before reversing downward into the articulated knuckle handholds. Because of the larger piece of wood needed to accommodate the arm shape, the knuckles do not have the usual glued construction.

This Windsor armchair has no known parallels. In addition to certain aspects of its design, some construction features, like the rear posts projecting through the bottom and pegged, fall outside the range of known practices. However, the extra work in evidence throughout the chair seems to be consistent within the object. The resulting object is simply exceptional. Establishing firmer relationships to other objects is a necessary next step to understanding this chair. Given the complexity and pervasiveness of Windsor chairmaking throughout New England and America, those ties are likely to exist. Yet Windsor chairmakers also demonstrated a consistent, if less common, propensity to adapt and experiment. It is possible that this armchair represents a chairmaker's effort to make a singular design statement to satisfy unknown circumstances.

*Philip D. Zimmerman*

Gift of Virginia and Robert V. Krikorian
M1981.130

1. See Santore, *Windsor Style in America*, 2:83–84.
2. Acc. nos. 59.1617 and 59.1650, the latter of which is illustrated as fig. 15 in Ormsbee, *Windsor Chair*, pp. 66–67.
3. Wallace Nutting illustrates a fanback armchair with three baluster turnings in the rear posts, but the third is located below the juncture of the arm (*Windsor Handbook*, pp. 60–61). A number of examples associated with Nantucket have reverse balusters below the arm.

## 88 *High-back Windsor armchair*

Pennsylvania, probably Philadelphia, 1760–80

*Description:* The carved oak crest rail is secured to the seven spindles by pins through the center and outermost spindles. (A pin set into a fourth spindle

appears to be later.) There is also a pin passing through the arm bow into the center spindle. The spindles pass through the arm bow and fit into round mortises in the carved, shield-shaped seat. The arm bow is composed of two shaped walnut arms that fit into the curved, thick back piece. The parts are all secured by pins in the hollowed ends of the back piece where it overlaps the arm sections. The deeply curved arm supports and the short spindles behind them pass through the arms and are wedged. Pins through the sides of the seat secure the tenon joint at the bottom of the arm supports. The legs pass through the seat and are wedged.

*Condition:* A plugged hole in the seat indicates a possible replacement of the left short spindle. Numerous splits where the walnut arms join the yellow-poplar arm bow have been repaired. Paint remnants under the ears of the crest suggest that the chair was once painted a dark green over a bright emerald green.

*Woods:* Seat, yellow-poplar; crest rail, white oak; spindles, hickory; middle section of arm bow, yellow-poplar; legs and stretchers, soft maple; arms and arm support, black walnut.

*Dimensions:* H. 40¼ in. (103.0 cm), S.H. 16¼ in. (41.6 cm), W. 24¾ in. (63.4 cm), D. 21 in. (53.8 cm).

*Bibliography:* Jones, "American Furniture," p. 980, fig. 9; Evans, "Design Sources," pp. 284, 288, fig. 9.

*Provenance:* Early history unknown; Miss Paula Uihlein, Milwaukee, Wis.

The high-back Windsor armchair is the earliest type of Windsor made in America. It appeared first in Philadelphia, where evidence suggests it was in production by the late 1740s.[1] The specific high-back form (also called a comb-back) is characterized by unbraced back spindles capped by an eared crest rail and reinforced in the middle by a curved arm rail. It and the low-back form, in which the back spindles end at the arm rail, were popular products of pre-Revolutionary Philadelphia and have long been identified with that region.[2] Toward the end of the eighteenth century, high-backs were made elsewhere, notably in Connecticut and

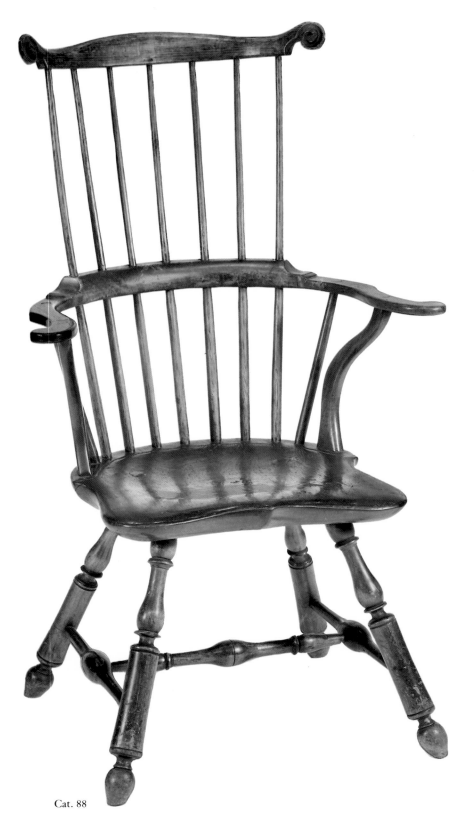

Cat. 88

New York, but this Windsor chair design fell out of favor soon thereafter.

English Windsor chairs are clearly the design source for the earlier types of American Windsors. Nancy Evans has demonstrated persuasively that English Windsors appeared around 1720.[3] Although details concerning their early use are scarce, they were associated with use in gardens. As the chair form matured, Windsors assumed a much broader role as seating furniture. By the third quarter of the eighteenth century, American Windsors could be found in general household use including dining; in civic use, as exemplified by the Windsors purchased for the Philadelphia State House; in use in taverns and inns because of their low cost and durability; as well as in use outdoors.[4]

The Milwaukee high-back is a distinctive example. It follows English prototypes yet renders the various design details in a very recognizable Philadelphia manner.[5] It retains the earliest form of turned legs. Composed of three design parts separated from each other by reel turnings, the legs have a baluster above a substantial cylindrical element, and they terminate in bulbous ("blunt-arrow") feet. The heavy cylinder, which is drilled to receive the round tenons of the stretchers, flares slightly toward the bottom, a small detail that adds movement to what might otherwise be a dull turning. The feet, moreover, retain most of their length, including the taper which emphasizes their outward projection.

The carved shield-shaped seat is the structural anchor for the entire chair. The seat is sufficiently thick to provide firm support for the legs, which are tenoned through, then wedged into place. The upper members are held rigid by pins in the crest, deep sockets in the seat, and arm supports tenoned and pinned into the seat. Although other Philadelphia high-backs have nine or even as many as fifteen spindles across the back, the seven spindles of this chair are well-spaced and in good proportion to the seat and legs.[6] Their upward taper gives the top of the back a delicate, airy appearance.

The curved arm supports are a notable feature. Derived from numerous English examples, which typically curve in only one direction, the curve of these elements

reverses underneath the arm. The curve of the arm support and the flare of the arms creates a strong outward thrust which echoes the pronounced ears of the crest rail. Moreover, this carved element was more time-consuming to make and more costly in materials than the turned substitutes found on most examples of this chair form.

The arm supports are carved from walnut, as are the two arm sections fitted into the larger yellow-poplar middle section. Wood choice in Windsors typically was based on the material characteristics of the particular species. Maple and ash turn well and are typically found in the legs; hickory is strong and bends without breaking, making it suitable for bows and spindles; and so forth. Differences in wood grain and color were covered by paint, often green at this time. Walnut carves well, but its selection for the arms and supports may also have been made because they might have been left un-painted, thus emphasizing their design function. The chair was once painted an emerald green, as indicated by paint remnants on the crest rail, but all evidence of the original finish on the arms appears to have been removed.

*Philip D. Zimmerman*

Gift of Miss Paula Uihlein
M1968.36

1. David Chambers advertised that he made Windsors in the August 23, 1748, issue of the *Pennsylvania Gazette* (quoted in Evans, "Design Sources," p. 283). See Hornor, *Blue Book*, pp. 296–97, for discussion of a listing of "5 Windsor Chairs" in the 1747 estate inventory of Philadelphia furniture maker Joseph Armitt.
2. J. Stodgell Stokes, for example, identifies a similar high-back as a Philadelphia product in "American Windsor Chair," fig. 4. As early as 1917, Wallace Nutting recognized the distinctive turned-leg design as a Pennsylvania regional trait (*Windsor Handbook*, pp. 13, 15, 29).
3. Evans, "History and Background of English Windsor Furniture," pp. 27–31.
4. Hornor, *Blue Book*, pp. 297–98.
5. English prototypes are illustrated in Santore, *Windsor Style in America*, 1:39, fig. 11; and Evans, "Design Sources," p. 288, fig. 10.
6. A chair virtually identical to the Milwaukee example is illustrated as fig. 88d, top left, in Nutting, *Windsor Handbook*, n.p. For illustrations of other high-backs, see Santore, *Windsor Style in America*, 2:43–58. Fig. 18, p. 54, is similar in design, although some wood use is different.

## 89A–B  *Pair of sack-back Windsor armchairs*

New England, probably Connecticut, 1780–1800

*Description:* The spindles are set into the bow which is held into the arm by wooden pegs. The arm bow is a single piece of wood bent into a tight U shape. The carved grips have blocks applied to the underside to give additional massing (those on .A are crude replacements). The arm supports of .A pass through the seat and are wedged from the front. Those of .B are tenoned into the seat and held by large pegs through the side of the seat. The center back spindle of each chair passes through the seat and is wedged from the bottom. The seats are thick planks, .A being about ¼ in. (.6 cm) thinner than .B which is nearly 2 in. (5.1 cm) thick. The bark layer is evident at the bottom rear edge of the seat of .B. A missing facet in the same place on .A may also indicate a bark layer. The legs do not pass through the seat.

*Inscriptions:* "Mrs M C Martin/Burlington/Wisc" is written in pencil on the underside of .A and faintly on the underside of .B. "FULTON" is stamped twice with a modern ink pad stamp on the underside of the seat of .B.

*Condition:* The center three spindles have worked through the top of the bow in each chair. In .A, the second from the left side has also opened at the top. The medial stretcher and fronts of the two side stretchers of .A have had their joints reinforced by nails. One chair, .A, has a heavily deteriorated paint surface of a dark green over a medium green over a bright emerald green; .B has the same paint sequence under a uniform coat of very dark green. Its medial stretcher appears not to have the earlier coats of paint, indicating that it is a replacement. The dished-out portion of the seat of .A has been painted with the same dark color.

*Woods:* Seat, yellow-poplar; arm bow, back bow, and spindles, white oak; legs and stretchers, soft maple; arm support and knuckles, maple.

*Dimensions:* H. 37¼ in. (95.4 cm), S.H. 17⅛ in. (43.8 cm), W. 23⅜ in. (59.8 cm), D. 17¾ in. (45.4 cm).

*Provenance:* Early history unknown; Mr. and Mrs. Robert M. Fulton, Milwaukee, Wis.

Sack-back armchairs, often called bow-backs today, were introduced by the 1760s.[1] In 1765, for example, Andrew Gautier advertised painted "High-back'd, low-back'd, Sack-back'd, Chairs and Settees, or double seated, fit for piazzas or gardens— Children's dining and low Chairs, &c." in the *New York Journal*.[2] A similarly worded advertisement specifying Philadelphia-made Windsors appeared the next year under the name of Sheed and White in the *South Carolina Gazette*.[3] These two references not only demonstrate the geographical range of these Windsor forms, but their similarity suggests a common source in Philadelphia engaged in extensive marketing. In a relatively brief time, however, local Windsor chairmakers throughout Pennsylvania, New York, and New England competed with Philadelphia makers for local markets.

Sack-back Windsor armchairs were made throughout the colonies. These chairs commonly had baluster-turned legs with tapered feet, joined by swelled stretchers. The arm bow was laid flat and supported at the ends by baluster-turned elements. The bow itself was tenoned into the arm bow behind the first or second spindle.[4] Most had oval seats, although D-shaped and shield-shaped seats were occasionally used.

In striking contrast to most other kinds of seating, the differences in design of sack-backs from region to region are slight. Consequently, identification of places of origin, or more specific assignment to a maker, requires detailed examination of certain turned elements, especially arm supports, stretchers, and upper legs, as well as articulation of handholds and shaping of the seat. Even these various characteristics are often insufficient measures, especially when the possibility of variation within a region or shop is considered.

The Milwaukee sack-backs resemble a number of chairs made in Connecticut,

although Massachusetts should also be considered a possible place of origin. One of the design characteristics often associated with Connecticut makers, especially Ebenezer Tracy and related craftsmen like Amos D. Allen, whom Tracy trained, is the use of swelled spindles. Their massing gives a strong focus to the lower portion of the back while emphasizing the lightness and airiness of the upper section. In this example, however, the unevenness in height of the swellings is visually disconcerting. This may reflect a certain degree of latitude in workmanship standards but may also point to early replacement of the variant spindles, although no other evidence confirms this possibility.

Other features may indicate a possible Connecticut origin. In keeping with a number of documented Connecticut Windsors, the chair's splayed legs do not pass through the seat, which is thick, oval in shape, and lacks a gauged line in front of the spindles at the point of contour. Common to New England examples, the turned balusters in each leg are relatively more compact and higher, leaving a longer taper to the foot. The back bow traces a high domed curve, rather than being flattened somewhat across the top. Identification of a body of documented sack-backs with similar arm support turnings might lead to a more precise determination of where this example was made. Given the wide distribution of Windsor chair designs, and chair parts in some cases, comparisons based on single parts must be treated carefully.

*Philip D. Zimmerman*

Gift of Mr. and Mrs. Robert M. Fulton, in Memory of Mrs. William A. Fulton
M1967.113A–B

1. Wallace Nutting correctly associated the period term with the bow-back armchair in 1917 in *Windsor Handbook*, p. 19. Nutting illustrates a very similar example on p. 18.
2. Advertisement illustrated as fig. 16 in Santore, *Windsor Style in America*, 1:42.
3. Quoted in Santore, *Windsor Style in America*, 1:43.
4. Commonly the first if there are seven spindles across the back, and the second if there are nine or more spindles across the back.

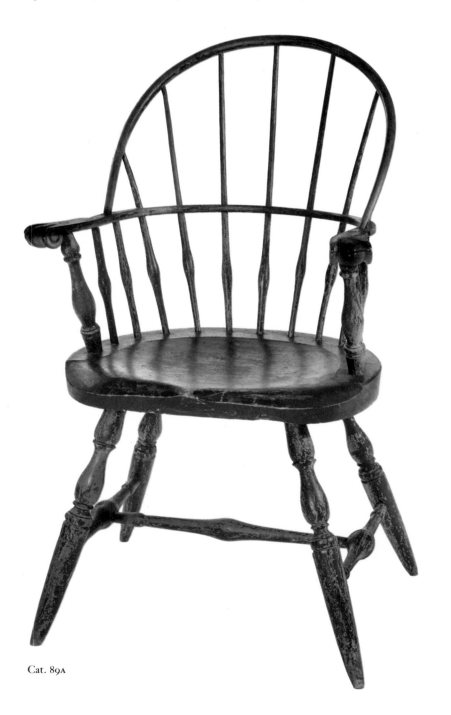

Cat. 89A

## 90 *High-post bedstead*

Philadelphia, Pennsylvania, ca. 1800–1815

*Description:* The four rails are fastened with bolts through the posts at staggered heights. The ends of the bolts are concealed with ornamental brass covers. Turned hickory knobs line the rabbeted upper edges of the rails. The headboard fits into two slots cut in the headposts. The tester frame fits over the top of each post.

*Condition:* The tester is original. The knobs for the original rope mattress support are mostly intact, although iron braces for a modern box spring have

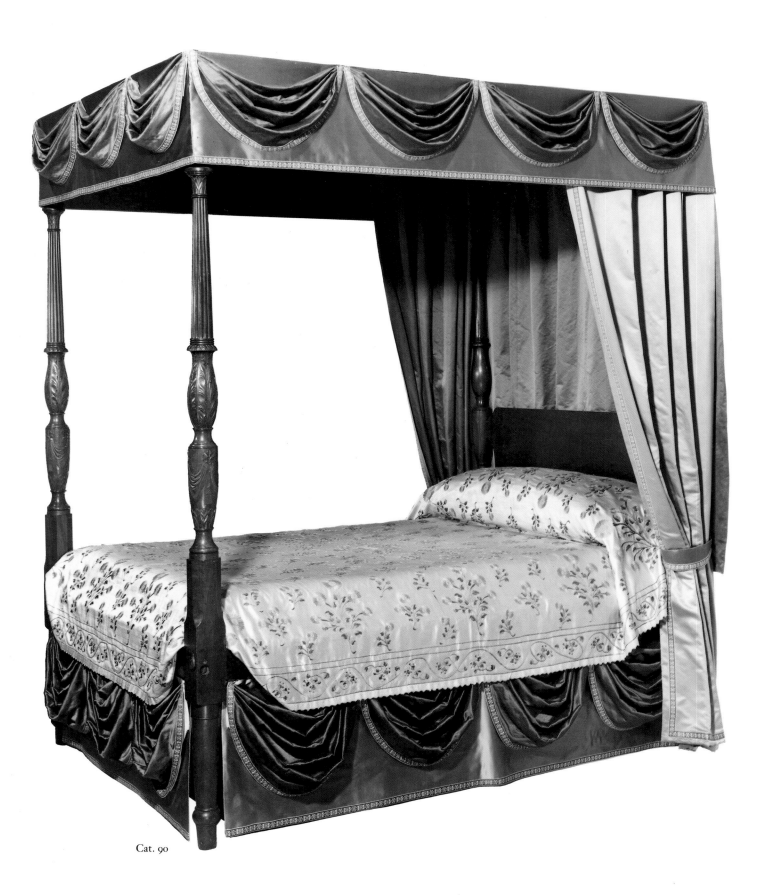

Cat. 90

been added. The bolt covers have been replaced, and the front left one is missing. The present bed hangings were designed and installed in 1979 by Ernest Lo Nano, Sheffield, Mass.

*Woods:* Posts and rails, mahogany; tester frame, eastern white pine; roping knobs, hickory.

*Dimensions:* H. 97 in. (246.3 cm), H. rail 24¾ in. (62.8 cm), w. 59⅜ in. (150.8 cm), D. 82 in. (208.2 cm).

*Provenance:* Appears to be the same bed sold at Parke-Bernet (sale 2753; October 26, 1968), lot 313; Joe Kindig, Jr., and Son, York, Pa. (dealer).

A fully dressed high-post canopy bedstead was among the most costly furniture that a wealthy person could own in the eighteenth century and throughout the federal period, often outranking even silver plate. Room-by-room probate inventories traditionally begin with the bedstead and bedding, and household linens were often the second most costly possession. As with upholstered easy chairs, the expense of a bed derived from the yards of fabric that covered it rather than from its wooden frame.

In an 1802 letter to a Delaware client, the Philadelphia upholsterer Richard Wevill set forth the relative values of a bedstead and its bedding. The cost of a frame for a canopy bedstead like this one ranged from $16 to $20 ("according to the manner of finishing and size"), whereas the price of its hair mattress ranged from $27 to $35. A plump feather bolster and pillows ranged from $35 to $50, more than twice the bed itself.[1] One year later, Wevill had died, yet his exhaustive estate inventory records the number and variety of fabrics, trimmings, hardware, and myriad accessories that comprised a well-equipped upholstery business, the total value of which stood well above that of most large cabinet shops. Among the accessories that upholsterers routinely supplied for beds were the cord and a sailcloth sacking to support the mattress, also custom-made by an upholsterer. Although this bed has lost its original sacking, the knobs for lacing the cord remain intact.

The bed hangings for a bed like Milwaukee's were extensive. A fully

equipped bed required dozens of yards of material for its several components, including curtains, headcloth (hung behind the headboard), canopy, valances, base valances (hung from the rails), and counterpane (coverlet). In the best chambers, the window curtains as well as the seating furniture would have been covered with fabric to match the bed hangings, thereby creating a rich but unified effect. An elaborately carved bedstead like this one probably had less voluminous curtains and valances in order to reveal more of its underlying carved ornament.[2] The headposts, unusual for being turned to match the lines of the footposts, are uncarved and without reeding because they were normally concealed behind the bed curtains.

The remarkable consistency of turned and carved ornament on many Philadelphia bedsteads indicates a local preference for this configuration of vase turnings with carved leaves, swags, and tassels. Similarly carved drapery, with a fringed tassel emerging from the center of a flower, occurs with little variation on several other bedsteads made in Philadelphia.[3]

Few documented examples survive to indicate attributions to individual cabinetmakers or upholsterers. An elaborate bed made by Joseph Barry for the du Pont family (Hagley Museum) includes many of the same carved details as this bed. Others including this one have been attributed to Henry Connelly or to Ephraim Haines on the unlikely basis of bulbous turned feet and the resemblance of their carving to a documented group of furniture commissioned by Stephen Girard in 1806–7.[4] For that commission, Haines subcontracted turned work from Barney Schumo and carving from John Morris, yet most cabinetmakers and upholsterers carried several grades of bedsteads in their inventories.

*Thomas S. Michie*

Gift of Collectors' Corner
M1978.10

1. Patricia Chapin O'Donnell, "Richard Wevill, Upholsterer," in Cooke, *Upholstery in America and Europe*, p. 116.
2. See Florence M. Montgomery, "18th-Century American Bed and Window Hangings," and Jane C. Nylander, "Bed and Window Hangings in New England, 1790–1870," in

Cooke, *Upholstery in America and Europe*, pp. 168, 175–85.

3. See Hornor, *Blue Book*, pls. 244–51, 253–54. See also Sack, *American Antiques*, 6:1600 and 7:1735, 1806; Parke Bernet (sale 1002; November 6, 1948), lot 131; Sotheby's (sale 5680; January 28–30, 1988), lot 1227; *Antiques* 124, no. 2 (August 1983): 265; and *Antiques* 126, no. 1 (July 1984): 80.

4. See Philadelphia Museum, *Three Centuries*, pp. 211–13.

## 91  *Chest of drawers*

Portsmouth, New Hampshire, area, ca. 1800–1820

*Description:* The top is constructed in two layers, the first comprising two boards dovetailed to the case sides, one in front and one in back. Three pine boards extending from back to front are set on top and bridge the space between them. On these rests the thin mahogany top. The drawer dividers and runners are let into the sides of the case and veneered on their front edges. The stringing and banding across the top and case front continue around the sides of the case. The shaped drawer fronts are built up with four

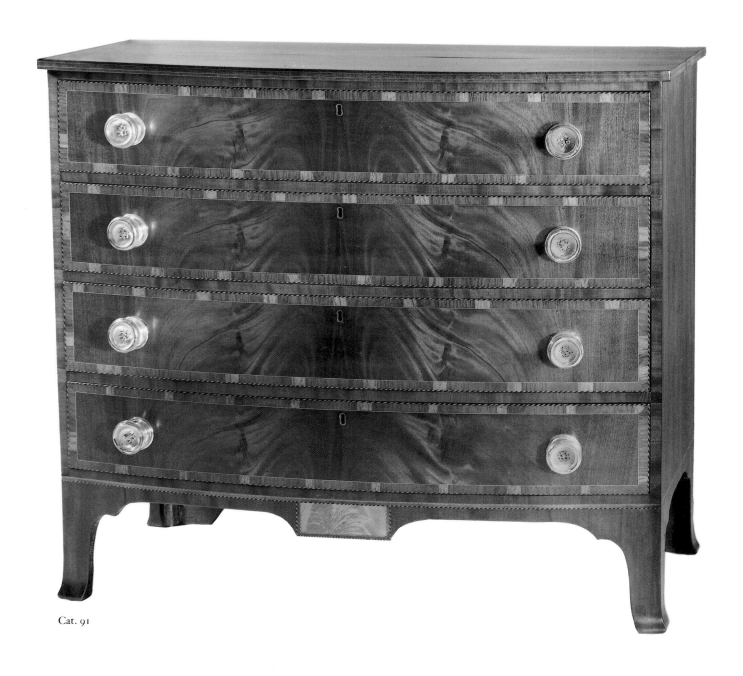

Cat. 91

horizontal laminations and veneered. The drawer sides are dovetailed to the fronts and backs. The drawer bottoms are set into grooved sides and fronts and secured at the front with small glue blocks. The bottoms overlap the backs and are nailed to them between thin, removable running strips. The thick pine bottom of the case is set into the mahogany sides and fastened underneath with fifteen evenly spaced glue blocks. The feet are pine boards attached to the bottom, secured with load-bearing corner blocks, and veneered. The back is covered with three horizontal pine boards nailed to the rabbeted backs of the sides.

*Inscriptions:* "Bowen Crehors [?] / Lent to Mrs. Tucker" is inscribed in white chalk on the underside of the bottom.

*Condition:* The drawer runners have been replaced. The diagonal glue blocks bracing the underside of the bottom board at all four corners are modern additions. The drawer pulls are old but not original.

*Woods:* Case top and sides, mahogany; framing rails, corner blocks, and drawer laminations, eastern white pine; crotch veneer panel at bottom center of case, possibly birch; banding on drawers, probably a tropical species.

*Dimensions:* H. 37 in. (93.9 cm), w. 40⅞ in. (103.8 cm), D. 21¼ in. (53.9 cm).

*Exhibition: Villa Terrace,* cat. 55.

*Bibliography:* Jones, "American Furniture," p. 980, pl. v.

*Provenance:* Purchased in 1967 from Philip Budrose Antiques, Marblehead, Mass. (dealer).

As one of New England's most prosperous seaports and market towns in the federal period, Portsmouth supported several cabinetmakers and other furniture-related craftsmen who worked in the latest neoclassical styles to satisfy the growing number of successful residents, many of whose splendid mansion houses are still standing.

"Swell-front" chests of drawers, or bureaus, as blockfront, serpentine, and bowfront chests were collectively called, had been popular in this country since the mid eighteenth century and remained among the most popular furniture forms in the federal period, judging from the large number of similar chests and related desks with New Hampshire histories that have survived. In addition to Portsmouth examples made by the firm of Judkins and Senter and others owned by Supply Ham, related chests by Ephraim Mallard of Gilmanton, J. Coffin Avery of Sandwich, and Eliphalet Briggs of Keene indicate that chests like this one were a regional specialty of southern New Hampshire. A related chest signed "Bowen" and attributed to the Marblehead cabinetmaker Nathan Bowen indicates that their popularity extended to the north shore of Massachusetts as well.[1] Although no New Hampshire cabinetmaker by the name of Bowen Crehore is recorded, an Ebenezer Crehore was working as a cabinetmaker in Walpole around the time that this chest was probably made.[2]

Attenuated bracket feet and a striking pattern of crotch veneers, banding, and light and dark stringing on each of the four drawer fronts update and enliven the Milwaukee chest's otherwise plain form. Typical of New Hampshire work are the straight-sided bracket feet ending in square toes and the prominent boards cut diagonally that brace the rear feet. The construction of the top, which rests on two pine boards dovetailed to the sides of the case joined by struts, is also distinctive of this group.[3]

The drawers on many of the related chests are divided into three separate veneered panels set off by bands of contrasting wood. On one New Hampshire chest, each of the inlaid drawer panels has a brass knob, and the center panel of the skirt functions as a drawer.[4] The cabinetmaker of the Milwaukee chest animated its facade by more subtle means. By opposing two matched flitches of crotch veneer on each drawer, he created a shimmering, flamelike band down the center of the chest that enhances the outward swell of the facade, leaving the brass knobs to ornament the plainer outer ends. In addition, the banding around each drawer has been selected for the irregular intervals between its light and dark portions that enhance the vibrant pattern of the chest's surface.

*Thomas S. Michie*

Purchase, Acquisition Fund
Gift of Collectors' Corner, 1969
M1967.24

1. A chest by Judkins and Senter is illustrated in *Antiques* 121, no. 3 (March 1982): 578, and a desk attributed to the firm was sold at Sotheby's (sale 5001; January 27–29, 1983), lot 425. A desk branded by Supply Ham was owned by Israel Sack (*Antiques* 92, no. 6 [December 1967]: inside cover), and a shelf clock marked by Ham with a related case was sold at AAA-Anderson Galleries (sale 4281; December 3–5, 1936), lot 505. For chests by Ephraim Mallard, see Garvin, Garvin, and Page, *Plain and Elegant, Rich and Common,* no. 23; Bernard and S. Dean Levy, *Brochure 6* (January 1988): 149; and *Antiques* 131, no. 5 (May 1987): 998. The chest by J. Coffin Avery appears in *Antiques* 123, no. 4 (April 1983): 738; that by Nathan Bowen in *Antiques* 106, no. 2 (August 1974): 200. For the chest by Eliphalet Briggs, see Little, *Little by Little,* p. 70.

2. See Giffen, "New Hampshire Cabinetmakers and Allied Craftsmen," p. 80.

3. See Buckley, "Fine Federal Furniture," pp. 196–200, and compare Montgomery, *American Furniture,* no. 138; Rodriguez Roque, *Chipstone,* no. 10; and Ward, *American Case Furniture,* no. 67.

4. *Antiques* 131, no. 5 (May 1987): 1004.

## 92 *Writing desk*

Boston-Salem, Massachusetts, area, ca. 1790–1810

*Description:* The mahogany sides and pine back of the lower case are framed into the legs, as are the two lower drawer dividers. The drawers are supported by runners nailed and screwed to pine strips set between the legs against the sides of the case. The top of the lower case is a pine board with mahogany ends attached with tongue-and-groove moldings. The molding below the tambour is glued to the hinged writing leaf and keeps it level when open. The perimeter of both the fixed and hinged writing surfaces is covered with mahogany veneer mitered at the corners. The tambour section is a pine box veneered with mahogany. The tambours slide in grooves cut into a mahogany strip applied to the front of the box. They retract between the sides of the case and the pigeonholes. The interior drawers have pine sides dovetailed to

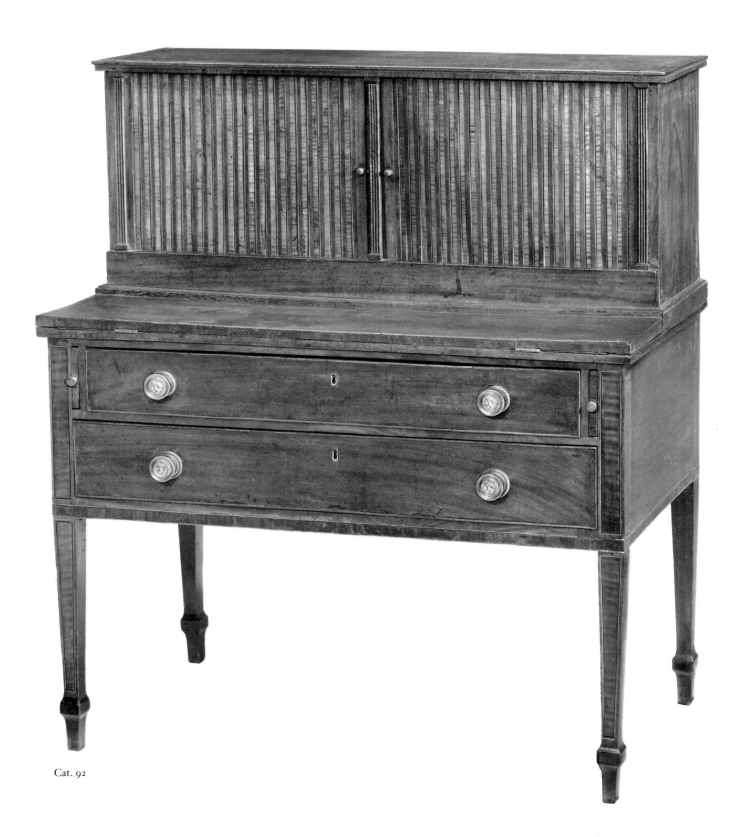

Cat. 92

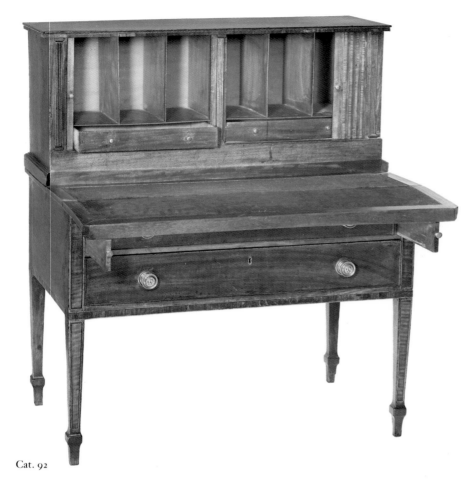

Cat. 92

Cat. 92

the fronts and nailed to the backs. The bottoms are set flush with the fronts, overlapping the sides and backs, to which they are nailed. The drawer sides in the lower case are dovetailed to the fronts and backs. Beneath applied running strips, the bottoms are flush with the sides and are secured to the rabbeted fronts with thin glue blocks. They overlap the backs and are nailed to them.

*Inscriptions:* "John Smith / Baltimore / MD" is inscribed in red chalk on the underside of the top drawer. "No. 15" is typed on an old gummed label (similar to that on cat. 83) affixed to the inner right side of the top drawer.

*Condition:* There have been small losses to the veneer on the left loper front and along the frieze under the top. The right front hinge area has been patched, as has the front left of the hinged writing surface and the front right corner of the upper case's top. The lower case drawers have been reinforced with wire nails and have new glue blocks and running strips. The blue-green paint covering the interior compartments and the velvet on the writing surface are twentieth-century additions. The brasses on the lower two drawers appear to be original, and the top right knob retains its old leather washer. Both interior drawers have new hardware, and the back of the left drawer has been replaced.

*Woods:* Face boards and outer veneers of upper case, mahogany; bottom and framing members of upper case, eastern white pine; backs of upper drawers and lower drawer front, cherry; front and sides of upper drawers, tambour guide, compartment dividers, lower drawer sides, backs, bottoms, and top of lower case, basswood; tambour slats, soft maple; keyhole surrounds, bone.

*Dimensions:* H. 43½ in. (110.4 cm), w. 37 in. (93.9 cm), D. 20½ in. (52.0 cm).

*Bibliography:* Stoneman, *John and Thomas Seymour*, p. 77; Otto, "The Secretary with the Tambour Cartonnier," p. 379; Jones, "American Furniture," p. 982, fig. 12.

*Provenance:* John Smith, Baltimore, Md.; descent unknown to Israel Sack, Inc., Boston, Mass., and New York, N. Y.; purchased in 1930 by Henry Ford Museum,

Dearborn, Mich. (acc. no. 30-834-11); sold sometime after 1960 to Joe Kindig, Jr., and Son, York, Pa. (dealer).

Though frequently attributed to the celebrated English-born Boston cabinetmakers John and Thomas Seymour on the basis of only three surviving labeled examples, dozens of small writing desks with tambour shutters were produced by many different cabinetmakers throughout urban and rural New England, New York, and the Western Reserve in Ohio.[1] They represent the height of Anglo-American fashion at the end of the eighteenth century, although the design for a small writing desk on tall legs ultimately derives from the French writing desk known as a *bonheur du jour* and its attached filing cabinet, or *cartonnier*. The French design, intended for more intimate residential quarters than imposing desks and bookcases, which were designed to contain business ledgers and small valuables, found favor with English and American patrons and designers. Thomas Sheraton presented similar designs in his *Cabinet-Maker and Upholsterer's Drawing-Book* of 1793 that New England cabinetmakers in turn adapted to include glazed bookcase sections, solid doors in place of tambour shutters, and other variations.

At least one account survives of a fifteen-year-old Providence girl's response to this novel furniture form upon seeing a tambour desk in Salem for the first time in 1798:

*Dr. Prince has a new kind of desk made and I wish Papa would permit me to have one like it. The lower part of it is like a bureau then there is a desk that doubles together like a card table and back of that is a parcel of drawers hid with doors made in reeds to slip back.... 'Tis the handsomest thing of the kind I ever saw and the most beautifully varnished.... 'Tis admired by all.*[2]

The finest Boston and Salem examples exhibit carefully selected veneers on their drawer fronts, unusually thin drawer parts, several kinds of wood and bone inlay and banding, and English enamel drawer pulls. The Milwaukee desk is relatively plain by comparison, although its thin mahogany top with checkerboard banding below a delicately molded front edge, thin mahogany interior dividers, and tapered "therm" legs are all consis-tent with the best workmanship of Boston and Salem cabinet shops.

On the other hand, the poor fit of the applied capitals above the reeded pilasters in the upper section suggests less careful use of interchangeable parts. The substitution of alternating light and dark maple tambour slats for more delicate mahogany reeding also gives this desk a bolder, unmistakably American appearance. The absence of such minor refinements as a second tier of interior drawers and a lock for the tambour section (often concealed behind the folded writing flap) speaks for the patron's selection of less costly options.

The cursive inscription in chalk on the underside of the top drawer appears to be that of a contemporary owner in Baltimore. Its early presence there confirms the extensive coastwise trade of furniture and other goods recorded in so many Salem, Boston, and Baltimore cabinetmakers' bills and newspaper accounts. A second tambour desk as well as an earlier bombé desk and bookcase from Boston have also survived with histories of ownership in Baltimore from as early as the 1780s.[3] Considering Baltimore's rapid growth and prosperity in the decade following the Revolution, it is not surprising that local cabinetmakers and merchants imported tambour desks from New England in order to meet the increasing demand for stylish furniture.

*Thomas S. Michie*

Purchase, Layton Art Collection
L1975.60

1. Notes on eight signed or labeled examples by William English, Thaxter and Rouse, and John and Thomas Seymour of Boston; Thomas R. Williams, Edmund Johnson, and Mark Pitman of Salem; and William Clark of Providence are in the MAM files.
2. Quoted in Ott, "John Innes Clark," p. 131.
3. Weidman, *Furniture in Maryland*, cats. 24, 98. For imports from New England, see p. 44.

## 93 *Worktable*

Boston, Massachusetts, ca. 1790–1810

*Description:* The sides and back are pine boards faced with veneer. The sides are attached at either end to vertical corner blocks behind each leg. The rear board is set between the sides of an inner frame that runs the full depth of the case and to which the drawer runners are nailed. The drawer dividers are tenoned to the sides of the inner frame, the upper one flush with the drawer fronts and covered with veneer, the lower one set back to receive the molded mahogany front of the sewing-bag frame. The sides of the bag frame are dovetailed to the front, and the back is tenoned to the sides. Both drawers have thin mahogany backs and sides whose tops are finished with an incised bead. The drawer sides are mitered and dovetailed to the fronts and backs. The pine bottoms are set flush with the fronts and sides. They overlap the backs to which they are nailed.

*Condition:* Portions of the base molding have been replaced, as have portions of the veneer surrounding the drawer openings. The rear-right corner of the top has cracked and been repaired, as has the back-left corner of the case. The top has been removed and reset with new glue blocks, and four screws that once secured the top are missing. The top drawer is missing one of its interior dividers; the lower drawer lacks all four. The hinges on the writing board have been replaced, as have portions of the runners holding the sewing bag. The sewing bag itself was replaced in 1987 with period fabric and fringe.

*Woods:* Top, legs, drawer fronts, sides, backs, and sewing bag's sliding frame, mahogany; veneer on drawer fronts, satinwood; drawer bottoms, sewing bag's inner support, and upper frame, eastern white pine; hinged board, chestnut.

*Dimensions:* H. 29⅜ in. (74.6 cm), W. 16⅞ in. (42.8 cm), D. 13⅛ in. (33.3 cm).

*Bibliography: Antiques* 124, no. 3 (September 1983): 320.

*Provenance:* John Walton, Inc., Jewett City, Conn. (dealer); private collection; Sotheby's (sale 4590Y; May 1, 1981), lot

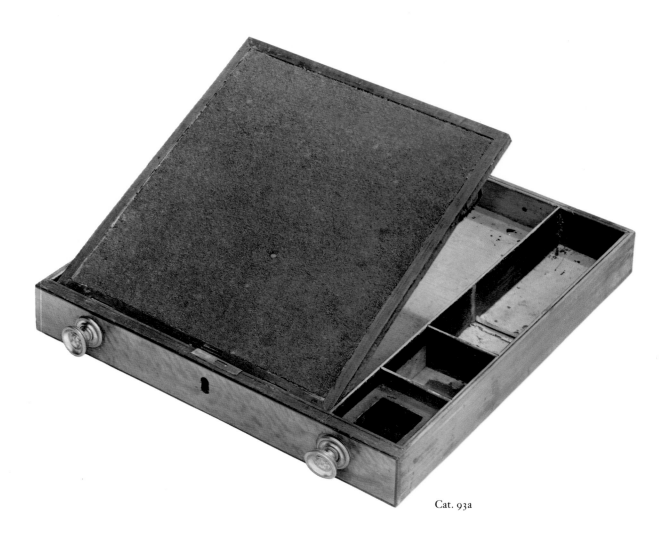

Cat. 93a

1016; repurchased by John Walton, Inc., Jewett City, Conn., and acquired from Walton in 1985.

With the rise of female seminaries and needlework schools in the federal period grew the need for specialized furniture suited to women's pastimes. Among these, needlework typically occupied several hours of a well-to-do woman's day and eventually became synonymous with a virtuous and aristocratic, albeit passive, way of life.[1] Worktables are compact, lightweight, and therefore portable. Casters permitted one to move the table around a room and to reposition it easily for sewing or writing. Despite the simplicity of their overall form, essentially a box on tall legs, worktables were fre-

quently embellished with a variety of veneers and turnings and designed to assist at a comparable variety of domestic activities.

The top drawer of this table contains a baize-covered writing tablet (cat. 93a) hinged at the front that allows it to be inclined for either reading or writing. To its right are one rectangular and three square compartments for writing accessories, including bottles for ink and blotting sand. The precision and delicacy of the smallest construction details are consistent with the finest Boston workmanship at the turn of the eighteenth century. The mahogany drawer sides, for example, are extremely thin, molded along the top edge, mitered at the corners, and secured with minuscule dovetails. Light

blue laid paper covers the underside of the writing tablet, as was the custom of both English and American cabinetmakers. Price books refer to blue lining paper, an option that recalls the blue-green paint applied to pigeonholes on furniture by the Seymours, William Appleton, and other Boston and Salem cabinetmakers.[2] The bottoms of the drawers are similarly lined with pink and marbleized papers.

The lower drawer was once divided into at least four compartments for sewing equipment, judging from the grooves at the center of each side. The sewing bag below extends to catch sewing scraps or simply to store needlework in progress. The front of its wooden frame conforms neatly with the applied moldings around the bottom of the case, which in

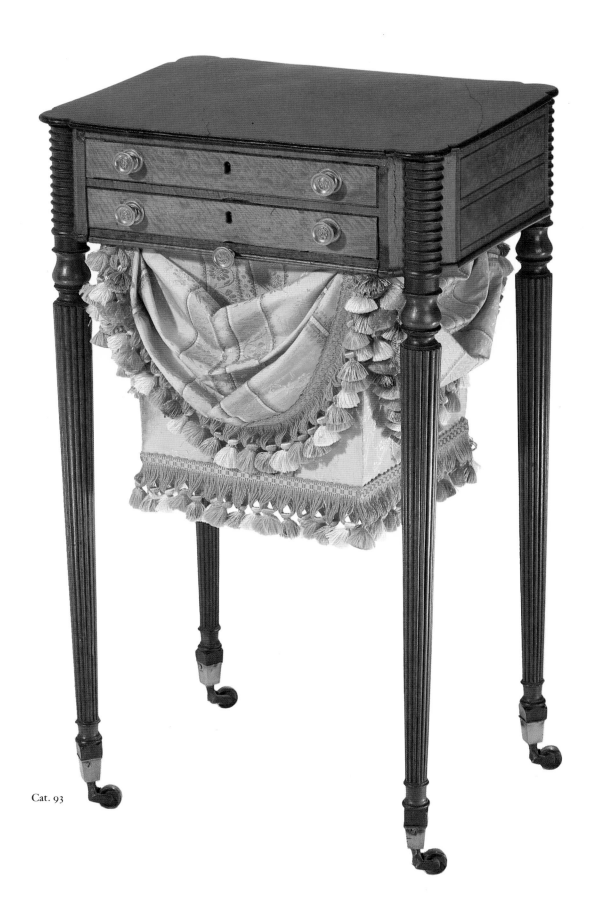

Cat. 93

turn complements the table's thin thumbnail-molded top. A more subtle device that visually unifies the upper and lower portions of the table are the offset spade feet that conform to the chamfered corners of the case.[3] By setting double panels of satinwood veneer into the sides and back of the case corresponding to the drawer fronts, the cabinetmaker has successfully unified all four sides and made an elegant case worthy to be seen standing free.

The same arrangement of contrasting veneers and refined construction occurs on a small group of related Boston work-tables.[4] All have tops with ovolo corners, writing tablets in the top drawer, and tapered, reeded legs with similarly turned bases and capitals. Most have been attributed at one time to Thomas Seymour, although only one worktable survives with its 1812 bill from Seymour's Boston Cabinet Manufactory, where it sold for $36.[5]

The consistent style of turned, tapered, and reeded legs among these and other contemporary Boston card tables attests to an extensive piecework system, in which specialized turners mass-produced table legs in several sizes for different kinds of tables that were assembled by many different cabinetmakers in the Boston area. According to Benjamin Hewitt's statistical analysis of card-table legs, the base turnings on this table resemble both Salem and Boston products, whereas the compressed vase-and-ring turnings above the reeded shaft are distinctive of Boston tables.[6] To date, no individual Boston turner's work has been identified, although Thomas Seymour's debt of over $1,000 to Stephen Badlam in 1815 suggests that Badlam may have been one of the chief sources of turned legs for Boston and Salem cabinet shops.[7]

*Thomas S. Michie*

Purchase, Layton Art Collection
L1985.1

1. For a feminist historian's interpretation of embroidery and its subjects, see Parker, *Subversive Stitch*, ch. 6.

2. Montgomery, "Tambour Desks and the Work of William Appleton," p. 45.

3. A second worktable with rare spade feet is illustrated in *Antiques* 82, no. 6 (December 1962): 570.

4. For related tables, see Montgomery and Kane, *American Art*, no. 134 (Wunsch); Montgomery, *American Furniture*, no. 412 (Winterthur); Rodriguez Roque, *Chipstone*, no. 180 (Stone); Fairbanks and Cooper, *Paul Revere's Boston*, no. 258 (du Pont); and Flanigan, *American Furniture*, no. 80 (Kaufman). A labeled worktable by Jacob Forster has a different case but similarly turned legs (*Antiques* 76, no. 3 [September 1959]: 183).

5. Stoneman, *John and Thomas Seymour*, p. 239.

6. Hewitt, Kane, and Ward, *Work of Many Hands*, p. 65.

7. Swan, "General Stephen Badlam," pp. 382–83.

## 94 *Pole screen*

Massachusetts, or possibly Rhode Island, ca. 1790–1810

*Description:* The framed needlework panel is raised and lowered on a pulley counterbalanced by the weighted tassel. The back of the pole's rectangular shaft is hollowed out for the tackle, which is concealed by a mahogany strip applied to the back of the shaft. The pole fits into the top of the base. The legs are tenoned into the base and glued to a raised disk on the underside.

*Condition:* The front of the pole has cracked at the base and been repaired.

*Materials:* Pole, base, legs, and inner frame of screen, mahogany; outer frame of screen, cherry; finial, birch; embroidered silk panel.

*Dimensions:* H. 56½ in. (143.5 cm), W. 19½ in. (49.5 cm), D. 16 in. (40.6 cm).

*Bibliography:* Sack, *American Antiques*, 4:1049.

*Provenance:* Anita W. Hinkley, Providence, R.I.; Israel Sack, Inc., New York, N.Y. (dealer).

Fire screens performed both practical and decorative functions in the days when open fireplaces were the chief source of heat and light in the home. An adjustable screen on a portable base provided protection from the direct heat that could easily melt the wax-based cosmetics that

Cat. 94

women used. Screens also shielded a sitter's eyes from firelight, which could be bothersome in an otherwise dimly illuminated room. In addition, screens provided a prominent surface for the decorative display of fancy needlework. In the early eighteenth century, fire screens were often imposing pieces of furniture with elaborately carved and gilt frames and bases. At the opposite extreme were small screens that stood on tabletops, and those that were hand held. This example from the federal period is based on English Regency–style examples, among the most delicate designs.

Hepplewhite's *Guide* (1788) offered advice for the decoration of screen panels, which might be "ornamented variously with maps, Chinese figures, needlework, etc." In this country, the last option was by far the most popular solution, judging from the number of screens surviving with needlework or other textile panels intact. An alternative was a solid piece of wood, available in a variety of neoclassical shapes such as a shield or oval that could be inlaid, painted, or left plain to show off its lively grain. On this example, the octagonal frame of cherry and mahogany contains a silk panel with floral embroidery of the kind that young girls learned at the needle-work schools and female academies that flourished during the federal period.

The stance of the tripod base is exceptional for its attenuated, serpentine legs springing from "therm" feet, an option whose very name conjures up its sources in classical antiquity. Even more unusual, however, is the pulley mechanism by which the height of the screen is adjusted. Most other American screens make use of a simple ring that tightens with a screw against the pole. On the Milwaukee screen, the pulley runs through a channel in the laminated pole and is counter-balanced by a weight embellished with an elaborate tassel. Thomas Sheraton described the same device in his *Drawing-Book* of 1793 (plate 38):

*The rods of these screens are all supposed to have a hole through them, and a pulley let in near the top on which the line passes, and a weight being enclosed in the tassel, the screen is balanced to any height.*

Cat. 94

Dumbwaiters operate on a similar principle, and one is reminded of numerous mechanical devices enthusiastically embraced in the late eighteenth century by a society that prized "useful knowledge" and in which many gentlemen were amateur scientists and architects.

Due to the limited stylistic variation among pole screens from this period, the dearth of American examples with documented histories of manufacture or ownership, and the frequent absence of telltale secondary woods, regional origins are difficult to establish. A related screen with a long history of ownership in Providence suggests a Massachusetts or Rhode Island origin for this screen. However, the large turned and inlaid disk that makes the transition from the legs to the central pole is more often found on English examples; American pole screens more typically have additional vase-and-ring turnings.[1] Furthermore, the only native American woods on this example occur at the most ephemeral points: the needlework frame and the finial.

Though purchased out of the Edward Dexter House (built 1799) in Providence, this screen did not form part of its original furnishings. The house itself, which was moved to its present site at 72 Waterman Street in the mid nineteenth century, has belonged to several early collectors of American furniture, most notably Charles Pendleton, who bequeathed his collection in 1904 to the Rhode Island School of Design.[2] Anita Hinkley, the earliest recorded owner of this screen, was herself an ardent collector of Americana in the 1920s. She purchased antiques from a number of different sources but also inherited Boston furniture that had descended from her husband's Storer, Smith, and Cruft family forebears.          *Thomas S. Michie*

Purchase, Layton Art Collection
L1986.2

1. A strikingly similar pole screen also having its original needlework panel is illustrated in *Antiques* 91, no. 6 (June 1967): 686. Another attributed to England was sold at Richard A. Bourne Co., Hyannis, Mass. (June 25, 1974), lot 105.
2. Monkhouse and Michie, *American Furniture in Pendleton House*, pp. 34, 78–79.

## 95  *Card table*

Boston, Massachusetts, area,
ca. 1790–1820

*Description:* The curved front and side rails are built up with two vertical laminations. The front and side rails are set into the front legs and secured with vertical glue blocks. The side rails are dovetailed to the rear rail, which is constructed with a filler that allows the back left leg to swing on its flush hinge. The underside of the top is secured with five screws, one through the rear rail, two through the front rail, and two at either end. A single leaf-edge tenon stabilizes the top when open.

*Condition:* The tapered ends of all four feet have been replaced and refinished.

*Woods:* Top and legs, mahogany; frame, rails, and corner blocks, eastern white pine; veneers and stringing, burl and mahogany.

*Dimensions:* H. 29⅝ in. (75.2 cm), W. 35½ in. (90.2 cm), D. closed 17½ in. (44.5 cm).

*Bibliography:* Stoneman, *John and Thomas Seymour*, p. 213, no. 127.

*Provenance:* Purchased in 1972 from Philip Budrose Antiques, Marblehead, Mass. (dealer).

Card playing was never more popular in this country than during the federal period. As card games became an acceptable form of evening entertainment both in public and at home, their popularity was both cause and effect of the number and variety of fashionable tables produced for the purpose. Tables like this one with a square top, elliptic front, half-elliptic ends, and ovolo corners were especially popular in New England. Slightly less versatile than circular tables, the most popular shape, the square table's pronounced corners clearly define the playing surface for four players, like vestigial remnants of the raised corners on earlier gaming tables (see cat. 67). When not in use, card tables often served as side or pier tables that could be placed symmetrically against a wall. Their dual function helps to explain why they were frequently purchased in pairs and used

Cat. 95

Cat. 95

in several different rooms throughout the house.[1]

Both structural and ornamental details of this table are consistent with hundreds of other card tables made in the Boston area. Like the turned legs on the lady's worktable (cat. 93), this particular configuration of vase-and-ring turnings on the capitals was especially popular in Boston but also appears on tables made in New Hampshire.[2] On the other hand, the attenuated turned foot and its pronounced collar are statistically unique to Boston. The lunette inlay along the edge of the folding leaf and lower edge of the skirt, once thought to be the exclusive trademark of John and Thomas Seymour, was undoubtedly made by a specialist in Boston and sold to many different cabinet shops throughout New England. It occurs with small variations on much federal furniture produced in both urban and rural areas between northern Massachusetts and Rhode Island.

The contrast between the burl veneers of the skirt and the darker mahogany of the top and legs distinguishes this table from more conventional designs and heightens its mixture of styles. The legs are turned with rings to simulate bamboo, a material first popularized in the 1750s by Sir William Chambers that reached the height of popularity during the English Regency. Bamboo turnings are rarely found on American furniture of the federal period, other than a variant style for Windsor chairs. This style of ring turning occurs on a few other Boston card, work, and dining tables in the English taste.[3] In their zeal for chinoiserie, Westerners ignored the irony that in China, bamboo was generally reserved for rudimentary household furniture. Boston merchants imported bamboo from China and Japan that eventually satisfied the growing taste in the nineteenth century for exotic materials in general and Oriental designs in particular.[4] The bamboo on this table, however, remains thoroughly Western in its evocation.                    *Thomas S. Michie*

Gift of Virginia and Robert V. Krikorian
M1987.30

1. According to Stoneman, this table was one of a pair (Stoneman, *John and Thomas Seymour*, p. 213). For the use of card tables in federal-period homes, see Gerald W.R. Ward, "Avarice and Conviviality," in Hewitt, Kane, and Ward, *Work of Many Hands*, pp. 15–38. For additional inventory evidence, see Cooke, "Domestic Space in the Federal Period," pp. 248–64.

2. Hewitt, Kane, and Ward, *Work of Many Hands*, p. 65. For two related New Hampshire tables by I. Wilder, see Hewitt, Kane, and Ward, *Work of Many Hands*, cat. 7, and Garvin, Garvin, and Page, *Plain and Elegant, Rich and Common*, no. 55.

3. See *Antiques* 108, no. 4 (October 1975): 659. A related Massachusetts card table and a Charleston clock with similar turnings are illustrated in Battison and Kane, *American Clock*, p. 163. See also Sotheby's (sale 4180; November 16–18, 1978), lot 975, and Parke-Bernet (sale 955; April 9–10, 1948), lot 308. A Boston drop-leaf dining table with similar turnings is at Gore Place (Hammond and Wilbur, *Gay and Graceful Style*, p. 56, no. 48). For a Boston worktable with similar turnings, see Stoneman, *John and Thomas Seymour*, p. 223, no. 135.

4. See Monkhouse and Michie, *American Furniture in Pendleton House*, cat. 141.

## 96 *Sideboard table*

Philadelphia, or possibly Maryland, ca. 1790–1815

*Description:* The shaped rails consist of five horizontal laminations. The three front segments are let into the tops of the front legs; the back rail is set into the back legs and fastened with vertical glue blocks. Three medial braces join the back and front rails. The top is secured from below with fourteen screws through the rails. A thin piece of mahogany has been glued to the underside of the center of the top.

*Condition:* All four legs have been extended from just above their banded cuffs. Some crossbanding on the top and along the lower edge of the skirt has been replaced.

*Woods:* Legs, top, mahogany; frame, braces, glue blocks, yellow-poplar.

*Dimensions:* H. 35 in. (89.0 cm), W. 50⅛ in. (127.2 cm), D. 23¼ in. (59.0 cm).

*Provenance:* Said to have been found in central Pennsylvania; Lee Nichols (dealer); purchased in 1986 from Red Mill Antiques, Bloomsburg, Pa. (dealer).

Sideboard, pier, and mixing tables are all related forms with either wooden or marble tops that were used in federal-period dining and sitting rooms. Designed to stand against a wall, as was this table with its top overhanging at the back, they provided a convenient surface for setting out and serving food and drink, as well as a prominent expanse for the display of precious silver, glass, and ceramics. In an 1827 handbook for servants, Robert Roberts, the butler at Gore Place in Waltham, Massachusetts, observed that "you must think that ladies and gentlemen that have splendid and costly articles, wish to have them seen and set out to the best advantage."[1] This preference is confirmed by Sarah Emery's description of a Newburyport sideboard in the early nineteenth century bearing "some half dozen cut-glass decanters filled with wine, brandy and other liquors; they were flanked by trays of wine glasses and tumblers."[2]

In New England, where this new form of furniture became popular in the 1780s, the most common design was a "commode" sideboard comprising one long drawer for flatware or linens, a large flanking drawer divided for bottles, and a cupboard for storing plates, glasses, or the occasional chamber pot. To the south, tall sideboard tables without drawers or cupboards seem to have been more popular, as were the cellarettes designed to stand beneath them. In Benjamin Franklin's Philadelphia house, for example, a sideboard and two matching sideboard tables were ordered in 1778, their relative values suggested by another Philadelphia inventory in which the "mahogany Side board" was valued at £2 and the one "with drawers" at £7.10.[3]

Aspects of this side table's design and ornament recall furniture made in more than one region between Philadelphia and the Carolinas. Its shape, with serpentine front and rounded ends, and the five-part laminated construction of the frame were especially popular features of neoclassical card tables made in Philadelphia.[4] However, many Baltimore sideboards have the same kidney shape as this table, and related sideboard tables are known to have been made there, as well as in the South.[5]

Philadelphia patrons rarely embellished

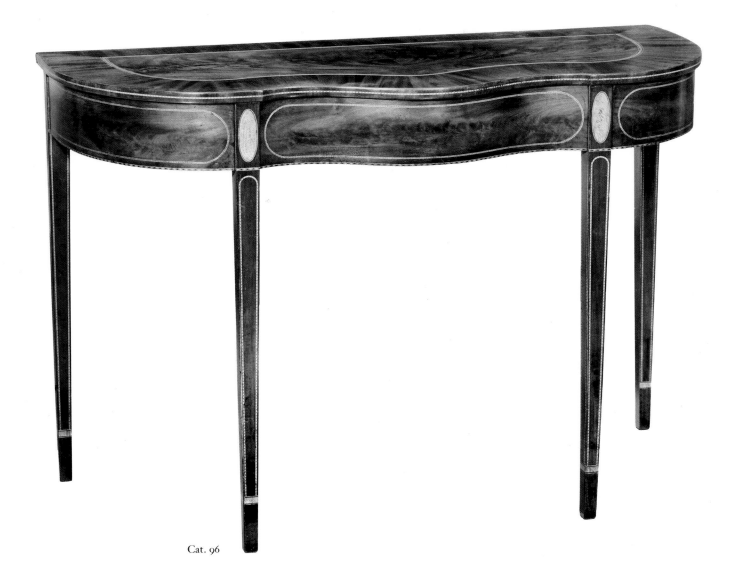

Cat. 96

their neoclassical furniture with pictorial inlay, evidently preferring the plain and neat style that Hepplewhite prescribed for dining rooms and parlors. The general conservatism of Philadelphia furniture helps to distinguish it from furniture made in Baltimore, where several specialist inlay makers worked. However restrained, this table is beautifully veneered to complement its curving shape. The center of the top is set with matching flitches of crotch mahogany and outlined with light stringing, while the perimeter is set off by a skillfully inset crossbanded border. Imagined within the context of a fashionable dining room, where it might have been accompanied by a commode sideboard, this table embodies the elegance of the finest federal-period furniture based on English designs and adapted to suit a variety of architectural settings in different regions of the new republic.     *Thomas S. Michie*

Gift of Virginia and Robert V. Krikorian
M1987.33

1. Robert Roberts, *The House Servant's Directory* (Boston, 1827), pp. 48–49, quoted in Garrett, "The American Home, Part IV: The Dining Room," p. 916.

2. Sarah Emery, *Reminiscences of a Nonagenarian* (Newburyport, 1879), p. 244, quoted in Montgomery, *American Furniture*, p. 358.

3. Hornor, *Blue Book*, pp. 135–36.

4. According to statistics on federal-period card tables compiled by Benjamin Hewitt, this shape was more than ten times as popular in Philadelphia than in any other region. See Hewitt, Kane, and Ward, *Work of Many Hands*, pp. 67, 164–66.

5. For related Baltimore sideboards and tables, see Miller, *American Antique Furniture*, 1: 538–40; Elder and Stokes, *American Furniture*, cats. 110, 112; and Garrett, "American Furniture in the DAR Museum," p. 755. The southern sideboard table is discussed in Montgomery, *American Furniture*, cat. 356.

## 97 *Card table*

New York, New York, ca. 1810–25

*Description:* The front, sides, and back of the frame are laminated with a mahogany rim and veneered. At the midpoint of the frame, a board the full thickness of the rails is tenoned to the front and back rails, and it is on this surface that the top leaves turn ninety degrees counterclockwise. On the left, the underside of the frame is sealed with a board that forms a well. At the right, the frame is open and built out to the same thickness as the top of the turned rear support. The lower leaf has three tenons and is framed on all sides with mahogany strips. The front and sides of the hinged leaf are rabbeted to receive the band of cast-and-gilt brass ornament. The base is veneered on its top and all sides. Both front and rear legs are tenoned into the underside of the base; the carved wings on the front legs are pinned to the underside and further secured with vertical glue blocks.

*Condition:* The veneered top of the lower leaf has cracked along its length and been repaired, as has the left underside and hinge area of the hinged leaf. Three screw holes through the frame and the bottom leaf indicate that the top was once fixed in its closed position.

*Woods:* Top and veneered surfaces, mahogany; front legs and feet, ash; rear legs, birch; carved wings, cherry; framing members of top and base, eastern white pine; corner blocks, mahogany.

*Dimensions:* H. 31½ in. (80.0 cm), w. 36 in. (91.4 cm), D. closed. 18 in. (45.8 cm).

*Provenance:* Purchased in 1984 from Joe Kindig, Jr., and Son, York, Pa. (dealer).

In the years of turmoil surrounding the French Revolution, thousands of French emigrated to the United States, settling principally in the fastest-growing cities of New York, Philadelphia, and Baltimore. Among them were many architects and *ébénistes,* or cabinetmakers, and other furniture-related craftsmen who introduced furniture in the latest French Directoire and Empire styles. Most notable among them was Charles-Honoré Lannuier, who had arrived in New York City by 1803 and died there in 1819, but he was not alone.

The design and ornamentation of this table reflect the impact of Napoleonic archaeological discoveries that were quickly adopted by artists in every medium. The winged paw feet, for example, are painted in imitation of bronze, and their carved fur, gilded feathers, and acanthus leaves are archaeologically "correct," like the paw feet on the contemporary lyre-back chair (cat. 86). Empire furniture designs were popularized by fashion journals such as Pierre de la Mésangère's *Meubles et objets de goût,* published serially between 1802 and 1835, from which elements of this card table's design may derive.

Whereas on federal-period card tables the legs are hinged to redistribute support for the opened top, the legs on this table remain fixed, while the top rotates and is supported by the frame. The left half of the frame then becomes an open well for storing cards. The base is obviously designed to be viewed frontally and to be placed against a wall. The inverted cornucopias are carved only on their front surfaces, the back legs extend laterally instead of flaring outward like the front two, and the front feet have only frontal wings. By placing the rear supports closer together than the cornucopias, the cabinetmaker reveals a concern with perspective, for the back supports are neatly framed when viewed from the front. Similar bases are found on contemporary pier and console tables, but usually their asymmetry is optically corrected by their reflection in mirrored back panels.

The carved and gilt acanthus leaves extending over the legs were a standard item of the carver's repertory.[1] The well-articulated winged animal legs and cornucopias required a more skillful carver, and yet similar details frequently occur with minor variations on other New York furniture, including sofas, pier tables, and secretaries. Cornucopias suggest an additional function for this table as a dining table. Writing in the *Cabinet-Maker and Upholsterer's Companion,* first published in 1829, J. Stokes refers to "card tables, being used for breakfast purposes, as well as for the evening party."[2] The iconographic value of fruit and cornucopias as

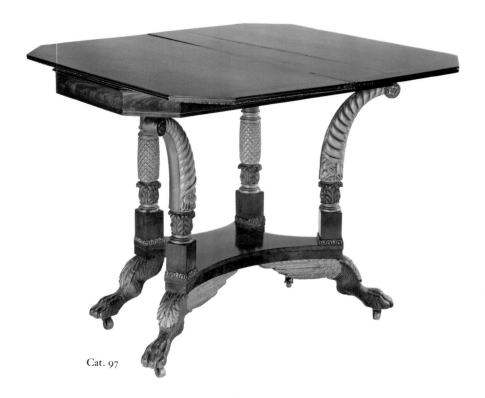

Cat. 97

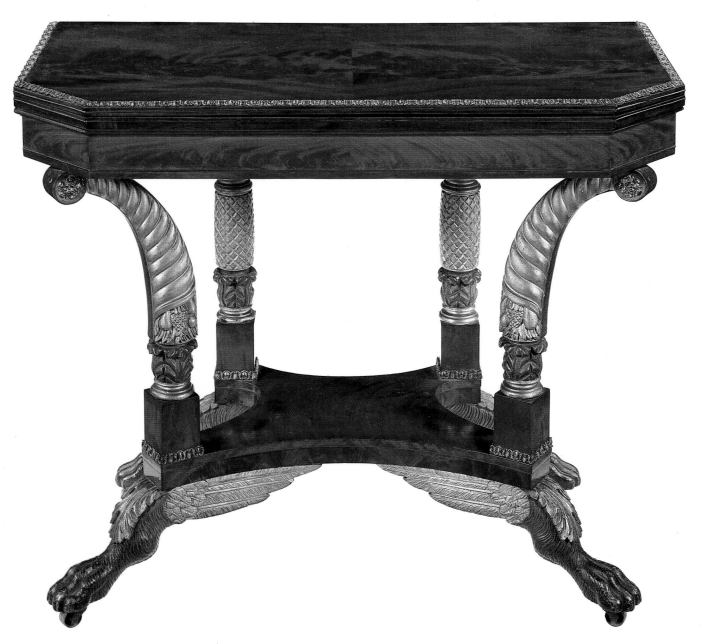

Cat. 97

symbols of peace and prosperity must have appealed to patrons in a young country, one that embraced French furniture styles as warmly as it later welcomed Lafayette.

Compared with card tables by Lannuier and other French *ébénistes* working in New York, the design and execution of this table are restrained.[3] The well-modeled ormolu mounts applied to the plinths and let into the upper edge of the top notwithstanding, the stiffness of the "standards" (supports), their carving, and awkward inversion suggest the work of craftsmen trying to keep up with the high standards set by French cabinet-makers. Although still strikingly neoclassical, the prominence of representational carvings and the resulting ambiguities of this table's function foreshadow the taste in the later nineteenth century for even more vivid and anecdotal ornamentation of furniture according to its function in the Victorian home.

*Thomas S. Michie*

Purchase, Layton Art Collection
L1984.140

1. A carver's preparatory drawing for a similar leaf is illustrated in Child, "Furniture Makers of Rochester," p. 98b.
2. Stokes, *Cabinet-Maker and Upholsterer's Companion*, p. 39.
3. For examples of Lannuier's work, see Rice, *New York Furniture*, pp. 32–36, and Weidman, *Furniture in Maryland*, nos. 160–63.

## 98   *Looking glass*

New York, New York, ca. 1790–1810

*Description:* The face of the frame and its separately carved and applied crest and pendant are entirely veneered. The thick pine backing is rabbeted to receive the mirror plate, which is framed by gilt moldings. The pendant husks are pinned to the unveneered sides of the frame with steel wire.

*Condition:* A triangular patch has been let into the veneer of the bottom center.

*Woods:* Pediment and frame, mahogany veneer; backboard of top section, yellow-

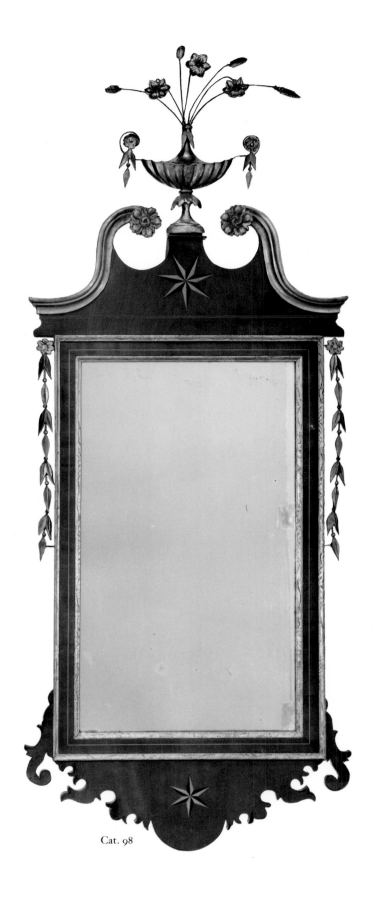

Cat. 98

poplar; bottom scroll, rail, and glue blocks, eastern white pine; armatures, steel wire.

*Dimensions:* H. 57 in. (144.8 cm), w. 24 in. (60.9 cm).

*Bibliography: Antiques* 98, no. 4 (October 1970): 481; Jones, "American Furniture," p. 983, fig. 13.

*Provenance:* Purchased in 1970 from Ginsburg and Levy, New York, N. Y. (dealer).

The addition of neoclassical ornament, such as a carved and gilt urn with composition leaves and flowers on wire stems, to an older style of looking glass, was particularly popular with American patrons, much as the high chest and the lolling chair were American innovations adapted from traditional English furniture forms. As with the New York–New Jersey tall clock (cat. 102), the broken-scroll pediment on this looking glass is more attenuated than on older examples. The reduced width of the parcel-gilt frame is also consistent with the prevailing taste in the federal period for delicate proportions. The intricate scrollwork of the base, on the other hand, harks back to rococo asymmetry characteristic of frames from midcentury, whose scrollwork is often embellished with shallow, gilt carving.[1]

The use of eastern white pine and yellow-poplar as secondary woods on this looking glass indicates that it was probably made in this country. Both New York and Boston carvers and gilders produced excellent looking glasses, and both cities supported large-scale importers such as William Wilmerding and John Doggett. Nevertheless, many looking glasses, including those labeled by American retailers, continued to be imported to this country from Britain and the Continent, where the highly specialized trades of plate-glassmaking and glass silvering dominated fledgling American ventures.

This particular style of looking glass with carved and gilt garlands wired to each side, and an inlaid and scrolled base, relates to a large group of looking glasses traditionally attributed to New York City and Albany.[2] Several bearing the labels of the Del Vecchio family of New York led Charles F. Montgomery to

propose that they might have been the innovators, or perhaps the chief promoters, of the style in this country. Since then, other labeled examples have come to light but little other information that helps further to identify the source of imported looking glasses or to distinguish them from American-made examples.[3]

The account books of the Boston carver and gilder John Doggett remain one of the best sources of information about a carver and gilder in the federal period, and yet his Bostonian patrons' preference for rectilinear looking glasses with engaged pilasters in the Sheraton style means that there is little material in his ledgers concerning this hybrid of early and later Georgian styles that was so popular in New York.             *Thomas S. Michie*

Gift of Collectors' Corner
M1970.77

1. See Hinckley, *Queen Anne and Georgian Looking Glasses*, pp. 159–62.
2. Montgomery, *American Furniture*, nos. 214–15.
3. See Montgomery, *American Furniture*, no. 215, and *Antiques* 114, no. 3 (September 1978): 356.

## 99 *Convex mirror*

England, ca. 1810–20

*Description:* The glass tablet is set into the rabbeted pine frame and encircled by both ebonized and gilt applied moldings. Both upper and lower carved ornaments are backed by rectangular struts keyed into the frame. The metal candle branches are affixed to blocks behind the carved side ornaments.

*Condition:* Several gilt balls have been replaced and the eagle reinforced with modern screws. The frame has been regilt, and the glass candle branches and pendants have been replaced.

*Woods:* Frame, carved pedestal at top, and glue blocks, spruce; eagle and carved foliage at base, sylvestris pine.

*Dimensions:* H. 43 in. (109.2 cm), w. 27 in. (68.5 cm), D. 11 in. (27.9 cm).

*Exhibition: Villa Terrace*, cat. 62.

*Provenance:* Early history unknown; Mr. and Mrs. Fitzhugh Scott.

"In apartments where an extensive view offers itself, these glasses become an elegant and useful ornament, reflecting objects in beautiful perspective on their convex surfaces; the frames, at the same time they form an elegant decoration on the walls, are calculated to support lights." Thus in 1808 George Smith, cabinet-maker and upholsterer to the Prince of Wales, described the virtues of the convex mirror, popularly known today as a girandole.[1] Judging from remarks by Smith, Thomas Sheraton, and other contemporary designers, the convex mirror's primary function was decorative, a source of optical amusement whose condensed reflection of a room added interest and, conversely, dispersed light. The optical novelty of convex mirrors was eloquently expressed by the English architect Sir John Soane, who incorporated several into the dome and arches of the breakfast parlor and drawing room in his own house and praised the resulting "succession of those fanciful effects which constitute the poetry of Architecture."[2]

Like many looking glasses (see cat. 98), convex mirrors were mostly imported to this country from England and Ireland, although in some cases imported glass may have been added to frames that were carved and gilt in this country. English manufacturers' trade catalogues occasionally include the reeded and ebonized frames in graduated sizes for inner liners, as found on this example. Gilt spheres for ornamenting frames and brackets were available in this country, where quantities are recorded in the ledgers of John Doggett of Boston. In 1804, for example, he charged Stephen Badlam for "4 dozen inch balls @ $7 per groce," and in 1806 supplied Badlam's rival looking-glass makers Cermanati and Monfrino with "a half gross of large balls."[3] "Cornice mirrors," as this kind were sometimes called, typically cost twice as much as an overmantel mirror and four times as much as a common looking glass with carved and gilt columns.[4]

The carved phoenix rising from its burning bundle of blackened twigs and reddened flames is especially appropriate for a mirror ornament, since the name of

this primeval bird, sacred to the Egyptian sun-god, derives from verbs meaning "to rise in brilliance" or "to shine."[5] During the Regency period in England, convex mirrors inspired by French examples appeared in several styles decorated at their tops and bottoms with other exotic birds, beasts, and floral motifs. Compared to many mirrors with composition ornaments encircling the entire frame, the curling acanthus leaves on this example are restrained, yet well carved as they overlap themselves and extend along the candle branches. On other examples, an eagle stands in place of the phoenix. Eagles are found as frequently on European mirror frames as on American examples, and though not restricted to mirrors made for the American market, they certainly found favor here in the early years of the republic.

*Thomas S. Michie*

Gift of Mr. and Mrs. Fitzhugh Scott
M1968.72

1. Smith, *Collection of Designs*, p. 25, pls. 135–36.
2. Soane, *Description of the House and Museum*, p. 54.
3. John Doggett's daybook and letter book are in the Downs Manuscript and Microfilm Library at Winterthur Museum.
4. See Montgomery, *American Furniture*, p. 257, and Smith, "Architecture and Sculpture in Nineteenth-Century Mirror Frames," pp. 350–59.
5. Hart, *Dictionary of Egyptian Gods*, s.v. "Benu."

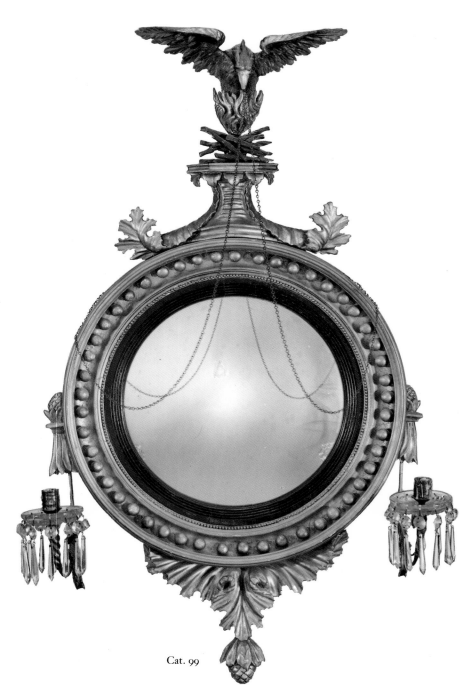

Cat. 99

## 100 *Shelf clock*

Levi Hutchins (1761–1855) and
Abel Hutchins (1763–1853)
Concord, New Hampshire, ca. 1805

*Description:* The case is in two sections. The top board of the pediment is dovetailed to the sides, which are faced with mahogany. The backs of the sides are rabbeted to receive the single backboard. The sides of the hood are dovetailed at top and bottom. The seat board supports are nailed to the lower case sides and rabbeted to allow the hood to pass over them as it rests on the applied front and side moldings. The moldings rest on the

capitals of the pilasters applied to the front and sides of the lower case. The bottom board is dovetailed, screwed, and nailed to the sides.

*Inscriptions:* The dial is inscribed "L. & A. Hutchins / Concord." A paper label attached to the inside of the backboard states: "This clock was made by Levi & Abel Hutchins between the year of 1785 and 1805. It was the property of Rev. Ezra Leonard and Estate from 1805 until the death of his widow Aug. 23d 1850. Rev. Ezra Leonard was born in 1775, graduated from Browns University 1801, ordained pastor of the fourth parish of Gloucester December fifth (5th) 1804. He died April 22nd 1832 after a pastorate of twenty eight years. After numerous wanderings this clock came into my possession November 1st, 1891. Otis E. Smith." A second label glued to the back states: "Bought from L. Richmond June 10, 1940. Came from Sommerville, N. J. lighthouse. Clock works were in bad condition." A note inscribed on a label glued to the back of the front panel reads: "This clock repaired May 7th 1814 / [indecipherable]"; and below in pencil: "v1040."

*Condition:* Originally, thin boards extended from the rabbeted back edge of the scroll pediment to the raised extension of the backboard to enclose the top. The backboard has split and been reinforced with an iron strap and with linen tape. According to notation, the clock was repaired in 1814 and was said in 1940 to be in "bad condition." The brass finial has been replaced since the Haskell sale in 1944. The entire case has been refinished.

*Woods:* Outer case sides, moldings, and door, mahogany; inner case and seat board, eastern white pine; movement, brass; dial, painted iron.

*Dimensions:* H. 31⅜ in. (79.7 cm), W. 13½ in. (34.3 cm), D. 6⅞ in. (17.5 cm).

*Bibliography:* Sotheby's (sale 561; April 26–29, 1944), lot 705.

*Provenance:* The Rev. Ezra Leonard (1775–1832), Gloucester, Mass.; to his widow, Nancy Woodbury Leonard (d. 1850); descent unknown to Otis E. Smith, 1891; to Louis Richmond,

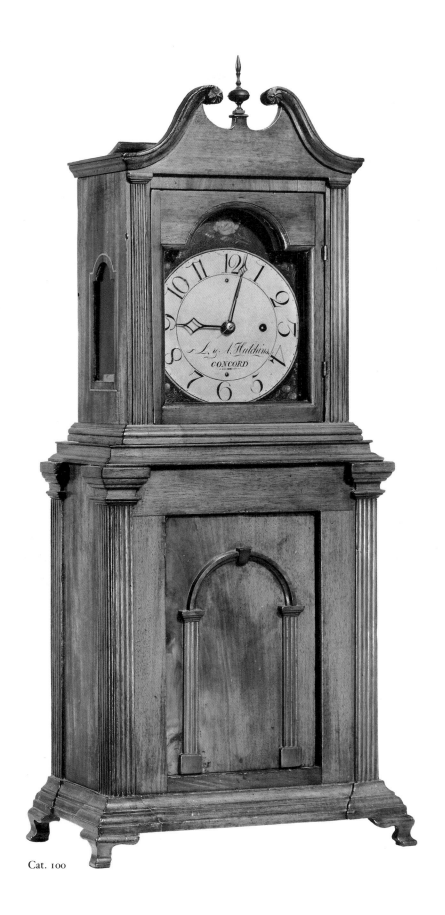

Cat. 100

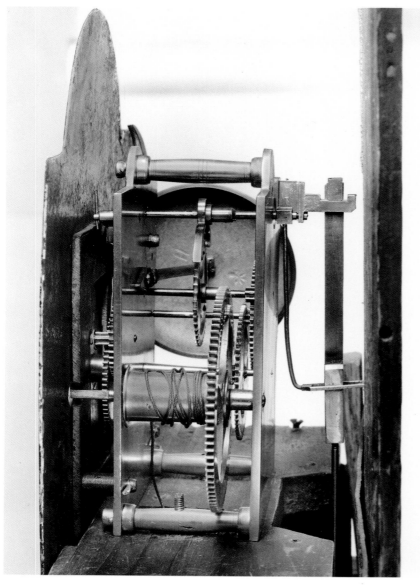

Cat. 100

Freehold, N.J.; purchased ca. 1940 by Mrs. J. Amory Haskell, New York, N. Y.; sold at Sotheby's (sale 561; April 26–29, 1944), lot 705; to Mr. and Mrs. Reginald N. Lewis; purchased ca. 1961 by Joe Kindig, Jr., and Son, York, Pa. (dealer).

Three years after Simon Willard attained his majority, he took on as his first apprentices the brothers Levi and Abel Hutchins. Born to a peripatetic father who had worked seasonally as a storekeeper, farmer, and gristmiller in

Pembroke and Haverhill, Massachusetts, and in Coventry and Concord, New Hampshire, Levi attended Byfield and Andover academies before apprenticing to Willard. Abel's 1777 indenture of apprenticeship survives, and it is assumed that Levi was apprenticed at the same time.[1] According to his autobiography, Levi left Willard after only three years for Abington, Connecticut, where he sought "to acquire some knowledge of the art of repairing watches."[2] Levi was back in Concord, New Hampshire, by

1783 and by 1786 had formed a business partnership with his brother Abel that lasted until 1807.

During the time of their apprenticeship, Simon Willard was experimenting with shelf clocks (see cat. 101) and clock jacks and sometimes personally distributing his wares throughout New England. A shelf clock by him that is not unlike this one but with Levi's and Abel's names engraved on the dial is presumed to have been presented to the brothers by their master at the end of their apprenticeship, or perhaps upon formation of their partnership in 1786.[3] In the same year, Abel's marriage to Elizabeth Partridge of Roxbury secured his place within the fraternity of clockmakers, as each of the other Partridge sisters married former Willard apprentices: Aaron Willard, Elnathan Taber, and Samuel Curtis.

Stylistically, this case with applied, fluted pilasters, pronounced capitals, and a distinctive arch on the removable front panel would be assigned a date earlier than an inlaid case, such as cat. 101. However, their painted dials are similarly decorated, and both have diamond-shaped hands and chapter rings with arabic numerals, details often cited to support a later date. Ezra Leonard's marriage in 1805 provides a likely date for this clock, whereas the Willard shelf clock (cat. 101) could conceivably be ten years older.

Neither Levi nor Abel Hutchins produced many shelf clocks, and only two New Hampshire clocks are known that have distinctive architectural cases like this one.[4] Hutchins tall-clock cases with scrolled pediments have been attributed to David Young of Hopkinton, and at least four other Concord cabinetmakers were making clock cases during this period, although no signed or labeled examples by any of them are known.[5] A number of similar cases contain shelf clocks by David Wood and Daniel Balch of Newburyport, where William Fitz had also lived before moving to Portsmouth in 1791. The account book of the Newburyport cabinetmaker Jonathan Kettell records twenty-two clock cases supplied to Balch between 1788 and 1792.[6] It is possible that the first owner of this clock, Ezra Leonard of Gloucester, like many clock owners, turned to a local

Essex County cabinetmaker rather than paying Hutchins to supply a case.

*Thomas S. Michie*

Purchase, Layton Art Collection and Milwaukee Art Museum through funds provided by gift of Anne H. Vogel and Frederick Vogel III
L1982.159

1. See Parsons, *New Hampshire Clocks*, p. 344.

2. Hutchins, *Autobiography*, p. 56.

3. See Cummin, "A Willard Clock," pp. 46–47.

4. Both are by William Fitz of Portsmouth. See letter from Charles Parsons to Philip Zimmerman (October 27, 1986) in MAM files. See also Parsons, *New Hampshire Clocks*, pp. 182, 319–20.

5. A Fitz clock is illustrated in Parsons, *New Hampshire Clocks*, fig. 319, and another in the Garbisch collection was sold at Sotheby Parke-Bernet (sale H-2, vol. 4; May 23–25, 1980), lot 1063. A case attributed to David Young is illustrated in *Maine Antique Digest* (September 1987): 40-A.

6. For related clocks by Wood and Balch, see Montgomery, *American Furniture*, no. 168; Heckscher, *American Furniture*, cat. 201; Sack, *American Antiques*, 8: 2104, 2363; and Christie's (January 23, 1988), lot 279. For Jonathan Kettell, see Fales, *Essex County Furniture*, cat. 59, and Benes, *Old-Town and the Waterside*, p. 78.

## 101 *Shelf clock*

Simon Willard (1753–1848)
Roxbury, Massachusetts, ca. 1790–1810

*Description:* The case is in two portions. The upper case has mahogany sides with an applied, molded base over pine boards that support the movement. The front bracket feet stand on brass pads, and the shaped ends fit snugly over small strips applied to the tops of the base. The lower case has mahogany sides, to which the thin mahogany front board is nailed. The central cove molding rests on the tops of the sides and continues around the back of the case. The pine bottom is flush with the sides, and the center portion has been left open to allow the weight to fall. The base moldings are mitered and applied. The bracket feet rest on separate blocks that stabilize the case. The glass

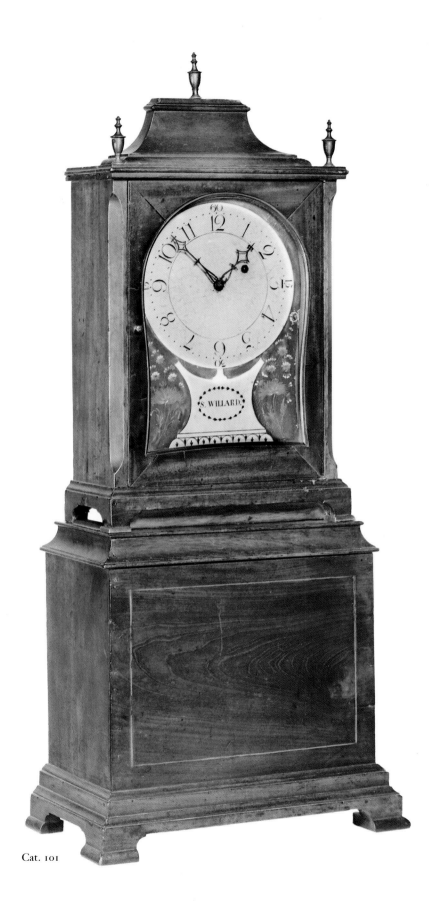

Cat. 101

on the hinged door sits in the frame, which is made of four separate mahogany pieces with mitered corners.

*Condition:* The right front foot of the lower case has been replaced, as have the moldings on the reverse of the glazed door. Portions of the banding are missing from the front of the base.

*Woods:* Upper and lower case sides and front, base moldings and feet, door, mahogany; lower backboard, inner frame of lower case, seat board, and upper case back and frame, eastern white pine; movement, brass; dial, painted iron.

*Dimensions:* H. 33 in. (83.8 cm), w. 14⅛ in. (35.8 cm), D. 7⅛ in. (18.1 cm).

*Provenance:* Purchased in 1986 from Joe Kindig, Jr., and Son, York, Pa. (dealer).

Of the four clockmaking Willard brothers, Simon was certainly the most prolific and the most inventive. Though excessively aggrandized by his great-great-grandson's biography of 1911, Simon Willard undoubtedly possessed unusual mechanical abilities and seems to have tinkered incessantly.[1] Probably apprenticed to his older bother Benjamin, Simon collaborated with him in the clockmaking shop on the family farm at Grafton, but moved around 1780 to Boston, where he established an independent business on "The Neck," the isthmus linking Boston with Roxbury on the mainland.

As a talented young clockmaker in Boston, Willard was well poised to dominate the trade established there by his brother Benjamin and left wide open by the deaths of Benjamin Bagnall in 1773 and Gawen Brown in 1801, the two leading clockmakers of the preceding generation. In a 1784 newspaper advertisement, Willard described at length the variety of weight- and spring-driven clocks he sold. In addition to a "new constructed astronomical time keeper" and watches "in the neatest manner," he offered a "new invented roasting jack," a portable mechanism with a clocklike escapement that turned spits or skewers within a reflecting oven. Though this latter device was soon refused by merchants from Portland to New York as a drug on the market, Willard's mechanical facility was

apparent from the start and was soon redirected toward shelf clocks like this one, a far less costly alternative to a tall clock.[2]

Its overall design derives from the thirty-hour wall clocks that Simon had made while still in Grafton. Both rely upon the illusion of two separate components, in this case a European-style bracket clock resting on an independent base. Earlier versions with a bell-shaped upper case referred even more explicitly to their European prototypes.[3] The front bracket feet of brass and the adjoining base molding belie the fact that the upper and lower cases connect internally, the lower case concealing the weight and the pendulum that hang from above. The base resembles that of a tall clock, thereby giving the appearance of greater stability. By eliminating the intricate tracery and fretwork of the wall clock, Willard made this model more economical to produce. On later shelf clocks, he eliminated the false bracket feet altogether, in favor of even more substantial cases. The painted dial enabled him to resolve an awkward feature of the wall clocks: the location and fit of the small dial within the upper case. Here, a more ample sheet-iron dial fills its surround, while decorative painting and the prominently inscribed plinth help fill the space around it.

Like most of Simon's clock designs, the "Massachusetts shelf clock" was widely imitated by his brother Aaron, former apprentices, and their competitors.[4] Whereas other clockmakers were content to maintain production of this successful model, Simon was soon adapting aspects of this shelf clock to an unprecedented design, the so-called banjo timepiece, for which he received a patent in 1802, the first of several in a long and remarkably productive career that extended until 1839.          *Thomas S. Michie*

Purchase, Layton Art Collection
L1986.3

1. See Willard, *Simon Willard.*
2. Willard's advertisement appeared in the (Worcester) *Massachusetts Spy,* March 11, 1784. Clock jacks were the subject of many letters between Willard and his sales agent, Paul Revere. Their correspondence is preserved among the Revere family papers at the Massachusetts Historical Society, Boston.

3. See, for example, Sack, *American Antiques,* 8:2174, and a second example sold from the Lansdell Christie collection at Sotheby's (sale 3422; October 12–20, 1972), lot 77. For a technical discussion of Simon Willard's clocks, see Husher and Welch, *A Study of Simon Willard's Clocks.*
4. For examples, see Fales, *Essex County Furniture,* cat. 59; Sack, *American Antiques,* 1:121, 7:2010; and Distin and Bishop, *American Clock,* pp. 92–99.

## 102 *Tall clock*

New Jersey or New York, ca. 1800–1825

*Description:* The back is a single board that runs the entire height of the case and is flush with the thin mahogany sides of the waist section. The sides of the base are similarly constructed with the addition of the cyma molding, the inverse of the molding that supports the hood. The mahogany door front is applied over a cherry board. The front and sides of the hood are mahogany, enclosing a flat-top pine box that protects the eight-day brass movement. The glazed door frame is mitered and the lower rails tenoned to the sides.

*Condition:* The base molding at the right side of the hood is cracked, and the rear portion is missing. The plinth block supporting the finial has been replaced. The lower right front foot and corner of the case have been split and repaired.

*Woods:* Case and veneers, mahogany; backboards, glue blocks and inner frame behind hood door, yellow-poplar; seat board, case framing, and bottom board, eastern white pine; waist door, cherry; hood door and base frame, redgum; eight-day movement, brass; dial, painted iron.

*Dimensions:* H. 95 in. (241.3 cm), w. 19⅛ in. (48.6 cm), D. 10⅛ in. (25.7 cm).

*Bibliography:* Antiques 88, no. 4 (October 1965): 422; Jones, "American Furniture," p. 983, fig. 14.

*Provenance:* Robert Burkhardt, Kutztown, Pa. (by 1965); purchased in 1976 from Benjamin Ginsburg Antiquary, New York, N. Y. (dealer).

The combination of crotch veneers, contrasting woods, patterned and pictorial inlays, stringing, and banding that enlivens the surface of this clock provides a sample of the rich vocabulary of neoclassical ornament popular in federal America. This clock case also demonstrates better than any other piece in the Milwaukee collection the prevailing taste of the period for taut surfaces enriched by geometrical ornament and patriotic images appropriate to the arts of the new republic.

Rising from delicate bracket feet, the linear progression from concentric inlaid squares and circles on the base, to vertical and horizontal rectangles in bands of contrasting woods, and vertical inlaid ovals on the door, reflects an additive approach to design made possible by ready-made inlays and encouraged by cabinetmakers' price books of similar options to be selected by patrons. For example, in place of expensive brass hardware on the quarter columns of the waist, the cabinetmaker has substituted less expensive wooden plinths and capitals. Likewise, inlaid strips of wood take the place of fluting and brass stop-flutes. Above the columns in both sections are integrated inlays of vertical stripes that resemble triglyphs in the cornice of a building, thus enhancing the architectural nature of the clock case. Many of the features on this clock case appear in contemporary price books, such as "panelling with band," "banding a panel with four hollow corners," and "quartering up ovals or circles."[1]

Unlike the Hutchins and Willard shelf clocks whose case designs were American innovations (see cats. 100 and 101), the style of this tall case derives from English prototypes that remained popular well into the nineteenth century and were popular throughout the mid-Atlantic region in this country. A drawing by a Chester, England, cabinetmaker of the 1820s reveals many similarities with New York–New Jersey and Pennsylvania–Delaware clock cases, including the use of inlaid mahogany circles, ovals, and rectangles, identified as an "arch head clock case . . .with curl in door and bottom."[2] A more traditional aspect of this clock case's design is the steeply

pitched, scrolled pediment of the hood that recalls designs of the previous generation. The attenuated scrolls embellished with brass rosettes relate directly to contemporary New York looking glasses (see cat. 98).

Clocks and clock cases made in northern New Jersey and New York during the federal period are frequently indistinguishable unless they bear the label or signature of a maker. Their similarity reflects not only geographic proximity but also the subcontracting of New Jersey craftsmen by larger New York cabinet shops. This practice is already well documented among New Jersey silversmiths.[3] The large number of similar clock cases made between Bridgetown in southern New Jersey and Utica in upstate New York provides further evidence of the mutually advantageous exchange between urban clockmakers with a surfeit of orders and cabinetmakers in outlying regions with oversaturated markets.[4] The cabinetmakers Wood and Taylor, on the other hand, fled New York City in order to escape the smallpox epidemic of the early 1800s. In addition to cabinetwork, painted dials were widely marketed in distant regions, as indicated by New York tall clocks with dials by Samuel Curtis of Boston.[5]

Labeled clock cases similar to Milwaukee's are known by several New Jersey and New York cabinetmakers: Matthew Egerton, Jr., and Oliver Parsell of New Brunswick; Ichabod Williams and the firm of Rosett and Mulford in Elizabethtown; John Scudder of Westfield; and Wood and Taylor of Florida, New York. All four towns are within thirty-five miles of New York City.[6] This clock has been attributed to a fifth cabinetmaker, Michael Allison of New York City, on the basis of its inlaid eagle, a variant of which occurs on a labeled chest of drawers by Allison in the Metropolitan Museum. However, because inlays made by specialist craftsmen were available to many cabinetmakers, they are unreliable as a basis for attribution. This particular inlay, for example, occurs on the Rosett and Mulford clock case, as well as on Boston card tables. The case of a clock by Isaac Schoonmaker of Paterson, New Jersey, incorporates so many of the same

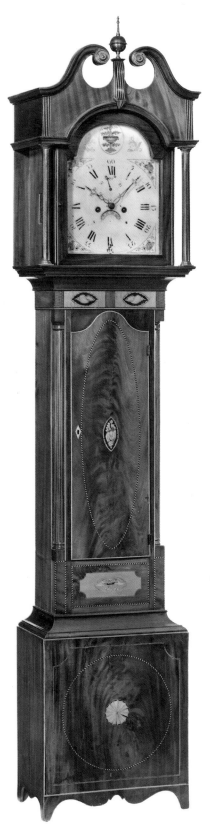

Cat. 102

details as this clock as to be reasonably attributed to the same anonymous cabinet-maker.[7]                    *Thomas S. Michie*

Purchase, Layton Art Collection
L1977.2

1. See *The New-York Revised Prices for Manufacturing Cabinet and Chair Work* (New York: Southwick and Peluse, 1810), tables 5, 6.
2. Moore, "A Chester Cabinet Maker's Specification Book," pp. 76–77. A Delaware clock in a related case is at Winterthur (Montgomery, *American Furniture*, no. 154).
3. See Laidlaw, "'Silver by the Dozen,'" pp. 25–50.
4. For a study of this phenomenon among contemporary New England clockmakers, see Zea, "Clockmaking and Society," pp. 43–59.
5. See Sack, *American Antiques*, 6:1492; and *Maine Antique Digest* (November 1987): 11-A.
6. See Sack, *American Antiques*, 8:2106–7, 5:1363 (Egerton); *Antiques* 87, no. 3 (March 1965): 253 (Parsell); *Antiques* 106, no. 3 (September 1974): 319 (Williams); *Antiques* 19, no. 3 (March 1931): 232 (Rosett and Mulford); *Antiques* 91, no. 2 (February 1967): 151 (Scudder); and Scherer, *New York Furniture*, cat. 32 (Woods and Taylor).
7. Sack, *American Antiques*, 2:356.

## 103 *Jug*

China, 1785–94

*Description:* The domed cover is topped by a finely molded gilt Fo or temple lion finial. The crossed-strap handle with floral terminals also bears traces of gilding. In addition to the large polychrome overglaze-enameled medallions on two sides of the barrel-shaped body, the jug has simple symmetrical grisaille decoration of small floral sprigs and black and gilt scrolled borders.

*Inscriptions:* "ss" appears in gilt on each side below the polychrome emblem. The emblem is inscribed "Societas Cincinnatorum Instituta. 1783" on the recto and "Omnia Relinquit Servare Rempublicam" on the verso. Painted on the bottom is "22.1974.19A," a long-term loan number of an unknown museum.

*Condition:* The jug is in excellent condition, with only slight wear to gilt surfaces.

*Materials:* Porcelain, overglaze enamel and gilt decoration.

*Dimensions:* H. 9⅛ in. (23.2 cm), W. 7½ in. (19.0 cm), D. 6 in. (15.3 cm).

*Exhibition:* Previously on long-term loan to an undetermined museum.

*Bibliography:* Gordon, *Collecting Chinese Export Porcelain*, p. 126, fig. 113.

*Provenance:* Owned by Elinor Gordon, Villanova, Pa. (dealer), since at least 1974; purchased from her in 1988.

Two exquisitely painted emblems representing the badge of the Society of Cincinnati are the most striking features of this distinguished Chinese export porcelain jug. Below one of the polychromed badges appears the gilt cypher, "ss," of the original owner, Samuel Shaw (1754–94). Shaw ordered a service with this decoration while serving as supercargo on board the first voyage of the *Empress of China* from New York to Canton in 1784. The *Empress* was the first American vessel to enter the China trade.[1]

Samuel Shaw was entitled to use the emblem of the Society of Cincinnati by virtue of having served as an officer of colonial troops during the Revolutionary War. The emblem honors George Washington, the society's leading member, who was looked upon as a latter-day Cincinnatus (heroic Roman farmer and soldier, ca. 500 B.C.).[2] The two faces of the badge are depicted on the opposite sides of the jug with the central medallion of the recto face illustrating Fame crowning Cincinnatus and the verso showing Cincinnatus receiving a sword from three Roman senators.

It is difficult to be more precise in the dating of this jug because of the undetermined amount of time required for the potting and extremely fine decoration and, finally, for delivery by ship of the several dozen pieces that made up the service. Adding further to the uncertainty is the knowledge that Shaw owned two such services, and it is not known whether they were ordered simultaneously.[3] However, it seems likely that Shaw had at least one service in hand by 1790 when he sent a tea set in the same pattern as his own to Dr. David Townsend of Boston.[4]

Townsend's service and a third, which Shaw sent to Major General Henry Knox, differ from each other only in the various initials which make up their cyphers.[5]
                    *Jayne E. Stokes*

Gift of Collectors' Corner and the Passmore Bequest in Memory of Gertrude C. Passmore
M1988.17

1. Currie and Wright, "New York and the China Trade," pp. 438–39.
2. *Brewers Dictionary of Phrase and Fable*, rev. ed. (London: Cassell, 1965), p. 205.
3. Currie and Wright, "New York and the China Trade," p. 439; this article illustrates some of the seventeen pieces of Shaw's Cincinnati porcelain in the collection of the New-York Historical Society. Two more pieces in the Winterthur Museum are illustrated in Palmer, *Winterthur Guide to Chinese Export Porcelain*, p. 54, fig. 22; p. 134, fig. 90.
4. Austin and Spang, "Historic Deerfield: Ceramics," p. 673, pl. v.
5. A coffee/chocolate pot from the Knox service is illustrated in Mudge, *Chinese Export Porcelain*, p. 213, pl. 345.

## 104A–C *Coffeepot, saucer, and cream pitcher*

China, 1790–1810

*Description:* These three polychrome pieces have borders of an undulating line of tiny pink dots with pink blossoms under every fourth arc. The foot of the cream pitcher (cat. 104C) carries a border of gilt bellflowers with three-dot blossoms in blue enamel. The cast berry finial on the coffeepot (cat. 104A), the pot's handle, and the cast twig-form handle of the cream pitcher (cat. 104C) have gilt highlights.

*Inscriptions:* Each piece is marked "AFS" in gilt script above the ship, with the "F" larger, indicating the first letter of the surname. "18002" is in gilt below the ship on each piece.

*Condition:* The gilding and glaze around the cypher has been scratched on all three pieces. The gilding of the date is worn on all three pieces and nearly oblit-

Cat. 103

Cat. 104A

erated on the saucer (cat. 104 B). There is a Y-shaped hairline crack on the saucer wall.

*Materials:* Porcelain, overglaze polychrome enamels, gilding.

*Dimensions:* H. coffeepot 9⅜ in. (23.8 cm), W. 8⅝ in. (21.9 cm), D. 5 in. (12.7 cm). DIAM. saucer 6⅛ in. (16.2 cm). H. cream pitcher 5⅜ in. (13.6 cm), W. 6¾ in. (17.2 cm), D. 3⅜ in. (8.6 cm).

*Provenance:* Early history unknown; Mrs. William D. Kyle, Milwaukee, Wis.

The forms of these three pieces, what remains of a Chinese export porcelain beverage service, clearly demonstrate the linearity and symmetry of the neoclassical style. The shape of the cream pitcher (cat. 104C) is essentially the period's ubiquitous urn form, although with its broad, dished rim, it is easy to understand how the form has come to be known as a "helmet" pitcher. The saucer (cat. 104B), standing on a simple ring foot, is absolutely pure in line. The body of the coffeepot (cat. 104A) is a plain, tapered cylinder or cone, its spout repeating this form with the domed cover visually completing and containing the circular body. The coffeepot's crossed-strap handle, its most elaborate element, is a linear design with a thin profile, vastly different from the complex scrolled handles of rococo ceramics. This handle, with two ridged strips of clay crossing at top and bottom and attached with four fern-like terminals, is thought to derive from English ceramics produced at Leeds in the last half of the eighteenth century.[1] The shape of the pot and its long, low-placed spout are derived from a much earlier prototype. The tapered profile is a Near Eastern design, the result of the discovery of coffee there in the mid fifteenth century. These earliest pots were of brass, a metal that was also used on the Continent as the beverage gained acceptance. However, the brass coffeepot was quickly augmented by pots in silver and, especially, in tin-glazed earthenware.[2] This latter type served as the model for the earliest coffeepots produced by the Chinese, in the 1690s.[3]

Although the form of the Milwaukee coffeepot may have evolved from fifteenth-century progenitors, the decoration found on it and its accompanying pitcher and saucer is clearly contemporary with the 1802 date found on each piece. Written "18002" in gilt, just below the ship portrait, the date is a literal translation of "eighteen hundred and two," and reminds us that the Chinese decorators were indeed writing in a foreign language. A second inscription—the cypher "ASF," with the "F" central and dominant—is visible above the ship, despite a deliberate attempt some time ago to remove it. Perhaps the effort was made in order to update the cypher for a new owner. The central decorative motif, the sailing ship flying two American flags, indicates that the owner of the service was probably associated with the burgeoning shipping activity of post-Revolutionary America, possibly even the China trade itself. The ship and the green sea on which it floats are brightly painted in polychrome overglaze enamels, detailed to include a gilt figurehead at the bow. Although carefully drawn, the portrait is not of a specific vessel. Thousands of Chinese export porcelains were decorated with ships drawn after images in books or engravings; the

Cat. 104B

Cat. 104C

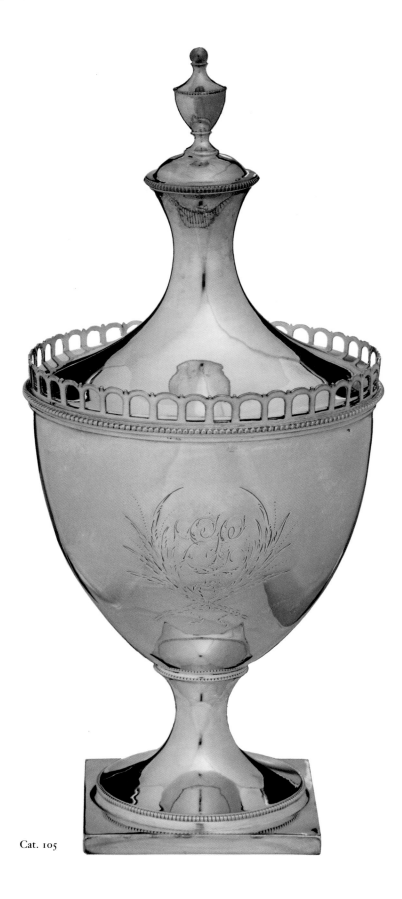

Cat. 105

specifics of flag and cypher could be commissioned as desired.[4]

*Jayne E. Stokes*

Gift of Mrs. William D. Kyle
M1980.283–85

1. Mudge, *Chinese Export Porcelain*, p. 198.
2. Mudge, *Chinese Export Porcelain*, p. 152.
3. For examples see Mudge, *Chinese Export Porcelain*, p. 102, fig. 155; p. 114, fig. 168.
4. Gordon, *Collecting Chinese Export Porcelain*, pp. 129–30.

## 105  *Sugar urn*

Joseph Richardson, Jr. (1752–1831)
Philadelphia, Pennsylvania, 1790–1800

*Description:* The beading and finial, including the low dome below the finial, are cast. The pierced gallery molding may be mechanically stamped. The vertical faces of the plinth are soldered to the raised base/stem unit. The urn and cover are both raised.

*Marks:* On the underside of the base "J · R" is struck in two opposite corners.

*Inscriptions:* "16 oz 11 dwt" is scratched on the lower interior of the stem. "EL" is engraved on the body between curving boughs which cross at the base and are draped with a bow. "EL" is scratched in a corner of the base. These initials were once thought to represent Elizabeth Levis (1690–1777), and the urn was believed to have descended through the Shipley, Bringhurst, and Ferris families to the Hargraves family, all of Wilmington, Delaware.[1] However, it is not possible for Elizabeth Levis, the second wife of William Shipley (1693–1768, married 1728), to have owned this urn as the maker's marks clearly indicate that it could not have been made before 1790 (Joseph Richardson, Jr.'s marks are discussed more fully in the text of this entry). If the piece descended in these families it is more likely that the connection is through Mary Levis (d. 1843), who married Joseph Shipley (1752–1832) in 1773. She may have inherited it from the Levis family.

*Condition:* The urn is in excellent condition.

*Material:* Silver.

*Dimensions:* H. 10½ in. (26.7 cm), DIAM. 3⅝ in. (9.2 cm), WT. 16 oz. 3 dwt. (502.3 gm).

*Bibliography:* Hindes, *Reflections in Silver*, cat. 26; Goldstein, *Milwaukee Art Museum*, p. 75.

*Provenance:* S. J. Shrubsole Corp., New York, N.Y. (dealer).

Were it not for the differences in the engraved cyphers on their sides, this sugar urn and a tea or coffeepot by Samuel Williamson (cat. 106) in the Milwaukee collection might have been used in the same service. The classical urn is the basic form for each and although each was crafted by a different silversmith, each has a ring of tiny beads to accent the simple geometry of circles and concave and convex curves. The square plinth and urn-shaped finial are also repeated on both objects. The pierced gallery that surrounds the rim of the sugar urn is not found on the Williamson coffeepot although the gallery, like the tiny beads, is a characteristic of Philadelphia silver in the neoclassical taste. The character and style of the bright-cut engraving harmonize with the light, unfussy form of the piece.

Joseph Richardson, Jr., was part of the third generation of silversmiths in his family to work in Philadelphia. The survival of many records by his own and his father's hand has left a detailed image of this dynasty of Quaker silversmiths.[2]

Joseph Richardson, Sr., was an extraordinary craftsman in the rococo style, and an elaborate kettle on stand by his hand is considered one of the masterpieces of American eighteenth-century silver.[3] Joseph Richardson, Jr., and his brother Nathaniel were apprenticed to their father and worked alongside him until his retirement in 1777. In that year Joseph, Jr., and Nathaniel began to use the mark "I · NR" on the silver they produced to indicate their partnership.[4] In 1790 Nathaniel left the shop for the hardware business and Joseph, Jr., began to use only his initials to mark the silver.[5]

The marks on this sugar urn clearly date it from this post-1790 period. A nearly identical urn, part of a large service made by Richardson, Jr., is in the Winterthur Museum collection.[6]    *Jayne E. Stokes*

Gift of Karl and Helen Uihlein Peters
M1983.198

1. The urn was connected with Elizabeth Levis in an exhibition of the Hargraves family silver at the Rockwood Museum, which was originally the family home. I would like to thank Rebecca Hammell, Curator of the Rockwood Museum, for her considerable help in clarifying the provenance.
2. For Joseph Richardson, Jr., see Fales, *Joseph Richardson*, especially pp. 152–97.
3. Hood, *American Silver*, pp. 124–25, 127, fig. 128. This piece is at Yale University and is illustrated in Buhler and Hood, *American Silver*, cat. 845.
4. Fales, *Joseph Richardson*, p. 153.
5. Fales, *Joseph Richardson*, pp. 167, 183.
6. Fales, *American Silver*, fig. 118.

## 106  *Tea- or coffeepot*

Samuel Williamson (d. 1843)
Philadelphia, Pennsylvania, 1794–1805

*Description:* The spout, finial, and beading are cast. All other elements are raised, with the exception of the vertical faces of the plinth, which are soldered to its horizontal surface. Small circular vents are punched just below the beading of the top dome.

*Marks:* "WILLIAMSON" is struck upside-down on the face of the plinth below the engraving.

*Inscriptions:* "31 oz 10 dwt" is scratched on the underside of the base. "JBS" in script is bright-cut engraved on the body and enclosed on three sides by curved boughs.

*Condition:* Several shallow dents are grouped on one side of the upper concave section of the top. The finial may have been reattached. The handle has been repaired just below the leaf carving.

*Materials:* Silver, fruitwood handle.

*Dimensions:* H. 12⅞ in. (32.7 cm), W. 10¼ in. (26.0 cm), DIAM. 5⅜ in. (13.7 cm), WT. 32 oz. 5 dwt. (1,000 gm).

*Bibliography:* *Antiques* 115, no. 2 (February 1979): 312.

*Provenance:* Purchased in 1977 from S.J. Shrubsole Corp., New York, N.Y. (dealer).

From its square base to the reiterative geometry of the urn finial, this tea- or coffeepot reflects the neoclassical taste for symmetry and purity of line which marked every aspect of design in federal-period America. The predominant form is of an urn, a shape adapted from classical Greek and Roman prototypes as the result of archaeological finds that brought early pottery and statuary to light in the late eighteenth century. The circular form of the body is emphasized by rings of tiny beads at the top and bottom of the flared conical foot and at the widest point of the body just above the upper handle socket. Each of the sockets is ringed with beading. The diminishing pyriform of the upper half of the vessel is in two parts; the lower half is a part of the body, the upper half is the removable, closely fitted top. The top has three rings of beading marking its diminishing circumference as it ascends to the small dome on which the miniature urn finial is secured.

It is significant that Williamson did not, like some of his colleagues, hinge the top to the body.[1] He crafted a deep flange on the lower edge of the top in order to avoid placing a hinge at this juncture—an element that would have broken up the wonderful rhythm of the circles from foot to finial. The necessary appendages of spout and handle have been crafted with appropriate simplicity, and maintain the balance of the whole. The C-shaped handle is carved to a thin profile through its lower half, reflecting the diminution of the upper end of the spout, and giving the dark fruitwood handle as light a presence as possible. The reverse-curved acanthus-leaf carving at the top of the handle provides the required purchase for the pourer and is echoed by the leaf casting on the upper surface of the spout mouth. The spout has ten narrow vertical facets which give it strength while helping to diminish it visually. The bright-cut engraving of a pair of crossed boughs enframing the

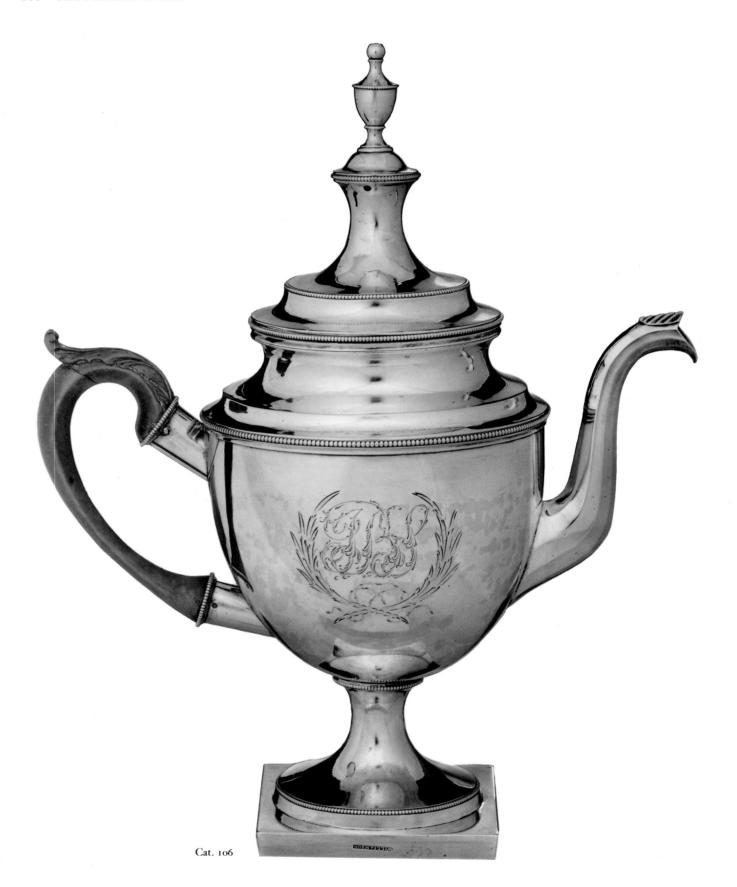

Cat. 106

initials "JBS" is yet another element of the neoclassical vocabulary.

This vessel may have been made to serve as either a coffee- or teapot. The silversmith could have sold it as either, its ultimate use for the consumer to determine. If one were to remove the long, footed stem of this vessel it would recall prototypical low, globular teapots (see cat. 54). With the stem it becomes a hybrid, fitting between the wholly vertical, traditional coffeepot form (see cat. 73) and the teapot. All three of these forms were produced in the federal period. The low teapot in the neoclassical style was predominantly oval in section, its untapering sides resting flush with its bottom. The true coffeepot remained the tallest form, with a stemmed foot replacing its molded, domed foot. In between is the low-stemmed Williamson-form pot. Two silver services illustrate how purchasers used this low-stemmed vessel. The first service, in the Winterthur Museum, has nineteen pieces by Philadelphia silversmith Joseph Richardson, Jr. (see cat. 105), each marked "AE."[2] The service has two identical low oval teapots and a third low-stemmed pot for coffee. A second service from Philadelphia, by Christian Wiltberger (1769–1851), has two pouring vessels: a low-stemmed pot for tea and a traditional tall coffeepot.[3]

Samuel Williamson was apprenticed to Joseph Lownes, a Philadelphia silversmith, in 1787. He opened his own shop in 1794.[4] The pot in this entry and a pair in the Philadelphia Museum of Art that are nearly identical to it demonstrate his skill and knowledge of current form and style. Despite this talent, Williamson moved to Chester County, Pennsylvania, to farm rather than work silver. He is listed in Uwchlan Township tax lists as a farmer from 1814 until his death in 1843.[5]

*Jayne E. Stokes*

Gift of Collectors' Corner
M1977.34

1. For a similar pot with a hinged lid by Robert and William Wilson, see Buhler, *American Silver*, cat. 538, p. 635.
2. Fales, *Joseph Richardson*, p. 187, fig. 166.
3. Illustrated in catalogue for Christie's (sale 6748; January 20, 1989), lot 13.
4. Biographical information about Williamson is from Beasley, "Samuel

Williamson," as cited in a letter from Deborah Dependahl Waters to the MAM, December 13, 1978.
5. Belden, *Marks*, p. 447.

## 107 *Candle lamp*

Possibly America or England, 1815–25

*Description:* The painted body of the base is formed in two parts; the foot ring is a separate turning from the shaft, and the two are joined by a glued mortise-and-tenon joint. A lead ring is set into a channel around the underside of the foot. At the top of the base is a cylindrical brass sleeve held by a single screw which passes through the uppermost turning of the stem. This sleeve has a threaded shank at the center top, and the pressed and cast-brass socket which holds the shade fits over it. The shade socket is secured by the cast-brass candle socket which screws onto the central shank.

The copper-wheel-engraved glass shade is blown with a cylindrical neck at its base; this has a brass-plated copper sleeve around its outer face. A thick, plaster-like material forms an adhesive layer between the glass and the metal.

*Condition:* The lamp is in near-original condition with slight wear to the gilt decoration.

*Materials:* Shade, blown glass, brass-plated copper; base, mahogany, cast brass, gilt stamped brass, painted and gilt decoration.

*Dimensions:* H. 22½ in. (57.2 cm), H. base 11¾ in. (29.9 cm), DIAM. base 5⅞ in. (14.9 cm), DIAM. shade 7½ in. (14.1 cm).

*Bibliography:* Schiffer, *Brass Book*, p. 176, fig. A.

*Provenance:* Purchased in 1984 from Joseph Kindig III, York, Pa. (dealer).

The thick, multiple spool-and-reel turnings of this wooden candle-lamp base are styled after late neoclassical candlesticks made from the more traditional materials of brass and pewter.[1] Brass is used here, but only for the cast candle socket and the elaborate gilt stamped-brass collar which surrounds the base of the shade.

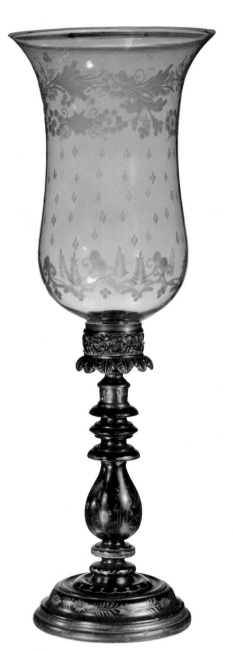

Cat. 107

The wooden base is far less weighty than its metal counterparts and has had a channel cut on the underside to let in a lead ring, which counterbalances the tall glass shade. Visual weight for the base, which is smaller in volume than the upper half, is created through painting it in imitation of Oriental lacquer. The stem and foot have a black ground with the swelling of the stem decorated with a bearded Oriental man smoking a long pipe and an Oriental woman with a parasol. The foot is ringed with blossoms and foliage. Similar scrolled floral bands and foliage decorate the gilt collar and the original copper-wheel-engraved shade. The repetition of these bands ties the individual elements together to make a coherent, pleasing whole. This effect must have been doubled when the candle was lit, accenting the gilding and engraving.                *Jayne E. Stokes*

Layton Art Collection and by gift of Anne H. Vogel and Frederick Vogel III
L1984.147

1. Butler, *Candleholders*, pp. 99–100.

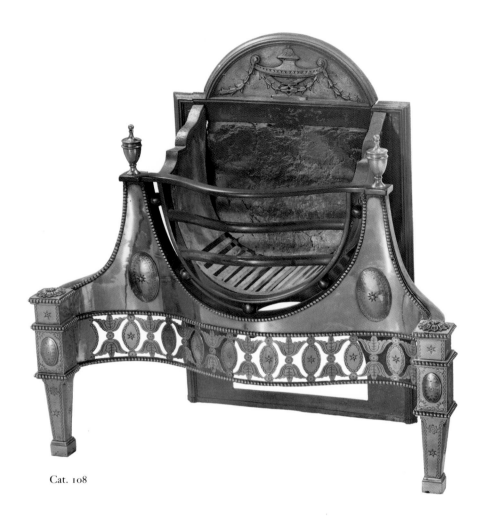

Cat. 108

## 108  *Fire grate*

England, 1765–85

*Description:* The cast-iron fireback has a semicircular opening for the firebrick which is held by an iron band across its midpoint at the back. The openwork grating bottom and its curved sides are supported in the rear by curved L-irons bolted through the fireback. The paktong facade is supported by a horizontal iron bar placed just above the pierced apron. This bar joins vertical iron rods at the core of the hollow-cast sectional legs. Curved support bars extend up and back from the upper leg to the finial and form the deep arc which supports the front of the grating. The beaded trim and bosses are cast and held with rivets and bolts, respectively. The solid-cast finials have a threaded shank and screw into the upper grate bar.

*Inscriptions:* Stamped on the underside of the lower support bar of the apron is

"BF(E?)G(C?)T." Alongside are a crown and a flower that may be a thistle.

*Condition:* The fireback is cracked in two places along the upper horizontal molding.

*Materials:* Cast iron, paktong, firebrick.

*Dimensions:* H. 31¼ in. (79.4 cm), W. 32 in. (81.3 cm), D. 13 in. (33.0 cm).

*Provenance:* Purchased in 1983 by the donors from Jane and Michael Dunn, Claverack, N.Y. (dealer).

This English fire grate employs many elements of Adamesque decoration which were an integral part of federal-period design in America. The urn form, seen here twice as the central element of the cast fireback and again in the finials flanking the grate bars, is one of the most

ubiquitous motifs of this era. Bellflowers, too, were often repeated by neoclassical designers and are used here to form a swag across the fireback urn and to create, with alternating ovals, the pierced apron along the lower front of the grate. The ovals of the apron are repeated by the slightly convex applied oval bosses on the midsection of the stiles. The bosses are enlarged when used on the undecorated facade flanking the iron grate and, finally, the oval is seen literally as the central motif of this fire grate, incorporating the outline of the U-shaped grate with the arch of the fireback to make the single dominating oval form. Small elements of stamped and engraved decoration enliven the lower third of the form. Adding to this effect is the beading which marks the perimeter of the facade and accents the break between the complex

cutouts of the apron and the smooth reflective surface above it.

The design of the fire grate and its decorative elements is further enhanced by the use of paktong, the silver-colored alloy of copper, zinc, and nickel, for the front legs, stiles, and facade. The rare metal permitted the creation of a grate that was close to silver in appearance yet circumvented the disadvantages of that metal's softness and tendency to tarnish.[1] It is known that Robert Adam (1728–92), English progenitor of neoclassicism, designed fire grates executed in paktong; such grates would have made a dazzling addition to the fireplaces of the privileged who commissioned him.[2]

Fire grates were in use in some parts of the American colonies in the eighteenth century, particularly in Virginia where coal was mined in the James River area.[3] It is possible that an elaborate, expensive grate, such as this one, would have been imported for use in one of the wealthy plantation owners' houses. However, for much of eighteenth-century America, wood burning was the principal method of heating, and hearths continued to be equipped with andirons well into the nineteenth century.    *Jayne E. Stokes*

Gift of Virginia and Robert V. Krikorian
M1986.154

1. See cat. 75 for further discussion of this metal.
2. John and Coombes, *Paktong*, pp. 12, 13.
3. Seale, *Recreating the Historic House Interior*, p. 60.

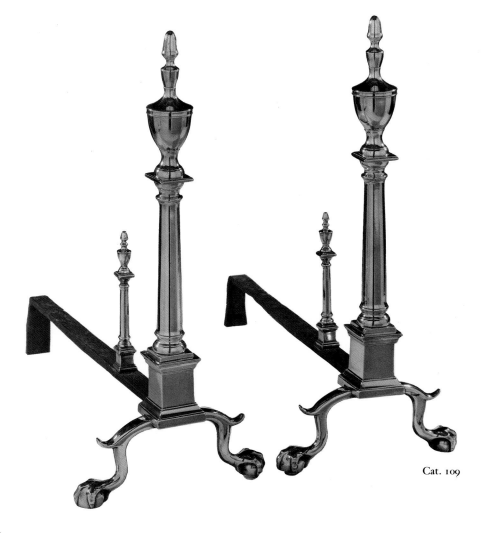

Cat. 109

## 109 *Andirons*

America, 1785–1800

*Description:* The body of the andirons is composed of three units, each cast in halves and soldered together. These units —the plinth, the shaft, and the head—fit over an iron rod which extends up through the center of the legs and the forepart of the billet bar. The top of this rod is threaded, and the finial screws on. The cast legs are hollowed on the back to save metal. The log stop is solid cast; an iron extension from its base is peened over on the underside of the billet bar. The billet bars are long and originally had a secondary support leg placed behind the log stop.

*Condition:* A plugged hole behind each log stop indicates the absence of the original secondary leg.

*Materials:* Bell metal, iron.

*Dimensions:* H. 25½ in. (64.8 cm), W. 11½ in. (29.2 cm), D. 23½ in. (59.7 cm).

*Bibliography:* Kauffman and Bowers, *Early American Andirons*, p. 96.

*Provenance:* Purchased in 1975 from Quentin H. Bowers, Camp Hill, Pa. (collector).

The chaste lines of these column-and-urn andirons are in the neoclassical taste typical of post-Revolutionary America. Though elements of the earlier rococo style remain, most notably in the cabriole legs and ball-and-claw feet, the undecorated Doric columnar shaft and ovolo-form urn finial dominate the design and are fully within the later style.

The use of basic geometric forms separates these andirons from the rococo version of the column-and-urn andiron in which the shaft is fluted and decorated with more complex moldings and the urn is ogivally shaped and frequently topped with a flame-shaped finial. These earlier Chippendale-style andirons are most often

associated with Philadelphia and most particularly with brass founder Daniel King (1731–1806).[1] The association is based on a pair of signed andirons by King in the Winterthur Museum collection.[2] Assumptions based on the King andirons have resulted in the attribution of many federal-style column-and-urn andirons to Philadelphia origins.[3] This extrapolation of a brass founder's work in a single style to a later period is undocumented and difficult to support. By this period, America had brass founders in every major city and throughout the colonies; there is no strong evidence that andirons of the type illustrated here were the product of any one maker or regional preference.[4]

Whatever the origins of these andirons, they are a credit to their maker. Their styling is elegant, from the elongated acorn atop the compound urn finial through the unornamented shaft and rectangular plinth. Each of these elements is carefully repeated on a diminutive scale for the log stops. The fineness of the irons is enhanced by casting in bell metal, much rarer in comparison to brass.[5] Bell metal, an alloy of copper and tin, has a redder hue than brass, an alloy of copper and zinc. The name is derived from its frequent use in the making of bells, because of its tonal qualities when struck.

*Jayne E. Stokes*

Purchase, Layton Art Collection
L1975.58A,B

1. Cooper, *In Praise of America*, p. 38.
2. Kauffman, *Early American Copper and Brass*, p. 152.
3. Schiffer, *Brass Book*, pp. 68 A–C, 69 A,E, 71 B.
4. The single marked pair, which are closely related in styling though clearly not from the same foundry as the present examples, are by Richard Wittingham of New York (probably Richard Wittingham, Sr., w. America 1791–1818). The New York column-and-urn irons are illustrated in Kauffman and Bowers, *Early American Andirons*, p. 51. Wittingham's work is also illustrated in cat. 110A.
5. Fennimore, "Metalwork," p. 103.

## 110A *Andirons*

Probably the Wittingham Foundry
(1795–1850)
New York, New York, 1810–30

*Description:* These andirons are constructed in a series of interlocking fixed elements; only the urn finial is removable. The shaft and finial are in two sections, each cast in halves. The finial section separates from the shaft above the complex moldings which form the head of the pedestal base. Both sections fit over an iron rod which is peened over under the center of the arc of the legs, passes through the legs, and forms the core for the pedestal. The top of the rod is threaded for the attachment of the finial section. The stepped-down iron billet bars are curved at the front and ensleeved on the top and sides with brass. The cast urn-shaped log stop secures the sleeve. An iron core extends from the stop through the billet and is peened over at the foot of the brass secondary leg. Both the stop and leg are cast in halves. The pierced gallery is held by three rivets on the rear face of the billet sleeve and also tenons into the pedestal through a slit at the back.

*Inscriptions:* Both have been stamped "ll" on the back of the plinth just in front of the gallery.

*Condition:* .A has had a circular patch let in at the top of the pedestal, probably a period repair to a casting fault. .B has a dent in the urn finial. The secondary legs of both andirons are missing a portion of their feet.

*Materials:* Brass, iron.

*Dimensions:* H. 23⅝ in. (60.0 cm), W. 11 in. (28.0 cm), D. 25 in. (63.5 cm).

*Bibliography:* Kauffman and Bowers, *Early American Andirons*, p. 64; Schiffer, *Brass Book*, p. 74, fig. C.

*Provenance:* Purchased in 1975 from Quentin H. Bowers, Camp Hill, Pa. (collector).

Purchase, Layton Art Collection
L1975.57A,B

## 110B *Andirons*

New York, New York, 1810–30

*Description:* The ball and steeple-topped andirons disassemble more readily than cat. 110A. The head, from the collar below the ball to the top of the steeple, is a single unit, cast in halves. The pedestal is a separate element cast in halves. The pedestal slides over the iron core rod which passes up through the center arc of the legs. The finial screws into the rod end. The raised, forward 6 in. (15.2 cm) of the step-down billet bar is ensleeved in brass. The log stop, a diminutive replica of the ball-and-steeple top, screws onto a threaded rod at the rear of the sleeve.

*Condition:* The rear billet bar of both has been repaired and .B has been shortened.

*Materials:* Brass, iron.

*Dimensions:* H. 18¾ in. (47.6 cm), W. 9⅛ in. (23.2 cm), D. (.A) 19⅞ in. (50.5 cm), D. (.B) 18¾ in. (47.6 cm).

*Provenance:* Purchased by the donors at the Mariwynne Shop, Independence, Ohio, in 1969.

Gift of Anne H. Vogel and Frederick Vogel III
M1970.73.A, B

Produced in the late federal period, the elaborate, galleried andirons (cat. 110A) are probably the work of the New York City foundry established by Richard Wittingham, Sr., in 1795. Wittingham, born in England in 1747/48, emigrated from the brass-founding center of Birmingham to Philadelphia in 1791. After working briefly in Pennsylvania and in New Jersey, he was able to establish his own foundry four years later. The father of four sons, Wittingham saw three of them—Richard, Jr., Joseph, and Isaac —follow in his trade before his death in 1821. New York City directories list at least one Wittingham as a brass founder from 1795 to 1850.[1]

Many andirons with the Wittingham mark are known. Some of the earliest, judging stylistically, are of the column-and-urn form popular from the beginning of the federal period (see cat. 109).[2] The andirons seen here demonstrate the

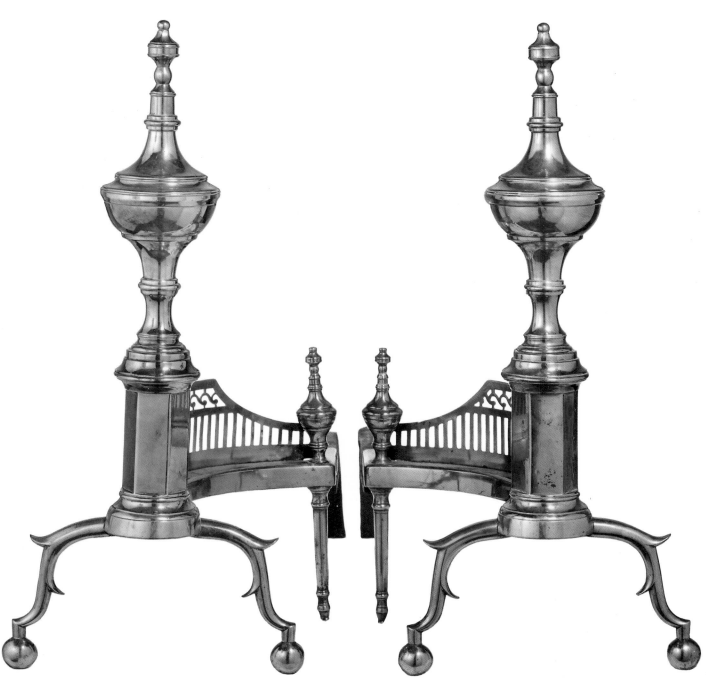

Cat. 110A

adaptation of the column into a short-ened hexagonal pedestal and the broad-ening of the urn top into a more complex, heavier shape in the late classical man-ner. Although several sets of Wittingham andirons with this stockier, later styling are known, they are all ball-topped or ball-and-steeple-topped andirons; no marked example of this large urn-topped, galleried form is known.[3] Despite the lack of a mark, there is a consistent and distinct shaping of the legs of the marked examples which points to the attribution made here. That is not to say that spurred, cabriole legs on stemmed ball feet are unique to the Wittinghams; on the con-trary, at least three other New York firms used them.[4] However, the Wittingham version of these legs is more vertical, with less splay than the others; the spurs are shorter with less curl and, seen in cross section, the leg is more cylindrical

when compared with the flattened, ellip-soidal legs cast by other firms. All the marked ball- and ball-and-steeple-topped andirons cited above share this basic leg conformation.

Although the Wittinghams employed a basic uniform leg shape, the marked examples illustrate the great number of embellishments which the foundry em-ployed to give variety to their products. In some instances the ball feet are at-tached directly to the spur at the end of the leg rather than having the cylindrical stem attachment of the present examples. The number of spurs could vary; one was always placed on the top of the knee, but a second might appear inside the knee and a third might be found as the terminal for the leg where the ball foot had no stem. The interchangeability of these bases with a number of pedestal and finial types allowed the Wittinghams

a large number of combinations to offer clients while permitting an early type of mass production.

A related simpler ball-and-steeple-topped pair of andirons from the muse-um's collection is also illustrated here (cat. 110B). Although unmarked, their lower half, from the hexagonal pedestal to the ball feet, follows the pattern of many identified New York foundries, including the Wittinghams'. It is not possible to be more specific in attributing a maker here; however, the ellipsoidal cross section of the legs rules out the Wittinghams, leaving us with an only slightly narrower field of possible New York makers. *Jayne E. Stokes*

1. Kauffman and Bowers, *Early American Andirons*, pp. 131–33, traces the family history.
2. Illustrated in Kauffman and Bowers, *Early American Andirons*, p. 51.
3. Three marked ball-top pairs have been published: Schiffer, *Brass Book*, p. 76, fig. A; Kauffman and Bowers, *Early American Andirons*, p. 12; Cooper, *In Praise of America*, p. 39, fig. 50. The marked ball-and-steeple-top pair are illustrated in Schiffer, *Brass Book*, p. 79, fig. D (the caption for which is incorrectly designated "E"). The latter pair is most closely related to the Milwaukee set, having curved billet bars at the front and sharing the features of hexagonal pedestals, identical secondary legs, and very similar primary legs, Milwaukee's having an additional spur on the inside of the knee.
4. All three are illustrated in Schiffer, *Brass Book*: a pair by John Bailey, p. 78, fig. A; a pair by O. Phillip, p. 79, fig. C; and a pair by Griffiths and Green, p. 80, fig. C.

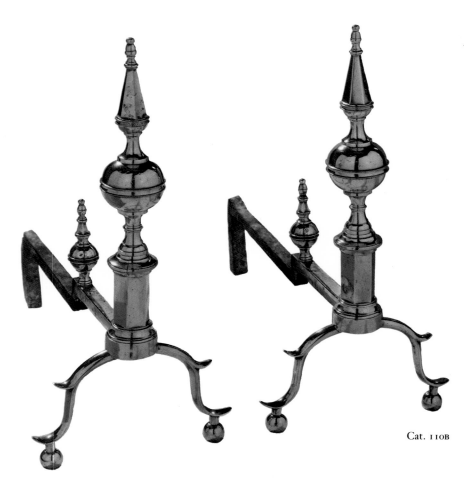

Cat. 110B

## 111 *Coverlet*

England, ca. 1780

*Description:* The coverlet is decorated with different sized sprigs of daisies and a border of meandering vine and pansies in delicate shades of green, purple, gold, and rose on cream.

*Condition:* The coverlet is in fine condi-tion with good color.

*Materials:* Silk, warp-float faced satin weave; embroidered with silk floss in stem and a variety of satin stitches; bul-lion and French knots; edged with a later

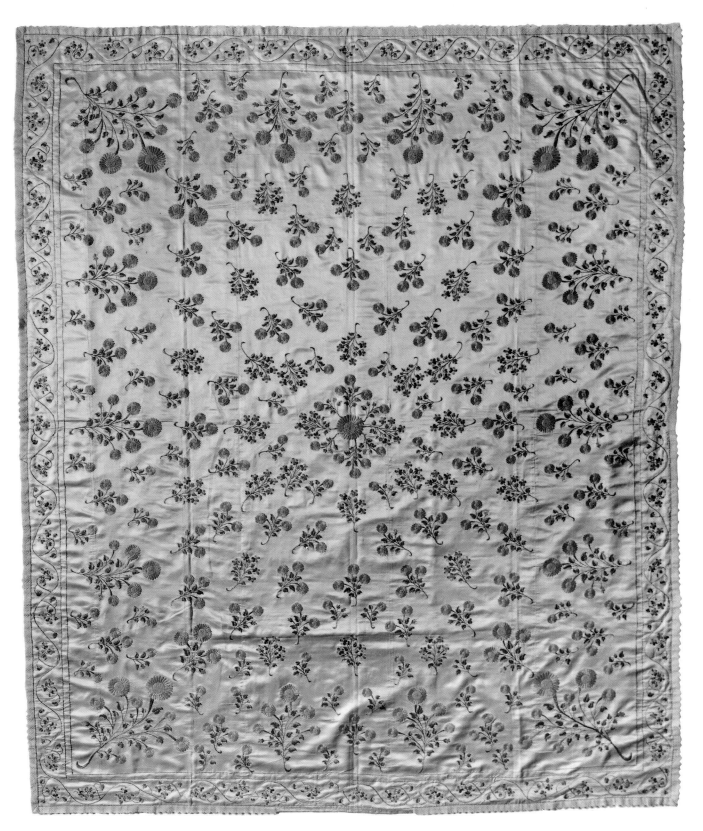

Cat. 111

addition of silk plain weave with supplementary patterning warps and extended ground weft uncut fringe.[1]

*Dimensions:* L. 102 in. (259.1 cm), w. 8¾ in. (210.2 cm).

*Provenance:* Purchased in 1980 from Ginsburg and Levy, New York, N.Y. (dealer).

In the eighteenth century, silks gradually replaced crewels to decorate bed furnishings as designs became lighter and more delicate. As this coverlet displays, a return to the old naturalistic flowers occurred, becoming widely spaced and arranged in formal patterns. Similar motifs were found on dresses, stomachers, and waistcoats.                   *Anne H. Vogel*

Purchase, Layton Art Collection
L1980.43

1. Examined microscopically for fiber content and structure by Lorna Ann Filippini, Department of Textiles, Art Institute of Chicago, through the courtesy of Christa C. Mayer-Thurman, Curator, Department of Textiles.

## 112 *Embroidered picture*

Fanny Winsor (1791–1883)
Providence, Rhode Island, ca. 1802

*Description:* The silk foundation is a warp-float faced satin weave embroidered with silk chenille yarns, silk floss, and yarns in split, stem, and a variety of satin stitches, laidwork, French knots, and metal paillettes.[1] The composition of an urn with flowers in a landscape is composed of colored threads in tones of blue, green, gold, rose, and ivory. The frame is contemporary to the embroidered panel and a *Providence Gazette* from April 2, 1803, is glued to the backing board.

*Marks:* The needlework picture is signed in pencil "wrought by FW."

*Condition:* There is some soiling and tearing to the sides of the white silk foundation. Otherwise the picture is in good condition, with only slight fading to the tones of the roses.

*Materials:* Silk, chenille, and spangles on silk.

*Dimensions:* H. 17½ in. (44.5 cm), w. 21¹¹/₁₆ in. (55.1 cm).

*Exhibitions:* "America's Treasures: An Exhibition of Needlework," Milwaukee Art Museum exhibition at Villa Terrace, June 1977; Vogel, *Focus: The Flower in Art*, no. 48.

*Bibliography: Antiques* 106, no. 3 (September 1974): 333; Ring, "Balch School," pl. VIII; Ring, *Let Virtue Be a Guide to Thee*, p. 164, pl. 68.

*Provenance:* Mrs. Ambrose E. Burnside, Fanny Winsor's daughter; to Mrs. Raymond G. Moury, granddaughter; to Ralph B. Taylor, Providence, R.I.; sold at Christie's (January 25, 1976), lot 253; acquired in 1977 from Benjamin Ginsburg Antiquary, New York, N.Y. (dealer).

Fanny Winsor was the daughter of Ira Winsor (1764–1819) and Patience Bullock (1767–1838). She married a shipmaster, Nathaniel Bishop (1784–1860). Of her four children only her daughter, Mary Richmond Bishop, survived into adulthood, becoming the wife of General Ambrose Everett Burnside, governor of Rhode Island from 1866 to 1869. She was the recipient of her mother's silk embroidery.

Fanny Winsor's picture exemplifies work from the Mary Balch school (1785–1831), one of the first New England dame schools to embrace the neoclassical fashion for delicate silk-on-silk ornamental embroideries. Along with Fanny, several of the students made a distinctive group of silk pictures which featured baskets of fruit or flower-filled vases set upon hillocks beneath swagged garlands suspended from silk bowknots.[2] This type of composition was greatly outnumbered during the first quarter of the nineteenth century by the more popular mourning scenes. Fanny is known to have stitched a mourning piece with the typical urns and two weeping willow trees. Its present location is unknown.[3]

Fanny Winsor's sister-in-law, Sally Bishop, also of the Mary Balch school, stitched a comparable silk embroidery, comprising an urn with flowers on a

hillock under a garland. Her composition, however, includes additional components: two baskets of fruit and a lower tier of stylized trees. Sally's picture was incorrectly attributed to Fanny Winsor until her barely visible penciled signature was discovered under the urn.[4]

These silk embroideries were examples of schoolgirl work made under the supervision of a teacher rather than at home with instruction from a mother. Many students immortalized their teachers by stitching their names into their work, leading to the later identification by scholars of schools and styles.[5] Proficiency with a needle was an essential skill for all girls, and they were sent to school at an early age to learn to read, spell, and sew. Their sampler or needlework pictures represented their academic achievement and, as was the case with Fanny Winsor's work, were passed from one generation to the next as treasured heirlooms.

The demanding art of silk-on-silk pictures echoed the newly popular neoclassical taste for furnishing interiors. The intricately veneered lightweight furniture forms relate to the glimmering silken picture surfaces. Some of the furniture was designed to meet women's needlework needs. The worktable with sewing bag (cat. 93) accommodated the storage of embroidery projects. It is not difficult to visualize Fanny Winsor's still-life design in a vertical shape as a suitable material to decorate a pole screen (cat. 94). The popularity of the urn, garland, and bow-knot motifs which Fanny chose is indisputable. In fact, Fanny, working at a Providence, Rhode Island, dame school, mirrored the fashion of the times, the educational restrictions still placed upon women at the turn of the century, and the resourcefulness and skill of their domestic art.                  *Anne H. Vogel*

Gift of Collectors' Corner
M1977.20

1. Examined microscopically for fiber content and structure by Lorna Ann Filippini, Department of Textiles, Art Institute of Chicago, through the courtesy of Christa C. Mayer-Thurman, Curator, Department of Textiles.
2. Ring, *Let Virtue Be a Guide to Thee*, pls. 66, 67, 68, 69.
3. Ring, *Let Virtue Be a Guide to Thee*, p. 164, n. 1.

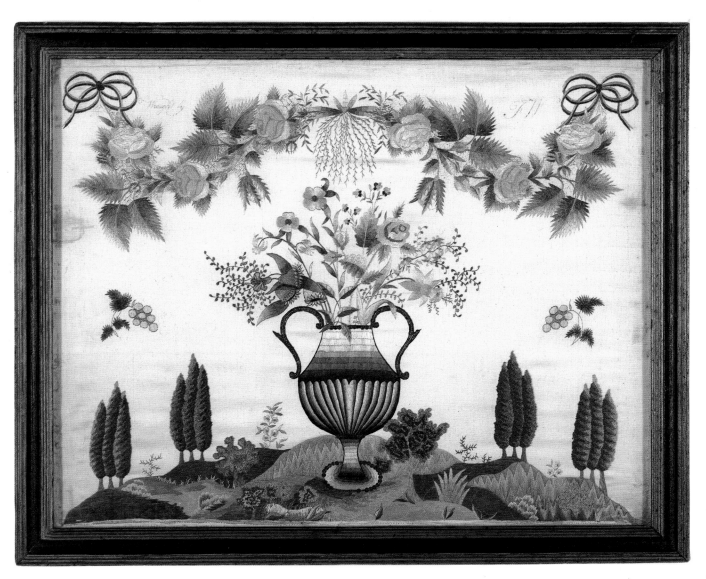

Cat. 112

4. Sally Bishop's picture was illustrated as the work of Fanny Winsor in Ott, *John Brown House Loan Exhibition*, cat. 95, pp. 144–45. This attribution is corrected in Ring, *Let Virtue Be a Guide to Thee*, cat. 67, p. 163.

5. Betty Ring investigates a variety of distinctive needlework regional styles in her publication *American Needlework Treasures*.

## 113 *Bowl*

Probably Redwood Glass Works
(1832–ca.1880)
Redwood, New York, 1832–50

*Description:* This large bowl is blown of clear, bright blue-green glass. From a gather of glass applied to the bottom of the bowl, twelve scrolled arms with circular pads have been pulled up the exterior wall, alternating long and short as they form waves around the perimeter. The thick crimped foot provides weight to counterbalance the broadly flared rim which is protected by a deep folded edge.

*Condition:* There is a 1-in. (2.6-cm) chip on the lower edge of the foot rim.

*Material:* Non-lead glass.

*Dimensions:* H. 5¼ in. (13.3 cm), DIAM. 14⅝ in. (37.1 cm).

*Provenance:* Descended in the Ogdensburg, N. Y., family of the donors, Mr. and Mrs. John H. Paige.

The provenance of this bowl, which descended through an Ogdensburg, New York, family, is a primary indicator of the glassworks that produced it. Ogdensburg is on the St. Lawrence River approximately thirty miles north of the village of Redwood, once the site of the Redwood Glass Works. Established in 1832 by John S. Foster, this glasshouse largely produced window glass until it closed in the early 1880s.[1] A decorative object, such as this bowl, would have been crafted as an "off-hand" piece made on request, or perhaps as a gift, by a glass gaffer whose normal occupation was making windows or bottles.[2] Redwood was the nearest glassworks to Ogdensburg; two other contemporary producers in northern New York—Harrisburg (1841–43) and Redford (1831–52)—were at least twice the distance away.[3]

Without its provenance it would be difficult to tie this bowl directly to the Redwood Glass Works. However, the color of the glass and its form and decoration definitely place it in northern New York. The strong, fully developed lily-pad decoration is typical of glass from this area. Although the lily pad was first used in America by our earliest glasshouses in southern New Jersey, the design migrated around the country as some glassblowers moved to other regions in the nineteenth century.[4] Those who interpreted the design in northern New York used it boldly, drawing the broad arms of the applied pads of glass well up on the body of a piece.[5] On the Milwaukee bowl the decoration nearly touches the rim. While this styling distinguishes northern New York glass, it does not help to distinguish among individual glasshouses there. This is especially true of the Redwood and Redford Glass Works because both had the same founding superintendent, John S. Foster. The techniques Foster knew, and perhaps even some of the workmen he used in Redford, would have been employed by him at Redwood. The present example, with its strong Redwood provenance, is an important element in understanding the impact of John Foster and in reaching a broader understanding of blown glass of the second quarter of the nineteenth century made in northern New York.

*Jayne E. Stokes*

Gift of Mr. and Mrs. John H. Paige
M1973.168

1. McKearin, *American Glass*, p. 193.
2. Zerwick, *Short History of Glass*, p. 65.
3. McKearin, *Two Hundred Years of American Blown Glass*, p. 121.
4. McKearin, "Wistarberg," pp. 274–80.
5. McKearin, *Two Hundred Years of American Blown Glass*, pl. 7, nos. 3, 5; pl. 16, pl. 22, nos. 1–3.

Cat. 113

# Identification of Woods in the Furniture Collection

## R. BRUCE HOADLEY

### Introduction

It has always been customary to think of an object of furniture in terms of its primary wood. We refer to "a cherry desk" rather than simply "a desk." Increasingly, attention is also focused upon the identification of species of secondary woods, now considered indispensable in an object's attribution and interpretation. Early in the preparation of this catalogue the decision was made to compile a thorough and accurate record of all original woods—both primary and secondary—present in the objects in the collection.

I occasionally hear the term *wood analysis*, which to me could include anything from chemical assay to physical and mechanical evaluation. Usually, of course, the term refers to nothing more than identifying the kinds of wood present, which is routinely accomplished by the visual recognition of specific wood features. However, because the most reliable wood identification features are minute and require the use of a microscope to observe, *microscopic analysis* is considered necessary.

An understanding of the overall process of wood identification in a collection such as this one involves not only an acquaintance with the general techniques of wood identification but also an appreciation of the problems involved when working with priceless objects. But because apparent discrepancies in wood identification can result from inconsistency and confusion of nomenclature, some comments regarding the names of trees and their woods are in order.

### The Names of Woods

The ultimate objective in wood identification is to determine the species of tree from which a particular piece of wood was obtained. The term *species* designates the final level of separation of plant classification. Under accepted botanical taxonomy, trees common to our part of the world fall into either of two Classes, the *Gymnosperms*, which include the conifers or "softwoods," and the *Angiosperms*, wherein we find the "hardwoods." In turn, Classes are further divided into orders, families, genera (singular, genus), and, finally, species (singular, species).

Each species is assigned a scientific name, which is a binomial term comprising its genus name followed by its species name or "epithet." For example, the species we know by the common name sugar maple has the scientific name *Acer saccharum, Acer* indicating the genus name for all maples, and *saccharum* the epithet for the sugar maple species. As established by taxonomists, the Latinized scientific names are universally accepted among the community of scientists, and used mostly in scientific and technical writing. We usually prefer to use common names. We say "yellow birch" rather than *Betula alleghaniensis*, or "eastern white pine" rather than *Pinus strobus*. Unfortunately, although taxonomists have also assigned a standard common name to each species, most woods confusingly have more than one name of reference, reflecting traditional favorites, regional variants, or trade names. One of the classic examples is *Liriodendron tulipifera*,

whose preferred common name is yellow-poplar, but which also goes by "tulipwood," "tuliptree," "tulip-poplar," "whitewood," and so on. Along with the growing interest in wood identification in the study of decorative arts, the use of standardized common names should be encouraged.[1]

Few people are familiar with orders or families. With trees, we are usually familiar with various species within the more common genera. For example, we may not only be acquainted with the pines, but may know the several individual species (such as eastern white pine, pitch pine, red pine, etc.) native to our area. But most of us think of woods at the genus level and refer to them by generic names. We speak of an oak table or a birch rocker or a maple chest without concern for species.

It is always proper as well as desirable to use the species name of a tree to designate a piece of its wood. Unfortunately, the woods of species within a genus are commonly so similar that they lack distinguishing features and cannot be separated. In this situation the scientific name of the genus is given, followed by "sp." ("spp." would denote plural) indicating an inde-terminate species. For example, because woods of the various birches cannot be reliably separated, an un-known sample is identified simply as "birch," giving its scientific name as *Betula* sp. In some genera it is at least possible to narrow a wood down to a group within the genus, which is appropriately designated. For example, the many species of oak can be separated only into red oak (that is, the red oaks collectively or "red oak group"), as separate from white oak ("white oak group"). An unknown of either group would be indicated as *Quercus* sp. In still other genera, the wood of some species can be individually identified while others can be placed only into a group. In the genus *Pinus*, for example, eastern white pine (*Pinus strobus*) can be specifically identified but the wood of longleaf pine can only be designated as southern yellow pine (*Pinus* sp.).

The accompanying table (table 1) lists the species of wood found among objects in the Milwaukee collec-tion, with the appropriate designations of scientific and common names.

In establishing furniture origin, the identification of a wood species is especially important in cases where different species represent different geographical ranges. It is obviously valuable, for example, that black wal-nut (*Juglans nigra*), a North American species, can be positively separated from European walnut (*Juglans regia*). But unfortunately, among certain other genera, inseparable woods from widely ranging species offer little clue to origin. For example, the woods of Euro-pean birches cannot be separated from those of North American species. Even within North America, the "southern yellow pine" group includes woods of ten species whose native range extends from Florida to southern Maine.

In applying wood identification information to in-terpretive analysis, it is important to know both the level of identification possible for a particular type of wood as well as the natural geographic ranges of the woods in question.

## Wood Identification Techniques

There is no single technique or method of wood identification which fits every situation or which is best for every species. Surely the process begins by taking advantage of any obvious and unique features which may immediately hint at the answer. Heart-wood color is occasionally helpful, such as the rich chocolate brown of black walnut, the deep purple-red of eastern redcedar, or the glaring green of certain pieces of yellow-poplar. Sometimes recognizable odor will reveal the wood, such as the sweet spicy aroma of Atlantic white-cedar or the faint musty smell of bass-wood. Physical properties, such as the greater density and hardness of sugar maple compared to the lightness and softness of aspen, can be useful. Sometimes a particular wood has an abnormality or irregularity of figure which helps in its identification. For example, the classic bird's-eye figure is exclusive to sugar maple, one of the hard maples. Curly figure, on the other hand, can occur in virtually any other species, but when seen in maple it will far more often turn out to be soft maple than hard maple. But in historic objects, colors usually fade or deepen with age, or have been altered by stains and finishes, odors dissipate with time, density is usually too variable or difficult to assess with accuracy, or helpful figure may be ob-scured by a layer of paint or gesso. Any immediate visual or tactile assessment must be routinely checked with more precise and reliable means. In the end, wood identification relies on an understanding of the structural anatomy of the wood.

### TABLE I
*Woods Encountered in the Furniture Collection*

Common and scientific names of North American species are designated in accordance with Little, *Checklist of United States Trees (Native and Naturalized)*. In addition, for some woods, alternate names in common use are included in parentheses. Notes to table one continue on p. 276.

| Common Name | Scientific Name | Notes |
|---|---|---|
| **CONIFERS** | | |
| white pine [group] | *Pinus* spp. | 3 |
| eastern white pine | *P. strobus* | |
| southern yellow pine | | 4 |
| (taeda pine) | | |
| [group] | *Pinus* spp. | |
| longleaf pine | *P. palustris* | |
| shortleaf pine | *P. echinata* | |
| loblolly pine | *P. taeda* | |
| slash pine | *P. elliottii* | |
| pitch pine | *P. rigida* | 6 |
| [et al.] | | |
| sylvestris pine [group] | *Pinus* spp. | 2,5 |
| red pine | | |
| (Norway pine) | *P. resinosa* | |
| Scots pine | *P. sylvestris* | 9 |
| spruce | *Picea* spp. | 4,5 |
| red spruce | *P. rubens* | |
| white spruce | *P. glauca* | |
| [et al.] | | |
| redcedar (juniper) | *Juniperus* spp. | 3 |
| eastern redcedar | *J. virginiana* | |
| Atlantic white-cedar | *Chamaecyparis thyoides* | 2 |
| **HARDWOODS** | | |
| red oak [group] | *Quercus* spp. | 4 |
| northern red oak | *Q. rubra* | |
| [et al.] | | |
| white oak [group] | *Quercus* spp. | 4,5 |
| white oak | *Q. alba* | |
| [et al.] | | |
| chestnut | *Castanea* spp. | 3,5 |
| American chestnut | *C. dentata* | |
| ash | *Fraxinus* spp. | 3,5 |
| white ash | *F. americana* | |
| green ash | *F. pennsylvanica* | |
| black ash | *F. nigra* | |
| hickory | *Carya* spp. | 4 |
| shagbark hickory | *C. ovata* | |
| pignut hickory | *C. glabra* | |
| [et al.] | | |
| black walnut | *Juglans nigra* | 2 |
| American beech | | |
| (beech) | *Fagus grandifolia* | 1,5 |
| hard maple [group] | *Acer* spp. | 3,5 |
| sugar maple | *A. saccharum* | |
| soft maple [group] | *Acer* spp. | 3,5 |
| red maple | *A. rubrum* | |
| silver maple | *A. saccharinum* | |
| birch | *Betula* spp. | 4,5 |
| yellow birch | *B. alleghaniensis* | |
| [et al.] | | |
| cherry | *Prunus* spp. | 3,5 |
| black cherry | *P. serotina* | |
| yellow-poplar | *Liriodendron tulipifera* | 1 |
| (tulip poplar) | | |
| basswood | *Tilia* spp. | 3,5,7 |
| American basswood | *T. americana* | |
| sweetgum (redgum) | *Liquidambar styraciflua* | 1 |
| poplar | | |
| (cottonwood, aspen) | *Populus* spp. | 4,5,8 |
| eastern cottonwood | *P. deltoides* | |
| quaking aspen | *P. tremuloides* | |
| bigtooth aspen | *P. grandidentata* | |
| [et al.] | | |
| **TROPICAL HARDWOODS** | | |
| mahogany | | |
| American mahogany | *Swietenia* spp. | 4 |
| African mahogany | *Khaya* spp. | 4 |
| Spanish-cedar | *Cedrela* spp. | 4 |
| rosewood | *Dalbergia* spp. | 4 |
| Brazilian rosewood | *D. nigra* | |
| satinwood | *Chloroxylon swietenia* | |
| courbaril | *Hymenea courbaril* | |

Notes to table:

1. Genus has a single North American species, the wood of which can be reliably identified on the basis of anatomy (e.g., yellow-poplar, *Liriodendron tulipifera*).

2. Genus has more than one North American species, but wood of the species listed can be anatomically distinguished from others (e.g., black walnut, *Juglans nigra*).

3. Genus (or subgroup within the genus) has more than one North American species, but the species listed is (are) the only major one (s) in the eastern region and will therefore account for virtually every occurrence in early furniture of eastern North America (e.g., eastern white pine, *Pinus strobus*).

4. Genus has more than one species likely to have been converted into lumber. Principal species are given as examples, but other major and locally important minor species are part of the genus (or subgroup within the genus), and their woods are indistin-

Wood is little more than a composite mass of countless numbers of cells. These cells were produced by cell division of the cambium, a layer of tissue beneath the bark, and the cyclic variations of these cells are recognizable in most woods as growth rings. Each wood cell has an outer cell wall which surrounds an internal cell cavity. Wood cells are typically elongated, varying from short barrel shapes to extremely long fibers. Most of the cells (usually over 90 percent) are elongated in the stem direction of the tree or branch, the axial direction of the cells giving wood its "grain direction," parallel to the stem axis. The remainder of the cells are ray cells, elongated horizontally in the tree. They are arranged to form flat, ribbonlike groups, called rays, which radiate outward from the central pith of the stem, like sparse bristles in a bottle brush.

### HAND-LENS IDENTIFICATION

In identifying wood, a routine starting point is to cut the wood across the grain, thus exposing the longitudinal cells in cross section. If the surface has been cleanly cut with a razor-sharp edge, the width and orientation of the growth rings are usually immediately apparent.

In a few species of hardwoods, such as mahogany, oak, ash, and hickory, the vessel cells (called "pores" in cross section) are large enough to be visible without magnification. For the majority of woods it is best to examine further with a low-power magnifier. A 10x magnifier, referred to simply as a "hand lens," is most commonly used. With this low magnification, even the smallest pores of the hardwoods can also be seen. This also serves to separate the hardwoods from the

softwoods in which none of the cells is large enough to be distinct even with a hand lens.

The hardwoods can be roughly classified by pore size and arrangement. If the large pores are grouped into the first-formed portion of the growth ring, forming a conspicuous "ring" of pores, the wood is termed ring-porous, as in the oaks, ashes, and chestnut. If the pores are uniform in size and evenly distributed across the growth ring, the wood is diffuse-porous. Although pores are visible with a hand lens, all other cells are too small to be seen individually, but masses or groups of certain types of cells may be recognized; masses of denser fiber cells usually form a darker background against which groups of thinner walled parenchyma cells produce lighter-colored patterns. Perpendicular to the growth rings, the rather straight lines of ray cells are also apparent. In the

FIG. 1. Cross-sectional surface view (x15) of red oak (*Quercus* sp.), a ring-porous hardwood, as seen with a hand lens. The distinguishing identification features are the large rays, the large earlywood pores, the smaller but conspicuous latewood pores, and the distinctive patterns of lighter-colored masses of parenchyma cells.

---

guishable (e.g., northern red oak, *Quercus rubra*, is but one of more than a dozen major and minor species in the red oak group).

5. Genus (or subgroup within the genus) has major European species, the woods of which are routinely indistinguishable from those of similar North American species (e.g., Scots pine, *Pinus sylvestris* [Europe], and red pine, *Pinus resinosa* [North America]).

6. Although the range of most southern yellow pines is from New Jersey southward, the range of pitch pine extends from northern Georgia to southern Maine. Therefore, pitch pine, technically a member of the southern yellow pine group, is nevertheless a native species of the Northeast.

7. In the United Kingdom, wood of *Tilia* (excepting *T. americana*) is called lime.

8. Species of the genus *Populus* cannot be separated with certainty; however, the cottonwoods are typically more coarse textured (i.e., have larger pores) than the aspens.

9. Native range in Europe and Asia.

ring-porous oaks, the rays are distinctively large and provide an immediate and reliable means of identifying *Quercus*. In white oak they may emerge on board surfaces forming visible markings which are up to several inches in the grain direction of the wood, an easily recognizable identification feature. In red oak, the rays are also conspicuous, but rarely exceed an inch in height. In beech and sycamore, diffuse-porous hardwoods, they are clearly visible also and provide a fairly reliable identification of these woods.

In summary, some hardwoods can be identified at least to genus, with nothing more than a hand lens, by observing the size and distribution of pores, the size and distinctiveness of rays, and characteristic patterns of parenchyma cells (see figs. 1–2).[2]

With the hand lens alone, identification of the conifers is tentative at best. The bulk of the wood tissue consists of uniformly small and indistinct tracheids, confusingly similar among all species of conifers. One helpful feature is resin canals. In viewing a cross section, if resin canals are present, the wood belongs to one of four genera: the pines (*Pinus*), spruces (*Picea*), larches (*Larix*), or Douglas-fir (*Pseudotsuga*). That's a start. Next, within a growth ring, the degree of contrast between the lighter layer of earlywood tracheids and the darker latewood is considered. For example, in eastern white pine the rings are fairly "even-grained," with relatively little contrast and a gradual transition from earlywood to latewood. In southern yellow pine, however, there is an abrupt

[A]

[B]

FIG. 2. As seen in cross section with a hand lens (x15), the woods of American mahogany (*Swietenia* sp.) [A] and black walnut (*Juglans nigra*) [B] are easily separated. Mahogany is diffuse-porous with uniformly large pores (sometimes with chalky white or reddish gum contents), distinct rays, and a distinct line of marginal parenchyma

delineating each growth ring. In contrast, black walnut is semi-ring-porous, its pores have bubblelike tyloses (but lack white or reddish contents), its rays are inconspicuous, and marginal parenchyma is absent.

transition from earlywood to the very dense latewood; the wood is therefore described as "uneven grained" (fig. 3).

These features, however, will mainly suggest possible answers, and further identification depends on microscopic examination of cellular details in thin sections of wood tissue.

### MICROSCOPIC EXAMINATION

For microscopic examination, tissue sections must be carefully cut from any of the three principal planes of wood structure: (1) across the grain, (2) along the grain tangentially (in a plane parallel to the growth layers), or (3) along the grain radially (in a plane perpendicular to the growth layers). Using the

FIG. 4. The small fragment of wood on the right is typical of samples taken for identification. From it, a tiny thin section, removed with a razor blade, is mounted on a slide, as shown, for microscopic examination.

growth-ring orientation revealed by first cutting a cross section, surfaces can be split or shaved down along the radial and tangential planes in the grain direction. When working on objects it is sometimes possible to cut sections from furniture parts directly. In other cases it is more expedient to cut first a tiny piece from the object and then cut sections from it. Typically a piece 3 × 3 × 12 mm will be sufficient.

From the surface of any of the principal planes a tiny slice of wood—approximately ⅛ inch by ⅛ inch by less than 1/1000 inch in thickness—is carefully sliced off with a razor blade. This thin section of wood tissue is ideally no more than one or two cell-diameters thick. The section is placed on a glass microscope slide, moistened with water, and covered with a thin cover glass. When placed on the stage of a standard compound light microscope, the translucent section is illuminated with transmitted light and the cellular detail can be examined at magnifications up to 500x (fig.4).

Among the conifers, microscopic details offer the most distinctive differences from one species to another and thus provide the most reliable basis for separation. Among the routinely useful features are the height and width of the rays, the types of ray cells present, the shape and number of cell-wall pits (holes in the cell walls connecting adjacent cells), the smoothness of the cell walls, the presence and color of contents of the cell walls, or spiral thickenings in the

FIG. 3. Cross-sectional surface view (x15) of southern yellow pine, an "uneven-grained" conifer, as seen with a hand lens. The occasional large resin canals are conspicuous against the background mass of indistinct tracheids. The lighter earlywood makes abrupt transition to darker, denser latewood.

FIG. 5. Radial microscopic views (x420) of eastern white pine [A] and southern yellow pine [B] showing ray cells (horizontal) crossing vertical tracheids. Within the horizontal ray cells, the walls of ray tracheids (RT) are smooth in eastern white pine, dentate in southern

yellow pine. The pitting of ray parenchyma cells (RP) is large, and single or double, in eastern white pine, but smaller and multiple in southern yellow pine. These features reliably separate the two woods.

(RT)
(RP)

[A]

(RT)
(RP)

[B]

tracheids. Such detail is often quick and easy to see and evaluate. For example, among the pines, the cell walls of ray tracheids are smooth in the soft pines (such as eastern white pine), providing a certain separation from the hard pines, which have "dentate" ray tracheids with jagged walls (figs. 5a, 5b). Among the hard pines, the southern yellow pines (e.g., pitch pine) have multiple elliptical pits in the ray parenchyma cells, the sylvestris pines (e. g., red pine) have large rounded single or double pits. In some cases,

however, the separation process may be far more tedious, but in the end rewarding. For example, the woods of red pine and Scots pine cannot be separated at a glance, but by taking thirty or more microscopic measurements of fusiform ray height, the average value will usually indicate the species. This procedure enabled the woods in the slip seat of the New York side chair (cat. 60) to be identified as Scots pine.

Among the hardwoods—the diffuse-porous hardwoods especially—microscopic analysis also provides

[A]

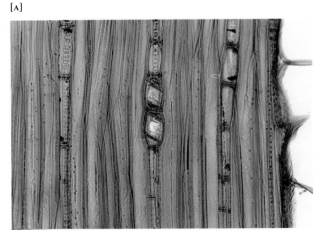

[B]   (RT)

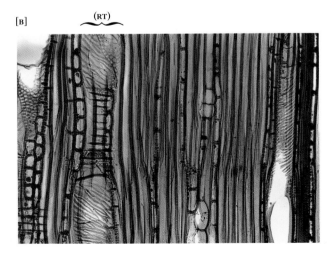

FIG. 6. Radial microscopic views of black walnut showing crystals in longitudinal parenchyma cells [A, x210], and reticulate thickenings (RT) —called "gash-like pits"— in latewood vessel elements

[B, x105]. These two features provide positive separation of black walnut (*Juglans nigra*) from European walnut (*Juglans regia*) in which both features are absent.

the best means of confirming many genera, and in most cases, the only way of separating species within a genus. In the walnut genus, *Juglans,* for example, two important microscopic features—crystals in longitudinal parenchyma cells and reticulate thickenings (called "gash-like pits") on certain vessel walls—provide positive separation of North American black walnut (*Juglans nigra*) from European walnut (*Juglans regia*) (figs. 6a, 6b). Among maples, the soft maples have rays which are rarely over five cells in width; the hard maples have rays which are commonly up to eight cells in width. But even among the ring-porous woods which can routinely be identified on the basis of visual or hand-lens examination, as with the oaks, microscopic sections are often valuable, as when the object is painted and only a tiny bit of tissue is available. In such cases it is handy to know that the latewood vessels have thick walls in the red oaks, thin walls in the white oaks.

For each species encountered, a definite set of features must be known which will verify the species; these may be macroscopic features, microscopic features, or a combination of both.

### Working on the Collection

Identifying an unknown wood in a laboratory is one thing; identifying all the woods in an entire furniture collection is quite another. In tackling the Milwaukee collection one challenge was the sheer numbers involved— more than sixty objects, each with up to one hundred or more component pieces of wood. Yet, the project must be as thorough and complete as possible, with accurate results. There were also some important constraints. Many woods would be aged beyond recognition or covered with paint so that visual identification would routinely be difficult and microscopic examination would need to be relied upon. Nevertheless, handling of objects and disturbance of surfaces for sampling would have to be absolutely minimal.

I have had similar assignments of wood identification in a number of other collections, among which have been the Garvan collection at Yale University, the Bayou Bend collection of the Museum of Fine Arts, Houston, the Bybee collection at the Dallas Museum of Art, and the collections in the Diplomatic Reception Rooms at the United States Department of State.

Through this experience I have gradually evolved a somewhat standard and reasonably efficient routine which involves moving the laboratory to the collection and working directly among the objects. Therefore, in undertaking the Milwaukee collection, a "mobile field laboratory" of sorts was contrived within the museum. A small worktable was provided, equipped with a work lamp, a cutting block, a microscope, and necessary accessories. At hand also were a padded examination table, a stepladder, examination lamps, flashlights, and mirrors. Starting at one end of the collection, the setup moved from area to area, working from object to object.

As each piece of furniture was encountered, an initial visual survey was made of the overall construction, first with regard to primary woods, then on to the secondary woods. As needed, doors were opened, lids raised, tambours rolled back, drawers removed, slip seats lifted, bonnets withdrawn, and secret compartments invaded. The lighter objects, such as chairs, tables, or small chest carcasses were flipped over onto the padded table for easier access to such inner structure as frames, rails, drawer runners, braces, and glue blocks—and more glue blocks. Heavy objects, such as large chests, or delicate objects, such as tall clocks, remained in place and required a lot of bending over, crawling under, climbing ladders, and maneuvering of lights and mirrors to seek out every last wooden piece and part.

During this initial examination, tentative visual identification was made on each component, or parts remained as "unknowns." Next, a sampling scheme was decided upon for anatomical verification of every apparently different wood present. For example, in a chest of drawers, sampling to verify the primary wood might include one drawer front, one side panel, one front corner post, and the top board. If a single species of secondary wood were apparent, the sampling might include a backboard of the case, a drawer side, a drawer runner, a foot block, and two glue blocks. Where multiple species were evident, at least two samples were taken to verify each different type of wood. In one card table (cat. 67), for example, where a total of seven different species were found, a total of fifteen anatomical verifications were made.

In any particular case the method used for anatomical verification was tied to the species involved as well as to the accessibility of sampling or direct viewing.

For the few woods which could be verified by direct hand-lens examination, a tiny portion of end grain was surfaced and examined directly on the piece. This could typically be done on the bottom of a leg, the end of a drawer front, or the rear end of a molding. Where microscopic anatomical detail was needed for identification, direct sectioning was first considered. On a drawer side, for example, a quick look at the growth ring placement would usually show which edge could yield either a radial or tangential section. Cracks due to shrinkage, common in drawer bottoms, are usually radial fractures; a perfect radial section can be easily removed from either face of the crack with a razor blade.

In the majority of cases, however, it was necessary to remove a small bit of wood tissue. A piece approximately 2–3 mm in cross section by 10–12 mm in length was usually sufficient. This piece was first sectioned to show end grain, and then further sectioned radially or tangentially as needed for slide preparation. These samples were taken in an unseen location, such as the rear lower edge of a drawer front, the top inner edge of a leg post, the portion of a chair frame hidden by upholstery, or the inside of a large crack on a turned foot.

The identification process is not without certain limitations. Throughout, human judgment is relied upon to decide first which different woods should be sampled and verified; undoubtedly the occasional additional species is present but goes undetected. This is probably most common in painted furniture, where there is little basis for knowing what is present short of sampling every piece. Another shortcoming is

where inlays are involved, which commonly consist of small pieces of nondescript diffuse-porous hardwoods, often dyed an unnatural color. They cannot be sampled without defacing the object, and without sectioning they cannot be accurately identified. Although it is believed that the identification project was accurate to the extent that sampling was possible, it is conceded that the sampling could not be absolutely complete.

Despite these limitations and drawbacks, the approach of on-site identification by a wood anatomist has obvious advantages. The trained eye will better recognize the several different woods present in a given object, and often can detect one or more species which might otherwise be overlooked, thereby strengthening the usefulness of secondary woods as an indicator of regional origin. Further, damage to the object is minimized, because fewer components may need to be sampled for microscopic verification, and because the trained anatomist can take the minimal sized sample necessary for a positive identification.

The identification of woods was important in the preparation of this catalogue. Hopefully this information will also be valuable in the future to other research endeavors involving objects in the Milwaukee furniture collection.

1. A recommended standard for both scientific and common names for North American woods is Little, *Checklist of United States Trees (Native and Naturalized)*.

2. Additional macrophotographs of common woods are found in Hoadley, *Understanding Wood*, chap. 3. More extensive coverage of the subject will be found in my *Identifying Wood: Accurate Results with Simple Tools* (Newtown, Conn.: The Taunton Press, 1991).

# Ethafoam Treatment for a Boston Easy Chair (Cat. 44)

## ELIZABETH G. LAHIKAINEN

Increasingly within the last few years, curators and conservators have expressed concern about the widespread practice of reupholstering period furniture as part of the process of preparing an artifact for display. For example, using traditional upholstery techniques to cover an eighteenth-century easy chair requires approximately 1½ to 2 pounds of iron tacks to secure the upholstery materials to the frame. This process adds hundreds of additional holes to the frame that can jeopardize the structural stability of the object and disturb, or even obliterate, original upholstery evidence. In 1982, in a pioneering effort to find a less damaging method for upholstering period furniture, Robert Mussey, Chief Furniture Conservator at the Society for the Preservation of New England Antiquities, developed the concept of carving ethafoam to replace traditional underupholstery materials. The advantage of this treatment is that the ethafoam is not attached to the frame, making tacking unnecessary. It also allows the parts of the frame to be exposed so the object can be studied. Technical development of ethafoam methods proved to be successful, and ethafoam has since been routinely used at SPNEA for seat bottoms in side chairs and, more recently, in more complex forms such as easy chairs.

The technique outlined below adapts Mussey's concept to a Queen Anne–style easy chair in the Milwaukee collection (cat. 44). This process combines the skills of woodworker, upholsterer, and seamstress into a straightforward and uncomplicated solution that should be cost effective for museums and collectors alike.[1]

For any upholstery conservation project, historical documentation guides the many choices that have to be made during treatment. In this case, a Boston easy chair at the Brooklyn Museum (32.38) provided an ideal model (fig. 1). It not only matched the Milwaukee chair (fig. 2) in style, date, and origin, but it also retains all of its original upholstery. The Brooklyn chair was used as the prototype to determine the shape of the underupholstery and appropriate replacement fabrics and trim.

For this treatment, we sought materials that were readily available and relatively inexpensive. The primary material, ethafoam, is technically described as expanded polyethylene, a plastic material that is bubbled up into a foam. It has a closed cell structure. This means that the individual air bubbles cannot be penetrated by moisture, spores, or pollution, and therefore ethafoam will not support bacterial life over time. It can be easily worked with hand or power tools and can be manipulated by heat with a heat gun or hand iron. It comes in several densities and is dimensionally stable if not exposed to extreme conditions.[2] It is also widely available through foam-plastic dealers.

Other replacement materials for the upholstery process were Plexiglas, pine sealed with an epoxy paint saturated with aluminum flakes (aluminum prevents the migration of acids from the wood), zinc-chromate-coated steel screws (zinc-chromate inhibits corrosion), sheet aluminum, upholsterer's polyester batting, stainless-steel pins, polyester ribbon, medium-weight linen fabric (washed and rinsed several times to reduce residues and finishes), drapery-weight cot-

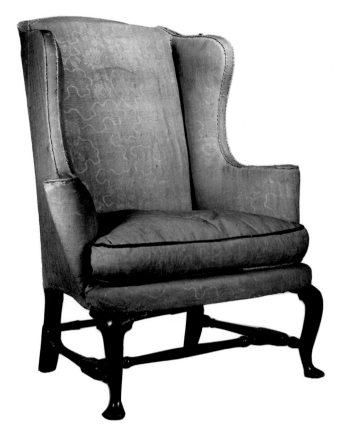

FIG. 1. Easy chair, Boston, Massachusetts, 1745–65. (The Brooklyn Museum, 32.38.)

ton thread, and cotton cording. All of these materials are regarded as stable and well suited for their function within this conservation treatment.

The decorative replacement fabrics and trims duplicate eighteenth-century precedents in both texture and color. The Brooklyn chair is upholstered in a stamped moreen and trimmed with a red-and-yellow tape woven in a geometric pattern. On the wings and arms, the trim is sewn over a flax cord, which helps define the lines of the chair. For the Milwaukee chair, we acquired from Classic Revivals, Inc., a reproduction stamped moreen that was recently copied from a set of bed hangings in the Essex Institute collection (103,285). This fabric is the most similar to that of the Brooklyn chair that can be purchased on the market today. We turned to Scalamandré for a silk tape that closely approximates the geometric pattern of the original. It was not possible to duplicate a two-color

trim in a way that was affordable, so we piece-dyed white goods to match the fabric. We purchased cotton cording to pad the trim on the wings and arms.

The technical process of assembling the reupholstery materials can be divided into five general steps. These steps correspond to the layers of materials, which in order of assembly are: the seat bottom, ethafoam, the batting, the finish fabric, and finally the trim and other detailing.

First, the seat bottom, or deck, was fabricated out of ¼-in. (.6-cm) thick Plexiglas and ½-in. (1.3-cm) pine. The pine covered the top of the front rail and was shaped on the underside to accommodate the warp of the rail. It also provided a nailing ground for the ethafoam edge roll. The rest of the deck was covered by a sheet of Plexiglas that was held in place by pine guides on the underside. All pine parts were sealed with epoxy paint containing aluminum flakes. The deck's function was to support the down-filled cushion.

In the second step, 3-in. (7.6-cm) thick blocks of ethafoam were fitted to the seat back and the two wing arm units (fig. 3). Rabbets cut into the back faces of these blocks match the frame openings. Each unit was then shaped to approximate the contours of the upholstery of the Brooklyn chair. Once fitted to the frame, the wing arm units hold the seat-back unit in place. Polyester ribbons hold the wing arm units to the frame.

Polyester batting, the third layer, gives the object the visual and tactile softness characteristic of a traditionally upholstered surface. We used this layer to build the final form and the graceful line intended by the original craftsman, which was achieved by layering and feathering the batting. This layer was secured by a linen undercover fitted tightly over the three major stuffed areas. The linen fabric was drawn over the foam and batting, drawn around the frame, and then pinned into the ethafoam on the outside faces. Ethafoam planks (¾ in. [1.9 cm] thick) were cut to fit the seat bottom to provide a pinning surface for the textile layers. This also shapes the edge roll of the seat front.

To simulate a traditionally upholstered chair, the finish fabric had to be constructed to fit tightly over the first layers. The pieces were applied similarly to the undercover. The finish fabric was rough cut and draped onto the frame. After shaping and drawing the

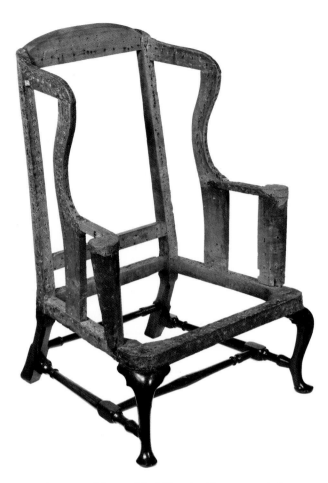

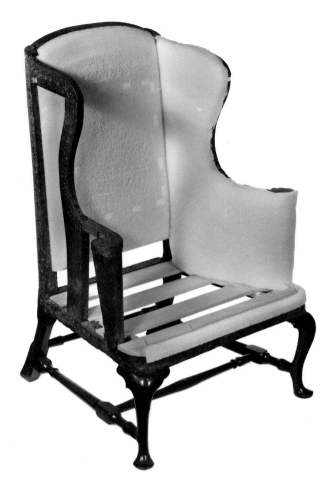

FIG. 2. The exposed frame of the Milwaukee Boston easy chair (cat. 44).

FIG. 3. The Milwaukee Boston easy chair (cat. 44) with 3-in. (7.6-cm) thick blocks of ethafoam fitted to the seat back and the two wing arm units.

fabric into place, the fabric edges were pinned into the ethafoam where possible, securing the cover to the piece to obtain the correct shape. As the various fabric pieces became aligned, they were hand sewn together at the fabric edge, occasionally being secured to the undercover to keep the shape close to the frame. The front rail cover, although separate, was applied in the same way. A 3-in. (7.6-cm) wide piece of sheet aluminum, shaped to fit behind the outside of the arm cone, clamped the adjoining fabrics in that area from the underside as it was screwed into the ethafoam. This provided a clean edge that was secure against the frame. The back-post seams were hand sewn; part of the seams could be removed and replaced for study purposes. Additional blocks of ethafoam were applied

to the underside of the seat rails so the bottom edges of the fabric could be easily secured. A separate down-filled cushion was fitted to the seat deck of the upholstered chair to be covered and trimmed and placed over the Plexiglas deck.

Applying the decorative trim was the final stage of treatment. Silk tape was hand sewn to the edges of the cover, including the cushion, in the same design as found on the Brooklyn chair. The tapes stretching from the cone of the arm wing across the crest rail and down to the opposite cone were padded with cording as in the Brooklyn example. Further embellishment was achieved by duplicating the practice of using white nails to hold the fabric and trim along the lower edges of the frame. This was accomplished by clip-

ping the shank from a tack head similar to a period example and gluing the head to the finish fabric.[3]

This treatment provides a workable option for accurately recreating upholstery on period furniture without compromising the structural integrity of the frame or risking the loss of valuable historical evidence or construction details. Although each object requires its own modifications in a treatment, this process is adaptable to many examples of seating furniture in museum collections. Modern standards of conservation can be met without diminishing the enjoyment of the chair as a luxurious symbol of eighteenth-century comfort.

The technical development of this process was a collaboration between Elizabeth G. Lahikainen, Head Upholstery Conservator, and Joseph Twichell, Furniture Conservator, SPNEA Conservation Center. The author wishes to thank Brock Jobe and Joseph Twichell for their assistance.

1. With minor modifications, this technique would be suitable for pieces that are occasionally used. If constructed properly, ethafoam is strong enough to hold a sitter, but it is not a soft material; therefore, the upholstery is not "comfortable" in the traditional sense.

2. Prolonged exposure to the heat of photo lamps expanded the lower density foam, and when used to span a long distance, such as in a sofa bottom, without additional supports, the foam tends to bow over time.

3. Andrew Passeri and Robert F. Trent discuss the use of white nails in "American Classics #13; More on Easy Chairs," *Maine Antique Digest* (December 1987): 2-B.

# BIBLIOGRAPHY

ADAMS, CHARLES FRANCIS, ed. *The Works of John Adams*. Boston: Little, Brown and Co., 1856.

ANDREWS, CHARLES M., ed. *Some Cursory Remarks Made by James Birket in His Voyage to North America, 1750–1751*. New Haven, Conn.: Yale University Press, 1916.

ARCHER, MICHAEL. "The Dating of Delftware Chargers." *Transactions of the English Ceramics Circle* (London) 2, pt. 2 (1982): 112–21.

AUSTIN, JOHN C., and JOSEPH PETER SPANG. "Historic Deerfield: Ceramics." *Antiques* 127, no. 3 (March 1985): 670–75.

*Baltimore Furniture: The Work of Baltimore and Annapolis Cabinetmakers from 1760 to 1810*. Baltimore, Md.: Baltimore Museum of Art, 1947.

BATTISON, EDWIN A., and PATRICIA E. KANE. *The American Clock, 1725–1865: The Mabel Brady Garvan and Other Collections at Yale University*. Greenwich, Conn.: New York Graphic Society, 1973.

BAUMGARTEN, LINDA. *Eighteenth-Century Clothing at Williamsburg*. Williamsburg, Va.: Colonial Williamsburg Foundation, 1986.

BEASLEY, ELLEN. "Samuel Williamson, Philadelphia Silversmith, 1794–1813." M.A. thesis, University of Delaware, 1964.

BECKERDITE, LUKE. "Philadelphia Carving Shops." Part 1, "James Reynolds." *Antiques* 125, no. 5 (May 1984): 1120–33. Part 2, "Bernard and Jugiez," *Antiques* 128, no. 3 (September 1985): 498–513. Part 3, "Hercules Courtenay and His School." *Antiques* 131, no. 5 (May 1987): 1044–63.

BELDEN, LOUISE CONWAY. *Marks of American Silversmiths in the Ineson-Bissell Collection*. Charlottesville: University Press of Virginia for the Henry Francis du Pont Winterthur Museum, 1980.

BENES, PETER, with assistance from Gregory H. Laing and Wilhelmina V. Lunt. *Old-Town and the Waterside: Two Hundred Years of Tradition and Change in Newbury, Newburyport, and West Newbury, 1635–1835*. Newburyport, Mass.: Historical Society of Old Newbury, 1986.

BENJAMIN, ASHER. *The Builder's Guide*. 1839. Reprint. New York: Da Capo Press, 1974.

BENN, R. DAVIS. *Style in Furniture*. London: Longmans, Green, and Co., 1904.

BEURDELEY, MICHAEL. *Chinese Trade Porcelain*. Rutland, Vt.: Charles E. Tuttle Co., 1962.

BJORK, GORDON C. "The Weaning of the American Economy: Independence, Market Changes, and Economic Development." *Journal of Economic History* 24, no. 4 (December 1964): 541–60.

BLACKBURN, RODERIC H. "Dutch Arts and Culture in Colonial America." *Antiques* 130, no. 1 (July 1986): 140–51.

BLACKBURN, RODERIC H., and RUTH PIWONKA, with an essay on paintings by Mary Black and additional contributions by Charlotte Wilcoxen, Joyce Volk, and Nancy Kelley. *Remembrance of Patria: Dutch Arts and Culture in Colonial America, 1609–1776*. Albany, N. Y.: Publishing Center for Cultural Resources for the Albany Institute of History and Art, 1988.

BOLTON, CHARLES KNOWLES. *Bolton's American Armory*. Baltimore, Md.: Heraldic Book Co., 1964.

*Boston Furniture of the Eighteenth Century*. Publications of the Colonial Society of Massachusetts, vol. 48, edited by Walter Muir Whitehill, Jonathan L. Fairbanks, and Brock W. Jobe. Boston: Colonial Society of Massachusetts, 1974; distributed by University Press of Virginia.

BOYETT, TANYA. "Thomas Handasyd Perkins: An Essay on Material Culture." *Old-Time New England* 70 (1980): 45–62.

BRANYON, LAWRENCE, NEAL FRENCH, and JOHN SANDON. *Worcester Blue and White Porcelain, 1751–1790*. London: Barrie and Jenkins; Westfield, N. J.: Eastview Editions, 1981.

BRETT, KATHERINE B. *English Embroidery*. Ontario: Royal Ontario Museum, 1972.

BRITTON, FRANK. *English Delftware in the Bristol Collection*. London: Sotheby's Publications, 1982.

BRITTON, FRANK. *London Delftware*. London: Jonathan Horne Publications, 1986.

BROWN, MICHAEL K. "Duncan Phyfe." M.A. thesis, University of Delaware, 1978.

BROWN, RICHARD D. "Modernization and the Modern Personality in Early America, 1600–1865: A Sketch of a Synthesis." *Journal of Interdisciplinary History* 2, no. 3 (Winter 1972): 201–28.

BUCKLEY, CHARLES E. "Fine Federal Furniture Attributed to Portsmouth." *Antiques* 83, no. 2 (February 1963): 196–200.

BUHLER, KATHRYN C. *American Silver, 1655–1825, in the Museum of Fine Arts, Boston.* 2 vols. Boston, Mass.: Museum of Fine Arts, Boston, 1972. Distributed by New York Graphic Society.

BUHLER, KATHRYN C. "Some Engraved American Silver: Part I, Prior to 1740." *Antiques* 48, no. 5 (November 1945): 268–71.

BUHLER, KATHRYN C., and GRAHAM HOOD. *American Silver: Garvan and Other Collections in the Yale University Art Gallery.* 2 vols. New Haven, Conn., and London: Yale University Press for the Yale University Art Gallery, 1970.

BULKELEY, HOUGHTON. "A Discovery on the Connecticut Chest." *Connecticut Historical Society Bulletin* 23, no. 1 (January 1958): 17–19.

BURKS, JEAN. *Birmingham Brass Candlesticks.* Charlottesville: University Press of Virginia, 1986.

BURKS, JEAN. "English and Continental Brass Candlesticks." *Antiques* 132, no. 6 (December 1987): 1281–89.

BURR, GRACE HARDENDORFF. *Hispanic Furniture.* New York: The Archive Press, 1964.

BURTON, E. MILBY. *Charleston Furniture, 1700–1825.* Charleston, S. C.: Charleston Museum, 1955.

BUTLER, JOSEPH T. *Candleholders in America, 1650–1900: A Comprehensive Collection of American and European Candle Fixtures Used in America.* New York: Crown Publishers, 1967.

BUTLER, JOSEPH T. *Sleepy Hollow Restorations: A Cross Section of the Collection.* New York: Sleepy Hollow Press, 1983.

CABOT, NANCY GRAVES. "Engravings and Embroideries: The Sources of Some Designs in the Fishing Lady Pictures." *Antiques* 40, no. 6 (December 1941): 367–69.

CABOT, NANCY GRAVES. "Engravings as Pattern Sources." *Antiques* 58, no. 6 (December 1950): 476–81.

CABOT, NANCY GRAVES. "Pattern Sources of Scriptural Subjects in Tudor and Stuart Embroideries." *Bulletin of the Needle and Bobbin Club* 30 (1946): 3–58.

CALDWELL, DESIREE. "Germanic Influences on Philadelphia Early Georgian Seating Furniture." M.A. thesis, University of Delaware, 1985.

CARPENTER, RALPH E., JR. *The Arts and Crafts of Newport, Rhode Island, 1640–1820.* Newport, R. I.: Preservation Society of Newport County, 1954.

CAVALLO, ADOLPH S. *Needlework.* The Smithsonian Illustrated Library of Antiques, edited by Brenda Gilchrist. New York: Cooper-Hewitt Museum, 1979.

CESCINSKY, HERBERT. *English Furniture from Gothic to Sheraton.* Garden City, N. Y.: Garden City Publishing Company, 1937.

CHILD, JOHN LYNN. "Furniture Makers of Rochester, New York." *New York History* 37, no. 1 (January 1956): 97–106.

CHINNERY, VICTOR. *Oak Furniture, the British Tradition: A History of Early Furniture in the British Isles and New England.* Woodbridge, England: Antique Collectors' Club, 1979.

CHIPPENDALE, THOMAS. *The Gentleman & Cabinet-Maker's Director.* 3d ed. London, 1762. Reprint. New York: Dover Publications, 1966.

CLARKE, SAMUEL M. *Worcester Porcelain in the Colonial Williamsburg Collection.* Williamsburg, Va.: Colonial Williamsburg Foundation, 1987.

CLAYTON, MICHAEL. *The Collectors' Dictionary of the Silver and Gold of Great Britain and North America.* New York: World Publishing Co., 1971.

CLUNIE, MARGARET BURKE. "Furniture Craftsmen of Salem, Massachusetts, in the Federal Period." *Essex Institute Historical Collections* 113, no. 3 (July 1977): 191–203.

CLUNIE, MARGARET BURKE. "Joseph True and the Piecework System in Salem." *Antiques* 111, no. 5 (May 1977): 1006–13.

CLUNIE, MARGARET BURKE, ANNE FARNAM, and ROBERT F. TRENT. *Furniture at the Essex Institute.* Salem, Mass.: Essex Institute, 1980.

COMMAGER, HENRY STEELE. *The Empire of Reason.* Garden City, N.Y.: Anchor Press, 1977.

COMSTOCK, HELEN. *American Furniture: Seventeenth, Eighteenth, and Nineteenth Century Styles.* New York: Viking Press, 1962.

COMSTOCK, HELEN. "The Collection of Dr. William S. Serri." *Antiques* 71, no. 3 (March 1957): 256–57.

COMSTOCK, HELEN. *The Looking Glass in America.* New York: Viking Press, 1964.

CONGER, CLEMENT E., and JANE W. POOL. "Some Eagle-Decorated Furniture at the Department of State." *Antiques* 105, no. 5 (May 1974): 1072–81.

COOKE, EDWARD S., JR. "Boston Clothespresses of the Mid-Eighteenth Century." *Journal of the Museum of Fine Arts, Boston* 1 (1989): 75–95.

COOKE, EDWARD S., JR. "Domestic Space in the Federal Period." *Essex Institute Historical Collections* 116, no. 4 (October 1980): 248–64.

COOKE, EDWARD S., JR. "The Warland Chest: Early Georgian Furniture in Boston." *Maine Antique Digest* (March 1987): 10C–13C.

COOKE, EDWARD S., JR., ed. *Upholstery in America and Europe from the Seventeenth Century to World War I.* New York: W. W. Norton and Co., 1987.

COOPER, WENDY A. "The Furniture and Furnishings of the Farm at Danvers." *Bulletin of the Museum of Fine Arts, Boston* 81 (1983): 24–45.

COOPER, WENDY A. *In Praise of America: American Decorative Arts, 1650–1830/Fifty Years of Discovery since the 1929 Girl Scouts Loan Exhibition.* New York: Alfred A. Knopf, 1980.

CORNELIUS, CHARLES O. "Two American Mantelpieces." *Bulletin of the Metropolitan Museum of Art* 14, no. 2 (March 1919): 36–37.

CUMMIN, HAZEL E. "A Willard Clock of Unusual Interest." *Antiques* 16, no. 1 (July 1929): 46–47.

CUMMINGS, ABBOTT LOWELL, ed. *Rural Household Inventories: Establishing the Names, Uses, and Furnishings of Rooms in the Colonial New England Home, 1675–1775.* Boston, Mass.: Society for the Preservation of New England Antiquities, 1964.

CURRIE, ELIZABETH M., and CONRAD WRIGHT. "New York and the China Trade." *Antiques* 125, no. 2 (February 1984): 438–43.

DAVIDSON, MARSHALL B. *The American Heritage History of Colonial Antiques.* New York: American Heritage Publishing Co., 1967.

DAVIS, JOHN D. *English Silver at Williamsburg.* Williamsburg, Va.: Colonial Williamsburg Foundation, 1976.

DELHOM, M. MELLANAY. *The Delhom Gallery Guide: English Pottery.* Charlotte, N. C.: Mint Museum, 1982.

DELORME, ELEANORE P. "James Swan's French Furniture." *Antiques* 107, no. 3 (March 1975): 452–61.

DEL PUGLIA, RAFFAELLA, and CARLO STEINER. *Mobili e Ambienti Italiani dal gotico al floreale.* 2 vols. Milan: Bramante Editrice, 1963.

*The Dictionary of English Furniture Makers, 1660–1840.* Edited by Geoffrey Beard and Christopher Gilbert. London: W.S. Maney and Sons for the Furniture History Society, 1986.

DISTIN, WILLIAM H., and ROBERT BISHOP. *The American Clock: A Comprehensive Pictorial Survey, 1723–1900, with a Listing of 6,153 Clockmakers.* New York: E. P. Dutton, 1976. Reprint. New York: Bonanza Books, 1983.

DOW, GEORGE FRANCIS, comp. *The Arts and Crafts in New England, 1704–1775.* Topsfield, Mass.: Wayside Press, 1927. Reprint. New York: Da Capo Press, 1967.

DOWNING, ANTOINETTE F., and VINCENT J. SCULLY, JR. *The Architectural Heritage of Newport, Rhode Island, 1640–1915.* 2d rev. ed. New York: Bramhall House, 1967.

DOWNS, JOSEPH. *American Furniture: Queen Anne and Chippendale Periods in the Henry Francis du Pont Winterthur Museum.* New York: Macmillan Company, 1952.

DOWNS, JOSEPH. "The Furniture of Goddard and Townsend." *Antiques* 52, no. 6 (December 1947): 427–31.

DRURY, MARTIN. "Early Eighteenth-Century Furniture at Erddig." *Apollo* 108, no. 197 (July 1978): 46–55.

ECKHARDT, GEORGE H. *Pennsylvania Clocks and Clockmakers: An Epic of Early American Science, Industry, and Craftsmanship.* New York: Bonanza Books, 1955.

EDWARDS, RALPH, and MARGARET JOURDAIN. *Georgian Cabinet-Makers, c. 1700–1800.* 3d rev. ed. London: Country Life, 1955.

ELDER, WILLIAM VOSS, III, and JAYNE E. STOKES, with the assistance of Lu Bartlett, Ann V. Christie, Audrey Frantz, Faith M. Holland, and M. B. Munford. *American Furniture 1680–1880 from the Collection of the Baltimore Museum of Art.* Baltimore, Md.: Baltimore Museum of Art, 1987.

ELLSWORTH, ROBERT HATFIELD. *Chinese Furniture: Hardwood Examples of the Ming and Early Ch'ing Dynasties.* New York: Random House, 1971.

EMBURY, AYMAR, III. "A Comparative Study of a Group of Early American Doorways." *White Pine Series of Architectural Monographs* 7 (April 1921): 3–13; 7 (October 1921): 3–13.

ENSKO, STEPHEN G. C. *American Silversmiths and Their Marks III.* New York: Privately printed for Robert Ensko, Inc., 1948.

EVANS, NANCY GOYNE. "Design Sources for Windsor Furniture: Part I, The Eighteenth Century." *Antiques* 133, no. 1 (January 1988): 282–97.

EVANS, NANCY GOYNE. "The Genealogy of a Bookcase Desk." In *Winterthur Portfolio 9,* edited by Ian M. G. Quimby, pp. 213–22. Charlottesville: University Press of Virginia for the Henry Francis du Pont Winterthur Museum, 1974.

EVANS, NANCY GOYNE. "A History and Background of English Windsor Furniture." *Furniture History* 15 (1979): 24–53.

FAILEY, DEAN F., with the assistance of Robert J. Hefner and Susan E. Klaffky. *Long Island Is My Nation: The Decorative Arts and Craftsmen, 1640–1830.* Setauket, N. Y.: Society for the Preservation of Long Island Antiquities, 1976.

FAIRBANKS, JONATHAN L., and ELIZABETH BIDWELL BATES. *American Furniture, 1620 to the Present.* New York: Richard Marek, 1981.

FAIRBANKS, JONATHAN L., WENDY A. COOPER, ANNE FARNAM, BROCK W. JOBE, and MARTHA B. KATZ-HYMAN. *Paul Revere's Boston: 1735–1818.* Boston, Mass.: Museum of Fine Arts, Boston, 1975.

FAIRBANKS, JONATHAN L., and ROBERT F. TRENT. *New England Begins: The Seventeenth Century.* 3 vols. Boston, Mass.: Museum of Fine Arts, Boston, 1982. Vol. 1, *Introduction: Migration and Settlement;* vol. 2, *Mentality and Environment;* vol. 3, *Style.*

FALES, DEAN A., JR. *Essex County Furniture: Documented Treasures from Local Collections, 1660–1860.* Salem, Mass.: Essex Institute, 1965.

FALES, DEAN A., JR. *The Furniture of Historic Deerfield.* New York: E.P. Dutton, 1976.

FALES, MARTHA GANDY. *American Silver in the Henry Francis du Pont Winterthur Museum.* Winterthur, Del.: Henry Francis du Pont Winterthur Museum, 1958.

FALES, MARTHA GANDY. *Early American Silver for the Cautious Collector.* New York: Funk and Wagnalls, 1970.

FALES, MARTHA GANDY. *Joseph Richardson and Family, Philadelphia Silversmiths.* Middletown, Conn.: Wesleyan University Press for the Historical Society of Pennsylvania, 1974.

FENNIMORE, DONALD L. "Metalwork." *American Art Journal* 7, no. 1 (May 1975): 93–106.

FITCHEN, JOHN. *Building Construction before Mechanization.* Cambridge, Mass.: MIT Press, 1986.

FLANIGAN, J. MICHAEL, with introductory essays by Wendy A. Cooper, Morrison H. Heckscher, and Gregory R. Weidman. *American Furniture from the Kaufman Collection.* Washington, D. C.: National Gallery of Art, 1986.

FLYNT, HENRY N., and MARTHA GANDY FALES. *The Heritage Foundation Collection of Silver, with Biographical Sketches of New England Silversmiths, 1625–1825.* Old Deerfield, Mass.: Heritage Foundation, 1968.

FORMAN, BENNO M. *American Seating Furniture, 1630–1730: An Interpretive Catalogue.* New York: W. W. Norton and Co., 1988.

FORMAN, BENNO M. "The Chest of Drawers in America, 1635–1730: The Origin of the Joined Chest of Drawers." *Winterthur Portfolio* 20, no. 1 (Spring 1985): 1–30.

FORMAN, BENNO M. "Delaware Valley 'Crookt Foot' and Slat-Back Chairs: The Fussell-Savery Connection." *Winterthur Portfolio* 15, no. 1 (Spring 1980): 41–64.

FORMAN, BENNO M. "Furniture for Dressing in Early America, 1650–1730." *Winterthur Portfolio* 22, nos. 2/3 (Summer/Autumn 1987): 149–64.

FORMAN, BENNO M. "Mill Sawing in 17th-Century Massachusetts." *Old-Time New England* 60, no. 4 (April/June 1970): 110–30.

FORMAN, BENNO M. "The Origins of the Joined Chest of Drawers." *Nederlands Kunsthistorisch Jaarboek* 31 (1981): 169–83.

FOWLER, JOHN, and JOHN CORNFORTH. *English Decoration in the 18th Century.* Princeton, N.J.: Pyne Press, 1974.

FOX, PAMELA. "Nathan Appleton's Beacon Street Houses." *Old-Time New England* 70 (1980): 111–24.

FRASER, ESTHER STEVENS. "A Pedigreed Lacquered Highboy." *Antiques* 15, no. 5 (May 1929): 398–401.

*Frederick K. and Margaret R. Barbour's Furniture Collection.* Hartford: Connecticut Historical Society, 1963.

GARNER, F. H., and MICHAEL ARCHER. *English Delftware.* London: Faber and Faber, 1972.

GARRETT, ELIZABETH DONAGHY. "American Furniture in the DAR Museum." *Antiques* 109, no. 4 (April 1976): 750–59.

GARRETT, ELIZABETH DONAGHY. "The American Home: Part IV, The Dining Room." *Antiques* 126, no. 4 (October 1984): 910–22.

GARRETT, WENDELL D. "French Decorative Arts in America." *Antiques* 135, no. 3 (March 1989): 696–707.

GARRETT, WENDELL D. "The Goddard and Townsend Joiners of Newport: Random Biographical and Bibliographical Notes." *Antiques* 121, no. 5 (May 1982): 1153–55.

GARRETT, WENDELL D. "John Adams and the Limited Role of the Fine Arts." In *Winterthur Portfolio One,* pp. 243–55. Winterthur, Del.: Henry Francis du Pont Winterthur Museum, 1964.

GARRETT, WENDELL D. "Providence Cabinetmakers, Chairmakers, Upholsterers, and Allied Craftsmen, 1756–1838." *Antiques* 90, no. 4 (October 1966): 514–19.

GARVAN, BEATRICE B. *Federal Philadelphia, 1785–1825: The Athens of the Western World.* Philadelphia: Philadelphia Museum of Art, 1987.

GARVIN, JAMES L., DONNA-BELLE GARVIN, and JOHN F. PAGE. *Plain and Elegant, Rich and Common: Documented New Hampshire Furniture, 1750–1850.* Concord: New Hampshire Historical Society, 1979.

GENTLE, RUPERT, and RACHEL FEILD. *English Domestic Brass, 1680–1810, and the History of Its Origins.* New York: E. P. Dutton, 1975.

GIBBS, JAMES W. *Pennsylvania Clocks and Watches: Antique Timepieces and Their Makers.* University Park: Pennsylvania State University Press, 1984.

GIFFEN, JANE C. "New Hampshire Cabinetmakers and Allied Craftsmen, 1790–1850: A Checklist." *Antiques* 94, no. 1 (July 1968): 78–87.

GILBERT, CHRISTOPHER. *Furniture at Temple Newsam House and Lotherton Hall.* 2 vols. Leeds, England: National Arts Collections Fund and the Leeds Art Collections Fund, 1978.

GILBERT, CHRISTOPHER. "Newly-Discovered Furniture by William Hallett." *Connoisseur* 157, no. 634 (December 1964): 224–25.

[*Girl Scouts Loan Exhibition*]. *Loan Exhibition of Eighteenth and Nineteenth Century Furniture and Glass.* New York: American Art Galleries, 1929.

GOLDSTEIN, ROSALIE, ed. *Milwaukee Art Museum: Guide to the Permanent Collection.* Milwaukee, Wis.: Milwaukee Art Museum, 1986.

GOLDWEITZ, HARRIET CARLTON. "An American Collection of English Pottery: A Chronology, 1635–1778." *Transactions of the English Ceramics Circle* (London) 12, pt. 1 (1984): 8–25.

GORDON, ELINOR. *Collecting Chinese Export Porcelain.* New York: Universe Books, The Main Street Press, 1977.

*The Great River: Art and Society of the Connecticut Valley, 1635–1820.* Edited by William N. Hosley, Jr., and Gerald W.R. Ward. Hartford, Conn.: Wadsworth Atheneum, 1985.

GREENLAW, BARRY A. *New England Furniture at Williamsburg.* Williamsburg, Va.: Colonial Williamsburg Foundation, 1974.

GREY, AMY ELIZABETH. "Fanlights and 'Good Style' in Providence, Rhode Island, 1790–1800." Unpublished research paper, John Nicholas Brown Center for the Study of American Civilization, Providence, Rhode Island, 1988.

GRIMWADE, ARTHUR. *London Goldsmiths, 1697–1837.* London: Faber and Faber, 1976.

GUSLER, WALLACE B. *Furniture of Williamsburg and Eastern Virginia, 1710–1790.* Richmond: Virginia Museum, 1979.

HACKENBROCH, YVONNE. *English and Other Needlework in the Irwin Untermyer Collection.* London: Thames and Hudson, 1960.

HAMMOND, CHARLES A., and STEPHEN A. WILBUR. *Gay and Graceful Style: A Catalogue of Objects Associated with Christopher and Rebecca Gore.* Waltham, Mass.: Gore Place Society, 1982.

HANKS, DAVID A. "American Silver at the Art Institute of Chicago." *Antiques* 98, no. 3 (September 1970): 418–22.

HANLEY, HOPE. *Needlework Styles for Period Furniture.* New York: Charles Scribner's Sons, 1978.

HART, GEORGE. *A Dictionary of Egyptian Gods and Goddesses.* London: Routledge and Kegan Paul, 1986.

HECKSCHER, MORRISON H. *American Furniture in the Metropolitan Museum of Art.* Vol. 2, *Late Colonial Period: The Queen Anne and Chippendale Styles.* New York: Metropolitan Museum of Art and Random House, 1985.

HECKSCHER, MORRISON H. *In Quest of Comfort: The Easy Chair in America.* New York: Metropolitan Museum of Art, 1971.

HECKSCHER, MORRISON H. "John Townsend's Block-and-Shell Furniture." *Antiques* 131, no. 5 (May 1982): 1144–52.

HECKSCHER, MORRISON H., FRANCES GRUBER SAFFORD, and PETER LAWRENCE FODERA. "Boston Japanned Furniture in the Metropolitan Museum of Art." *Antiques* 129, no. 5 (May 1986): 1046–67.

HERBERT, ROBERT. "Neo-Classicism and the French Revolution." In *The Age of Neo-Classicism*, pp. lxxii–lxxv. London: Arts Council of Great Britain, 1972.

HEWITT, BENJAMIN A., PATRICIA E. KANE, and GERALD W.R. WARD. *The Work of Many Hands: Card Tables in Federal America, 1790–1820.* New Haven, Conn.: Yale University Art Gallery, 1982.

HILDYARD, ROBIN. *Browne Muggs: English Brown Stoneware.* London: Victoria and Albert Museum, 1985.

HINCKLEY, F. LEWIS. *A Directory of Queen Anne, Early Georgian, and Chippendale Furniture, Establishing the Preeminence of the Dublin Craftsmen.* New York: Crown Publishers, 1971.

HINCKLEY, F. LEWIS. *Queen Anne and Georgian Looking Glasses.* New York: Washington Mews, 1987.

HINDES, RUTHANNA. *Reflections in Silver: Rockwood Remembered.* Wilmington, Del.: Rockwood Museum, 1979.

HIPKISS, EDWIN J. *Eighteenth-Century American Arts: The M. and M. Karolik Collection of Paintings, Drawings, Engravings, Furniture, Silver, Needlework & Incidental Objects Gathered to Illustrate the Achievements of American Artists and Craftsmen of the Period from 1720 to 1820.* Cambridge, Mass.: Harvard University Press for the Museum of Fine Arts, Boston, 1941.

HOADLEY, R. BRUCE. *Understanding Wood: A Craftsman's Guide to Wood Technology.* Newtown, Conn.: Taunton Press, 1980.

HOLLAND, MARGARET. *Silver: An Illustrated Guide to American and British Silver.* London: Octopus Books, 1973.

HOOD, GRAHAM. *American Silver: A History of Style, 1650–1900.* New York: Praeger, 1971.

HOPKINS, THOMAS SMITH, and WALTER SCOTT COX, comps. *Colonial Furniture of West New Jersey.* Haddonfield, N.J.: Historical Society of Haddonfield, 1936.

HORNE, JONATHAN. *A Catalogue of English Brown Stoneware.* London: Jonathan Horne, 1985.

HORNOR, WILLIAM MACPHERSON, JR. *Blue Book, Philadelphia Furniture: William Penn to George Washington.* 1935. Reprint. Washington, D.C.: Highland House, 1977.

HOSLEY, WILLIAM N., JR., and PHILIP ZEA. "Decorated Board Chests of the Connecticut River Valley." *Antiques* 119, no. 5 (May 1981): 1146–51.

HOWE, DANIEL WALKER. *The Unitarian Conscience: Harvard Moral Philosophy, 1805–1861.* Cambridge, Mass.: Harvard University Press, 1970.

HUGHES, THERLE. *English Domestic Needlework, 1660–1860.* New York: Macmillan Co., 1961.

HUMMEL, CHARLES F. *A Winterthur Guide to American Chippendale Furniture: Middle Atlantic and Southern Colonies.* New York: Crown, 1976.

HUSHER, R. W., and W. W. WELCH. *A Study of Simon Willard's Clocks.* Nahant, Mass.: By the authors, 1980.

[HUTCHINS, LEVI]. *The Autobiography of Levi Hutchins: With a Preface, Notes, and Addenda, by His Youngest Son.* Cambridge, Mass.: Riverside Press, 1865.

INCE, WILLIAM, and JOHN MAYHEW. *The Universal System of Household Furniture*. London, 1762. Reprint. London: Alex Tiranti, 1960.

IRWIN, JOHN. "Origins of the 'Oriental Style' in English Decorative Art." *Burlington Magazine* 97 (April 1955): 106–14.

IVERSON, MARION DAY. "The Bed Rug in Colonial America." *Antiques* 85, no. 1 (January 1964): 107–9.

JACKSON, CHARLES JAMES. *English Goldsmiths and Their Marks*. 2d ed. London, 1921. Reprint. New York: Dover Publications, 1964.

JOBE, BROCK W. "A Desk by Benjamin Frothingham." *Currier Gallery of Art Bulletin* (1976): 3–23.

JOBE, BROCK W., and MYRNA KAYE. *New England Furniture, the Colonial Era: Selections from the Collection of the Society for the Preservation of New England Antiquities*. Boston: Houghton Mifflin, 1985.

JOHN, WILLIAM DAVID, and KATHERINE COOMBES. *Paktong: The Non-Tarnishable Chinese "Silver" Alloy Used for Adam Firegrates and Early Georgian Candlesticks*. Newport, England: Ceramic Book Co., 1970.

JOHNSTONE, PAULINE. *Three Hundred Years of Embroidery, 1600–1900: Treasures from the Collection of the Embroiderers' Guild of Great Britain*. South Australia: Wakefield Press, 1986.

JONES, KAREN M. "American Furniture in the Milwaukee Art Center." *Antiques* 111, no. 5 (May 1977): 974–83.

JONES, KAREN M. "Museum Accessions." *Antiques* 107, no. 5 (May 1975): 828.

JOURDAIN, MARGARET A. *The History of English Secular Embroidery*. London: Kegan Paul, Trench, Trubner and Co., 1910.

KAMMEN, MICHAEL R. *A Season of Youth: The American Revolution and the Historical Imagination*. New York: Alfred A. Knopf, 1978.

KANE, PATRICIA E. "The Joiners of Seventeenth-Century Hartford County." *Connecticut Historical Society Bulletin* 35, no. 3 (July 1970): 65–85.

KANE, PATRICIA E. *300 Years of American Seating Furniture: Chairs and Beds from the Mabel Brady Garvan and Other Collections at Yale University*. Boston: New York Graphic Society, 1976.

KAUFFMAN, HENRY J. *American Copper and Brass*. Camden, N.J.: Thomas Nelson, 1968. Reprint. New York: Bonanza Books, 1979.

KAUFFMAN, HENRY J. *The American Fireplace*. Nashville, Tenn., and New York: Thomas Nelson, 1972.

KAUFFMAN, HENRY J., and QUENTIN H. BOWERS. *Early American Andirons and Other Fireplace Accessories*. Nashville, Tenn., and New York: Thomas Nelson, 1974.

KENDRICK. A. F. *English Needlework*. London: A. & C. Black, 1933.

KENNEDY, ROGER G. *Orders from France: The Americans and the French in a Revolutionary World, 1780–1820*. New York: Alfred A. Knopf, 1989.

KIDDELL, A. J. B. "Wrotham Slipware and the Wrotham Brickyard." *Transactions of the English Ceramics Circle* (London) 3, pt. 2 (1954): 105–18.

KIRK, JOHN T. *American Chairs, Queen Anne and Chippendale*. New York: Alfred A. Knopf, 1972.

KIRK, JOHN T. *American Furniture and the British Tradition to 1830*. New York: Alfred A. Knopf, 1982.

KIRK, JOHN T. *Connecticut Furniture, Seventeenth and Eighteenth Centuries*. Hartford, Conn.: Wadsworth Atheneum, 1967.

KOLTER, JANE BENTLEY, ed. *Early American Silver and Its Makers*. New York: Mayflower Books, 1979.

KREISEL, HEINRICH. *Die Kunst des deutschen Mobels—Erster Band von den Anfangen bis zum Hochbarock*. Munich: Verlag C. H. Beck, 1968.

LAIDLAW, CHRISTINE WALLACE. "'Silver by the Dozen': The Wholesale Business of Teunis D. DuBois." *Winterthur Portfolio* 23, no. 1 (Spring 1988): 25–50.

LAWTON, MRS. JAMES M. "The Emblematical Flower and Distinguishing Color of the Huguenots." *Proceedings of the Huguenot Society of America* 2 (1894): 237–45.

LEVY, BERNARD, and S. DEAN LEVY, INC. "*Opulence and Splendor*": *The New York Chair, 1690–1830*. New York: By the gallery, 1984.

LIPSKI, LOUIS L., and MICHAEL ARCHER. *Dated English Delftware: Tin-Glazed Earthenware, 1600–1800*. London: Sotheby's Publications, 1984.

LITTLE, ELBERT L. *Checklist of United States Trees (Native and Naturalized)*. United States Department of Agriculture Handbook no. 541. Washington, D. C.: United States Government Printing Office, 1979.

LITTLE, NINA FLETCHER. *Little by Little: Six Decades of Collecting American Decorative Arts*. New York: E. P. Dutton, 1984.

"Living with Antiques: The Connecticut Home of Mr. and Mrs. Louis L. Davis." *Antiques* 51, no. 5 (May 1947): 313–15.

LOCKWOOD, LUKE VINCENT. *Colonial Furniture in America*. New York: Charles Scribner's Sons, 1901.

LYNES, WILSON. "Slat-Back Chairs of New England and the Middle Atlantic States." *Antiques* 24, no. 6 (December 1933): 208–10; 25, no. 3 (March 1934): 104–7.

LYON, IRVING W. *The Colonial Furniture of New England: A Study of the Domestic Furniture in Use in the Seventeenth and Eighteenth Centuries*. 1891. 1892. 1925. Reprint. New York: E. P. Dutton, 1977.

MCCLELLAND, NANCY. *Duncan Phyfe and the English Regency, 1795–1830*. New York: Willard R. Scott, 1939. Reprint. New York: Dover Publications, 1980.

MCELROY, CATHRYN J. "Furniture of the Philadelphia Area: Forms and Craftsmen before 1730." M.A. thesis, University of Delaware, 1970.

MCKEARIN, GEORGE. "Wistarburg and South Jersey Glass." *Antiques* 9, no. 4 (October 1926): 274–80.

MCKEARIN, GEORGE S., and HELEN MCKEARIN. *American Glass.* New York: Crown Publishers, 1941.

MCKEARIN, HELEN, and GEORGE S. MCKEARIN. *Two Hundred Years of American Blown Glass.* New York: Crown Publishers, 1949.

MCKENDRICK, NEIL, JOHN BREWER, and J. H. PLUMB. *The Birth of a Consumer Society: The Commercialization of Eighteenth-Century England.* Bloomington: Indiana University Press, 1982.

MACQUOID, PERCY. *A History of English Furniture.* 4 vols. London: Lawrence and Bullen, 1904–8.

MACQUOID, PERCY, and RALPH EDWARDS. *The Dictionary of English Furniture.* 3 vols. 2d rev. ed. London: Country Life, 1954.

MAYER-THURMAN, CHRISTA C. *Masterpieces of Western Textiles from the Art Institute of Chicago.* Chicago: Art Institute of Chicago, 1969.

MICHAELIS, RONALD F. *Old Domestic Base-Metal Candlesticks from the 13th to the 19th Century Produced in Bronze, Brass, Paktong, and Pewter.* Woodbridge, England: Antique Collectors' Club, 1978.

MILES, ELIZABETH B. *English Silver: The Elizabeth B. Miles Collection.* Hartford, Conn.: Wadsworth Atheneum, 1976.

MILLER, EDGAR G., JR. *American Antique Furniture: A Book for Amateurs.* 2 vols. 1937. Reprint. New York: Dover Publications, 1966.

MONAHON, ELEANOR BRADFORD. "The Rawson Family of Cabinetmakers in Providence, Rhode Island." *Antiques* 118, no. 6 (July 1980): 134–47.

MONKHOUSE, CHRISTOPHER P., and THOMAS S. MICHIE, with the assistance of John M. Carpenter. *American Furniture in Pendleton House.* Providence, R. I.: Museum of Art, Rhode Island School of Design, 1986.

MONTGOMERY, CHARLES F. *American Furniture: The Federal Period in the Henry Francis du Pont Winterthur Museum.* New York: Viking Press, 1966.

MONTGOMERY, CHARLES F. "Tambour Desks and the Work of William Appleton of Salem." In *The Walpole Society Note Book 1965,* pp. 44–47. Printed for the Walpole Society, 1966.

MONTGOMERY, CHARLES F., and PATRICIA E. KANE, eds. *American Art: 1750–1800, Towards Independence.* Boston: New York Graphic Society, 1976.

MONTGOMERY, FLORENCE M. "A Pattern-Woven 'Flamestitch' Fabric." *Antiques* 80, no. 5 (November 1961): 453–55.

MONTGOMERY, FLORENCE M. "A Set of English Crewelwork Bed Hangings." *Antiques* 115, no. 2 (February 1979): 330–41.

MONTGOMERY, FLORENCE M. *Textiles in America, 1650–1870.* New York: W. W. Norton and Co., 1984.

MOORE, NICHOLAS. "A Chester Cabinet Maker's Specification Book." *Regional Furniture* 1 (1987): 76–77.

MORSE, FRANCES CLARY. *Furniture of the Olden Time.* 2d ed. New York: Macmillan Co., 1926.

MORSE, JOHN D., ed. *Country Cabinetwork and Simple City Furniture.* Charlottesville: University Press of Virginia for the Henry Francis du Pont Winterthur Museum, 1970.

MOSES, MICHAEL. *Master Craftsmen of Newport: The Townsends and Goddards.* Tenafly, N. J.: MMI Americana Press, 1984.

MUDGE, JEAN MCCLURE. *Chinese Export Porcelain in North America.* New York: Clarkson N. Potter, 1986.

MULLIN, ROBERT BRUCE, ed. *Moneygripe's Apprentice: The Personal Narrative of Samuel Seabury III.* New Haven, Conn.: Yale University Press, 1989.

MUSEUM OF OUR NATIONAL HERITAGE. *Unearthing New England's Past: The Ceramic Evidence.* Lexington, Mass.: Museum of Our National Heritage, 1984.

NASH, GARY B. *The Urban Crucible: Social Change, Political Consciousness, and the Origins of the American Revolution.* Cambridge, Mass.: Harvard University Press, 1979.

NEVINSON, JOHN L. *Catalogue of English Domestic Embroidery.* 1938. Reprint. London: Victoria and Albert Museum, 1950.

NEVINSON, JOHN L. "English Domestic Embroidery Patterns of the Sixteenth and Seventeenth Centuries." *Walpole Society* 28 (1939–40): 1–13.

NEVINSON, JOHN L. "Peter Stent and John Overton, Publishers of Embroidery Designs." *Apollo* 24, no. 143 (November 1936): 279–83.

*New England Furniture: Essays in Memory of Benno M. Forman.* Boston: Society for the Preservation of New England Antiquities, 1987. [Published as *Old-Time New England,* vol. 72, serial number 259.]

NEWLANDS, JAMES. *The Carpenter and Joiner's Assistant.* London: Blackie and Son, 1880.

NICHOLS, SARAH C. "Furniture Made by Gillow and Company for Workington Hall." *Antiques* 127, no. 6 (June 1985): 1352–59.

NOËL HUME, IVOR. *Early English Delftware from London and Virginia.* Williamsburg, Va.: Colonial Williamsburg Foundation, 1977.

NORTON, MALCOLM A. "More Light on the Block-Front." *Antiques* 3, no. 2 (February 1923): 63–66.

NUTTING, WALLACE. *Furniture of the Pilgrim Century, 1620–1720, Including Colonial Utensils and Hardware.* Boston: Marshall Jones Co., 1921

NUTTING, WALLACE. *Furniture of the Pilgrim Century (of American Origin), 1620–1720, with Maple and Pine to 1800, Including Colonial Utensils and Wrought-Iron House Hardware into the Nineteenth Century.* Rev. and enl. ed. Framingham, Mass.: Old America Co., 1924.

NUTTING, WALLACE. *Furniture Treasury (Mostly of American Origin): All Periods of American Furniture with Some Foreign Examples in America, also American Hardware and Household Utensils.* (Vol. 3 subtitled, *Being a Record of Designers, Details of Designs and Structure, with Lists of Clock Makers in America, and a Glossary of Furniture Terms, Richly Illustrated.*) 3 vols. Framingham, Mass.: Old America Co., 1928–33.

NUTTING, WALLACE. *A Windsor Handbook.* Framingham and Boston, Mass.: Old America Co., 1917.

ODORN, WILLIAM M. *A History of Italian Furniture.* 2 vols. New York: Doubleday, Page and Co., 1918.

OMAN, CHARLES. *English Silversmiths' Work, Civil and Domestic.* London: Victoria and Albert Museum, 1965.

ORMSBEE, THOMAS H. *The Windsor Chair.* New York: Hearthside Press, 1962.

OSWALD, ADRIAN, R. J. C. HILDYARD, and R. G. HUGHES. *English Brown Stoneware, 1670–1900.* London: Faber and Faber, 1982.

OTT, JOSEPH K. "John Innes Clark and His Family: Beautiful People in Providence." *Rhode Island History* 32, no. 4 (Fall 1973): 123–32.

OTT, JOSEPH K., ed. *The John Brown House Loan Exhibition of Rhode Island Furniture, Including Some Notable Portraits, Chinese Export Porcelain, and Other Items.* Providence: Rhode Island Historical Society, 1965.

OTTO, CELIA JACKSON. "The Secretary with the Tambour Cartonnier." *Antiques* 77, no. 4 (April 1960): 378–81.

PALARDY, JEAN. *The Early Furniture of French Canada.* Translated by Eric McLean. 1963. 2d ed., 1971. Toronto: Macmillan of Canada, 1978.

PALMER, ARLENE M. *A Winterthur Guide to Chinese Export Porcelain.* New York: Crown Publishers, 1976.

PARKER, ROZSIKA. *The Subversive Stitch: Embroidery and the Making of the Feminine.* 1984. Reprint. London: Women's Press, 1986.

PARSONS, CHARLES S. *New Hampshire Clocks and Clockmakers.* Exeter, N. H.: Adams Brown Co., 1976.

PASSERI, ANDREW, and ROBERT F. TRENT. "A New Model Army of Cromwellian Chairs." *Maine Antique Digest* (September 1986): 10C–16C.

PEDRINI, AUGUSTO. *Il Mobilio gli Ambienti e le Decorazioni del Rinascimento in Italia.* Florence: Azienda Libraria Editoriale Fiorentina, 1948.

PHILADELPHIA MUSEUM OF ART. *Philadelphia: Three Centuries of American Art.* Philadelphia: Philadelphia Museum of Art, 1976.

PHILLIPS, JOHN MARSHALL. *American Silver.* New York: Chanticleer Press, 1949.

PIERSON, WILLIAM H., JR. *American Buildings and Their Architects: The Colonial and Neo-Classical Styles.* Garden City, N. Y.: Anchor Books, 1976.

POESCH, JESSIE J. *Early Furniture of Louisiana.* New Orleans: Lousiana State Museum, 1972.

PREST, JOHN. *The Garden of Eden.* New Haven, Conn.: Yale University Press, 1981.

PRIME, ALFRED COXE, comp. *The Arts and Crafts in Philadelphia, Maryland, and South Carolina: Gleanings from Newspapers.* Part 1, *1721–1785.* 1929. Reprint. New York: Da Capo Press, 1969. Part 2, *1786–1800.* The Walpole Society, 1932.

PUIG, FRANCIS J., and MICHAEL CONFORTI, eds. *The American Craftsman and the European Tradition, 1620–1820.* Minneapolis: Minneapolis Institute of Arts, 1989. Distributed by University Press of New England.

QUIMBY, IAN M.G., ed. *American Furniture and Its Makers: Winterthur Portfolio 13.* Chicago: University of Chicago Press for the Henry Francis du Pont Winterthur Museum, 1979.

QUIMBY, IAN M.G., ed. *American Painting to 1776: A Reappraisal.* Charlottesville: University Press of Virginia for the Henry Francis du Pont Winterthur Museum, 1971.

QUIMBY, IAN M.G., ed. *Arts of the Anglo-American Community in the Seventeenth Century.* Charlottesville: University Press of Virginia for the Henry Francis du Pont Winterthur Museum, 1975.

QUINAN, JACK. "Daniel Raynerd, Stucco Worker." *Old-Time New England* 65, nos. 3–4 (Winter-Spring 1975): 1–21.

RACKHAM, BERNARD. *Catalogue of the Glaisher Collection of Pottery and Porcelain in the Fitzwilliam Museum, Cambridge.* Cambridge, England: At the University Press, 1935.

RANDALL, RICHARD H., JR. *American Furniture in the Museum of Fine Arts, Boston.* Boston: Museum of Fine Arts, Boston, 1965.

RANDALL, RICHARD H., JR. "Boston Chairs." *Old-Time New England* 54, no. 1 (July 1963): 12–20.

RAY, ANTHONY. *English Delftware Pottery in the Robert Hall Warren Collection, Ashmolean Museum, Oxford.* Boston: Boston Book and Art Shop, 1968.

REMINGTON, PRESTON. *English Domestic Needlework.* New York: Metropolitan Museum of Art, 1943.

RHOADES, ELIZABETH, and BROCK W. JOBE. "Recent Discoveries in Boston Japanned Furniture." *Antiques* 105, no. 5 (May 1974): 1082–91.

RICE, NORMAN S. *New York Furniture before 1840 in the Collection of the Albany Institute of History and Art.* Albany, N. Y.: Albany Institute of History and Art, 1962.

RING, BETTY. "The Balch School in Providence, Rhode Island." *Antiques* 107, no. 4 (April 1975): 660–71.

RING, BETTY. *Let Virtue Be A Guide to Thee*. Providence: Rhode Island Historical Society, 1983.

ROBINSON, ALBERT G. *Old New England Doorways*. New York: Charles Scribner's Sons, 1920.

ROCHE, SERGE, GERMAIN COURAGE, and PIERRE DEVINOY. *Mirrors*. New York: Rizzoli, 1985.

ROCK, HOWARD B. *Artisans of the New Republic: The Tradesmen of New York City in the Age of Jefferson*. New York: New York University Press, 1979.

RODRIQUEZ ROQUE, OSWALDO. *American Furniture at Chipstone*. Madison: University of Wisconsin Press, 1984.

ROELKER, WILLIAM G., and CLARKSON A. COLLINS. *One Hundred Fifty Years of Providence Washington Insurance Company, 1799–1949*. Providence, R.I.: Providence Washington Insurance Co., 1949.

RORABAUGH, W. J. *The Craft Apprentice: From Franklin to the Machine Age in America*. New York: Oxford University Press, 1986.

ROTH, RODRIS. "Tea-Drinking in Eighteenth-Century America: Its Etiquette and Equipage." In Robert Blair St. George, ed., *Material Life in America, 1600–1860*, pp. 439–62. Boston: Northeastern University Press, 1988.

ROWE, ANN POLLARD. "Crewel Embroidered Bed Hangings in Old and New England." *Bulletin of the Museum of Fine Arts, Boston* 71, nos. 365–66 (1973): 102–63.

RUTHERFORD, F.J. "The Furnishing of Hampton Court Palace, 1715–1737." *Old Furniture* 2, no. 7 (December 15, 1927): 180–81.

SACK, ALBERT. *Fine Points of Furniture: Early American*. New York: Crown Publishers, 1950.

SACK, HAROLD. "The Development of the American High Chest of Drawers." *Antiques* 133, no. 5 (May 1988): 112–27.

SACK, ISRAEL, INC. *American Antiques from Israel Sack Collection*. 9 vols. Washington, D.C.: Highland House Publishers, 1969–89.

ST. GEORGE, ROBERT B. "New England Turned Chairs of the Seventeenth Century: A Preliminary Manuscript." Unpublished manuscript, 1978.

ST. GEORGE, ROBERT B. *The Wrought Covenant: Source Material for the Study of Craftsmen and Community in Southeastern New England, 1620–1700*. Brockton, Mass.: Brockton Art Center/Fuller Memorial, 1979.

[SANGER, ABNER]. *Very Poor and of a Lo Make: The Journal of Abner Sanger*. Edited by Lois K. Stabler. Portsmouth, N.H.: Peter E. Randall for the Historical Society of Cheshire County, 1986.

SANTORE, CHARLES. *The Windsor Style in America*. 2 vols. Philadelphia: Running Press, 1981, 1987. Vol. 1, *A Pictorial Study of the History and Regional Characteristics of the Most Popular Furniture Form of 18th-Century America, 1730–1830*; vol. 2, *A Continuing Pictorial Study of the History and Regional Characteristics of the Most Popular Furniture Form of Eighteenth-Century America, 1730–1840*.

SCHERER, JOHN L. *New York Furniture at the New York State Museum*. Old Town Alexandria, Va.: Highland House Publishers, 1984.

SCHIFFER, HERBERT F. *The Mirror Book: English, American, and European*. Exton, Pa.: Schiffer Publishing, 1983.

SCHIFFER, PETER, NANCY SCHIFFER, and HERBERT SCHIFFER. *The Brass Book: American, English, and European, Fifteenth Century through 1850*. Exton, Pa.: Schiffer Publishing, 1978.

SCHIPPER-VAN LOTTUM, M.C.A. "A Work-Basket with a Sewing Cushion." *Bulletin of the Needle and Bobbin Club* 62 (1979): 3–44.

SEALE, WILLIAM. *Recreating the Historic House Interior*. Nashville, Tenn.: American Association for State and Local History, 1979.

SEMON, KURT M., ed. *A Treasury of Old Silver*. New York: Robert M. McBride and Co., 1947.

SHIXIANG, WANG. *Classic Chinese Furniture: Ming and Qing Dynasties*. London: Han-Shan Tang, 1986.

SINGLETON, ESTHER. *The Furniture of Our Forefathers*. New York: Doubleday, Page and Co., 1900–1901.

SLOANE, JEANNE VIBERT. "A Duncan Phyfe Bill and the Furniture It Documents." *Antiques* 131, no. 5 (May 1987): 1106–13.

SMITH, GEORGE. *A Collection of Designs for Household Furniture and Interior Decoration*. London, 1808. Reprint. New York: Praeger, 1970.

SMITH, ROBERT C. "Architecture and Sculpture in Nineteenth-Century Mirror Frames." *Antiques* 109, no. 2 (February 1976): 350–59.

SNOOK, BARBARA. *Florentine Embroidery*. New York: Charles Scribner's Sons, 1967.

SOANE, SIR JOHN. *Description of the House and Museum . . . The Residence of Sir John Soane*. London: Levey, Robson, and Franklyn, 1835.

SPALDING, DEXTER EDWIN. "Abner Toppan, Cabinetmaker." *Antiques* 15, no. 6 (June 1929): 493–95.

SPOFFORD, HARRIET PRESCOTT. *Art Decoration Applied to Furniture*. New York: Harper and Brothers, 1878.

SPRAGUE, LAURA FECYCH. "John Seymour in Portland, Maine." *Antiques* 131, no. 2 (February 1987): 444–49.

SPRAGUE, LAURA FECYCH, ed. *Agreeable Situations: Society, Commerce, and Art in Southern Maine, 1780–1830*. Kennebunk, Me.: Brick Store Museum, 1987.

STOCKWELL, DAVID. "Irish Influence in Pennsylvania Queen Anne Furniture." *Antiques* 79, no. 3 (March 1961): 269–71.

STOKES, J. *The Cabinet-Maker and Upholsterer's Companion.* 4th ed. Philadelphia: Henry Carey Baird, 1850.

STOKES, J. STOGDELL. "The American Windsor Chair." *Antiques* 9, no. 4 (April 1926): 222–27.

STONEMAN, VERNON C. *John and Thomas Seymour, Cabinetmakers in Boston, 1794–1816.* Boston: Special Publications, 1959.

STRETCH, CAROLYN WOOD. "Early Colonial Clockmakers in Philadelphia." *Pennsylvania Magazine of History and Biography* 56, no. 3 (1932): 225–35.

SWAIN, MARGARET. *Historical Needlework: A Study of Influences in Scotland and Northern England.* New York: Charles Scribner's Sons, 1970.

SWAN, MABEL MUNSON. "Coastwise Cargoes of Venture Furniture." *Antiques* 55, no. 4 (April 1949): 278–80.

SWAN, MABEL MUNSON. "General Stephen Badlam, Cabinetmaker and Looking-Glass Maker." *Antiques* 65, no. 5 (May 1954): 382–83.

SWAN, SUSAN BURROWS. *A Winterthur Guide to American Needlework.* New York: Crown Publishers, 1976.

SWAN, SUSAN BURROWS. "Worked Pocketbooks." *Antiques* 107, no. 2 (February 1975): 298–303.

SWANK, SCOTT T., et al. *Arts of the Pennsylvania Germans.* Edited by Catherine E. Hutchins. New York: W. W. Norton and Co. for the Henry Francis du Pont Winterthur Museum, 1983.

SWEENEY, KEVIN M. "Furniture and Furniture Making in Mid-Eighteenth-Century Wethersfield, Connecticut." *Antiques* 125, no. 5 (May 1984): 1156–63.

SWEENEY, KEVIN M. "Furniture and the Domestic Environment in Wethersfield, Connecticut, 1639–1800." *Connecticut Antiquarian* 36, no. 2 (December 1984): 10–39.

SYMONDS, R. W. "Cane Chairs of the Late 17th and Early 18th Centuries." *Connoisseur* 93, no. 391 (March 1934): 173–81.

SYMONDS, R. W. "Charles II. Couches, Chairs, and Stools." Part I, "1660–1670." *Connoisseur* 93, no. 289 (January 1934): 15–23. Part II, "1670–1680." *Connoisseur* 93, no. 290 (February 1934): 86–95.

SYMONDS, R. W. *English Furniture from Charles II to George II.* London: Connoisseur, 1929.

SYMONDS, R. W. "Two English Writing Cabinets." *Connoisseur* 141, no. 568 (April 1958): 83.

SYNGE, LANTO. *Antique Needlework.* Poole, England: Blandford Press, 1982.

SYNGE, LANTO, ed. *The Royal School Book of Needlework and Embroidery.* London: William Collins Sons & Co., 1986.

THORNTON, PETER. *Authentic Decor: The Domestic Interior, 1620–1920.* New York: Viking Press, 1984.

THORNTON, PETER. *Seventeenth-Century Interior Decoration in England, France, and Holland.* New Haven, Conn.: Yale University Press, 1978.

TRENT, ROBERT F. "The Chest of Drawers in America, 1635–1730: A Postscript." *Winterthur Portfolio* 20, no. 1 (Spring 1985): 31–48.

TRENT, ROBERT F. *Hearts and Crowns: Folk Chairs of the Connecticut Coast, 1720–1840, as Viewed in the Light of Henri Focillon's Introduction to Art Populaire.* New Haven, Conn.: New Haven Colony Historical Society, 1977.

TRENT, ROBERT F. *Historic Furnishing Report: Saugus Iron Works, National Historic Site.* Harpers Ferry, W.V.: Harpers Ferry Center, National Park Service, 1982.

TRENT, ROBERT F. "The Spencer Chairs and Regional Chair Making in the Connecticut River Valley, 1639–1820." *Connecticut Historical Society Bulletin* 49, no. 4 (Fall 1984): 175–94.

TRENT, ROBERT F. "Wheels within Wheels: The Genealogies of Some Major Connecticut River Valley Woodworking Artisans, 1720–1800." Typescript, Connecticut Historical Society, Hartford, 1984.

TRENT, ROBERT F., ed. *Pilgrim Century Furniture: An Historical Survey.* New York: Main Street/Universe Books, 1976.

TRENT, ROBERT F., and PETER ARKELL. "The Lawton Cupboard: A Unique Masterpiece of Early Boston Joinery and Turning." *Maine Antique Digest* (March 1988): 1C–3C.

TRENT, ROBERT F., and NANCY LEE NELSON. "New London County Joined Chairs, 1720–1790." *Connecticut Historical Society Bulletin* 50, no. 4 (Fall 1985): 1–195.

VAN DEVANTER, ANN C. *"Anywhere So Long as There Be Freedom": Charles Carroll of Carrollton, His Family, and His Maryland.* Baltimore: Baltimore Museum of Art, 1975.

VENABLE, CHARLES. *American Furniture in the Bybee Collection.* Austin: University of Texas Press in association with the Dallas Museum of Art, 1989.

VERLET, PIERRE. *French Royal Furniture.* London: Barrie and Rockliff, 1963.

VERLET, PIERRE. *Le Mobilier Royal Francais: Meubles de la Couronne Conserve en France.* Paris: Les Editions d'art et d'histoire, 1945.

*Villa Terrace Inaugural Exhibition, June 11 through July 30, 1967.* Introduction by Tracy Atkinson. Milwaukee: Milwaukee Art Center—Museum of Decorative Arts, 1967.

VOGEL, ANNE H. *Focus: The Flower in Art.* Milwaukee: Milwaukee Art Museum, 1986.

VON BODE, WILHELM. *Italian Renaissance Furniture.* New York: William Helburn, 1921.

VON FALKE, OTTO. *Deutsche Mobel des Mittelalters und der Renaissance.* Stuttgart: Verlag von Julius Hoffman, 1924.

WARD, BARBARA MCLEAN, and GERALD W.R. WARD, eds. *Silver in American Life: Selections from the Mabel Brady Garvan and Other Collections at Yale University.* New York: The American Federation of Arts; Boston: David R. Godine, 1979.

WARD, GERALD W.R. *American Case Furniture in the Mabel Brady Garvan and Other Collections at Yale University.* New Haven, Conn.: Yale University Art Gallery, 1988. Distributed by Yale University Press.

WARD, GERALD W.R., ed. *Perspectives on American Furniture.* New York: W. W. Norton and Co., 1988.

WARDLE, PATRICIA. *Guide to English Embroidery.* London: Victoria and Albert Museum, 1970.

WARREN, DAVID B. *Bayou Bend: American Furniture, Paintings, and Silver from the Bayou Bend Collection.* Houston: Museum of Fine Arts, Houston, 1975.

WARREN, DAVID B., KATHERINE S. HOWE, and MICHAEL K. BROWN, with an introduction by Gerald W. R. Ward. *Marks of Achievement: Four Centuries of American Presentation Silver.* New York: Museum of Fine Arts, Houston, in association with Harry N. Abrams, 1987.

WARREN, WILLIAM L., and HERBERT CALLISTER. *Bed Ruggs, 1722–1833.* Hartford, Conn.: Wadsworth Atheneum, 1972.

WATSON, FRANCIS J. B. "The Eye of Thomas Jefferson: Americans and French 18th-Century Furniture in the Age of Jefferson." *Antiques* 110, no. 1 (July 1976): 118–25.

WEIDMAN, GREGORY R. *Furniture in Maryland, 1740–1940: The Collection of the Maryland Historical Society.* Baltimore: Maryland Historical Society, 1984.

WELLS-COLE, ANTHONY. "An Oak Bed at Montacute: A Study in Mannerist Decoration." *Furniture History* 17 (1981): 1–19.

WILLARD, JOHN WARE. *Simon Willard and His Clocks.* 1911. Reprint. New York: Dover Publications, 1968.

*The Williamsburg Collection of Antique Furnishings.* Williamsburg, Va.: Colonial Williamsburg Foundation, 1973.

WILSON, MICHAEL I. *William Kent: Architect, Designer, Painter, Gardener, 1685–1748.* London: Routledge and Kegan Paul, 1984.

YOUNG, M. ADA. "Five Secretaries and the Cogswells." *Antiques* 88, no. 4 (October 1965): 478–85.

ZEA, PHILIP. "Clockmaking and Society at the River and the Bay: Jedediah and Jabez Baldwin, 1790–1820." In *The Bay and the River: 1600–1900*, edited by Peter Benes, pp. 43–59. Annual Proceedings of the Dublin Seminar for New England Folklife, vol. 6 (1981). Boston, Mass.: Boston University Scholarly Publications, 1982.

ZEA, PHILIP. "Furniture." In *The Great River: Art and Society of the Connecticut Valley, 1635–1820*, edited by William N. Hosley, Jr., and Gerald W. R. Ward, pp. 185–91. Hartford, Conn.: Wadsworth Atheneum, 1985.

ZERWICK, CHLOE. *A Short History of Glass.* Corning, N.Y.: Corning Museum of Glass, 1980.

ZIMMERMAN, PHILIP D. "Workmanship as Evidence: A Model for Object Study." *Winterthur Portfolio* 16, no. 4 (Winter 1981): 283–307.

# INDEX

Page numbers in *italics* refer to illustrations.

# PHOTOGRAPH CREDITS

With the exceptions noted below, all of the original photographs reproduced in this book were taken by P. RICHARD EELLS.

RICHARD CHEEK
Colorplates: frontispiece, cats. 3, 5 (detail), 16, 26, 41, 43 (detail), 45 (closed), 58, 62 (detail), 62, 77, 97, 102, 112.
Black-and-white illustrations: Cats. 3, 3d, 26, 45 (open), 62, 102; Appendix B, figs. 2, 3.

THE BROOKLYN MUSEUM
Appendix B, fig. 1.

R. BRUCE HOADLEY
Appendix A, figs. 1–6.

WINTERTHUR MUSEUM LIBRARY
p. 163.

# NOTES ON THE AUTHORS

R. BRUCE HOADLEY received his undergraduate degree in forestry from the University of Connecticut and his doctorate in wood technology from Yale University. He is the author of *Understanding Wood: A Craftsman's Guide to Wood Technology* (1980), *Identifying Wood: Accurate Results with Simple Tools* (1991), a contributing editor of *Fine Woodworking*, and author of many articles in professional journals. He is a professor of wood science and technology at the University of Massachusetts in Amherst.

BROCK W. JOBE is Chief Curator of the Society for the Preservation of New England Antiquities in Boston, Massachusetts. A graduate of Wake Forest University, he received his master's degree from the Winterthur Program at the University of Delaware and is a doctoral candidate in American and New England Studies at Boston University. He was a member of the curatorial staffs of the Museum of Fine Arts, Boston, and Colonial Williamsburg before joining SPNEA in 1979. He is co-author of *New England Furniture, the Colonial Era: Selections from the Society for the Preservation of New England Antiquities* (1984) and a contributor to *Paul Revere's Boston, 1735–1818* (1975). Among the works he has edited are *Boston Furniture of the Eighteenth Century* (1974) and *New England Furniture: Essays in Memory of Benno M. Forman* (1987).

ELIZABETH G. LAHIKAINEN is Head Upholstery Conservator at the Conservation Center of the Society for the Preservation of New England Antiquities in Waltham, Massachusetts. She received her undergraduate degree in textile studies from Syracuse University, where she also did her graduate work in textile conservation and textile history. She was a Kress Foundation Fellow for Advanced Training in Conservation in 1984–85, and is a noted lecturer and consultant on various aspects of conservation.

THOMAS S. MICHIE, a graduate of Williams College, holds the A.M. and M.Phil. degrees in the history of art from Yale University. Currently Curator of Decorative Arts at the Museum of Art of the Rhode Island School of Design in Providence, where he has been on the staff since 1984, he is the co-author of *American Furniture in Pendleton House* (1986) and *Furniture in Print: Pattern Books from the Redwood Library* (1989), and editor of *John Prip: Master Metalsmith* (1987). His other publications include the chapter on "Timepieces" in *Decorative Arts and Household Furnishings in America, 1650–1920: An Annotated Bibliography* (1989) and *Festivities of Form: Historical Crafts from New England Collections* (1984).

JAYNE E. STOKES is Assistant Curator of Decorative Arts at the Milwaukee Art Museum. A graduate of the University of New Hampshire, she received her master's degree in history museum studies from the Cooperstown Graduate Programs. She has been on the staff of the Society for the Preservation of New England Antiquities and the Baltimore Museum of Art, and has served as a consultant to the Mattatuck Museum, New Jersey Historical Society, Canterbury Shaker Village, and other institutions. She is co-author of *American Furniture, 1680–1880, from the Collection of the Baltimore Museum of Art* (1987).

ROBERT F. TRENT, a graduate of Boston University, received his master's degree from the Winterthur Program at the University of Delaware and has done additional graduate work at Yale University. Formerly on the staff of the Museum of Fine Arts, Boston, and the Connecticut Historical Society, he is currently Curator and In Charge of Furniture at the Henry Francis du Pont Winterthur Museum. He is particularly noted for his major role in the exhibition and catalogue entitled *New England Begins: The Seventeenth Century* (1982). He is the author of *Hearts and Crowns: Folk Chairs of the Connecticut Coast, 1710–1840* (1977), co-author of "New London County Joined Chairs, 1720–1790" (1985), editor of *Pilgrim Century Furniture: An Historical Survey* (1976), and has pub-

lished many articles and exhibition catalogues on
early American furniture and upholstery.

ANNE H. VOGEL, a graduate of Vassar College,
received her master's degree in art history from the
University of Wisconsin-Milwaukee. She has orga-
nized several exhibitions at the Milwaukee Art
Museum, including "Candlesticks: Four Hundred
Years, 1400–1800" (1979) and "Focus: The Flower in
Art" (1986). Her publications include *American Colonial
Portraits* (1983), *Focus: The Flower in Art* (1986), and
contributions to *The Art of the Marvelous: The Baroque in
Italy* (1984) and *Hidden Treasures: Wisconsin Collects
Painting and Sculpture* (1987).

GERALD W.R. WARD, a graduate of Harvard College,
received his Ph.D. in American and New England
Studies from Boston University. Formerly on the staff
of the Yale University Art Gallery and Winterthur
Museum, he is currently Curator of Strawbery Banke
Museum in Portsmouth, New Hampshire. He is the
author of *American Case Furniture in the Mabel Brady
Garvan and Other Collections at Yale University* (1988).
Among the publications he has edited or substantially
contributed to are *The Eye of the Beholder: Fakes, Replicas,
and Alterations in American Art* (1977), *Silver in American
Life* (1979), *The Work of Many Hands: Card Tables in
Federal America, 1790–1820* (1982), *The American

*Illustrated Book in the Nineteenth Century* (1987),
*Perspectives on American Furniture* (1988), and *Decorative
Arts and Household Furnishings in America, 1650–1920:
An Annotated Bibliography* (1989). He has served as
editor and book review editor of the Decorative Arts
Society *Newsletter* (1981–85) and as an associate editor
and book review editor of *Winterthur Portfolio* (1985–88).

PHILIP D. ZIMMERMAN, a graduate of Yale College,
received his master's degree from the Winterthur
Program at the University of Delaware and his doctor-
ate in American and New England Studies from
Boston University. Formerly Curator of the Currier
Gallery of Art and Executive Director of the Historical
Society of York County, he has been Senior Curator
and Director of the Museum Collections Division at
the Winterthur Museum since 1986. He is the author
of *Turn of the Century Glass: The Murray Collection of
Glass* (1983), co-author of *New England Meeting House
and Church, 1630–1850* (1979), and has published several
major articles on American furniture, including
"Regionalism in American Furniture Studies" in
*Perspectives on American Furniture* (1988) and
"Workmanship as Evidence: A Model for Object
Study" (1981) and "A Methodological Study in the
Identification of Some Important Philadelphia
Chippendale Furniture" (1979) in *Winterthur Portfolio*.

The Reverend Timothy Cutler D.D.
of Christ Church Boston N:E:

P. Pelham pinx: et fecit 1750.                    Sold by P. Pelham in Boston.

**THE REVEREND TIMOTHY CUTLER, D.D.**
**INSTRUCTOR, LEARNED SCHOLAR, THEOLOGIAN, PREACHER**

*Born March 31, 1684, at Charlestown, Massachusetts.*
*Baptized in the Congregational Church.*
*Graduated from Harvard College, A.B. 1701.*
*Ordained January 1709 and married Elizabeth Andrew, March 1710.*
*Father of eight children.*
*Rector of Yale College, 1719–22.*
*Convert to the Church of England and advocate of the Episcopal faith.*
*Minister of Christ Church, Boston, the "Old North Church."*
*Died at Boston, August 17, 1765, at the age of 81.*

**MEZZOTINT BY PETER PELHAM (1695[?]–1751)**
**AFTER A PAINTING OF TIMOTHY CUTLER BY THE ARTIST.**
*Published in Boston in 1750. Signed by Pelham in the plate.*

**GIVEN TO THE MILWAUKEE ART MUSEUM IN MEMORY OF ROBERT LANE COBURN**
**BY ANNE H. VOGEL AND FREDERICK VOGEL III**
**M1980.74**